WRITING FICTION

A Guide to Narrative Craft

Fifth Edition

JANET BURROWAY

Florida State University

An imprint of Addison Wesley Longman, Inc.

New York • Reading, Massachusetts • Menlo Park, California • Harlow, England
Don Mills, Ontario • Sydney • Mexico City • Madrid • Amsterdam

Acquisitions Editor: Janice Wiggins Clarke

Sponsoring Development Manager: Arlene Bessenoff

Development Editor: Carol Hollar-Zwick Marketing Manager: Melanie Goulet

Full Service Production Manager: Valerie Zaborski

Project Coordination, Text Design, and Electronic Page Makeup: Elm Street

Publishing Services, Inc.

Cover Designer/Manager: Nancy Danahy

Cover Montage: Nancy Danahy Senior Print Buyer: Hugh Crawford

Printer and Binder: The Maple-Vail Book Manufacturing Group

Cover Printer: Coral Graphic Services

For permission to use copyrighted material, grateful acknowledgment is made to the copyright holders on page 377, which are hereby made part of this copyright page.

Library of Congress Cataloging-in-Publication Data

Burroway, Janet.

Writing fiction: a guide to narrative craft / Janet Burroway.—5th ed.

p. cm.

Includes bibliographical references (p. 371) and index.

ISBN 0-321-02689-6

1. Fiction—Technique. 2. Fiction—Authorship. 3. Narration (Rhetoric).

4. Creative writing. I. Title.

PN3355.B79 2000

808.3—dc21

99-25518

CIP

Copyright © 2000 by Janet Burroway

All rights reserved. No part of this publication may be reproduced, stored in a retrieval system, or transmitted, in any form or by any means, electronic, mechanical, photocopying, recording, or otherwise, without the prior written permission of the publisher. Printed in the United States.

Please visit our website at http://www.awlonline.com

ISBN 0-321-02689-6

2345678910—MA—02010099

For David Daiches, mentor and friend

Banish your chities
for your first dropt,
welcome her back for
the revesion.

In Tulyer

CONTENTS

Dro	taca	VI
PIE	face	χi

I	WHATEVER WORKS: The Writing Process
	Get Started 3
	Journal Keeping 3
	Freewriting 4
	Clustering 5
	The Computer 8
	The Critic: A Caution 8
	Choosing a Subject 9
	Keep Going 13
	A Word about Theme 15
	"Shitty First Drafts" 16 ANNE LAMOTT
	From "The Writing Life" 19 ANNIE DILLARD
	Writing Assignments 26
2	THE TOWER AND THE NET: Story Form and Structure 27
	Conflict, Crisis, and Resolution 29
	Connection and Disconnection 33
	Story Form as a Check Mark 35
	Story and Plot 39
	The Short Story and the Novel 41

3 SEEING IS BELIEVING: Showing and Telling 53
Significant Detail 54
Filtering 59

"The Use of Force" 42
WILLIAM CARLOS WILLIAMS
"How Far She Went" 46

MARY HOOD
Writing Assignments 52

The Active Voice 61 Prose Rhythm 63 Mechanics 66

"The Things They Carried" 67

TIM O'BRIEN

"Where Are You Going, Where Have You Been?" 80 JOYCE CAROL OATES

Retrospect 92 Writing Assignments 92

4 BOOK PEOPLE: Characterization, Part I 94

Credibility 97

Purpose 99

Complexity 100

The Indirect Method of Character Presentation:

Authorial Interpretation 102

The Direct Methods of Character Presentation 104

Appearance 104

Action 106

"The Enormous Radio" 109

IOHN CHEEVER

"Yours" 117

MARY ROBISON

"The Only Traffic Signal on the Reservation Doesn't Flash Red

Anymore" 119

SHERMAN ALEXIE

Retrospect 125

Writing Assignments 125

THE FLESH MADE WORD: Characterization, Part II

The Direct Methods of Character Presentation (Continued) 128

Speech 128

Format and Style 135

Thought 138

Conflict Between Methods of Presentation 139

Creating a Group or Crowd 143

Character: A Summary 144

"Girls at War" 145

CHINUA ACHEBE

"Saint Marie" 156

LOUISE ERDRICH

Retrospect 165

Writing Assignments 165

6 LONG AGO AND FAR AWAY: Fictional Place and Time 167

Setting and Atmosphere 169

Harmony and Conflict between Character and Background 170

Symbolic and Suggestive Setting 171

Alien and Familiar Setting 175

An Exercise in Setting 176

Some Aspects of Narrative Time 178

Summary and Scene 178

Flashback 182

Slow Motion 183

"A Very Old Man with Enormous Wings" 185

GABRIEL GARCÍA MARQUEZ

"Bullet in the Brain" 190

TOBIAS WOLFF

Retrospect 194

Writing Assignments 194

7 CALL ME ISHMAEL: Point of View. Part I 196

Who Speaks? 197

Third Person 197

Second Person 202

First Person 204

To Whom? 205

The Reader 206

Another Character 207

The Self 208

In What Form? 211

"Girl" 213

JAMAICA KINCAID

"Hips" 215

SANDRA CISNEROS

"Royal Beatings" 217

ALICE MUNRO

Retrospect 233

Writing Assignments 234

8 ASSORTED LIARS: Point of View, Part II 235

At What Distance? 235
Spatial and Temporal Distance 237
Intangible Distance 240

With What Limitations? 243

The Unreliable Narrator 244

An Exercise in Unreliability 245

Unreliability in Other Viewpoints 247

"Gryphon" 248

CHARLES BAXTER

"Jealous Husband Returns in Form of Parrot" 261

ROBERT OLEN BUTLER

Retrospect 266

Writing Assignments 266

9 IS AND IS NOT: Comparison 268

Types of Metaphor and Simile 269
Metaphoric Faults to Avoid 273
Allegory 277
Symbol 278
The Objective Correlative 280

"San" 282

LAN SAMANTHA CHANG

"The Falling Girl" 290

DINO BUZZATI

"Menagerie" 294

CHARLES JOHNSON

Retrospect 301

Writing Assignments 301

10 I GOTTA USE WORDS WHEN I TALK TO YOU:

Theme 303

Idea and Morality in Theme 304 How Fictional Elements Contribute to Theme 30

"A Man Told Me the Story of His Life" 307

GRACE PALEY

Developing Theme as You Write 309

"Ralph the Duck" 313

FREDERICK BUSCH

"Ad Infinitum: A Short Story" 324
JOHN BARTH

Retrospect 329 Writing Assignments 330

11 PLAY IT AGAIN, SAM: Revision 332

Worry It and Walk Away 333 Criticism 335 Revision Questions 336 An Example of the Revision Process 337

"Wanting to Fly" 342
STEPHEN DUNNING

"The Bath" 344

RAYMOND CARVER

"A Small, Good Thing" 349
RAYMOND CARVER

Retrospect 366 Writing Assignments 366

Appendix A: Kinds of Fiction 367

Appendix B: Suggestions for Further Reading 371

Credits 377

Index 378

- The set of the Albert The Albert

and the second

PREFACE

Writing Fiction is primarily intended for use in the college-level writing workshop—a phenomenon still tentative at mid-century, but now so firmly established that nearly every higher institution in America offers some form of workshop-based creative writing course or program, and sufficiently evolved that it has given rise to a new verb—"to workshop."

To workshop is much more than to discuss. It implies a commitment on the part of everyone concerned to give close attention to work that is embryonic. The atmosphere of such a group is intense and personal in a way that other college classes are not; it must be so, since a major text of the course is also the raw effort of its participants. At the same time, unlike the classic model of the artist's atelier or the music conservatory, the instruction is assumed to come largely from the group rather than from a single master of technical expertise, and this assumption is in turn based on the notion that both language and storytelling are the province of everyone. Thus the workshop represents a democratization of both the material for college study and its teaching.

Although workshops inevitably vary, a basic pattern has evolved in which twelve to twenty students are led by an instructor who is also a published writer. The students take turns writing, copying, and distributing stories, which the others take away, read, and critique. The group meets for discussion of two to five of these, each discussion usually begun by a class member who has agreed to prepare a "reading" of the story. Others join in, questioning or clarifying interpretation, pointing out strengths and weaknesses, offering suggestions toward revision. In some workshops the author is given a chance, late in the discussion, to ask questions. What is sought in such a group is mutual goodwill—the desire to make the story under scrutiny the best that it can be—together with an agreed-to toughness on the part of writer and readers.

This sounds simple enough, but the workshop has proved both powerful and controversial. As with all democratization, the perceived danger is that the process will flatten out the standards of the writer-teacher or the writer-student or both—a line of thought compounded by postmodern critics who would like to level all culture, claiming that Shakespeare, Dickinson, Drabble, Madonna, and The Rugrats occupy spaces side-by-side on our scale of English-language artifacts. The danger is partly real and deserves care and attention. Partly, however, such fear masks protectiveness toward the image—solitary, remote, romantic—of the writer's life.

Some of the wittiest and wickedest writers have turned their barbs on the target. Gore Vidal claimed that "Teaching has ruined more American novelists than

drink." Asked if she thought that universities stifled writers, Flannery O'Connor famously replied, "My opinion is that they don't stifle enough of them."

But it's my experience that—as with religion, perhaps, or divorce, or therapy, or the owning of pets-most of those who decry creative writing in the university tend to be those who did not take part in the process, and those who did tend to champion and recommend it. John Gardner, one of the most positive practitioners of the workshop, asserted that not only could writing be taught, but that "writing ability is mainly a product of good teaching supported by a deep-down love of writing. Though learning to write takes time and a great deal of practice, writing up to the world's ordinary standards is fairly easy." John Irving says of his instructors, "they clearly saved me valuable time . . . [and] time is precious for a young writer." Robert Stone has observed, "The idea that young writers ought to be out slinging hash or covering the fights or whatever is bullshit. There's a point where a class can do a lot of good. You know, you throw the rock and you get the splash." Isabel Allende says, "The process is lonely, but the response connects you with the world.... Every reader writes the other half of the book. You only give them half, and they provide the rest with their own biography, with their own experiences, their values." And Kurt Vonnegut has cogently assessed that, "In a creative writing class of twenty people anywhere in the country, six students will be startlingly talented."

There are, I think, three questions about the workshop endeavor that have to be asked: Is it good for the most startlingly talented, those who will go on to "become" published professional writers? Is it good for the majority who will not publish, but will instead become (as some of my most gifted students have) restaurateurs, photographers, financial consultants, high-school teachers? And is it good for literature and literacy generally to have the not-particularly-gifted struggle toward this play and this craft?

My answer must in all cases be a vigorous yes. The workshop aids both the vocation and the avocation. Writing is a solitary struggle, and from the beginning writers have sought relief in the company and understanding of other writers. At its best the workshop provides an intellectual, emotional, and social (and some argue a spiritual) discipline. For the potential professionals there is the important focus on craft; course credit is a form of early pay-for-writing; deadlines help you find the time and discipline to do what you really want to; and above all, the workshop offers attention ("you get the splash") in an area where attention is hard to command. For those who are testing their talent and commitment and will leave this work for some other, it offers the testing ground. For those who will not be professionals, a course in writing fiction performs the same function as a course in history or physics does for those who will not be professional historians or physicists; it is a valuable part of a liberal education. It can make for better readers, better letters home, better company reports, and better private memoirs. For everyone, the workshop can help develop critical thinking, a respect for craft, and important social skills.

There are also some pitfalls in the process: that students will develop unrealistic expectations of their chances in a chancy profession; that they will dull or provincialize their talents by trying to please the teacher or the group; that they will be

buoyed into self-satisfaction by too-lavish praise or crushed by too-harsh criticism. On the other hand, workshop peers recognize and revere originality, vividness, and truth at least as often as professional critics. Hard work counts for more than anyone but writers realize, and facility with the language can be learned out of obsessive attention to it. The driven desire is no guarantee of talent, but it is an annealing force. And amazing transformations can and do occur in the creative writing class. Sometimes young writers who exhibit only a propensity for cliché and the most hackneved initial efforts make sudden, breathtaking progress. Sometimes the leap of imaginative capacity is inexplicable, like a sport of nature.

The appropriate atmosphere in which to foster this metamorphosis is what the Italians call mesura. It is a balance constructed of right-brain creative play and leftbrain crafted language, of obligations among readers, writers, and teacher, some of them mundane and some of them unique to the workshop. Of these obligations, a

few seem to me worth noting.

The most basic is that the manuscript itself should be professionally presented that is, double-spaced on one side of white 81/2-by-11-inch paper, with generous margins, in clear copies, proofread for grammar, spelling, and punctuation. In most workshops the matter is left entirely to the writer, with no censorship of subject. As regards form, on the other hand, it's understood that college workshops are for people who want to learn to write literary fiction. Genre fiction (fantasy, romance, adventure) are likely to be unacceptable because they rely on narrow formulae referential to the genre rather than to vivid or original use of the language. Most students and teachers are not equipped to critique the use of these formulae, nor will their learning improve the literary skills of other workshop members.

The reader's obligation is to read the story twice, once for its sense and story, a second time with pen in hand to make marginal comments, observations, suggestions. A summarizing end note is usual and helpful. This should be done with the understanding that the work at hand is by definition a work in progress. If it were finished then there would be no reason to bring it into workshop. Such a reading demands a discipline not called for in most college classes, a deliberate stilling of the irritation that is an automatic or a trained reaction to the imperfect. Workshop readers should school themselves to identify the successes that are in every story, the potential strength, the interesting subject matter, the pleasing shape, or the vivid

detail.

It's my experience that the workshop itself proceeds most usefully to the writer if each discussion begins with a critically neutral description and interpretation of the story. This is important because workshopping can descend into a litany of I like, I don't like, and it's the responsibility of the presenter to provide a coherent reading as a basis for discussion. It's often a good idea to begin with a detailed summary of the narrative action—useful because if class members understand the events of the story differently, or are unclear about what happens, this is important information for the author, a signal that she has not revealed what, or all, she meant. The reading might then address such questions as: What kind of story is this? What other stories does it suggest? What is its relation to the conflict-crisis-resolution structure? What is it about? What does it say about what it is about? What degree of identification with the protagonist does it invite? How does its imagery relate to its theme? How is point of view employed? What effect on the reader does it seem to want to produce?

Only after some such questions are addressed should the critique begin to deal with whether the story is successful in its effects. The presenter should try to close with two or three questions that, in his/her opinion, the story raises, and invite the class to consider these. Most of the questions will be technical: Is the action clear, is the point of view consistent, are the characters fully drawn, is the imagery vivid and specific? But now and again it is well to pause and return to more substantive matters: What's the spirit of this story, what is it trying to say, what does it make me feel?

For the writer, the obligations are more emotionally strenuous, but the rewards are great. The hardest part of being a writer in a workshop is to learn this: Be still, be greedy for suggestions, take everything in, and don't defend.

This is difficult because the story under discussion is a sort of baby on the block. The progenitor has a strong impulse to explain and plead, and even to blame the reader. If the criticism is this isn't clear, it's hard not to feel you didn't read it right—even if you understand that although the workshop members have an obligation to read with special care, it is not up to them to "get it" but up to the author to be clear. If the complaint is this isn't credible, it's very hard not to respond but it really happened!—even though you know perfectly well that credibility is a different sort of fish than fact, and that autobiography is irrelevant. There is also a self-preservative impulse to keep from changing the core of what you've done: Why should I put in all that effort?

But only the effort of complete receptivity will make the workshop work. The chances are that your first draft really does not say the most meaningful thing inherent in the story, and that most meaningful thing may announce itself sideways, in a detail, within parentheses, an afterthought, a slip. Somebody else may see the design before you do, and perhaps even reveal something you did not—and may never—see. Sometimes the best advice comes from the most surprising source. The thing you resist the hardest may be exactly what you need.

After the workshop, the writer's obligation alters slightly. It's important to take the written critiques and take them seriously, let them sink in with as good a will as you brought to the workshop. But part of the need is also not to let them sink in too far. Reject without regret whatever seems on reflection wrongheaded, dull, destructive, or irrelevant to your vision. It's just as important to be able to discriminate between helpful and unhelpful criticism as it is to be able to write. It is in fact the same thing as being able to write. So listen to everything and receive all criticism as if it were golden. Then listen to yourself and toss the dross.

I want to add one more note of advice for workshop members, because my colleagues and I have noticed over recent years an increasing anxiety, both in the workshop and in individual young writers, about "developing a voice."

Voice—which involves syntax, vocabulary, rhythm, and tone, but is more than the sum of those parts—can be heard in dialogue, in a narrator, and also over the span of a career—the "author's voice." It's this last that seems a source of angst. The concept is both simple and elusive. Voice is what used to be called style, but with an

added emphasis on recognizability. Just as, on the phone, after a phrase or two you recognize a familiar voice, so the printed voice of an author or character, and even an author through a character, identifies itself, though how it does so might take more than a little skill and science to analyze.

The advice part is this: Forget about it. Tell your story, know your characters, search for clear, direct, and original language. Like a "universal" message, voice is something that emerges through and from the writing and cannot be *intended*. Like a rainbow, it won't be where you go to seek it. It is as intrinsic as personality, and like personality, will announce any efforts at artificial construction. Keep the work in focus; the voice will come.

So many people have helped with the fifth edition of *Writing Fiction* that they constitute a far-flung workshop. I want to thank first of all Beth Watzke for industry and insight, and as always my colleagues in the Writing Program at Florida State University, especially Mark Winegardner and Sheila Taylor; and Claudia Johnson in the Film School. Jamy Patterson asked the right questions, and Stanley Burroway added some needed answers. Julia Kling was always ready to let me moil aloud. My husband, Peter Ruppert, fed me in more ways than one while I was at work.

Susan Weinberg of Appalachian State University was once again both generous and focused in her suggestions, as was Tony Ardizzone of Indiana University at Bloomington. I am grateful to my reviewers: Barbara Barnard, Hunter College; Mary Baron, University of North Florida; William Boggs, Slippery Rock University; Julie Checkoway, University of Georgia; Renny Christopher, California State University—Stanislaus; James L. Clark, University of North Carolina—Greensboro; Brian Fitch, University of Wisconsin-Stout; Elizabeth Franken Hepburn, University of Illinois at Chicago; Jack Hicks, University of California—Davis; Will Hochman, University of Southern Colorado; Marianna Hofer, University of Findlay; Robert Houston, University of Arizona; Jo-Ann Mapson, University of California—Irvine; Nancy McLelland, Mendocino College; Alyce Miller, Indiana University—Bloomington; William Miller, George Mason University; Kathleen O'Shaughnessy, Portland Community College; Joseph Powell, Central Washington University; Lynn Wallace, Gulf Coast Community College; Margaret Blair Young, Brigham Young University; to my development editor Carol Hollar-Zwick, and my project editor Michele Heinz.

WHATEVER WORKS The Writing Process

- · Get Started
- · Keep Going
- · A Word about Theme

You want to write. Why is it so hard?

There are a few lucky souls for whom the whole process of writing is easy, for whom the smell of fresh paper is better than air, whose minds chuckle over their own agility, who forget to eat, and who consider the world at large an intrusion on their good time at the typewriter. But you and I are not among them. We are in love with words except when we have to face them. We are caught in a guilty paradox in which we grumble over our lack of time, and when we have the time, we sharpen pencils, make phone calls, or clip the hedges.

Of course, there's also joy. We write for the satisfaction of having wrestled a sentence to the page, for the rush of discovering an image, for the excitement of seeing a character come alive. Even the most successful writers will sincerely say that these pleasures—not money, fame, or glamour—are the real rewards of writing. Fiction writer Alice Munro concedes:

It may not look like pleasure, because the difficulties can make me morose and distracted, but that's what it is—the pleasure of telling the story I mean to tell as wholly as I can tell it, of finding out in fact what the story is, by working around the different ways of telling it.

Nevertheless we may forget what such pleasure feels like when we confront a blank page, like the heroine of Anita Brookner's novel Look at Me:

Sometimes it feels like a physical effort simply to sit down at the desk and pull out the notebook. . . . Sometimes the effort of putting pen to paper is so great that I literally feel a pain in my head. . .

It helps to know that most writers share the paradox of least wanting to do what we most want to do. It also helps to know some of the reasons for our reluctance. Jacques Barzun, in "A Writer's Discipline," suggests that it stems first of all from fear. The writer's intention, he says:

... is to transfer a part of our intellectual and emotional insides into an independent and self-sustaining outside. It follows that if we have any doubts about the strength, truth or beauty of our insides, the doubt acts as an automatic censor which quietly forbids the act of exhibition.

Novelist Richard Koster offers absolution for what writers tend to think of as "wasting time." In the process of creating a fiction we must divorce ourselves from the real world, he points out. And that is hard. The real world is insistent not only in its distractions but also in its brute physical presence. To remove ourselves from that sphere and achieve a state in which our mental world is more real requires a disciplined effort of displacement.

We may even sense that it is unnatural or dangerous to live in a world of our own creation. People love to read stories about the dreamer nobody thinks will amount to much, and who turns out to be a genius inventor, scientist, artist, or savior. Part of the reason such stories work is that we like to escape from the way the world really works, including the way it works in us. We all feel the pressure of the practical. The writer may sympathize with the dreamer-in-the-story but forget to sympathize with the dreamer-in-himself-or-herself.

There's another impediment to beginning, expressed by a writer character in Lawrence Durrell's *Alexandria Quartet*. Durrell's Pursewarden broods over the illusory significance of what he is about to write, unwilling to begin in case he spoils it. Many of us do this: The idea, whatever it is, seems so luminous, whole, and fragile, that to begin to write about that idea is to commit it to rubble. Knowing in advance that words will never exactly capture what we mean or intend, we must gingerly and gradually work ourselves into a state of accepting what words can do instead. No matter how many times we find out that what words can do is quite all right, we still shy again from the next beginning. Against this wasteful impulse I have a motto over my desk that reads: "Don't Dread; Do." It's a fine motto, and I contemplated it for several weeks before I began writing this chapter.

The mundane daily habits of writers are apparently fascinating. No author offers to answer questions at the end of a public reading without being asked: *Do you write in the morning or at night? Do you write every day? Do you compose on a word processor?* Sometimes such questions show a reverent interest in the workings of genius. More often, I think, they are a plea for practical help: *Is there something I can do to make this job less horrific? Is there a trick that will unlock my words?*

Get Started

The variety of authors' habits suggests that there is no magic to be found in any particular one. Donald Hall will tell you that he spends a dozen hours a day at his desk, moving back and forth between as many projects. Philip Larkin said that he wrote a poem only every eighteen months or so and never tried to write one that was not a gift. Gail Godwin goes to her workroom every day "because what if the angel came and I wasn't there?" Diane Wakowski thinks that to work against your will is evidence of bourgeois neurosis. Maria Irene Fornes begins her day with a half hour of loosening-up exercises, finding a comfortable center of gravity before she sits down to work. Mary Lee Settle advises that writers who teach must work in the morning, before the analytical habits of the classroom take over the brain; George Cuomo replies that he solves this problem by taking an afternoon nap. Dickens could not deal with people when he was working: "The mere consciousness of an engagement will worry a whole day." Hemingway and Thomas Wolfe wrote standing up. Some writers can plop at the kitchen table without clearing the breakfast dishes; others need total seclusion, a beach, a cat, a string quartet.

There is something to be learned from all this, though. It is not an "open sesame" but a piece of advice older than fairy tales: Know thyself. The bottom line is that if you do not at some point write your story down, it will not get written. Having decided that you will write it, the question is not "How do you get it done?" but "How do you get it done?" Any discipline or indulgence that actually helps nudge you into position facing the page is acceptable and productive. If jogging after breakfast energizes your mind, then jog before you sit. If you have to pull an all-nighter on a coffee binge, do that. Some schedule, regularity, pattern in your writing day (or night) will always help, but only you can figure out what that pattern is for you.

IOURNAL KEEPING

There are, though, a number of tricks you can teach yourself in order to free the writing self, and the essence of these is to give yourself permission to fail. The best place for such permission is a private place, and for that reason a writer's journal is an essential, likely to be the source of originality, ideas, experimentation, and growth.

Keep a journal. A journal is an intimate, a friend that will accept you as you are. Pick a notebook you like the look of, one you feel comfortable with, as you would pick a friend. I find a bound blank book too elegant to live up to, preferring instead a loose-leaf because I write my journal mainly at the computer and can stick anything in at the flip of a three-hole punch. But you can glue scribbled napkins into a spiral, too.

Keep the journal regularly, at least at first. It doesn't matter what you write and it doesn't matter very much how much, but it does matter that you make a steady habit of the writing. A major advantage of keeping a journal regularly is that it will put you in the habit of observing in words. If you know at dawn that you are committed

to writing so many words before dusk, you will half-consciously tell the story of your day to yourself as you live it, finding a phrase to catch whatever catches your eye. When that habit is established, you'll begin to find that whatever invites your attention or sympathy, your anger or curiosity, may be the beginning of invention. Whoever catches your attention may be the beginning of a character.

But before the habit is developed, you may find that even a blank journal page has the awesome aspect of a void, and you may need some tricks of permission to let yourself start writing there. The playwright Maria Irene Fornes says that there are two of you: one who wants to write and one who doesn't. The one who wants to write had better keep tricking the one who doesn't. Or another way to think of this conflict is between right brain and left brain—the spatial, playful, detail-loving creator, and the linear, cataloging, categorizing critic. The critic is an absolutely essential part of the writing process. The trick is to shut him or her up until there is something to criticize.

FREEWRITING

Freewriting is a technique that allows you to take very literally the notion of getting something down on paper. It can be done whenever you want to write, or just to free up the writing self. The idea is to put

anything on paper and I mena anything, it doesn't matter as long as it's coming out of your head nad hte ends of your fingers, down ont the page I wonder if;m improving, if this process gets me going better now than it did all those—hoewever many years ago? I know my typing is geting worse, deteriorating even as we speak (are we speaking? to whom? IN what forM? I love it when i hit the caps button by mistake, it makes me wonder whether there isn;t something in the back or bottom of the brain that sez PAY ATTENTION now, which makes me think of a number of things, freud and his slip o tonuge, self-deception, the myriad way it operates in everybody's life, no not everybody's but in my own exp. llike Aunt Ch. mourniong for the dead cats whenevershe hasn't got her way and can't disconnect one kind of sadness from another, I wonder if we ever disconnect kinds of sadness, if the first homesickness doesn;t operatfor everybody the same way it does for me, grandma's house the site of it, the grass out the window and the dog rolling a tin pie plate under the willow tree, great heavy hunger in the belly, the empty weight of loss, loss, loss

That's freewriting. Its point is to keep going, and that is the only point. When the critic intrudes and tells you that what you're doing is awful, tell the critic to take a dive, or acknowledge her/him (typing is getting worse) and keep writing. If you work on a computer, try dimming the screen so you can't see what you're doing. If you freewrite often, pretty soon you'll be bored with writing about how you don't feel like writing (though that is as good a subject as any; the subject is of no importance and neither is the quality of the writing) and you will find your mind and your

5

phrases running on things that interest you. Fine. It doesn't matter. Freewriting is the literary equivalent of scales at the piano or a short gym workout. All that matters is that you do it. The verbal muscles will develop of their own accord.

Though freewriting is mere technique, it can affect the freedom of the content. Many writers feel themselves to be *an instrument through which*, rather than a *creator* of, and whether you think of this possibility as humble or holy, it is worth finding out what you say when you aren't monitoring yourself. Fiction is written not so much to inform as to find out, and if you force yourself into a mode of informing when you haven't yet found out, you're likely to end up pontificating or lying some other way.

In Becoming a Writer, a book that only half-facetiously claims to do what teachers of writing claim cannot be done—to teach genius—Dorothea Brande suggests that the way to begin is not with an idea or a form at all, but with an unlocking of your thoughts at the typewriter. She advises that you rise each day and go directly to your desk (if you have to have coffee, put it in a thermos the night before) and begin writing whatever comes to mind, before you are quite awake, before you have read anything or talked to anyone, before reason has begun to take over from the dreamfunctioning of your brain. Write for twenty or thirty minutes and then put away what you have written without reading it over. After a week or two of this, pick an additional time during the day when you can salvage a half hour or so to, write, and when that time arrives, write, even if you "must climb out over the heads of your friends" to do it. It doesn't matter what you write. What does matter is that you develop the habit of beginning to write the moment you sit down to do so.

CLUSTERING

Clustering is a technique, described in full by Gabriele Rico in her book Writing the Natural Way, that helps you organize on the model of the right brain rather than the left, organically rather than sequentially. Usually when we plan a piece of writing in advance, it is in a linear fashion—topic sentences and subheadings in the case of an essay, usually an outline of the action in the case of fiction. Clustering is a way of quite literally making spatial and visual the organization of your thoughts.

To practice the technique, choose a word that represents your central subject, write it in the center of the page, and circle it. Then for two or three minutes free-associate by jotting down around it any word—image, action, abstraction, or part of speech—that comes to mind. Every now and again, circle the words you have written and draw lines or arrows between words that seem to connect. As with freewriting, it is crucial to keep going, without self-censoring and without worrying about whether you're making sense. What you're doing is *making*; sense will emerge. When you've clustered for two or three minutes, you will have a page that looks like a cobweb with very large dewdrops, and you will probably sense when it is enough. Take a few seconds, no more, to look at what you have done. (*Look at* seems more relevant here than *read over*, because the device does make you see the words as part of a visual composition.) Then start writing. Don't let the critic in yet. This will not be a

genuine freewrite because you've chosen the subject, but think of it as a freedraft or focused freewrite—and keep writing.

Here is a sample cluster of the preceding passage:

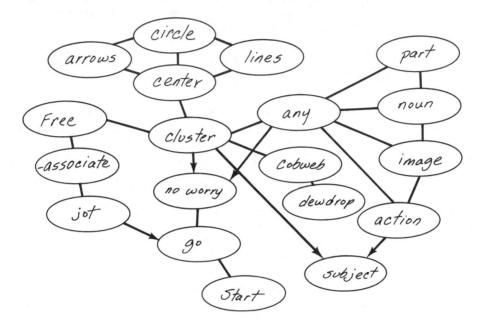

When I first encountered this device, I was aware that it was widely used for English composition classes and that it had also led to poetry and prose poems, but I doubted its usefulness for a fiction writer. I decided to try it, though, so I sat down to the first exercise offered in Rico's book, which was to cluster on the word "fear." I was not very thrilled with the project, but I wrote the word in the center of my page. As soon as I circled it, I realized that in the novel I was then writing, there was a lot of fear in the mind of the heroine, a Baltimore Catholic headed for the desert Southwest in 1914. I started free-associating her fear rather than my own, and images erupted out of nowhere, out of her childhood—a cellar, the smell of rotting apples and mice droppings, old newspapers, my heroine as a little girl squatting in the dank dark, the priest upstairs droning on about the catechism. Where had it all come from? Within fifteen minutes I had a two-paragraph memory for my character that revealed her to me, and to my reader, more clearly than anything I had yet written.

Now I cluster any scene, character, narrative passage, or reflection that presents me with the least hint of resistance. When I have a complicated scene with several characters in it, I cluster each character so I have a clear idea at the beginning how each is feeling in that situation. Even if, as is usually the case, the passage is written from the point of view of only one of them, I will know how to make the other characters react, speak, and move if I've been gathering cobwebs in their minds.

To take a simple example, suppose you are writing a scene in which Karl is furiously berating Jess for being late when an important guest was expected for dinner. The dialogue comes easily. But you're unclear about Jess's reaction. So you cluster what's going on in her mind:

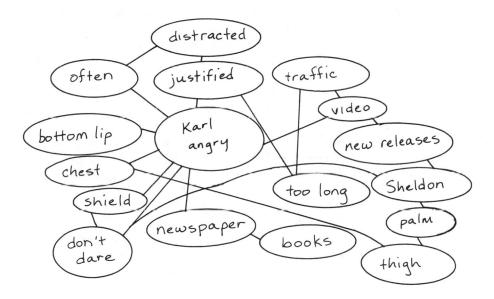

Naturally your cluster would be entirely different from this one and suited to your story. But though I started without any concept of these characters, the clustering tossed up these ideas in a few minutes: Karl is justified, Jess thinks; she got distracted at the video store when she ran into her old boyfriend Sheldon sifting through the new releases, and she stopped to talk to him for too long and got caught in rush-hour traffic—none of which she dares say to Karl. She's often distracted these days. Right now she can't concentrate on what Karl is saying because she's so interested in the way his bottom lip shakes when he's angry and the way he holds his newspaper like a shield over his chest—Sheldon always cupped his books in his palm and swung them against his thigh, she remembers. She wouldn't dare mention that either.

If the story were told from inside Jess's mind, then you might use much of this directly. But even if it were told from Karl's angry point of view, it would help you (and him) see her—the way she tries to poke the video out of sight in her handbag, the way she seems to be concentrating on his newspaper as if she were trying to read it off his chest. It might also help you hear her, how she mumbles complaining about rush hour, how she starts a sentence and then gives up on it.

Clustering is an excellent technique for journal keeping. It focuses your thoughts, cuts out extraneous material, and reduces writing time. In composing fiction, I recommend frequent clustering, followed by freedrafting and light editing. Then put the passage away for twenty-four hours. Like most recommendations, all this one means is that it seems to work for me.

I instinctively but unhappily followed a similar habit for many years before I discovered that I could make it work for me instead of against. I would sit at my desk from mid-morning to noon paralyzed by the cosmic weight of needing to write something absolutely wonderful. I would lunch at my desk regularly in despair. By midafternoon I would hate myself so thoroughly that I'd decide to splash anything down, any trash at all, just to be free of the blank page and feel justified in fleeing my paper prison. The whole evening would be tainted by the knowledge of having written such garbage. Next morning I would find that although it was mostly orange peels and eggshells, there was a little bit of something salvageable here and there. For a couple of intent hours I would work on that to make it right, feeling better, feeling good. Then I'd be faced with a new passage to begin, which, unlike that mess I'd cleaned up from yesterday, was going to emerge in rough draft as Great Literature. Lunch loomed in gloom.

Now, most days (allowing for a few failures, a few relapses into old habits), I write the junk quite happily straight away. Then I begin to tinker, usually with something I did yesterday or last week—which is where I concentrate, lose myself, and am transported into the word world. Often it's two o'clock before I remember to stop for my apple and chunk of cheese.

Cluster, freedraft, lightly edit, put away. I do urge you to try this, several times. What you are at this moment reading is no doubt a many-times turned-around, picked-at, honed, and buffed version of my paragraphs on clustering. But as I finish the first version, the document on my computer screen runs to three and a half pages, and only seventeen minutes have passed on my desk clock since I sat down to cluster the word "clustering." Moreover, I'm alert and having fun, and I feel like going on to add a word about the computer and the critic.

THE COMPUTER

I think it's important for a writer to try a pencil from time to time so as not to lose the knack of writing by hand, of jotting at the park or the beach without any source of energy but your own hand and mind.

But for most writers, a computer is a great aid to spontaneity. Freewriting frees more freely on a computer. The knowledge that you can so easily delete makes it easier to quiet the internal critic and put down whatever comes. The "wraparound" feature of the computer means that you need never be aware that what you write is chopped into lines of type on the page. Turn down the screen or ignore it, stare out the window into middle space. You can follow the thread of your thought without a pause.

THE CRITIC: A CAUTION

The cautionary note that needs to be sounded regarding all the techniques and technology that free you to write is that the critic is absolutely essential afterwards. Because revision—the heart of the writing process—will continue until you finally finish or abandon a piece of work, a chapter on revision is the last in this book. But

the revising process is continuous and begins as soon as you choose to let your critic in. Clustering and freedrafting allow you to create before you criticize, do the essential play before the essential work. Don't forget the essential work. The computer lets you write a lot because you can so easily cut. Don't forget to do so.

CHOOSING A SUBJECT

Some writers are lucky enough never to be faced with the problem of choosing a subject. The world presents itself to them in terms of conflict, crisis, and resolution. Ideas for stories pop into their heads day after day; their only difficulty is choosing among them. In fact, the habit of mind that produces stories is a habit and can be cultivated, so that the more and the longer you write, the less likely you are to run out of ideas.

But sooner or later you may find yourself faced with the desire (or the deadline necessity) to write a story when your mind is a blank. The sour and untrue impulse crosses your thoughts: Nothing has ever happened to me. The task you face then is to recognize among all the paraphernalia of your mind a situation, idea, perception, or character that you can turn into a story.

Some teachers and critics advise beginning writers to write only from their personal experience, but I feel that this is a misleading and demeaning rule. If your imagination never gets beyond your age group or off campus, never tackles issues larger than dormitory life, then you are severely underestimating the range of your imagination. It is certainly true that you must draw on your own experience (including your experience of the shape of sentences). But the trick is to identify what is interesting, unique, original in your experience (including your experience of the shape of sentences), which will therefore surprise and attract the reader.

The kind of "writing what you know" that is least likely to produce good fiction is trying to tell just exactly what happened to you at such and such a time. Probably all good fiction is "autobiographical" in some way, but the awful or hilarious or tragic thing you went through may offer as many problems as possibilities when you start to turn it into fiction. The first of these is that to the extent you want to capture "what really happened," you remove your focus from what will work as narrative. Young writers, offended by being told that a piece is unconvincing, often defend themselves by declaring that *it really happened*. But credibility in words has almost nothing to do with fact. Aristotle went so far as to say that a "probable impossibility" made a better story than an "improbable possibility," meaning that a skillful author can sell us glass mountains, UFOs, and hobbits, whereas a less skilled writer may not be able to convince us that Mary Lou has a crush on Sam.

The first step toward using autobiography in fiction is to accept this: Words are not experience. Even the most factual account of a personal experience is a series of voluntary and involuntary choices, an acceptance of limitations, an interpretation, a lie. If you are writing a memoir or personal essay, then it is important to maintain a basis in fact because, as Annie Dillard says, "that is the convention and the covenant between the nonfiction writer and his reader." But between fiction writer and reader it is the revelation of meaning through the creation of character,

the vividness of scene, the affect of action that take priority over ordinary veracity. The test of this other truth is at once spiritual and visceral; its validity has nothing to do with whether such things did, or could, occur. Lorrie Moore says:

... the proper relationship of a writer to his or her own life is similar to a cook with a cupboard. What the cook makes from the cupboard is not the same thing as what's in the cupboard . . .

And Henry James resorts to kitchen imagery as well when he speaks of the need to

boil down so many facts . . . so that the distilled result, the produced appearance, should have intensity, lucidity, brevity . . .

Good. Now: what was it about this experience that made it matter to you? Try writing a very brief summary of what happened—no more than a hundred words. What kind of story might this be? Can the raw material of incident, accident, and choice be reshaped, plumped up, pared to the bone, refleshed, differently spiced? You experienced whatever it was chronologically—but is that the best way to tell it so as to bring its meaning out? Perhaps you experienced it over a period of months or years; what are the fewest scenes in the least amount of time that could contain the action? If "you" are at the center of the action then "you" must be thoroughly characterized, and that may be difficult. Can you augment some revealing aspect of yourself, change yourself so you are forced to see anew, even make someone else altogether the central character? Use some of the suggestions in this chapter. Try freewriting moments from your memory in no particular order. Or freewrite the last scene first. Pick a single word that sums up the experience and cluster that word. Then write a scene that does not use the word. Describe a place and exaggerate the description; if it's cold, make it murderously cold, if messy then a disastrous mess. Describe the central character and be at least partly unflattering. All of these are devices to put some distance between you and raw experience so you can begin to shape the different thing that fiction is.

John Gardner, in *The Art of Fiction*, agrees that "nothing can be more limiting to the imagination" than the advice that you write about what you know. He suggests instead that you "write the kind of story you know and like best."

This is a better idea, because the kind of story you know and like best has also taught you something about the way such stories are told, how they are shaped, what kind of surprise, conflict, and change they involve. Many beginning writers who are not yet avid readers have learned from television more than they realize about structure, the way characters behave and talk, how a joke is arranged, how a lie is revealed, and so forth. The trouble is that if you learn fiction from television, or if the kind of story you know and like best is genre fiction—science fiction, fantasy, romance, mystery—you may have learned about technique without having learned anything about the unique contribution you can make to such a story. The result is that you end up writing imitation soap opera or space odyssey, second-rate somebody else instead of first-rate you.

The essential thing is that you write about something you really care about, and the first step is to find out what that is. Playwright Claudia Johnson advises her students to identify their real concerns by making a "menu" of them. Pick the big emotions and make lists in your journal: What makes you angry? What are you afraid of? What do you want? What hurts? Or consider the crucial turning points of your life: What really changed you? Who really changed you? Those will be the areas to look to for stories, whether or not those stories are autobiographical. Novelist Ron Carlson says, "I always write from my own experiences, whether I've had them or not."

Another journal idea is to jot down the facts of the first seven years of your life under several categories: *Events*, *People*, *Your Self*, *Inner Life*, *Characteristic Things*. What from those first seven years still occupies your mind? Underline or highlight the items on your page(s) that you aren't done with yet. Those items are clues to your concerns and a possible source of storytelling.

A related device for your journal might be borrowed from the *Pillow Book* of Sei Shonagun. A courtesan in tenth-century Japan, she kept a diary of the goings-on at court and concealed it in her wooden pillow—hence *pillow book*. Sei Shonagun made lists under various categories of specific, often quirky *Things*. This device is capable of endless variety and can reveal yourself to you as you find out what sort of things you want to list: *Things I wish had never been said*. Red things. *Things more embarrassing than nudity*. Things to put off as long as possible. Things to die for. Acid things. Things that last only a day.

Such devices may be necessary because identifying what we care about is not always easy. We are surrounded by a constant barrage of information, drama, ideas, and judgments offered to us live, printed, and electronically. It is so much easier to know what we ought to think and feel than what we actually do. Worthy authorities constantly exhort us to care about worthy causes, only a few of which really touch us, whereas what we care about at any given moment may seem trivial, self-conscious, or self-serving.

This, I think, is in large part the value of Brande's first exercise, which forces you to write in the intuitively honest period of first light, when the half-sleeping brain is still dealing with its real concerns. Often what seems unworthy is precisely the thing that contains a universal, and by catching it honestly, then stepping back from it, you may achieve the authorial distance that is an essential part of significance. (All you really care about this morning is how you'll look at the dance tonight? This is a trivial obsession that can hit anyone, at any age, anywhere. Write about it as honestly as you can. Now who else might have felt this way? Someone you hate? Someone remote in time from you? Look out: You're on your way to a story.) Sometimes pursuing what you know and feel to its uttermost limits will take you into the realms of fantasy. Sometimes your fantasies will transform themselves into reality.

Brande advises that once you have developed the habit of regular freewriting, you should read your pages over and pick a passage that seems to suggest a simple story. Muse on the idea for a few days, find its shape, and then fill that shape with people, settings, details from your own experience, observation, and imagination. Turn the story over in your mind. Sleep on it—more than once. Finally, pick a time when you are going to write the story, and when that time comes, go to the desk and write a

complete first draft as rapidly as possible. Then put it away, at least overnight. When you take it out again, you will have something to work with, and the business of the reason may begin.

Eventually you will learn what sort of experience sparks ideas for your sort of story—and you may be astonished at how such experiences accumulate, as if your life were arranging itself to produce material for you. In the meantime, here are a half dozen suggestions for the kind of idea that may be fruitful.

The Dilemma, or Catch-22. You find yourself facing—or know someone who is facing, or read about someone who is facing—a situation that offers no solution whatsoever. Any action taken would be painful and costly. You have no chance of solving this dilemma in real life, but you're a writer, and it costs nothing to solve it with imaginary people in an imaginary setting, even if the solution is a tragic one. Some writers use newspaper stories to generate this sort of idea. The situation is there in the bland black and white of this morning's news. But who are these people, and how did they come to be in such a mess? Make it up, think it through.

The Incongruity. Something comes to your attention that is interesting precisely because you can't figure it out. It doesn't seem to make sense. Someone is breeding pigs in the backyard of a mansion in the most affluent section of town. Who is it? Why is she doing it? Your inventing mind can find the motives and the meanings. An example from my own experience: Once when my phone was out of order, I went out very late at night to make a call from a public phone at a supermarket plaza. At something like two in the morning all the stores were closed but the plaza was not empty. There were three women there, one of them with a baby in a stroller. What were they doing there? It was several years before I figured out a possible answer, and that answer was a short story.

The Connection. You notice a striking similarity in two events, people, places, or periods that are fundamentally unlike. The more you explore the similarity, the more striking it becomes. My novel *The Buzzards* came from such a connection: The daughter of a famous politician was murdered, and I found myself in the position of comforting the dead girl's fiancé. At the same time I was writing lectures on the Agamemnon of Aeschylus. Two politicians, two murdered daughters—one in ancient Greece and one in contemporary America. The connection would not let go of me until I had thought it through and set it down.

The Memory. Certain people, places, and events stand out in your memory with an intensity beyond logic. There's no earthly reason you should remember the smell of Aunt K's rouge. It makes no sense that you still flush with shame at the thought of that ball you "borrowed" when you were in fourth grade. But for some reason these things are still vivid in your mind. That vividness can be explored, embellished, given form. Stephen Minot in *Three Genres* wisely advises, though, that if you are going to write from a memory, it should be a memory more than a year old. Otherwise you are likely to be unable to distinguish between what happened and what

must happen in the story or between what is in your mind and what you have conveyed on the page.

The Transplant. You find yourself having to deal with a feeling that is either startingly new to you or else obsessively old. You feel incapable of dealing with it. As a way of distancing yourself from that feeling and gaining some mastery over it, you write about the feeling as precisely as you can, but giving it to an imaginary someone in an imaginary situation. What situation other than your own would produce such a feeling? Who would be caught in that situation? Think it through.

The Revenge. An injustice has been done, and you are powerless to do anything about it. But you're not really, because you're a writer. Reproduce the situation with another set of characters, in other circumstances or another setting. Cast the outcome to suit yourself. Punish whomever you choose. Even if the story ends in a similar injustice, you have righted the wrong by enlisting your reader's sympathy on the side of right. (Dante was particularly good at this: He put his enemies in the inferno and his friends in paradise.) Remember too that as human beings we are intensely, sometimes obsessively, interested in our boredom, and you can take revenge against the things that bore you by making them absurd or funny on paper.

Keep Going

A story idea may come from any source at any time. You may not know you have an idea until you spot it in the random jottings of your journal. Once you've identified the idea, the process of thinking it through begins and doesn't end until you finish (or abandon) the story. Most writing is done between the mind and the hand, not between the hand and the page. It may take a fairly competent typist about three hours to type a twelve-page story. It may take days or months to write it. It follows that, even when you are writing well, most of the time spent writing is not spent putting words on the page. If the story idea grabs hard hold of you, the process of thinking through may be involuntary, a gift. If not, you need to find the inner stillness that will allow you to develop your characters, get to know them, follow their actions in your mind—and it may take an effort of the will to find such stillness.

The metamorphosis of an idea into a story has many aspects, some deliberate and some mysterious. "Inspiration" is a real thing, a gift from the subconscious to the conscious mind. But over and over again, successful writers attest that unless they prepare the conscious mind with the habit of work, the gift does not come. Writing is mind-farming. You have to plow, plant, weed, and hope for growing weather. Why a seed turns into a plant is something you are never going to understand, and the only relevant response to it is gratitude. You may be proud, however, of having plowed.

Many writers besides Dorothea Brande have observed that it is ideal, having turned your story over in your mind, to write the first draft at one sitting, pushing on through the action to the conclusion, no matter how dissatisfied you are with this

paragraph, that character, this phrasing, or that incident. There are two advantages to doing this. The first is that you are more likely to produce a coherent draft when you come to the desk in a single frame of mind with a single vision of the whole, than when you write piecemeal, having altered ideas and moods. The second is that fast writing tends to make for fast pace in the story. It is always easier, later, to add and develop than it is to sharpen the pace. If you are the sort of writer who stays on page one for days, shoving commas around and combing the thesaurus for a word with slightly better connotations, then you should probably force yourself to try this method (more than once). A note of caution, though: If you write a draft at one sitting, it will not be the draft you want to show anyone, so schedule the sitting well in advance of whatever deadline you may have.

However, this method does not always work, for a variety of reasons. Obviously it won't work for a novel (though the British author Gabriel Josipovici once startled me by observing that the first draft of a novel could be written in a month: "Ten pages a day for thirty days gives you three hundred—and then you rewrite it seventeen times"). Novelist Sheila Taylor recounts how she accomplished her first book: She decided that she would give herself permission to write one bad page a day for a year. At the end of the year she had three hundred and sixty-five pages. She will not show them to anyone, but she had proved that she could write a novel, and her second, third, and fourth novels are in print in several languages.

It may happen—always keeping in mind that a single-sitting draft is the ideal—that as you write, the story will take off of its own accord in some direction totally other than you intended. You thought you knew where you were going and now you don't, and you know that unless you stop for a while and think it through again, you'll go wrong. You may find that although you are doing precisely what you had in mind, it doesn't work, and it needs more imaginative mulching before it will bear fruit. Or you may find, simply, that your stamina gives out, and that though you have done your exercises, been steadfast, loyal, and practiced every writerly virtue known, you're stuck. You have writer's block.

Writer's block is not so popular as it was a few years ago. I suspect people got tired of hearing or even talking about it—sometimes writers can be sensitive even to their own clichés. But it may also be that writers began to understand and accept their difficulties. Sometimes the process seems to require working yourself into a muddle and past the muddle to despair; until you have done this, it may be impossible suddenly to see what the shape of a thing ought to be. When you're writing, this feels terrible. You sit spinning your wheels, digging deeper and deeper into the mental muck. You decide you are going to trash the whole thing and walk away from it—only you can't, and you keep coming back to it like a tongue to an aching tooth. Or you decide you are going to sit there until you bludgeon it into shape—and as long as you sit there it remains recalcitrant. W. H. Auden observed that the hardest part of writing is not knowing whether you are procrastinating or must wait for the words to come.

I know a newspaper editor who says that writer's block always represents a lack of information. I thought this inapplicable to fiction until I noticed that I was mainly

frustrated when I didn't know enough about my characters, the scene, or the action—when I had not gone to the imaginative depth where information lies.

So I learned something, but it led to the familiar guilt: *procrastinating again!* Victoria Nelson, in *On Writer's Block: A New Approach to Creativity* says that if you accuse yourself of procrastinating, you aren't a procrastinator, you're an accuser.

Whenever I ask a group of writers what they find most difficult, a significant number answer that they feel they aren't good enough, that the empty page intimidates them, that they are in some way afraid. Many complain of their own laziness, but laziness, like money, doesn't really exist except to represent something else—in this case fear, severe self-judgment, or what Natalie Goldberg calls "the cycle of guilt, avoidance, and pressure."

Encouragement comes from the poet William Stafford, who advised his students always to write to their lowest standard. Somebody always corrected him: "You mean your highest standard." No, he meant your lowest standard. Jean Cocteau's editor gave him the same advice. "The thought of having to produce a masterpiece is giving you writer's cramp. You're paralysed at the sight of a blank sheet of paper. So begin any old way. Write: 'One winter evening . . .'" Victoria Nelson points out that "there is an almost mathematical ratio between soaring, grandiose ambition . . . and severe creative block." More writers prostitute themselves "up" than "down"; more are false in the determination to write great literature than to throw off a romance.

A rough draft is rough; that's its nature. Let it be rough. Think of it as making clay. The molding and the gloss come later.

And remember: Writing is easy. Not writing is hard.

A Word about Theme

The process of discovering, choosing, and revealing the theme of your story begins as early as a first freewrite and continues, probably, beyond publication. The theme is what your story is about and what you think about it, its core and the spin you put on it. John Gardner points out that theme "is not imposed on the story but evoked from within it—initially an intuitive but finally an intellectual act on the part of the writer."

What your story has to say will gradually reveal itself to you and to your reader through every choice you as a writer make—the actions, characters, setting, dialogue, objects, pace, metaphors and symbols, viewpoint, atmosphere, style, even syntax and punctuation, and even in some cases typography.

Because of this comprehensive nature of theme, I have placed the discussion of it in chapter 10, after the individual story elements have been addressed. But this is not entirely satisfactory, since each of those elements contribute to the theme as it unfolds. You may want to skip ahead to take a look at that chapter, or you may want to anticipate the issue by asking at every stage of your manuscript: What really interests me about this? How does this (image, character, dialogue, place . . .) reveal what I care about? What connections do I see between one image and another? How can I

strengthen those connections? Am I saying what I really mean, telling my truth about it?

All the later chapters in this book are followed by short stories that operate as examples of the elements of fiction under consideration. What follows here, however, are two excerpts from books on the writing process, very different from each other in content, tone, and form.

Shitty First Drafts

ANNE LAMOTT FROM BIRD BY BIRD

Now, practically even better news than that of short assignments is the idea of shitty first drafts. All good writers write them. This is how they end up with good second drafts and terrific third drafts. People tend to look at successful writers, writers who are getting their books published and maybe even doing well financially, and think that they sit down at their desks every morning feeling like a million dollars, feeling great about who they are and how much talent they have and what a great story they have to tell; that they take in a few deep breaths, push back their sleeves, roll their necks a few times to get all the cricks out, and dive in, typing fully formed passages as fast as a court reporter. But this is just the fantasy of the uninitiated. I know some very great writers, writers you love who write beautifully and have made a great deal of money, and not one of them sits down routinely feeling wildly enthusiastic and confident. Not one of them writes elegant first drafts. All right, one of them does, but we do not like her very much. We do not think that she has a rich inner life or that God likes her or can even stand her. (Although when I mentioned this to my priest friend Tom, he said you can safely assume you've created God in your own image when it turns out that God hates all the same people you do.)

Very few writers really know what they are doing until they've done it. Nor do they go about their business feeling dewy and thrilled. They do not type a few stiff warm-up sentences and then find themselves bounding along like huskies across the snow. One writer I know tells me that he sits down every morning and says to himself nicely, "It's not like you don't have a choice, because you do—you can either type or kill your-self." We all often feel like we are pulling teeth, even those writers whose prose ends up being the most natural and fluid. The right words and sentences just do not come pouring out like ticker tape most of the time. Now, Muriel Spark is said to have felt that she was taking dictation from God every morning—sitting there, one supposes, plugged into a Dictaphone, typing away, humming. But this is a very hostile and aggressive position. One might hope for bad things to rain down on a person like this.

For me and most of the other writers I know, writing is not rapturous. In fact, the only way I can get anything written at all is to write really, really shitty first drafts.

The first draft is the child's draft, where you let it all pour out and then let it romp all over the place, knowing that no one is going to see it and that you can shape it later. You just let this childlike part of you channel whatever voices and visions come through and onto the page. If one of the characters wants to say, "Well, so what, Mr. Poopy Pants?," you let her. No one is going to see it. If the kid wants to get into really sentimental, weepy, emotional territory, you let him. Just get it all down on paper, because there may be something great in those six crazy pages that you would never have gotten to by more rational, grown-up means. There may be something in the very last line of the very last paragraph on page six that you just love, that is so beautiful or wild that you now know what you're supposed to be writing about, more or less, or in what direction you might go—but there was no way to get to this without first getting through the first five and a half pages.

I used to write food reviews for California magazine before it folded. (My writing food reviews had nothing to do with the magazine folding, although every single review did cause a couple of canceled subscriptions. Some readers took umbrage at my comparing mounds of vegetable puree with various ex-presidents' brains.) These reviews always took two days to write. First I'd go to a restaurant several times with a few opinionated, articulate friends in tow. I'd sit there writing down everything anyone said that was at all interesting or funny. Then on the following Monday I'd sit down at my desk with my notes, and try to write the review. Even after I'd been doing this for years, panic would set in. I'd try to write a lead, but instead I'd write a couple of dreadful sentences, xx them out, try again, xx everything out, and then feel despair and worry settle on my chest like an x-ray apron. It's over I'd think, calmly. I'm not going to be able to get the magic to work this time. I'm ruined. I'm through. I'm toast, Maybe, I'd think, I can get my old job back as a clerk-typist. But probably not. I'd get up and study my teeth in the mirror for a while. Then I'd stop, remember to breathe, make a few phone calls, hit the kitchen and chow down. Eventually I'd go back and sit down at my desk, and sigh for the next ten minutes. Finally I would pick up my one-inch picture frame, stare into it as if for the answer, and every time the answer would come: all I had to do was to write a really shitty first draft of, say, the opening paragraph. And no one was going to see it.

So I'd start writing without reining myself in. It was almost just typing, just making my fingers move. And the writing would be *terrible*. I'd write a lead paragraph that was a whole page, even though the entire review could only be three pages long, and then I'd start writing up descriptions of the food, one dish at a time, bird by bird, and the critics would be sitting on my shoulders, commenting like cartoon characters. They'd be pretending to snore, or rolling their eyes at my overwrought descriptions, no matter how hard I tried to tone those descriptions down, no matter how conscious I was of what a friend said to me gently in my early days of restaurant reviewing. "Annie," she said, "it is just a piece of *chicken*. It is just a bit of *cake*."

But because by then I had been writing for so long, I would eventually let myself trust the process—sort of, more or less. I'd write a first draft that was maybe twice as long as it should be, with a self-indulgent and boring beginning, stupefying descriptions of the meal, lots of quotes from my black-humored friends that made them

sound more like the Manson girls than food lovers, and no ending to speak of. The whole thing would be so long and incoherent and hideous that for the rest of the day I'd obsess about getting creamed by a car before I could write a decent second draft. I'd worry that people would read what I'd written and believe that the accident had really been a suicide, that I had panicked because my talent was waning and my mind was shot.

The next day, though, I'd sit down, go through it all with a colored pen, take out everything I possibly could, find a new lead somewhere on the second page, figure out a kicky place to end it, and then write a second draft. It always turned out fine, sometimes even funny and weird and helpful. I'd go over it one more time and mail it in.

Then, a month later, when it was time for another review, the whole process would start again, complete with the fears that people would find my first draft before I could rewrite it.

Almost all good writing begins with terrible first efforts. You need to start somewhere. Start by getting something—anything—down on paper. A friend of mine says that the first draft is the down draft—you just get it down. The second draft is the up draft—you fix it up. You try to say what you have to say more accurately. And the third draft is the dental draft, where you check every tooth, to see if it's loose or cramped or decayed, or even, God help us, healthy.

What I've learned to do when I sit down to work on a shitty first draft is to quiet the voices in my head. First there's the vinegar-lipped Reader Lady, who says primly, "Well, that's not very interesting, is it?" And there's the emaciated German male who writes these Orwellian memos detailing your thought crimes. And there are your parents, agonizing over your lack of loyalty and discretion; and there's William Burroughs, dozing off or shooting up because he finds you as bold and articulate as a houseplant; and so on. And there are also the dogs: let's not forget the dogs, the dogs in their pen who will surely hurtle and snarl their way out if you ever *stop* writing, because writing is, for some of us, the latch that keeps the door of the pen closed, keeps those crazy ravenous dogs contained.

Quieting these voices is at least half the battle I fight daily. But this is better than it used to be. It used to be 87 percent. Left to its own devices, my mind spends much of its time having conversations with people who aren't there. I walk along defending myself to people, or exchanging repartee with them, or rationalizing my behavior, or seducing them with gossip, or pretending I'm on their TV talk show or whatever. I speed or run an aging yellow light or don't come to a full stop, and one nanosecond later am explaining to imaginary cops exactly why I had to do what I did, or insisting that I did not in fact do it.

I happened to mention this to a hypnotist I saw many years ago, and he looked at me very nicely. At first I thought he was feeling around on the floor for the silent alarm button, but then he gave me the following exercise, which I still use to this day.

Close your eyes and get quiet for a minute, until the chatter starts up. Then isolate one of the voices and imagine the person speaking as a mouse. Pick it up by the tail and drop it into a mason jar. Then isolate another voice, pick it up by the tail,

drop it in the jar. And so on. Drop in any high-maintenance parental units, drop in any contractors, lawyers, colleagues, children, anyone who is whining in your head. Then put the lid on, and watch all these mouse people clawing at the glass, jabbering away, trying to make you feel like shit because you won't do what they want—won't give them more money, won't be more successful, won't see them more often. Then imagine that there is a volume-control button on the bottle. Turn it all the way up for a minute, and listen to the stream of angry, neglected, guilt-mongering voices. Then turn it all the way down and watch the frantic mice lunge at the glass, trying to get to you. Leave it down, and get back to your shitty first draft.

A writer friend of mine suggests opening the jar and shooting them all in the head. But I think he's a little angry, and I'm sure nothing like this would ever occur to you.

From "The Writing Life"

ANNIE DILLARD

When you write, you lay out a line of words. The line of words is a miner's pick, a wood-carver's gouge, a surgeon's probe. You wield it, and it digs a path you follow. Soon you find yourself deep in new territory. Is it a dead end, or have you located the real subject? You will know tomorrow, or this time next year.

You make the path boldly and follow it fearfully. You go where the path leads. At the end of the path, you find a box canyon. You hammer out reports, dispatch bulletins.

The writing has changed, in your hands, and in a twinkling, from an expression of your notions to an epistemological tool. The new place interests you because it is not clear. You attend. In your humility, you lay down the words carefully, watching all the angles. Now the earlier writing looks soft and careless. Process is nothing; erase your tracks. The path is not the work. I hope your tracks have grown over; I hope birds ate the crumbs; I hope you will toss it all and not look back.

The line of words is a hammer. You hammer against the walls of your house. You tap the walls, lightly, everywhere. After giving many years' attention to these things, you know what to listen for. Some of the walls are bearing walls; they have to stay, or everything will fall down. Other walls can go with impunity; you can hear the difference. Unfortunately, it is often a bearing wall that has to go. It cannot be helped. There is only one solution, which appalls you, but there it is. Knock it out. Duck.

Courage utterly opposes the bold hope that this is such fine stuff the work needs it, or the world. Courage, exhausted, stands on bare reality: this writing weakens the work. You must demolish the work and start over. You can save some of the sentences, like bricks. It will be a miracle if you can save some of the paragraphs, no matter how excellent in themselves or hard-won. You can waste a year worrying about it, or you can get it over with now. (Are you a woman, or a mouse?)

The part you must jettison is not only the best-written part; it is also, oddly, that

part which was to have been the very point. It is the original key passage, the passage on which the rest was to hang, and from which you yourself drew the courage to begin. Henry James knew it well, and said it best. In his preface to *The Spoils of Poynton*, he pities the writer, in a comical pair of sentences that rises to a howl: "Which is the work in which he hasn't surrendered, under dire difficulty, the best thing he meant to have kept? In which indeed, before the dreadful done, doesn't he ask himself what has become of the thing all for the sweet sake of which it was to proceed to that extremity?"

So it is that a writer writes many books. In each book, he intended several urgent and vivid points, many of which he sacrificed as the book's form hardened. "The youth gets together his materials to build a bridge to the moon," Thoreau noted mournfully, "or perchance a palace or temple on the earth, and at length the middle-aged man concludes to build a wood-shed with them." The writer returns to these materials, these passionate subjects, as to unfinished business, for they are his life's work.

It is the beginning of a work that the writer throws away.

A painting covers its tracks. Painters work from the ground up. The latest version of a painting overlays earlier versions, and obliterates them. Writers, on the other hand, work from left to right. The discardable chapters are on the left. The latest version of a literary work begins somewhere in the work's middle, and hardens toward the end. The earlier version remains lumpishly on the left; the work's beginning greets the reader with the wrong hand. In those early pages and chapters anyone may find bold leaps to nowhere, read the brave beginnings of dropped themes, hear a tone since abandoned, discover blind alleys, track red herrings, and laboriously learn a setting now false.

Several delusions weaken the writer's resolve to throw away work. If he has read his pages too often, those pages will have a necessary quality, the ring of the inevitable, like poetry known by heart; they will perfectly answer their own familiar rhythms. He will retain them. He may retain those pages if they possess some virtues, such as power in themselves, though they lack the cardinal virtue, which is pertinence to, and unity with, the book's thrust. Sometimes the writer leaves his early chapters in place from gratitude; he cannot contemplate them or read them without feeling again the blessed relief that exalted him when the words first appeared—relief that he was writing anything at all. That beginning served to get him where he was going, after all; surely the reader needs it, too, as groundwork. But no.

Every year the aspiring photographer brought a stack of his best prints to an old, honored photographer, seeking his judgment. Every year the old man studied the prints and painstakingly ordered them into two piles, bad and good. Every year the old man moved a certain landscape print into the bad stack. At length he turned to the young man: "You submit this same landscape every year, and every year I put it on the bad stack. Why do you like it so much?" The young photographer said, "Because I had to climb a mountain to get it."

A cabdriver sang his songs to me, in New York. Some we sang together. He had turned the meter off; he drove around midtown, singing. One long song he

sang twice; it was the only dull one. I said, You already sang that one; let's sing something else. And he said, "You don't know how long it took me to get that one together."

How many books do we read from which the writer lacked courage to tie off the umbilical cord? How many gifts do we open from which the writer neglected to remove the price tag? Is it pertinent, is it courteous, for us to learn what it cost the writer personally?

You write it all, discovering it at the end of the line of words. The line of words is a fiber optic, flexible as wire; it illumines the path just before its fragile tip. You probe with it, delicate as a worm. . . .

When you are stuck in a book; when you are well into writing it, and know what comes next, and yet cannot go on; when every morning for a week or a month you enter its room and turn your back on it; then the trouble is either of two things. Either the structure has forked, so the narrative, or the logic, has developed a hairline fracture that will shortly split it up the middle—or you are approaching a fatal mistake. What you had planned will not do. If you pursue your present course, the book will explode or collapse, and you do not know about it yet, quite.

In Bridgeport, Connecticut, one morning in April 1987, a six-story concrete-slab building under construction collapsed, and killed twenty-eight men. Just before it collapsed, a woman across the street leaned from her window and said to a passerby, "That building is starting to shake." "Lady," he said, according to the Hartford Courant, "you got rocks in your head."

You notice only this: your worker—your one and only, your prized, coddled, and driven worker—is not going out on that job. Will not budge, not even for you, boss. Has been at it long enough to know when the air smells wrong; can sense a tremor through boot soles. Nonsense, you say; it is perfectly safe. But the worker will not go. Will not even look at the site. Just developed heart trouble. Would rather starve. Sorry.

What do you do? Acknowledge, first, that you cannot do nothing. Lay out the structure you already have, x-ray it for a hairline fracture, find it, and think about it for a week or a year; solve the insoluble problem. Or subject the next part, the part at which the worker balks, to harsh tests. It harbors an unexamined and wrong premise. Something completely necessary is false or fatal. Once you find it, and if you can accept the finding, of course it will mean starting again. This is why many experienced writers urge young men and women to learn a useful trade.

Every morning you climb several flights of stairs, enter your study, open the French doors, and slide your desk and chair out into the middle of the air. The desk and chair float thirty feet from the ground, between the crowns of maple trees. The furniture is in place; you go back for your thermos of coffee. Then, wincing, you step out again through the French doors and sit down on the chair and look over the desktop. You can see clear to the river from here in winter. You pour yourself a cup of coffee.

Birds fly under your chair. In spring, when the leaves open in the maples' crowns, your view stops in the treetops just beyond the desk; yellow warblers hiss and whisper on the high twigs, and catch flies. Get to work. Your work is to keep cranking the flywheel that turns the gears that spin the belt in the engine of belief that keeps you and your desk in midair. . . .

The reason to perfect a piece of prose as it progresses—to secure each sentence before building on it—is that original writing fashions a form. It unrolls out into nothingness. It grows cell to cell, bole to bough to twig to leaf; any careful word may suggest a route, may begin a strand of metaphor or event out of which much, or all, will develop. Perfecting the work inch by inch, writing from the first word toward the last, displays the courage and fear this method induces. The strain, like Giacometti's penciled search for precision and honesty, enlivens the work and impels it toward its truest end. A pile of decent work behind him, no matter how small, fuels the writer's hope, too; his pride emboldens and impels him. One Washington writer—Charlie Butts—so prizes momentum, and so fears self-consciousness, that he writes fiction in a rush of his own devising. He leaves his house on distracting errands, hurries in the door, and without taking off his coat, sits at a typewriter and retypes in a blur of speed all of the story he has written to date. Impetus propels him to add another sentence or two before he notices he is writing and seizes up. Then he leaves the house and repeats the process; he runs in the door and retypes the entire story, hoping to squeeze out another sentence the way some car engines turn over after the ignition is off, or the way Warner Bros.' Wile E. Coyote continues running for several yards beyond the edge of a cliff, until he notices.

The reason not to perfect a work as it progresses is that, concomitantly, original work fashions a form the true shape of which it discovers only as it proceeds, so the early strokes are useless, however fine their sheen. Only when a paragraph's role in the context of the whole work is clear can the envisioning writer direct its complexity of detail to strengthen the work's ends.

Fiction writers who toss up their arms helplessly because their characters "take over"—powerful rascals, what is a god to do?—refer, I think, to these structural mysteries that seize any serious work, whether or not it possesses fifth-column characters who wreak havoc from within. Sometimes part of a book simply gets up and walks away. The writer cannot force it back in place. It wanders off to die. . . .

You climb a long ladder until you can see over the roof, or over the clouds. You are writing a book. You watch your shod feet step on each round rung, one at a time; you do not hurry and do not rest. Your feet feel the steep ladder's balance; the long muscles in your thighs check its sway. You climb steadily, doing your job in the dark. When you reach the end, there is nothing more to climb. The sun hits you. The bright wideness surprises you; you had forgotten there was an end. You look back at the ladder's two feet on the distant grass, astonished.

The line of words fingers your own heart. It invades arteries, and enters the heart on a flood of breath; it presses the moving rims of thick valves; it palpates the dark muscle strong as horses, feeling for something, it knows not what. A queer picture beds in the muscle like a worm encysted—some film of feeling, some song forgotten, a scene in a dark bedroom, a corner of the woodlot, a terrible dining room, that ex-

alting sidewalk; these fragments are heavy with meaning. The line of words peels them back, dissects them out. Will the bared tissue burn? Do you want to expose these scenes to the light? You may locate them and leave them, or poke the spot hard till the sore bleeds on your finger, and write with that blood. If the sore spot is not fatal, if it does not grow and block something, you can use its power for many years, until the heart resorbs it.

The line of words feels for cracks in the firmament.

The line of words is heading out past Jupiter this morning. Traveling 150 kilometers a second, it makes no sound. The big yellow planet and its white moons spin. The line of words speeds past Jupiter and its cumbrous, dizzying orbit; it looks neither to the right nor to the left. It will be leaving the solar system soon, single-minded, rapt, rushing heaven like a soul. You are in Houston, Texas, watching the monitor. You saw a simulation: the line of words waited still, hushed, pointed with longing. The big yellow planet spun toward it like a pitched ball and passed beside it, low and outside. Jupiter was so large, the arc of its edge at the screen's bottom looked flat. The probe twined on; its wild path passed between white suns small as dots; these stars fell away on either side, like the lights on a tunnel's walls.

Now you watch symbols move on your monitor; you stare at the signals the probe sends back, transmits in your own tongue, numbers. Maybe later you can guess at what they mean—what they might mean about space at the edge of the solar system, or about your instruments. Right now, you are flying. Right now, your job is to hold your breath. . . .

What is this writing life? I was living alone in a house once, and had set up a study on the first floor. A portable green Smith-Corona typewriter sat on the table against the wall. I made the mistake of leaving the room.

I was upstairs when I felt the first tremor. The floor wagged under my feet—what was that?—and the picture frames on the wall stirred. The house shook and made noise. There was a pause; I found my face in the dresser mirror, deadpan. When the floor began again to sway, I walked downstairs, thinking I had better get down while the stairway held.

I saw at once that the typewriter was erupting. The old green Smith-Corona typewriter on the table was exploding with fire and ash. Showers of sparks shot out of its caldera—the dark hollow in which the keys lie. Smoke and cinders poured out, noises exploded and spattered, black dense smoke rose up, and a wild, deep fire lighted the whole thing. It shot sparks.

I pulled down the curtains. When I leaned over the typewriter, sparks burnt round holes in my shirt, and fire singed a sleeve. I dragged the rug away from the sparks. In the kitchen I filled a bucket with water and returned to the erupting typewriter. The typewriter did not seem to be flying apart, only erupting. On my face and hands I felt the heat from the caldera. The yellow fire made a fast, roaring noise. The typewriter itself made a rumbling, grinding noise; the table pitched. Nothing seemed to require my bucket of water. The table surface was ruined, of course, but not aflame. After twenty minutes or so, the eruption subsided.

That night I heard more rumblings—weak ones, ever farther apart. The next day I cleaned the typewriter, table, floor, wall, and ceiling. I threw away the burnt shirt. The following day I cleaned the typewriter again—a film of lampblack still coated the caldera—and then it was over. I have had no trouble with it since. Of course, now I know it can happen. . . .

The sensation of writing a book is the sensation of spinning, blinded by love and daring. It is the sensation of rearing and peering from the bent tip of a grassblade, looking for a route. At its absurd worst, it feels like what mad Jacob Boehme, the German mystic, described in his first book. He was writing, incoherently as usual, about the source of evil. The passage will serve as well for the source of books.

"The whole Deity has in its innermost or beginning Birth, in the Pith or Kernel, a very tart, terrible *Sharpness*, in which the astringent Quality is very horrible, tart, hard, dark and cold Attraction or Drawing together, like *Winter*, when there is a fierce, bitter cold Frost, when Water is frozen into Ice, and besides is very intolerable."

If you can dissect out the very intolerable, tart, hard, terribly sharp Pith or Kernel, and begin writing the book compressed therein, the sensation changes. Now it feels like alligator wrestling, at the level of the sentence.

This is your life. You are a Seminole alligator wrestler. Half naked, with your two bare hands, you hold and fight a sentence's head while its tail tries to knock you over. Several years ago in Florida, an alligator wrestler lost. He was grappling with an alligator in a lagoon in front of a paying crowd. The crowd watched the young Indian and the alligator twist belly to belly in and out of the water; after one plunge, they failed to rise. A young writer named Lorne Ladner described it. Bubbles came up on the water. Then blood came up, and the water stilled. As the minutes elapsed, the people in the crowd exchanged glances; silent, helpless, they quit the stands. It took the Indians a week to find the man's remains.

At its best, the sensation of writing is that of any unmerited grace. It is handed to you, but only if you look for it. You search, you break your heart, your back, your brain, and then—and only then—it is handed to you. From the corner of your eye you see motion. Something is moving through the air and headed your way. It is a parcel bound in ribbons and bows; it has two white wings. It flies directly at you; you can read your name on it. If it were a baseball, you would hit it out of the park. It is that one pitch in a thousand you see in slow motion; its wings beat slowly as a hawk's.

One line of a poem, the poet said—only one line, but thank God for that one line—drops from the ceiling. Thornton Wilder cited this unnamed writer of sonnets: one line of a sonnet falls from the ceiling, and you tap in the others around it with a jeweler's hammer. Nobody whispers it in your ear. It is like something you memorized once and forgot. Now it comes back and rips away your breath. You find and finger a phrase at a time; you lay it down cautiously, as if with tongs, and wait suspended until the next one finds you: Ah yes, then this; and yes, praise be, then this.

Einstein likened the generation of a new idea to a chicken's laying an egg: "Kieks—auf einmal ist es da." Cheep—and all at once there it is. Of course, Einstein was not above playing to the crowd....

Push it. Examine all things intensely and relentlessly. Probe and search each object in a piece of art. Do not leave it, do not course over it, as if it were understood, but instead follow it down until you see it in the mystery of its own specificity and strength. Giacometti's drawings and paintings show his bewilderment and persistence. If he had not acknowledged his bewilderment, he would not have persisted. A twentieth-century master of drawing, Rico Lebrun, taught that "the draftsman must aggress; only by persistent assault will the live image capitulate and give up its secret to an unrelenting line." Who but an artist fierce to know-not fierce to seem to know—would suppose that a live image possessed a secret? The artist is willing to give all his or her strength and life to probing with blunt instruments those same secrets no one can describe in any way but with those instruments' faint tracks.

Admire the world for never ending on you—as you would admire an opponent, without taking your eyes from him, or walking away.

One of the few things I know about writing is this: spend it all, shoot it, play it, lose it, all, right away, every time. Do not hoard what seems good for a later place in the book, or for another book; give it, give it all, give it now. The impulse to save something good for a better place later is the signal to spend it now. Something more will arise for later, something better. These things fill from behind, from beneath, like well water. Similarly, the impulse to keep to yourself what you have learned is not only shameful, it is destructive. Anything you do not give freely and abundantly becomes lost to you. You open your safe and find ashes.

After Michelangelo died, someone found in his studio a piece of paper on which he had written a note to his apprentice, in the handwriting of his old age: "Draw, Antonio, draw, Antonio, draw and do not waste time. . . . "

Suggestions for Discussion

- 1. Anne Lamott takes a "just do it" approach to writing, while Annie Dillard stresses the difficulty and intensity of the work. Which most nearly describes your own process? Could you improve your work by leaning toward the other mode?
- 2. Consider Annie Dillard's statement that "It is the beginning of a work that the writer throws away" with regard to something you have written. Can a stronger, more interesting, or more original piece be made by chopping off the first paragraph? Page? Three pages?
- 3. Suggestions for discussion in subsequent chapters of this book will ask you to focus on techniques of fiction in published stories, but you already know a great deal about these techniques and can recognize them when they are used. What elements of fiction can you identify in each of these essays? Where do the authors make their points with the use of dialogue, metaphor, scene, conflict? Where do they characterize, and how?

Writing Assignments

Keep a journal for two weeks. Decide on a comfortable amount to write daily, and then determine not to let a day slide. In addition to the journal suggestions already in this chapter—freewriting, page 4; the Dorothea Brande exercise, page 5; clustering, pages 5–7; a menu of concerns, page 11; a review of your first seven years, page 11; a set of *Pillow Book* lists, page 11—you might try these:

- 1. Prove to yourself the abundance of your invention by opening this book and pointing at random. Take the noun nearest where your finger falls, cluster it for two or three minutes, and freedraft a paragraph on the subject.
- 2. Sketch a floor plan of the first house you remember. Place an X on the spots in the plan where significant events happened to you. Write a tour of the house as if you were a guide, pointing out its features and its history.
- 3. Identify the kernel of a short story from your experience of one of the following:
 - first memory
 - a dream
 - parents
 - · loss
 - · unfounded fear
 - your body
 - yesterday

Cluster the word and freedraft a passage about it. Outline a story based on it. Write the first page of the story.

- 4. Identify a passage in one of the two excerpts above that seems to parallel or echo your own experience. Cluster, then freedraft, a response to it.
- 5. Write a short memoir of some moment that has to do with reading or writing—the moment you discovered that you could read, for example, or could write your name; or an early influence that has led you toward writing.
- 6. A classroom exercise: After you have written every day for a week, bring in what you consider your *worst* piece of writing. Tell the class what's wrong with it. The others' assignment is to point out its strengths and all the possibilities in it.

At the end of the two weeks, assess yourself and decide what habit of journal keeping you can develop and stick to. A page a day? A paragraph a day? Three pages a week? Then do it. Probably at least once a day you have a thought worth wording, and sometimes it's better to write one sentence a day than to let the habit slide. Like exercise and piano practice, a journal is most useful when it's kept up regularly and frequently. If you pick an hour during which you write each day, no matter how much or how little, you may find yourself looking forward to, and saving things up for, that time.

THE TOWER AND THE NET

Story Form and Structure

- · Conflict, Crisis, and Resolution
- Connection and Disconnection
- · Story Form as a Check Mark
 - · Story and Plot
- The Short Story and the Novel

What makes you want to write?

It seems likely that the earliest storytellers—in the tent or the harem, around the campfire or on the Viking ship—told stories out of an impulse to tell stories. They made themselves popular by distracting their listeners from a dull or dangerous evening with heroic exploits and a skill at creating suspense: What happened next? And after that? And then what happened?

Natural storytellers are still around, and a few of them are very rich. Some are on the best-seller list; more are in television and film. But it's probable that your impulse to write has little to do with the desire or the skill to work out a plot. On the contrary, you want to write because you are sensitive. You have something to say that does not answer the question, What happened next? You share with most—and the best—twentieth-century fiction writers a sense of the injustice, the absurdity, and the beauty of the world; and you want to register your protest, your laughter, and your affirmation.

Yet readers still want to wonder what happened next, and unless you make them wonder, they will not turn the page. You must master plot, because no matter how profound or illuminating your vision of the world may be, you cannot convey it to those who do not read you.

E. M. Forster, in Aspects of the Novel, mourns the necessity of storytelling.

Let us listen to three voices. If you ask one type of man, "What does a novel do?" he will reply placidly: "Well—I don't know—it seems a funny sort of question to ask—a novel's a novel—well, I don't know—I suppose it kind of tells a story, so to speak." He is quite good-tempered and vague, and probably driving a motor bus at the same time and paying no more attention to literature than it merits. Another man, whom I visualize as on a golf-course, will be aggressive and brisk. He will reply: "What does a novel do? Why, tell a story of course, and I've no use for it if it didn't. I like a story. Very bad taste on my part, no doubt, but I like a story. You can take your art, you can take your literature, you can take your music, but give me a good story. And I like a story to be a story, mind, and my wife's the same." And a third man, he says in a sort of drooping regretful voice, "Yes—oh dear yes—the novel tells a story." I respect and admire the first speaker. I detest and fear the second. And the third is myself. Yes—oh dear yes—the novel tells a story. That is the fundamental aspect without which it could not exist. That is the highest factor common to all novels, and I wish that it was not so, that it could be something different—melody, or perception of the truth, not this low atavistic form.

When editors take the trouble to write a rejection letter to a young author (and they do so only when they think the author talented), the gist of the letter most frequently is: "This piece is sensitive (perceptive, vivid, original, brilliant, funny, moving), but it is not a *story*."

How do you know when you have written a story? And if you're not a natural-born wandering minstrel, can you go about learning to write one?

It's interesting that we react with such different attitudes to the words "formula" and "form" as they apply to a story. A formula story is hackwork, the very lowest "atavistic" form of supplying a demand. To write one, you read three dozen copies of Cosmopolitan or Amazing Stories, make a list of what kinds of characters and situations the editors buy, shuffle nearly identical characters around in slightly altered situations, and sit back to wait for the check. Whereas form is a term of the highest artistic approbation, even reverence, with overtones of order, harmony, model, archetype.

And "story" is a "form" of literature. Like a face, it has necessary features in a necessary harmony. We're aware of the infinite variety of human faces, aware of their unique individuality, which is so powerful that you can recognize a face you know even after twenty years of age and fashion have done their work on it. We're aware that minute alterations in the features can express grief, anger, or joy. If you place side by side two photographs of, say, Gwyneth Paltrow and Geronimo, you are instantly aware of the fundamental differences of age, race, sex, class, and century; yet these two faces are more like each other than either is like a foot or a fern, both of which have their own distinctive forms. Every face has two eyes, a nose between them, a mouth below, a forehead, two cheeks, two ears, and a jaw. If a face is missing one of these features, you may say, "I love this face in spite of its lacking a nose," but you must acknowledge the *in spite of*. You can't simply say, "This is a wonderful face."

The same is true of a story. You might say, "I love this piece even though there's no crisis action in it." You can't simply say, "This is a wonderful story."

Conflict, Crisis, and Resolution

One of the useful ways of describing the necessary features of story form is to speak of *conflict*, *crisis*, and *resolution*.

Conflict is the first encountered and the fundamental element of fiction, funda-

mental because in literature only trouble is interesting.

Only trouble is interesting. This is not so in life. Life offers periods of comfortable communication, peaceful pleasure, and productive work, all of which are extremely interesting to those involved. But such passages about such times by themselves make for dull reading; they can be used as lulls in an otherwise tense situation, as a resolution, even as a hint that something awful is about to happen. They cannot be used as a whole plot.

Suppose, for example, you go on a picnic. You find a beautiful deserted meadow with a lake nearby. The weather is splendid and so is the company. The food's delicious, the water's fine, and the insects have taken the day off. Afterward, someone asks you how your picnic was. "Terrific," you reply, "really perfect." No story.

But suppose the next week you go back for a rerun. You set your picnic blanket on an anthill. You all race for the lake to get cold water on the bites, and one of your friends goes too far out on the plastic raft, which deflates. He can't swim and you have to save him. On the way in you gash your foot on a broken bottle. When you get back to the picnic, the ants have taken over the cake and a possum has demolished the chicken. Just then the sky opens up. When you gather your things to race for the car, you notice an irritated bull has broken through the fence. The others run for it, but because of your bleeding heel the best you can do is hobble. You have two choices: try to outrun him or stand perfectly still and hope he's interested only in a moving target. At this point, you don't know if your friends can be counted on for help, even the nerd whose life you saved. You don't know if it's true that a bull is attracted by the smell of blood.

A year later, assuming you're around to tell about it, you are still saying, "Let me tell you what happened last year." And your listeners are saying, "What a story!"

As Charles Baxter, in Burning Down the House, more vividly puts it:

Say what you will about it, Hell is story-friendly. If you want a compelling story, put your protagonist among the damned. The mechanisms of hell are nicely attuned to the mechanisms of narrative. Not so the pleasures of Paradise. Paradise is not a story. It's about what happens when the stories are over.

If it takes trouble to make a picnic into a story, this is equally true of the great themes of life: birth, love, sex, work, and death. Here is a very interesting love story to live: Jan and Jon meet in college. Both are beautiful, intelligent, talented, popular, and well adjusted. They're of the same race, class, religion, and political persuasion. They are sexually compatible. Their parents become fast friends. They marry

on graduating, and both get rewarding work in the same city. They have three children, all of whom are healthy, happy, beautiful, intelligent, and popular; the children love and respect their parents to a degree that is the envy of everyone. All the children succeed in work and marriage. Jan and Jon die peacefully, of natural causes, at the same moment, at the age of eighty-two, and are buried in the same grave.

No doubt this love story is very interesting to Jan and Jon, but you can't make a novel of it. Great love stories involve intense passion and a monumental impediment to that passion's fulfillment. So: They love each other passionately, but their parents are sworn enemies (*Romeo and Juliet*). Or: They love each other passionately, but he's black and she's white, and he has an enemy who wants to punish him (*Othello*). Or: They love each other passionately, but she's married (*Anna Karenina*). Or: He loves her passionately, but she falls in love with him only when she has worn out his passion ("Frankly, my dear, I don't give a damn").

In each of these plots, there is both intense desire and great danger to the achievement of that desire; generally speaking, this shape holds good for all plots. It can be called 3-D: *Drama* equals *desire* plus *danger*. One common fault of talented young writers is to create a main character who is essentially passive. This is an understandable fault; as a writer you are an observer of human nature and activity, and so you identify easily with a character who observes, reflects, and suffers. But such a character's passivity transmits itself to the page, and the story also becomes passive. Charles Baxter regrets that, "In writing workshops, this kind of story is often the rule rather than the exception." He calls it:

the fiction of finger-pointing . . . In such fiction, people and events are often accused of turning the protagonist into the kind of person the protagonist is, usually an unhappy person. That's the whole story. When blame has been assigned, the story is over.

Baxter interestingly suggests that our "political climate of disavowals" leads toward such fiction, in which the central character seems to take, and the author seems to take for the character, no responsibility for what that character wants to happen. This is quite different from Aristotle's rather startling claim that a man is his desire. In fiction, in order to engage our attention and sympathy, the protagonist must want, and want intensely.

The thing that the character wants need not be violent or spectacular; it is the intensity of the wanting that introduces an element of danger. She may want, like *The Suicide's Wife* in David Madden's novel, no more than to get her driver's license, but if so she must feel that her identity and her future depend on her getting a driver's license, while a corrupt highway patrolman tries to manipulate her. He may want, like Samuel Beckett's Murphy, only to tie himself to his rocking chair and rock, but if so he will also want a woman who nags him to get up and get a job. She may want, like the heroine of Margaret Atwood's *Bodily Harm*, only to get away from it all for a rest, but if so she must need rest for her survival, while tourists and terrorists involve her in machinations that begin in discomfort and end in mortal danger.

It's important to realize that the great dangers in life and in literature are not nec-

essarily the most spectacular. Another mistake frequently made by young writers is to think that they can best introduce drama into their stories by way of muggers, murderers, crashes, and monsters, the external stock dangers of pulp and TV. In fact, all of us know that the most profound impediments to our desire usually lie close to home, in our own bodies, personalities, friends, lovers, and families. Fewer people have cause to panic at the approach of a stranger with a gun than at the approach of mama with the curling iron. More passion is destroyed at the breakfast table than in a time warp.

A frequently used critical tool divides possible conflicts into several basic categories: man against man, man against nature, man against society, man against machine, man against God, man against himself. Most stories fall into these categories, and they can provide a useful way of discussing and comparing works. But the employment of categories can be misleading to someone behind the typewriter, insofar as it suggests that literary conflicts take place in these abstract, cosmic dimensions. A writer needs a specific story to tell, and if you sit down to pit "man" against "nature," you will have less of a story than if you pit seventeen-year-old James Tucker of Weehawken, New Jersey, against a two-and-a-half-foot bigmouth bass in the backwoods of Toomsuba, Mississippi. (The value of specificity is a point to which we will return again and again.)

Once conflict is established and developed in a story, the conflict must come to a crisis and a resolution. Order is a major value that literature offers us, and order implies that the subject has been brought to closure. In life this never quite happens. Even the natural "happy endings," marriage and birth, leave domesticity and child-rearing to be dealt with; the natural "tragic endings," separation and death, leave trauma and bereavement in their wake. Literature absolves us of these nuisances. Whether or not the lives of the characters end, the story does, and we are left with a satisfying sense of completion. This is one reason we enjoy crying or feeling terrified or even nauseated by fiction; we know in advance that it's going to be over, and by contrast with the continual struggle of living, all that ends, ends well.

What I want to do now is to present several ways—they are all essentially metaphors—of seeing this pattern of *conflict-crisis-resolution* in order to make the shape and its variations clearer, and particularly to indicate what a crisis action is.

The editor and teacher Mel McKee states flatly that "a story is a war. It is sustained and immediate combat." He offers four imperatives for the writing of this "war" story.

(1) get your fighters fighting, (2) have something—the stake—worth their fighting over, (3) have the fight dive into a series of battles with the last battle in the series the biggest and most dangerous of all, (4) have a walking away from the fight.

The stake over which wars are fought is usually a territory, and it's important that this "territory" in a story be as tangible and specific as the Gaza Strip. For example, in William Carlos Williams's story "The Use of Force," found at the end of this chapter, the war is fought over the territory of the little girl's mouth, and the fight

begins narrowing to that territory from the first paragraph. As with warring nations, the story territory itself can come to represent all sorts of serious abstractions—self-determination, domination, freedom, dignity, identity—but the soldiers fight yard by yard over a particular piece of grass or sand.

Just as a minor "police action" may gradually escalate into a holocaust, story form follows its most natural order of "complications" when each battle is bigger than the last. It begins with a ground skirmish, which does not decide the war. Then one side brings in spies, and the other, guerrillas; these actions do not decide the war. So one side brings in the air force, and the other answers with antiaircraft. One side takes to missiles, and the other answers with rockets. One side has poison gas, and the other has a hand on the nuclear button. Metaphorically, this is what happens in a story. As long as one antagonist can recoup enough power to counterattack, the conflict goes on. But, at some point in the story, one of the antagonists will produce a weapon from which the other cannot recover. The crisis action is the last battle and makes the outcome inevitable; there can no longer be any doubt who wins the particular territory—though there can be much doubt about moral victory. When this has happened the conflict ends with a significant and permanent change—which is the definition, in fiction, of a resolution.

Notice that although a plot involves a desire and a danger to that desire, it does not necessarily end happily if the desire is achieved, nor unhappily if it is not. In *Hamlet*, Hamlet's desire is to kill King Claudius, and he is prevented from doing so for most of the play by other characters, intrigues, and his own mental state. When he finally succeeds, it is at the cost of every significant life in the play, including his own. Although the hero "wins" his particular "territory," the play is a tragedy. In Margaret Atwood's *Bodily Harm*, on the other hand, the heroine ends up in a political prison. Yet the discovery of her own strength and commitment is such that we know she has achieved salvation.

Novelist Michael Shaara described a story as a power struggle between equal forces. It is imperative, he argued, that each antagonist have sufficient power that the reader is left in doubt about the outcome. We may be wholly in sympathy with one character and even reasonably confident that she or he will triumph. But the antagonist must represent a real and potent danger, and the pattern of the story's complications will be achieved by *shifting the power back and forth from one antagonist to the other*. Finally, an action will occur that will shift the power irretrievably in one direction.

It is also important to understand that "power" takes many forms, some of which have the external appearance of weakness. Anyone who has ever been tied to the demands of an invalid can understand this: Sickness can be great strength. Weakness, need, passivity, an ostensible desire not to be any trouble to anybody—all these can be used as manipulative tools to prevent the protagonist from achieving his or her desire. Martyrdom is immensely powerful, whether we sympathize with it or not; a dying man absorbs all our energies.

The power of weakness has generated the central conflict in many stories and plays. Here is a passage in which it is swiftly and deftly sketched:

This sepulchral atmosphere owed a lot to the presence of Mrs. Taylor herself. She was a tall, stooped woman with deep-set eyes. She sat in her living room all day long and chain-smoked cigarettes and stared out the picture window with an air of unutterable sadness, as if she knew things beyond mortal bearing. Sometimes she would call Taylor over and wrap her arms around him, then close her eyes and hoarsely whisper, "Terence, Terence!" Eyes still closed, she would turn her head and resolutely push him away.

Tobias Wolff, This Boy's Life

Connection and Disconnection

Some critics of recent years have pointed out the patriarchal nature of narrative seen as a war or power struggle. Seeing the world in terms of conflict and crisis, of enemies and warring factions, not only limits the possibilities of literature, they argue, but also promulgates an aggressive and antagonistic view of our own lives. Further, the notion of resolution is untrue to life, and holds up perfection, unity, and singularity as goals at the expense of acceptance, nuance, and variety.

Speaking of the "gladiatorial view of fiction," Ursula Le Guin writes:

People are cross-grained, aggressive, and full of trouble, the storytellers tell us; people fight themselves and one another, and their stories are full of their struggles. But to say that that *is* the story is to use one aspect of existence, conflict, to subsume all other aspects, many of which it does not include and does not comprehend.

Romeo and Juliet is a story of the conflict between two families, and its plot involves the conflict of two individuals with those families. Is that all it involves? Isn't Romeo and Juliet about something else, and isn't it the something else that makes the otherwise trivial tale of a feud into a tragedy?

I'm indebted to dramatist Claudia Johnson for this further—and, it seems to me, crucial—insight about that "something else": Whereas the hierarchical or "vertical" nature of narrative, the power struggle, has long been acknowledged, there also appears in all narrative a "horizontal" pattern of connection and disconnection between characters that is the main source of its emotional effect. In discussing human behavior, psychologists speak in terms of "tower" and "network" patterns, the need to climb (which implies conflict) and the need for community, the need to win out over others and the need to belong to others; and these two forces also drive fiction.

In *Romeo and Juliet*, for example, the Montague and Capulet families are fiercely disconnected, but the young lovers manage to connect in spite of that. Throughout the play they meet and part, disconnect from their families in order to connect with each other, finally part from life in order to be with each other eternally. Their ultimate departure in death reconnects the feuding families.

Johnson puts it this way:

... underlying any good story, ficticious or true—is a deeper pattern of change, a pattern of connection and disconnection. The conflict and the surface events are like waves, but underneath is an emotional tide, the ebb and flow of human connection. . . .

And she points out:

Rooted in the same Latin prefix (con—together), conflict (from the Latin confligere—to clash or strike together) and connection (from the Latin connectere, to bind or tie together) are complimentary forces.

Patterns of conflict and connection occur in every story, and sometimes they are evident in much smaller compass, as in this scene from Richard Bausch's "Consolation," where a young widowed mother and her sister have come to show the baby to his grandparents:

Last night, when the baby started crying at dinner, both the Harmons seemed to sulk, and finally Wally's father excused himself and went to bed—went into his bedroom and turned a radio on. His dinner was still steaming on his plate; they hadn't even quite finished passing the food around. The music sounded through the walls of the small house, while Milly, Wally's mother and Meg sat through the meal trying to be cordial to each other, the baby fussing between them.

Finally Wally's mother said, "Perhaps if you nurse him."

"I just did," Milly told her.

"Well, he wants something."

"Babies cry," Meg put in, and the older woman looked at her as though she had said something off-color.

"Hush," Milly said to the baby. "Be quiet." Then there seemed nothing left to say.

Mrs. Harmon's hands trembled over the lace edges of the tablecloth. "Can I get you anything?" she said.

At the end of the evening she took Milly by the elbow and murmured, "I'm afraid you have to forgive us, we're just not used to the commotion."

"Commotion," Meg said as they drove back to the motel. "Jesus. Commotion."

Notice how in this very brief segment of narrative, the baby's noise disconnects the father-in-law from the three women, who try to maintain cordial contact; a conflict ensues between mother, sister and daughter-in-law; the daughter-in-law is alienated from both the woman and her baby; the mother-in-law makes abortive attempts to reconnect; then on the way home one sister uses the conflict with the older couple to connect with the other. All this in less than a page! By the end of this story, surprising alliances have been made, and unexpected alienations have grown out of the dance of conflict and connection.

Human wills clash; human belonging is necessary. Like conflict and its complications, connection and its complications can produce a pattern of change, and both inform the process of change recorded in a story.

Story Form as a Check Mark

The nineteenth-century German critic Gustav Freitag analyzed plot in terms of a pyramid of five actions: an exposition, followed by a complication (or nouement, "knotting up," of the situation), leading to a crisis, which is followed by a "falling action" or anticlimax, resulting in a resolution (or dénouement, "unknotting").

In the compact short story form, the falling action is likely to be very brief or nonexistent, and often the crisis action itself implies the resolution, which is not necessarily stated but exists as an idea established in the reader's mind.

So for our purposes it is probably more useful to think of story shape not as a pyramid with sides of equal length but as an inverted check mark. If we take the familiar tale of Cinderella and diagram it on such a shape in terms of the power struggle, we can see how the various elements reveal themselves even in this simple children's story.

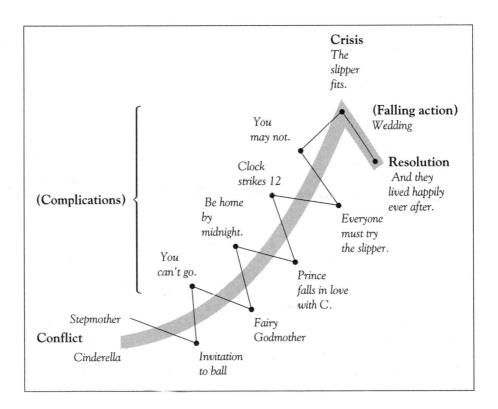

At the opening of the tale we're given the basic conflict: Cinderella's mother has died, and her father has married a brutal woman with two waspish daughters. Cinderella is made to do all the dirtiest and most menial work, and she weeps among the cinders. The Stepmother has on her side the strength of ugliness and evil (two very powerful qualities in literature as in life). With her daughters she also has the strength of numbers, and she has parental authority. Cinderella has only beauty and goodness, but (in literature and life) these are also very powerful.

At the beginning of the struggle in "Cinderella," the power is very clearly on the Stepmother's side. But the first event (action, battle) of the story is that an invitation arrives from the Prince, which explicitly states that *all* the ladies of the land are invited to a ball. Notice that Cinderella's desire is not to triumph over her Stepmother (though she eventually will, much to our satisfaction); such a desire would diminish her goodness. She simply wants to be relieved of her mistreatment. She wants equality, so that the Prince's invitation, which specifically gives her a right equal to the Stepmother's and Stepdaughters' rights, shifts the power to her.

The Stepmother takes the power back by blunt force: You may not go; you must get us ready to go. Cinderella does so, and the three leave for the ball.

Then what happens? The Fairy Godmother appears. It is very powerful to have magic on your side. The Fairy Godmother offers Cinderella a gown, glass slippers, and a coach with horses and footmen, giving her more force than she has yet had.

But the magic is not all-potent. It has a qualification that portends bad luck. It will last only until midnight (unlike the Stepmother's authority), and Cinderella must leave the ball before the clock strikes twelve or risk exposure and defeat.

What happens next? She goes to the ball and the Prince falls in love with her—and love is an even more powerful weapon than magic in a literary war. In some versions of the tale, the Stepmother and stepsisters are made to marvel at the beauty of the Princess they don't recognize, pointing to the irony of Cinderella's new power.

And then? The magic quits. The clock strikes twelve, and Cinderella runs down the steps in her rags to her rats and pumpkin, losing a slipper, bereft of her power in every way.

But after that, the Prince sends out a messenger with the glass slipper and a dictum (a dramatic repetition of the original invitation in which all ladies were invited to the ball) that every female in the land is to try on the slipper. Cinderella is given her rights again by royal decree.

What happens then? In most good retellings of the tale, the Stepmother also repeats her assumption of brute authority by hiding Cinderella away, while our expectation of triumph is tantalizingly delayed with grotesque comedy: one sister cuts off a toe, the other a heel, trying to fit into the heroine's rightful slipper.

After that, Cinderella tries on the slipper and it fits. This is the crisis action. Magic, love, and royalty join to recognize the heroine's true self; evil, numbers, and authority are powerless against them. At this point, the power struggle has been decided; the outcome is inevitable. When the slipper fits, no further action can occur that will deprive Cinderella of her desire. The change in the lives of all concerned is significant and permanent.

The tale has a brief "falling action" or "walking away from the fight": the Prince

sweeps Cinderella up on his white horse and gallops away to their wedding. The story comes to closure with the classic resolution of all comedy: They lived happily ever after.

If we look at "Cinderella" in terms of connection/disconnection, we see a pattern as clear as that represented by the power struggle. The first painful disconnection is that Cinderella's mother has died; her father has married (connected with) a woman who spurns (disconnects from) her; the prince's invitation offers connection, the Stepmother's cruelty alienates again. The Fairy Godmother connects as a magical friend, but the disappearance of the coach and gown disconnect Cinderella temporarily from that grand and glorious fairytale union, marriage to the Prince. If we consult the emotions that this tale engenders—pity, anger, hope, fear, romance, anticipation, disappointment, triumph—we see that both the struggle between antagonist/protagonist and the pattern of alienation/connectedness is necessary to ensure, not only that there is an action, but also that we care about its outcome. The traditional happy ending is the grand connection, marriage; the traditional tragic outcome is the final disconnection, death.

In the *Poetics*, the first extensive work of extant Western literary criticism, Aristotle referred to the crisis action of a tragedy as a *peripeteia*, or reversal of the protagonist's fortunes. Critics and editors agree that a reversal of some sort is necessary to all story structure, comic as well as tragic. Although the protagonist need not lose power, land, or life, he or she must in some significant way be changed or moved by the action. Aristotle specified that this reversal came about because of *hamartia*, which has for centuries been translated as a "tragic flaw" in the protagonist's character, usually assumed to be, or defined as, pride. But more recent critics have defined and translated *hamartia* much more narrowly as a "mistake in identity" with the reversal coming about in a "recognition."

It is true that recognition scenes have played a disproportionately large role in the crisis actions of plots both comic and tragic, and that these scenes frequently stretch credibility. In real life, you are unlikely to mistake the face of your mother, son, uncle, or even friend, and yet such mistakes have provided the turning point of many a plot. If, however, the notion of "recognition" is extended to more abstract and subtle realms, it becomes a powerful metaphor for moments of "realization." In other words, the "recognition scene" in literature may stand for that moment in life when we "recognize" that the man we have considered good is evil, the event we have considered insignificant is crucial, the woman we have thought out of touch with reality is a genius, the object we have thought desirable is poison. There is in this symbolic way a recognition in "Cinderella." We knew that she was essentially a princess, but until the Prince recognizes her as one, our knowledge must be frustrated.

James Joyce developed a similar idea when he spoke of, and recorded both in his notebooks and in his stories, moments of what he called *epiphany*. As Joyce saw it, epiphany is a crisis action in the mind, a moment when a person, an event, or a thing is seen in a light so new that it is as if it has never been seen before. At this recognition, the mental landscape of the viewer is permanently changed.

In many of the finest modern short stories and novels, the true territory of strug-

gle is the main character's mind, and so the real crisis action must occur there. Yet it is important to grasp that Joyce chose the word *epiphany* to represent this moment of reversal, and that the word means "a *manifestation* of a supernatural being"; specifically, in Christian doctrine, "the manifestation of Christ to the gentiles." By extension, then, in a short story any mental reversal that takes place in the crisis of a story must be *manifested*; it must be triggered or shown by an action. The slipper must fit. It would not do if the Stepmother just happened to change her mind and give up the struggle; it would not do if the Prince just happened to notice that Cinderella looked like his love. The moment of recognition must be manifested in an action.

This point, that the crisis must be manifested or externalized in an action, is absolutely central, although sometimes difficult to grasp when the struggle of the story takes place in a character's mind.

It is easy to see, for example, how the conflict in a revenge story must come to crisis. The common revenge plot, from *Hamlet* to *Death Wish 4* takes this form: Someone important to the hero (father, sister, lover, friend) is killed, and for some reason the authorities who ought to be in charge of justice can't or won't avenge the death. The hero must do so, then, and the crisis action is manifested in the swing of the dagger, the blast of the gun, the swallowing of the poison, whatever.

But suppose the story is about a struggle between two brothers on a fishing trip, and the change that takes place is that the protagonist, believing for most of the action that he holds his older brother in contempt, discovers at the end of the story that they are deeply bound by love and family history. Clearly this change is an epiphany, a mental reversal. A writer insufficiently aware of the nature of crisis action might signal the change in a paragraph that begins "suddenly Larry remembered their father and realized that Jeff was very much like him." Well, unless that memory and that realization are manifested in an action, the reader is unable to share them, and therefore cannot be moved with the character.

Jeff reached for the old net and neatly bagged the trout, swinging round to offer it with a triumphant, "Got it! We got it, didn't we?" The trout flipped and struggled, giving off a smell of weed and water and fecund mud. Jeff's knuckles were lined with grime. The knuckles and the rich river smell filled him with a memory of their first fishing trip together, the sight of their father's hands on the same scarred net....

Here the epiphany, a memory leading to a realization, is triggered by an action and sensory details that the reader can share; the reader now has a good chance of also being able to share the epiphany.

Much great fiction, and the preponderance of serious modern fiction, echoes life in its suggestion that there are no clear or permanent solutions, that the conflicts of character, relationship, and the cosmos cannot be permanently resolved. Most of the stories in this volume have the feel of the twentieth century, with its ambiguities and unfinished struggles; none could end "they lived happily ever after" or even "they lived unhappily ever after."

Yet the story form demands a resolution. Is there such a thing as a no-resolution

resolution? Yes, and it has a very specific form. Go back to the metaphor that "a story is a war." After the skirmish, after the guerrillas, after the air strike, after the poison gas and the nuclear holocaust, imagine that the two surviving combatants, one on each side, emerge from their fallout shelters. They crawl, then stumble to the fence that marks the border. Each possessively grasps the barbed wire with a bloodied fist. The "resolution" of this battle is that neither side will ever give up and that no one will ever win; there will never be a resolution. This is a distinct reversal (the recognition takes place in the reader's mind) of the opening scene, in which it seemed eminently worthwhile to open a ground skirmish. In the statement of the conflict was an inherent possibility that one side or another could win. Inherent in the resolution is a statement that no one can ever win. That is a distinct reversal and a powerful change.

Story and Plot

So far, I have used the words "story" and "plot" interchangeably. The equation of the two terms is so common that they are often comfortably understood as synonyms. When an editor says, "This is not a story," the implication is not that it lacks character, theme, setting, or even incident, but that it has no plot.

Yet there is a distinction frequently drawn between the two terms, a distinction that although simple in itself, gives rise to manifold subtleties in the craft of narrative and that also represents a vital decision that you as a writer must make: Where should your narrative begin?

The distinction is easily made. A *story* is a series of events recorded in their chronological order. A *plot* is a series of events deliberately arranged so as to reveal their dramatic, thematic, and emotional significance.

Here, for example, is a fairly standard story: A sober, industrious, and rather dull young man meets the woman of his dreams. She is beautiful, brilliant, passionate, and compassionate; more wonderful still, she loves him. They plan to marry, and on the eve of their wedding his friends give him a stag party in the course of which they tease him, ply him with liquor, and drag him off to a whorehouse for a last fling. There he stumbles into a cubicle . . . to find himself facing his bride-to-be.

Where does this story become interesting? Where does the plot begin?

You may start, if you like, with the young man's Mayflower ancestry. But if you do, it's going to be a very long story, and we're likely to close the book about the middle of the nineteenth century. You may begin with the first time he meets the extraordinary woman, but even then you must cover at least weeks, probably months, in a few pages; and that means you must summarize, skip, and generalize, and you'll have a hard time both maintaining your credibility and holding our attention. Begin at the stag party? Better. If you do so, you will somehow have to let us know all that has gone before, either through dialogue or through the young man's memory, but you have only one evening of action to cover, and we'll get to the conflict quickly. Suppose you begin instead the next morning, when the man wakes with a hangover in bed in a brothel with his bride on his wedding day. Is that, perhaps, the best of all? An immediate conflict that must lead to a quick and striking crisis?

Humphry House, in his commentaries on Aristotle, defines story as everything

the reader needs to know to make coherent sense of the plot, and *plot* as the particular portion of the story the author chooses to present—the "present tense" of the narrative. The story of *Oedipus Rex*, for example, begins before Oedipus's birth with the oracle predicting that he will murder his father and marry his mother. It includes his birth, his abandonment with hobbled ankles, his childhood with his foster parents, his flight from them, his murder of the stranger at the crossroads, his triumph over the Sphinx, his marriage to Jocasta and his reign in Thebes, his fatherhood, the Theban plague, his discovery of the truth, and his self-blinding and self-banishment. When Sophocles set out to plot a play on this story, he began at dawn on the very last day of it. All the information about Oedipus's life is necessary to understand the plot, but the plot begins with the conflict: How can Oedipus get rid of the plague in Thebes? Because the plot is so arranged, it is the revelation of the past that makes up the action of the play, a process of discovery that gives rise to the significant theme: Who am I? Had Sophocles begun with the oracle before Oedipus's birth, no such theme and no such significance could have been explored.

E. M. Forster makes substantially the same distinction between plot and story. A story, he says, is:

the chopped off length of the tape worm of time . . . a narrative of events arranged in their time sequence. A plot is also a narrative of events, the emphasis falling on causality. "The king died, and then the queen died," is a story. "The king died, and then the queen died of grief," is a plot. The time sequence is preserved, but the sense of causality overshadows it. Or again: "The queen died, no one knew why, until it was discovered that it was through grief at the death of the king." This is a plot with a mystery in it, a form capable of high development. It suspends the time sequence, it moves as far away from the story as its limitations will allow. Consider the death of the queen. If it is in a story we say, "and then?" If it is in a plot we ask, "why?"

The human desire to know why is as powerful as the desire to know what happened next, and it is a desire of a higher order. Once we have the facts, we inevitably look for the links between them, and only when we find such links are we satisfied that we "understand." Rote memorization in a science bores almost everyone. Grasp and a sense of discovery begin only when we perceive why "a body in motion tends to remain in motion" and what an immense effect this actuality has on the phenomena of our lives.

The same is true of the events of a story. Random incidents neither move nor illuminate; we want to know why one thing leads to another and to feel the inevitability of cause and effect.

Here is a series of uninteresting events chronologically arranged.

Ariadne had a bad dream. She woke up tired and cross. She ate breakfast. She headed for class. She saw Leroy.
She fell on the steps and broke her ankle.
Leroy offered to take notes for her.
She went to a hospital.

This series of events does not constitute a plot, and if you wish to fashion it into a plot, you can do so only by letting us know the meaningful relations among the events. We first assume that Ariadne woke in a temper because of her bad dream, and that Leroy offered to take notes for her because she broke her ankle. But why did she fall? Perhaps because she saw Leroy? Does that suggest that her bad dream was about him? Was she, then, thinking about his dream-rejection as she broke her egg irritably on the edge of the frying pan? What is the effect of his offer? Is it a triumph or just another polite form of rejection when, really, he could have missed class once to drive her to the x-ray lab? The emotional and dramatic significance of these ordinary events emerges in the relation of cause to effect, and where such relation can be shown, a possible plot comes into existence. Notice also that in this brief attempt to form the events into a plot, I have introduced both conflict and a pattern of connection/disconnection.

Ariadne's is a story you might very well choose to tell chronologically: it needs to cover only an hour or two, and that much can be handled in the compressed form of the short story. But such a choice of plot is not inevitable even in this short compass. Might it be more gripping to begin with the wince of pain as she stumbles? Leroy comes to help her up and the yolk yellow of his T-shirt fills her field of vision. In the shock of pain she is immediately back in her dream. . . .

When "nothing happens" in a story, it is because we fail to sense the causal relation between what happens first and what happens next. When something does "happen," it is because the resolution of a short story or a novel describes a change in the character's life, an effect of the events that have gone before. This is why Aristotle insisted with such apparent simplicity on "a beginning, a middle, and an end." A story is capable of many meanings, and it is first of all in the choice of structure—which portion of the story forms the plot—that you offer us the gratifying sense that we "understand."

The Short Story and the Novel

Many editors and writers insist on an essential disjunction between the form of the short story and that of the novel. It is my belief, however, that, like the distinction between story and plot, the distinction between the two forms is very simple, and the many and profound possibilities of difference proceed from that simple source: A short story is short, and a novel is long.

Because of this, a short story can waste no words. It can deal with only one or a very few consciousnesses. It may recount only one central action and one major change or effect in the life of the central character or characters. It can afford no digression that does not directly affect the action. A short story strives for a single emotional impact and imparts a single understanding, though both impact and un-

derstanding may be complex. The virtue of a short story is its density. If it is tight, sharp, economic, well knit, and charged, then it is a good short story because it has exploited a central attribute of the form—that it is short.

All of these qualities are praiseworthy in a novel, but a novel may also be comprehensive, vast, and panoramic. It may have power, not because of its economy but because of its scope, breadth, and sweep—the virtues of a medium that is long. Therefore, a novel may range through many consciousnesses, cover many years or generations, and travel the world. It may deal with a central line of action and one or several subplots. Many characters may change; many and various effects may constitute our final understanding. Many digressions may be tolerated and will not destroy the balance of the whole as long as they lead, finally, to some nuance of that understanding.

These differences in the possibilities of the novel and short-story forms may directly affect the relationship between story and plot. With the narrative leisure available to a novelist, it may very well be possible to begin with a character's birth, or even ancestry, even though the action culminates in middle or old age.

My own feeling as a writer is that in a novel I may allow myself, and ask the reader to share, an exploration of character, setting, and theme, letting these develop in the course of the narrative. When I am writing a short story, I must reject more, and I must select more rigorously.

One constant principle of artistic effectiveness is that you must discover what a medium cannot do and forget it; and discover what it can do and exploit it. Television is a good medium for domestic drama, but for a battle with a cast of thousands, you need a movie screen twelve feet high. For a woodland scene, watercolor is fine; but for the agony of St. Sebastian, choose oil. If you are writing for radio, the conflict must be expressible in sound; if you are writing a mime, it must be expressible in movement.

This is not to say that one form is superior to another but simply that each is itself and that no medium and no form of that medium can do everything. The greater the limitation in time and space, the greater the necessity for pace, sharpness, and density. For this reason, it is a good idea to learn to write short stories before you attempt the scope of the novel, just as it is good to learn to write a lyric before you attempt an epic or to learn to draw an apple before you paint a god.

Nevertheless, the form of the novel is an expanded story form. It asks for a conflict, a crisis, and a resolution, and no technique described in this book is irrelevant to its effectiveness.

The Use of Force

WILLIAM CARLOS WILLIAMS

They were new patients to me, all I had was the name, Olson. Please come down as soon as you can, my daughter is very sick.

When I arrived I was met by the mother, a big startled looking woman, very clean and apologetic who merely said, Is this the doctor? and let me in. In the back, she added. You must excuse us, doctor, we have her in the kitchen where it is warm. It is very damp here sometimes.

The child was fully dressed and sitting on her father's lap near the kitchen table. He tried to get up, but I motioned for him not to bother, took off my overcoat and started to look things over. I could see that they were all very nervous, eyeing me up and down distrustfully. As often, in such cases, they weren't telling me more than they had to, it was up to me to tell them; that's why they were spending three dollars on me.

The child was fairly eating me up with her cold, steady eyes, and no expression to her face whatever. She did not move and seemed, inwardly, quict; an unusually attractive little thing, and as strong as a heifer in appearance. But her face was flushed, she was breathing rapidly, and I realized that she had a high fever. She had magnificent blonde hair, in profusion. One of those picture children often reproduced in advertising leaflets and the photogravure sections of the Sunday papers.

She's had a fever for three days, began the father, and we don't know what it comes from. My wife has given her things, you know, like people do, but it don't do no good. And there's been a lot of sickness around. So we tho't you'd better look her over and tell us what is the matter.

As doctors often do I took a trial shot at it as a point of departure. Has she had a sore throat?

Both parents answered me together, No... No, she says her throat don't hurt

Does your throat hurt you? added the mother to the child. But the little girl's expression didn't change, nor did she move her eyes from my face.

Have you looked?

I tried to, said the mother, but I couldn't sec.

As it happens, we had been having a number of cases of diphtheria in the school to which this child went during that month and we were all, quite apparently, thinking of that, though no one had as yet spoken of the thing.

Well, I said, suppose we take a look at the throat first. I smiled in my best professional manner and asking for the child's first name I said, come on, Mathilda, open your mouth and let's take a look at your throat.

Nothing doing.

Aw, come on, I coaxed, just open your mouth wide and let me take a look. Look, I said opening both hands wide, I haven't anything in my hands. Just open up and let me see.

Such a nice man, put in the mother. Look how kind he is to you. Come on, do what he tells you to. He won't hurt you.

At that I ground my teeth in disgust. If only they wouldn't use the word "hurt" I might be able to get somewhere. But I did not allow myself to be hurried or disturbed, but speaking quietly and slowly I approached the child again.

As I moved my chair a little nearer, suddenly with one catlike movement both her hands clawed instinctively for my eyes and she almost reached them too. In fact she knocked my glasses flying and they fell, though unbroken, several feet away from me on the kitchen floor.

Both the mother and father almost turned themselves inside out in embarrassment and apology. You bad girl, said the mother, taking her and shaking her by one arm. Look what you've done. The nice man.

For heaven's sake, I broke in. Don't call me a nice man to her. I'm here to look at her throat on the chance that she might have diphtheria and possibly die of it. But that's nothing to her. Look here, I said to the child, we're going to look at your throat. You're old enough to understand what I'm saying. Will you open it now by yourself or shall we have to open it for you?

Not a move. Even her expression hadn't changed. Her breaths however were coming faster and faster. Then the battle began. I had to do it. I had to have a throat culture for her own protection. But first I told the parents that it was entirely up to them. I explained the danger but said that I would not insist on a throat examination so long as they would take the responsibility.

If you don't do what the doctor says you'll have to go to the hospital, the mother admonished her severely.

Oh yeah? I had to smile to myself. After all, I had already fallen in love with the savage brat, the parents were contemptible to me. In the ensuing struggle they grew more and more abject, crushed, exhausted while she surely rose to magnificent heights of insane fury of effort bred of her terror of me.

The father tried his best, and he was a big man but the fact that she was his daughter, his shame at her behavior and his dread of hurting her made him release her just at the critical moment several times when I had almost achieved success, till I wanted to kill him. But his dread also that she might have diphtheria made him tell me to go on, go on though he himself was almost fainting, while the mother moved back and forth behind us raising and lowering her hands in an agony of apprehension.

Put her in front of you on your lap, I ordered, and hold both her wrists.

But as soon as he did the child let out a scream. Don't, you're hurting me. Let go of my hands. Let them go I tell you. Then she shrieked terrifyingly, hysterically. Stop it! Stop it! You're killing me!

Do you think she can stand it, doctor! said the mother.

You get out, said the husband to his wife. Do you want her to die of diphtheria? Come on now, hold her, I said.

Then I grasped the child's head with my left hand and tried to get the wooden tongue depressor between her teeth. She fought, with clenched teeth, desperately! But now I also had grown furious—at a child. I tried to hold myself down but I couldn't. I know how to expose a throat for inspection. And I did my best. When finally I got the wooden spatula behind the last teeth and just the point of it into the mouth cavity, she opened up for an instant but before I could see anything she came down again and gripping the wooden blade between her molars she reduced it to splinters before I could get it out again.

Aren't you ashamed, the mother yelled at her. Aren't you ashamed to act like that in front of the doctor?

Get me a smooth-handled spoon of some sort, I told the mother. We're going through with this. The child's mouth was already bleeding. Her tongue was cut and she was screaming in wild hysterical shrieks. Perhaps I should have desisted and come back in an hour or more. No doubt it would have been better. But I have seen at least two children lying dead in bed of neglect in such cases, and feeling that I must get a diagnosis now or never I went at it again. But the worst of it was that I too had got beyond reason. I could have torn the child apart in my own fury and enjoyed it. It was a pleasure to attack her. My face was burning with it.

The damned little brat must be protected against her own idiocy, one says to one's self at such times. Others must be protected against her. It is social necessity. And all these things are true. But a blind fury, a feeling of adult shame, bred of a longing for muscular release are the operatives. One goes on to the end.

In a final unreasoning assault I overpowered the child's neck and jaws. I forced the heavy silver spoon back of her teeth and down her throat till she gagged. And there it was—both tonsils covered with membrane. She had fought valiantly to keep me from knowing her secret. She had been hiding that sore throat for three days at least and lying to her parents in order to escape just such an outcome as this.

Now truly she was furious. She had been on the defensive before but now she attacked. Tried to get off her father's lap and fly at me while tears of defeat blinded her eyes.

Suggestions for Discussion

Each story at the end of a chapter in this book will be followed by a few suggestions for discussion that ask not What does this story mean? but How does this story work? Learning to read as a writer involves focusing on the craft, the choices and the techniques of the author. This is an ongoing and sometimes a difficult task, both because we are trained to interpret and search for theme rather than to focus on form, and because the two tasks can never be wholly separated: There must be some sense of what does this do? before we can ask how does it do it? But it's worth the struggle. T.S. Eliot remarked that "bad poets imitate; good poets steal," and reading as a writer is casing the joint. Ideally, you should read each story once quickly and uncritically, to let it work on you. Then consider: What is memorable, effective, affecting? Read it again in a more analytical frame of mind, watching for the techniques and devices that produced those reactions in you. Why has the author chosen to begin the plot here rather than somewhere else? Why did s/he make this choice of imagery, scene, atmosphere. ending? What techniques contribute to this effect of tension, sympathy? Be greedy from your own viewpoint as an author: What, from this story, can I learn/take/imitate/ attempt/steal?

 Identify the central conflict, the crisis, and the resolution in "The Use of Force."

- 2. This story has the feel of twentieth-century life, not at all the feel of a tale. Can it be positioned like "Cinderella" on the diagram?
- 3. The doctor is clearly in a position of power with these poor people. How is that power shown to be eroded?
- 4. What techniques does Williams use to show connection between these characters? How does he show disconnection?

How Far She Went

MARY HOOD

They had quarreled all morning, squalled all summer about the incidentals: how tight the girl's cut-off jeans were, the "Every Inch a Woman" T-shirt, her choice of music and how loud she played it, her practiced inattention, her sullen look. Her granny wrung out the last boiled dishcloth, pinched it to the line, giving the basin a sling and a slap, the water flying out in a scalding arc onto the Queen Anne's lace by the path, never mind if it bloomed, that didn't make it worth anything except to chiggers, but the girl would cut it by the everlasting armload and cherish it in the old churn, going to that much trouble for a week but not bending once—unbegged—to pick the nearest bean; she was sulking now. Bored. Displaced.

"And what do you think happens to a chigger if nobody ever walks by his weed?" her granny asked, heading for the house with that sidelong uneager unanswered glance, hoping for what? The surprise gift of a smile? Nothing. The woman shook her head and said it. "Nothing." The door slammed behind her. Let it.

"I hate it here!" the girl yelled then. She picked up a stick and broke it and threw the pieces—one from each hand—at the laundry drying in the noon. Missed. Missed.

Then she turned on her bare, haughty heel and set off high-shouldered into the heat, quick but not far, not far enough—no road was *that* long—only as far as she dared. At the gate, a rusty chain swinging between two lichened posts, she stopped, then backed up the raw drive to make a run at the barrier, lofting, clearing it clean, her long hair wild in the sun. Triumphant, she looked back at the house where she caught at the dark window her granny's face in its perpetual eclipse of disappointment, old at fifty. She stepped back, but the girl saw her.

"You don't know me!" the girl shouted, chin high, and ran till her ribs ached.

As she rested in the rattling shade of the willows, the little dog found her. He could be counted on. He barked all the way, and squealed when she pulled the burr from his ear. They started back to the house for lunch. By then the mailman had long come and gone in the old ruts, leaving the one letter folded now to fit the woman's apron pocket.

If bad news darkened her granny's face, the girl ignored it. Didn't talk at all, an-

other of her distancings, her defiances. So it was as they ate that the woman summarized, "Your daddy wants you to cash in the plane ticket and buy you something. School clothes. For here."

Pale, the girl stared, defenseless only an instant before blurting out, "You're lying."

The woman had to stretch across the table to leave her handprint on that blank cheek. She said, not caring if it stung or not, "He's been planning it since he sent you here."

"I could turn this whole house over, dump it! Leave you slobbering over that stinking jealous dog in the dust!" The girl trembled with the vision, with the strength it gave her. It made her laugh. "Scatter the Holy Bible like confetti and ravel the crochet into miles of stupid string! I could! I will! I won't stay here!" But she didn't move, not until her tears rose to meet her color, and then to escape the shame of minding so much she fled. Just headed away, blind. It didn't matter, this time, how far she went.

The woman set her thoughts against fretting over their bickering, just went on unalarmed with chores, clearing off after the uneaten meal, bringing in the laundry, scattering corn for the chickens, ladling manure tea onto the porch flowers. She listened though. She always had been a listener. It gave her a cocked look. She forgot why she had gone into the girl's empty room, that ungirlish, tenuous lodging place with its bleak order, its ready suitcases never unpacked, the narrow bed, the contested radio on the windowsill. The woman drew the cracked shade down between the radio and the August sun. There wasn't anything else to do.

It was after six when she tied on her rough oxfords and walked down the drive and dropped the gate chain and headed back to the creosoted shed where she kept her tools. She took a hoe for snakes, a rake, shears to trim the grass where it grew, and seed in her pocket to scatter where it never had grown at all. She put the tools and her gloves and the bucket in the trunk of the old Chevy, its prime and rust like an Appaloosa's spots through the chalky white finish. She left the trunk open and the tool handles sticking out. She wasn't going far.

The heat of the day had broken, but the air was thick, sultry, weighted with honeysuckle in second bloom and the Nu-Grape scent of kudzu. The maple and poplar leaves turned over, quaking, silver. There wouldn't be any rain. She told the dog to stay, but he knew a trick. He stowed away when she turned her back, leaped right into the trunk with the tools, then gave himself away with exultant barks. Hearing him, her court jester, she stopped the car and welcomed him into the front seat beside her. Then they went on. Not a mile from her gate she turned onto the blue gravel of the cemetery lane, hauled the gearshift into reverse to whoa them, and got out to take the idle walk down to her buried hopes, bending all along to rout out a handful of weeds from between the markers of old acquaintance. She stood there and read, slow. The dog whined at her hem; she picked him up and rested her chin in his head, then he wriggled and whined to run free, contrary and restless as a child.

The crows called strong and bold MOM! MOM! A trick of the ear to hear it like that. She knew it was the crows, but still she looked around. No one called her that

now. She was done with that. And what was it worth anyway? It all came to this: solitary weeding. The sinful fumble of flesh, the fear, the listening for a return that never came, the shamed waiting, the unanswered prayers, the perjury on the certificate—hadn't she lain there weary of the whole lie and it only beginning? and a voice telling her, "Here's your baby, here's your girl," and the swaddled package meaning no more to her than an extra anything, something store-bought, something she could take back for a refund.

"Tie her to the fence and give her a bale of hay," she had murmured, drugged, and they teased her, excused her for such a welcoming, blaming the anesthesia, but it went deeper than that; she knew, and the baby knew: there was no love in the begetting. That was the secret, unforgivable, that not another good thing could ever make up for, where all the bad had come from, like a visitation, a punishment. She knew that was why Sylvie had been wild, had gone to earth so early, and before dying had made this child in sudden wedlock, a child who would be just like her, would carry the hurting on into another generation. A matter of time. No use raising her hand. But she had raised her hand. Still wore on its palm the memory of the sting of the collision with the girl's cheek; had she broken her jaw? Her heart? Of course not. She said it aloud: "Takes more than that."

She went to work then, doing what she could with her old tools. She pecked the clay on Sylvie's grave, new-looking, unhealed after years. She tried again, scattering seeds from her pocket, every last possible one of them. Off in the west she could hear the pulpwood cutters sawing through another acre across the lake. Nearer, there was the racket of motorcycles laboring cross-country, insect-like, distracting.

She took her bucket to the well and hung it on the pump. She had half filled it when the bikers roared up, right down the blue gravel, straight at her. She let the bucket overflow, staring. On the back of one of the machines was the girl. Sylvie's girl! Her bare arms wrapped around the shirtless man riding between her thighs. They were first. The second biker rode alone. She studied their strangers' faces as they circled her. They were the enemy, all of them. Laughing. The girl was laughing too, laughing like her mama did. Out in the middle of nowhere the girl had found these two men, some moth-musk about her drawing them (too soon!) to what? She shouted it: "What in God's—" They roared off without answering her, and the bucket of water tipped over, spilling its stain blood-dark on the red dust.

The dog went wild barking, leaping after them, snapping at the tires, and there was no calling him down. The bikers made a wide circuit of the churchyard, then roared straight across the graves, leaping the ditch and landing upright on the road again, heading off toward the reservoir.

Furious, she ran to her car, past the barking dog, this time leaving him behind, driving after them, horn blowing nonstop, to get back what was not theirs. She drove after them knowing what they did not know, that all the roads beyond that point dead-ended. She surprised them, swinging the Impala across their path, cutting them off; let them hit it! They stopped. She got out, breathing hard, and said, when she could, "She's underage." Just that. And put out her claiming hand with an authority that made the girl's arms drop from the man's insolent waist and her legs tremble.

"I was just riding," the girl said, not looking up.

Behind them the sun was heading on toward down. The long shadows of the pines drifted back and forth in the same breeze that puffed the distant sails on the lake. Dead limbs creaked and clashed overhead like the antlers of locked and furious beasts.

"Sheeeut," the lone rider said. "I told you." He braced with his muddy boot and leaned out from his machine to spit. The man the girl had been riding with had the invading sort of eyes the woman had spent her lifetime bolting doors against. She met him now, face to face.

"Right there, missy," her granny said, pointing behind her to the car.

The girl slid off the motorcycle and stood halfway between her choices. She started slightly at the poosh! as he popped another top and chugged the beer in one uptilting of his head. His eyes never left the woman's. When he was through, he tossed the can high, flipping it end over end. Before it hit the ground he had his pistol out and, firing once, winged it into the lake.

"Freaking lucky shot," the other one grudged.

"I don't need luck," he said. He sighted down the barrel of the gun at the woman's head. "POW!" he yelled, and when she recoiled, he laughed. He swung around to the girl; he kept aiming the gun, there, high, low, all around. "Y'all settle it," he said, with a shrug.

The girl had to understand him then, had to know him, had to know better. But still she hesitated. He kept looking at her, then away.

"She's fifteen," her granny said. "You can go to jail."

"You can go to hell," he said.

"Probably will," her granny told him. "I'll save you a seat by the fire." She took the girl by the arm and drew her to the car; she backed up, swung around, and headed out the road toward the churchyard for her tools and dog. The whole way the girl said nothing, just hunched against the far door, staring hard-eyed out at the pines going past.

The woman finished watering the seed in, and collected her tools. As she worked, she muttered, "It's your own kin buried here, you might have the decency to glance this way one time . . ." The girl was finger-tweezing her eyebrows in the side mirror. She didn't look around as the dog and the woman got in. Her granny shifted hard, sending the tools clattering in the trunk.

When they came to the main road, there were the men. Watching for them. Waiting for them. They kicked their machines into life and followed, close, bumping them, slapping the old fenders, yelling. The girl gave a wild glance around at the one by her door and said, "Gran'ma?" and as he drew his pistol, "Gran'ma!" just as the gun nosed into the open window. She frantically cranked the glass up between her and the weapon, and her granny, seeing, spat, "Fool!" She never had been one to pray for peace or rain. She stamped the accelerator right to the floor.

The motorcycles caught up. Now she braked, hard, and swerved off the road into an alley between the pines, not even wide enough for the school bus, just a fire scrape that came out a quarter mile from her own house, if she could get that far. She slewed on the pine straw, then righted, tearing along the dark tunnel through the woods. She had for the time being bested them; they were left behind. She was

winning. Then she hit the wallow where the tadpoles were already five weeks old. The Chevy plowed in and stalled. When she got it cranked again, they were stuck. The tires spattered mud three feet up the near trunks as she tried to spin them out, to rock them out. Useless. "Get out and run!" she cried, but the trees were too close on the passenger side. The girl couldn't open her door. She wasted precious time having to crawl out under the steering wheel. The woman waited but the dog ran on.

They struggled through the dusky woods, their pace slowed by the thick straw and vines. Overhead, in the last light, the martins were reeling free and sure after their prey.

"Why?" the girl gasped, as they lunged down the old deer trail. Behind them they could hear shots, and glass breaking as the men came to the bogged car. The woman kept on running, swatting their way clear through the shoulder-high weeds. They could see the Greer cottage, and made for it. But it was ivied-over, padlocked, the woodpile dry-rotting under its tarp, the electric meterbox empty on the pole. No help there.

The dog, excited, trotted on, yelping, his lips white-flecked. He scented the lake and headed that way, urging them on with thirsty yips. On the clay shore, treeless, deserted, at the utter limit of land, they stood defenseless, listening to the men coming on, between them and home. The woman pressed her hand to her mouth, stifling her cough. She was exhausted. She couldn't think.

"We can get under!" the girl cried suddenly, and pointed toward the Greers' dock, gap-planked, its walkway grounded on the mud. They splashed out to it, wading in, the woman grabbing up the telltale, tattletale dog in her arms. They waded out to the far end and ducked under. There was room between the foam floats for them to crouch neck-deep.

The dog wouldn't hush, even then, never had yet, and there wasn't time to teach him. When the woman realized that, she did what she had to do. She grabbed him, whimpering; held him; held him under till the struggle ceased and the bubbles rose silver from his fur. They crouched there then, the two of them, submerged to the shoulders, feet unsteady on the slimed lake bed. They listened. The sky went from rose to ocher to violet in the cracks over their heads. The motorcycles had stopped now. In the silence there was the glissando of locusts, the dry crunch of boots on the flinty beach, their low man-talk drifting as they prowled back and forth. One of them struck a match.

"—they in these woods we could burn 'em out."

The wind carried their voices away into the pines. Some few words eddied back.

"—lippy old smartass do a little work on her knees besides praying—"

Laughter. It echoed off the deserted house. They were getting closer.

One of them strode directly out to the dock, walked on the planks over their heads. They could look up and see his boot soles. He was the one with the gun. He slapped a mosquito on his bare back and cursed. The carp, roused by the troubling of the waters, came nosing around the dock, guzzling and snorting. The girl and her granny held still, so still. The man fired his pistol into the shadows, and a wounded fish thrashed, dying. The man knelt and reached for it, chuffing out his beery breath. He belched. He pawed the lake for the dead fish, cursing as it floated out of reach.

He shot it again, firing at it till it sank and the gun was empty. Cursed that too. He stood then and unzipped and relieved himself of some of the beer. They had to listen to that. To know that about him. To endure that, unprotesting.

Back and forth on shore the other one ranged, restless. He lit another cigarette. He coughed. He called, "Hey! They got away, man, that's all. Don't get your shorts in a wad. Let's go."

"Yeah." He finished. He zipped. He stumbled back across the planks and leaped to shore, leaving the dock tilting amid widening ripples. Underneath, they waited.

The bike cranked. The other ratcheted, ratcheted, then coughed, caught, roared. They circled, cut deep ruts, slung gravel, and went. Their roaring died away and away. Crickets resumed and a near frog bic-bic-bicked.

Under the dock, they waited a little longer to be sure. Then they ducked below the water, scraped out from under the pontoon, and came up into free air, slogging toward shore. It had seemed warm enough in the water. Now they shivered. It was almost night. One streak of light still stood reflected on the darkening lake, drew itself thinner, narrowing into a final cancellation of day. A plane winked its way west.

The girl was trembling. She ran her hands down her arms and legs, shedding water like a garment. She sighed, almost a sob. The woman held the dog in her arms; she dropped to her knees upon the random stones and murmured, private, haggard, "Oh, honey," three times, maybe all three times for the dog, maybe once for each of them. The girl waited, watching. Her granny rocked the dog like a baby, like a dead child, rocked slower and slower and was still.

"I'm sorry," the girl said then, avoiding the dog's inert, empty eye.

"It was him or you," her granny said, finally, looking up. Looking her over. "Did they mess with you? With your britches? Did they?"

"No!" Then, quieter, "No, ma'am."

When the woman tried to stand up she staggered, lightheaded, clumsy with the freight of the dog. "No, ma'am," she echoed, fending off the girl's "Let me." And she said again, "It was him or you. I know that. I'm not going to rub your face in it." They saw each other as well as they could in that failing light, in any light.

The woman started toward home, saying, "Around here, we bear our own burdens." She led the way along the weedy shortcuts. The twilight bleached the dead limbs of the pines to bone. Insects sang in the thickets, silencing at their oncoming.

"We'll see about the car in the morning," the woman said. She bore her armful toward her own moth-ridden dusk-to-dawn security light with that country grace she had always had when the earth was reliably progressing underfoot. The girl walked close behind her, exactly where *she* walked, matching her pace, matching her stride, close enough to put her hand forth (if the need arose) and touch her granny's back where the faded voile was clinging damp, the merest gauze between their wounds.

Suggestions for Discussion

- 1. What kinds of power are each of the characters given?
- 2. Identify three or four moments in the story where the power shifts from one character to another. How is this achieved? Examine how Hood makes each "battle" bigger than the last.
- 4. Where do connections and disconnections occur? How does Hood vary these moments? How does she make each more significant than the last?
- 5. How, literally, is the situation at the end of this story the opposite of the situation at the beginning? How does Hood signal this?

Writing Assignments

- 1. Write a scene placing two characters in this very fundamental conflict: One wants something that the other does not want to give. The something may be anything—money, respect, jewelry, sex, information, a match—but be sure to focus on the one desire.
- 2. A slightly more complicated variation on the same theme: Each of two characters has half of something that is no good without the other half. Neither wants to give up his or her half.
- 3. Write a scene in which a character changes from
 - · angry to ashamed
 - attracted to disgusted
 - exhausted to enthusiastic
 - or determined to uncertain
- 4. Write a short story on a postcard. Send it. Notice that if you're going to manage a conflict, crisis, and resolution in this small space, you'll have to introduce the conflict immediately.
- 5. Place a character in conflict with some aspect of nature. The character need not be fighting for survival; the danger may be as small as a mosquito. But balance the forces equally so that the reader is not sure who will "win" until the crisis action happens.
- 6. Write a short story, no longer than three pages, in which the protagonist does *not* get what s/he wants, but which nevertheless ends happily.
- 7. Write a scene involving two pairs of people. Introduce a conflict. Disconnect the pairs and reconnect them in some other pattern.

SEEING IS BELIEVING

Showing and Telling

- Significant Detail
 - · Filtering
- The Active Voice
 - · Prose Rhythm
 - Mechanics

The purpose of all the arts, including literature, is to quell boredom. People recognize that it feels good to feel and that not to feel is unhealthy. "I don't feel anything" can be said in fear, defiance, or complaint. It is not a boast. The final absence of feeling is death.

But feeling is also dangerous, and it can be deadly. Both the body and the psyche numb themselves in the presence of pain too strong to bear. People often (healthily and unhealthily) avoid good feelings—intimacy, power, speed, drunkenness, possession—having learned that feelings have consequences and that powerful feelings have powerful consequences.

Literature offers feelings for which we do not have to pay. It allows us to love, condemn, condone, hope, dread, and hate without any of the risks those feelings ordinarily involve. Fiction must contain ideas, which give significance to characters and events. If the ideas are shallow or untrue, the fiction will be correspondingly shallow or untrue. But the ideas must be experienced through or with the characters; they must be felt or the fiction will fail also.

Much nonfiction writing, including literary criticism, also tries to persuade us to feel one way rather than another, and some—polemics and propaganda, for exam-

ple—exhort us to feel strongly. But nonfiction works largely by means of reason and reasoning in order to appeal to and produce emotion. Fiction tries to reproduce the emotional impact of experience. And this is a more difficult task, because written words are symbols representing sounds, and the sounds themselves are symbols representing things, actions, qualities, spatial relationships, and so on. Written words are thus at two removes from experience. Unlike the images of film and drama, which directly strike the eye and ear, words are transmitted first to the mind, where they must be translated into images.

In order to move your reader, the standard advice runs, "Show, don't tell." This dictum can be confusing, considering that words are all a writer has to work with. What it means is that your job as a fiction writer is to focus attention not on the words, which are inert, nor on the thoughts these words produce, but through these to felt experience, where the vitality of understanding lies. There are techniques for accomplishing this—for making narrative vivid, moving, and resonant—which can be partly learned and always strengthened.

Significant Detail

In The Elements of Style, William Strunk, Jr., writes:

If those who have studied the art of writing are in accord on any one point, it is on this: the surest way to arouse and hold the attention of the reader is by being specific, definite and concrete. The greatest writers . . . are effective largely because they deal in particulars and report the details that matter.

Specific, definite, concrete, particular details—these are the life of fiction. Details (as every good liar knows) are the stuff of persuasiveness. Mary is sure that Ed forgot to go pay the gas bill last Tuesday, but Ed says, "I know I went, because this old guy in a knit vest was in front of me in the line, and went on and on about his twin granddaughters"—and it is hard to refute a knit vest and twins even if the furnace doesn't work. John Gardner in *The Art of Fiction* speaks of details as "proofs," rather like those in a geometric theorem or a statistical argument. The novelist, he says, "gives us such details about the streets, stores, weather, politics, and concerns of Cleveland (or wherever the setting is) and such details about the looks, gestures, and experiences of his characters that we cannot help believing that the story he tells us is true."

A detail is "definite" and "concrete" when it appeals to the senses. It should be seen, heard, smelled, tasted, or touched. The most superficial survey of any bookshelf of published fiction will turn up dozens of examples of this principle. Here is a fairly obvious one.

It was a narrow room, with a rather high ceiling, and crowded from floor to ceiling with goodies. There were rows and rows of hams and sausages of all shapes and colors—white, yellow, red and black; fat and lean and round and

long—rows of canned preserves, cocoa and tea, bright translucent glass bottles of honey, marmalade and jam.

I stood enchanted, straining my ears and breathing in the delightful atmosphere and the mixed fragrance of chocolate and smoked fish and earthy truffles. I spoke into the silence, saying: "Good day" in quite a loud voice; I can still remember how my strained, unnatural tones died away in the stillness. No one answered. And my mouth literally began to water like a spring. One quick, noiseless step and I was beside one of the laden tables. I made one rapturous grab into the nearest glass urn, filled as it chanced with chocolate creams, slipped a fistful into my coat pocket, then reached the door, and in the next second was safely round the corner.

Thomas Mann, Confessions of Felix Krull, Confidence Man

The shape of this passage is a tour through the five senses. Mann lets us see: narrow room, high ceiling, hums, sausages, preserves, cocoa, tea, glass bottles, honey, marmalade, jam. He lets us smell: fragrance of chocolate, smoked fish, earthy truffles. He lets us hear: "Good day," unnatural tones, stillness. He lets us taste: mouth, water like a spring. He lets us touch: grab, chocolate creams, slipped, fistful into my coat pocket. The writing is alive because we do in fact live through our sense perceptions, and Mann takes us past words and through thought to let us perceive the scene in this way.

In this process, a number of ideas not stated reverberate off the sense images, so that we are also aware of a number of generalizations the author might have made but does not need to make; we will make them ourselves. Mann could have had his character "tell" us: I was quite poor, and I was not used to seeing such a profusion of food, so that although I was very afraid there might be someone in the room and that I might be caught stealing, I couldn't resist taking the risk.

This version would be very flat, and none of it is necessary. The character's relative poverty is inherent in the tumble of images of sight and smell; if he were used to such displays, his eyes and nose would not dart about as they do. His fear is inherent in the "strained, unnatural tones" and their dying away in the stillness. His desire is in his watering mouth, his fear in the furtive speed of "quick" and "grab" and "slipped."

The points to be made here are two, and they are both important. The first is that the writer must deal in sense detail. The second is that these must be details "that matter." As a writer of fiction you are at constant pains not simply to say what you mean, but to mean more than you say. Much of what you mean will be an abstraction or a judgment. But if you write in abstractions or judgments, you are writing an essay, whereas if you let us use our senses and do our own generalizing and interpreting, we will be involved as participants in a real way. Much of the pleasure of reading comes from the egotistical sense that we are clever enough to understand. When the author explains to us or interprets for us, we suspect that he or she doesn't think us bright enough to do it for ourselves.

A detail is concrete if it appeals to one of the five senses; it is significant if it also

conveys an idea or a judgment or both. The windowsill was green is concrete, because we can see it. The windowsill was shedding flakes of fungus-green paint is concrete and also conveys the idea that the paint is old and suggests the judgment that the color is ugly. The second version can also be seen more vividly.

Here is a passage from a young writer, which fails through lack of appeal to the senses.

Debbie was a very stubborn and completely independent person and was always doing things her way despite her parents' efforts to get her to conform. Her father was an executive in a dress manufacturing company and was able to afford his family all the luxuries and comforts of life. But Debbie was completely indifferent to her family's affluence.

This passage contains a number of judgments we might or might not share with the author, and she has not convinced us that we do. What constitutes stubbornness? Independence? Indifference? Affluence? Further, since the judgments are supported by generalizations, we have no sense of the individuality of the characters, which alone would bring them to life on the page. What things was she always doing? What efforts did her parents make to get her to conform? What level of executive? What dress manufacturing company? What luxuries and comforts?

Debbie would wear a tank top to a tea party if she pleased, with fluorescent earrings and ankle-strap sandals.

"Oh, sweetheart," Mrs. Chiddister would stand in the doorway wringing her hands. "It's not nice."

"Not who?" Debbie would say, and add a fringed belt.

Mr. Chiddister was Artistic Director of the Boston branch of Cardin and had a high respect for what he called "elegant textures," which ranged from handwoven tweed to gold filigree, and which he willingly offered his daughter. Debbie preferred her laminated wrist bangles.

We have not passed a final judgment on the merits of these characters, but we know a good deal more about them, and we have drawn certain interim conclusions that are our own and not forced on us by the author. Debbie is independent of her parents' values, rather careless of their feelings, energetic, and possibly a tart. Mrs. Chiddister is quite ineffectual. Mr. Chiddister is a snob, though perhaps Debbie's taste is so bad we'll end up on his side.

But maybe that isn't at all what the author had in mind. The point is that we weren't allowed to know what the author did have in mind. Perhaps it was more like this version.

One day Debbie brought home a copy of *Ulysses*. Mrs. Strum called it "filth" and threw it across the sunporch. Debbie knelt on the parquet and retrieved her bookmark, which she replaced. "No, it's not," she said.

"You're not so old I can't take a strap to you!" Mr. Strum reminded her.

Mr. Strum was controlling stockholder of Readywear Conglomerates and was proud of treating his family, not only on his salary, but also on his expense account. The summer before he had justified their company on a trip to Belgium, where they toured the American Cemetery and the torture chambers of Ghent Castle. Entirely ungrateful, Debbie had spent the rest of the trip curled up in the hotel with a shabby copy of some poet.

Now we have a much clearer understanding of stubbornness, independence, indifference, and affluence, both their natures and the value we are to place on them. This time our judgment is heavily weighed in Debbie's favor—partly because people who read books have a sentimental sympathy with people who read books—but also because we hear hysteria in "filth" and "take a strap to you," whereas Debbie's resistance is quiet and strong. Mr. Strum's attitude toward his expense account suggests that he's corrupt, and his choice of "luxuries" is morbid. The passage does contain two overt judgments, the first being that Debbie was "entirely ungrateful." Notice that by the time we get to this, we're aware that the judgment is Mr. Strum's and that Debbie has little enough to be grateful for. We understand not only what the author says but also that she means the opposite of what she says, and we feel doubly clever to get it; that is the pleasure of irony. Likewise, the judgment that the poet's book is "shabby" shows Mr. Strum's crass materialism toward what we know to be the finer things. At the very end of the passage, we are denied a detail that we might very well be given: What poet did Debbie curl up with? Again, by this time we understand that we are being given Mr. Strum's view of the situation and that it's Mr. Strum (not Debbie, not the author, and certainly not us) who wouldn't notice the difference between John Keats and Stanley Kunitz.

It may be objected that both rewrites of the passage are longer than the original. Doesn't "adding" so much detail make for long writing? The answer is yes and no. No, because in the rewrites we know so much more about the values, activities, lifestyles, attitudes, and personalities of the characters that it would take many times the length of the original to "tell" it all in generalizations. Yes, in the sense that detail requires words, and if you are to realize your characters through detail, then you must be careful to select the details that convey the characteristics essential to our understanding. You can't convey a whole person, or a whole action, or everything there is to be conveyed about a single moment of a single day. You must select the significant.

No amount of concrete detail will move us unless it also implicitly suggests meaning and value. Following is a passage that fails, not through lack of appeal to the senses, but through lack of significance.

Terry Landon, a handsome young man of twenty-two, was six foot four and broad-shouldered. He had medium-length thick blond hair and a natural tan, which set off the blue of his intense and friendly long-lashed eyes.

Here we have a good deal of sensory information, but we still know very little about Terry. There are so many broad-shouldered twenty-two-year-olds in the world,

so many blonds, and so on. This sort of cataloging of characteristics suggests an all-points bulletin: *Male Caucasian, medium height, dark hair, last seen wearing gray rain-coat.* Such a description may help the police locate a suspect in a crowd, but the assumption is that the identity of the person is not known. As an author you want us to know the character individually and immediately.

The fact is that all our ideas and judgments are formed through our sense perceptions, and daily, moment by moment, we receive information that is not merely sensuous in this way. Four people at a cocktail party may *do* nothing but stand and nibble canapés and may *talk* nothing but politics and the latest films. But you feel perfectly certain that X is furious at Y, who is flirting with Z, who is wounding Q, who is trying to comfort X. You have only your senses to observe with. How do you reach these conclusions? By what gestures, glances, tones, touches, choices of words?

It may be that this constant emphasis on judgment makes the author, and the reader, seem opinionated or self-righteous. "I want to present my characters objectively/neutrally. I'm not making any value judgments. I want the reader to make up his or her own mind." This can be a legitimate position, and the whole school of experimental French fiction, the *nouveau roman*, strives to be wholly objective and to eschew the judgmental. But this is a highly sophisticated form, and writing such fiction entails a difficulty and a danger. The difficulty arises because human beings are constantly judging: How was the film? He seemed friendly. What a boring class! Do you like it here? What did you think of them? That's kind of you. Which do you want? I'm not convinced. She's very thin. That's fascinating. I'm so clumsy. You're gorgeous tonight. Life is crazy, isn't it?

The danger results from the fact that when we are not passing such judgments, it's because we aren't much interested; we are indifferent. Although you may not want to sanctify or damn your characters, you do want us to care about them, and if you refuse to direct our judgment, you may be inviting our indifference. Usually, when you "don't want us to judge," you mean that you want our feelings to be mixed, paradoxical, complex. She's horribly irritating, but it's not her fault. He's sexy, but there's something cold about it underneath. If this is what you mean, then you must direct our judgment in both or several directions, not in no direction.

Even a character who doesn't exist except as a type or function will come to life if presented through significant detail, as in this example from *The Right Stuff* by Tom Wolfe.

The matter mustn't be bungled!—that's the idea. No, a man should bring the news when the time comes, a man with some official or moral authority, a clergyman or a comrade of the newly deceased. Furthermore, he should bring the bad news in person. He should turn up at the front door and ring the bell and be standing there like a pillar of coolness and competence, bearing the bad news on ice, like a fish.

For a character who is just "a man," we have a remarkably clear image of this personage! Notice how Wolfe moves us from generalization toward sharpness of image,

gradually bringing the nonexistent character into focus. First he has only a gender, then a certain abstract quality, "authority"; then a distinct role, "a clergyman or a comrade." Then he appears "in person" at the front door, then acts, ringing the doorbell. Finally, his quality is presented to us in the sharp focus of similes that also suggest his deadly message: pillar, ice, fish.

In the following paragraph from Virginia Woolf's Mrs. Dalloway, we are introduced to an anonymous crowd and four other characters, none of whom we ever see again.

The crush was terrific for the time of day. Lords, Ascot, Hurlingham, what was it? she wondered, for the street was blocked. The British middle classes sitting sideways on the tops of omnibuses with parcels and umbrellas, yes, even furs on a day like this, were, she thought, more ridiculous, more unlike anything there has ever been than one could conceive; and the Queen herself held up; the Queen herself unable to pass. Clarissa was suspended on one side of Brook Street; Sir John Buckhurst, the old Judge on the other, with the car between them (Sir John had laid down the law for years and liked a well-dressed woman) when the chauffeur, leaning ever so slightly, said or showed something to the policeman, who saluted and raised his arm and jerked his head and moved the omnibus to the side and the car passed through.

The whole range of British class and class consciousness is conveyed in this brief passage through the use of significant detail. Clarissa's wry attitude toward the British middle classes is given credence by the fussiness of "parcels and umbrellas" and the pretension of "furs on a day like this." The judge's aristocratic hauteur is carried in the clichés he would use, "laid down the law" and "liked a well-dressed woman." That the Queen's chauffeur is described as leaning "ever so slightly" shows his consciousness of his own position's superiority to that of the policeman, who "saluted" him but then exercises his own brand of authority as he "jerked his head" to order the traffic about. Only the Queen is characterized by no detail of object or action, and that she is not emphasizes her royal remoteness: "the Queen herself, the Queen herself."

The point is not that an author must never express an idea, quality, or judgment. In the foregoing passages from Mann, Wolfe, and Woolf, each author uses several generalizations: I stood enchanted, delightful atmosphere; the matter mustn't be bungled, coolness and competence; the crush was terrific, more unlike anything there has ever been than one could conceive. The point is that in order to carry the felt weight of fiction, these abstractions must be realized through an appeal to the senses. It is in the details that they live.

Filtering

John Gardner, in *The Art of Fiction*, points out that in addition to the faults of insufficient detail and excessive use of abstraction, there's a third failure.

... the needless filtering of the image through some observing consciousness. The amateur writes: "Turning, she noticed two snakes fighting in among the rocks." Compare: "She turned. In among the rocks, two snakes were fighting." (The improvement can of course be further improved. The phrase "two snakes were fighting" is more abstract than, say, "two snakes whipped and lashed, striking at each other"; and verbs with auxiliaries "were fighting" are never as sharp in focus as verbs without auxiliaries, since the former indicate indefinite time, whereas the latter e.g., "fought," suggest a given instant.) Generally speaking—though no laws are absolute in fiction—vividness urges that almost every occurrence of such phrases as "she noticed" and "she saw" be suppressed in favor of direct presentation of the thing seen.

The filter is a common fault and often difficult to recognize—although once the principle is grasped, it's a cheeringly easy means to more vivid writing. As a fiction writer you will often, perhaps almost always, be working through "some observing consciousness." When you leave that consciousness and ask us to observe the observer, in effect you rip us minutely out of the scene. You start to tell-not-show and consequently get in our line of sight. Here, for example, is a student passage quite competent except for the filtering:

Mrs. Blair made her way to the chair by the window and sank gratefully into it. She looked out the window and there, across the street, she saw the ivory BMW parked in front of the fire plug once more. It seemed to her, though, that something was wrong with it. She noticed that it was listing slightly toward the back and side, and then saw that the back rim was resting almost on the asphalt.

Remove the filters from this paragraph and we are allowed to stay in Mrs. Blair's consciousness, watching with her eyes, sharing understanding as it unfolds for her:

Mrs. Blair made her way to the chair by the window and sank gratefully into it. Across the street the ivory BMW was parked in front of the fire plug again. Something was wrong with it, though. It was listing toward the back and side, the back rim resting almost on the asphalt.

A similar filtering occurs when the writer chooses to begin a flashback and mistakenly supposes that the reader is not clever enough to follow this technique without a guiding transition:

Mrs. Blair thought back to the time that she and Henry had owned an ivory car, though it had been a Chevy. She remembered clearly that it had a hood shaped like a sugar scoop, and chrome bumpers that stuck out a foot front and back. And there was that funny time, she recalled, when Henry had to change the flat tire on Alligator Alley, and she'd thought the alligators would come up out of the swamp.

Just as the present scene will be more present to the reader without a filter, so we will be taken more thoroughly back to the time of the memory without a filter:

She and Henry had owned an ivory car once, though it had been a Chevy, with a hood shaped like a sugar scoop and chrome bumpers that stuck out a foot front and back. And there was that funny time Henry had to change the flat tire on Alligator Alley, and she'd thought the alligators would come up out of the swamp.

Observe that the pace of the reading is improved by the removal of the filters—at least partly, literally, because one or two lines of type have been removed.

The Active Voice

If your prose is to be vigorous as well as vivid, if your characters are to be people who do rather than people to whom things are done, if your descriptions are to "come to life," you must make use of the active voice.

The active voice occurs when the subject of a sentence performs the action described by the verb of that sentence: She spilled the milk. When the passive voice is used, the object of the active verb becomes the subject of the passive verb: The milk was spilled by her. The passive voice is more indirect than the active; the subject is acted upon rather than acting, and the effect is to weaken the prose and to distance the reader from the action.

The passive voice does have an important place in fiction, precisely because it expresses a sense that the character is being acted upon. If a prison guard is kicking the hero, then I was slammed into the wall; I was struck blindingly from behind and forced to the floor appropriately carries the sense of his helplessness.

In general, you should seek to use the active voice in all prose and use the passive only when the actor is unknown or insignificant or when you want to achieve special stylistic effects like the one above.

But there is one other common grammatical construction that is in effect passive and can distance the reader from a sense of immediate experience. The verbs that we learn in school to call linking verbs are effectively passive because, as Gardner points out in the quotation on filtering, these verbs with auxiliaries suggest an indefinite time and are never "as sharp in focus" as active verbs. Further, they invite complements that tend to be generalized or judgmental: Her hair was beautiful. He was very happy. The room seemed expensively furnished. They became morose. Let her hair bounce, tumble, cascade, or swing; we'll see better. Let him laugh, leap, cry, or hug a tree; we'll experience his joy.

The following is a passage with very little action, nevertheless made vital by the use of active verbs:

At Mixt she neither drinks nor eats. Each of the sisters furtively stares at her as she tranquilly sits in post-Communion meditation with her hands immersed in her habit. *Lectio* has been halted for the morning, so there is only the Great Silence and the tinks of cutlery, but handsigns are being traded as the sisters lard their hunks of bread or fold and ring their dinner napkins. When the prioress stands, all rise up with her for the blessing, and then Sister Aimee gives Mariette the handsigns. *You*, *infirmary*.

Ron Hansen, Mariette in Ecstasy

Here, though the action is minimal, it would be inappropriate to suggest lifelessness or lack of will, so a number of the verbs suggest suppressed power: stares, sits, lard, fold, ring, stands, rise, gives.

Compare the first passage about Debbie with the rewrite (page 56). In the generalized original we have was stubborn, was doing things, was executive, was able, was indifferent. Apart from the compound verb was doing, all these are linking verbs. In the rewrite the characters brought, called, threw, knelt, retrieved, replaced, said, reminded, justified, toured, spent, and curled up. What energetic people! The rewrite contains two linking verbs: Mr. Strum was stockholder and was proud; these properly represent static states, a position and an attitude.

One beneficial side effect of active verbs is that they tend to call forth significant details. If you say "she was shocked," you are telling us; but if you are to show us that she was shocked through an action, you are likely to have to search for an image as well. "She clenched the arm of the chair so hard that her knuckles whitened." *Clenched* and *whitened* actively suggest shock, and at the same time we see her knuckles on the arm of the chair.

To be is the most common of the linking verbs and also the most overused, but all the linking verbs invite generalization and distance. To feel, to seem, to look, to appear, to experience, to express, to show, to demonstrate, to convey, to display—all these suggest in fiction that the character is being acted upon or observed by someone rather than doing something. She felt happy/sad/amused/mortified does not convince us. We want to see her and infer her emotion for ourselves. He very clearly conveyed his displeasure. It isn't clear to us. How did he convey it? To whom?

Most linking verbs have active as well as effectively passive senses, and it is important to distinguish between them. She felt sad is effectively passive, but she felt his forehead is an action. If the magician appeared, he is acting; but if he appeared annoyed, then the verb is a linking verb, and the only action implied is that of the observer who perceives this.

Linking verbs, like the passive voice, can appropriately convey a sense of passivity or helplessness when that is the desired effect. Notice that in the passage by Mann quoted earlier in this chapter, where Felix Krull is momentarily stunned by the sight of the food before him, linking verbs are used: *It was a narrow room, there were rows and rows*, while all the colors and shapes buffet his senses. Only as he gradually recovers can he *stand*, *breathe*, *speak*, and eventually *grab*.

In the following excerpt from Lawrence Durrell's *Justine*, Melissa is trapped into a ride she doesn't want, and we feel her passivity with her while the car and the headlights take all the power.

Melissa was afraid now. She was aghast at what she had done. There was no way of refusing the invitation. She dressed in her shabby best and carrying her fatigue like a heavy pack followed Selim to the great car which stood in deep shadow. She was helped in beside Nessim. They moved off slowly into the dense crepuscular evening of an Alexandria which, in her panic, she no longer recognized. They scouted a sea turned to sapphire and turned inland, folding up the slum, toward Mareotis and the bituminous slag-heaps of Mex where the pressure of the headlights now peeled off layer after layer of the darkness.

Was afraid, was aghast, was no way, was helped in—all imply Melissa's impotence. The active verbs that apply specifically to her either express weakness (she followed) or are negated (no longer recognized); the most active thing she can manage is to dress. In contrast, the "great car" stands, and it is inside and under the power of the car that they move off, scout, turn, and fold up; it is the headlights that peel off.

I don't mean to suggest either that Durrell is deliberately using a linking verb here, the passive or the active voice there, or that as an author you should analyze your grammar as you go along. Most word choice is instinctive, and instinct is often the best guide. I do mean to suggest that you should be aware of the vigor and variety of available verbs, and that if a passage lacks energy, it may be because your instinct has let you down. How often *are* things or are they acted *upon*, when they could more forcefully *do*?

A note of caution about active verbs: Make sparing use of what John Ruskin called the "pathetic fallacy"—the attributing of human emotions to natural and man-made objects. Even a description of a static scene can be invigorated if the houses *stand*, the streets *wander*, and the trees *bend*. But if the houses *frown*, the streets *stagger drunkenly*, and the trees *weep*, we will feel more strain than energy in the writing.

Prose Rhythm

Novelists and short-story writers are not under the same obligation as poets to reinforce sense with sound. In prose, on the whole, the rhythm is all right if it isn't clearly wrong. But it can be wrong if, for example, the cadence contradicts the meaning; on the other hand, rhythm can greatly enhance the meaning if it is sensitively used.

The river moved slowly. It seemed sluggish. The surface lay flat. Birds circled lazily overhead. Jon's boat slipped forward.

In this extreme example, the short, clipped sentences and their parallel structures—subject, verb, modifier—work against the sense of slow, flowing movement. The rhythm could be effective if the character whose eyes we're using is not appreciating or sharing the calm; otherwise it needs recasting.

The surface lay flat on the sluggish, slow-moving river, and the birds circled lazily overhead as Jon's boat slipped forward.

There is nothing very striking about the rhythm of this version, but at least it moves forward without obstructing the flow of the river.

The first impression I had as I stopped in the doorway of the immense City Room was of extreme rush and bustle, with the reporters moving rapidly back and forth in the long aisles in order to shove their copy at each other or making frantic gestures as they shouted into their many telephones.

This long and leisurely sentence cannot possibly provide a sense of rush and bustle. The phrases need to move as fast as the reporters; the verbiage must be pared down because it slows them down.

I stopped in the doorway. The City Room was immense, reporters rushing down the aisles, shoving copy at each other, bustling back again, flinging gestures, shouting into telephones.

The poet Rolfe Humphries remarked that "very is the least very word in the language." It is frequently true that adverbs expressing emphasis or suddenness—extremely, rapidly, suddenly, phenomenally, quickly, immediately, instantly, definitely, terribly, awfully—slow the sentence down so as to dilute the force of the intended meaning. "'It's a very nice day," said Humphries, "is not as nice a day as 'It's a day!'" Likewise, "They stopped very abruptly" is not as abrupt as "They stopped."

The rhythm of an action can be imitated by the rhythm of a sentence in a rich variety of ways. In the previous example, simplifying the clauses helped create a sense of rush. James Joyce, in the short story "The Dead," structures a long sentence with a number of prepositional phrases so that it carries us headlong.

Lily, the caretaker's daughter, was literally run off her feet. Hardly had she brought one gentleman into the little pantry behind the office on the ground floor and helped him off with his overcoat than the wheezy hall-door bell clanged and she had to scamper along the bare hallway to let in another guest.

Lily's haste is largely created by beginning the sentence, "Hardly had she brought," so that we anticipate the clause that will finish the meaning, "than the bell clanged." Our anticipation forces us to scamper like Lily through the intervening actions.

Not only action but also character can be revealed and reinforced by sensitive use of rhythm. In Tillie Olsen's "Tell Me a Riddle," half a dozen grown children of a couple who have been married for forty-seven years ask each other what, after all this time, could be tearing their parents apart. The narrative answers:

Something tangible enough.

Arthritic hands, and such work as he got, occasional. Poverty all his life, and there was little breath left for running. He could not, could not turn away from this desire: to have the troubling of responsibility, the fretting with money, over and done with; to be free, to be *carefree* where success was not measured by accumulation, and there was use for the vitality still in him.

The old man's anguished irritability is conveyed by syncopation, the syntax wrenched, clauses and qualifiers erupting out of what would be their natural place in the sentence, just as they would erupt in the man's mind. Repetition conveys his frustration: "He could not, could not" and "to be free, to be carefree."

Just as action and character can find an echo in prose rhythm, so it is possible to help us experience a character's emotions and attitudes through control of the starts and stops of prose tempo. In the following passage from *Persuasion*, Jane Austen combines generalization, passive verbs, and a staccato speech pattern to produce a kind of breathless blindness in the heroine.

... a thousand feelings rushed on Anne, of which this was the most consoling, that it would soon be over. And it was soon over. In two minutes after Charles's preparation, the others appeared; they were in the drawing room. Her eye half met Captain Wentworth's, a bow, a courtesy passed; she heard his voice; he talked to Mary, said all that was right, said something to the Miss Musgroves, enough to mark an easy footing; the room seemed full, full of persons and voices, but a few minutes ended it.

Sometimes a contrast in rhythm can help reinforce a contrast in characters, actions, attitudes, and emotions. In this passage from Frederick Busch's short story "Company," a woman whose movements are relatively confined watches her husband move, stop, and move again.

Every day did not start with Vince awake that early, dressing in the dark, moving with whispery sounds down the stairs and through the kitchen, out into the autumn morning while groundfog lay on the milkweed burst open and on the stumps of harvested corn. But enough of them did.

I went to the bedroom window to watch him hunt in a business suit. He moved with his feet in the slowly stirring fog, moving slowly himself

He moved with his feet in the slowly stirring fog, moving slowly himself with the rifle held across his body and his shoulders stiff. Then he stopped in a frozen watch for woodchucks. His stillness made the fog look faster as it blew across our field behind the barn. Vince stood. He waited for something to shoot. I went back to bed and lay between our covers again. I heard the bolt click. I heard the unemphatic shot, and then the second one, and after a while his feet on the porch, and soon the rush of water, the rattle of the pots on top of the stove, and later his feet again, and the car starting up as he left for work an hour before he had to.

The long opening sentence is arranged in a series of short phrases to move Vince forward. By contrast, "But enough of them did" comes abruptly, its abruptness as well as the sense of the words suggesting the woman's alienation. When Vince starts off again more slowly, the repetition of "moved, slowly stirring, moving slowly," slows down the sentence to match his strides. "Vince stood" again stills him, but the author also needs to convey that Vince stands for a long time, waiting, so we have the repetitions "he stopped, his stillness, Vince stood. He waited." As his activity speeds up again, the tempo of the prose speeds up with another series of short phrases, of which only the last is drawn out with a dependent clause, "as he left for work an hour before he had to," so that we feel the retreat of the car in the distance. Notice that Busch chooses the phrase "the rush of water," not the flow or splash of water, as the sentence and Vince begin to rush. Here, meaning reinforces a tempo that, in turn, reinforces meaning.

"The Things They Carried" by Tim O'Brien at the end of this chapter demonstrates a range of rhythms with a rich variation of effects. Here is one:

The things they carried were largely determined by necessity. Among the necessities or near-necessities were P-38 can openers, pocket knives, heat tabs, wristwatches, dog tags, mosquito repellent, chewing gum, candy, cigarettes, salt tablets, packets of Kool-Aid, lighters, matches, sewing kits, Military Payment Certificates, C rations, and two or three canteens of water. Together, these items weighed between 15 and 20 pounds . . .

In this passage the piling of items one on the other has the effect of loading the men down (poets will recognize iambic meter in the list of goods), and at the same time increasingly suggests the rhythm of their marching as they "hump" their stuff. Similar lists through the story create a rhythmic thread, while variations and stoppages underlie shifts of emotion and sudden crises.

Mechanics

Significant detail, the active voice, and prose rhythm are techniques for achieving the sensuous in fiction, means of taking the reader past the words and the thought to feeling and experience. None is of much use if the reader's eye is wrenched back to the surface; for that reason a word or two ought to be said here about the mechanics of the written language.

Spelling, grammar, and punctuation are a kind of magic; their purpose is to be invisible. If the sleight of hand works, we will not notice a comma or a quotation mark but will translate each instantly into a pause or an awareness of voice; we will not focus on the individual letters of a word but extract its sense whole. When the mechanics are incorrectly used, the trick is revealed and the magic fails; the reader's focus is shifted from the story to its surface. The reader is irritated at the author, and of all the emotions the reader is willing to experience, irritation at the author is not one.

There is no intrinsic virtue in standardized mechanics, and you can depart from

them whenever you produce an effect that adequately compensates for the attention called to the surface. But only then. Unlike the techniques of narrative, the rules of spelling, grammar, and punctuation can be coldly learned anywhere in the English-speaking world—and they should be learned by anyone who aspires to write. Poor mechanics read instant amateurism to an editor. Perhaps a demonstrated genius can get away with sloppy mechanics, but in that case some other person must be hired to fill in. Since ghostwriters and editors are likely to be paid more per hour for their work than the author, this would constitute a heavy drain on the resources of those who publish fiction.

The Things They Carried

TIM O'BRIEN

First Lieutenant Jimmy Cross carried letters from a girl named Martha, a junior at Mount Sebastian College in New Jersey. They were not love letters, but Lieutenant Cross was hoping, so he kept them folded in plastic at the bottom of his rucksack. In the late afternoon, after a day's march, he would dig his foxhole, wash his hands under a canteen, unwrap the letters, hold them with the tips of his fingers, and spend the last hour of light pretending. He would imagine romantic camping trips into the White Mountains in New Hampshire. He would sometimes taste the envelope flaps, knowing her tongue had been there. More than anything, he wanted Martha to love him as he loved her, but the letters were mostly chatty, elusive on the matter of love. She was a virgin, he was almost sure. She was an English major at Mount Sebastian, and she wrote beautifully about her professors and roommates and midterm exams, about her respect for Chaucer and her great affection for Virginia Woolf. She often quoted lines of poetry; she never mentioned the war, except to say, Jimmy, take care of yourself. The letters weighed 10 ounces. They were signed Love, Martha, but Lieutenant Cross understood that Love was only a way of signing and did not mean what he sometimes pretended it meant. At dusk, he would carefully return the letters to his rucksack. Slowly, a bit distracted, he would get up and move among his men, checking the perimeter, then at full dark he would return to his hole and watch the night and wonder if Martha was a virgin.

The things they carried were largely determined by necessity. Among the necessities or near-necessities were P-38 can openers, pocket knives, heat tabs, wristwatches, dog tags, mosquito repellent, chewing gum, candy, cigarettes, salt tablets, packets of Kool-Aid, lighters, matches, sewing kits, Military Payment Certificates, C rations, and two or three canteens of water. Together, these items weighed between 15 and 20 pounds, depending upon a man's habits or rate of metabolism. Henry Dobbins, who was a big man, carried extra rations; he was especially fond of canned peaches in heavy syrup over pound cake. Dave Jensen, who practiced field hygiene, carried a toothbrush, dental floss, and several hotel-sized bars of soap he'd stolen on R&R in

Sydney, Australia. Ted Lavender, who was scared, carried tranquilizers until he was shot in the head outside the village of Than Khe in mid-April. By necessity, and because it was SOP, they all carried steel helmets that weighed 5 pounds including the liner and camouflage cover. They carried the standard fatigue jackets and trousers. Very few carried underwear. On their feet they carried jungle boots—2.1 pounds and Dave Jensen carried three pairs of socks and a can of Dr. Scholl's foot powder as a precaution against trench foot. Until he was shot, Ted Lavender carried six or seven ounces of premium dope, which for him was a necessity. Mitchell Sanders, the RTO, carried condoms. Norman Bowker carried a diary. Rat Kiley carried comic books. Kiowa, a devout Baptist, carried an illustrated New Testament that had been presented to him by his father, who taught Sunday school in Oklahoma City, Oklahoma. As a hedge against bad times, however, Kiowa also carried his grandmother's distrust of the white man, his grandfather's old hunting hatchet. Necessity dictated. Because the land was mined and booby-trapped, it was SOP for each man to carry a steel-centered, nylon-covered flak jacket, which weighed 6.7 pounds, but which on hot days seemed much heavier. Because you could die so quickly, each man carried at least one large compress bandage, usually in the helmet band for easy access. Because the nights were cold, and because the monsoons were wet, each carried a green plastic poncho that could be used as a raincoat or groundsheet or makeshift tent. With its quilted liner, the poncho weighed almost two pounds, but it was worth every ounce. In April, for instance, when Ted Lavender was shot, they used his poncho to wrap him up, then to carry him across the paddy, then to lift him into the chopper that took him away.

They were called legs or grunts.

To carry something was to hump it, as when Lieutenant Jimmy Cross humped his love for Martha up the hills and through the swamps. In its intransitive form, to hump meant to walk, or to march, but it implied burdens far beyond the intransitive.

Almost everyone humped photographs. In his wallet, Lieutenant Cross carried two photographs of Martha. The first was a Kodacolor snapshot signed Love, though he knew better. She stood against a brick wall. Her eyes were gray and neutral, her lips slightly open as she stared straight-on at the camera. At night, sometimes, Lieutenant Cross wondered who had taken the picture, because he knew she had boyfriends, because he loved her so much, and because he could see the shadow of the picture-taker spreading out against the brick wall. The second photograph had been clipped from the 1968 Mount Sebastian yearbook. It was an action shotwomen's volleyball—and Martha was bent horizontal to the floor, reaching, the palms of her hands in sharp focus, the tongue taut, the expression frank and competitive. There was no visible sweat. She wore white gym shorts. Her legs, he thought, were almost certainly the legs of a virgin, dry and without hair, the left knee cocked and carrying her entire weight, which was just over one hundred pounds. Lieutenant Cross remembered touching that left knee. A dark theater, he remembered, and the movie was Bonnie and Clyde, and Martha wore a tweed skirt, and during the final scene, when he touched her knee, she turned and looked at him in a sad, sober way that made him pull his hand back, but he would always remember the feel of the

tweed skirt and the knee beneath it and the sound of the gunfire that killed Bonnie and Clyde, how embarrassing it was, how slow and oppressive. He remembered kissing her good night at the dorm door. Right then, he thought, he should've done something brave. He should've carried her up the stairs to her room and tied her to the bed and touched that left knee all night long. He should've risked it. Whenever he looked at the photographs, he thought of new things he should've done.

What they carried was partly a function of rank, partly of field specialty.

As a first lieutenant and platoon leader, Jimmy Cross carried a compass, maps, code books, binoculars, and a .45-caliber pistol that weighed 2.9 pounds fully loaded. He carried a strobe light and the responsibility for the lives of his men.

As an RTO, Mitchell Sanders carried the PRC-25 radio, a killer, 26 pounds with its battery.

As a medic, Rat Kiley carried a canvas satchel filled with morphine and plasma and malaria tablets and surgical tape and comic books and all the things a medic must carry, including M&M's for especially bad wounds, for a total weight of nearly 20 pounds.

As a big man, therefore a machine gunner, Henry Dobbins carried the M-60, which weighed 23 pounds unloaded, but which was almost always loaded. In addition, Dobbins carried between 10 and 15 pounds of ammunition draped in belts across his chest and shoulders.

As PFCs or Spec 4s, most of them were common grunts and carried the standard M-16 gas-operated assault rifle. The weapon weighed 7.5 pounds unloaded, 8.2 pounds with its full 20-round magazine. Depending on numerous factors, such as topography and psychology, the riflemen carried anywhere from 12 to 20 magazines, usually in cloth bandoliers, adding on another 8.4 pounds at minimum, 14 pounds at maximum. When it was available, they also carried M-16 maintenance gear—rods and steel brushes and swabs and tubes of LSA oil—all of which weighed about a pound. Among the grunts, some carried the M-79 grenade launcher, 5.9 pounds unloaded, a reasonably light weapon except for the ammunition, which was heavy. A single round weighed 10 ounces. The typical load was 25 rounds. But Ted Lavender, who was scared, carried 34 rounds when he was shot and killed outside Than Khe, and he went down under an exceptional burden, more than 20 pounds of ammunition, plus the flak jacket and helmet and rations and water and toilet paper and tranquilizers and all the rest, plus the unweighed fear. He was dead weight. There was no twitching or flopping. Kiowa, who saw it happen, said it was like watching a rock fall, or a big sandbag or something—just boom, then down—not like the movies where the dead guy rolls around and does fancy spins and goes ass over teakettle not like that, Kiowa said, the poor bastard just flat-fuck fell. Boom. Down. Nothing else. It was a bright morning in mid-April. Lieutenant Cross felt the pain. He blamed himself. They stripped off Lavender's canteens and ammo, all the heavy things, and Rat Kiley said the obvious, the guy's dead, and Mitchell Sanders used his radio to report one U.S. KIA and to request a chopper. Then they wrapped Lavender in his poncho. They carried him out to a dry paddy, established security, and sat smoking the dead man's dope until the chopper came. Lieutenant Cross kept to himself. He pictured Martha's smooth young face, thinking he loved her more than anything, more than his men, and now Ted Lavender was dead because he loved her so much and could not stop thinking about her. When the dustoff arrived, they carried Lavender aboard. Afterward they burned Than Khe. They marched until dusk, then dug their holes, and that night Kiowa kept explaining how you had to be there, how fast it was, how the poor guy just dropped like so much concrete. Boom-down, he said. Like cement.

In addition to the three standard weapons—the M-60, M-16, and M-79—they carried whatever presented itself, or whatever seemed appropriate as a means of killing or staying alive. They carried catch-as-catch-can. At various times, in various situations, they carried M-14s and CAR-15s and Swedish Ks and grease guns and captured AK-47s and Chi-Coms and RPGs and Simonov carbines and black market Uzis and .38-caliber Smith & Wesson handguns and 66 mm LAWs and shotguns and silencers and blackjacks and bayonets and C-4 plastic explosives. Lee Strunk carried a slingshot; a weapon of last resort, he called it. Mitchell Sanders carried brass knuckles. Kiowa carried his grandfather's feathered hatchet. Every third or fourth man carried a Claymore antipersonnel mine—3.5 pounds with its firing device. They all carried fragmentation grenades—14 ounces each. They all carried at least one M-18 colored smoke grenade—24 ounces. Some carried CS or tear gas grenades. Some carried white phosphorus grenades. They carried all they could bear, and then some, including a silent awe for the terrible power of the things they carried.

In the first week of April, before Lavender died, Lieutenant Jimmy Cross received a good-luck charm from Martha. It was a simple pebble, an ounce at most. Smooth to the touch, it was a milky white color with flecks of orange and violet, oval-shaped, like a miniature egg. In the accompanying letter, Martha wrote that she had found the pebble on the Jersey shoreline, precisely where the land touched water at high tide, where things came together but also separated. It was this separate-but-together quality, she wrote, that had inspired her to pick up the pebble and to carry it in her breast pocket for several days, where it seemed weightless, and then to send it through the mail, by air, as a token of her truest feelings for him. Lieutenant Cross found this romantic. But he wondered what her truest feelings were, exactly, and what she meant by separate-but-together. He wondered how the tides and waves had come into play on that afternoon along the Jersey shoreline when Martha saw the pebble and bent down to rescue it from geology. He imagined bare feet. Martha was a poet, with the poet's sensibilities, and her feet would be brown and bare, the toenails unpainted, the eyes chilly and somber like the ocean in March, and though it was painful, he wondered who had been with her that afternoon. He imagined a pair of shadows moving along the strip of sand where things came together but also separated. It was phantom jealousy, he knew, but he couldn't help himself. He loved her so much. On the march, through the hot days of early April, he carried the pebble in his mouth, turning it with his tongue, tasting sea salt and moisture. His mind wandered. He had difficulty keeping his attention on the war. On occasion he would yell at his men to spread out the column, to keep their eyes open, but then he would slip away into daydreams, just pretending, walking barefoot along the Jersey shore, with Martha, carrying nothing. He would feel himself rising. Sun and waves and gentle winds, all love and lightness.

What they carried varied by mission.

When a mission took them to the mountains, they carried mosquito netting, machetes, canvas tarps, and extra bug juice.

If a mission seemed especially hazardous, or if it involved a place they knew to be bad, they carried everything they could. In certain heavily mined AOs, where the land was dense with Toe Poppers and Bouncing Betties, they took turns humping a 28-pound mine detector. With its headphones and big sensing plate, the equipment was a stress on the lower back and shoulders, awkward to handle, often useless because of the shrapnel in the earth, but they carried it anyway, partly for safety, partly for the illusion of safety.

On ambush, or other night missions, they carried peculiar little odds and ends. Kiowa always took along his New Testament and a pair of moccasins for silence. Dave Jensen carried night-sight vitamins high in carotene. Lee Strunk carried his slingshot; ammo, he claimed, would never be a problem. Rat Kiley carried brandy and M&M's candy. Until he was shot, Ted Lavender carried the starlight scope, which weighed 6.3 pounds with its aluminum carrying case. Henry Dobbins carried his girlfriend's pantyhose wrapped around his neck as a comforter. They all carried ghosts. When dark came, they would move out single file across the meadows and paddies to their ambush coordinates, where they would quietly set up the Claymores and lie down and spend the night waiting.

Other missions were more complicated and required special equipment. In mid-April, it was their mission to scarch out and destroy the elaborate tunnel complexes in the Than Khe area south of Chu Lai. To blow the tunnels, they carried onepound blocks of pentrite high explosives, four blocks to a man, 68 pounds in all. They carried wiring, detonators, and battery-powered clackers. Dave Jensen carried earplugs. Most often, before blowing the tunnels, they were ordered by higher command to search them, which was considered bad news, but by and large they just shrugged and carried out orders. Because he was a big man, Henry Dobbins was excused from tunnel duty. The others would draw numbers. Before Lavender died there were 17 men in the platoon, and whoever drew the number 17 would strip off his gear and crawl in headfirst with a flashlight and Lieutenant Cross's .45-caliber pistol. The rest of them would fan out as security. They would sit down or kneel, not facing the hole, listening to the ground beneath them, imagining cobwebs and ghosts, whatever was down there—the tunnel walls squeezing in—how the flashlight seemed impossibly heavy in the hand and how it was tunnel vision in the very strictest sense, compression in all ways, even time, and how you had to wiggle inass and elbows—a swallowed-up feeling—and how you found yourself worrying about odd things: Will your flashlight go dead? Do rats carry rabies? If you screamed, how far would the sound carry? Would your buddies hear it? Would they have the courage to drag you out? In some respects, though not many, the waiting was worse than the tunnel itself. Imagination was a killer.

On April 16, when Lee Strunk drew the number 17, he laughed and muttered something and went down quickly. The morning was hot and very still. Not good, Kiowa said. He looked at the tunnel opening, then out across a dry paddy toward the village of Than Khe. Nothing moved. No clouds or birds or people. As they waited, the men smoked and drank Kool-Aid, not talking much, feeling sympathy for Lee Strunk but also feeling the luck of the draw. You win some, you lose some, said Mitchell Sanders, and sometimes you settle for a rain check. It was a tired line and no one laughed.

Henry Dobbins ate a tropical chocolate bar. Ted Lavender popped a tranquilizer and went off to pee.

After five minutes, Lieutenant Jimmy Cross moved to the tunnel, leaned down, and examined the darkness. Trouble, he thought—a cave-in maybe. And then suddenly, without willing it, he was thinking about Martha. The stresses and fractures, the quick collapse, the two of them buried alive under all that weight. Dense, crushing love. Kneeling, watching the hole, he tried to concentrate on Lee Strunk and the war, all the dangers, but his love was too much for him, he felt paralyzed, he wanted to sleep inside her lungs and breathe her blood and be smothered. He wanted her to be a virgin and not a virgin, all at once. He wanted to know her. Intimate secrets: Why poetry? Why so sad? Why that grayness in her eyes? Why so alone? Not lonely, just alone—riding her bike across campus or sitting off by herself in the cafeteria—even dancing, she danced alone—and it was the aloneness that filled him with love. He remembered telling her that one evening. How she nodded and looked away. And how, later, when he kissed her, she received the kiss without returning it, her eyes wide open, not afraid, not a virgin's eyes, just flat and uninvolved.

Lieutenant Cross gazed at the tunnel. But he was not there. He was buried with Martha under the white sand at the Jersey shore. They were pressed together, and the pebble in his mouth was her tongue. He was smiling. Vaguely, he was aware of how quiet the day was, the sullen paddies, yet he could not bring himself to worry about matters of security. He was beyond that. He was just a kid at war, in love. He was twenty-four years old. He couldn't help it.

A few moments later Lee Strunk crawled out of the tunnel. He came up grinning, filthy but alive. Lieutenant Cross nodded and closed his eyes while the others clapped Strunk on the back and made jokes about rising from the dead.

Worms, Rat Kiley said. Right out of the grave. Fuckin' zombie.

The men laughed. They all felt great relief.

Spook city, said Mitchell Sanders.

Lee Strunk made a funny ghost sound, a kind of moaning, yet very happy, and right then, when Strunk made that high happy moaning sound, when he went *Ahhooooo*, right then Ted Lavender was shot in the head on his way back from peeing. He lay with his mouth open. The teeth were broken. There was a swollen black bruise under his left eye. The cheekbone was gone. Oh shit, Rat Kiley said, the guy's

dead. The guy's dead, he kept saying, which seemed profound—the guy's dead. I mean really.

The things they carried were determined to some extent by superstition. Lieutenant Cross carried his good-luck pebble. Dave Jensen carried a rabbit's foot. Norman Bowker, otherwise a very gentle person, carried a thumb that had been presented to him as as gift by Mitchell Sanders. The thumb was dark brown, rubbery to the touch, and weighed four ounces at most. It had been cut from a VC corpse, a boy of fifteen or sixteen. They'd found him at the bottom of an irrigation ditch, badly burned, flies in his mouth and eyes. The boy wore black shorts and sandals. At the time of his death he had been carrying a pouch of rice, a rifle, and three magazines of ammunition.

You want my opinion, Mitchell Sanders said, there's a definite moral here.

He put his hand on the dead boy's wrist. He was quiet for a time, as if counting a pulse, then he patted the stomach, almost affectionately, and used Kiowa's hunting hatchet to remove the thumb.

Henry Dobbins asked what the moral was.

Moral?

You know. Moral.

Sanders wrapped the thumb in toilet paper and handed it across to Norman Bowker. There was no blood. Smiling, he kicked the boy's head, watched the flies scatter, and said, It's like what that old TV show—Paladin. Have gun, will travel.

Henry Dobbins thought about it.

Yeah, well, he finally said. I don't see no moral.

There it is, man.

Fuck off.

They carried USO stationery and pencils and pens. They carried Sterno, safety pins, trip flares, signal flares, spools of wire, razor blades, chewing tobacco, liberated joss sticks and statuettes of the smiling Buddha, candles, grease pencils, The Stars and Stripes, fingernail clippers, Psy Ops leaflets, bush hats, bolos, and much more. Twice a week, when the resupply choppers came in, they carried hot chow in green mermite cans and large canvas bags filled with iced beer and soda pop. They carried plastic water containers, each with a two-gallon capacity. Mitchell Sanders carried a set of starched tiger fatigues for special occasions. Henry Dobbins carried Black Flag insecticide. Dave Jensen carried empty sandbags that could be filled at night for added protection. Lee Strunk carried tanning lotion. Some things they carried in common. Taking turns, they carried the big PRC-77 scrambler radio, which weighed 30 pounds with its battery. They shared the weight of memory. They took up what others could no longer bear. Often, they carried each other, the wounded or weak. They carried infections. They carried chess sets, basketballs, Vietnamese-English dictionaries, insignia of rank, Bronze Stars and Purple Hearts, plastic cards imprinted with the Code of Conduct. They carried diseases, among them malaria and dysentery. They carried lice and ringworm and leeches and paddy algae and various rots and molds. They carried the land itself-Vietnam, the place, the soil-a powderv

orange-red dust that covered their boots and fatigues and faces. They carried the sky. The whole atmosphere, they carried it, the humidity, the monsoons, the stink of fungus and decay, all of it, they carried gravity. They moved like mules. By daylight they took sniper fire, at night they were mortared, but it was not battle, it was just the endless march, village to village, without purpose, nothing won or lost. They marched for the sake of the march. They plodded along slowly, dumbly, leaning forward against the heat, unthinking, all blood and bone, simple grunts, soldiering with their legs, toiling up the hills and down into the paddies and across the rivers and up again and down, just humping, one step and then the next and then another, but no volition, no will, because it was automatic, it was anatomy, and the war was entirely a matter of posture and carriage, the hump was everything, a kind of inertia, a kind of emptiness, a dullness of desire and intellect and conscience and hope and human sensibility. Their principles were in their feet. Their calculations were biological. They had no sense of strategy or mission. They searched the villages without knowing what to look for, not caring, kicking over jars of rice, frisking children and old men, blowing tunnels, sometimes setting fires and sometimes not, then forming up and moving on to the next village, then other villages, where it would always be the same. They carried their own lives. The pressures were enormous. In the heat of early afternoon, they would remove their helmets and flak jackets, walking bare, which was dangerous but which helped ease the strain. They would often discard things along the route of march. Purely for comfort, they would throw away rations, blow their Claymores and grenades, no matter, because by nightfall the resupply choppers would arrive with more of the same, then a day or two later still more, fresh watermelons and crates of ammunition and sunglasses and woolen sweaters—the resources were stunning-sparklers for the Fourth of July, colored eggs for Easter—it was the great American war chest—the fruits of science, the smokestacks, the canneries, the arsenals at Hartford, the Minnesota forests, the machine shops, the vast fields of corn and wheat—they carried like freight trains; they carried it on their backs and shoulders—and for all the ambiguities of Vietnam, all the mysteries and unknowns, there was at least the single abiding certainty that they would never be at a loss for things to carry.

After the chopper took Lavender away, Lieutenant Jimmy Cross led his men into the village of Than Khe. They burned everything. They shot chickens and dogs, they trashed the village well, they called in artillery and watched the wreckage, then they marched for several hours through the hot afternoon, and then at dusk, while Kiowa explained how Lavender died, Lieutenant Cross found himself trembling.

He tried not to cry. With his entrenching tool, which weighed five pounds, he began digging a hole in the earth.

He felt shame. He hated himself. He had loved Martha more than his men, and as a consequence Lavender was now dead, and this was something he would have to carry like a stone in his stomach for the rest of the war.

All he could do was dig. He used his entrenching tool like an ax, slashing, feeling both love and hate, and then later, when it was full dark, he sat at the bottom of his foxhole and wept. It went on for a long while. In part, he was grieving for Ted Lavender, but mostly it was for Martha, and for himself, because she belonged to another world, which was not quite real, and because she was a junior at Mount Sebastian College in New Jersey, a poet and a virgin and uninvolved, and because he realized she did not love him and never would.

Like cement, Kiowa whispered in the dark. I swear to God—boom, down. Not a word.

I've heard this, said Norman Bowker.

A pisser, you know? Still zipping himself up. Zapped while zipping.

All right, fine. That's enough.

Yeah, but you had to see it, the guy just-

I heard, man. Cement. So why not shut the fuck up?

Kiowa shook his head sadly and glanced over at the hole where Lieutenant Jimmy Cross sat watching the night. The air was thick and wet. A warm dense fog had settled over the paddies and there was the stillness that precedes rain.

After a time Kiowa sighed.

One thing for sure, he said. The lieutenant's in some deep hurt. I mean that crying jag—the way he was carrying on—it wasn't fake or anything, it was real heavyduty hurt. The man cares.

Sure, Norman Bowker said.

Say what you want, the man does care.

We all got problems.

Not Lavender.

No, I guess not, Bowker said. Do me a favor, though.

Shut up?

That's a smart Indian. Shut up.

Shrugging, Kiowa pulled off his boots. He wanted to say more, just to lighten up his sleep, but instead he opened his New Testament and arranged it beneath his head as a pillow. The fog made things seem hollow and unattached. He tried not to think about Ted Lavender, but then he was thinking how fast it was, no drama, down and dead, and how it was hard to feel anything except surprise. It seemed unchristian. He wished he could find some great sadness, or even anger, but the emotion wasn't there and he couldn't make it happen. Mostly he felt pleased to be alive. He liked the smell of the New Testament under his cheek, the leather and ink and paper and glue, whatever the chemicals were. He liked hearing the sounds of night. Even his fatigue, it felt fine, the stiff muscles and the prickly awareness of his own body, a floating feeling. He enjoyed not being dead. Lying there, Kiowa admired Lieutenant Jimmy Cross's capacity for grief. He wanted to share the man's pain, he wanted to care as Jimmy Cross cared. And yet when he closed his eyes, all he could think was Boom-down, and all he could feel was the pleasure of having his boots off and the fog curling in around him and the damp soil and the Bible smells and the plush comfort of night.

After a moment Norman Bowker sat up in the dark.

What the hell, he said. You want to talk, talk. Tell it to me.

Forget it.

No, man, go on. One thing I hate, it's a silent Indian.

For the most part they carried themselves with poise, a kind of dignity. Now and then, however, there were times of panic, when they squealed or wanted to squeal but couldn't, when they twitched and made moaning sounds and covered their heads and said Dear Jesus and flopped around on the earth and fired their weapons blindly and cringed and sobbed and begged for the noise to stop and went wild and made stupid promises to themselves and to God and to their mothers and fathers, hoping not to die. In different ways, it happened to all of them. Afterward, when the firing ended, they would blink and peek up. They would touch their bodies, feeling shame, then quickly hiding it. They would force themselves to stand. As if in slow motion, frame by frame, the world would take on the old logic—absolute silence, then the wind, then sunlight, then voices. It was the burden of being alive. Awkwardly, the men would reassemble themselves, first in private, then in groups, becoming soldiers again. They would repair the leaks in their eyes. They would check for casualties, call in dustoffs, light cigarettes, try to smile, clear their throats and spit and begin cleaning their weapons. After a time someone would shake his head and say, No lie, I almost shit my pants, and someone else would laugh, which meant it was bad, yes, but the guy had obviously not shit his pants, it wasn't that bad, and in any case nobody would ever do such a thing and then go ahead and talk about it. They would squint into the dense, oppressive sunlight. For a few moments, perhaps, they would fall silent, lighting a joint and tracking its passage from man to man, inhaling, holding in the humiliation. Scary stuff, one of them might say. But then someone else would grin or flick his eyebrows and say, Roger-dodger, almost cut me a new asshole, almost.

There were numerous such poses. Some carried themselves with a sort of wistful resignation, others with pride or stiff soldierly discipline or good humor or macho zeal. They were afraid of dying but they were even more afraid to show it.

They found jokes to tell.

They used a hard vocabulary to contain the terrible softness. *Greased* they'd say. Offed, lit up, zapped while zipping. It wasn't cruelty, just stage presence. They were actors. When someone died, it wasn't quite dying, because in a curious way it seemed scripted, and because they had their lines mostly memorized, irony mixed with tragedy, and because they called it by other names, as if to encyst and destroy the reality of death itself. They kicked corpses. They cut off thumbs. They talked grunt lingo. They told stories about Ted Lavender's supply of tranquilizers, how the poor guy didn't feel a thing, how incredibly tranquil he was.

There's a moral here, said Mitchell Sanders.

They were waiting for Lavender's chopper, smoking the dead man's dope.

The moral's pretty obvious, Sanders said, and winked. Stay away from drugs. No joke, they'll ruin your day every time.

Cute, said Henry Dobbins.

Mind blower, get it? Talk about wiggy. Nothing left, just blood and brains.

They made themselves laugh.

There it is, they'd say. Over and over—there it is, my friend, there it is—as if the repetition itself were an act of poise, a balance between crazy and almost crazy, knowing without going, there it is, which meant be cool, let it ride, because Oh yeah, man, you can't change what can't be changed, there it is, there it absolutely and positively and fucking well is.

They were tough.

They carried all the emotional baggage of men who might die. Grief, terror, love, longing—these were intangibles, but the intangibles had their own mass and specific gravity, they had tangible weight. They carried shameful memories. They carried the common secret of cowardice barely restrained, the instinct to run or freeze or hide, and in many respects this was the heaviest burden of all, for it could never be put down, it required perfect balance and perfect posture. They carried their reputations. They carried the soldier's greatest fear, which was the fear of blushing. Men killed, and died, because they were embarrassed not to. It was what had brought them to the war in the first place, nothing positive, no dreams of glory or honor, just to avoid the blush of dishonor. They died so as not to die of embarrassment. They crawled into tunnels and walked point and advanced under fire. Each morning, despite the unknowns, they made their legs move. They endured. They kept humping, they did not submit to the obvious alternative, which was simply to close the eyes and fall. So easy, really. Go limp and tumble to the ground and let the muscles unwind and not speak and not budge until your buddies picked you up and lifted you into the chopper that would roar and dip its nose and carry you off to the world. A mere matter of falling, yet no one ever fell. It was not courage, exactly; the object was not valor. Rather, they were too frightened to be cowards.

By and large they carried these things inside, maintaining the masks of composure. They sneered at sick call. They spoke bitterly about guys who had found release by shooting off their own toes or fingers. Pussies, they'd say. Candy-asses. It was fierce, mocking talk, with only a trace of envy or awe, but even so the image played itself out behind their eyes.

They imagined the muzzle against flesh. So easy: squeeze the trigger and blow away a toe. They imagined it. They imagined the quick, sweet pain, then the evacuation to Japan, then a hospital with warm beds and cute geisha nurses.

And they dreamed of freedom birds.

At night, on guard, staring into the dark, they were carried away by jumbo jets. They felt the rush of takeoff. Gone! they yelled. And then velocity—wings and engines—a smiling stewardess—but it was more than a plane, it was a real bird, a big sleek silver bird with feathers and talons and high screeching. They were flying. The weights fell off; there was nothing to bear. They laughed and held on tight, feeling the cold slap of wind and altitude, soaring, thinking It's over, I'm gone!—they were naked, they were light and free—it was all lightness, bright and fast and buoyant, light as light, a helium buzz in the brain, a giddy bubbling in the lungs as they were taken up over the clouds and the war, beyond duty, beyond gravity and mortification and global entanglements—Sin loi! they yelled. I'm sorry, motherfuckers, but I'm out of it, I'm goofed, I'm on a space cruise, I'm gone!—and it was a restful, unencumbered sensation, just riding the light waves, sailing that big silver freedom bird over the

mountains and oceans, over America, over the farms and great sleeping cities and cemeteries and highways and the golden arches of McDonald's, it was flight, a kind of fleeing, a kind of falling, falling higher and higher, spinning off the edge of the earth and beyond the sun and through the vast, silent vacuum where there were no burdens and where everything weighed exactly nothing—Gone! they screamed. I'm sorry but I'm gone!—and so at night, not quite dreaming, they gave themselves over to lightness, they were carried, they were purely borne.

On the morning after Ted Lavender died, First Lieutenant Jimmy Cross crouched at the bottom of his foxhole and burned Martha's letters. Then he burned the two photographs. There was a steady rain falling, which made it difficult, but he used heat tabs and Sterno to build a small fire, screening it with his body, holding the photographs over the tight blue flame with the tips of his fingers.

He realized it was only a gesture. Stupid, he thought. Sentimental, too, but mostly just stupid.

Lavender was dead. You couldn't burn the blame.

Besides, the letters were in his head. And even now, without photographs, Lieutenant Cross could see Martha playing volleyball in her white gym shorts and yellow T-shirt. He could see her moving in the rain.

When the fire died out, Lieutenant Cross pulled his poncho over his shoulders and ate breakfast from a can.

There was no great mystery, he decided.

In those burned letters Martha had never mentioned the war, except to say, Jimmy, take care of yourself. She wasn't involved. She signed the letters Love, but it wasn't love, and all the fine lines and technicalities did not matter. Virginity was no longer an issue. He hated her. Yes, he did. He hated her. Love, too, but it was a hard, hating kind of love.

The morning came up wet and blurry. Everything seemed part of everything else, the fog and Martha and the deepening rain.

He was a soldier, after all.

Half smiling, Lieutenant Jimmy Cross took out his maps. He shook his head hard, as if to clear it, then bent forward and began planning the day's march. In ten minutes, or maybe twenty, he would rouse the men and they would pack up and head west, where the maps showed the country to be green and inviting. They would do what they had always done. The rain might add some weight, but otherwise it would be one more day layered upon all the other days.

He was realistic about it. There was that new hardness in his stomach. He loved her but he hated her.

No more fantasies, he told himself.

Henceforth, when he thought about Martha, it would be only to think that she belonged elsewhere. He would shut down the daydreams. This was not Mount Sebastian, it was another world, where there were no pretty poems or mid-term exams, a place where men died because of carelessness and gross stupidity. Kiowa was right. Boom-down, and you were dead, never partly dead.

Briefly, in the rain, Lieutenant Cross saw Martha's gray eyes gazing back at him. He understood.

It was very sad, he thought. The things men carried inside. The things men did or felt they had to do.

He almost nodded at her, but didn't.

Instead he went back to his maps. He was now determined to perform his duties firmly and without negligence. It wouldn't help Lavender, he knew that, but from this point on he would comport himself as an officer. He would dispose of his goodluck pebble. Swallow it, maybe, or use Lee Strunk's slingshot, or just drop it along the trail. On the march he would impose strict field discipline. He would be careful to send out flank security, to prevent straggling or bunching up, to keep his troops moving at the proper pace and at the proper interval. He would insist on clean weapons. He would confiscate the remainder of Lavender's dope. Later in the day, perhaps, he would call the men together and speak to them plainly. He would accept the blame for what had happened to Ted Lavender. He would be a man about it. He would look them in the eyes, keeping his chin level, and he would issue the new SOPs in a calm, impersonal tone of voice, a lieutenant's voice, leaving no room for argument or discussion. Commencing immediately, he'd tell them, they would no longer abandon equipment along the route of march. They would police up their acts. They would get their shit together, and keep it together, and maintain it neatly and in good working order.

He would not tolerate laxity. He would show strength, distancing himself.

Among the men there would be grumbling, of course, and maybe worse, because their days would seem longer and their loads heavier, but Lieutenant Jimmy Cross reminded himself that his obligation was not to be loved but to lead. He would dispense with love; it was not now a factor. And if anyone quarreled or complained, he would simply tighten his lips and arrange his shoulders in the correct command posture. He might give a curt little nod. Or he might not. He might just shrug and say, Carry on, then they would saddle up and form into a column and move out toward the villages west of Than Khe.

Suggestions for Discussion

- 1. For the most part, "The Things They Carried" uses a matter-of-fact tone listing an accumulation of concrete details. How do these details help direct the reader's judgment toward the war and the soldiers there?
- 2. What is the effect of insisting on the exact weight of things?
- 3. What active verbs in addition to "to carry" move the story forward?
- 4. How and where does a change of rhythm change the emotion, alter the action, signal a turning point?

5. At several points the soldiers carry, in addition to their gear, abstracts like distrust of the white man, all they could bear, infections, grief, terror, love, fear. How does O'Brien get away with using so many grand abstractions?

Where Are You Going, Where Have You Been? IOYCE CAROL OATES

for Bob Dylan

Her name was Connie. She was fifteen and she had a quick nervous giggling habit of craning her neck to glance into mirrors, or checking other people's faces to make sure her own was all right. Her mother, who noticed everything and knew everything and who hadn't much reason any longer to look at her own face, always scolded Connie about it. "Stop gawking at yourself, who are you? You think you're so pretty?" she would say. Connie would raise her eyebrows at these familiar complaints and look right through her mother, into a shadowy vision of herself as she was right at that moment: she knew she was pretty and that was everything. Her mother had been pretty once too, if you could believe those old snapshots in the album, but now her looks were gone and that was why she was always after Connie.

"Why don't you keep your room clean like your sister? How've you got your hair fixed—what the hell stinks? Hair spray? You don't see your sister using that junk."

Her sister June was twenty-four and still lived at home. She was a secretary in the high school Connie attended, and if that wasn't bad enough—with her in the same building—she was so plain and chunky and steady that Connie had to hear her praised all the time by her mother and her mother's sisters. June did this, June did that, she saved money and helped clean the house and cooked and Connie couldn't do a thing, her mind was all filled with trashy daydreams. Their father was away at work most of the time and when he came home he wanted supper and he read the newspaper at supper and after supper he went to bed. He didn't bother talking much to them, but around his bent head Connie's mother kept picking at her until Connie wished her mother was dead and she herself was dead and it was all over. "She makes me want to throw up sometimes," she complained to her friends. She had a high, breathless, amused voice which made everything she said a little forced, whether it was sincere or not.

There was one good thing: June went places with girl friends of hers, girls who were just as plain and steady as she, and so when Connie wanted to do that her mother had no objections. The father of Connie's best girl friend drove the girls the three miles to town and left them off at a shopping plaza, so that they could walk through the stores or go to a movie, and when he came to pick them up again at eleven he never bothered to ask what they had done.

They must have been familiar sights, walking around that shopping plaza in their shorts and flat ballerina slippers that always scuffed the sidewalk, with charm

bracelets jingling on their thin wrists; they would lean together to whisper and laugh secretly if someone passed by who amused or interested them. Connie had long dark blond hair that drew anyone's eye to it, and she wore part of it pulled up on her head and puffed out and the rest of it she let fall down her back. She wore a pullover jersey blouse that looked one way when she was at home and another way when she was away from home. Everything about her had two sides to it, one for home and one for anywhere that was not home: her walk that could be childlike and bobbing, or languid enough to make anyone think she was hearing music in her head, her mouth which was pale and smirking most of the time, but bright and pink on these evenings out, her laugh which was cynical and drawling at home—"Ha, ha, very funny"—but high-pitched and nervous anywhere else, like the jingling of the charms on her bracelet.

Sometimes they did go shopping or to a movic, but sometimes they went across the highway, ducking fast across the busy road, to a drive-in restaurant where older kids hung out. The restaurant was shaped like a big bottle, though squatter than a real bottle, and on its cap was a revolving figure of a grinning boy who held a hamburger aloft. One night in midsummer they ran across, breathless with daring, and right away someone leaned out a car window and invited them over, but it was just a boy from high school they didn't like. It made them feel good to be able to ignore him. They went up through the maze of parked and cruising cars to the bright-lit, fly-infested restaurant, their faces pleased and expectant as if they were entering a sacred building that loomed out of the night to give them what haven and what blessing they yearned for. They sat at the counter and crossed their legs at the ankles, their thin shoulders rigid with excitement and listened to the music that made everything so good: the music was always in the background like music at a church service, it was something to depend upon.

A boy named Eddie came in to talk with them. He sat backwards on his stool, turning himself jerkily around in semi-circles and then stopping and turning again, and after a while he asked Connie if she would like something to eat. She said she did and so she tapped her friend's arm on her way out—her friend pulled her face up into a brave droll look-and Connie said she would meet her at eleven, across the way. "I just hate to leave her like that," Connie said earnestly, but the boy said that she wouldn't be alone for long. So they went out to his car and on the way Connie couldn't help but let her eyes wander over the windshields and faces all around her, her face gleaming with the joy that had nothing to do with Eddie or even this place; it might have been the music. She drew her shoulders up and sucked in her breath with the pure pleasure of being alive, and just at that moment she happened to glance at a face just a few feet from hers. It was a boy with shaggy black hair, in a convertible jalopy painted gold. He stared at her and then his lips widened into a grin. Connie slit her eyes at him and turned away, but she couldn't help glancing back and there he was still watching her. He wagged a finger and laughed and said, "Gonna get you, baby," and Connie turned away again without Eddie noticing anything.

She spent three hours with him, at the restaurant where they are hamburgers and drank Cokes in wax cups that were always sweating, and then down an alley a mile

or so away, and when he left her off at five to eleven only the movie house was still open at the plaza. Her girl friend was there, talking with a boy. When Connie came up the two girls smiled at each other and Connie said, "How was the movie?" and the girl said, "You should know." They rode off with the girl's father, sleepy and pleased, and Connie couldn't help but look at the darkened shopping plaza with its big empty parking lot and its signs that were faded and ghostly now, and over at the drive-in restaurant where cars were still circling tirelessly. She couldn't hear the music at this distance.

Next morning June asked her how the movie was and Connie said, "So-so."

She and that girl and occasionally another girl went out several times a week that way, and the rest of the time Connie spent around the house—it was summer vacation—getting in her mother's way and thinking, dreaming, about the boys she met. But all the boys fell back and dissolved into a single face that was not even a face, but an idea, a feeling, mixed up with the urgent insistent pounding of the music and the humid night air of July. Connie's mother kept dragging her back to the daylight by finding things for her to do or saying suddenly, "What's this about the Pettinger girl?"

And Connie would say nervously, "Oh, her. That dope." She always drew thick clear lines between herself and such girls, and her mother was simple and kindly enough to believe her. Her mother was so simple, Connie thought, that it was maybe cruel to fool her so much. Her mother went scuffling around the house in old bedroom slippers and complained over the telephone to one sister about the other, then the other called up and the two of them complained about the third one. If June's name was mentioned her mother's tone was approving, and if Connie's name was mentioned it was disapproving. This did not really mean she disliked Connie and actually Connie thought that her mother preferred her to June because she was prettier, but the two of them kept up a pretense of exasperation, a sense that they were tugging and struggling over something of little value to either of them. Sometimes, over coffee, they were almost friends, but something would come up—some vexation that was like a fly buzzing suddenly around their heads—and their faces went hard with contempt.

One Sunday Connie got up at eleven—none of them bothered with church—and washed her hair so that it could dry all day long, in the sun. Her parents and sister were going to a barbecue at an aunt's house and Connie said no, she wasn't interested, rolling her eyes, to let mother know just what she thought of it. "Stay home alone then," her mother said sharply. Connie sat out back in a lawn chair and watched them drive away, her father quiet and bald, hunched around so that he could back the car out, her mother with a look that was still angry and not at all softened through the windshield, and in the back seat poor old June all dressed up as if she didn't know what a barbecue was, with all the running yelling kids and the flies. Connie sat with her eyes closed in the sun, dreaming and dazed with the warmth about her as if this were a kind of love, the caresses of love, and her mind slipped over onto thoughts of the boy she had been with the night before and how nice he had been, how sweet it always was, not the way someone like June would suppose

but sweet, gentle, the way it was in movies and promised in songs; and when she opened her eyes she hardly knew where she was, the back yard ran off into weeds and a fenceline of trees and behind it the sky was perfectly blue and still. The asbestos "ranch house" that was now three years old startled her—it looked small. She shook her head as if to get awake.

It was too hot. She went inside the house and turned on the radio to drown out the quiet. She sat on the edge of her bed, barefoot, and listened for an hour and a half to a program called XYZ Sunday Jamboree, record after record of hard, fast, shrieking songs she sang along with, interspersed by exclamations from "Bobby King": "An' look here you girls at Napoleon's—Son and Charley want you to pay real close attention to this song coming up!"

And Connie paid close attention herself, bathed in a glow of slow-pulsed joy that seemed to rise mysteriously out of the music itself and lay languidly about the airless little room, breathed in and breathed out with each gentle rise and fall of her chest.

After a while she heard a car coming up the drive. She sat up at once, startled, because it couldn't be her father so soon. The gravel kept crunching all the way in from the road—the driveway was long—and Connie ran to the window. It was a car she didn't know. It was an open jalopy, painted a bright gold that caught the sun opaquely. Her heart began to pound and her fingers snatched at her hair, checking it, and she whispered "Christ. Christ," wondering how bad she looked. The car came to a stop at the side door and the horn sounded four short taps as if this were a signal Connie knew.

She went into the kitchen and approached the door slowly, then hung out the screen door, her bare toes curling down off the step. There were two boys in the car and now she recognized the driver: he had shaggy, shabby black hair that looked crazy as a wig and he was grinning at her.

"I ain't late, am I?" he said.

"Who the hell do you think you are?" Connie said.

"Toldja I'd be out, didn't I?"

"I don't even know who you are."

She spoke sullenly, careful to show no interest or pleasure, and he spoke in a fast bright monotone. Connie looked past him to the other boy, taking her time. He had fair brown hair, with a lock that fell onto his forehead. His sideburns gave him a fierce, embarrassed look, but so far he hadn't even bothered to glance at her. Both boys wore sunglasses. The driver's glasses were metallic and mirrored everything in miniature.

"You wanta come for a ride?" he said.

Connie smirked and let her hair fall loose over one shoulder.

"Don'tcha like my car? New paint job," he said. "Hey."

"What?"

"You're cute."

She pretended to fidget, chasing flies away from the door.

"Dont'cha believe me, or what?" he said.

"Look, I don't even know who you are," Connie said in disgust.

"Hey, Ellie's got a radio, see. Mine's broke down." He lifted his friend's arm and showed her the little transistor the boy was holding, and now Connie began to hear the music. It was the same program that was playing inside the house.

"Bobby King?" she said.

"I listen to him all the time. I think he's great."

"He's kind of great," Connie said reluctantly.

"Listen, that guy's great. He knows where the action is."

Connie blushed a little, because the glasses made it impossible for her to see just what this boy was looking at. She couldn't decide if she liked him or if he was just a jerk, and so she dawdled in the doorway and wouldn't come down or go back inside. She said, "What's all that stuff painted on your car!"

"Can'tcha read it?" He opened the door very carefully, as if he was afraid it might fall off. He slid out just as carefully, planting his feet firmly on the ground, the tiny metallic world in his glasses slowing down like gelatine hardening and in the midst of it Connie's bright green blouse. "This here is my name, to begin with," he said. ARNOLD FRIEND was written in tar-like black letters on the side, with a drawing of a round grinning face that reminded Connie of a pumpkin, except it wore sunglasses. "I wanta introduce myself, I'm Arnold Friend and that's my real name and I'm gonna be your friend, honey, and inside the car's Ellie Oscar, he's kinda shy." Ellie brought his transistor up to his shoulder and balanced it there. "Now these numbers are a secret code, honey," Arnold Friend explained. He read off the numbers 33, 19, 17 and raised his eyebrows at her to see what she thought of that, but she didn't think much of it. The left rear fender had been smashed and around it was written, on the gleaming gold background: DONE BY CRAZY WOMAN DRIVER. Connie had to laugh at that. Arnold Friend was pleased at her laughter and looked up at her. "Around the other side's a lot more—you wanta come and see them?"

"No."

"Why not?"

"Why should I?"

"Don'tcha wanta see what's on the car? Don'tcha wanta go for a ride?"

"I don't know."

"Why not?"

"I got things to do."

"Like what?"

"Things."

He laughed as if she had said something funny. He slapped his thighs. He was standing in a strange way, leaning back against the car as if he were balancing himself. He wasn't tall, only an inch or so taller than she would be if she came down to him. Connie liked the way he was dressed, which was the way all of them dressed: tight faded jeans stuffed into black, scuffed boots, a belt that pulled his waist in and showed how lean he was, and a white pull-over shirt that was a little soiled and showed the hard small muscles of his arms and shoulders. He looked as if he probably did hard work, lifting and carrying things. Even his neck looked muscular. And his face was a familiar face, somehow: the jaw and chin and cheeks slightly darkened,

because he hadn't shaved for a day or two, and the nose long and hawk-like, sniffing as if she were a treat he was going to gobble up and it was all a joke.

"Connie, you ain't telling the truth. This is your day set aside for a ride with me and you know it," he said, still laughing. The way he straightened and recovered from his fit of laughing showed that it had been all fake.

"How do you know what my name is?" she said suspiciously.

"It's Connie."

"Maybe and maybe not."

"I know my Connie," he said, wagging his finger. Now she remembered him even better, back at the restaurant, and her cheeks warmed at the thought of how she sucked in her breath just at the moment she passed him—how she must have looked to him. And he had remembered her. "Ellie and I come out here especially for you," he said. "Ellie can sit in back. How about it?"

"Where?"

"Where what?"

"Where're we going?"

He looked at her. He took off the sunglasses and she saw how pale the skin around his eyes was, like holes that were not in shadow but instead in light. His eyes were like chips of broken glass that catch the light in an amiable way. He smiled. It was as if the idea of going for a ride somewhere, to some place, was a new idea to

"Just for a ride, Connie sweetheart."

"I never said my name was Connie," she said.

"But I know what it is. I know your name and all about you, lots of things," Arnold Friend said. He had not moved yet but stood still leaning back against the side of his jalopy. "I took a special interest in you, such a pretty girl, and found out all about you like I know your parents and sister are gone somewheres and I know where and how long they're going to be gone, and I know who you were with last night, and your best friend's name is Betty. Right?"

He spoke in a simple lilting voice, exactly as if he were reciting the words to a song. His smile assured her that everything was fine. In the car Ellie turned up the volume on his radio and did not bother to look around at them.

"Ellie can sit in the back seat," Arnold Friend said. He indicated his friend with a casual jerk of his chin, as if Ellie did not count and she should not bother with him.

"How'd you find out all that stuff?" Connie said.

"Listen: Betty Schultz and Tony Fitch and Jimmy Pettinger and Nancy Pettinger," he said, in a chant. "Raymond Stanley and Bob Hutter—"

"Do you know all those kids?"

"I know everybody."

"Look, you're kidding. You're not from around here."

"Sure."

"But—how come we never saw you before?"

"Sure you saw me before," he said. He looked down at his boots, as if he were a little offended. "You just don't remember."

"I guess I'd remember you," Connie said.

"Yeah?" He looked up at this, beaming. He was pleased. He began to mark time with the music from Ellie's radio, tapping his fists lightly together. Connie looked away from his smile to the car, which was painted so bright it almost hurt her eyes to look at it. She looked at that name, ARNOLD FRIEND. And up at the front fender was an expression that was familiar—MAN THE FLYING SAUCERS. It was an expression kids had used the year before, but didn't use this year. She looked at it for a while as if the words meant something to her that she did not yet know.

"What're you thinking about? Huh?" Arnold Friend demanded. "Not worried about your hair blowing around in the car, are you?"

"No."

"Think I maybe can't drive good?"

"How do I know?"

"You're a hard girl to handle. How come?" he said. "Don't you know I'm your friend? Didn't you see me put my sign in the air when you walked by?"

"What sign?"

"My sign." And he drew an X in the air, leaning out toward her. They were maybe ten feet apart. After his hand fell back to his side the X was still in the air, almost visible. Connie let the screen door close and stood perfectly still inside it, listening to the music from her radio and the boy's blend together. She stared at Arnold Friend. He stood there so stiffly relaxed, pretending to be relaxed, with one hand idly on the door handle as if he were keeping himself up that way and had no intention of ever moving again. She recognized most things about him, the tight jeans that showed his thighs and buttocks and the greasy leather boots and the tight shirt, and even that slippery friendly smile of his, that sleepy dreamy smile that all the boys used to get across ideas they didn't want to put into words. She recognized all this and also the singsong way he talked, slightly mocking, kidding, but serious and a little melancholy, and she recognized the way he tapped one fist against the other in homage to the perpetual music behind him. But all these things did not come together.

She said suddenly, "Hey, how old are you?"

His smile faded. She could see then that he wasn't a kid, he was much older—thirty, maybe more. At this knowledge her heart began to pound faster.

"That's a crazy thing to ask. Can'tcha see I'm your own age?"

"Like hell you are."

"Or maybe a coupla years older, I'm eighteen."

"Eighteen?" she said doubtfully.

He grinned to reassure her and lines appeared at the corners of his mouth. His teeth were big and white. He grinned so broadly his eyes became slits and she saw how thick the lashes were, thick and black as if painted with a black tar-like material. Then he seemed to become embarrassed, abruptly, and looked over his shoulder at Ellie. "Him, he's crazy," he said. "Ain't he a riot, he's a nut, a real character." Ellie was still listening to the music. His sunglasses told nothing about what he was thinking. He wore a bright orange shirt unbuttoned halfway to show his chest, which was a pale, bluish chest and not muscular like Arnold Friend's. His shirt collar was

turned up all around and the very tips of the collar pointed out past his chin as if they were protecting him. He was pressing the transistor radio up against his ear and sat there in a kind of daze, right in the sun.

"He's kinda strange," Connie said.

"Hey, she says you're kinda strange! Kinda strange!" Arnold Friend cried. He pounded on the car to get Ellie's attention. Ellie turned for the first time and Connie saw with shock that he wasn't a kid either—he had a fair, hairless face, cheeks reddened slightly as if the veins grew too close to the surface of his skin, the face of a forty-year-old baby. Connie felt a wave of dizziness rise in her at this sight and she stared at him as if waiting for something to change the shock of the moment, make it all right again. Ellie's lips kept shaping words, mumbling along with the words blasting his ear.

"Maybe you two better go away," Connie said faintly.

"What? How come?" Arnold Friend cried. "We come out here to take you for a ride. It's Sunday." He had the voice of the man on the radio now. It was the same voice, Connie thought. "Don'tcha know it's Sunday all day and honey, no matter who you were with last night today you're with Arnold Friend and don't you forget it!—Maybe you better step out here," he said, and this last was in a different voice. It was a little flatter, as if the heat was finally getting to him.

"No. I got things to do."

"Hey."

"You two better leave."

"We ain't leaving until you come with us."

"Like hell I am-"

"Connie, don't fool around with me. I mean. I mean, don't fool around," he said, shaking his head. He laughed incredulously. He placed his sunglasses on top of his head, carefully, as if he were indeed wearing a wig, and brought the stems down behind his ears. Connie stared at him, another wave of dizziness and fear rising in her so that for a moment he wasn't even in focus but was just a blur, standing there against his gold car, and she had the idea that he had driven up the driveway all right but had come from nowhere before that and belonged nowhere and that everything about him and even the music that was so familiar to her was only half real.

"If my father comes and sees you—"

"He ain't coming. He's at a barbecue."

"How do you know that?"

"Aunt Tillie's. Right now they're—uh—they're drinking. Sitting around," he said vaguely, squinting as if he were staring all the way to town and over to Aunt Tillie's back yard. Then the vision seemed to clear and he nodded energetically. "Yeah. Sitting around. There's your sister in a blue dress, huh? And high heels, the poor sad bitch—nothing like you, sweetheart! And your mother's helping some fat woman with the corn, they're cleaning the corn—husking the corn—"

"What fat woman?" Connie cried.

"How do I know what fat woman. I don't know every goddam fat woman in the world!" Arnold Friend laughed.

"Oh, that's Mrs. Hornby. . . . Who invited her?" Connie said. She felt a little light-headed. Her breath was coming quickly.

"She's too fat. I don't like them fat. I like them the way you are, honey," he said, smiling sleepily at her. They stared at each other for a while, through the screen door. He said softly, "Now what you're going to do is this: you're going to come out that door. You're going to sit up front with me and Ellie's going to sit in the back, the hell with Ellie, right? This isn't Ellie's date. You're my date. I'm your lover, honey."

"What? You're crazy—"

"Yes, I'm your lover. You don't know what that is but you will," he said. "I know that too. I know all about you. But look: it's real nice and you couldn't ask for nobody better than me, or more polite. I always keep my word. I'll tell you how it is, I'm always nice at first, the first time. I'll hold you so tight you won't think you have to try to get away or pretend anything because you'll know you can't. And I'll come inside you where it's all secret and you'll give in to me and you'll love me—"

"Shut up! You're crazy!" Connie said. She backed away from the door. She put her hands against her ears as if she'd heard something terrible, something not meant for her. "People don't talk like that, you're crazy," she muttered. Her heart was almost too big now for her chest and its pumping made sweat break out all over her. She looked out to see Arnold Friend pause and then take a step toward the porch lurching. He almost fell. But, like a clever drunken man, he managed to catch his balance. He wobbled in his high boots and grabbed hold of one of the porch posts.

"Honey?" he said. "You still listening?"

"Get the hell out of here!"

"Be nice, honey. Listen."

"I'm going to call the police—"

He wobbled again and out of the side of his mouth came a fast spat curse, an aside not meant for her to hear. But even this "Christ!" sounded forced. Then he began to smile again. She watched this smile come, awkward as if he were smiling from inside a mask. His whole face was a mask, she thought wildly, tanned down onto his throat but then running out as if he had plastered make-up on his face but had forgotten about his throat.

"Honey—? Listen, here's how it is. I always tell the truth and I promise you this: I ain't coming in that house after you."

"You better not! I'm going to call the police if you—if you don't—"

"Honey," he said, talking right through her voice, "honey, I'm not coming in there but you are coming out here. You know why?"

She was panting. The kitchen looked like a place she had never seen before, some room she had run inside but which wasn't good enough, wasn't going to help her. The kitchen window had never had a curtain, after three years, and there were dishes in the sink for her to do—probably—and if you ran your hand across the table you'd probably feel something sticky there.

"You listening, honey? Hey?"

"—going to call the police—"

"Soon as you touch the phone I don't need to keep my promise and can come inside. You won't want that."

She rushed forward and tried to lock the door. Her fingers were shaking. "But why lock it," Arnold Friend said gently, talking right into her face. "It's just a screen door. It's just nothing." One of his boots was at a strange angle, as if his foot wasn't in it. It pointed out to the left, bent at the ankle. "I mean, anybody can break through a screen door and glass and wood and iron or anything else if he needs to, anybody at all and specially Arnold Friend. If the place got lit up with a fire, honey, you'd come running out into my arms, right into my arms and safe at home—like you knew I was your lover and'd stopped fooling around. I don't mind a nice shy girl but I don't like no fooling around." Part of those words were spoken with a slight rhythmic lilt, and Connie somehow recognized them—the echo of a song from last year, about a girl rushing into her boy friend's arms and coming home again—

Connie stood barefoot on the linoleum floor, staring at him. "What do you want?" she whispered.

"I want you," he said.

"What?"

"Seen you that night and thought, that's the one, yes sir. I never needed to look any more."

"But my father's coming back. He's coming to get me. I had to wash my hair first—" She spoke in a dry, rapid voice, hardly raising it for him to hear.

"No, your daddy is not coming and yes, you had to wash your hair and you washed it for me. It's nice and shining and all for me, I thank you, sweetheart," he said, with a mock bow, but again he almost lost his balance. He had to bend and adjust his boots. Evidently his feet did not go all the way down; the boots must have been stuffed with something so that he would seem taller. Connie stared out at him and behind him Ellie in the car, who seemed to be looking off toward Connie's right, into nothing. This Ellie said, pulling the words out of the air one after another as if he were just discovering them, "You want me to pull out the phone?"

"Shut your mouth and keep it shut," Arnold Friend said, his face red from bending over or maybe from embarrassment because Connie had seen his boots. "This ain't none of your business."

"What—what are you doing? What do you want?" Connie said. "If I call the police they'll get you, they'll arrest you—"

"Promise was not to come in unless you touch that phone, and I'll keep that promise," he said. He resumed his erect position and tried to force his shoulders back. He sounded like a hero in a movie, declaring something important. He spoke too loudly and it was as if he were speaking to someone behind Connie. "I ain't made plans for coming in that house where I don't belong but just for you to come out to me, the way you should. Don't you know who I am?"

"You're crazy," she whispered. She backed away from the door but did not want to go into another part of the house, as if this would give him permission to come through the door. "What do you. . . . You're crazy, you. . . ."

"Huh? What're you saying, honey?"

Her eyes darted everywhere in the kitchen. She could not remember what it was,

"This is how it is, honey: you come out and we'll drive away, have a nice ride. But

if you don't come out we're gonna wait till your people come home and then they're all going to get it."

"You want that telephone pulled out?" Ellie said. He held the radio away from his ear and grimaced, as if without the radio the air was too much for him.

"I toldja shut up, Ellie." Arnold Friend said, "You're deaf, get a hearing aid, right? Fix yourself up. This little girl's no trouble and's gonna be nice to me, so Ellie keep to yourself, this ain't your date—right? Don't hem in on me. Don't hog. Don't crush. Don't bird dog. Don't trail me," he said in a rapid meaningless voice, as if he were running through all the expressions he'd learned but was no longer sure which one of them was in style, then rushing on to new ones, making them up with his eyes closed, "Don't crawl under my fence, don't squeeze in my chipmunk hole, don't sniff my glue, suck my popsicle, keep your own greasy fingers on yourself!" He shaded his eyes and peered in at Connie, who was backed against the kitchen table. "Don't mind him, honey, he's just a creep. He's a dope. Right? I'm the boy for you and like I said you come out here nice like a lady and give me your hand, and nobody else gets hurt, I mean, your nice old bald-headed daddy and your mummy and your sister in her high heels. Because listen: why bring them in this?"

"Leave me alone," Connie whispered.

"Hey, you know that old woman down the road, the one with the chickens and stuff—you know her?"

"She's dead!"

"Dead? What? You know her?" Arnold Friend said.

"She's dead—"

"Don't you like her?"

"She's dead—she's—she isn't here any more—"

"But don't you like her, I mean, you got something against her? Some grudge or something?" Then his voice dipped as if he were conscious of rudeness. He touched the sunglasses on top of his head as if to make sure they were still there. "Now you be a good girl."

"What are you going to do?"

"Just two things, or maybe three," Arnold Friend said. "But I promise it won't last long and you'll like me that way you get to like people you're close to. You will. It's all over for you here, so come on out. You don't want your people in any trouble, do you?"

She turned and bumped against a chair or something, hurting her leg, but she ran into the back room and picked up the telephone. Something roared in her ear, a tiny roaring, and she was so sick with fear that she could do nothing but listen to it—the telephone was clammy and very heavy and her fingers groped down to the dial but were too weak to touch it. She began to scream into the phone, into the roaring. She cried out, she cried for her mother, she felt her breath start jerking back and forth in her lungs as if it were something Arnold Friend were stabbing her with again and again with no tenderness. A noisy sorrowful wailing rose all about her and she was locked inside it the way she was locked inside this house.

After a while she could hear again. She was sitting on the floor, with her wet back against the wall.

Arnold Friend was saying from the door, "That's a good girl. Put the phone back."

She kicked the phone away from her.

"No, honey. Pick it up. Put it back right."
She picked it up and put it back. The dial tone stopped.

"That's a good girl. Now you come outside."

She was hollow with what had been fear, but what was now just an emptiness. All that screaming had blasted it out of her. She sat, one leg cramped under her, and deep inside her brain was something like a pinpoint of light that kept going and would not let her relax. She thought, I'm not going to see my mother again. She thought, I'm not going to sleep in my bed again. Her bright green blouse was all wet.

Arnold Friend said, in a gentle-loud voice that was like a stage voice, "The place where you came from ain't there any more, and where you had in mind to go is cancelled out. This place you are now—inside your daddy's house—is nothing but a cardboard box I can knock down any time. You know that and always did know it. You hear me?"

She thought, I have got to think. I have to know what to do.

"We'll go out to a nice field, out in the country here where it smells so nice and it's sunny," Arnold Friend said. "I'll have my arms tight around you so you won't need to try to get away and I'll show you what love is like, what it does. The hell with this house! It looks solid all right," he said. He ran a fingernail down the screen and the noise did not make Connie shiver, as it would have the day before. "Now put your hand on your heart, honey. Feel that? That feels solid too but we know better, be nice to me, be sweet like you can because what else is there for a girl like you but to be sweet and pretty and give in?—and get away before her people come back?"

She felt her pounding heart. Her hands seemed to enclose it. She thought for the first time in her life that it was nothing that was hers, that belonged to her, but just a pounding, living thing inside this body that wasn't hers either.

"You don't want them to get hurt," Arnold Friend went on. "Now get up, honey. Get up all by yourself."

She stood.

"Now turn this way. That's right. Come over liere to me—Ellie, put that away, didn't I tell you? You dope. You miserable creepy dope," Arnold Friend said. His words were not angry but only part of an incantation. The incantation was kindly. "Now come out through the kitchen to me honey and let's see a smile, try it, you're a brave sweet little girl and now they're eating corn and hotdogs cooked to bursting over an outdoor fire, and they don't know one thing about you and never did and honey you're better than them because not one of them would have done this for you."

Connie felt the linoleum under her feet; it was cool. She brushed her hair back out of her eyes. Arnold Friend let go of the post tentatively and opened his arms for her, his elbows pointing up toward each other and his wrists limp, to show that this was an embarrassed embrace and a little mocking, he didn't want to make her self-conscious.

She put out her hand against the screen. She watched herself push the door

slowly open as if she were safe back somewhere in the other doorway, watching this body and this head of long hair moving out into the sunlight where Arnold Friend waited.

"My sweet little blue-eyed girl," he said, in a half-sung sigh that had nothing to do with her brown eyes but was taken up just the same by the vast sunlit reaches of the land behind him and on all sides of him, so much land that Connie had never seen before and did not recognize except to know that she was going to it.

Suggestions for Discussion

- 1. Analyze the first paragraph of "Where Are You Going, Where Have You Been?" for the contrast between generalities and concrete details. What are the functions of each?
- 2. Locate physical descriptions of Connie and show what abstractions about her are implied.
- 3. As the details that describe Arnold Friend change, how does our understanding of him change?
- 4. Take any long paragraph of this story and underline the active verbs. Try substituting them with passive constructions and linking verbs. What is the effect?
- 5. Note the rhythm of the paragraph beginning "And Connie paid close attention . . . " on page 83. Contrast the following paragraph. How do the two rhythms reinforce the meaning?

Retrospect

- 1. Examine the first page of the excerpt from Annie Dillard's The Writing Life on page 19 to see how she uses active verbs to describe the writing process.
- 2. Compare the conflicts in "How Far She Went" and "Where Are You Going, Where Have You Been?" How do differences in the concrete details chosen by the two authors signal the differences in mood, setting, character, and resolution?

Writing Assignments

1. The playwright Bertold Brecht had over his desk a sign that read "The Truth is Concrete." You will notice, however, that this sentence is an abstraction (he didn't mean that the truth is cement). In your journal, cluster the word "concrete." Write a passage about it. When you're finished, check

- whether you have used any abstractions or generalizations that could be effectively replaced by concrete details.
- 2. Paint a self-portrait in words. Prop a mirror in front of you and describe, in the most focused sight details you can manage, twenty or thirty things that you see. Then try to distance yourself from your portrait and choose the two or three details that most vividly and concisely convey the image you want to present. What attitude do you want the reader to have? Should we find you funny, intense, pitiable, vain, dedicated? Add a detail of sound, touch, smell, or taste that will help convey the image.
- 3. Write a passage using significant details and active verbs about a character who conveys one of the following:
 - belongs to another century
 - ccmplete harmony
 - · brains are fried
 - out of control
 - · kittenish or puppy-like
 - · the absolute boss
- 4. Write a description of a rural landscape, a city street, a room, or the desk in front of you. Use only active verbs to describe inanimate as well as animate things. Avoid the **pathetic fallacy** (see page 63 for review).
- 5. Write about a boring situation. Convince us that the situation is boring and that your characters are bored or boring or both. Fascinate us. Or make us laugh. Use no generalizations, no judgments, and no verbs in the passive voice.
- 6. Write about one of the following and suggest the rhythm of the subject in your prose: a machine, a vehicle, a piece of music, sex, something that goes in a circle, an avalanche.
- 7. Write about a character who begins at a standstill, works up to great speed, and comes to a halt again. The rush may be purely emotional, or it may represent the speed of a vehicle, of pursuit, of a sport, or whatever you choose. The halt may be abrupt or gradual. In any case, let the prose rhythm reflect the changes.
- 8. Take any scene you have already written and "shrink for details." That is, imagine yourself from the vantage point of something *very* small—no bigger than a button, a cockroach, an earlobe, a baked bean—and write a paragraph or a page using the details you see from that perspective.

4

BOOK PEOPLE

Characterization, Part I

- · Credibility
 - Purpose
- · Complexity
- The Indirect Method of Character Presentation
- The Direct Methods of Character Presentation

Human character is in the foreground of all fiction, however the humanity might be disguised. Anthropomorphism may be a scientific sin, but it is a literary necessity. Bugs Bunny isn't a rabbit; he's a plucky youth in ears. Peter Rabbit is a mischievous boy. Brer Rabbit is a sassy rebel. The romantic heroes of *Watership Down* are out of the Arthurian tradition, not out of the hutch. And that doesn't cover fictional *rabbits*.

Henri Bergson, in his essay "On Laughter," observes:

... the comic does not exist outside the pale of what is strictly human. A landscape may be beautiful, charming or sublime, or insignificant and ugly; it will never be laughable.

Bergson is right, but it is just as true that only the human is tragic. We may describe a landscape as "tragic" because nature has been devastated by industry, but the tragedy lies in the cupidity of those who wrought the havoc, in the dreariness, poverty, or disease of those who must live there. A conservationist or ecologist (or a

novelist) may care passionately about nature and dislike people because they pollute oceans and cut down trees. Then we say he or she "identifies" with nature (a wholly human capacity) or "respects the natural unity" (of which humanity is a part) or wants to keep the earth habitable (for whom?) or "values nature for its own sake" (using standards of value that nature does not share). By all available evidence, the universe is indifferent to the destruction of trees, property, peoples, and planets. Only people care.

If this is so, then your fiction can be only as successful as the characters who move it and move within it. Whether they are drawn from life or are pure fantasy—and all fictional characters lie somewhere between the two—we must find them interesting, we must find them believable, and we must care about what happens to them.

As a writer you may have the lucky, facile sort of imagination to which characters spring full-blown, complete with gestures, histories, and passions. Or it may be that you need to explore in order to exploit, to draw your characters out gradually and coax them into being. That can be lucky, too.

For either kind of writer, but especially the latter, the journal is an invaluable help. A journal lets you coax and explore without committing yourself to anything or anyone. It allows you to know everything about your character whether you use it or not. Before you put a character in a story, know how well that character sleeps. Know what the character eats for lunch and how much it matters, what he buys and how the bills get paid, how she spends what we call working hours. Know how your character would prefer to spend evenings and weekends and why such plans get thwarted. Know what memories the character has of pets and parents, cities, snow, or school. You may end up using none of this information in the brief segment of your character's life that is your plot, but knowing it may teach you how your bookperson taps a pencil or twists a lock of hair, and when and why. When you know these things, you will have taken a step past invention toward the moment of imagination in which you become your character, live in his or her skin, and produce an action that, for the reader, rings universally true.

Use the journal to note your observations of people. Try clustering your impressions of the library assistant who annoys you or the loner at the bar who intrigues you. Try to capture a gesture or the messages that physical features and clothing send. Invent a reason for that harshness or that loneliness; invent a past. Then try taking the character out of context and setting her or him in another. Get your character in trouble, and you may be on your way to a short story.

It is interesting and relevant that actors schooled in what is called the Stanislavski Method write biographies of the characters they must play. Adherents of "The Method" believe that in the process of inventing a dramatic character's past, the actor will find points of emotional contact with that role and so know how to make the motives and actions prescribed by the script natural and genuine. As a writer you can also use "The Method," imagining much that you will not bring specifically to "the script" but that will enrich your sense of that character until you know with absolute certainty how he or she will move, act, react, and speak.

In any case, the key to rich characterization is the same as that outlined in the

preceding chapter, an attention to detail that is significant. Though critics often praise literature for exhibiting characteristics of the *individual*, the *typical*, and the *universal* all at the same time, I don't think this is of much use to the practicing writer. For though you may labor to create an individual character, and you may make that character a credible example of type, I don't think you can *set out to be* "universal."

It is true, I believe, that if literature has any social justification or use it is that readers can identify the common humanity in, and can therefore identify with, characters vastly different from themselves in century, geography, gender, culture, and beliefs; and that this enhances the scope of the reader's sympathy. It is also true that if the fiction does not have this universal quality—if a middle-class American male author creates as protagonist a middle-class American male with whom only middle-class American male readers can sympathize—then the fiction is thin and small. William Sloane voices the "frightening" demand of the reader in his book *The Craft of Writing:* "Tell me about me. I want to be more alive. Give me me." But unfortunately, the capacity for universality, like talent, is a trick of the genes or a miracle of the soul, and if you aim for the universal, you're likely to achieve the pompous, whereas if you aim for the individual, you're likely to achieve the typical, and the universal can't be forced.

Imagine this scene: The child chases a ball into the street. The tires screech, the bumper thuds, the blood geysers into the air, the pulp of the small body lies inert on the asphalt. How would a bystander react? (Is it universal?) How would a passing doctor react? (Is it typical?) How would Dr. Henry Lowes, just coming from the maternity ward of his own hospital, where his wife has had her fourth miscarriage, react? (Is it individual?) Each question narrows the range of convincing reaction, and as a writer you want to convince in each range. If you succeed in the third, you are likely to have succeeded in the other two.

My advice then is to labor in the range of the particular. If you aim for a universal character you may end up with a vague or dull or windy one. On the other hand, if you set out to write a typical character you're likely to produce a caricature, because people are typical only in the generalized qualities that lump them together. *Typical* is the most provincial adjective in a writer's vocabulary, signaling that you're writing only for those who share your assumptions. A "typical" schoolgirl in Dar es Salaam is a very different type from one in San Francisco. Furthermore, every person is typical of many things successively or simultaneously. She may be in turn a "typical" schoolgirl, bride, divorcée, and feminist. He may be at one and the same time a "typical" New Yorker, math professor, doting father, and adulterer. It is in the confrontation and convolution of types that much of our individuality is produced.

Writing in generalities and typicalities is akin to bigotry—we only see what's alike about people, not what's unique. When effective, a description of type blames the character for the failure to individualize, and if an author sets out deliberately to produce types rather than individuals, then that author invariably wants to condemn or ridicule those types. Joyce Carol Oates illustrates the technique in "How I Contemplated the World from the Detroit House of Correction and Began My Life Over Again":

George, Clyde G. 240 Sioux. A manufacturer's representative; children, a dog, a wife. Georgian with the usual columns. You think of the White House, then of Thomas Jefferson, then your mind goes blank on the white pillars and you think of nothing.

Mark Helprin, in "The Schreuderspitze," takes the ridicule of type to comic extreme:

In Munich are many men who look like weasels. Whether by genetic accident, meticulous crossbreeding, an early and puzzling migration, coincidence, or a reason that we do not know, they exist in great numbers. Remarkably, they accentuate this unfortunate tendency by wearing mustaches, Alpine hats, and tweed. A man who resembles a rodent should never wear tweed.

This is not to say that all characters must be fully drawn or "round." Flat characters—who exist only to exhibit a function or a single characteristic—are useful and necessary. Eric Bentley suggests in The Life of the Drama that if a messenger's function in a play is to deliver his message, it would be very tedious to stop and learn about his psychology. The same is true in fiction; the Queen's chauffeur in the passage from Mrs. Dalloway (see chapter 3) exists for no purpose but leaning "ever so slightly," and we do not want to hear about his children or his hernia. Nevertheless, onstage even a flat character has a face and a costume, and in fiction detail can give even a flat character a few angles and contours. The servant classes in the novels of Henry James are notoriously absent as individuals because they exist only in their functions (that excellent creature had already assembled the baggage, etc.), whereas Charles Dickens, who peoples his novels with dozens of flat characters, brings even these alive in detail.

And Mrs. Miff, the wheezy little pew opener—a mighty dry old lady, sparely dressed, with not an inch of fullness anywhere about her—is also here.

Dombey and Son

To borrow a notion from George Orwell's Animal Farm, all good characters are created round, but some are created rounder than others.

Credibility

Though you aim at individuality and not typicality in characters, your characters will exhibit typicality in the sense of "appropriateness." A Baptist Texan behaves differently from an Italian nun; a rural schoolboy behaves differently from a professor emeritus at Harvard. If you are to succeed in creating an individual character, particular and alive, you will also inevitably know what is appropriate to that sort of person and will let us know as much as we need to know to feel the appropriateness of the behavior.

We need to know soon, for instance, preferably in the first paragraph, the character's gender, age, and race or nationality. We need to know something of his or her class, period, and region. A profession (or the clear lack of it) and a marital status help, too. Almost any reader can identify with almost any character; what no reader can identify with is confusion. When some or several of the fundamentals of type are withheld from us-when we don't know whether we're dealing with a man or a woman, an adult or a child—the process of identifying cannot begin, and the story is slow to move us.

None of the information need come as information; it can be implied by appearance, tone, action, or detail. In the next example William Melvin Kelley pitches his protagonist straight into the conflict. Only the character's gender is given us directly. but by the end of the story's opening paragraph, we know a lot about his life and type.

To find this Cooley, the Black baby's father, he knew he would have to contact Opal Simmons. After dressing, he began to search for her address and number. Tam, very organized for a woman, saved everything. Among the envelopes containing the sports-clothes receipts, a letter from her dressmaker asking for payment, old airline tickets, the nursery school bill, the canceled checks and deposit slips, he finally found Opal's address.

"Passing"

We know from the apparently "irrelevant" collection of bills that the protagonist is middle-class, married, a father, affluent, and perhaps (that letter from the dressmaker) living at the edge of his income. Because he specifies a "Black baby," we know that he is white. We also know something about his attitudes toward both blacks ("this Cooley") and women ("very organized for a woman"). With an absolute minimum of exposition, letting us share the search for the address, Kelley has drawn clear boundaries of what we may expect from a character whose name we don't yet know.

The following passage is an even more striking example of indirect information.

Every time the same story. Your Barbie is roommates with my Barbie, and my Barbie's boyfriend comes over and your Barbie steals him, okay? Kiss kiss kiss. Then the two Barbies fight. You dumbbell! He's mine. Oh no he's not, you stinky! Only Ken's invisible, right? Because we don't have money for a stupidlooking boy doll when we'd both rather ask for a new Barbie outfit next Christmas. We have to make do with your mean-eyed Barbie and my bubblehead Barbie and our one outfit apiece not including the sock dress.

Sandra Cisneros, "Barbie-Q"

Here there is no description whatever of the characters, and no direct reference to them except for the designations you and I. What do we nevertheless know about their gender, their age, their financial status, the period in which they live, their personalities, their attitudes, their relationship, the narrator's emotions?

Students of writing are sometimes daunted by the need to give so much information immediately. The thing to remember is that credibility consists in the combination of appropriateness and specificity. The trick is to find telling details that will convey the information indirectly while our attention remains on the desire or emotion of the character. Nobody wants to read a story that begins:

She was a twenty-eight-year-old suburban American woman, relatively affluent, who was extremely distressed when her husband Peter left her.

But most of that, and much more besides, could be contained in a few details.

After Peter left with the VCR, the microwave, and the key to the garage, she went down to the kitchen and ate three jars of peanut butter without tasting a single spoonful.

I don't mean to imply that it is necessarily easy to signal the essentials of type immediately. It would be truer to say that it is necessary and hard. The opening paragraph of a story is its second strongest statement (the final paragraph is the strongest) and sets the tone for all that follows. If the right words don't come to you as a gift, you may have to sit sifting and discarding the inadequate ones for a long time before you achieve both clarity and interest.

Purpose

Your character's purpose—that is, the desire that impels her or him to action—will determine our degree of identification and sympathy on the one hand, or judgment on the other.

Aristotle, in The Poetics, says that "there will be an element of character if what a person says or does reveals a certain moral purpose; and a good element of character, if the purpose so revealed is good." It might seem that the antiheroes, brutes, hoods, whores, perverts, and bums who people modern literature do very little in the way of revealing good moral purpose. The history of Western literature shows a movement downward and inward: downward through society from royalty to gentry to the middle classes to the lower classes to the dropouts; inward from heroic action to social drama to individual consciousness to the subconscious to the unconscious. What has remained consistent is that, for the time spent in an author's world, we understand and identify with the protagonist or protagonists, we "see their point of view"; and the fiction succeeds largely because we are willing to grant them a goodness that we would not grant them in life. Aristotle goes on to explain that "such goodness is possible in every type of personage, even in a woman or a slave, though the one is perhaps an inferior, and the other a wholly worthless being"—and the sentence strikes us as both offensive and funny. But in Aristotle's society, women and slaves were legally designated inferior and worthless, and what Aristotle is saying is precisely what Ken Kesey acknowledges when he picks the inmates of an "Institute of Psychology" as his heroes: that the external status granted by society is not an accurate measure of good moral purpose.

This new redheaded admission, McMurphy, knows right away he's not a Chronic . . . The Acutes look spooked and uneasy when he laughs, the way kids look in a schoolroom when one ornery kid is raising too much hell . . .

... "Which one of you claims to be the craziest? Which one is the biggest looney? Who runs these card games? It's my first day, and what I like to do is make a good impression straight off on the right man if he can prove to me he is the right man. Who's the bull goose looney here?"

One Flew over the Cuckoo's Nest

If you met McMurphy in real life, you'd probably say he was crazy and you'd hope he would be locked up. If you encountered the Neanderthals of William Golding's The Inheritors on your evening walk, you'd run. If you were forced to live with the visionaries of Doris Lessing's Four-Gated City or the prisoners of Jean Genet's Our Lady of the Flowers, you would live in skepticism and fear. But while you read you expand your mental scope by identifying with, temporarily "becoming," a character who convinces you that the inmates of the asylum are saner than the staff, that the apemen are more human than Homo sapiens, that mental breakdown is mental breakthrough, that perversion is purer than the sexual code by which you live. For the drama audiences of fourth-century B.C. Athens, it was easier to see human nobility embodied in the heroic external actions of those designated by class as noble. It is largely because literature has moved inward, within the mind, that it is possible to move downward in social status—even to women and slaves!—and maintain this sympathy. In our own minds each of us is fundamentally justified, however conscious we are of our flaws-indeed, the more conscious of our flaws, the more commendable we are. As readers we are allowed to borrow a different mind. Fiction, as critic Laurence Gonzales said of rock music, "lets you wander around in someone else's hell for a while and see how similar it is to your own."

Obviously we don't identify with all characters, and those whose purpose is revealed as ambiguous or evil will invite varying degrees of judgment. When on page 86 of the story "Where Are You Going, Where Have You Been?" Arnold Friend is described as "stiffly relaxed," with a "slippery friendly smile" and a series of familiar styles that "did not come together," we are immediately skeptical of him; because we suspect his purpose toward Connie, we pass judgment on his fundamental character.

Complexity

If the characters of your story are credible through being appropriate and individual, and if they invite identification or judgment through a sense of their purpose, they also need to be complex. They need to exhibit enough conflict and contradic-

tion that we can recognize them as belonging to the contradictory human race; and they should exhibit a range of possibility so that a shift of power in the plot can also produce a shift of purpose or morality. That is, they need to be capable of change.

Conflict is at the core of character as it is of plot. If plot begins with trouble, then character begins with a person in trouble; and trouble most dramatically occurs because we all have traits, tendencies, and desires that are at war, not simply with the world and other people, but with other of our own traits, tendencies, and desires. All of us probably know a woman of the strong, striding, independent sort, attractive only to men who like a strong and striding woman. And when she falls in love? She becomes a clinging sentimentalist. All of us know a father who is generous, patient, and dependable. And when the children cross the line? He smashes crockery and wields a strap. All of us are gentle, violent; logical, schmaltzy; tough, squeamish; lusty, prudish; sloppy, meticulous; energetic, apathetic; manic, depressive. Perhaps you don't fit that particular list of contradictions, but you are sufficiently in conflict with yourself that as an author you have characters enough in your own psyche to people the work of a lifetime if you will identify, heighten, and dramatize these conflicts within character, which Aristotle called "consistent inconsistencies."

If you think of the great characters of literature, you can see how consistent inconsistency brings each to a crucial dilemma. Hamlet is a strong and decisive man who procrastinates. Dorothea Brooke of *Middlemarch* is an idealistic and intellectual young woman, a total fool in matters of the heart. Ernest Hemingway's Francis Macomber wants to test his manhood against a lion and cannot face the test. Here, in a moment of crisis from *Mom Kills Self and Kids*, Alan Saperstein reveals with great economy the consistent inconsistency of his protagonist, a man who hadn't much time for his family until their absence makes clear how dependent he has been on them.

When I arrived home from work I found my wife had killed our two sons and taken her own life.

I uncovered a blast of foul, black steam from the pot on the stove and said, "Hi, hon, what's for dinner?" But she did not laugh. She did not bounce to her feet and pirouette into the kitchen to greet me. My little one didn't race into my legs and ask what I brought him. The seven-year-old didn't automatically beg me to play a game knowing my answer would be a tired, "Maybe later."

In "The Self as Source," Cheryl Moskowitz proposes a fiction technique that relies specifically on identifying conflicting parts of the writer's personality. She points to Robert Lewis Stevenson's *The Strange Case of Dr. Jekyll and Mr. Hyde* as a fairly blatant model for such fiction, and quotes from Dr. Jekyll:

... I thus drew steadily nearer to that truth ... that man is not truly one, but two. I say two, because the state of my own knowledge does not pass beyond that point. ... I hazard the guess that man will ultimately be known for a mere polity of multifarious, incongruous and independent denizens.

Moskowitz suggests "character imaging," making lists of the qualities, images, and actions that describe such incongruities in the writer's personality. Here is a sample list from a student exercise:

Elegant

silk scarf to the knees still frowns at library noise startled gazelle unexploded hand grenade Waterford crystal a single white rosebud walks alone into the woods

Vulgar

sequins on a fringed cowhide vest laughing hands out candy slobbering puppy pink and orange sunset souvenir plate made in Mexico two dozen overblown red roses throws a costume party

At this point the contradictions could be signed into characters by giving them names. Then, where might they meet? In what situation might they find themselves? How would a confrontation between these two play out?

It is, of course, impossible to know to what degree Shakespeare, Eliot, Hemingway, or Saperstein used consistent inconsistencies of which they were aware in themselves to build and dramatize their characters. An author works not only from his or her own personality but also from observation and imagination, and I fully believe that you are working at full stretch only when all three are involved. The question of autobiography is a complicated one, and as writer you frequently won't know yourself how much you have experienced, how much you have observed, and how much you have invented. Actress Mildred Dunnock once observed that drama is possible "because people can feel what they haven't experienced"; if this is true of audiences and readers, I see no reason the capacity should be denied to writers. A vast proportion of our experience is mental, and it is safe to say that all your writing is autobiographical in the sense that it must have passed through your mind.

The Indirect Method of Character Presentation

AUTHORIAL INTERPRETATION

In the writing itself, there are five basic methods of character presentation, of which the indirect method, authorial interpretation, and two of the four direct methods, appearance and action, will be discussed in this chapter. Two further direct methods, speech and thought, will be discussed in chapter 5. Employing a variety of these methods can help you draw a full character. If you produce a conflict among the methods, it can also help you create a three-dimensional character.

The indirect method of presenting a character is authorial interpretation—"telling" us the character's background, motives, values, virtues, and the like. The advantages of the indirect method are enormous, for its use leaves you free to move in time and space; to know anything you choose to know whether the character

knows it or not; and, godlike, to tell us what we are to feel. The indirect method allows you to convey a great deal of information in a short time.

The most excellent Marquis of Lumbria lived with his two daughters, Caroline, the elder, and Luisa; and his second wife, Doa Vicenta, a woman with a dull brain, who, when she was not sleeping, was complaining of everything, especially the noise . . .

The Marquis of Lumbria had no male children, and this was the most painful thorn in his existence. Shortly after having become a widower, he had married Doa Vicenta, his present wife, in order to have a son, but she proved sterile.

The Marquis' life was as monotonous and as quotidian, as unchanging and regular, as the murmur of the river below the cliff or as the liturgic services in the cathedral.

Miguel De Unamuno, The Marquis of Lumbria

The disadvantages of this indirect method are outlined in chapter 3. Indeed, in the passage above, it may well be part of Unamuno's purpose to convey the "monotonous and quotidian" quality of the Marquis's life by this summarized and distanced rehearsal of facts, motives, and judgments. Nearly every author will use the indirect method occasionally, and you may find it useful when you want to cover the exposition quickly. Occasionally you may convince us that you are so much more knowledgeable about a character than we can be, and so much more subtle at analyzing him or her, that we will accept your explanations. Very occasionally an author will get away with explaining the characters as much as, or more than, they are directly presented. Henry James is such an author; he is not an author I would advise anyone to imitate.

Mrs. Touchett was certainly a person of many oddities, of which her behavior on returning to her husband's house after many months was a noticeable specimen. She had her own way of doing all that she did, and this is the simplest description of a character which, although it was by no means without benevolence, rarely succeeded in giving an impression of softness. Mrs. Touchett might do a great deal of good, but she never pleased.

Portrait of a Lady

The very clear presence of the author in this passage, commenting, guiding our reactions, is the hallmark of James's prose, and (although it is by no means without benevolence) the technique is a difficult one to sustain. Direct presentation of the characters is much more likely to please the modern reader.

The Direct Methods of Character Presentation

The four methods of direct presentation are appearance, action, speech, and thought. A character may also be presented through the opinions of other characters, which may be considered a second indirect method. When this method is employed, however, the second character must give his or her opinions in speech, action, or thought. In the process, the character is inevitably also characterized. Whether we accept the opinion depends on what we think of that character as he or she is thus directly characterized. In this scene from Jane Austen's Mansfield Park, for example, the busybody Mrs. Norris gives her opinion of the heroine.

"... there is something about Fanny, I have often observed it before,—she likes to go her own way to work; she does not like to be dictated to; she takes her own independent walk whenever she can; she certainly has a little spirit of secrecy, and independence, and nonsense, about her, which I would advise her to get the better of."

As a general reflection on Fanny, Sir Thomas thought nothing could be more unjust, though he had been so lately expressing the same sentiments himself, and he tried to turn the conversation, tried repeatedly before he could succeed.

Here Mrs. Norris's opinion is directly presented in her speech and Sir Thomas's in his thoughts, each of them being characterized in the process. It is left to the reader to decide (without much difficulty) whose view of Fanny is the more reliable.

APPEARANCE

Of the four methods of direct presentation, appearance is especially important because our eyes are our most highly developed means of perception, and we therefore receive more nonsensuous information by sight than by any other sense. Beauty is only skin deep, but people are embodied, and whatever beauty—or ugliness—there is in them must somehow surface in order for us to perceive it. Such surfacing involves speech and action as well as appearance, but it is appearance that prompts our first reaction to people, and everything they wear and own bodies forth some aspect of their inner selves.

Writers are sometimes inclined to neglect or even deny this power of the visible. The choice of writing as a profession or avocation usually contains an implicit rejection of materialism (an English degree won't get you a job; your folks wish you'd major in business; starving in a gloomy basement is a likely option), and writers are concerned to see beyond mere appearances.

In fact, much of the tension and conflict in character does proceed from the truth that appearance is not reality. But in order to know this, we must see the appearance, and it is often in the contradiction between appearance and reality that the truth comes out. Features, shape, style, clothing, and objects can make statements of internal values that are political, religious, social, intellectual, and essential. The man in the Ultrasuede jacket is making a different statement from the one in the

holey sweatshirt. The woman with the cigarctte holder is telling us something different from the one with the palmed joint. Even a person who has forsaken our materialistic society altogether, sworn off supermarkets, and gone to the country to grow organic potatoes has a special relationship with his or her hoe. However indifferent we may be to our looks, that indifference is the result of experiences with our bodies. A twenty-two-year-old Apollo who has been handsome since he was six is a very different person from the man who spent his childhood cocooned in fat and burst the chrysalis at age sixteen.

Following are four very brief portraits of women. Each is mainly characterized by such trivialities as fabric, hairdo, and cosmetics. It would nevertheless be impossible to mistake the essential nature of any one of them for that of any of the others.

Mrs. Withers, the dietician, marched in through the back door, drew up, and scanned the room. She wore her usual Betty Grable hairdo and open-toed pumps, and her shoulders had an aura of shoulder pads even in a sleeveless dress.

Margaret Atwood, The Edible Woman

My grandmother had on not just one skirt, but four, one over the other. It should not be supposed that she wore one skirt and three petticoats; no, she wore four skirts; one supported the next, and she wore the lot of them in accordance with a definite system, that is, the order of the skirts was changed from day to day . . . The one that was closest to her yesterday clearly disclosed its pattern today, or rather its lack of pattern: all my grandmother Anna Bronski's skirts favored the same potato color. It must have been becoming to her.

Günter Grass, The Tin Drum

How beautiful Helen is, how elegant, how timeless: how she charms Esther Songford and how she flirts with Edwin, laying a scarlet fingernail on his dusty lapel, mesmerizing.

She comes in a chauffered car. She is all cream and roses. Her stockings are purest silk; her underskirt, just briefly showing, is lined with lace.

Fay Weldon, Female Friends

As soon as I entered the room, a pungent odor of phosphorus told me she'd taken rat poison. She lay groaning between the quilts. The tatami by the bed was splashed with blood, her waved hair was matted like rope waste, and a bandage tied round her throat showed up unnaturally white . . . The painted mouth in her waxen face created a ghastly effect, as though her lips were a gash open to the ears.

Masuji Ibuse, "Tajinko Village"

Vividness and richness of character are created in these four passages, which use nothing more than appearance to characterize.

ACTION

The significant characters of a fiction must be both capable of causing an action and capable of being changed by it.

It is important to understand the difference between action and movement, terms that are not synonymous. Physical movement is generally necessary to the action, but it is not adequate to ensure that there will be an action. Much movement in a story—the way he crosses his legs, the way she charges down the hall—is actually part of appearance and characterizes without necessarily moving the plot forward. Often movement is part of the setup of the scene, a way of establishing the situation before a change-producing dramatic action begins.

If we accept that a story records a process of change, how is this change brought about? Fundamentally it is effected in two ways: chance and choice. (Myriad authors from Sophocles to Shakespeare to Henrik Ibsen to Flannery O'Connor have included a third possibility, that of destiny, which might be represented as Fate or God or a biological or social necessity. But most fiction suggests "inevitability" as the interplay of chance and choice in character. Fate is, so to speak, voluntary.)

Basically then, human beings face chance and choice, or discovery and decision—the involuntary and the voluntary. A character driven by desire takes an action with an expected result, but something intervenes. Some force outside the self presents itself, in the form of information or accident or the behavior of others or the elements. The unknown becomes known, and then the discoverer must take action or deliberately not take action. Whereas a character's movements may be dramatically static, a character acted upon by something outside herself will almost certainly act or react in a way that involves us in the tension of the narrative query: and then what happens?

Here is a passage from Toni Morrison's "Recitatif" that demonstrates first movement, then discovery, then decision:

It was August and a bus crowd was just unloading. They would stand around a long while: going to the john, and looking at gifts and junk-for-sale machines, reluctant to sit down so soon. Even to eat. I was trying to fill the coffeepots and get them all situated on the electric burners when I saw her. She was sitting in a booth smoking a cigarette with two guys smothered in head and facial hair. Her own hair was so big and wild I could hardly see her face. But the eyes. I would know them anywhere. She had on a powder-blue halter and shorts outfit and earrings the size of bracelets. Talk about lipstick and eyebrow pencil. She made the big girls look like nuns. I couldn't get off the counter until seven o'clock, but I kept watching the booth in case they got up to leave before that. My replacement was on time for a change, so I counted and stacked my receipts as fast as I could and signed off. I walked over to the booth . . .

Here, unloading, milling around, and filling coffeepots is movement that represents scene-setting and characterization. The significant action begins with the discovery, "I saw her." Notice that "she" is characterized directly by appearance whereas the narrator is mainly characterized by her movements (expressed in active verbs)—watching, counting, stacking, signing off—until the moment when she acts on her decision. At the points of both the discovery and the decision we anticipate the possibility of change: what happens next?

In the next passage the movement is even blander before the moment that involves us in suspense:

I turned on a light in the living room and looked at Rachel's books. I chose one by an author named Lin Yutang and sat down on a sofa under a lamp. Our living room is comfortable. The book seemed interesting. I was in a neighborhood where most of the front doors were unlocked, and on a street that is very quiet on a summer night. All the animals are domesticated, and the only night birds that I've ever heard are some owls way down by the railroad track. So it was very quiet. I heard the Barstows' dog bark, briefly, as if he had been waked by a nightmare, and then the barking stopped. Everything was quiet again. Then I heard, very close to me, a footstep and a cough.

I felt my flesh get hard—you know that feeling—but I didn't look up from my book, although I felt that I was being watched.

John Cheever, "The Cure"

This scene is set with movement and one choice—that book—that offers no particular opportunity for change and no particular dramatic force. With the moment "Then I heard," however, a discovery or realization of a different sort occurs, and there is suddenly the possibility of real change and so, suddenly, real dramatic tension. Notice that in the last paragraph the narrator discovers a familiar and entirely involuntary reaction—"I felt my flesh get hard"—followed by the decision not to take what would be the instinctive action. In fiction as in life, restraint, the decision to do nothing, is fraught with potential tension.

Here is a third passage, where the character's insistence that there is no discovery to be made—the disease is no mystery, she knows how a virus works—throws into dramatic relief her discovery that her perception has changed.

I wonder if it is possible to prepare yourself for anything. Of course I lay there, saying, This is the flu, it isn't supposed to last more than two or three days, I should find the Tylenol. In the moment I didn't feel bad, really, a little queasy, a degree feverish. The disease wasn't a mystery to me. I know what a virus looks like, how it works. I could imagine the invasion and the resistance. In fact, imagining the invasion and the resistance took my attention off the queasiness and the feverishness. But when I opened my eyes and my gaze fell upon the bookcases looming above me in the half-light, I shuddered reflexively, because the books seemed to swell outward from the wall and threaten to drop on me,

and my thoughts about the next few days had exactly that quality as well. I did not see how we would endure, how I would endure.

Jane Smiley, "The Age of Grief"

You don't want your technique to show, and once you're sure of your structure, you need to bury it. In the next example, from Raymond Carver's "Neighbors," the pattern of change—Bill Miller's gradual intrusion into his neighbor's house—is based on a series of decisions that Carver does not explicitly state. The passage ends with a turning point, a moment of discovery.

When he returned to the kitchen the cat was scratching in her box. She looked at him steadily for a minute before she turned back to the litter. He opened all the cupboards and examined the canned goods, the cereals, the packaged foods, the cocktail and wine glasses, the china, the pots and pans. He opened the refrigerator. He sniffed some celery, took two bites of cheddar cheese, and chewed on an apple as he walked into the bedroom. The bed seemed enormous, with a fluffy white bedspread draped to the floor. He pulled out a nightstand drawer, found a half-empty package of cigarettes and stuffed them into his pocket. Then he stepped to the closet and was opening it when the knock sounded at the front door.

There is hardly grand larceny being committed here, but the actions build toward tension through two distinct techniques. The first is that they do actually "build": At first Bill only "examines." The celery he only sniffs, whereas he takes two bites of the cheese, then a whole apple, then half a pack of cigarettes. He moves from the kitchen to the bedroom, which is a clearer invasion of privacy, and from cupboard to refrigerator to nightstand to closet, each a more intimate intrusion than the last.

The second technique is that the narrative subtly hints at Bill's own sense of stealth. It would be easy to imagine a vandal who performed the same actions with complete indifference. But Bill thinks the cat looks "steadily" at him, which is hardly of any importance except that he feels it to be. His awareness of the enormous white bed hints at sexual guilt. When the knock at the front door sounds, we start, as he must, in a clear sense of getting caught.

Thus it turns out that the internal or mental moment of change is where the action lies. Much movement in a story is mere event, and this is why descriptions of actions, like stage directions in a dull play, sometimes add little or nothing. When the wife picks up a cup of coffee, that is mere event. If she finds that the lipstick on the cup is not her shade, that is a dramatic event, a discovery; it makes a difference. She makes a decision to fling it at the woman with the Cherry Ice mouth. Flinging it is an action, but the dramatic change occurs with the second character's realization (discovery) that she has been hit—and so on.

Every story is a pattern of change (events connected, as Forster observed, primar-

ily by cause and effect) in which small and large changes are made through decision and discovery.

The Enormous Radio

IOHN CHEEVER

Jim and Irene Westcott were the kind of people who seem to strike that satisfactory average of income, endeavor, and respectability that is reached by the statistical reports in college alumni bulletins. They were the parents of two young children, they had been married nine years, they lived on the twelfth floor of an apartment house near Sutton Place, they went to the theatre on an average of 10.3 times a year, and they hoped someday to live in Westchester. Irene Westcott was a pleasant, rather plain girl with soft brown hair and a wide, fine forehead upon which nothing at all had been written, and in the cold weather she wore a coat of fitch skins dyed to resemble mink. You could not say that Jim Westcott looked younger than he was, but you could at least say of him that he seemed to feel younger. He wore his graying hair cut very short, he dressed in the kind of clothes his class had worn at Andover, and his manner was earnest, vehement, and intentionally naïve. The Westcotts differed from their friends, their classmates, and their neighbors only in an interest they shared in serious music. They went to a great many concerts—although they seldom mentioned this to anyone—and they spent a good deal of time listening to music on the radio.

Their radio was an old instrument, sensitive, unpredictable, and beyond repair. Neither of them understood the mechanics of radio—or of any of the other appliances that surrounded them—and when the instrument faltered, Jim would strike the side of the cabinet with his hand. This sometimes helped. One Sunday afternoon, in the middle of a Schubert quartet, the music faded away altogether. Jim struck the cabinet repeatedly, but there was no response; the Schubert was lost to them forever. He promised to buy Irene a new radio, and on Monday when he came home from work he told her that he had got one. He refused to describe it, and said it would be a surprise for her when it came.

The radio was delivered at the kitchen door the following afternoon, and with the assistance of her maid and the handyman Irene uncrated it and brought it into the living room. She was struck at once with the physical ugliness of the large gumwood cabinet. Irene was proud of her living room, she had chosen its furnishings and colors as carefully as she chose her clothes, and now it seemed to her that the new radio stood among her intimate possessions like an aggressive intruder. She was confounded by the number of dials and switches on the instrument panel, and she studied them thoroughly before she put the plug into a wall socket and turned the radio on. The dials flooded with a malevolent green light, and in the distance she heard the music of a piano quintet. The quintet was in the distance for only an instant; it

bore down upon her with a speed greater than light and filled the apartment with the noise of music amplified so mightily that it knocked a china ornament from a table to the floor. She rushed to the instrument and reduced the volume. The violent forces that were snared in the ugly gumwood cabinet made her uneasy. Her children came home from school then, and she took them to the Park. It was not until later in the afternoon that she was able to return to the radio.

The maid had given the children their suppers and was supervising their baths when Irene turned on the radio, reduced the volume, and sat down to listen to a Mozart quintet that she knew and enjoyed. The music came through clearly. The new instrument had a much purer tone, she thought, than the old one. She decided that tone was most important and that she could conceal the cabinet behind a sofa. But as soon as she had made her peace with the radio, the interference began. A crackling sound like the noise of a burning powder fuse began to accompany the singing of the strings. Beyond the music, there was a rustling that reminded Irene unpleasantly of the sea, and as the quintet progressed, these noises were joined by many others. She tried all the dials and switches but nothing dimmed the interference, and she sat down, disappointed but bewildered, and tried to trace the flight of the melody. The elevator shaft in her building ran beside the living-room wall, and it was the noise of the elevator that gave her a clue to the character of the static. The rattling of the elevator cables and the opening and closing of the elevator doors were reproduced in her loudspeaker, and, realizing that the radio was sensitive to electrical currents of all sorts, she began to discern through the Mozart the ringing of telephone bells, the dialing of phones, and the lamentation of a vacuum cleaner. By listening more carefully, she was able to distinguish doorbells, elevator bells, electric razors, and Waring mixers, whose sounds had been picked up from the apartments that surrounded hers and transmitted through her loudspeaker. The powerful and ugly instrument, with its mistaken sensitivity to discord, was more than she could hope to master, so she turned the thing off and went into the nursery to see her children.

When Jim Westcott came home that night, he went to the radio confidently and worked the controls. He had the same sort of experience Irene had had. A man was speaking on the station Jim had chosen, and his voice swung instantly from the distance into a force so powerful that it shook the apartment. Jim turned the volume control and reduced the voice. Then, a minute or two later, the interference began. The ringing of telephones and doorbells set in, joined by the rasp of the elevator doors and the whir of cooking appliances. The character of the noise had changed since Irene had tried the radio earlier; the last of the electric razors was being unplugged, the vacuum cleaners had all been returned to their closets, and the static reflected that change in pace that overtakes the city after the sun goes down. He fiddled with the knobs but couldn't get rid of the noises, so he turned the radio off and told Irene that in the morning he'd call the people who had sold it to him and give them hell.

The following afternoon, when Irene returned to the apartment from a luncheon date, the maid told her that a man had come and fixed the radio. Irene went into the living room before she took off her hat or her furs and tried the instrument. From the

loudspeaker came a recording of the "Missouri Waltz." It reminded her of the thin, scratchy music from an old-fashioned phonograph that she sometimes heard across the lake where she spent her summers. She waited until the waltz had finished, expecting an explanation of the recording, but there was none. The music was followed by silence, and then the plaintive and scratchy record was repeated. She turned the dial and got a satisfactory burst of Caucasian music—the thump of bare feet in the dust and the rattle of coin jewelry—but in the background she could hear the ringing of bells and a confusion of voices. Her children came home from school then, and she turned off the radio and went to the nursery.

When Jim came home that night, he was tired, and he took a bath and changed his clothes. Then he joined Irene in the living room. He had just turned on the radio when the maid announced dinner, so he left it on, and he and Irene went to

the table.

Jim was too tired to make even a pretense of sociability, and there was nothing about the dinner to hold Irene's interest, so her attention wandered from the food to the deposits of silver polish on the candlesticks and from there to the music in the other room. She listened for a few minutes to a Chopin prelude and then was surprised to hear a man's voice break in. "For Christ's sake, Kathy," he said, "do you always have to play the piano when I get home?" The music stopped abruptly. "It's the only chance I have," a woman said. "I'm at the office all day." "So am I," the man said. He added something and melancholy music began again.

"Did you hear that?" Irene asked.

"What?" Jim was eating his dessert.

"The radio. A man said something while the music was still going on—something dirty."

"It's probably a play."

"I don't think it is a play," Irene said.

They left the table and took their coffee into the living room. Irene asked Jim to try another station. He turned the knob. "Have you seen my garters?" a man asked. "Button me up," a woman said. "Have you seen my garters?" the man said again. "Just button me up and I'll find your garters," the woman said. Jim shifted to another station. "I wish you wouldn't leave apple cores in the ashtrays," a man said. "I hate the smell."

"This is strange," Jim said.

"Isn't it?" Irene said.

Jim turned the knob again. "'On the coast of Coromandel where the early pumpkins blow," a woman with a pronounced English accent said, "'in the middle of the woods lived the Yonghy-Bonghy-Bo. Two old chairs, and half a candle, one old jug without a handle . . . "

"My God!" Irene cried. "That's the Sweeneys' nurse."

"'These were all his worldly goods,'" the British voice continued.

"Turn that thing off," Irene said. "Maybe they can hear us." Jim switched the radio off. "That was Miss Armstrong, the Sweeneys' nurse," Irene said. "She must be reading to the little girl. They live in 17-B. I've talked with Miss Armstrong in the Park. I know her voice very well. We must be getting other people's apartments."

"That's impossible," Jim said.

"Well, that was the Sweeneys' nurse," Irene said hotly. "I know her voice. I know it very well. I'm wondering if they can hear us."

Jim turned the switch. First from a distance and then nearer, nearer, as if borne on the wind, came the pure accents of the Sweeneys' nurse again: "'Lady Jingly! Lady Jingly!'" she said, "'sitting where the pumpkins blow, will you come and be my wife? said the Yonghy-Bonghy-Bo..."

Jim went over to the radio and said "Hello" loudly into the speaker.

"I am tired of living singly," the nurse went on, "on this coast so wild and shingly, I'm a-weary of my life; if you'll come and be my wife, quite serene would be my life . . .'"
"I guess she can't hear us," Irene said. "Try something else."

Jim turned to another station, and the living room was filled with the uproar of a cocktail party that had overshot its mark. Someone was playing the piano and singing the "Whiffenpoof Song," and the voices that surrounded the piano were vehement and happy. "Eat some more sandwiches," a woman shrieked. There were screams of laughter and a dish of some sort crashed to the floor.

"Those must be the Fullers, in 11-E," Irene said. "I knew they were giving a party this afternoon. I saw her in the liquor store. Isn't this too divine? Try something else. See if you can get those people in 18-C."

The Westcotts overheard that evening a monologue on salmon fishing in Canada, a bridge game, running comments on home movies of what had apparently been a fortnight at Sea Island, and a bitter family quarrel about an overdraft at the bank. They turned off their radio at midnight and went to bed, weak with laughter. Sometime in the night, their son began to call for a glass of water and Irene got one and took it to his room. It was very early. All the lights in the neighborhood were extinguished, and from the boy's window she could see the empty street. She went into the living room and tried the radio. There was some faint coughing, a moan, and then a man spoke. "Are you all right, darling?" he asked. "Yes," a woman said wearily. "Yes, I'm all right, I guess," and then she added with great feeling, "But, you know, Charlie, I don't feel like myself any more. Sometimes there are about fifteen or twenty minutes in the week when I feel like myself. I don't like to go to another doctor, because the doctor's bills are so awful already, but I just don't feel like myself." They were not young, Irene thought. She guessed from the timbre of their voices that they were middle-aged. The restrained melancholy of the dialogue and the draft from the bedroom window made her shiver, and she went back to bed.

The following morning, Irene cooked breakfast for the family—the maid didn't come up from her room in the basement until ten—braided her daughter's hair, and waited at the door until her children and her husband had been carried away in the elevator. Then she went into the living room and tried the radio. "I don't want to go to school," a child screamed. "I hate school, I won't go to school. I hate school." "You will go to school," an enraged woman said. "We paid eight hundred dollars to get you into that school and you'll go if it kills you." The next number on the dial produced the worn record of the "Missouri Waltz." Irene shifted the control and invaded the privacy of several breakfast tables. She overheard demonstrations of indi-

gestion, carnal love, abysmal vanity, faith, and despair. Irene's life was nearly as simple and sheltered as it appeared to be, and the forthright and sometimes brutal language that came from the loudspeaker that morning astonished and troubled her. She continued to listen until her maid came in. Then she turned off the radio quickly, since this insight, she realized, was a furtive one.

Irene had a luncheon date with a friend that day, and she left her apartment at a little after twelve. There were a number of women in the elevator when it stopped at her floor. She stared at their handsome and impassive faces, their furs, and the cloth flowers in their hats. Which one of them had been to Sea Island? she wondered. Which one had overdrawn her bank account? The elevator stopped at the tenth floor and a woman with a pair of Skye terriers joined them. Her hair was rigged high on her head and she wore a mink cape. She was humming the "Missouri Waltz."

Irene had two Martinis at lunch, and she looked searchingly at her friend and wondered what her secrets were. They had intended to go shopping after lunch, but Irene excused herself and went home. She told the maid that she was not to be disturbed; then she went into the living room, closed the doors, and switched on the radio. She heard, in the course of the afternoon, the halting conversation of a woman entertaining her aunt, the hysterical conclusion of a luncheon party, and a hostess briefing her maid about some cocktail guests. "Don't give the best Scotch to anyone who hasn't white hair," the hostess said. "See if you can get rid of that liver paste before you pass those hot things, and could you lend me five dollars? I want to tip the elevator man."

As the afternoon waned, the conversations increased in intensity. From where Irene sat, she could see the open sky above the East River. There were hundreds of clouds in the sky, as though the south wind had broken the winter into pieces and were blowing it north, and on her radio she could hear the arrival of cocktail guests and the return of children and businessmen from their schools and offices. "I found a good-sized diamond on the bathroom floor this morning," a woman said. "It must have fallen out of that bracelet Mrs. Dunston was wearing last night." "We'll sell it," a man said. "Take it down to the jeweler on Madison Avenue and sell it. Mrs. Dunston won't know the difference, and we could use a couple of hundred bucks ..." "'Oranges and lemons, say the bells of St. Clement's," the Sweeneys' nurse sang. "'Halfpence and farthings, say the bells of St. Martin's. When will you pay me? say the bells at old Bailey . . . "" "It's not a hat," a woman cried, and at her back roared a cocktail party. "It's not a hat, it's a love affair. That's what Walter Florell said. He said it's not a hat, it's a love affair," and then, in a lower voice, the same woman added, "Talk to somebody, for Christ's sake, honey, talk to somebody. If she catches you standing here not talking to anybody, she'll take us off her invitation list, and I love these parties."

The Westcotts were going out for dinner that night, and when Jim came home, Irene was dressing. She seemed sad and vague, and he brought her a drink. They were dining with friends in the neighborhood, and they walked to where they were going. The sky was broad and filled with light. It was one of those splendid spring evenings that excite memory and desire, and the air that touched their hands and faces felt very soft. A Salvation Army band was on the corner playing "Jesus Is

Sweeter." Irene drew on her husband's arm and held him there for a minute, to hear the music. "They're really such nice people, aren't they?" she said. "They have such nice faces. Actually, they're so much nicer than a lot of the people we know." She took a bill from her purse and walked over and dropped it into the tambourine. There was in her face, when she returned to her husband, a look of radiant melancholy that he was not familiar with. And her conduct at the dinner party that night seemed strange to him, too. She interrupted her hostess rudely and stared at the people across the table from her with an intensity for which she would have punished the children.

It was still mild when they walked home from the party, and Irene looked up at the spring stars. "'How far that little candle throws its beams," she exclaimed. "'So shines a good deed in a naughty world.'" She waited that night until Jim had fallen asleep, and then went into the living room and turned on the radio.

Jim came home at about six the next night. Emma, the maid, let him in, and he had taken off his hat and was taking off his coat when Irene ran into the hall. Her face was shining with tears and her hair was disordered. "Go up to 16-C, Jim!" she screamed. "Don't take off your coat. Go up to 16-C. Mr. Osborn's beating his wife. They've been quarreling since four o'clock, and now he's hitting her. Go up there and stop him."

From the radio in the living room, Jim heard screams, obscenities, and thuds. "You know you don't have to listen to this sort of thing," he said. He strode into the living room and turned the switch. "It's indecent," he said. "It's like looking in the windows. You know you don't have to listen to this sort of thing. You can turn it off."

"Oh, it's so horrible, it's so dreadful," Irene was sobbing. "I've been listening all day, and it's so depressing."

"Well, if it's so depressing, why do you listen to it? I bought this damned radio to give you some pleasure," he said. "I paid a great deal of money for it. I thought it might make you happy. I wanted to make you happy."

"Don't, don't, don't quarrel with me," she moaned, and laid her head on his shoulder. "All the others have been quarreling all day. Everybody's been quarreling. They're all worried about money. Mrs. Hutchinson's mother is dying of cancer in Florida and they don't have enough money to send her to the Mayo Clinic. At least, Mr. Hutchinson says they don't have enough money. And some woman in this building is having an affair with the handyman—with that hideous handyman. It's too disgusting. And Mrs. Melville has heart trouble and Mr. Hendricks is going to lose his job in April and Mrs. Hendricks is horrid about the whole thing and that girl who plays the 'Missouri Waltz' is a whore, a common whore, and the elevator man has tuberculosis and Mr. Osborn has been beating Mrs. Osborn." She wailed, she trembled with grief and checked the stream of tears down her face with the heel of her palm.

"Well, why do you have to listen?" Jim asked again. "Why do you have to listen to this stuff if it makes you so miserable?"

"Oh, don't, don't, don't," she cried. "Life is too terrible, too sordid and awful. But

we've never been like that, have we, darling? Have we? I mean, we've always been good and decent and loving to one another, haven't we? And we have two children, two beautiful children. Our lives aren't sordid, are they, darling? Are they?" She flung her arms around his neck and drew his face down to hers. "We're happy, aren't we, darling? We are happy, aren't we?"

"Of course we're happy," he said tiredly. He began to surrender his resentment. "Of course we're happy. I'll have that damned radio fixed or taken away tomorrow."

He stroked her soft hair. "My poor girl," he said.

"You love me, don't you?" she asked. "And we're not hypercritical or worried about money or dishonest, are we?"

"No, darling," he said.

A man came in the morning and fixed the radio. Irene turned it on cautiously and was happy to hear a California-wine commercial and a recording of Beethoven's Ninth Symphony, including Schiller's "Ode to Joy." She kept the radio on all day and nothing untoward came from the speaker.

A Spanish suite was being played when Jim came home. "Is everything all right?" he asked. His face was pale, she thought. They had some cocktails and went in to dinner to the "Anvil Chorus" from *Il Trovatore*. This was followed by Debussy's "La Mer."

"I paid the bill for the radio today," Jim said. "It cost four hundred dollars. I hope you'll get some enjoyment out of it."

"Oh, I'm sure I will," Irene said.

"Four hundred dollars is a good deal more than I can afford," he went on. "I wanted to get something that you'd enjoy. It's the last extravagance we'll be able to indulge in this year. I see that you haven't paid your clothing bills yet. I saw them on your dressing table." He looked directly at her. "Why did you tell me you'd paid them? Why did you lie to me?"

"I just didn't want you to worry, Jim," she said. She drank some water. "I'll be able to pay my hills out of this month's allowance. There were the slipcovers last month,

and that party."

"You've got to learn to handle the money I give you a little more intelligently, Irene," he said. "You've got to understand that we won't have as much money this year as we had last. I had a very sobering talk with Mitchell today. No one is buying anything. We're spending all our time promoting new issues, and you know how long that takes. I'm not getting any younger, you know. I'm thirty-seven. My hair will be gray next year. I haven't done as well as I'd hoped to do. And I don't suppose things will get any better."

"Yes, dear," she said.

"We've got to start cutting down," Jim said. "We've got to think of the children. To be perfectly frank with you, I worry about money a great deal. I'm not at all sure of the future. No one is. If anything should happen to me, there's the insurance, but that wouldn't go very far today. I've worked awfully hard to give you and the children a comfortable life," he said bitterly. "I don't like to see all of my energies, all of my youth, wasted in fur coats and radios and slipcovers and—"

"Please, Jim," she said. "Please. They'll hear us."

"Who'll hear us? Emma can't hear us."

"The radio."

"Oh, I'm sick!" he shouted. "I'm sick to death of your apprehensiveness. The radio can't hear us. Nobody can hear us. And what if they can hear us? Who cares?"

Irene got up from the table and went into the living room. Jim went to the door and shouted at her from there. "Why are you so Christly all of a sudden? What's turned you overnight into a convent girl? You stole your mother's jewelry before they probated her will. You never gave your sister a cent of that money that was intended for her—not even when she needed it. You made Grace Howland's life miserable, and where was all your piety and your virtue when you went to that abortionist? I'll never forget how cool you were. You packed your bag and went off to have that child murdered as if you were going to Nassau. If you'd had any reasons, if you'd had any good reasons—"

Irene stood for a minute before the hideous cabinet, disgraced and sickened, but she held her hand on the switch before she extinguished the music and the voices, hoping that the instrument might speak to her kindly, that she might hear the Sweeneys' nurse. Jim continued to shout at her from the door. The voice on the radio was suave and noncommittal. "An early morning railroad disaster in Tokyo," the loudspeaker said, "killed twenty-nine people. A fire in a Catholic hospital near Buffalo for the care of blind children was extinguished early this morning by nuns. The temperature is forty-seven. The humidity is eighty-nine."

Suggestions for Discussion

- 1. Cheever begins "The Enormous Radio" with a generalized portrait of middle-class New Yorkers. What techniques does he use to do this? What is the function of numbers in this effect?
- 2. Examine how Jim and Irene Westcott are increasingly individualized. How do details of appearance contribute to the change? To the quick sketching of minor characters?
- 3. How does Cheever signal internal conflicts in the major characters?
- 4. Identify half a dozen moments of discovery, of decision.
- 5. What device, effect, or technique would you like to steal from this story?

Yours

MARY ROBISON

Allison struggled away from her white Renault, limping with the weight of the last of the pumpkins. She found Clark in the twilight on the twig-and leaf-littered porch, behind the house. He wore a tan wool shawl. He was moving up and back in a cushioned glider, pushed by the ball of his slippered foot.

Allison lowered a big pumpkin and let it rest on the porch floor.

Clark was much older than she—seventy-eight to Allison's thirty-five. They had been married for four months. They were both quite tall, with long hands, and their faces looked something alike. Allison wore a natural-hair wig. It was a thick blond hood around her face. She was dressed in bright-dyed denims today. She wore durable clothes, usually, for she volunteered afternoons at a children's daycare center.

She put one of the smaller pumpkins on Clark's long lap. "Now, nothing surreal," she told him. "Carve just a *regular* face. These are for kids."

In the foyer, on the Hepplewhite desk, Allison found the maid's chore list, with its cross-offs, which included Clark's supper. Allison went quickly through the day's mail: a garish coupon packet, a flyer advertising white wines at Jamestown Liquors, November's pay-TV program guide, and—the worst thing, the funniest—an already opened, extremely unkind letter from Clark's married daughter, up North. "You're an old fool," Allison read, and "You're being cruelly deceived." There was a gift check for twenty-five dollars, made out to Clark, enclosed—his birthday had just passed—but it was uncashable. It was signed "Jesus H. Christ."

Late, late into this night, Allison and Clark gutted and carved the pumpkins together, at an old table set out on the back porch. They worked over newspaper after soggy newspaper, using paring knives and spoons and a Swiss Army knife Clark liked for the exact shaping of teeth and eyes and nostrils. Clark had been a doctor—an internist—but he was also a Sunday watercolor painter. His four pumpkins were expressive and artful. Their carved features were suited to the sizes and shapes of the pumpkins. Two looked ferocious and jagged. One registered surprise. The last was serene and beaming.

Allison's four faces were less deftly drawn, with slits and areas of distortion. She had cut triangles for noses and eyes. The mouths she had made were all just wedges—two turned up and two turned down.

By 1 a.m., they were finished. Clark, who had bent his long torso forward to work, moved over to the glider again and looked out sleepily at nothing. All the neighbors' lights were out across the ravine. For the season and time, the Virginia night was warm. Most of the leaves had fallen and blown away already, and the trees stood unbothered. The moon was round, above them.

Allison cleaned up the mess.

"Your jack-o'-lanterns are much much better than mine," Clark said to her.

"Like hell," Allison said.

"Look at me," Clark said, and Allison did. She was holding a squishy bundle of newspapers. The papers reeked sweetly with the smell of pumpkin innards. "Yours are far better," he said.

"You're wrong. You'll see when they're lit," Allison said.

She went inside, came back with yellow vigil candles. It took her a while to get each candle settled into a pool of its own melted wax inside the jack-o'-lanterns, which were lined up in a row on the porch railing. Allison went along and relit each candle and fixed the pumpkin lids over the little flames. "See?" she said. They sat together a moment and looked at the orange faces.

"We're exhausted. It's good-night time," Allison said. "Don't blow out the candles. I'll put in new ones tomorrow."

In her bedroom, a few weeks earlier in her life than had been predicted, she began to die. "Don't look at me if my wig comes off," she told Clark. "Please." Her pulse cords were fluttering under his fingers. She raised her knees and kicked away the comforter. She said something to Clark about the garage being locked.

At the telephone, Clark had a clear view out back and down to the porch. He wanted to get drunk with his wife once more. He wanted to tell her, from the greater perspective he had, that to own only a little talent, like his, was an awful, plaguing thing; that being only a little special meant you expected too much, most of the time, and liked yourself too little. He wanted to assure her that she had missed nothing.

Clark was speaking into the phone now. He watched the jack-o'-lanterns. The jack-o'-lanterns watched him.

Suggestions for Discussion

- 1. The author is very modest about interpreting characters' actions. Yet some information is "told" us by the indirect method rather than coming to us directly. Identify such information.
- 2. What details of appearance operate as immediate clues to character and to the characters' situation? What actions?
- 3. How do the pumpkin faces reveal character?
- 4. This is a very short story. Are the characters made complex? If so, how? How do the actions of the characters as they unfold reveal *unexpected* traits of character?
- 5. What these characters face is involuntary. How do the choices they make nevertheless propel the plot? How are their purposes revealed?

The Only Traffic Signal on the Reservation Doesn't Flash Red Anymore

SHERMAN ALEXIE

"Go ahead," Adrian said. "Pull the trigger."

I held a pistol to my temple. I was sober but wished I was drunk enough to pull the trigger.

"Go for it," Adrian said. "You chickenshit."

While I still held that pistol to my temple, I used my other hand to flip Adrian off. Then I made a fist with my third hand to gather a little bit of courage or stupidity, and wiped sweat from my forehead with my fourth hand.

"Here," Adrian said. "Give me the damn thing."

Adrian took the pistol, put the barrel in his mouth, smiled around the metal, and pulled the trigger. Then he cussed wildly, laughed, and spit out the BB.

"Are you dead yet?" I asked.

"Nope," he said. "Not yet. Give me another beer."

"Hey, we don't drink no more, remember? How about a Diet Pepsi?"

"That's right, enit? I forgot. Give me a Pepsi."

Adrian and I sat on the porch and watched the reservation. Nothing happened. From our chairs made rockers by unsteady legs, we could see that the only traffic signal on the reservation had stopped working.

"Hey, Victor," Adrian asked. "Now when did that thing quit flashing?"

"Don't know," I said.

It was summer. Hot. But we kept our shirts on to hide our beer bellies and chicken-pox scars. At least, I wanted to hide my beer belly. I was a former basketball star fallen out of shape. It's always kind of sad when that happens. There's nothing more unattractive than a vain man, and that goes double for an Indian man.

"So," Adrian asked. "What you want to do today?"

"Don't know."

We watched a group of Indian boys walk by. I'd like to think there were ten of them. But there were actually only four or five. They were skinny, darkened by sun, their hair long and wild. None of them looked like they had showered for a week.

Their smell made me jealous.

They were off to cause trouble somewhere, I'm sure. Little warriors looking for honor in some twentieth-century vandalism. Throw a few rocks through windows, kick a dog, slash a tire. Run like hell when the tribal cops drove slowly by the scene of the crime.

"Hey," Adrian asked. "Isn't that the Windmaker boy?"

"Yeah," I said and watched Adrian lean forward to study Julius Windmaker, the best basketball player on the reservation, even though he was only fifteen years old.

"He looks good," Adrian said.

"Yeah, he must not be drinking."

"Yet."

"Yeah, yet."

Julius Windmaker was the latest in a long line of reservation basketball heroes, going all the way back to Aristotle Polatkin, who was shooting jumpshots exactly one year before James Naismith supposedly invented basketball.

I'd only seen Julius play a few times, but he had that gift, that grace, those fingers like a goddamn medicine man. One time, when the tribal school traveled to Spokane to play this white high school team, Julius scored sixty-seven points and the Indians won by forty.

"I didn't know they'd be riding horses," I heard the coach of the white team say when I was leaving.

I mean, Julius was an artist, moody. A couple times he walked right off the court during the middle of a game because there wasn't enough competition. That's how he was. Julius could throw a crazy pass, surprise us all, and send it out of bounds. But nobody called it a turnover because we all knew that one of his teammates should've been there to catch the pass. We loved him.

"Hey, Julius," Adrian yelled from the porch. "You ain't shit."

Julius and his friends laughed, flipped us off, and shook their tail feathers a little as they kept walking down the road. They all knew Julius was the best ballplayer on the reservation these days, maybe the best ever, and they knew Adrian was just confirming that fact.

It was easier for Adrian to tease Julius because he never really played basket-ball. He was more detached about the whole thing. But I used to be quite a ball-player. Maybe not as good as some, certainly not as good as Julius, but I still felt that ache in my bones, that need to be better than everyone else. It's that need to be the best, that feeling of immortality, that drives a ballplayer. And when it disappears, for whatever reason, that ballplayer is never the same person, on or off the court.

I know when I lost it, that edge. During my senior year in high school we made it to the state finals. I'd been playing like crazy, hitting everything. It was like throwing rocks into the ocean from a little rowboat. I couldn't miss. Then, right before the championship game, we had our pregame meeting in the first-aid room of the college where the tournament was held every year.

It took a while for our coach to show up so we spent the time looking at these first-aid manuals. These books had all kinds of horrible injuries. Hands and feet smashed flat in printing presses, torn apart by lawnmowers, burned and dismembered. Faces that had gone through windshields, dragged over gravel, split open by garden tools. The stuff was disgusting, but we kept looking, flipping through photograph after photograph, trading books, until we all wanted to throw up.

While I looked at those close-ups of death and destruction, I lost it. I think everybody in that room, everybody on the team, lost that feeling of immortality. We went out and lost the championship game by twenty points. I missed every shot I took. I missed everything.

"So," I asked Adrian. "You think Julius will make it all the way?"

"Maybe, maybe."

There's a definite history of reservation heroes who never finish high school, who never finish basketball seasons. Hell, there's been one or two guys who played just a few minutes of one game, just enough to show what they could have been. And there's the famous case of Silas Sirius, who made one move and scored one basket in his entire basketball career. People still talk about it.

"Hey," I asked Adrian. "Remember Silas Sirius?"

"Hell," Adrian said. "Do I remember? I was there when he grabbed that defensive rebound, took a step, and flew the length of the court, did a full spin in midair, and then dunked that fucking ball. And I don't mean it looked like he flew, or it was so beautiful it was almost like he flew. I mean, he flew, period."

I laughed, slapped my legs, and knew that I believed Adrian's story more as it sounded less true.

"Shit," he continued. "And he didn't grow no wings. He just kicked his legs a little. Held that ball like a baby in his hand. And he was smiling. Really. Smiling when he flew. Smiling when he dunked it, smiling when he walked off the court and never came back. Hell, he was still smiling ten years after that."

I laughed some more, quit for a second, then laughed a little longer because it was the right thing to do.

"Yeah," I said. "Silas was a ballplayer."

"Real ballplayer," Adrian agreed.

In the outside world, a person can be a hero one second and a nobody the next. Think about it. Do white people remember the names of those guys who dove into that icy river to rescue passengers from that plane wreck a few years back? Hell, white people don't even remember the names of the dogs who save entire families from burning up in house fires by barking. And, to be honest, I don't remember none of those names either, but a reservation hero is remembered. A reservation hero is a hero forever. In fact, their status grows over the years as the stories are told and retold.

"Yeah," Adrian said. "It's too bad that damn diabetes got him. Silas was always talking about a comeback."

"Too bad, too bad."

We both leaned further back into our chairs. Silence. We watched the grass grow, the rivers flow, the winds blow.

"Damn," Adrian asked. "When did that fucking traffic signal quit working?"

"Don't know."

"Shit, they better fix it. Might cause an accident."

We both looked at each other, looked at the traffic signal, knew that about only one car an hour passed by, and laughed our asses off. Laughed so hard that when we tried to rearrange ourselves, Adrian ended up with my ass and I ended up with his. That looked so funny that we laughed them off again and it took us most of an hour to get them back right again.

Then we heard glass breaking in the distance.

"Sounds like beer bottles," Adrian said.

"Yeah, Coors Light, I think."

"Bottled 1988."

We started to laugh, but a tribal cop drove by and cruised down the road where Julius and his friends had walked earlier.

"Think they'll catch them?" I asked Adrian.

"Always do."

After a few minutes, the tribal cop drove by again, with Julius in the backseat and his friends running behind.

"Hey," Adrian asked. "What did he do?"

"Threw a brick through a BIA pickup's windshield," one of the Indian boys yelled back.

"Told you it sounded like a pickup window," I said.

"Yeah, yeah, a 1982 Chevy."

"With red paint."

"No, blue."

We laughed for just a second. Then Adrian sighed long and deep. He rubbed his head, ran his fingers through his hair, scratched his scalp hard.

"I think Julius is going to go bad," he said.

"No way," I said. "He's just horsing around."

"Maybe, maybe."

It's hard to be optimistic on the reservation. When a glass sits on a table here, people don't wonder if it's half filled or half empty. They just hope it's good beer. Still, Indians have a way of surviving. But it's almost like Indians can easily survive the big stuff. Mass murder, loss of language and land rights. It's the small things that hurt the most. The white waitress who wouldn't take an order, Tonto, the Washington Redskins.

And, just like everybody else, Indians need heroes to help them learn how to survive. But what happens when our heroes don't even know how to pay their bills?

"Shit, Adrian," I said. "He's just a kid."

"Ain't no children on a reservation."

"Yeah, yeah, I've heard that before. Well," I said. "I guess that Julius is pretty good in school, too."

"And?"

"And he wants to maybe go to college."

'Really?'

"Really," I said and laughed. And I laughed because half of me was happy and half of me wasn't sure what else to do.

A year later, Adrian and I sat on the same porch in the same chairs. We'd done things in between, like ate and slept and read the newspaper. It was another hot summer. Then again, summer is supposed to be hot.

"I'm thirsty," Adrian said. "Give me a beer."

"How many times do I have to tell you? We don't drink anymore."

"Shit," Adrian said. "I keep forgetting. Give me a goddamn Pepsi."

"That's a whole case for you today already."

"Yeah, yeah, fuck these substitute addictions."

We sat there for a few minutes, hours, and then Julius Windmaker staggered down the road.

"Oh, look at that," Adrian said. "Not even two in the afternoon and he's drunk as a skunk."

"Don't he have a game tonight?"

"Yeah, he does."

"Well, I hope he sobers up in time."

"Me, too."

I'd only played one game drunk and it was in an all-Indian basketball tournament after I got out of high school. I'd been drinking that night before and woke up feeling kind of sick, so I got drunk again. Then I went out and played a game. I felt disconnected the whole time. Nothing seemed to fit right. Even my shoes, which had fit perfectly before, felt too big for my feet. I couldn't even see the basketball or basket clearly. They were more like ideas. I mean, I knew where they were generally supposed to be, so I guessed at where I should be. Somehow or another, I scored ten points.

"He's been drinking quite a bit, enit?" Adrian asked.

"Yeah, I hear he's even been drinking Sterno."

"Shit, that'll kill his brain quicker than shit."

Adrian and I left the porch that night and went to the tribal school to watch Julius play. He still looked good in his uniform, although he was a little puffy around the edges. But he just wasn't the ballplayer we remembered or expected. He missed shots, traveled, threw dumb passes that we all knew were dumb passes. By the fourth quarter, Julius sat at the end of the bench, hanging his head, and the crowd filed out, all talking about which of the younger players looked good. We talked about some kid named Lucy in the third grade who already had a nice move or two.

Everybody told their favorite Julius Windbreaker stories, too. Times like that, on a reservation, a basketball game felt like a funeral and wake all rolled up together.

Back at home, on the porch, Adrian and I sat wrapped in shawls because the evening was kind of cold.

"It's too bad, too bad," I said. "I thought Julius might be the one to make it all the way."

"I told you he wouldn't. I told you so."

"Yeah, yeah. Don't rub it in."

We sat there in silence and remembered all of our heroes, ballplayers from seven generations, all the way back. It hurts to lose any of them because Indians kind of see ballplayers as saviors. I mean, if basketball would have been around, I'm sure Jesus Christ would've been the best point guard in Nazareth. Probably the best player in the entire world. And in the beyond. I just can't explain how much losing Julius Windmaker hurt us all.

"Well," Adrian asked. "What do you want to do tomorrow?"

"Don't know."

"Shit, that damn traffic signal is still broken. Look."

Adrian pointed down the road and he was right. But what's the point of fixing it in a place where the STOP signs are just suggestions?

"What time is it?" Adrian asked.

"I don't know. Ten, I think."

"Let's go somewhere."

"Where?"

"I don't know, Spokane, anywhere. Let's just go."

"Okay," I said, and we both walked inside the house, shut the door, and locked it tight. No. We left it open just a little bit in case some crazy Indian needed a place to sleep. And in the morning we found crazy Julius passed out on the living room carpet.

"Hey, you bum," Adrian yelled. "Get off my floor."

"This is my house, Adrian," I said.

"That's right. I forgot. Hey, you burn, get your ass off Victor's floor."

Julius groaned and farted but he didn't wake up. It really didn't bother Adrian that Julius was on the floor, so he threw an old blanket on top of him. Adrian and I grabbed our morning coffee and went back out to sit on the porch. We had both just about finished our cups when a group of Indian kids walked by, all holding basketballs of various shapes and conditions.

"Hey, look," Adrian said. "Ain't that the Lucy girl?"

I saw that it was, a little brown girl with scarred knees, wearing her daddy's shirt. "Yeah, that's her," I said.

"I heard she's so good that she plays for the sixth grade boys team."

"Really? She's only in the third grade herself, isn't she?"

"Yeah, yeah, she's a little warrior."

Adrian and I watched those Indian children walk down the road, walking toward another basketball game.

"God, I hope she makes it all the way," I said.

"Yeah, yeah," Adrian said, stared into the bottom of his cup, and then threw it across the yard. And we both watched it with all of our eyes, while the sun rose straight up above us and settled down behind the house, watched the cup revolve, revolve, until it came down whole to the ground.

Suggestions for Discussion

- 1. None of the elements of type except ethnicity are given as direct information in "The Only Traffic Signal on the Reservation Doesn't Flash Red Anymore." How do we know the age, gender, period, class, region, profession, and marital status of the characters?
- 2. How are Adrian and Victor characterized by contrast with the appearance and movements of Julius Windmaker?
- 3. Adrian and Victor have given up. What do they nevertheless want, and how does Alexie convey that this represents purpose? Are there moments of decision that amount to action?

4. What images, qualities, and actions show conflict within character in this story?

Retrospect

- 1. Show how elements of type are revealed in the characters of "The Use of Force."
- 2. What does O'Brien achieve by the use of "flat" characters in "The Things They Carried"?
- 3. Examine any story you have read (in this book or otherwise) and identify moments of discovery, moments of decision.

Writing Assignments

- 1. Each day for two weeks, cluster and write a paragraph in your journal about a character drawn from memory, observation, or invention. Each day, go back and add to a former characterization. Focus on details of appearance and action.
- 2. Following is a list of familiar types, each of them comic or unsympathetic to the degree that they have become clichés. Write a short character sketch of one or two of them, individualizing the character through particular details that will make us sympathize and/or identify with him or her.
 - an absent-minded professor
 - a lazy laborer
 - · an aging film star
 - a domineering wife
 - · her timid husband
 - a tyrannical boss
 - a staggering drunk
- 3. In the sociological science of garbology, human habits are assessed by studying what people throw away. Write a character sketch by describing the contents of a wastebasket or garbage can.
- 4. For an exercise (only), try writing a character sketch without any of the elements of type. We shouldn't be able to tell the age, race, gender, nationality, or class of your character. Can you do it? Is it satisfying?
- 5. Pick two contrasting or contradictory qualities of your own personality (consistent inconsistencies). "Character image" them by making lists of contrasting qualities, actions, and images. Create a character that embodies each, and set them in conflict with each other. Since you are not writing about yourself but aiming at heightening and dramatizing these qualities, make each character radically different from yourself in at least one fundamental aspect of type: age, race, gender, nationality, or class.

- 6. Write a scene from your own life in which a discovery led to a quick decision. Rewrite it changing the character to someone significantly different from yourself.
- 7. Take an earlier assignment you have written and sharpen characterization by clarifying (especially for yourself) the protagonist's central desire and by introducing an element of "consistent inconsistency" in him or her.

THE FLESH MADE WORD

Characterization, Part II

• The Direct Methods of Character Presentation (continued)

Character: A Summary

Appearance and action reveal, which is one thing meant by *showing* rather than telling in fiction. But characters also reveal themselves in the way they speak and think, and the revelation is more profound when they are also shown in these ways.

Note that sense impressions other than sight are still a part of the way a character "appears." A limp handshake or a soft cheek; an odor of Chanel, oregano, or decay—if we are allowed to taste, smell, or touch a character through the narrative, then these sense impressions characterize much the way looks do.

The sound and associations of a character's name, too, can give a clue to personality: The affluent Mr. Chiddister in chapter 3 is automatically a more elegant sort than the affluent Mr. Strum; Huck Finn must have a different life from that of the Marquis of Lumbria. Although names with a blatant meaning—Joseph Surface, Billy Pilgrim, Martha Quest—tend to stylize a character and should be used sparingly, if at all, ordinary names can hint at traits you mean to heighten, and it is worth combing any list of names, including the telephone book, to find suggestive sounds. My own telephone book yields, at a glance this morning, Linda Holladay, Marvin Entzminger, and Melba Peebles, any one of which might set me to speculating on a character.

Sound also characterizes as a part of "appearance" insofar as sound represents timbre, tenor, or quality of noise and speech, the characterizing reediness or gruffness of a voice, the lift of laughter or stiffness of delivery.

The Direct Methods of Character Presentation (continued)

SPEECH

Speech, however, characterizes in a way that is different from appearance, because speech represents an effort, mainly voluntary, to externalize the internal and to manifest not merely taste or preference but also deliberated thought. Like fiction itself, human dialogue attempts to marry logic to emotion.

We have many means of communicating that are direct expressions of emotion: laughing, leering, shaking hands, screaming, shouting, shooting, making love. We have many means of communicating that are symbolic and emotionless: mathematical equations, maps, checkbooks, credit cards, and chemical formulas. Between body language and pure math lies language, in which judgments and feelings take the form of structured logic: in vows, laws, news, notes, essays, letters, and talk; and the greatest of these is talk.

Speech can be conveyed in fiction with varying degrees of directness. It can be summarized as part of the narrative so that a good deal of conversation is condensed:

At home in the first few months, he and Maizie had talked brightly about changes that would make the company more profitable and more attractive to a prospective buyer: new cuts, new packaging, new advertising, new incentives to make supermarkets carry the brand.

Joan Wickersham, "The Commuter Marriage"

It can be reported in the third person as *indirect speech* so that it carries, without actual quotation, the feel of the exchange:

Had he brought the coffee? She had been waiting all day long for coffee. They had forgot it when they ordered at the store the first day.

Gosh, no, he hadn't. Lord, now he'd have to go back. Yes, he would if it killed him. He thought, though, he had everything else. She reminded him it was only because he didn't drink coffee himself. If he did he would remember it quick enough.

Katherine Anne Porter, "Rope"

But usually when the exchange contains the possibility of discovery or decision, and therefore of dramatic action, it will be presented in *direct quotation*:

"But I thought you hardly knew her, Mr. Morning."

He picked up a pencil and began to doodle on a notebook page. "Did I tell you that?"

"Yes, you did."

"It's true. I didn't know her well."

"What is it you're after, then? Who was this person you're investigating?"

"I would like to know that too."

Siri Hustvedt, "Mr. Morning"

These three methods of presenting speech can be used in combination to take advantage of the virtues of each:

They differed on the issue of the holiday, and couldn't seem to find a common ground. (Summary.) She had an idea: why not some Caribbean island over Christmas? Well, but his mother expected them for turkey. (Indirect.)

"Oh, lord, yes, I wouldn't want to go without a vulctide gizzard." (Direct.)

Summary and indirect speech are often useful to get us quickly to the core of the scene, or when, for example, one character has to inform another of events that we already know, or when the emotional point of a conversation is that it has become tedious.

Carefully, playing down the danger, Len filled her in on the events of the long night.

Samantha claimed to be devastated. It was all very well if the Seversons wanted to let their cats run loose, but she certainly wasn't responsible for Lisbeth's parakeets, now was she?

But nothing is more frustrating to a reader than to be told that significant events are taking place in talk and to be denied the drama of the dialogue.

They whispered to each other all night long, and as he told her all about his past, she began to realize that she was falling in love with him.

Such a summary—it's telling—is a stingy way of treating the reader, who wants the chance to fall in love, too: Give me me!

Because direct dialogue has a dual nature—emotion within a logical structure its purpose in fiction is never merely to convey information. Dialogue may do that, but it needs simultaneously to characterize, provide exposition, set the scene, advance the action, foreshadow, and/or remind. William Sloane, in The Craft of Writing, says:

There is a tentative rule that pertains to all fiction dialogue. It must do more than one thing at a time or it is too inert for the purposes of fiction. This may sound harsh, but I consider it an essential discipline.

In considering Sloane's "tentative rule," I place the emphasis on rule. With dialogue as with significant detail, when you write you are constantly at pains to mean

more than you say. If a significant detail must both call up a sense image and mean, then the character's words, which presumably mean something, should simultaneously suggest image, personality, or emotion. Even rote exchanges can call up images. A character who says, "It is indeed a pleasure to meet you" carries his back at a different angle, dresses differently, from a character who says, "Hey, man, what it is?"

In the three very brief speeches that follow are three fictional men, sharply differentiated from each other not only by the content of what they say, but also by their diction (choice and use of words) and their syntax (the ordering of words in a sentence). Like appearance, these choices convey attributes of class, period, ethnicity, and so forth, as well as political or moral attitudes. How much do you know about each? How does each look?

"I had a female cousin one time—a Rockefeller, as it happened—" said the Senator, "and she confessed to me that she spent the fifteenth, sixteenth and seventeenth years of her life saying nothing but, No, thank you. Which is all very well for a girl of that age and station. But it would have been a damned unattractive trait in a male Rockefeller."

Kurt Vonnegut, God Bless You, Mr. Rosewater

"Hey, that's nice, Grandma," says Phantom as he motions me to come in the circle with him. "I'll tell you what. You can have a contest too. Sure. I got a special one for you. A sweater contest. You get all the grannies out on the porch some night when you could catch a death a chill, and see which one can wear the most sweaters. I got an aunt who can wear fourteen. You top that?"

Robert Ward, Shedding Skin

The Knight looked surprised at the question. "What does it matter where my body happens to be?" he said. "My mind goes on working all the same. In fact, the more head downward I am, the more I keep inventing new things.

"Now, the cleverest thing of the sort that I ever did," he went on after a pause, "was inventing a new pudding during the meat course."

Lewis Carroll, Through the Looking Glass

There are forms of insanity that condemn people to hear voices against their will, but as writers we invite ourselves to hear voices without relinquishing our hold on reality or our right to control. The trick to writing good dialogue is hearing voice. The question is, what would be or she say? The answer is entirely in language. The choice of language reveals content, character, and conflict, as well as type.

It's logical that if you must develop voices in order to develop dialogue, you'd do well to start with monologue and develop voices one by one. Use your journal to experiment with speech patterns that will characterize. Some people speak in telegraphically short sentences missing various parts of speech. Some speak in convoluted eloquence or in rhythms tedious with qualifying phrases. Some rush headlong without a pause for breath until they're breathless; others are measured or terse or begrudge even forming a sentence. Trust your "inner ear" and use your journal to practice catching voices. Freewriting is invaluable to dialogue writing because it is the manner of composition closest to speech. There is no time to mull or edit. Any qualifications, corrections, and disavowals must be made part of the process and the text.

When you hear a passage of speech that interests you, next time you sit down at your journal freedraft a monologue passage of that speech. Don't look for words that seem right; just listen to the voice and let it flow. The principle is the same as keeping your eye on the ball. If you feel you're going wrong, let yourself go wrong, and keep going. You're allowed to fail. And the process has two productive outcomes in any case: You begin to develop your own range of voices whether you catch a particular voice or not, and you develop your ear by the very process of "hearing" it go wrong.

You can also limber up in your journal by setting yourself deliberate exercises in making dialogue—or monologue—do more than one thing at a time. In addition to revealing character, dialogue can set the scene.

"We didn't know no one was here. We thought hit a summer camp all closed up. Curtains all closed up. Nothing here. No cars or gear nor nothing. Looks closed to me, don't hit to you, I.J.?"

Iov Williams, "Woods"

Dialogue can set the mood.

"I have a lousy trip to Philadelphia, lousy flight back, I watch my own plane blow a tire on closed-circuit TV, I go to my office, I find Suzy in tears because Warren's camped in her one-room apartment. I come home and I find my wife hasn't gotten dressed in two days."

Joan Didion, Book of Common Prayer

Dialogue can reveal the theme because, as William Sloane says, the characters talk about what the story is about.

"You feel trapped, don't you?"

Iane looks at her.

"Don't you?"

"No."

"O.K.—You just have a headache."

Milly waits a moment and then clears her throat and says, "You know, for a while there after Wally and I were married, I thought maybe I'd made a mistake. I remember realizing that I didn't like the way he laughed. I mean, let's face it, Wally laughs like a hyena . . ."

Richard Bausch, "The Fireman's Wife"

In all of the preceeding passages, the dialogue fulfills Sloane's rule because in addition to conveying whatever its content might be, it performs some narrative function either in moving the story forward or enriching our understanding.

Dialogue is also one of the simplest ways to *reveal the past* (a fundamental playwrighting device is to have a character who knows tell a character who doesn't know); and it is one of the most effective, because we get both the drama of the memory and the drama of the telling. Here is a passage from Toni Morrison's *The Bluest Eye* in which the past is evoked, the speaker characterized, the scene and mood set, and the theme revealed, all at the same time and in less than a dozen lines.

"The onliest time I be happy seem like was when I was in the picture show. Every time I got, I went. I'd go early, before the show started. They'd cut off the lights, and everything be black. Then the screen would light up, and I'd move right on in them pictures. White men taking such good care of they women, and they all dressed up in big clean houses with the bathtubs right in the same room with the toilet. Them pictures gave me a lot of pleasure, but it made coming home hard, and looking at Cholly hard. I don't know."

If the telling of a memory *changes the relationship* between the teller and the listener (what is in theater called an emotional recall), then you have a scene of high drama, and the dialogue can *advance the action*.

This is an important device, because dialogue is most valuable to fiction when it is itself a means of telling the story.

In the following passage, for example, the mother of a seriously ill toddler looks anxiously to a radiologist for information:

"The surgeon will speak to you," says the Radiologist.

"Are you finding something?"

"The surgeon will speak to you," the Radiologist says again. "There seems to be something there, but the surgeon will talk to you about it."

"My uncle once had something on his kidney," says the Mother. "So they removed the kidney and it turned out the something was benign."

The Radiologist smiles a broad, ominous smile. "That's always the way it is," he says. "You don't know exactly what it is until it's in the bucket."

"In the bucket," the Mother repeats.

"That's doctor talk," the Radiologist says.

"It's very appealing," says the Mother. "It's a very appealing way to talk."

Lorrie Moore, "People Like That Are the Only People Here"

Here the Radiologist's speech alters the mother's feeling toward him from hopeful to hostile in one short exchange. The level of fear for the child rises, and the dialogue itself has effected change.

A crucial (and sometimes difficult) distinction to make is between speech that is mere discussion or debate and speech that is drama or action. If in doubt, ask yourself: Can this conversation between characters really change anything? Dialogue is action when it contains the possibility of change. When two characters have made up their minds and know each others' positions on some political or philosophical matter, for instance, they may argue with splendid eloquence but there will be no discovery and nothing to decide, and therefore no option for change. No matter how significant their topic, we are likely to find them wooden and uninteresting. The story's question what happened next? will suggest only more talk:

"This has been the traditional fishing spot of the river people for a thousand years, and we have a moral responsibility to aid them in preserving their way of life. If you put in these rigs, it may undermine the ecosystem and destroy the aguifer of the entire county!"

"Join the real world, Sybil. Free enterprise is based on this kind of technological progress, and without it we would endanger the economic base."

Ho-hum. In order to engage us emotionally in a disagreement, the characters must have an emotional stake in the outcome; we need to feel that, even if it's unlikely they would change their minds, they might change their lives.

"If you sink that drill tomorrow morning, I'll be gone by noon." "Sybil, I have no choice."

Often the most forceful dialogue can be achieved by not having the characters say what they mean. People in extreme emotional states—whether of fear, pain, anger, or love—are at their least articulate. There is more narrative tension in a love scene where the lovers make anxious small talk, terrified of revealing their feelings, than in one where they hop into bed. A character who is able to say "I hate you!" hates less than one who bottles the fury and pretends to submit, unwilling to expose the truth. Dialogue can fall flat if characters define their feelings too precisely and honestly, because often the purpose of human exchange is to conceal as well as to reveal; to impress, hurt, protect, seduce, or reject. In this example from Alice Munro's "Before the Change," the daughter of a doctor who performed illegal abortions up until his recent death takes a phone call:

A woman on the phone wants to speak to the doctor.

"I'm sorry. He's dead."

"Dr. Strachan. Have I got the right doctor?"

"Yes but I'm sorry, he's dead."

"Is there anyone—does he by any chance have a partner I could talk to? Is there anybody else there?"

"No. No partner."

"Could you give me any other number I could call? Isn't there some other doctor that can—"

"No. I haven't any number. There isn't anybody that I know of."

"You must know what this is about. It's very crucial. There are very special circumstances—"

"I'm sorry."

It's clear here that neither woman is willing to mention abortion, and that the daughter will also not (and probably could not) speak about her complicated feelings toward her father and his profession. The exchange is rich with irony in that both women and also the reader know the "special circumstance" they are guardedly referring to; only the daughter and the reader are privy to the events surrounding the doctor's death and to the daughter's feelings.

Notice that this is not a very articulate exchange, but it does represent dramatic action, because for both women the stakes are high; they are both emotionally involved, but in ways that put them at cross purposes.

The Munro passage also illustrates an essential element of conflict in dialogue: Tension and drama are heightened when characters are constantly (in one form or another) saying no to each other. In the following exchange from Ernest Hemingway's *The Old Man and the Sea*, the old man feels only love for his young protégé, and their conversation is a pledge of affection. Nevertheless, it is the old man's steady denial that lends the scene tension.

"Can I go out and get sardines for you tomorrow?"

"No. Go and play baseball. I can still row and Rogelio will throw the net."

"I would like to go. If I cannot fish with you, I would like to serve in some way."

"You brought me a beer," the old man said. "You are already a man."

"How old was I when you first took me in a boat?"

"Five and you were nearly killed when I brought the fish in too green and he nearly tore the boat to pieces. Can you remember?"

"I can remember the tail slapping and banging and the thwart breaking and the noise of the clubbing. I can remember you throwing me into the bow where the wet coiled lines were and feeling the whole boat shiver and the noise of you clubbing him like chopping a tree down and the sweet blood smell all over me."

"Can you really remember that or did I just tell it to you?"

"I remember everything from when we first went together."

The old man looked at him with his sunburned, confident loving eyes.

"If you were my boy I'd take you out and gamble," he said. "But you are your father's and mother's and you are in a lucky boat."

Neither of these characters is consciously eloquent, and the dialogue is extremely simple. But look how much more it does than "one thing at a time"! It provides ex-

position on the beginning of the relationship, and it conveys the mutual affection of the two and the conflict within the old man between his love for the boy and his loyalty to the parents. It conveys the boy's eagerness to persuade and carries him into the emotion he had as a small child while the fish was clubbed. The dialogue represents a constant shift of power back and forth between the boy and the old man, as the boy, whatever else he is saying, continues to say *please*, and the old man, whatever else he is saying, continues to say *no*.

The same law of plausibility operates in dialogue as in narrative. We will tend to believe a character who speaks in concrete details and to be skeptical of one who generalizes or who delivers judgments unsupported by example. When the boy in the Hemingway passage protests, "I remember everything," we believe him because of the vivid details in his memory of the fish. If one character says, "It's perfectly clear from all his actions that he adores me and would do anything for me," and another says, "I had my hands all covered with the clay slick, and he just reached over to lift a lock of hair out of my eyes and tuck it behind my ear," which character do you believe is the more loved?

It's interesting to observe that whereas in narrative you will demonstrate control if you state the facts and let the emotional value rise off of them, in dialogue you will convey information more naturally if the emphasis is on the speaker's feelings. "My brother is due to arrive at midafternoon and is bringing his four children with him" reads as bald exposition; whereas, "That idiot brother of mine thinks he can walk in in the middle of the afternoon and plunk his four kids in my lap!" or, "I can't wait till my brother gets here at three! You'll see—those are the four sweetest kids this side of the planet"—will sound like talk and will slip us the information sideways.

Examine your dialogue to see if it does more than one thing at a time. Do the sound and syntax characterize by region, education, attitude? Do the choice of words and their syntax reveal that the character is stiff, outgoing, stifling anger, ignorant of the facts, perceptive, bigoted, afraid? Is the conflict advanced by "no-dialogue," in which the characters say no to each other? Is the drama heightened by the characters' inability or unwillingness to tell the whole truth?

Once you are comfortable with the voice of your character, it is well to acknowledge that everyone has many voices and that what that character says will be, within his or her verbal range, determined by the character to whom it is said. All of us have one sort of speech for the vicar and another for the man who pumps the gas. Huck Finn, whose voice is idiosyncratically his own, says, "Yes, sir" to the judge and "Maybe I am, maybe I ain't" to his degenerate dad.

FORMAT AND STYLE

The *format and style of dialogue*, like punctuation, has as its goal to be invisible; and though there may be occasions when departing from the rules is justified by some special effect, it's best to consider such occasions rare. Here are some basic guidelines:

What a character says aloud should be in quotation marks; thoughts should not.

This helps clearly differentiate between the spoken and the internal, especially by acknowledging that speech is more deliberately formulated. If you feel that thoughts need to be set apart from narrative, use italics instead of quotation marks.

Begin the dialogue of each new speaker as a new paragraph. This helps orient the reader and keep clear who is speaking. If an action is described between the dialogue lines of two speakers, put that narrative in the paragraph of the speaker it describes:

"I wish I'd taken that picture." Larry traced the horizon with his index finger. Janice snatched the portfolio away. "You've got chicken grease on your hands," she said, "and this is the only copy!"

Notice that the punctuation goes inside the quotation marks.

A dialogue tag, like a luggage tag or a name tag, is for the purpose of identification, and said is usually adequate to the task. People also ask and reply and occasionally add, recall, remember, or remind. But sometimes an unsure writer will strain for emphatic synonyms: She gasped, he whined, they chorused, John snarled, Mary spat. This is unnecessary and obtrusive, because although unintentional repetition usually makes for awkward style, the word said is as invisible as punctuation. When reading we're scarcely aware of it, whereas we are forced to be aware of she wailed. If it's clear who is speaking without any dialogue tag at all, don't use one. Usually an identification at the beginning of a dialogue passage and an occasional reminder are sufficient. If the speaker is inherently identified in the speech pattern, so much the better.

Similarly, tonal dialogue tags should be used sparingly: he said with relish; she added limply. Such phrases are blatant "telling," and the chances are that good dialogue will convey its own tone. "Get off my case!" she said angrily. We do not need to be told that she said this angrily. If she said it sweetly, then we would probably need to be told. If the dialogue does not give us a clue to the manner in which it is said, an action will often do so better than an adverb. "I'll have a word with Mr. Ritter about it," he said with finality is weaker than "I'll have a word with Mr. Ritter about it," he said, and picked up his hat.

It helps to make the dialogue tag unobtrusive if it comes within the spoken line: "Don't give it a second thought," he said. "I was just going anyway." A tag that comes at the beginning of the line calls attention to itself as a device: He said, "Don't give it a second thought . . ." whereas a tag that comes after too much speech becomes confusing or superfluous: "Don't give it a second thought. I was going anyway, and I'll just take these and drop them at the copy shop on the way," he said." If we didn't know who was speaking long before this tag appears, it's too late to be of use and again calls attention to itself.

Dialect is a tempting, and can be an excellent, means of characterizing, but it is difficult to do well and easy to overdo. Dialect should always be achieved by word choice and syntax, and misspellings kept to a minimum. They distract and slow the reader, and worse, they tend to make the character seem stupid rather than regional. There is no point in spelling phonetically any word as it is ordinarily pronounced: Almost all of us say things like "fur" for for, "uv" for of, "wuz" for was, "an" for and,

and "sez" for says. It's common to drop the g in words ending in ing. When you misspell these words in dialogue, you indicate that the speaker is ignorant enough to spell them that way when writing. Even if you want to indicate ignorance, you may alienate the reader by the means you choose to do so.

These rules for dialect have changed in the past fifty years or so, largely for political reasons. Nineteenth-century authors felt free to misspell the dialogue of foreigners, the lower classes, and racial, regional, and ethnic groups. This literary habit persisted into the first decades of the twentieth century. But the world is considerably smaller now, and its consciousness has been raised. Dialect, after all, is entirely relative, and we disdain the implication that regionality is ignorance. Ignorance itself is a charged issue. If you misspell a foreign accent or black English, the reader is likely to have a political rather than a literary reaction. A line of dialogue that runs "Doan rush me nun, Ah be gwine" reads as caricature, whereas "Don't rush me none, I be going" makes legitimate use of black English syntax and lets us concentrate on the meaning and emotion. John Updike puts this point well when he complains of a Tom Wolfe character:

"(his) non-U pronunciations are steadfastly spelled out—'sump'm' for 'something,' 'far fat' for 'fire fight'—in a way that a Faulkner character would be spared. For Faulkner, Southern life was life; for Wolfe it is a provincial curiosity . . ."

It is largely to avoid the charge of creating "provincial curiosities" that most fiction writers now avoid misspellings.

It can be even trickier catching the voice of a foreigner with imperfect English, because everyone has a native language, and when someone whose native language is French or Ibu starts to learn English, the grammatical mistakes they make will be based on the grammatical structure of the native language. Unless you know French or Ibu, you will make mistaken mistakes, and your dialogue is likely to sound as if it came from second-rate sitcoms. We're all tired of German characters who say "Ve vant you should feel goot," and Native Americans who—whether Sioux, Crow, or Navaho— can't tell the difference between "I" and "Me"—as in "Me no want paleface wampum." If you seem to be indicating ignorance in a character of whose native language you are ignorant, your reader instinctively mistrusts you.

In dialect or standard English, the bottom-line rule is that dialogue must be speakable. If it isn't speakable, it isn't dialogue.

"Certainly I had had a fright I wouldn't soon forget," Reese would say later, "and as I slipped into bed fully dressed except for my shoes, which I flung God-knowswhere, I wondered why I had subjected myself to a danger only a fool would fail to foresee for the dubious pleasure of spending one evening in the company of a somewhat less than brilliant coed."

Nobody would say this because it can't be said. It is not only convoluted beyond reason but it also stumbles over its alliteration, "only a fool would fail to foresee for," and takes more breath than the human lungs can hold. Read your dialogue aloud

and make sure it is comfortable to the mouth, the breath, and the ear. If not, then it won't ring true as talk.

THOUGHT

Fiction has a flexibility denied to film and drama, where everything the spectator knows must be externally manifested. In fiction you have the privilege of entering a character's mind, sharing at its source internal conflict, reflection, and the crucial processes of decision and discovery. Like speech, a character's thought can be offered in summary (He hated the way she ate.), or as indirect thought (Why did she hold her fork straight up like that?) or directly, as if we are overhearing the character's own mind (My God, she's going to drop the yolk!) As with speech, the three methods can be alternated in the same paragraph to achieve at once immediacy and pace.

Methods of presenting a character's thought will be more fully discussed in chapters 7 and 8 on point of view. What's most important to characterization is that thought, like speech, reveals more than information. It can also set mood, reveal or betray desires, develop theme, and so forth.

The territory of a character's mind is above all likely to be the center of the action. Aristotle says, as we have seen, that a man "is his desire," that is, his character is defined by his ultimate purpose, good or bad. *Thought*, says Aristotle, is the process by which a person works backward in his mind from his goal to determine what action he can take toward that goal at a given moment.

It is not, for example, your ultimate desire to read this book. Very likely you don't even "want" to read it; you'd rather be asleep or jogging or making love. But your ultimate goal is, say, to be a rich, respected, and famous writer. In order to attain this goal, you reason, you must know as much about the craft as you can learn. To do this, you would like to take a graduate degree at the Writer's Workshop in Iowa. To do that, you must take an undergraduate degree in ______, where you now find yourself, and must get an A in Ms. or Mr. _______'s creative writing course. To do that, you must produce a character sketch from one of the assignments at the end of this chapter by a week from Tuesday. To do so, you must sit here reading this chapter now instead of sleeping, jogging, or making love. Your ultimate motive has led you logically backward to a deliberate "moral" decision on the action you can take at this minor crossroad. In fact, it turns out that you want to be reading after all.

The relation that Aristotle perceives among desire, thought, and action seems to me a very useful one for an author, both in structuring plot and in creating character. What does this protagonist want to happen in the last paragraph of this story? What is the particular thought process by which this person works backward to determine what she or he will do now, in the situation that presents itself on page one?

I was on my way to what I hoped would be *the* romantic vacation of my life, off to Door County for a whole week of sweet sane rest. More rest. I needed more rest.

The action, of course, may be the wrong one. Thought thwarts us, because it leads to a wrong choice, or because thought is full of conflicting desires and consistent inconsistencies, or because there is enormous human tension between suppressed thought and expressed thought:

When he shuts off the shower, the phone is ringing. A sense that it has been ringing for a long time—can a mechanical noise have a quality of desperation?—propels him naked and dripping into the living room. He picks up the phone and his caller, as he has suspected, is Mieko... He is already annoyed after the first hello. Mieko's voice is sharp, high, very Japanese, although she speaks superb English. He says, "Hello, Mieko," and he sounds annoyed.

Jane Smiley, "Long Distance"

In "Where Are You Going, Where Have You Been?" at the end of chapter 3, Connie wants to get away every chance she can from a family she despises. From the opening paragraphs, she devises a number of schemes and subterfuges to avoid their company. At the end of the story her success is probably permanent, at a cost she had not figured into her plan. Through the story she is richly characterized, inventing two personalities in order single-mindedly to pursue her freedom, finally caught between conflicting and paralyzing desires.

A person, a character, can't do much about what he or she wants; it just is (which is another way of saying that character is desire). What we can deliberately choose is our behavior, the action we take in a given situation. Achievement of our desire would be easy if the thought process between desire and act were not so faulty and so wayward, or if there were not such an abyss between the thoughts we think and those which we are willing and able to express.

CONFLICT BETWEEN METHODS OF PRESENTATION

The conflict that is the essence of character can be effectively (and, if it doesn't come automatically, quite consciously) achieved in fiction by producing a conflict between methods of presentation. A character can be directly revealed to us through appearance, speech, action, and thought. If you set one of these methods (in narrative practice most frequently thought) at odds with the others, then dramatic tension will be produced. Imagine, for example, a character who is impeccable and expensively dressed, who speaks eloquently, who acts decisively, and whose mind is revealed to us as full of order and determination. He is inevitably a flat character. But suppose that he is impeccable, eloquent, decisive, and that his mind is a mess of wounds and panic. He is at once interesting.

Here is the opening passage of Saul Bellow's *Seize the Day*, in which appearance and action are blatantly at odds with thought. Notice that it is the tension between suppressed thought and what is expressed through appearance and action that produces the rich character conflict.

When it came to concealing his troubles, Tommy Wilhelm was not less capable than the next fellow. So at least he thought, and there was a certain amount of evidence to back him up. He had once been an actor-no, not quite, an extraand he knew what acting should be. Also, he was smoking a cigar, and when a man is smoking a cigar, wearing a hat, he has an advantage: it is harder to find out how he feels. He came from the twenty-third floor down to the lobby on the mezzanine to collect his mail before breakfast, and he believed—he hoped—he looked passably well: doing all right.

Tommy Wilhelm is externally composed but mentally anxious, mainly anxious about looking externally composed. By contrast, in the next passage, from Samuel Beckett's Murphy, the landlady, Miss Carridge, who has just discovered a suicide in one of her rooms, is anxious in speech and action but is mentally composed.

She came speeding down the stairs one step at a time, her feet going so fast that she seemed on little caterpillar wheels, her forefinger sawing horribly at her craw for Celia's benefit. She slithered to a stop on the steps of the house and screeched for the police. She capered in the street like a consternated ostrich. with strangled distracted rushes towards the York and Caledonian Roads in turn, embarrassingly equidistant from the tragedy, tossing up her arms, undoing the good work of the samples, screeching for police aid. Her mind was so collected that she saw clearly the impropriety of letting it appear so.

In this third example, from Zora Neale Hurston's "The Gilded Six-Bits," it is the very intensity of the internal that both prevents and dictates action:

Missie May was sobbing. Wails of weeping without words. Joe stood, and after a while he found out that he had something in his hand. And then he stood and felt without thinking and without seeing with his natural eyes. Missie May kept on crying and Joe kept on feeling so much, and not knowing what to do with all his feelings, he put Slemmon's watch charm in his pants pocket and took a good laugh and went to bed.

I have said that thought is most frequently at odds with one or more of the other three methods of direct presentation—reflecting the difficulty we have expressing ourselves openly or accurately—but this is by no means always the case. A character may be successfully, calmly, even eloquently expressing fine opinions while betraying himself by pulling at his ear, or herself by crushing her skirt. Captain Queeg of Herman Wouk's The Caine Mutiny is a memorable example of this, maniacally clicking the steel balls in his hand as he defends his disciplinary code. Often we are not privy to the thoughts of a character at all, so that the conflicts must be expressed in a contradiction between the external methods of direct presentation, appearance, speech, and action. Character A may be speaking floods of friendly welcome, betraying his real feeling by backing steadily away. Character B, dressed in taffeta ruffles and ostrich plumes, may wail pityingly over the miseries of the poor. Notice that the no-

tion of "betraying oneself" is important here: We're more likely to believe the evidence unintentionally given than deliberate expression.

A classic example of such self-betrayal is found in Leo Tolstoy's The Death of Ivan Ilyich, where the widow confronts her husband's colleague at the funeral.

... Noticing that the table was endangered by his cigarette ash, she immediately passed him an ashtray, saying as she did so: "I consider it an affectation to say that my grief prevents my attending to practical affairs. On the contrary, if anything can—I won't say console me, but—distract me, it is seeing to everything concerning him." She again took out her handkerchief as if preparing to cry, but suddenly, as if mastering her feeling, she shook herself and began to speak calmly. "But there is something I want to talk to you about."

It is no surprise either to the colleague or to us that Praskovya Federovna wants to talk about getting money.

Finally, character conflict can be expressed by creating a tension between the direct and the indirect methods of presentation, and this is a source of much irony. The author presents us with a judgment of the character and then lets him or her speak, appear, act, and/or think in contradiction of this judgment.

Sixty years had not dulled his responses; his physical reactions, like his moral ones, were guided by his will and strong character, and these could be seen plainly in his features. He had a long tube-like face with a long rounded open jaw and a long depressed nose.

Flannery O'Connor, "The Artificial Nigger"

What we see here in the details of Mr. Head's features are not will and strong character but grimly unlikable qualities. "Tube-like" is an ugly image; an "open jaw" suggests stupidity; and "depressed" connotes more than shape, while the dogged repetition of "long" stretches the face grotesquely.

Janc Austen is a master of this ironic method, the authorial voice often having a naive goodwill toward the characters while the characters themselves prevent the reader from sharing it.

Mr. Woodhouse was fond of society in his own way. He liked very much to have his friends come and see him; and from various united causes, from his long residence at Hartfield, and his good nature, from his fortune, his house, and his daughter, he could command the visits of his own little circle in a great measure as he liked. He had not much intercourse with any families beyond that circle; his horror of late hours and large dinner parties made him unfit for any acquaintance but such as would visit him on his own terms. Upon such occasions poor Mr. Woodhouse's feelings were in sad warfare. He loved to have the cloth laid, because it had been the fashion of his youth; but his conviction of suppers being very unwholesome made him rather sorry to see anything put on

it; and while his hospitality would have welcomed his visitors to everything, his care for their health made him grieve that they would eat.

Emma

Here all the authorial generalizations about Mr. Woodhouse are generous and positive, whereas his actions and the "sad warfare" of his mind lead us to the conviction that we would just as soon not sup with this good-natured and generous man.

In addition to providing tension between methods of presentation, you can try a few other ways of making a character fresh and forceful in your mind before you start writing.

If the character is based on you or on someone you know, drastically alter the model in some external way: Change blond to dark or thin to thick; imagine the character as the opposite gender or radically alter the setting in which the character must act. Part of the trouble with writing directly from experience is that you know too much about it—what "they" did, how you felt. Under such circumstances it's hard to know whether everything in your mind is getting onto the page. An external alteration forces you to re-see, and so to see more clearly, and so to convey more clearly what you see.

On the other hand, if the character is created primarily out of your observation or invention and is unlike yourself, try to find an internal area that you have in common with the character. If you are a blond, slender young woman and the character is a fat, balding man, do you nevertheless have in common a love of French haute cuisine? Are you haunted by the same sort of dream? Do you share a fear of public performance or a susceptibility to fine weather?

I can illustrate these techniques only from my own writing, because I am the only author whose self I can identify with any certainty in fictional characters. In a recent novel, I wanted to open with a scene in which the heroine buries a dog in her backyard. I had recently buried a dog in my backyard. I wanted to capture the look and feel of red Georgia earth at sunrise, the tangle of roots, and the smell of decay. But I knew that I was likely to make the experience too much my own, too little my character's. I set about to make her not-me. I have long dark hair and an ordinary figure, and I tend to live in Levi's. I made Shaara Soole

... big boned, lanky, melon-breasted, her best feature was a head of rusty barbed-wire hair that she tried to control with a wardrobe of scarves and headband things. Like most costume designers, she dressed with more originality than taste, usually on the Oriental or Polynesian side, sometimes with voluminous loops of thong and matte metal over an ordinary shirt. This was somewhat eccentric in Hubbard, Georgia, but Shaara may have been oblivious to her eccentricity, being so concerned to keep her essential foolishness in check.

Having thus separated Shaara from myself, I was able to bury the dog with her arms and through her eyes rather than my own. On the other hand, a few pages later I was faced with the problem of introducing her ex-husband, Boyd Soole. I had volu-

minous notes on this character, and I knew that he was almost totally unlike me. A man, to begin with, and a huge man, a theater director with a natural air of power and authority and very little interest in domestic affairs. I sat at my desk for several days, unable to make him move convincingly. My desk oppressed me, and I felt trapped and uncomfortable, my work thwarted, it seemed, by the very chair and typewriter. Then it occurred to me that Boyd was *also* sitting at a desk trying to work.

The dresser at the Travelodge was some four inches too narrow and three inches too low. If he set his feet on the floor his knees would sit free of the drawer but would be awkwardly constricted left and right. If he crossed his legs, he could hook his right foot comfortably outside the left of the kneehole but would bruisc his thigh at the drawer. If he shifted back he was placed at an awkward distance from his script. And in this position he could not work.

This passage did not instantly allow me to live inside Boyd Soole's skin, nor did it solve all my problems with his characterization. But it did let me get on with the story, and it gave me a flash of sympathy for him that later grew much more profound than I had foreseen.

Often, identifying what you have in common with the feelings of your character will also clarify what is important about her or him to the story—why, in fact, you chose to write about such a person at all. Even if the character is presented as a villain, you have something in common, and I don't mean something forgivable. If he or she is intolerably vain, watch your own private gestures in front of the mirror and borrow them. If he or she is cruel, remember how you enjoyed hooking the worm.

There is no absolute requirement that a writer need behave honestly in life; there is absolutely no such requirement. Great writers have been public hams, domestic dictators, emotional con artists, and Nazis. What is required for fine writing is honesty on the page—not how the characters *should* react at the funeral, the surprise party, in bed, but how they *would*. In order to develop such honesty of observation on the page, you must begin with a willing honesty of observation (though mercifully not of behavior) in yourself.

CREATING A GROUP OR CROWD

Sometimes it is necessary to introduce several or many people in the same scene, and this needn't present a problem, because the principle is pretty much the same in every case, and is the same as in film: pan, then close-up. In other words, give us a sense of the larger scene first, then a few details to characterize individuals. If you begin by concentrating too long on one character only, we will tend to see that person as being alone.

Herm peered through the windshield and eased his foot up off the gas. Damn, he thought, it's not going to let up. The yellow lights made slick pools along the shoulder. He fiddled with the dial, but all he could get was blabber-radio and

somebody selling vinyl siding. His back ached. His eyes itched. A hundred and forty miles to go.

At this point, if you introduce a wife, two children, and a dog to the scene, we will have to make rapid and uncomfortable adjustments in our mental picture. Better to begin with the whole carful and then narrow it down to Herm:

Herm peered through the windshield and glanced over at Inga, who was snoring lightly against the window. The kids hadn't made a sound for about half an hour either, and only Cheza was wheezing dogbreath now and then on the back of his neck. He eased his foot up off the gas. Damn, he thought . . .

If the action involves several characters who therefore need to be seen right away, introduce them as a group and then give us a few characterizing details:

All the same there were four guns on him before he'd focused enough to count. "Peace," he said again. There were three old ones, one of them barely bigger than a midget, and the young one was fat. One of the old ones had on a uniform jacket much too big for him, hanging open on his slack chest. The young one spun a string of their language at him.

If the need is to create a crowd, it is still important, having established that there is a crowd, to give us a few details. We will believe more thoroughly in large numbers of people if you offer example images for us. Here, for example, is a passage from *Underworld* in which Don LeLillo introduces two parts of a crowd, the boys who are waiting to sneak into the ballpark and the last legitimate arrivals:

... they have found one another by means of slidy looks that detect the fellow foolhard and here they stand, black kids and white kids up from the subways or off the local Harlem streets, bandidos, fifteen in all, and according to topical legends maybe four will get through for every one that's caught.

They are waiting nervously for the ticket holders to clear the turnstiles, the last loose cluster of fans, the stragglers and loiterers. They watch the late-arriving taxis from downtown and the brilliantined men stepping dapper to the windows, policy bankers and supper club swells and Broadway hotshots, high aura'd, picking lint off their sleeves.

Character: A Summary

It may be helpful to summarize such practical advice on character as this chapter and the previous chapter contain.

- 1. Keep a journal and use it to explore and build ideas for characters.
- 2. Know all the influences that go into the making of your character's type: age, gender, race, nationality, marital status, region, education, religion, profession.

- 3. Know the details of your character's life: what he or she does during every part of the day, thinks about, remembers, wants, likes and dislikes, eats, says, means.
- 4. Identify, heighten, and dramatize consistent inconsistencies. What does your character want that is at odds with whatever else the character wants? What patterns of thought and behavior work against the primary goal?
- 5. Focus sharply on how the character looks, on what she or he wears and owns, and on how she or he moves. Let us focus on it, too.
- 6. Examine the character's speech to make sure it does more than convey information. Does it characterize, accomplish exposition, and reveal emotion, intent, or change? Does it advance the conflict through "no-dialogue"? Speak it aloud: Does it "say"?
- 7. Build action by making your characters discover and decide. Make sure that what happens is action and not mere event or movement, that is, that it contains the possibility for human change.
- 8. Know what your character wants, both generally out of life, and specifically in the context of the story. Keeping that desire in mind, "think backward" with the character to decide what he or she would do in any situation presented.
- 9. Be aware of the five methods of character presentation: authorial interpretation, appearance, speech, action, and thought. Reveal the character's conflicts by presenting attributes in at least one of these methods that contrast with attributes you present in the others.
- 10. If the character is based on a real model, including yourself, make a dramatic external alteration.
- 11. If the character is imaginary or alien to you, identify a mental or emotional point of contact.

Girls at War

CHINUA ACHEBE

The first time their paths crossed nothing happened. That was in the first heady days of warlike preparation when thousands of young men (and sometimes women too) were daily turned away from enlistment centres because far too many of them were coming forward burning with readiness to bear arms in defence of the exciting new nation.

The second time they met was at a check-point at Awka. Then the war had started and was slowly moving southwards from the distant northern sector. He was driving from Onitsha to Enugu and was in a hurry. Although intellectually he approved of thorough searches at road-blocks, emotionally he was always offended

whenever he had to submit to them. He would probably not admit it but the feeling people got was that if you were put through a search then you could not really be one of the big people. Generally he got away without a search by pronouncing in his deep, authoritative voice: "Reginald Nwankwo, Ministry of Justice." That almost always did it. But sometimes either through ignorance or sheer cussedness the crowd at the odd check-point would refuse to be impressed. As happened now at Awka. Two constables carrying heavy Mark 4 rifles were watching distantly from the road-side, leaving the actual searching to local vigilantes.

"I am in a hurry," he said to the girl who now came up to his car. "My name is Reginald Nwankwo, Ministry of Justice."

"Good afternoon, sir. I want to see your boot."

"Oh Christ! What do you think is in the boot?"

"I don't know, sir."

He got out of the car in suppressed rage, stalked to the back, opened the boot and holding the lid up with his left hand he motioned with the right as if to say: After you!

"Are you satisfied?" he demanded.

"Yes, sir. Can I see your pigeon-hole?"

"Christ Almighty!"

"Sorry to delay you, sir. But you people gave us this job to do."

"Never mind. You are damn right. It's just that I happen to be in a hurry. But never mind. That's the glove-box. Nothing there as you can see."

"All right sir, close it." Then she opened the rear door and bent down to inspect under the seats. It was then he took the first real look at her, starting from behind. She was a beautiful girl in a breasty blue jersey, khaki jeans and canvas shoes with the new-style hair-plait which gave a girl a defiant look and which they called—for reasons of their own—"air force base"; and she looked vaguely familiar.

"I am all right, sir," she said at last meaning she was through with her task. "You don't recognize me?"

"No. Should I?"

"You gave me a lift to Enugu that time I left my school to go and join the militia."

"Ah, yes, you were the girl. I told you, didn't I, to go back to school because girls were not required in the militia. What happened?"

"They told me to go back to my school or join the Red Cross."

"You see I was right. So, what are you doing now?"

"Just patching up with Civil Defence."

"Well, good luck to you. Believe me you are a great girl."

That was the day he finally believed there might be something in this talk about revolution. He had seen plenty of girls and women marching and demonstrating before now. But somehow he had never been able to give it much thought. He didn't doubt that the girls and the women took themselves seriously, they obviously did. But so did the little kids who marched up and down the streets at the time drilling with sticks and wearing their mothers' soup bowls for steel helmets. The prime joke of the time among his friends was the contingent of girls from a local secondary school marching behind a banner: WE ARE IMPREGNABLE!

But after that encounter at the Awka check-point he simply could not sneer at the girls again, nor at the talk of revolution, for he had seen it in action in that young woman whose devotion had simply and without self-righteousness convicted him of gross levity. What were her words? We are doing the work you asked us to do. She wasn't going to make an exception even for one who once did her a favour. He was sure she would have searched her own father just as rigorously.

When their paths crossed a third time, at least eighteen months later, things had got very bad. Death and starvation having long chased out the headiness of the early days, now left in some places blank resignation, in others a rock-like, even suicidal, defiance. But surprisingly enough there were many at this time who had no other desire than to corner whatever good things were still going and to enjoy themselves to the limit. For such people a strange normalcy had returned to the world. All those nervous check-points disappeared. Girls became girls once more and boys boys. It was a tight, blockaded and desperate world but none the less a world—with some goodness and some badness and plenty of heroism which, however, happened most times far, far below the eye-level of the people in this story—in out-of-the-way refugee camps, in the damp tatters, in the hungry and barehanded courage of the first line of fire.

Reginald Nwankwo lived in Owerri then. But that day he had gone to Nkwerri in search of relief. He had got from Caritas in Owerri a few heads of stock-fish, some tinned meat, and the dreadful American stuff called Formula Two which he felt certain was some kind of animal feed. But he always had a vague suspicion that not being a Catholic put one at a disadvantage with Caritas. So he went now to see an old friend who ran the WCC depot at Nkwerri to get other items like rice, beans and that excellent cereal commonly called *Gabon gari*.

He left Owerri at six in the morning so as to catch his friend at the depot where he was known never to linger beyond 8.30 for fear of air-raids. Nwankwo was very fortunate that day. The depot had received on the previous day large supplies of new stock as a result of an unusual number of plane landings a few nights earlier. As his driver loaded tins and bags and cartons into his car the starved crowds that perpetually hung around relief centres made crude, ungracious remarks like "War Can Continue!" meaning the WCC! Somebody clse shouted "Irevolu!" and his friends replied "shum!" "Irevolu!" "shum!" "Isofeli?" "Shum!" "Isofeli?" "Mba!"

Nwankwo was deeply embarrassed not by the jeers of this scarecrow crowd of rags and floating ribs but by the independent accusation of their wasted bodies and sunken eyes. Indeed he would probably have felt much worse had they said nothing, simply looked on in silence, as his boot was loaded with milk, and powdered egg and oats and tinned meat and stock-fish. By nature such singular good fortune in the midst of a general desolation was certain to embarrass him. But what could a man do? He had a wife and four children living in the remote village of Ogbu and completely dependent on what relief he could find and send them. He couldn't abandone them to kwashiokor. The best he could do—and did do as a matter of fact—was to make sure that whenever he got sizeable supplies like now he made over some of it to his driver, Johnson, with a wife and six, or was it seven?, children and a salary of ten pounds a month when gari in the market was climbing to one

pound per cigarette cup. In such a situation one could do nothing at all for crowds; at best one could try to be of some use to one's immediate neighbours. That was all.

On his way back to Owerri a very attractive girl by the roadside waved for a lift. He ordered the driver to stop. Scores of pedestrians, dusty and exhausted, some military, some civil, swooped down on the car from all directions.

"No, no, no," said Nwankwo firmly. "It's the young woman I stopped for. I have a bad tyre and can only take one person. Sorry."

"My son, please," cried one old woman in despair, gripping the door-handle.

"Old woman, you want to be killed?" shouted the driver as he pulled away, shaking her off. Nwankwo had already opened a book and sunk his eyes there. For at least a mile after that he did not even look at the girl until she finding, perhaps, the silence too heavy said:

"You've saved me today. Thank you."

"Not at all. Where are you going?"

"To Owerri. You don't recognize me?"

"Oh yes, of course. What a fool I am . . . You are . . . "

"Gladys."

"That's right, the militia girl. You've changed, Gladys. You were always beautiful of course, but now you are a beauty queen. What do you do these days?"

"I am in the Fuel Directorate."

"That's wonderful."

It was wonderful, he thought, but even more it was tragic. She wore a high-tinted wig and very expensive skirt and low-cut blouse. Her shoes, obviously from Gabon, must have cost a fortune. In short, thought Nwankwo, she had to be in the keep of some well-placed gentleman, one of those piling up money out of the war.

"I broke my rule today to give you a lift. I never give lifts these days."

"Why?"

"How many people can you carry? It is better not to try at all. Look at that old woman."

"I thought you would carry her."

He said nothing to that and after another spell of silence Gladys thought maybe he was offended and so added: "Thank you for breaking your rule for me." She was scanning his face, turned slightly away. He smiled, turned, and tapped her on the lap.

"What are you going to Owerri to do?"

"I am going to visit my girl-friend."

"Girl-friend? You sure?"

"Why not? . . . If you drop me at her house you can see her. Only I pray God she hasn't gone on weekend today; it will be serious."

"Why?"

"Because if she is not at home I will sleep on the road today."

"I pray to God that she is not at home."

"Why?"

"Because if she is not at home I will offer you bed and breakfast . . . What is that?" he asked the driver who had brought the car to an abrupt stop. There was no need

for an answer. The small crowd ahead was looking upwards. The three scrambled out of the car and stumbled for the bush, necks twisted in a backward search of the sky. But the alarm was false. The sky was silent and clear except for two high-flying vultures. A humorist in the crowd called them Fighter and Bomber and everyone laughed in relief. The three climbed into their car again and continued their journey.

"It is much too early for raids," he said to Gladys, who had both her palms on her breast as though to still a thumping heart. "They rarely come before ten o'clock."

But she remained tongue-tied from her recent fright. Nwankwo saw an opportunity there and took it at once.

"Where does your friend live?"

"250 Douglas Road."

"Ah; that's the very centre of town—a terrible place. No bunkers, nothing. I won't advise you to go there before 6 p.m.; it's not safe. If you don't mind I will take you to my place where there is a good bunker and then as soon as it is safe, around six, I shall drive you to your friend. How's that?"

"It's all right," she said lifelessly. "I am so frightened of this thing. That's why I refused to work in Owerri. I don't even know who asked me to come out today."

"You'll be all right. We are used to it."

"But your family is not there with you?"

"No," he said. "Nobody has his family there. We like to say it is because of airraids but I can assure you there is more to it. Owerri is a real swinging now, and we live the life of gay bachelors."

"That is what I have heard."

"You will not just hear it; you will see it today. I shall take you to a real swinging party. A friend of mine, a Lieutenant-Colonel, is having a birthday party. He's hired the Sound Smashers to play. I'm sure you'll enjoy it."

He was immediately and thoroughly ashamed of himself. He hated the parries and frivolities to which his friends clung like drowning men. And to talk so approvingly of them because he wanted to take a girl home! And this particular girl too, who had once had such beautiful faith in the struggle and was betrayed (no doubt about it) by some man like him out for a good time. He shook his head sadly.

"What is it?" asked Gladys.

"Nothing. Just my thoughts."

They made the rest of the journey to Owerri practically in silence.

She made herself at home very quickly as if she was a regular girl-friend of his. She changed into a house dress and put away her auburn wig.

"That is a lovely hair-do. Why do you hide it with a wig?"

"Thank you," she said leaving his question unanswered for a while. Then she said: "Men are funny."

"Why do you say that?"

"You are now a beauty queen," she mimicked.

"Oh, that! I mean every word of it." He pulled her to him and kissed her. She neither refused nor yielded fully, which he liked for a start. Too many girls were simply too easy those days. War sickness, some called it.

He drove off a little later to look in at the office and she busied herself in the kitchen helping his boy with lunch. It must have been literally a look-in, for he was back within half an hour, rubbing his hands and saying he could not stay away too long from his beauty queen.

As they sat down to lunch she said: "You have nothing in your fridge."

"Like what?" he asked, half-offended.

"Like meat," she replied undaunted.

"Do you still eat meat?" he challenged.

"Who am I? But other big men like you eat."

"I don't know which big men you have in mind. But they are not like me. I don't make money trading with the enemy or selling relief or . . ."

"Augusta's boy friend doesn't do that. He just gets foreign exchange."

"How does he get it? He swindles the government—that's how he gets foreign exchange, whoever he is. Who is Augusta, by the way?"

"My girl-friend."

"I see."

"She gave me three dollars last time which I changed to forty-five pounds. The man gave her fifty dollars."

"Well, my dear girl, I don't traffic in foreign exchange and I don't have meat in my fridge. We are fighting a war and I happen to know that some young boys at the front drink gari and water once in three days."

"It is true," she said simply. "Monkey de work, baboon de chop."

"It is not even that; it is worse," he said, his voice beginning to shake. "People are dying every day. As we talk now somebody is dying."

"It is true," she said again.

"Plane!" screamed his boy from the kitchen.

"My mother!" screamed Gladys. As they scuttled towards the bunker of palm stems and red earth, covering their heads with their hands and stooping slightly in their flight, the entire sky was exploding with the clamour of jets and the huge noise of home-made anti-aircraft rockets.

Inside the bunker she clung to him even after the plane had gone and the guns, late to start and also to end, had all died down again.

"It was only passing," he told her, his voice a little shaky. "It didn't drop anything. From its direction I should say it was going to the war front. Perhaps our people are pressing them. That's what they always do. Whenever our boys press them, they send an SOS to the Russians and Egyptians to bring the planes." He drew a long breath.

She said nothing, just clung to him. They could hear his boy telling the servant from the next house that there were two of them and one dived like this and the other dived like that.

"I see dem well well," said the other with equal excitement. "If no to say de ting de kill porson e for sweet for eye. To God."

"Imagine!" said Gladys, finding her voice at last. She had a way, he thought, of conveying with a few words or even a single word whole layers of meaning. Now it

was at once her astonishment as well as reproof, tinged perhaps with grudging admiration for people who could be so lighthearted about these bringers of death.

"Don't be so scared," he said. She moved closer and he began to kiss her and squeeze her breasts. She yielded more and more and then fully. The bunker was dark and unswept and might harbour crawling things. He thought of bringing a mat from the main house but reluctantly decided against it. Another plane might pass and send a neighbour or simply a chance passer-by crashing into them. That would be only slightly better than a certain gentleman in another air-raid who was seen in broad daylight fleeing his bedroom for his bunker stark naked pursued by a woman in a similar state!

Just as Gladys had feared, her friend was not in town. It would seem her powerful boy-friend had wangled for her a flight to Libreville to shop. So her neighbours thought anyway.

"Great!" said Nwankwo as they drove away. "She will come back on an arms plane loaded with shoes, wigs, pants, bras, cosmetics and what have you, which she will then sell and make thousands of pounds. You girls are really at war, aren't you?"

She said nothing and he thought he had got through at last to her. Then suddenly she said, "That is what you men want us to do."

"Well," lie said, "here is one man who doesn't want you to do that. Do you remember that girl in khaki jeans who searched me without merey at the check-point?"

She began to laugh.

"That is the girl I want you to become again. Do you remember her? No wig. I don't even think she had any earrings . . ."

"Ah, na lie-o. I had ear-rings."

"All right. But you know what I mean."

"That time done pass. Now everybody want survival. They call it number six. You put your number six; I put my number six. Everything all right."

The Lieutenant-Colonel's party turned into something quite unexpected. But before it did things had been going well enough. There was goat-meat, some chicken and rice and plenty of home-made spirits. There was one fiery brand nicknamed "tracer" which indeed sent a flame down your gullet. The funny thing was looking at it in the bottle it had the innocent appearance of an orange drink. But the thing that caused the greatest stir was the bread—one little roll for each person! It was the size of a golf-ball and about the same consistency too! But it was real bread. The band was good too and there were many girls. And to improve matters even further two white Red Cross people soon arrived with a bottle of Courvoisier and a bottle of Scotch! The party gave them a standing ovation and then scrambled to get a drop. It soon turned out from his general behaviour, however, that one of the white men had probably drunk too much already. And the reason it would seem was that a pilot he knew well had been killed in a crash at the airport last night, flying in relief in awful weather.

Few people at the party had heard of the crash by then. So there was an immediate

damping of the air. Some dancing couples went back to their seats and the band stopped. Then for some strange reason the drunken Red Cross man just exploded.

"Why should a man, a decent man, throw away his life. For nothing! Charley didn't need to die. Not for this stinking place. Yes, everything stinks here. Even these girls who come here all dolled up and smiling, what are they worth? Don't I know? A head of stockfish, that's all, or one American dollar and they are ready to tumble into bed."

In the threatening silence following the explosion one of the young officers walked up to him and gave him three thundering slaps—right! left! right!—pulled him up from his seat and (there were things like tears in his eyes) shoved him outside. His friend, who had tried in vain to shut him up, followed him out and the silenced party heard them drive off. The officer who did the job returned dusting his palms.

"Fucking beast!" said he with an impressive coolness. And all the girls showed with their eyes that they rated him a man and a hero.

"Do you know him?" Gladys asked Nwankwo.

He didn't answer her. Instead he spoke generally to the party:

"The fellow was clearly drunk," he said.

"I don't care," said the officer. "It is when a man is drunk that he speaks what is on his mind."

"So you beat him for what was on his mind," said the host, "that is the spirit, Joe."

"Thank you, sir," said Joe, saluting.

"His name is Joe," Gladys and the girl on her left said in unison, turning to each other.

At the same time Nwankwo and a friend on the other side of him were saying quietly, very quietly, that although the man had been rude and offensive what he had said about the girls was unfortunately the bitter truth, only he was the wrong man to say it.

When the dancing resumed Captain Joe came to Gladys for a dance. She sprang to her feet even before the word was out of his mouth. Then she remembered immediately and turned round to take permission from Nwankwo. At the same time the Captain also turned to him and said, "Excuse me."

"Go ahead," said Nwankwo, looking somewhere between the two.

It was a long dance and he followed them with his eyes without appearing to do so. Occasionally a relief plane passed overhead and somebody immediately switched off the lights saying it might be the Intruder. But it was only an excuse to dance in the dark and make the girls giggle, for the sound of the Intruder was well known.

Gladys came back feeling very self-conscious and asked Nwankwo to dance with her. But he wouldn't. "Don't bother about me," he said, "I am enjoying myself perfectly sitting here and watching those of you who dance."

"Then let's go," she said, "if you won't dance."

"But I never dance, believe me. So please enjoy yourself."

She danced next with the Lieutenant-Colonel and again with Captain Joe, and then Nwankwo agreed to take her home.

"I am sorry I didn't dance," he said as they drove away. "But I swore never to dance as long as this war lasts."

She said nothing.

"When I think of somebody like that pilot who got killed last night. And he had no hand whatever in the quarrel. All his concern was to bring us food . . ."

"I hope that his friend is not like him," said Gladys.

"The man was just upset by his friend's death. But what I am saying is that with people like that getting killed and our own boys suffering and dying at the war fronts I don't see why we should sit around throwing parties and dancing."

"You took me there," said she in final revolt. "They are your friends. I don't know them before."

"Look, my dear, I am not blaming you. I am merely telling you why I personally refuse to dance. Anyway, let's change the subject . . . Do you still say you want to go back tomorrow? My driver can take you early enough on Monday morning for you to go to work. No? All right, just as you wish. You are the boss."

She gave him a shock by the readiness with which she followed him to bed and by her language.

"You want to shell?" she asked. And without waiting for an answer said, "Go ahead but don't pour in troops!"

He didn't want to pour in troops either and so it was all right. But she wanted visual assurance and so he showed her.

One of the ingenious economies taught by the war was that a rubber condom could be used over and over again. All you had to do was wash it out, dry it and shake a lot of talcum powder over it to prevent its sticking; and it was as good as new. It had to be the real British thing, though, not some of the cheap stuff they brought in from Lisbon which was about as strong as a dry cocoyam leaf in the harmattan.

He had his pleasure but wrote the girl off. He might just as well have slept wirh a prostitute, he thought. It was clear as daylight to him now that she was kept by some army officer. What a terrible transformation in the short period of less than two years! Wasn't it a miracle that she still had memories of the other life, that she even remembered her name? If the affair of the drunken Red Cross man should happen again now, he said to himself, he would stand up beside the fellow and tell the party that here was a man of truth. What a terrible fate to befall a whole generation! The mothers of tomorrow!

By morning he was feeling a little better and more generous in his judgments. Gladys, he thought, was just a mirror reflecting a society that had gone completely rotten and maggotty at the centre. The mirror itself was intact; a lot of smudge but no more. All that was needed was a clean duster. "I have a duty to her," he told himself, "the little girl that once revealed to me our situation. Now she is in danger, under some terrible influence."

He wanted to get to the bottom of this deadly influence. It was clearly not just her good-time girl friend, Augusta, or whatever her name was. There must be some man at the centre of it, perhaps one of these heartless attack-traders who traffic in

foreign currencies and make their hundreds of thousands by sending young men to hazard their lives bartering looted goods for cigarettes behind enemy lines, or one of those contractors who receive piles of money daily for food they never deliver to the army. Or perhaps some vulgar and cowardly army officer full of filthy barrack talk and fictitious stories of heroism. He decided he had to find out. Last night he had thought of sending his driver alone to take her home. But no, he must go and see for himself where she lived. Something was bound to reveal itself there. Something on which he could anchor his saving operation. As he prepared for the trip his feeling towards her softened with every passing minute. He assembled for her half of the food he had received at the relief centre the day before. Difficult as things were, he thought, a girl who had something to eat would be spared, not all, but some of the temptation. He would arrange with his friend at the WCC to deliver something to her every fortnight.

Tears came to Gladys's eyes when she saw the gifts. Nwankwo didn't have too much cash on him but he got together twenty pounds and handed it over to her.

"I don't have foreign exchange, and I know this won't go far at all, but . . ."

She just came and threw herself at him, sobbing. He kissed her lips and eyes and mumbled something about victims of circumstances, which went over her head. In deference to him, he thought with exultation, she had put away her high-tinted wig in her bag.

"I want you to promise me something, he said.

"What?"

"Never use that expression about shelling again."

She smiled with tears in her eyes. "You don't like it? That's what all the girls call it."

"Well, you are different from all the girls. Will you promise?"

"OK."

Naturally their departure had become a little delayed. And when they got into the car it refused to start. After poking around the engine the driver decided that the battery was flat. Nwankwo was aghast. He had that very week paid thirty-four pounds to change two of the cells and the mechanic who performed it had promised him six months' service. A new battery, which was then running at two hundred and fifty pounds was simply out of the question. The driver must have been careless with something, he thought.

"It must be because of last night," said the driver.

"What happened last night?" asked Nwankwo sharply, wondering what insolence was on the way. But none was intended.

"Because we use the headlight."

"Am I supposed not to use my light then? Go and get some people and try pushing it." He got out again with Gladys and returned to the house while the driver went over to neighbouring houses to seek the help of other servants.

After at least half an hour of pushing it up and down the street, and a lot of noisy advice from the pushers, the car finally spluttered to life shooting out enormous clouds of black smoke from the exhaust.

It was eight-thirty by his watch when they set out. A few miles away a disabled soldier waved for a lift.

"Stop!" screamed Nwankwo. The driver jammed his foot on the brakes and then turned his head towards his master in bewilderment.

"Don't you see the soldier waving? Reverse and pick him up!"

"Sorry, sir," said the driver. "I don't know Master want to pick him."

"If you don't know you should ask. Reverse back."

The soldier, a mere boy, in filthy khaki drenched in sweat lacked his right leg from the knee down. He seemed not only grateful that a car should stop for him but greatly surprised. He first handed in his crude wooden crutches which the driver arranged between the two front seats, then painfully he levered himself in.

"Thanks sir," he said turning his neck to look at the back and completely out of breath.

"I am very grateful. Madame, thank you."

"The pleasure is ours," said Nwankwo. "Where did you get your wound?"

"At Azumini, sir. On tenth of January."

"Never mind. Everything will be all right. We are proud of you boys and will make sure you receive your due reward when it is all over."

"I pray God, sir."

They drove on in silence for the next half-hour or so. Then as the car sped down a slope towards a bridge somebody screamed—perhaps the driver, perhaps the soldier—"They have come!" The screech of the brakes merged into the scream and the shattering of the sky overhead. The doors flew open even before the car had come to a stop and they were fleeing blindly to the bush. Gladys was a little ahead of Nwankwo where they heard through the drowning tumult the soldier's voice crying: "Please come and open for me!" Vaguely he saw Gladys stop; he pushed past her shouting to her at the same time to come on. Then a high whistle descended like a spear through the chaos and exploded in a vast noise and motion that smashed up everything. A tree he had embraced flung him away through the bush. Then another terrible whistle starting high up and ending again in a monumental crash of the world; and then another, and Nwankwo heard no more.

He woke up to human noises and weeping and the smell and smoke of a charred world. He dragged himself up and staggered towards the source of the sounds.

From afar he saw his driver running towards him in tears and blood. He saw the remains of his car smoking and the entangled remains of the girl and the soldier. And he let out a piercing cry and fell down again.

Suggestions for Discussion

1. How do a contrast in diction and syntax create conflict in the first exchange of the story? How does this dialogue amount to dramatic action?

- 2. How do details of appearance and speech reveal both the characters of and the changes in Nwankwo and Gladys?
- 3. Find several examples of "no-dialogue." What is being conveyed besides information? How?
- 4. Identify several scenes where what the characters say is in conflict with what they do. What is the effect in each case?
- 5. How does Achebe use Nwankwo's thoughts to convey his consistent inconsistencies?

Saint Marie

LOUISE ERDRICH

Marie Lazarre

So when I went there, I knew the dark fish must rise. Plumes of radiance had soldered on me. No reservation girl had ever prayed so hard. There was no use in trying to ignore me any longer. I was going up there on the hill with the black robe women. They were not any lighter than me. I was going up there to pray as good as they could. Because I don't have that much Indian blood. And they never thought they'd have a girl from this reservation as a saint they'd have to kneel to. But they'd have me. And I'd be carved in pure gold. With ruby lips. And my toenails would be little pink ocean shells, which they would have to stoop down off their high horse to kiss.

I was ignorant. I was near age fourteen. The length of sky is just about the size of my ignorance. Pure and wide. And it was just that—the pure and wideness of my ignorance—that got me up the hill to Sacred Heart Convent and brought me back down alive. For maybe Jesus did not take my bait, but them Sisters tried to cram me right down whole.

You ever see a walleye strike so bad the lure is practically out its back end before you reel it in? That is what they done with me. I don't like to make that low comparison, but I have seen a walleye do that once. And it's the same attempt as Sister Leopolda made to get me in her clutch.

I had the mail-order Catholic soul you get in a girl raised out in the bush, whose only thought is getting into town. For Sunday Mass is the only time my father brought his children in except for school, when we were harnessed. Our soul went cheap. We were so anxious to get there we would have walked in on our hands and knees. We just craved going to the store, slinging bottle caps in the dust, making fool eyes at each other. And of course we went to church.

Where they have the convent is on top of the highest hill, so that from its windows the Sisters can be looking into the marrow of the town. Recently a windbreak was planted before the bar "for the purposes of tornado insurance." Don't tell me that. That poplar stand was put up to hide the drinkers as they get the transformation. As

they are served into the beast of their burden. While they're drinking, that body comes upon them, and then they stagger or crawl out the bar door, pulling a weight they can't move past the poplars. They don't want no holy witness to their fall.

Anyway, I climbed. That was a long-ago day. There was a road then for wagons that wound in ruts to the top of the hill where they had their buildings of painted brick. Gleaming white. So white the sun glanced off in dazzling display to set forms whirling behind your eyelids. The face of God you could hardly look at. But that day it drizzled, so I could look all I wanted. I saw the homelier side. The cracked whitewash and swallows nesting in the busted ends of eaves. I saw the boards sawed the size of broken windowpanes and the fruit trees, stripped. Only the tough wild rhubarb flourished. Goldenrod rubbed up their walls. It was a poor convent. I didn't see that then but I know that now. Compared to others it was humble, ragtag, out in the middle of no place. It was the end of the world to some. Where the maps stopped. Where God had only half a hand in the creation. Where the Dark One had put in thick bush, liquor, wild dogs, and Indians.

I heard later that the Sacred Heart Convent was a catchall place for nuns that don't get along elsewhere. Nuns that complain too much or lose their mind. I'll always wonder now, after hearing that, where they picked up Sister Leopolda. Perhaps she had scarred someone else, the way she left a mark on me. Perhaps she was just sent around to test her Sisters' faith, here and there, like the spot-checker in a factory. For she was the definite most-hard trial to anyone's endurance, even when they started out with veils of wretched love upon their eyes.

I was that girl who thought the black hem of her garment would help me rise. Veils of love which was only hate petrified by longing—that was me. I was like those bush Indians who stole the holy black hat of a Jesuit and swallowed little scraps of it to cure their fevers. But the hat itself carried smallpox and was killing them with belief. Veils of faith! I had this confidence in Leopolda. She was different. The other Sisters had long ago gone blank and given up on Satan. He slept for them. They never noticed his comings and goings. But Leopolda kept track of him and knew his habits, minds he burrowed in, deep spaces where he hid. She knew as much about him as my grandma, who called him by other names and was not afraid.

In her class, Sister Leopolda carried a long oak pole for opening high windows. It had a hook made of iron on one end that could jerk a patch of your hair out or throttle you by the collar—all from a distance. She used this deadly hook-pole for catching Satan by surprise. He could have entered without your knowing it—through your lips or your nose or any one of your seven openings—and gained your mind. But she would see him. That pole would brain you from behind. And he would gasp, dazzled, and take the first thing she offered, which was pain.

She had a stringer of children who could only breathe if she said the word. I was the worst of them. She always said the Dark One wanted me most of all, and I believed this. I stood out. Evil was a common thing I trusted. Before sleep sometimes he came and whispered conversation in the old language of the bush. I listened. He told me things he never told anyone but Indians. I was privy to both worlds of his knowledge. I listened to him, but I had confidence in Leopolda. She was the only one of the bunch he even noticed.

There came a day, though, when Leopolda turned the tide with her hook-pole. It was a quiet day with everyone working at their desks, when I heard him. He had sneaked into the closets in the back of the room. He was scratching around, tasting crumbs in our pockets, stealing buttons, squirting his dark juice in the linings and the boots. I was the only one who heard him, and I got bold. I smiled. I glanced back and smiled and looked up at her sly to see if she had noticed. My heart jumped. For she was looking straight at me. And she sniffed. She had a big stark bony nose stuck to the front of her face for smelling out brimstone and evil thoughts. She had smelled him on me. She stood up. Tall, pale, a blackness leading into the deeper blackness of the slate wall behind her. Her oak pole had flown into her grip. She had seen me glance at the closet. Oh, she knew. She knew just where he was. I watched her watch him in her mind's eye. The whole class was watching now. She was staring, sizing, following his scuffle. And all of a sudden she tensed down, posed on her bent kneesprings, cocked her arm back. She threw the oak pole singing over my head, through my braincloud. It cracked through the thin wood door of the back closet, and the heavy pointed hook drove through his heart. I turned. She'd speared her own black rubber overboot where he'd taken refuge in the tip of her darkest toe.

Something howled in my mind. Loss and darkness. I understood. I was to suffer for my smile.

He rose up hard in my heart. I didn't blink when the pole cracked. My skull was tough. I didn't flinch when she shrieked in my ear. I only shrugged at the flowers of hell. He wanted me. More than anything he craved me. But then she did the worst. She did what broke my mind to her. She grabbed me by the collar and dragged me, feet flying, through the room and threw me in the closet with her dead black overboot. And I was there. The only light was a crack beneath the odor. I asked the Dark One to enter into me and boost my mind. I asked him to restrain my tears, for they was pushing behind my eyes. But he was afraid to come back there. He was afraid of her sharp pole. And I was afraid of Leopolda's pole for the first time, too. I felt the cold hook in my heart. How it could crack through the door at any minute and drag me out, like a dead fish on a gaff, drop me on the floor like a gutshot squirrel.

I was nothing. I edged back to the wall as far as I could. I breathed the chalk dust. The hem of her full black cloak cut against my cheek. He had left me. Her spear could find me any time. Her keen ears would aim the hook into the beat of my heart.

What was that sound?

It filled the closet, filled it up until it spilled over, but I did not recognize the crying wailing voice as mine until the door cracked open, brightness, and she hoisted me to her camphor-smelling lips.

"He wants you," she said. "That's the difference. I give you love."

Love. The black hook. The spear singing through the mind. I saw that she had tracked the Dark One to my heart and flushed him out into the open. So now my heart was an empty nest where she could lurk.

Well, I was weak. I was weak when I let her in, but she got a foothold there. Hard to dislodge as the year passed. Sometimes I felt him—the brush of dim wings—but only rarely did his voice compel. It was between Marie and Leopolda now, and the struggle changed. I began to realize I had been on the wrong track with the fruits of

hell. The real way to overcome Leopolda was this: I'd get to heaven first. And then, when I saw her coming, I'd shut the gate. She'd be out! That is why, besides the bowing and the scraping I'd be dealt, I wanted to sit on the altar as a saint.

To this end, I went up on the hill. Sister Leopolda was the consecrated nun who had sponsored me to come there.

"You're not vain," she said. "You're too honest, looking into the mirror, for that. You're not smart. You don't have the ambition to get clear. You have two choices. One, you can marry a no-good Indian, bear his brats, die like a dog. Or two, you can give yourself to God."

"I'll come up there," I said, "but not because of what you think."

I could have had any damn man on the reservation at the time. And I could have made him treat me like his own life. I looked good. And I looked white. But I wanted Sister Leopolda's heart. And here was the thing: sometimes I wanted her heart in love and admiration. Sometimes. And sometimes I wanted her heart to roast on a black stick.

She answered the back door where they had instructed me to call. I stood there with my bundle. She looked me up and down.

"All right," she said finally. "Come in."

She took my hand. Her fingers were like a bundle of broom straws, so thin and dry, but the strength of them was unnatural. I couldn't have tugged loose if she was leading me into rooms of white-hot coal. Her strength was a kind of perverse miracle, for she got it from fasting herself thin. Because of this hunger practice her lips were a wounded brown and her skin deadly pale. Her eye sockets were two deep lashless hollows in a taut skull. I told you about the nose already. It stuck out far and made the place her eyes moved even deeper, as if she stared out the wrong end of a gun barrel. She took the bundle from my hands and threw it in the corner.

"You'll be sleeping behind the stove, child."

It was immense, like a great furnace. There was a small cot close behind it.

"Looks like it could get warm there," I said.

"Hot. It does."

"Do I get a habit?"

I wanted something like the thing she wore. Flowing black cotton. Her face was strapped in white bandages, and a sharp crest of starched white cardboard hung over her forehead like a glaring beak. If possible, I wanted a bigger, longer, whiter beak than hers.

"No," she said, grinning her great skull grin. "You don't get one yet. Who knows, you might not like us. Or we might not like you."

But she had loved me, or offered me love. And she had tried to hunt the Dark One down. So I had this confidence.

"I'll inherit your keys from you," I said.

She looked at me sharply, and her grin turned strange. She hissed, taking in her breath. Then she turned to the door and took a key from her belt. It was a giant key, and it unlocked the larder where the food was stored.

Inside there was all kinds of good stuff. Things I'd tasted only once or twice in my

life. I saw sticks of dried fruit, jars of orange peel, spice like cinnamon. I saw tins of crackers with ships painted on the side. I saw pickles. Jars of herring and the rind of pigs. There was cheese, a big brown block of it from the thick milk of goats. And besides that there was the everyday stuff, in great quantities, the flour and the coffee.

It was the cheese that got to me. When I saw it my stomach hollowed. My tongue dripped. I loved that goat-milk cheese better than anything I'd ever ate. I stared at it. The rich curve in the buttery cloth.

"When you inherit my keys," she said sourly, slamming the door in my face, "you can eat all you want of the priest's cheese."

Then she seemed to consider what she'd done. She looked at me. She took the key from her belt and went back, sliced a hunk off, and put it in my hand.

"If you're good you'll taste this cheese again. When I'm dead and gone," she said. Then she dragged out the big sack of flour. When I finished that heaven stuff she told me to roll my sleeves up and begin doing God's labor. For a while we worked in silence, mixing up the dough and pounding it out on stone slabs.

"God's work," I said after a while. "If this is God's work, then I've done it all my life."

"Well, you've done it with the Devil in your heart then," she said. "Not God." "How do you know?" I asked. But I knew she did. And I wished I had not brought up the subject.

"I see right into you like a clear glass," she said. "I always did."

"You don't know it," she continued after a while, "but he's come around here sulking. He's come around here brooding. You brought him in. He knows the smell of me, and he's going to make a last ditch try to get you back. Don't let him." She glared over at me. Her eyes were cold and lighted. "Don't let him touch you. We'll be a long time getting rid of him."

So I was careful. I was careful not to give him an inch. I said a rosary, two rosaries, three, underneath my breath. I said the Creed. I said every scrap of Latin I knew while we punched the dough with our fists. And still, I dropped the cup. It rolled under that monstrous iron stove, which was getting fired up for baking.

And she was on me. She saw he'd entered my distraction.

"Our good cup," she said. "Get it out of there, Marie."

I reached for the poker to snag it out from beneath the stove. But I had a sinking feel in my stomach as I did this. Sure enough, her long arm darted past me like a whip. The poker lighted in her hand.

"Reach," she said. "Reach with your arm for that cup. And when your flesh is hot, remember that the flames you feel are only one fraction of the heat you will feel in his hellish embrace."

She always did things this way, to teach you lessons. So I wasn't surprised. It was playacting, anyway, because a stove isn't very hot underneath right along the floor. They aren't made that way. Otherwise a wood floor would burn. So I said yes and got down on my stomach and reached under. I meant to grab it quick and jump up again, before she could think up another lesson, but here it happened. Although I groped for the cup, my hand closed on nothing. That cup was nowhere to be found. I heard her step toward me, a slow step. I heard the creak of thick shoe leather, the little *plat* as the folds of her heavy skirts met, a trickle of fine sand sifting, somewhere, perhaps in the bowels of her, and I was afraid. I tried to scramble up, but her foot came down lightly behind my ear, and I was lowered. The foot came down more firmly at the base of my neck, and I was held.

"You're like I was," she said. "He wants you very much."

"He doesn't want me no more," I said. "He had his fill. I got the cup!"

I heard the valve opening, the hissed intake of breath, and knew that I should not have spoke.

"You lie," she said. "You're cold. There is a wicked ice forming in your blood. You don't have a shred of devotion for God. Only wild cold dark lust. I know it. I know how you feel. I see the beast . . . the beast watches me out of your eyes sometimes. Cold."

The urgent scrape of metal. It took a moment to know from where. Top of the stove. Kettle. Lessons. She was steadying herself with the iron poker. I could feel it like pure certainty, driving into the wood floor. I would not remind her of pokers. I heard the water as it came, tipped from the spout, cooling as it fell but still scalding as it struck. I must have twitched beneath her foot, because she steadied me, and then the poker nudged up beside my arm as if to guide. "To warm your cold ash heart," she said. I felt how patient she would be. The water came. My mind went dead blank. Again. I could only think the kettle would be cooling slowly in her hand. I could not stand it. I bit my lip so as not to satisfy her with a sound. She gave me more reason to keep still.

"I will boil him from your mind if you make a peep," she said, "by filling up your ear."

Any sensible fool would have run back down the hill the minute Leopolda let them up from under her heel. But I was snared in her black intelligence by then. I could not think straight. I had prayed so hard I think I broke a cog in my mind. I prayed while her foot squeezed my throat. While my skin burst. I prayed even when I heard the wind come through, shrieking in the busted bird nests. I didn't stop when pure light fell, turning slowly behind my eyelids. God's face. Even that did not disrupt my continued praise. Words came. Words came from nowhere and flooded my mind.

Now I could pray much better than any one of them. Than all of them full force. This was proved. I turned to her in a daze when she let me up. My thoughts were gone, and yet I remember how surprised I was. Tears glittered in her eyes, deep down, like the sinking reflection in a well.

"It was so hard, Marie," she gasped. Her hands were shaking. The kettle clattered against the stove. "But I have used all the water up now. I think he is gone."

"I prayed," I said foolishly. "I prayed very hard."

"Yes," she said. "My dear one, I know."

We sat together quietly because we had no more words. We let the dough rise and punched it down once. She gave me a bowl of mush, unlocked the sausage from a special cupboard, and took that in to the Sisters. They sat down the hall, chewing their sausage, and I could hear them. I could hear their teeth bite through their

bread and meat. I couldn't move. My shirt was dry but the cloth stuck to my back, and I couldn't think straight. I was losing the sense to understand how her mind worked. She'd gotten past me with her poker and I would never be a saint. I despaired. I felt I had no inside voice, nothing to direct me, no darkness, no Marie. I was about to throw that cornmeal mush out to the birds and make a run for it, when the vision rose up blazing in my mind.

I was rippling gold. My breasts were bare and my nipples flashed and winked. Diamonds tipped them. I could walk through panes of glass. I could walk through windows. She was at my feet, swallowing the glass after each step I took. I broke through another and another. The glass she swallowed ground and cut until her starved insides were only a subtle dust. She coughed. She coughed a cloud of dust. And then she was only a black rag that flapped off, snagged in bob wire, hung there for an age, and finally rotted into the breeze.

I saw this, mouth hanging open, gazing off into the flagged boughs of trees.

"Get up!" she cried. "Stop dreaming. It is time to bake."

Two other Sisters had come in with her, wide women with hands like paddles. They were evening and smoothing out the firebox beneath the great jaws of the oven.

"Who is this one?" they asked Leopolda. "Is she yours?"

"She is mine," said Leopolda. "A very good girl."

"What is your name?" one asked me.

"Marie."

"Marie. Star of the Sea."

"She will shine," said Leopolda, "when we have burned off the dark corrosion." The others laughed, but uncertainly. They were mild and sturdy French, who did not understand Leopolda's twisted jokes, although they muttered respectfully at things she said. I knew they wouldn't believe what she had done with the kettle. There was no question. So I kept quiet.

"Elle est docile," they said approvingly as they left to starch the linens.

"Does it pain?" Leopolda asked me as soon as they were out the door.

I did not answer. I felt sick with the hurt.

"Come along," she said.

The building was wholly quiet now. I followed her up the narrow staircase into a hall of little rooms, many doors. Her cell was the quietest, at the very end. Inside, the air smelled stale, as if the door had not been opened for years. There was a crude straw mattress, a tiny bookcase with a picture of Saint Francis hanging over it, a ragged palm, a stool for sitting on, a crucifix. She told me to remove my blouse and sit on the stool. I did so. She took a pot of salve from the bookcase and began to smooth it upon my burns. Her hands made slow, wide circles, stopping the pain. I closed my eyes. I expected to see blackness. Peace. But instead the vision reared up again. My chest was still tipped with diamonds. I was walking through windows. She was chewing up the broken litter I left behind.

"I am going," I said. "Let me go."

But she held me down.

"Don't go," she said quickly. "Don't. We have just begun."

I was weakening. My thoughts were whirling pitifully. The pain had kept me strong, and as it left me I began to forget it; I couldn't hold on. I began to wonder if she'd really scalded me with the kettle. I could not remember. To remember this seemed the most important thing in the world. But I was losing the memory. The scalding. The pouring. It began to vanish. I felt like my mind was coming off its hinge, flapping in the breeze, hanging by the hair of my own pain. I wrenched out of her grip.

"He was always in you," I said. "Even more than in me. He wanted you even

more. And now he's got you. Get thee behind me!"

I shouted that, grabbed my shirt, and ran through the door throwing it on my body. I got down the stairs and into the kitchen, even, but no matter what I told myself, I couldn't get out the door. It wasn't finished. And she knew I would not leave. Her quiet step was immediately behind me.

"We must take the bread from the oven now," she said.

She was pretending nothing happened. But for the first time I had gotten through some chink she'd left in her darkness. Touched some doubt. Her voice was so low and brittle it cracked off at the end of her sentence.

"Help me, Marie," she said slowly.

But I was not going to help her, even though she had calmly buttoned the back of my shirt up and put the big cloth mittens in my hands for taking out the loaves. I could have bolted for it then. But I didn't. I knew that something was nearing completion. Something was about to happen. My back was a wall of singing flame. I was turning. I watched her take the long fork in one hand, to tape the loaves. In the other hand she gripped the black poker to hook the pans.

"Help me," she said again, and I thought, Yes, this is part of it. I put the mittens on my hands and swung the door open on its hinges. The oven gaped. She stood back a moment, letting the first blast of heat rush by. I moved behind her. I could feel the heat at my front and at my back. Before, behind. My skin was turning to beaten gold. It was coming quicker than I thought. The oven was like the gate of a personal hell. Just big enough and hot enough for one person, and that was her. One kick and Leopolda would fly in headfirst. And that would be one-millionth of the heat she would feel when she finally collapsed in his hellish embrace.

Saints know these numbers.

She bent forward with her fork held out. I kicked her with all my might. She flew in. But the outstretched poker hit the back wall first, so she rebounded. The oven was not so deep as I had thought.

There was a moment when I felt a sort of thin, hot disappointment, as when a fish slips off the line. Only I was the one going to be lost. She was fearfully silent. She whirled. Her veil had cutting edges. She had the poker in one hand. In the other she held that long sharp fork she used to tap the delicate crusts of loaves. Her face turned upside down on her shoulders. Her face turned blue. But saints are used to miracles. I felt no trace of fear.

If I was going to be lost, let the diamonds cut! Let her eat ground glass!

"Bitch of Jesus Christ!" I shouted. "Kneel and beg! Lick the floor!"

That was when she stabbed me through the hand with the fork, then took the poker up alongside my head, and knocked me out.

It must have been a half an hour later when I came around. Things were so strange. So strange I can hardly tell it for delight at the remembrance. For when I came around this was actually taking place. I was being worshiped. I had somehow gained the altar of a saint.

Leopolda was kneeling bolt upright, face blazing and twitching, a barely held fountain of blasting poison.

"Christ has marked me," I agreed.

I smiled the saint's smirk into her face. And then I looked at her. That was my mistake.

For I saw her kneeling there. Leopolda with her soul like a rubber overboot. With her face of a starved rat. With the desperate eyes drowning in the deep wells of her wrongness. There would be no one else after me. And I would leave. I saw Leopolda kneeling within the shambles of her love.

My heart had been about to surge from my chest with the blackness of my joyous heat. Now it dropped. I pitied her. I pitied her. Pity twisted in my stomach like that hook-pole was driven through me. I was caught. It was a feeling more terrible than any amount of boiling water and worse than being forked. Still, still, I could not help what I did. I had already smiled in a saint's mealy forgiveness. I heard myself speaking gently.

"Receive the dispensation of my sacred blood," I whispered.

But there was no heart in it. No joy when she bent to touch the floor. No dark leaping. I fell back into the white pillows. Blank dust was whirling through the light shafts. My skin was dust. Dust my lips. Dust the dirty spoons on the ends of my feet.

Rise up! I thought. Rise up and walk! There is no limit to this dust!

Suggestions for Discussion

- 1. By how many methods is Marie characterized? Find examples of each.
- 2. How does her narrative voice differ from the voice she uses in dialogue—its syntax, diction, imagery? How does this indicate a conflict between thought and speech?
- 3. One of the difficulties of a story told in the first person is that the narrator can't describe herself from the outside. How does Marie let us know what she looks like?
- 4. Find passages that move the action forward by the use of dialogue. How is this achieved?

5. Leopolda is characterized by appearance, speech, and action. Where and how do we know what she is thinking?

Retrospect

- 1. Arnold Friend is characterized in "Where Are You Going, Where Have You Been?" (pages 80–92) by appearance, action, and speech. Identify each. Is there a conflict employed between the methods?
- 2. How do the speech and actions of the doctor in "The Use of Force" contrast with his thoughts? What would be lost in this story if we did not know his thoughts?
- 3. Contrast the dialogue of "The Enormous Radio" with that of "The Only Traffic Signal on the Reservation Doesn't Flash Red Anymore" and try "translating" the content of one into the diction of the other.
- 4. What techniques does Sherman Alexie use to characterize a group of "ten Indian boys"?

Writing Assignments

- 1. Write a scene in which a character speaks politely or enthusiastically but whose thoughts run in strong contradiction. Characterize the listener by appearance, action, and dialogue.
- 2. Write a scene in which the central character does something palpably outrageous-violent, cruel, foolhardy, obscene. Let us, because we see into his or her mind, know that the character is behaving justly, kindly, or reasonably.
- 3. Write a character sketch describing the character both in generalizations (authorial interpretation) and in specific details. Let the details contradict the generalizations. ("Larry was the friendliest kid on the block. He had a collection of brass knucks he would let you see for fifty cents, and he would let you cock his BB gun for him as long as you were willing to hold the target.")
- 4. Write a scene in which a man (or boy) questions a woman (or girl) about her mother. Characterize all three.
- 5. Two friends are in love with the same person. One describes his or her feelings honestly and well; the other is unwilling or unable to do so, but betrays his or her feelings through appearance and action. Write the scene.
- 6. A class assignment: Each person folds a sheet of paper in four. Hold it so that one fold is down the center of the nose, the other across the middle of the eye. Grasp it in front of the eye, then tear out a small hole at that spot. Unfold the paper and draw a mask. Exchange them. Name the character you now have, and on the reverse side of the paper write a brief description

- of the character behind the mask. Go round the room, each person asking a question that can be answered for each character. (*Where was she or he born? How does she or he feel about rain? What is her/his first memory/favorite food, etc.*) Write the answers on the mask. Discuss what happened in the process.
- 7. Nearly every writer under pressure of a deadline at some point succumbs to the temptation of writing a story about writing a story. These stories are rarely successful because they offer so few possibilities of external conflict and lively characterization. So write this story: You must write a short story, and you must therefore get your major character to do whatever he or she is to do in the story. But the character is too lazy, irritable, sick, suicidal, cruel, stupid, frivolous, or having too good a time. You must trick, cajole, or force the character into the story. Do you succeed?

6

LONG AGO AND FAR AWAY Fictional Place and Time

- · Setting and Atmosphere
- · Some Aspects of Narrative Time

Our relation to place, time, and weather, like our relation to clothes and other objects, is charged with emotion more or less subtle, more or less profound. It is filled with judgment mellow or harsh. And it alters according to what happens to us. In some rooms you are always trapped; you enter them with grim purpose and escape them as soon as you can. Others invite you to settle in, to nestle or carouse. Some landscapes lift your spirits; others depress you. Cold weather gives you energy and bounce, or else it clogs your head and makes you huddle, struggling. You describe yourself as a night person or a morning person. The house you loved as a child now makes you, precisely because you were once happy there, think of loss and death.

It's central to fiction that all such emotion be used or heightened (or invented) to dramatic effect. Nothing happens nowhere—or, as Jerome Stern observed, a scene that seems to happen nowhere often seems not to happen at all. Just as the rhythm of your prose must work with and not against your intention, so the use of narrative place and time must work with and not against your ultimate meaning. Just as significant detail calls up a sense impression and also an abstraction, so the setting and atmosphere of a story impart both information and idea. Just as dialogue must do more than one thing at a time, so can setting characterize, reveal the mood, signal change, and so forth.

As I write, part of me is impatient with these speculations. Dully aware that every discussion of the elements of fiction necessarily includes the notions of atmosphere, setting, flashback, and so on, I have an impulse to deal with the matter summarily and get on to the next chapter. Events occur in time and through time; people move

in space and through space. Therefore, let your story occur during some time and in some place, and take some attitude or other.

But part of me is aware of a dull March day outside my window, a stubbled field of muddy snow, the students' heels sucked by the thawing path, the rubble of winter without any sign that the contract for spring is in the mail. The river is frozen to the bridge and breaking up fitfully below; ice fidgets at the bank. This morning, stretching too far in a series of sit-ups, I pulled my back out of joint, and now my movements are confined; my spine reaches cautiously for the back of the chair, and my hand moves gingerly toward my tea. The dullness in myself looks for dullness in the day, finds it, and creates it there. I am, in fact, fictionalizing this place and time.

In fiction, place, character, mood, and action impinge on each other constantly, each reinforcing, qualifying, contradicting, and creating each other.

... he was standing in the window of his father's cigar store, looking out at the street. He liked the striped, shady awnings across the way, the sunshiny cobbles, the heavy bent-head dray horse pulling a delivery wagon. He watched the sunshot ripple of muscles in the shoulder of the horse and a lady with green feathers in her hat . . .

Although Martin liked the sunny world beyond the window, he also liked the brown dusk of the cigar store, which even in summer was lit by gaslights on the walls. He liked the neat rows of cedarwood boxes with their lines of orderly cigars . . .

Steven Millhauser, Martin Dressler

Here both sun and shade unfold, through the details the boy notices, an image of innocence and unalloyed pleasure. Through this other window in Don DeLillo's Underworld, a more ambivalent mind observes the day:

The old nun rose at dawn, feeling her pain in every joint. She'd been rising at dawn since her days as postulant, kneeling on hardwood floors to pray. First she raised the shade. That's creation out there, little green apples and infectious disease.

Two things to notice: first, that character, setting, and mood occur simultaneously in these rich and efficient passages and, second, that setting can be manipulated to mean either the expected or the unexpected. In the next passage, J.G. Ballard depicts a third character at a third window and presents a cheerful prison:

... Luckily, his cell faced south and sunlight traversed it for most of the day. He divided its arc into ten equal segments, the effective daylight hours, marking the intervals with a wedge of mortar prized from the window ledge. Each segment he further subdivided into twelve smaller units.

Immediately he had a working timepiece, accurate to within virtually a minute . . .

"Chronopolis"

Note that although all fiction is bounded by place and time, the place and time may perfectly well be no place and outside time. The failure to create an atmosphere, to establish a sense of where or when the story takes place, always leaves us bored or confused. But an intensely created fantasy world makes new boundaries for the mind. Once upon a time, long ago and far away, a dream, hell, heaven, a time warp, a black hole, and the subconscious all have been the settings of excellent fiction. Even Utopian fiction, set Nowhere with a capital N (or nowhere spelled backwards, as Samuel Butler had it in Erehwon), happens in a nowhere of which the particular characteristics are the point. Outer space is an exciting setting precisely because its physical boundary is the outer edge of our familiar world. Obviously this does not absolve the writer from the necessity of giving outer space its own characteristics, atmosphere, and logic. If anything, these must be more intensely realized within the fiction, since we have less to borrow from in our own experience.

The westering sun shining in on his face woke Shevek as the dirigible, clearing the last high pass of the Ne Theras, turned south . . . He protted his face to the dusty window, and sure enough, down there between two low rusty ridges was a great walled field, the Port. He gazed eagerly, trying to see if there was a spaceship on the pad. Despicable as Urras was, still it was another world; he wanted to see a ship from another world, a voyager across the dry and terrible abyss, a thing made by alien hands. But there was no ship in the Port.

Ursula K. Le Guin, The Dispossessed

Setting and Atmosphere

Your fiction must have an atmosphere because without it your characters will be unable to breathe.

Part of the atmosphere of a scene or story is its setting, including the locale, period, weather, and time of day. Part of the atmosphere is its *tone*, an attitude taken by the narrative voice that can be described in terms of a quality—sinister, facetious, formal, solemn, wry. The two facets of atmosphere, setting and tone, are often inextricably mixed in the ultimate effect: A sinister atmosphere might be achieved partly by syntax, rhythm, and word choice; partly by night, dampness, and a desolated landscape.

You can orient your reader in place and time with straight information (On the southern bank of the Bayou Teche in the fall of '69 . . .), but as with the revelation of character, you may more effectively reveal place and time through concrete detail (The bugs hung over the black water in clusters of a steady hum.) Here the information

is indirect and we may have to wait for some of it, but the experience is direct. This technique of dropping us immediately into the scene (famously parodied by Snoopy in Peanuts as "It was a dark and stormy night") inevitably reveals an attitude toward the setting and produces an atmosphere.

HARMONY AND CONFLICT BETWEEN CHARACTER AND BACKGROUND

If character is the foreground of fiction, setting is the background, and as in a painting's composition, the foreground may be in harmony or in conflict with the background. If we think of the Impressionist paintings of the late nineteenth century, we think of the harmony of, say, women with light-scattering parasols strolling against summer landscapes of light-scattering trees. By contrast, the Spanish painter Jose Cortijo has a portrait of a girl on her Communion day; she sits curled and ruffled, in a lace mantilla, on an ornately carved Mediterranean throne against a backdrop of stark, harshly lit, poverty-stricken shacks.

Likewise the setting and characters of a story may be in harmony:

The Bus to St. James's—a Protestant Episcopal school for boys and girls—started its round at eight o'clock in the morning, from a corner of Park Avenue in the Sixties. The earliness of the hour meant that some of the parents who took their children there were sleepy and still without coffee, but with a clear sky the light struck the city at an extreme angle, the air was fresh, and it was an exceptionally cheerful time of day. It was the hour when cooks and door men walk dogs, and when porters scrub the lobby floor mats with soap and water.

John Cheever, "The Bus to St. James's"

Or there can be a inherent conflict between the background and foreground:

... He opened the door himself and started down the walk to get her going. The sky was a dying violet and the houses stood out darkly against it, bulbous livercolored monstrosities of a uniform ugliness though no two were alike. Since this had been a fashionable neighborhood forty years ago, his mother persisted in thinking they did well to have an apartment in it. Each house had a narrow collar of dirt around it in which sat, usually, a grubby child. Julian walked with his hands in his pockets, his head down and thrust forward and his eyes glazed with the determination to make himself completely numb during the time he would be sacrificed to her pleasure.

Flannery O'Connor, "Everything That Rises Must Converge"

Notice how images of the time of day work with concrete details of place to create very different atmospheres—on the one hand morning, Park Avenue, earliness, clear sky, light, extreme angle, air, fresh, cheerful, dogs, scrub, soap, water; and on the other dying violet, darkly, bulbous liver-colored monstrosities, uniform ugliness, narrow, dirt, grubby child. Notice also that where conflict occurs, there is already "narrative content," or the makings of a story. We might reasonably expect that in the Cheever story, where the characters are in apparent harmony with their background, there is or will be conflict between or among those children, parents, and perhaps the servitors who keep their lives so well scrubbed. It won't surprise us, toward the end of the story, to see this contrast between weather and narrative mood: "... Mr. Bruce led her out the door into the freshness of a winter evening, holding her, supporting her really, for she might have fallen."

SYMBOLIC AND SUGGESTIVE SETTING

Whether there is conflict between character and setting or the conflict takes place entirely in the foreground, within, between, or among the characters, the setting is important to our understanding of character type and of what to expect, as well as to the emotional value that arises from the conflict. As we need to know a character's gender, race, and age, we need to know in what atmosphere she or he operates to understand the significance of the action.

Since the rosy-fingered dawn came over the battlefield of Homer's *Iliad* (and no doubt well before that), poets and writers have used the context of history, night, storm, stars, sea, city, and plain to give their stories a sense of reaching out toward the universe. Sometimes the universe resonates with an answer. In his plays Shake-speare consistently drew parallels between the conflicts of the heavenly bodies and the conflicts of nations and characters. Whether or not an author deliberately uses this correspondence to suggest the influence of the macrocosm on the microcosm, a story's setting can give the significant sense of other without which, as in an infant's consciousness, there is no valid sense of self.

In "The Life You Save May Be Your Own," Flannery O'Connor uses the elements in a conscious Shakespearian way, letting the setting reflect and effect the theme.

The old woman and her daughter were sitting on their own porch when Mr. Shiflet came up their road for the first time. The old woman slid to the edge of her chair and leaned forward, shading her eyes from the piercing sunset with her hand. The daughter could not see far in front of her and continued to play with her fingers. Although the old woman lived in this desolate spot with only her daughter, and she had never seen Mr. Shiflet before, she could tell, even from a distance, that he was a tramp and no one to be afraid of. His left coat sleeve was folded up to show there was only half an arm in it and his gaunt figure listed lightly to the side as if the breeze were pushing him. He had on a black town suit and a brown felt hat that was turned up in the front and down in the back and he carried a tin tool box by a handle. He came on at an amble, up her road, his face turned toward the sun which appeared to be balancing itself on the peak of a small mountain.

The focus in this opening paragraph of the story is on the characters and their actions, and the setting is economically, almost incidentally, established: porch, road, sunset, breeze, peak, small mountain. What the passage gives us is a type of landscape, rural and harsh; the only adjectives in the description of the setting are piercing, desolate, and small. But this general background works together with details of action, thought, and appearance to establish a great deal more that is both informational and emotional. The old woman's peering suggests that people on the road are not only unusual but suspicious. On the other hand, that she is reassured to see a tramp suggests both a period and a set of assumptions about country life. That Mr. Shiflet wears a town suit establishes him as a stranger to this set of assumptions. That the sun appeared to be balancing itself (we are not sure whether it is the old woman's observation or the author's) leaves us, at the end of the paragraph, with a sense of anticipation and tension.

Now, what happens in the story is this: Mr. Shiflet repairs the old woman's car and (in order to get the car) marries her retarded daughter. He abandons the daughter on their honeymoon and picks up a hitchhiker who insults both Mr. Shiflet and the memory of his mother. The hitchhiker jumps out. Mr. Shiflet curses and drives on.

Throughout the story, as in the first paragraph, the focus remains on the characters and their actions. Yet the landscape and the weather make their presence felt, subtly commenting on attitudes and actions. As Mr. Shiflet's fortunes wax promising and he expresses satisfaction with his own morality, "A fat yellow moon appeared in the branches of the fig tree as if it were going to roost there with the chickens." When, hatching his plot, he sits on the steps with the mother and daughter, "The old woman's three mountains were black against the sky." Once he has abandoned the girl, the weather grows "hot and sultry, and the country had flattened out. Deep in the sky a storm was preparing very slowly and without thunder." Once more there is a sunset, but this time the sun "was a reddening ball that through his windshield was slightly flat on the bottom and top," and this deflated sun reminds us of the "balanced" one about to be punctured by the peak in its inevitable decline. When the hitchhiker has left him, a cloud covers the sun, and Mr. Shiflet in his fury prays for the Lord to "break forth and wash the slime from this earth!" His prayer is apparently answered.

After a few minutes there was a guffawing peal of thunder from behind and fantastic raindrops, like tin-can tops, crashed over the rear of Mr. Shiflet's car. Very quickly he stepped on the gas and with his stump sticking out the window he raced the galloping shower to Mobile.

The setting in this story, as this bald summary emphasizes, is deliberately used as a comment on the actions. The behavior of the elements, in ironic juxtaposition to the title, "The Life You Save May Be Your Own," makes clear that the "slime" Mr. Shiflet has damned may be himself. Yet the reader is never aware of this as a symbolic intrusion. The setting remains natural and realistically convincing, an incidental backdrop, until the heavens are ready to make their guffawing comment.

Robert Coover's settings rarely present a symbolic or sentient universe, but they produce in us an emotionally charged expectation of what is likely to happen here. The following passages are the opening paragraphs of three short stories from a single collection, *Pricksongs and Descants*. Notice how the three different settings are achieved not only by imagery and content, but also by the very different rhythms of the sentence structure.

A pine forest in the midafternoon. Two children follow an old man, dropping breadcrumbs, singing nursery tunes. Dense earthy greens seep into the darkening distance, flecked and streaked with filtered sunlight. Spots of red, violet, pale blue, gold, burnt orange. The girl carries a basket for gathering flowers. The boy is occupied with the crumbs. Their song tells of God's care for little ones.

"The Gingerbread House"

Situation: television panel game, live audience. Stage strobelit and cameras insecting about. Moderator, bag shape corseted and black suited behind desk/rostrum, blinking mockmodesty at lens and lamps, practised pucker on his soft mouth and brows arched in mild goodguy astonishment. Opposite him, the panel: Aged Clown, Lovely Lady and Mr. America, fat as the continent and bald as an eagle. There is an empty chair between Lady and Mr. A, which is now filled, to the delighted squeals of all, by a spectator dragged protesting from the Audience, nondescript introduced as Unwilling Participant, or more simply, Bad Sport. Audience: same as ever, docile, responsive, good-natured, terrifying. And the Bad Sport, you ask, who is he? fool! thou art!

"Panel Game"

She arrives at 7:40, ten minutes late, but the children, Jimmy and Bitsy, are still eating supper, and their parents are not ready to go yet. From the other rooms come the sounds of a baby screaming, water running, a television musical (no words: probably a dance number—patterns of gliding figures come to mind). Mrs. Tucker sweeps into the kitchen, fussing with her hair, and snatches a baby bottle full of milk out of a pan of warm water, rushes out again. Harry! she calls. The babysitter's here already!

"The Babysitter"

Here are three quite familiar places: a fairy-tale forest, a television studio, and a suburban house. In at least the first two selections, the locale is more consciously and insistently set than in the O'Connor opening, yet all three remain suggestive backdrops rather than active participants. Coover directs our attitude toward these places through imagery and tone. The forest is a neverland, and the time is once upon a time, though there are grimmer than Grimm hints of violence about it. The television studio is a place of hysteria, chaos, and hypocrisy, whereas the American

suburbia, where presumably such television shows are received, is boring rather than chaotic, not hysterical but merely hassled in a predictable sort of way.

In "The Gingerbread House," simple sentence structure helps establish the childlike quality appropriate to a fairy tale. But a more complex sentence intervenes, with surprising intensity of imagery: dense, earthy, seep, darkening, flecked, streaked, filtered. Because of this, the innocence of the tone is set askew, so that by the time we hear of God's care for little ones, we fully and accurately expect a brutal disillusionment.

Setting can often, and in a variety of ways, arouse reader expectation and foreshadow events to come. In "The Gingerbread House," there is an implied conflict between character and setting, between the sentimentality of the children's flowers and nursery tunes and the threatening forest, so that we are immediately aware of the central conflict of the story: innocence versus violence.

But as in the Cheever passage quoted earlier, anticipation can also be aroused by an insistent single attitude toward setting, and in this case the reader, being a contrary sort of person, is likely to anticipate a change or paradox. Here, for example, is part of the opening paragraph of E.M. Forster's A Passage to India:

Except for Marabar Caves—and they are twenty miles off—the city of Chandrapore presents nothing extraordinary. Edged rather than washed by the River Ganges, it trails for a couple of miles along the bank, scarcely distinguishable from the rubbish it deposits so freely . . . The streets are mean, the temples ineffective, and though a few fine houses exist they are hidden away in gardens or down alleys whose filth deters all but the invited guest.

The narrative continues in this way, creating an unrelenting portrait of the dreariness of Chandrapore-made of mud, mud moving, abased, monotonous, rotting, swelling, shrinking, low but indestructible form of life. The images are a little too onesided, and as we might protest in life against a too fanatical condemnation of a place—isn't there anything good about it?—so we are led to expect (accurately again) that in the pages that follow, somehow beauty and mystery will break forth from the dross. Likewise, but in the opposite way, the opening pages of Woolf's Mrs. Dalloway burst with affirmation, the beauty of London and spring, love of life and love of life and love of life again! We suspect (accurately once more) that death and hatred lurk.

Where conflict between character and setting is immediately introduced, as it is in both "The Gingerbread House" and "Panel Game," it is usually because the character is unfamiliar with, or uncomfortable in, the setting. In "Panel Game" it's both. The television studio, which is in fact a familiar and unthreatening place to most of us, has been made mad. This is achieved partly by violating expected grammar. The sentences are not sentences. They are missing vital verbs and logical connectives, so that the images are squashed against each other. The prose is cluttered, effortful, negative; as a result, as reader you know "the delighted squeals of all" do not include your own, and you're ready to sympathize with the unwilling central character (you!).

ALIEN AND FAMILIAR SETTING

Many poets and novelists have observed that the function of literature is to make the ordinary fresh and strange. F. Scott Fitzgerald, on the other hand, advised a young writer that reporting extreme things as if they were ordinary was the starting point of fiction. Both of these views are true, and they are particularly true of setting. Whether a place is familiar or unfamiliar, comfortable or discomfiting in fiction has nothing to do with whether the reader actually knows the place and feels good there. It is an attitude taken, an assumption made. In his detective novels, Ross MacDonald assumes a familiarity toward California that is perfectly translatable into Japanese ("I turned left off the highway and down an old switchback blacktop to a dead end"), whereas even the natives of North Hollywood must feel alien on Tom Wolfe's version of their streets.

... endless scorched boulevards lined with one-story stores, shops, bowling alleys, skating rinks, taco drive-ins, all of them shaped not like rectangles but like trapezoids, from the way the roofs slant up from the back and the plate-glass fronts slant out as if they're going to pitch forward on the sidewalk and throw up.

The Kandy-Kolored Tangerine-Flake Streamline Baby

The prose of Tom Wolfe, whether about rural North Carolina, Fifth Avenue, or Cape Kennedy, lives in a tone of constant astonishment. Ray Bradbury's outer space is pure down-home.

It was quiet in the deep morning of Mars, as quiet as a cool black well, with stars shining in the canal waters, and, breathing in every room, the children curled with their spiders in closed hands.

Martian Chronicles

The setting of the passage from Coover's "The Dabysitter" is ordinary and is presented as ordinary. The sentences have standard and rather leisurely syntax; neither form nor image startles. In fact, there are few details of the sort that produce interesting individuality: The house is presented without a style; the children are named but not seen; Mrs. Tucker behaves in a way predictable and familiar to anyone in late-twentieth-century America. What Coover has in fact done is to present us with a setting so usual that we begin to suspect that something unusual is afoot.

I have said of characterization that if the character is presented as typical, we would judge that character to be stupid or evil. The same is true of setting, but with results more varied and fruitful for an author's ultimate purpose. At the center of a fiction is a consciousness, one as individual and vital as the author can produce. If the setting remains dull and damnable, then there is conflict between character and setting, and this conflict can throw that individuality and vitality into relief. Many

great stories and novels have relied on setting as a means of showing the intensity and variety of human consciousness by contrasting consciousness with a social or physical world that is rule-hampered, insincere, and routine. Gustave Flaubert's Madame Bovary comes instantly to mind: The fullness and exactitude of the portrait is partly achieved by the provinciality of the background. This provinciality, which is French and nineteenth-century, remains typical to American readers of the 1990s, who are much more likely to have grown up in Coover's suburban house. It is Flaubert's tone that creates a sense of the familiar and the typical.

Much the same thing happens in "The Babysitter." The Tuckers, their house, their children, their car, their night out, and their babysitter remain unvaryingly typical through all the external actions in the course of the evening. Against this backdrop play the individual fantasies of the characters—brilliant, brutal, sexual,

dangerous, and violent—which provides the conflict of the story.

One great advantage of being a writer is that you may create the world. Places and the elements have the significance and the emotional effect you give them in language. As a person you may be depressed by rain, but as an author you are free to make rain mean freshness, growth, bounty, and God. You may choose; the only thing you are not free to do is not to choose.

As with character, the first requisite of effective setting is to know it fully, to experience it mentally, and the second is to create it through significant detail. What sort of place is this, and what are its peculiarities? What is the weather like, the light, the season, the time of day? What are the contours of the land and architecture? What are the social assumptions of the inhabitants, and how familiar and comfortable are the characters with this place and its lifestyle? These things are not less important in fiction than in life, but more, since their selection inevitably takes on significance. Charles Baxter, in Burning Down the House, admonishes the fiction writer toward the finest ideal of the process:

In the way I am describing them, however, the objects and things surrounding the fictional characters have the same status and energy as the characters themselves. Setting—in the way I want to define it—is not just a place where the action occurs. (Nor is the Earth just a prized location where our lives happen to happen . . .)

AN EXERCISE IN SETTING

Here are a series of passages about war, set in various periods and places. The first is in Russia during the campaign of Napoleon, the second in Italy during World War I, the third on the island of Pianosa during World War II, the fourth during the Vietnam War, the fifth in a post-holocaust future.

Compare the settings. How do climate, period, imagery, and language contribute to each? To what degree is setting a sentient force? Is there conflict between character and setting? How does setting affect and/or reveal the attitude taken toward the war? What mood, what emotions are implied?

Several tens of thousands of the slain lay in diverse postures and various uniforms. Over the whole field, previously so gaily beautiful with the glitter of bayonets and cloudlets of smoke in the morning sun, there now spread a mist of damp and smoke and a strange acid smell of saltpeter and blood. Clouds gathered and drops of rain began to fall on the dead and wounded, on the frightened, exhausted, and hesitating men, as if to say: Enough, men! Enough! Cease! Bethink yourselves! What are you doing?

Leo Tolstoy, War and Peace

In the late summer of that year we lived in a house in a village that looked across the river and plain to the mountains. In the bed of the river there were pebbles and boulders, dry and white in the sun, and the water was clear and swiftly moving and blue in the channels. Troops went by the house and down the road and the dust they raised powdered the leaves of the trees. The trunks of the trees too were dusty and the leaves fell early that year and we saw the troops marching along the road and the dust rising and leaves, stirred by the breeze, falling and the soldiers marching and afterward the road bare and white except for the leaves.

Ernest Hemingway, A Farewell to Arms

Their only hope was that it would never stop raining, and they had no hope because they all knew it would. When it did stop raining in Pianosa, it rained in Bologna. When it stopped raining in Bologna, it began again in Pianosa. If there was no rain at all, there were freakish, inexplicable phenomena like the epidemic of diarrhea or the bomb line that moved. Four times during the first six days they were assembled and briefed and then sent back. Once, they took off and were flying in formation when the control tower summoned them down. The more it rained, the worse they suffered. The worse they suffered, the more they prayed that it would continue raining.

Joseph Heller, Catch-22

The rain fed fungus that grew in the men's boots and socks, and their socks rotted, and their feet turned white and soft so that the skin could be scraped off with a fingernail, and Stink Harris woke up screaming one night with a leech on his tongue. When it was not raining, a low mist moved across the paddies, blending the elements into a single gray element, and the war was cold and pasty and rotten. Lieutenant Corson, who came to replace Lieutenant Sidney Martin, contracted the dysentery. The trip-flares were useless. The ammunition corroded and the foxholes filled with mud and water during the nights, and in the mornings there was always the next village and the war was the same.

Tim O'Brien, Going After Cacciato

She liked the wild, quatrosyllabic lilt of the word, Barbarian. Then, looking beyond the wooden fence, she saw a trace of movement in the fields beyond. It was not the wind among the young corn; or, if it was wind among the young corn, it carried her the whinny of a raucous horse. It was too early for poppies but she saw a flare of scarlet. She ceased to watch the Soldiers; instead she watched the movement flow to the fences and crash through them and across the tender wheat. Bursting from the undergrowth came horseman after horseman. They flashed with curious curved plates of metal dredged up from the ruins. Their horses were bizarrely caparisoned with rags, small knives, bells and chains dangling from manes and tails, and man and horse together, unholy centaurs crudely daubed with paint, looked twice as large as life. They fired long guns. Confronted with the terrors of the night in the freshest hours of the morning, the gentle crowd scattered, wailing.

Angela Carter, Heroes and Villains

Some Aspects of Narrative Time

Literature is, by virtue of its nature and subject matter, tied to time in a way the other arts are not. A painting represents a frozen instant in time, and the viewing time is a matter of the viewer's choice; no external limits are imposed in order to say that you have seen the painting. Music takes a certain time to hear, and the timing of the various parts is of utmost importance, but the time scheme is self-enclosed and makes no reference to time in the world outside itself. A book takes time to read, but the reader chooses his or her rate and may put it down and take it up at will. In narrative, the vital relationship to time is content time, the period covered in the story. It is quite possible to write a story that takes about twenty minutes to read and covers about twenty minutes of action (Jean-Paul Sartre performed experiments in this durational realism), but no one has suggested such a correspondence as a fictional requirement. Sometimes the period covered is telescoped, sometimes stretched. The history of the world up until now can be covered in a sentence; four seconds of crisis may take a chapter. It's even possible to do both at once: William Golding's entire novel Pincher Martin takes place between the time the drowning protagonist begins to take off his boots and the moment he dies with his boots still on. But when asked by a student, "How long does it really take?" Golding replied, "Eternity."

SUMMARY AND SCENE

Summary and scene are methods of treating time in fiction. A summary covers a relatively long period of time in relatively short compass; a scene deals at length with a relatively short period of time.

Summary is a useful and often necessary device: to give information, fill in a character's background, let us understand a motive, alter pace, create a transition, leap moments or years.

Scene is always necessary to fiction. Scene is to time what concrete detail is to

the senses; that is, it is the crucial means of allowing your reader to experience the story with the characters. A confrontation, a turning point, or a crisis occurs at given moments that take on significance as moments and cannot be summarized. The form of a story requires confrontation, turning points, and crises, and therefore requires scenes.

It is quite possible to write a short story in a single scene, without any summary at all. It is not possible to write a successful story entirely in summary. One of the most common errors beginning fiction writers make is to summarize events rather than to realize them as moments.

In the following paragraph from Margaret Atwood's Lady Oracle, the narrator has been walking home from her Brownie troop with older girls who tease and terrify her with threats of a bad man.

The snow finally changed to slush and then to water, which trickled down the hill of the bridge in two rivulets, one on either side of the path; the path itself turned to mud. The bridge was damp, it smelled rotten, the willow branches turned yellow, the skipping ropes came out. It was light again in the afternoons, and on one of them, when for a change Elizabeth hadn't run off but was merely discussing the possibilities with the others, a real man actually appeared.

He was standing at the far side of the bridge, a little off the path, holding a bunch of daffodils in front of him. He was a nice-looking man, neither old nor young, wearing a good tweed coat, not at all shabby or disreputable. He didn't have a hat on, his taffy-colored hair was receding and the sunlight gleamed on his high forehead.

The first paragraph of this quotation covers the way things were over a period of a few months and then makes a transition to one of the afternoons; the second paragraph specifies a particular moment. Notice that although summary sets us at a distance from the action, sense details remain necessary to its life: snow, path, bridge, willow branches, skipping ropes. These become more sharply focused as we concentrate on the particular moment. More importantly, the scene is introduced when an element of conflict and confrontation occurs. That the threatened bad man does appear and that he is surprisingly innocuous promises a turn of events and a change in the relationship among the girls. We need to see the moment when this change occurs.

Throughout *Lady Oracle*, which is by no means unusual in this respect, the pattern recurs: a summary leading up to, and followed by, a scene that represents a turning point.

My own job was fairly simple. I stood at the back of the archery range, wearing a red leather change apron, and rented out the arrows. When the barrels of arrows were almost used up, I'd go down to the straw targets. The difficulty was that we couldn't make sure all the arrows had actually been shot before we went down to clear the targets. Rob would shout, Bows DOWN, please, arrows OFF the string, but occasionally someone would let an arrow go, on purpose or by accident. This

was how I got shot. We'd pulled the arrows and the men were carrying the barrels back to the line; I was replacing a target face, and I'd just bent over.

The summaries in these two passages are of the two most common types, which I would call *sequential* and *circumstantial*, respectively. The summary in the first passage is sequential; it relates events in their sequence but compresses them: *snow finally changed to slush and then to water, willow branches turned yellow, and then skipping ropes came out*; the transition from winter to spring is made in a paragraph. The summary in the second excerpt is circumstantial because it describes the general circumstances during a period of time: This is how things were, this is what usually or frequently happened. The narrator in the second passage describes her job in such a way: I stood at the back of the archery range. I'd go down to the straw targets. Rob would shout. Again, when the narrator arrives at an event that changes her circumstance (I got shot), she focuses on a particular moment: I was replacing a target face, and I'd just bent over.

Some writers have a tendency to oversummarize, racing through more time and more events than necessary to tell the story. The danger here is lack of depth. Some by impulse undersummarize, finding it difficult to deal with quick leaps and transitions, dwelling at excessive length on every scene, including the scenes of the past. The danger of this writing is that it will outlast the reader's patience. After you have written (and especially workshopped) a few stories, you know which sort of writer you are, and which direction you need to work. If people say you have enough material for a novel, then you have probably not distilled your material down to the scene or very few scenes that contain the significance you seek. Pick one event of all you have included that contains a moment of crucial change in your character. Write that scene in detail, moment by moment. Take time to create the place and the period. Make us see, taste, smell. Let characters speak. Is there a way to indicate, sketch, contain—or simply omit—all that earlier life you raced through in summary? If this proves too difficult, have you really found out yet what your story is about? Explore the scene, rather than the summary, for clues.

If your critics say you write long or your story really begins on page three (or six, or eleven), have you indulged yourself to setting things up, or dwelt on the story's past at the expense of its present? Try condensing a scene to a sentence. Try fusing two or even three scenes into one. This sometimes seems impossible at first, and it may involve sacrificing a delicious phrase or a nifty nuance, but it is simply the necessary work of plotting.

In either case, if your readers are confused by what happens at the end, it may very well be that you have summarized the crisis instead of realizing it in a scene. The crisis moment in a story must always be presented as a scene. This is the moment we have been waiting for. This is the payoff when the slipper fits. We want to be there. We want "there" to be there. We want to feel the moment change happens, hear it, taste it, see it in color in close-up on the wide screen of our minds. This is also a hard job, sometimes the hardest a writer has to do—it's draining to summon up all that emo-

tion in all its intensity. And there isn't always a glass slipper handy when you need one; it may be difficult enough to identify the moment when you need that scene.

It may help to recognize the difference between summary and scene to compare the ideas of circumstantial, sequential, and scene to the process of your own memory, which also drastically condenses. You might think of your past as a movement through time: I was born in Arizona and lived there with my parents until I was eighteen; then I spent three years in New York before going on to England. Or you might remember the way things were during a period of that time: In New York we used to go down Broadway for a midnight snack, and Judy would always dare us to some nonsense or other before we got back. But when you think of the events that significantly altered either the sequence or the circumstances of your life, your mind will present you with a scene: Then one afternoon Professor Bovic stopped me in the hall after class and wagged his glasses at me. "Have you thought about studying in England?"

Jerome Stern, in *Making Shapely Fiction*, astutely observes that like a child in a tantrum, when you want everyone's full attention you "make a scene," using the writer's full complement of "dialogue, physical reactions, gestures, smells, sounds, and thoughts."

Frequently, the function of summary is precisely to heighten scene. It is in the scene, the "present" of the story that the drama, the discovery, the decision, the potential for change, engage our attention. But summary may be used within such a scene to suggest contrast with the past, to intensify mood, to delay while augmenting our anticipation of what will happen next. This example from Rosellen Brown's Before and After—in which a father disturbed by reports of a young girl's murder is checking out his son's car in a dark garage—does all three.

The snow was lavender where the light came down on it, like the weird illumination you see in planetariums that changes every color and makes white electric blue. Jacob and I loved to go to the science museum in Boston—not that long ago he had been at that age when the noisy saga of whirling planets and inexplicable anti-gravitational feats, narrated by a man with a deep official-facts voice, was thrilling. He was easily, unstintingly thrilled, or used to be. Not now, though.

Notice how Brown uses brief summaries both of the way things used to be and the way things have changed over time (both circumstantial and sequential summary), as well as images of time, weather, and even the whirling cosmos to rouse our fear toward the "instant" in which major change occurs:

At the last instant I thought I'd look at the trunk. I was beginning to feel relief wash over me like that moon-white air outside—a mystery still, where he might be, but nothing suspicious. The trunk snapped open and rose with the slow deliberation of a drawbridge, and then I thought I'd fall over for lack of breath. Because I knew I was looking at blood.

Examining your own mind for the three kinds of memory—sequential summary, circumstantial summary, and scene—will help make evident the necessity of scene in fiction. The moments that altered your life you remember at length and in detail; your memory tells you your story, and it is a great natural storyteller.

FLASHBACK

Flashback is one of the most magical of fiction's contrivances, easier and more effective in this medium than in any other, because the reader's mind is a swifter mechanism for getting into the past than anything that has been devised for stage or even film. All you must do is to give the reader smooth passage into the past, and the force of the story will be time warped to whenever and wherever you want it.

Nevertheless, many beginning writers use unnecessary flashbacks. This happens because flashback can be a useful way to provide background to character or the history of events—the information that has come to be known as *backstory*—and is often seen as the easiest or only way. It isn't. Dialogue, brief summary, a reference or detail can often tell us all we need to know, and when that is the case, a flashback becomes cumbersome and overlong, taking us from the present where the story and our interest lie. Furthermore, these intrusive passages of childhood, motivation, and explanation tend to come early in the story, before we are caught up in the action. Then we wonder whether there is any story on its way.

If you are tempted to use flashback to fill in the whole past, try using your journal for exploring background. Write down everything, fast. Then take a hard look at it to decide just how little of it you can use, how much of it the reader can infer, how you can sharpen an image to imply a past incident or condense a grief into a line of dialogue. Trust the reader's experience of life to understand events from attitudes. And keep the present of the story moving.

Flashback is effectively used in fiction to *reveal* at the *right time*. It does not so much take us from, as contribute to, the central action of the story, so that as readers we suspend the forward motion of the narrative in our minds as our understanding of it deepens. David Madden, in *A Primer of the Novel for Readers and Writers*, says that such time shifts are most effective if the very fact of their occurrence contributes to the revelation of character and theme.

If you find that you need an excursion into the past to reveal, at some point, why the character reacts as she does, or how totally he is misunderstood by those around him, or some other point of emotional significance, then there are several ways to get the reader to cooperate.

Provide some sort of transition. A connection between what's happening in the present and what happened in the past will often best transport the reader, just as it does the character.

Avoid blatant transitions, such as "Henry thought back to the time" and "I drifted back in memory." Assume the reader's intelligence and ability to follow a leap back.

The kid in the Converse high-tops lifted off on the tips of his toes and slamdunked it in.

Joe'd done that once, in the lot off Seymour Street, when he was still four inches shorter than Ruppert and had already started getting zits. It was early fall, and . . .

A graceful transition to the past allows you to summarize necessary background quickly, as in this example from James W. Hall's *Under Cover of Daylight*.

Thorn watched as Sugarman made a quick inspection of the gallery. Thorn sat on the couch where he'd done his homework as a boy, the one that looked out across the seawall toward Carysfort light.

That was how his nights had been once, read a little Thoreau, do some algebra, and look up, shifting his body so he could see through the louvers the fragile pulse of that marker light, and let his mind roam, first out the twelve miles to the reef and then pushing farther, out past the shipping lanes into a world he pictured as gaudy and loud, chaotic. Bright colors and horns honking, exotic vegetables and market stalls, and water, clear and deep and shadowy, an ocean of fish, larger and more powerful than those he had hauled to light. Beyond the reef.

If you are writing in the past tense, begin the flashback in the past perfect and use the construction "had (verb)" two or three times. Then switch to the simple past; the reader will be with you. If you are writing in the present tense, you may want to keep the whole flashback in the past.

Try to avoid a flashback within a flashback. If you find yourself tempted by this awkward shape, it probably means you're trying to let flashback carry too much of the story.

When the flashback ends, be very clear that you are catching up to the present again. Repeat an action or image that the reader will remember belongs to the basic time period of the story. Often simply beginning the paragraph with "Now . . ." will accomplish the reorientation.

SLOW MOTION

Flashback is a term borrowed from film, and I want to borrow another—slow motion—to point out a correlation between narrative time and significant detail.

When people experience moments of great intensity, their senses become especially alert and they register, literally, more than usual. In extreme crisis people have the odd sensation that time is slowing down, and they see, hear, smell, and remember ordinary sensations with extraordinary clarity. This psychological fact can work artistically in reverse: If you record detail with special focus and precision, it will create the effect of intensity. The phenomenon is so universal that it has become a standard film technique to register a physical blow, gunshot, sexual passion, or ex-

treme fear in slow motion. The technique works forcefully in fiction. Note in the quotation from Rosellen Brown above, how the trunk "snapped open and rose with the slow deliberation of a drawbridge."

Ian McEwan, in A Child in Time, demonstrates the technique:

. . . He was preparing to overtake when something happened—he did not quite see what—in the region of the lorry's wheels, a hiatus, a cloud of dust, and then something black and long snaked through a hundred feet towards him. It slapped the windscreen, clung there a moment and was whisked away before he had time to understand what it was. And then—or did this happen in the same moment?—the rear of the lorry made a complicated set of movements, a bouncing and swaying, and slewed in a wide spray of sparks, bright even in sunshine. Something curved and metallic flew off to one side. So far Stephen had had time to move his foot towards the brake, time to notice a padlock swinging on a loose flange, and 'Wash me please' scrawled in grime. There was a whinnying of scraped metal and new sparks, dense enough to form a white flame which seemed to propel the rear of the lorry into the air.

In this passage, McEwan records the psychological phenomenon traced above in such a way anyone who has faced some sort of accident, certainly anyone old enough to be reading the novel, can identify with the experience of sensual slowdown. But the technique works also with experiences most of us have not had and to which we must submit in imagination:

Blood was spurting from an artery in my left leg. I could not see it, and I do not recall how I knew it . . . for a short time I was alone with Patrick. I told myself I was in good hands, but I did not do this with words; I surrendered myself. I focused on breathing. I slowed my breathing, and tried to remain absolutely in the present, in each moment . . . waiting to die or stay alive was like getting an injection as a child, when you first learned not to think, but to gather yourself into the present, to breath slowly, to relax your muscles, even your arm as the nurse swabbed it with alcohol, to feel the cool alcohol, to smell it, to feel your feet on the floor and see the color of the wall, and nothing else as your slow breathing opened you up to the incredible length and breadth and depth of one second.

Andre Dubus, "Breathing"

And the technique will work when the intensity or trauma of the moment is not physical but emotional:

They were in the deep sleep of midnight when Pauline came quietly into her son's room and saw that there were two in his bed. She turned on the light. The room was cold and stuffy; warm in the core of it was the smell of a body she had known since she gave birth to him, unmistakable to her as the scent that leads a bitch to her puppy, and it was mingled with the scents of sexuality caressed from the female nectary. The cat was a rolled fur glove in an angle made by Sasha's bent knees. The two in the bed opened their eyes; they focussed out of sleep and saw Pauline. She was looking at them, at their naked shoulders above the covers . . .

Nadine Gordimer, A Sport of Nature

Central to this technique are the alert but matter-of-fact acceptance of the event and the observation of small, sometimes apparently arbitrary, details. The characters do not say, "Oh my God, we're going to die!" or "What an outrage!" They record a padlock swinging, the cool feel of an alcohol swab, a cat rolled into the angle of bent knees.

Beginning writers often rush through or skimp on the elements of setting and time, probably out of dreary memories of long descriptions they have read. But when atmosphere is well created we do not experience it as description; we experience it. We yawn over passages in which authors have indulged themselves in plum-colored homilies on the beauties of nature or the wealth of decor. But just as dialogue that only offers information is too inert for the purposes of fiction, so too is description that only describes. The full realization of locale and period, the revelation of a character through architecture or of emotion through weather, the advancement of plot through changes in season and history, are among the pleasures of both writer and reader. Once you become adept at the skill of manipulating atmosphere, you will find that the necessity of setting your story some place and some time is a liberating opportunity.

A Very Old Man with Enormous Wings

GABRIEL GARCÍA MARQUEZ TRANSLATED BY GREGORY RABASSA

On the third day of rain they had killed so many crabs inside the house that Pelayo had to cross his drenched courtyard and throw them into the sea, because the newborn child had a temperature all night and they thought it was due to the stench. The world had been sad since Tuesday. Sea and sky were a single ash-gray thing and the sands of the beach, which on March nights glimmered like powdered light, had become a stew of mud and rotten shellfish. The light was so weak at noon that when Pelayo was coming back to the house after throwing away the crabs, it was hard for him to see what it was that was moving and groaning in the rear of the courtyard. He had to go very close to see that it was an old man, a very old man, lying face down in the mud, who, in spite of his tremendous efforts, couldn't get up, impeded by his enormous wings.

Frightened by that nightmare, Pelayo ran to get Elisenda, his wife, who was

186

putting compresses on the sick child, and he took her to the rear of the courtyard. They both looked at the fallen body with mute stupor. He was dressed like a ragpicker. There were only a few faded hairs left on his bald skull and very few teeth in his mouth, and his pitiful condition of a drenched great-grandfather had taken away any sense of grandeur he might have had. His huge buzzard wings, dirty and half-plucked, were forever entangled in the mud. They looked at him so long and so closely that Pelayo and Elisenda very soon overcame their surprise and in the end found him familiar. Then they dared speak to him, and he answered in an incomprehensible dialect with a strong sailor's voice. That was how they skipped over the inconvenience of the wings and quite intelligently concluded that he was a lonely castaway from some foreign ship wrecked by the storm. And yet, they called in a neighbor woman who knew everything about life and death to see him, and all she needed was one look to show them their mistake.

"He's an angel," she told them. "He must have been coming for the child, but the poor fellow is so old that the rain knocked him down."

On the following day everyone knew that a flesh-and-blood angel was held captive in Pelayo's house. Against the judgment of the wise neighbor woman, for whom angels in those times were the fugitive survivors of a celestial conspiracy, they did not have the heart to club him to death. Pelayo watched over him all afternoon from the kitchen, armed with his bailiff's club, and before going to bed he dragged him out of the mud and locked him up with the hens in the wire chicken coop. In the middle of the night, when the rain stopped, Pelayo and Elisenda were still killing crabs. A short time afterward the child woke up without a fever and with a desire to eat. Then they felt magnanimous and decided to put the angel on a raft with fresh water and provisions for three days and leave him to his fate on the high seas. But when they went out into the courtyard with the first light of dawn, they found the whole neighborhood in front of the chicken coop having fun with the angel, without the slightest reverence, tossing him things to eat through the openings in the wire as if he weren't a supernatural creature but a circus animal.

Father Gonzaga arrived before seven o'clock, alarmed at the strange news. By that time onlookers less frivolous than those at dawn had already arrived and they were making all kinds of conjectures concerning the captive's future. The simplest among them thought that he should be named mayor of the world. Others of sterner mind felt that he should be promoted to the rank of five-star general in order to win all wars. Some visionaries hoped that he could be put to stud in order to implant on earth a race of winged wise men who could take charge of the universe. But Father Gonzaga, before becoming a priest, had been a robust woodcutter. Standing by the wire, he reviewed his catechism in an instant and asked them to open the door so that he could take a close look at that pitiful man who looked more like a huge decrepit hen among the fascinated chickens. He was lying in a corner drying his open wings in the sunlight among the fruit peels and breakfast leftovers that the early risers had thrown him. Alien to the impertinences of the world, he only lifted his antiquarian eyes and murmured something in his dialect when Father Gonzaga went into the chicken coop and said good morning to him in Latin. The parish priest had his first suspicion of an impostor when he saw that he did not understand the language of God or know how to greet His ministers. Then he noticed that seen close up he was much too human: he had an unbearable smell of the outdoors, the back side of his wings was strewn with parasites and his main feathers had been mistreated by terrestrial winds, and nothing about him measured up to the proud dignity of angels. Then he came out of the chicken coop and in a brief sermon warned the curious against the risks of being ingenuous. He reminded them that the devil had the bad habit of making use of carnival tricks in order to confuse the unwary. He argued that if wings were not the essential element in determining the difference between a hawk and an airplane, they were even less so in the recognition of angels. Nevertheless, he promised to write a letter to his bishop so that the latter would write to his primate so that the latter would write to the Supreme Pontiff in order to get the final verdict from the highest courts.

His prudence fell on sterile hearts. The news of the captive angel spread with such rapidity that after a few hours the courtyard had the bustle of a marketplace and they had to call in troops with fixed bayonets to disperse the mob that was about to knock the house down. Elisenda, her spine all twisted from sweeping up so much marketplace trash, then got the idea of fencing in the yard and charging five cents admission to see the angel.

The curious came from far away. A traveling carnival arrived with a flying acrobat who buzzed over the crowd several times, but no one paid any attention to him because his wings were not those of an angel but, rather, those of a sidereal bat. The most unfortunate invalids on earth came in search of health: a poor woman who since childhood had been counting her heartbeats and had run out of numbers; a Portuguese man who couldn't sleep because the noise of the stars disturbed him; a sleepwalker who got up at night to undo the things he had done while awake; and many others with less serious ailments. In the midst of that shipwreck disorder that made the earth tremble, Pelayo and Elisenda were happy with fatigue, for in less than a week they had crammed their rooms with money and the line of pilgrims waiting their turn to enter still reached beyond the horizon.

The angel was the only one who took no part in his own act. He spent his time trying to get comfortable in his borrowed nest, befuddled by the hellish heat of the oil lamps and sacramental candles that had been placed along the wire. At first they tried to make him eat some mothballs, which, according to the wisdom of the wise neighbor woman, were the food prescribed for angels. But he turned them down, just as he turned down the papal lunches that the penitents brought him, and they never found out whether it was because he was an angel or because he was an old man that in the end he ate nothing but eggplant mush. His only supernatural virtue seemed to be patience. Especially during the first days, when the hens pecked at him, searching for the stellar parasites that proliferated in his wings, and the cripples pulled out feathers to touch their defective parts with, and even the most merciful threw stones at him, trying to get him to rise so they could see him standing. The only time they succeeded in arousing him was when they burned his side with an iron for branding steers, for he had been motionless for so many hours that they thought he was dead. He awoke with a start, ranting in his hermetic language and with tears in his eyes, and he flapped his wings a couple of times, which brought on a whirlwind of chicken dung and lunar dust and a gale of panic that did not seem to be of this world. Although many thought that his reaction had been one not of rage but of pain, from then on they were careful not to annoy him, because the majority understood that his passivity was not that of a hero taking his ease but that of a cataclysm in repose.

Father Gonzaga held back the crowd's frivolity with formulas of maidservant inspiration while awaiting the arrival of a final judgment on the nature of the captive. But the mail from Rome showed no sense of urgency. They spent their time finding out if the prisoner had a navel, if his dialect had any connection with Aramaic, how many times he could fit on the head of a pin, or whether he wasn't just a Norwegian with wings. Those meager letters might have come and gone until the end of time if a providential event had not put an end to the priest's tribulations.

It so happened that during those days, among so many other carnival attractions, there arrived in town the traveling show of the woman who had been changed into a spider for having disobeyed her parents. The admission to see her was not only less than the admission to see the angel, but people were permitted to ask her all manner of questions about her absurd state and to examine her up and down so that no one would ever doubt the truth of her horror. She was a frightful tarantula the size of a ram and with the head of a sad maiden. What was most heart-rending, however, was not her outlandish shape but the sincere affliction with which she recounted the details of her misfortune. While still practically a child she had sneaked out of her parents' house to go to a dance, and while she was coming back through the woods after having danced all night without permission, a fearful thunderclap rent the sky in two and through the crack came the lightning bolt of brimstone that changed her into a spider. Her only nourishment came from the meatballs that charitable souls chose to toss into her mouth. A spectacle like that, full of so much human truth and with such a fearful lesson, was bound to defeat without even trying that of a haughty angel who scarcely deigned to look at mortals. Besides, the few miracles attributed to the angel showed a certain mental disorder, like the blind man who didn't recover his sight but grew three new teeth, or the paralytic who didn't get to walk but almost won the lottery, and the leper whose sores sprouted sunflowers. Those consolation miracles, which were more like mocking fun, had already ruined the angel's reputation when the woman who had been changed into a spider finally crushed him completely. That was how Father Gonzaga was cured forever of his insomnia and Pelayo's courtyard went back to being as empty as during the time it had rained for three days and crabs walked through the bedrooms.

The owners of the house had no reason to lament. With the money they saved they built a two-story mansion with balconies and gardens and high netting so that crabs wouldn't get in during the winter, and with iron bars on the windows so that angels wouldn't get in. Pelayo also set up a rabbit warren close to town and gave up his job as bailiff for good, and Elisenda bought some satin pumps with high heels and many dresses of iridescent silk, the kind worn on Sunday by the most desirable women in those times. The chicken coop was the only thing that didn't receive any attention. If they washed it down with creolin and burned tears of myrrh inside it every so often, it was not in homage to the angel but to drive away the dungheap stench that still hung everywhere like a ghost and was turning the new house into

an old one. At first, when the child learned to walk, they were careful that he not get too close to the chicken coop. But then they began to lose their fears and got used to the smell, and before the child got his second teeth he'd gone inside the chicken coop to play, where the wires were falling apart. The angel was no less standoffish with him than with other mortals, but he tolerated the most ingenious infamies with the patience of a dog who had no illusions. They both came down with chicken pox at the same time. The doctor who took care of the child couldn't resist the temptation to listen to the angel's heart, and he found so much whistling in the heart and so many sounds in his kidneys that it seemed impossible for him to be alive. What surprised him most, however, was the logic of his wings. They seemed so natural on that completely human organism that he couldn't understand why other men didn't have them too.

When the child began school it had been some time since the sun and rain had caused the collapse of the chicken coop. The angel went dragging himself about here and there like a stray dying man. They would drive him out of the bedroom with a broom and a moment later find him in the kitchen. He seemed to be in so many places at the same time that they grew to think that he'd been duplicated, that he was reproducing himself all through the house, and the exasperated and unhinged Elisenda shouted that it was awful living in that hell full of angels. He could scarcely eat and his antiquarian eyes had also become so foggy that he went about bumping into posts. All he had left were the bare cannulae of his last feathers. Pelayo threw a blanket over him and extended him the charity of letting him sleep in the shed, and only then did they notice that he had a temperature at night, and was delirious with the tongue twisters of an old Norwegian. That was one of the few times they became alarmed, for they thought he was going to die and not even the wise neighbor woman had been able to tell them what to do with dead angels.

And yet he not only survived his worst winter, but seemed improved with the first sunny days. He remained motionless for several days in the farthest corner of the courtyard, where no one would see him, and at the beginning of December some large, stiff feathers began to grow on his wings, the feathers of a scarecrow, which looked more like another misfortune of decrepitude. But he must have known the reason for those changes, for he was quite careful that no one should notice them, that no one should hear the sea chanteys that he sometimes sang under the stars. One morning Elisenda was cutting some bunches of onions for lunch when a wind that seemed to come from the high seas blew into the kitchen. Then she went to the window and caught the angel in his first attempts at flight. They were so clumsy that his fingernails opened a furrow in the vegetable patch and he was on the point of knocking the shed down with the ungainly flapping that slipped on the light and couldn't get a grip on the air. But he did manage to gain altitude. Elisenda let out a sigh of relief, for herself and for him, when she saw him pass over the last houses, holding himself up in some way with the risky flapping of a senile vulture. She kept watching him even when she was through cutting the onions and she kept on watching until it was no longer possible for her to see him, because then he was no longer an annoyance in her life but an imaginary dot on the horizon of the sea.

Suggestions for Discussion

- García Marquez frequently specifies the time in this story (on the third day; on the following day; before seven o'clock; when the child began school; at the beginning of December; one morning . . .) Besides keeping us oriented in time, what function does this serve?
- 2. "Magic realism" is a form in which fabulous events are told in the most detailed and matter-of-fact way. Where and how does García Marquez create a sense of the familiar in this unlikely chain of events?
- 3. How do references to seasons and weather reach toward a larger significance in this story?
- 4. Where is there harmony between characters and background? Where is there conflict? How do these help reveal the conflicts of the story as a whole?
- 5. Much of the plot is told in summary form. Identify circumstantial and sequential summaries and scenes. How do each of the scenes signal a change?
- 6. Where is flashback used, and to what purpose?

Bullet in the Brain

TOBIAS WOLFF

Anders couldn't get to the bank until just before it closed, so of course the line was endless and he got stuck behind two women whose loud, stupid conversation put him in a murderous temper. He was never in the best of tempers anyway, Anders—a book critic known for the weary, elegant savagery with which he dispatched almost everything he reviewed.

With the line still doubled around the rope, one of the tellers stuck a "POSI-TION CLOSED" sign in her window and walked to the back of the bank, where she leaned against a desk and began to pass the time with a man shuffling papers. The women in front of Anders broke off their conversation and watched the teller with hatred. "Oh, that's nice," one of them said. She turned to Anders and added, confident of his accord, "One of those little human touches that keep us coming back for more."

Anders had conceived his own towering hatred of the teller, but he immediately turned it on the presumptuous crybaby in front of him. "Damned unfair," he said. "Tragic, really. If they're not chopping off the wrong leg, or bombing your ancestral village, they're closing their positions."

She stood her ground. "I didn't say it was tragic," she said. "I just think it's a pretty lousy way to treat your customers."

"Unforgivable," Anders said. "Heaven will take note."

She sucked in her cheeks but stared past him and said nothing. Anders saw that the other woman, her friend, was looking in the same direction. And then the tellers stopped what they were doing, and the customers slowly turned, and silence came over the bank. Two men wearing black ski masks and blue business suits were standing to the side of the door. One of them had a pistol pressed against the guard's neck. The guard's eyes were closed, and his lips were moving. The other man had a sawed-off shotgun. "Keep your big mouth shut!" the man with the pistol said, though no one had spoken a word. "One of you tellers hits the alarm, you're all dead meat. Got it?"

The tellers nodded.

"Oh, bravo," Anders said. "Dead meat." He turned to the woman in front of him. "Great script, eh? The stern, brass-knuckled poetry of the dangerous classes."

She looked at him with drowning eyes.

The man with the shotgun pushed the guard to his knees. He handed the shotgun to his partner and yanked the guard's wrists up behind his back and locked them together with a pair of handcuffs. He toppled him onto the floor with a kick between the shoulder blades. Then he took his shotgun back and went over to the security gate at the end of the counter. He was short and heavy and moved with peculiar slowness, even torpor. "Buzz him in," his partner said. The man with the shotgun opened the gate and sauntered along the line of tellers, handing each of them a Hefty bag. When he came to the empty position he looked over at the man with the pistol, who said, "Whose slot is that?"

Anders watched the teller. She put her hand to her throat and turned to the man she'd been talking to. He nodded. "Mine," she said.

"Then get your ugly ass in gear and fill that bag."

"There you go," Anders said to the woman in front of him. "Justice is done."

"Hey! Bright boy! Did I tell you to talk?"

"No," Anders said.

"Then shut your trap."

"Did you hear that?" Anders said. "'Bright boy.' Right out of 'The Killers.'"

"Please be quiet," the woman said.

"Hey, you deaf or what?" The man with the pistol walked over to Anders. He poked the weapon into Anders' gut. "You think I'm playing games?"

"No," Anders said, but the barrel tickled like a stiff finger and he had to fight back the titters. He did this by making himself stare into the man's eyes, which were clearly visible behind the holes in the mask: pale blue and rawly red-rimmed. The man's left eyelid kept twitching. He breathed out a piercing, ammoniac smell that shocked Anders more than anything that had happened, and he was beginning to develop a sense of unease when the man prodded him again with the pistol.

"You like me, bright boy?" he said. "You want to suck my dick?"

"No," Anders said.

"Then stop looking at me."

Anders fixed his gaze on the man's shiny wing-tip shoes.

"Not down there. Up there." He stuck the pistol under Anders' chin and pushed it upward until Anders was looking at the ceiling.

Anders had never paid much attention to that part of the bank, a pompous old building with marble floors and counters and pillars, and gilt scrollwork over the tellers' cages. The domed ceiling had been decorated with mythological figures whose fleshy, toga-draped ugliness Anders had taken in at a glance many years earlier and afterward declined to notice. Now he had no choice but to scrutinize the painter's work. It was even worse than he remembered, and all of it executed with the utmost gravity. The artist had a few tricks up his sleeve and used them again and again—a certain rosy blush on the underside of the clouds, a coy backward glance on the faces of the cupids and fauns. The ceiling was crowded with various dramas, but the one that caught Anders' eye was Zeus and Europa—portrayed, in this rendition, as a bull ogling a cow from behind a haystack. To make the cow sexy, the painter had canted her hips suggestively and given her long, droopy eyelashes through which she gazed back at the bull with sultry welcome. The bull wore a smirk and his eyebrows were arched. If there'd been a bubble coming out of his mouth, it would have said, "Hubba hubba."

"What's so funny, bright boy?"

"Nothing."

"You think I'm comical? You think I'm some kind of clown?"

"No."

"You think you can fuck with me?"

"No."

"Fuck with me again, you're history. Capiche?"

Anders burst out laughing. He covered his mouth with both hands and said, "I'm sorry, I'm sorry," then snorted helplessly through his fingers and said, "Capiche—oh, God, capiche," and at that the man with the pistol raised the pistol and shot Anders right in the head.

The bullet smashed Anders' skull and ploughed through his brain and exited behind his right ear, scattering shards of bone into the cerebral cortex, the corpus callosum, back toward the basal ganglia, and down into the thalamus. But before all this occurred, the first appearance of the bullet in the cerebrum set off a crackling chain of iron transports and neuro-transmissions. Because of their peculiar origin these traced a peculiar pattern, flukishly calling to life a summer afternoon some forty years past, and long since lost to memory. After striking the cranium the bullet was moving at 900 feet per second, a pathetically sluggish, glacial pace compared to the synaptic lightning that flashed around it. Once in the brain, that is, the bullet came under the mediation of brain time, which gave Anders plenty of leisure to contemplate the scene that, in a phrase he would have abhorred, "passed before his eyes."

It is worth noting what Anders did not remember, given what he did remember. He did not remember his first lover, Sherry, or what he had most madly loved about her, before it came to irritate him—her unembarrassed carnality, and especially the cordial way she had with his unit, which she called Mr. Mole, as in, "Uh-oh, looks like Mr. Mole wants to play," and, "let's hide Mr. Mole!" Anders did not remember his wife, whom he had also loved before she exhausted him with her predictability, or his daughter, now a sullen professor of economics at Dartmouth. He did not remember standing just outside his daughter's door as she lectured her bear about his naughtiness and described the truly appalling punishments Paws would receive unless he changed his ways. He did not remember a single line of the hundreds of poems he had committed to memory in his youth so that he could give himself the shivers at will—not "Silent, upon a peak in Darien," or "My God, I heard this day," or "All my pretty ones? Did you say all? O hell-kite! All?" None of these did he remember; not one. Anders did not remember his dying mother saying of his father, "I should have stabbed him in his sleep."

He did not remember Professor Josephs telling his class how Athenian prisoners in Sicily had been released if they could recite Aeschylus, and then reciting Aeschylus himself, right there, in the Greek. Anders did not remember how his eyes had burned at those sounds. He did not remember the surprise of seeing a college classmate's name on the jacket of a novel not long after they graduated, or the respect he had felt after reading the book. He did not remember the pleasure of giving respect.

Nor did Anders remember seeing a woman leap to her death from the building opposite his own just days after his daughter was born. He did not remember shouting, "Lord have mercy!" He did not remember deliberately crashing his father's car into a tree, or having his ribs kicked in by three policemen at an anti-war rally, or waking himself up with laughter. He did not remember when he began to regard the heap of books on his desk with boredom and dread, or when he grew angry at writers for writing them. He did not remember when everything began to remind him of something else.

This is what he remembered. Heat. A baseball field. Yellow grass, the whirr of insects, himself leaning against a tree as the boys of the neighborhood gather for a pickup game. He looks on as the others argue the relative genius of Mantle and Mays. They have been worrying this subject all summer, and it has become tedious to Anders: an oppression, like the heat.

Then the last two boys arrive, Coyle and a cousin of his from Mississippi. Anders has never met Coyle's cousin before and will never see him again. He says hi with the rest but takes no further notice of him until they've chosen sides and someone asks the cousin what position he wants to play. "Shortstop," the boy says. "Short's the best position they is." Anders turns and looks at him. He wants to hear Coyle's cousin repeat what he's just said, but he knows better than to ask. The others will think he's being a jerk, ragging the kid for his grammar. But that isn't it, not at all—it's that Anders is strangely roused, elated, by those final two words, their pure unexpectedness and their music. He takes the field in a trance, repeating them to himself.

The bullet is already in the brain; it won't be outrun forever, or charmed to a halt. In the end it will do its work and leave the troubled skull behind, dragging its comet's tail of memory and hope and talent and love into the marble hall of commerce. That can't be helped. But for now Anders can still make time. Time for the

shadows to lengthen on the grass, time for the tethered dog to bark at the flying ball, time for the boy in right field to smack his sweat-blackened mitt and softly chant, They is, they is.

Suggestions for Discussion

- 1. Half of this story is set in a bank and half in a brain. How does Tobias Wolff orient us in each setting? How are the devices alike, and how are they different?
- 2. How does Anders's conflict with the first setting set up the conflict of the story? What is the effect of the contrast between the settings of the bank and baseball field?
- 3. How does the use of slow motion —"brain time"— work to establish credibility? To raise intensity?
- 4. What Anders "did not remember" amounts to a flashback of three paragraphs that covers three generations and introduces at least eight people. What can you learn (steal) from this about economy of backstory?
- 5. Examine the dialogue line by line. How does Wolff ensure that the dialogue is about what the story is about?

Retrospect

- 1. Find examples of slow motion in Joyce Carol Oates's "Where Are You Going, Where Have You Been?" How does the technique function in the story?
- 2. On page 68 of "The Things They Carried," there is a flashback to the time Jimmy Cross touched Martha's knee in a movie theater. How is the flashback introduced? Speculate on how much background is implied in this short passage and how much the author knew that he left out.
- 3. How do each of these function in "Saint Marie" by Louise Erdrich: alien setting, symbolic setting, circumstantial summary, slow motion?

Writing Assignments

- 1. Write a scene, involving only one character, who is uncomfortable in his or her surroundings: socially inadequate, frightened, revolted, painfully nostalgic, or the like. Using active verbs in your description of the setting, build forceful conflict between the person and the place.
- 2. Write a scene with two characters in conflict over the setting: One wants to go, and one wants to stay. The more interesting the setting you choose, the more interesting the conflict will inevitably be.

- 3. Write a scene in a setting that is likely to be quite familiar to your readers (supermarket, dormitory, classroom, movie theater, suburban house, etc.) but that is unfamiliar, strange, outlandish, or outrageous to the central character. Let us feel the strangeness through the character's eyes.
- 4. Write a scene set in a strange, exotic place or a time far distant either in the past or the future, in which the setting is quite familiar to the central character. Convince us of the ordinariness of the place.
- 5. Write a scene in which the character's mood is at odds with the weather and make the weather nevertheless express her or his mood: The rain is joyful, the clear skies are threatening, the snow is comforting, the summer beach is chilling.
- 6. Write a scene containing a flashback in which the information about the past is crucial to an understanding of the present.
- 7. Write a scene that begins with a circumstantial summary and then moves to a scene in slow motion.

CALL ME ISHMAEL Point of View, Part I

- · Who Speaks?
 - · To Whom?
- In What Form?

Point of view is the most complex element of fiction. Although it lends itself to analysis, it is finally a question of relationship among writer, characters, and reader—subject like any relationship to organic subtleties. We can discuss person, omniscience, narrative voice, tone, authorial distance, and reliability; but none of these things will ever pigeonhole a work in such a way that any other work may be placed in the exact same pigeonhole.

The first thing to do is to set aside the common use of the phrase "point of view" as synonymous with "opinion," as in *It's my point of view that they all ought to be shot*. An author's view of the world as it is and as it ought to be will ultimately be revealed by his or her manipulation of the technique of point of view, but not vice versa—identifying the author's beliefs will not describe the point of view of the work. Rather than thinking of point of view as an opinion or belief, begin with the more literal synonym of "vantage point." *Who* is standing *where* to watch the scene?

Better, since we are dealing with a verbal medium, these questions might be translated: Who speaks? To whom? In what form? At what distance from the action? With what limitations? All these issues go into the determination of the point of view. Because the author inevitably wants to convince us to share the same perspective, the answers will also help reveal her or his final opinion, judgment, attitude, or message.

This chapter deals with the first three questions: Who speaks? To whom? In what form? Distance and limitations are considered in chapter 8.

POINT OF VIEW

	Who Speaks?		
The Author	The Author	A Character	
In: Third Person	In: Second Person	In: First Person	
Editorial Omniscient	You As Character	Central Narrator	
Limited Omniscient	You As Reader-Turned-	Peripheral Narrator	
Objective	Character		
	To Whom?		
The Reader An	other Character or Characters	The Self	
Ja .	In What Form?		
Story, Monole	ogue, Letter, Journal, Interior	Monologue,	
	Stream of Consciousness, etc.		
344	At What Distance?		
Complete Identification	Complete O	Complete Opposition	
	With What Limitations?		
Reliable Narrator (or Au	thor) Unreliable N	Unreliable Narrator (or Author)	

Who Speaks?

The primary point-of-view decision that you as author must make before you can set down the first sentence of the story is *person*. This is the simplest and crudest subdivision that must be made in deciding who speaks. The story can be told in the third person (*she walked out into the harsh sunlight*), the second person (*you walked out into the harsh sunlight*), or the first person (*I walked out into the harsh sunlight*). Third- and second-person stories are told by an author; first-person stories, by a character.

THIRD PERSON

Third person, in which the author is telling the story, can be subdivided again according to the degree of knowledge, or *omniscience*, the author assumes. Notice that since this is a matter of degree, the subdivisions are again only a crude indication of the variations possible. As an author you are free to decide how much you know. You may know every universal and eternal truth; you may know what is in the mind of one character but not what is in the mind of another; or you may know only what can be externally observed. You decide, and very early in the story you signal to the reader what degree of omniscience you have chosen. Once given, this signal constitutes a "contract" between author and reader, and it will be difficult to break the contract gracefully. If you have restricted yourself to the mind of James Lordly for

five pages, as he observes the actions of Mrs. Grumms and her cats, you will violate the contract by suddenly dipping into Mrs. Grumms's mind to let us know what she thinks of James Lordly. We are likely to feel misused, and likely to cancel the contract altogether, if you suddenly give us the thoughts of the cats.

Apart from the use of significant detail, there is no more important skill for a writer of fiction to grasp than this, the control of point of view. These two are, as Carol Bly says in The Passionate, Accurate Story, "the two literary abilities that divide master from apprentice."

Novice writers who greet the concrete with a sense of discovery and joy often ignore or reject the second point. Sometimes, I think, it's hard simply to recognize that your narrative has leapt from one point of view to another—often, in workshop, students are troubled by a point-of-view shift in someone else's story but can't spot one in their own. In other cases there's a healthy desire to explore every possibility in a scene, and a mistaken sense that this can't be done without changing point of view. Or the writer is full of experimental energy, high on fiction's freedom. And then, of course, no writing rule is so frequently broken to such good effect as consistency in point of view. Any volume of stories including this one will turn up several examples of the rule in stunning shards at the foot of a forceful writer.

Nevertheless the rule holds, and a writer signals amateurism in the failure to make a contract and stick to it. In this area the analogy to arduous physical skill is apt: The basketball star and the ballerina make it look easy. This is only done by first mastering the basic layup, the plies. In the case of writing, and in the most practical terms, it probably means beginning with a very limited point of view (the first person or the third person with access to only one mind—both described below), recognizing when you are comfortably in that range, and sticking with it.

The omniscient author, sometimes referred to as the editorial omniscient author because she or he tells us directly what we are supposed to think, is then the most difficult point of view to control. The omniscient author has total knowledge. As omniscient author you are God. You can:

- 1. Objectively report what is happening;
- 2. Go into the mind of any character;
- 3. Interpret for us that character's appearance, speech, actions, and thoughts, even if the character cannot do so:
- 4. Move freely in time or space to give us a panoramic, telescopic, microscopic, or historical view; tell us what has happened elsewhere or in the past or what will happen in the future; and
- 5. Provide general reflections, judgments, and truths.

In all these aspects, we will accept what the omniscient author tells us. If you tell us that Ruth is a good woman, that Jeremy doesn't really understand his own motives, that the moon is going to explode in four hours, and that everybody will be better off for it, we will believe you. Here is a paragraph that blatantly exhibits all five of these areas of knowledge.

(1) Joe glared at the screaming baby. (2) Frightened by his scowl, the baby gulped and screamed louder. I hate that thing, Joe thought. (3) But it was not really hatred that he felt. (4) Only two years ago he himself had screamed like that. (5) Children can't tell hatred from fear.

This illustration is awkwardly compressed, but authors well in control of their craft can move easily from one area of knowledge to another. In the first scene of *War and Peace*, Tolstoy describes Anna Scherer.

To be an enthusiast had become her social vocation, and sometimes even when she did not feel like it, she became enthusiastic in order not to disappoint the expectations of those who knew her. The subdued smile which, though it did not suit her faded features, always played around her lips, expressed as in a spoiled child, a continual consciousness of her charming defect, which she neither wished, nor could, nor considered it necessary to correct.

In two sentences Tolstoy tells us what is in Anna's mind, what the expectations of her acquaintances are, what she looks like, what suits her, what she can and cannot do; and he offers a general reflection on spoiled children.

The omniscient voice is the voice of the classical epic ("And Meleager, far-off, knew nothing of this, but felt his vitals burning with fever"), of the Bible ("So the Lord sent a pestilence upon Israel; and there fell seventy thousand men"), and of most nineteenth-century novels ("Tito put out his hand to help him, and so strangely quick are men's souls that in this moment, when he began to feel that his atonement was accepted, he had a darting thought of the irksome efforts it entailed"). But it is one of the manifestations of literature's movement downward in class from heroic to common characters, inward from action to the mind, that authors of the twentieth century have largely avoided the godlike stance of the omniscient author and have chosen to restrict themselves to fewer areas of knowledge.

The *limited omniscient* viewpoint is one in which the author may move with some, but not all, of the omniscient author's freedom. You may grant yourself the right, for example, to know what the characters in a scene are thinking but not to interpret their thoughts. You may interpret one character's thoughts and actions but see the others only externally. You may see with microscopic accuracy but not presume to reach any universal truths. The most commonly used form of the limited omniscient point of view is one in which the author can see events objectively and also grants himself or herself access to the mind of one character, but not to the minds of the others, nor to any explicit powers of judgment. This point of view is particularly useful for the short story because it very quickly establishes the point-of-view character or *means of perception*. The short story is so compressed a form that there is rarely time or space to develop more than one consciousness. Staying with external observation and one character's thoughts helps control the focus and avoid awkward point-of-view shifts.

But the form is also frequently used for the novel, as in Gail Godwin's The Odd

Woman.

It was ten o'clock on the evening of the same day, and the permanent residents of the household on the mountain were restored to routines and sobriety. Jane, on the other hand, sat by herself in the kitchen, a glass of Scotch before her on the cleanly wiped table, going deeper and deeper into a mood she could recognize only as unfamiliar. She could not describe it; it was both frightening and satisfying. It was like letting go and being taken somewhere. She tried to trace it back. When, exactly, had it started?

It is clear here that the author has limited her omniscience. She is not going to tell us the ultimate truth about Jane's soul, nor is she going to define for us the unfamiliar mood that the character herself cannot define. The author has the facts at her disposal, and she has Jane's thoughts, and that is all.

The advantage of the limited omniscient over the omniscient voice is immediacy. Here, because we are not allowed to know more than Jane does about her own thoughts and feelings, we grope with her toward understanding. In the process, a contract has been made between the author and the reader, and this contract must not now be broken. If at this point the author should step in and answer Jane's question "When, exactly, had it started?" with "Jane was never to remember this, but in fact it had started one afternoon when she was two years old," we would feel it as an abrupt and uncalled-for *authorial intrusion*.

Nevertheless, within the limits the author has set herself, there is fluidity and a range of possibilities. Notice that the passage begins with a panoramic observation (ten o'clock, permanent residents, routines) and moves to the tighter focus of a view, still external, of Jane (sat by herself in the kitchen), before moving into her mind. The sentence "She tried to trace it back" is an indirect account of her mental process, whereas in the next sentence, "When, exactly, had it started?" we are in Jane's mind, overhearing her question to herself.

Although this common form of the limited omniscient (objective reporting plus one mind) may seem very restricted, given all the possibilities of omniscience, it has a freedom that no human being has. In life you have full access to only one mind, your own; and you are also the one person you may not externally observe. As a fiction writer you can do what no human being can do, be simultaneously inside and outside a given character; it is this that E. M. Forster describes in Aspects of the Novel as the fundamental difference between people in daily life and people in books.

In daily life we never understand each other, neither complete clairvoyance nor complete confessional exists. We know each other approximately, by external signs, and these serve well enough as a basis for society and even for intimacy. But people in a novel can be understood completely by the reader, if the novelist wishes; their inner as well as their outer life can be exposed. And this is why they often seem more definite than characters in history, or even our own friends.

If you choose the one-mind limited omniscient (or the first-person narrator, discussed below), it may at first seem difficult, sometimes impossible, to let the reader

know what she or he needs to know without the thoughts of the *opaque character* (the one whose mind we cannot see into). In fact this is one of the tests, and the joys, of skill—a limitation that can become an opportunity for invention and imagination. For the opaque character, whether or not that character is willing to speak truly, can betray his or her real feelings, intentions, or reactions with a gesture, actions, expressions, even clothing. Diane Schoemperlen takes advantage of the phenomenon in the story "Body Language," which is told in the limited omniscient from the viewpoint of the husband:

Or (on a good day) she would have been in the kitchen starting supper with the radio on, humming and chopping and stirring . . . In the kitchen he joyfully discovers that she has already changed out of her work clothes and is wearing her black silk kimono with the red dragon on the back. She greets him with a kiss. . . .

On a bad day she doesn't exactly push him away but turns, gracefully, out of his embrace, like a ring once stuck on a finger magically removed with soap. Both her skin and her kimono are slippery and he cannot hold on.

The *objective author* is not omniscient but impersonal. As an objective author, you restrict your knowledge to the external facts that might be observed by a human being; to the senses of sight, sound, smell, taste, and touch. In the story "Hills Like White Elephants," Ernest Hemingway reports what is said and done by a quarreling couple, both without any direct revelation of the characters' thoughts and without comment.

The American and the girl with him sat at a table in the shade, outside the building. It was very hot and the express from Barcelona would come in forty minutes. It stopped at this junction for two minutes and went on to Madrid.

"What should we drink?" the girl asked. She had taken off her hat and put it on the table.

"It's pretty hot," the man said.

"Let's drink beer."

"Dos cervezas," the man said into the curtain.

"Big ones?" a woman asked from the doorway.

"Yes. Two big ones."

The woman brought two glasses of beer and two felt pads. She put the felt pads and the beer glasses on the table and looked at the man and the girl. The girl was looking off at the line of hills. They were white in the sun and the country was brown and dry.

In the course of this story we learn, entirely by inference, that the girl is pregnant and that she feels herself coerced by the man into having an abortion. Neither pregnancy nor abortion is ever mentioned. The narrative remains clipped, austere, and external. What does Hemingway gain by this pretense of objective reporting? The reader is allowed to discover what is really happening. The characters avoid the sub-

ject, prevaricate, and pretend, but they betray their real meanings and feelings through gestures, repetitions, and slips of the tongue. The reader, focus directed by the author, learns by inference, as in life, so that we finally have the pleasure of knowing the characters better than they know themselves.

For the sake of clarity, the possibilities of third-person narration have been divided into the editorial omniscient, limited omniscient, and objective authors, but between the extreme stances of the editorial omniscient (total knowledge) and the objective author (external observation only), the powers of the limited omniscient are immensely variable. Because you are most likely to choose your authorial voice in this range, you need to be aware that you make your own rules and that having made them, you must stick to them. Your position as a writer is analogous to that of a poet who may choose whether to write free verse or a ballad stanza. If the poet chooses the stanza, then he or she is obliged to rhyme. Beginning writers of prose fiction are often tempted to shift viewpoint when it is both unnecessary and disturbing.

Leo's neck flushed against the prickly weave of his uniform collar. He concentrated on his buttons and tried not to look into the face of the bandmaster, who, however, was more amused than angry.

This is an awkward point-of-view shift because, having felt Leo's embarrassment with him, we are suddenly asked to leap into the bandmaster's feelings. The shift can be corrected by moving instead from Leo's mind to an observation that he might make.

Leo's neck flushed against the prickly weave of his uniform collar. He concentrated on his buttons and tried not to look into the face of the bandmaster, who, however, was astonishingly smiling.

The rewrite is easier to follow because we remain with Leo's mind as he observes that the bandmaster is not angry. It further serves the purpose of implying that Leo fails to concentrate on his buttons, and so intensifies his confusion.

SECOND PERSON

First and third persons are most common in literature; the second person remains an idiosyncratic and experimental form, but it is worth mentioning because several twentieth-century authors have been attracted to its possibilities.

Person refers to the basic mode of a piece of fiction. In the third person, all the characters will be referred to as he, she, or they. In the first person, the character telling the story will refer to himself or herself as I and to other characters as he, she, or they. The second person is the basic mode of the story only when a character is referred to as you. When one character addresses "you" in letter or monologue, that narrative is still told by the "I" character. When an omniscient author addresses the reader as you (You will remember that John Doderring was left dangling on the cliff at

Dover), this does not alter the basic mode of the piece from third to second person. Only when "you" become an actor in the drama, so designated by the author, is the story or novel written in second person.

In Even Cowgirls Get the Blues, Tom Robbins exhibits these last two uses of the

second person.

If you could buckle your Bugs Bunny wristwatch to a ray of light, your watch would continue ticking but its hands wouldn't move.

The you involved here is a generalized reader, and the passage is written in the stance of an omniscient author delivering a general "truth."

But when the author turns to address his central character, Sissy Hankshaw, the basic mode of the narration becomes that of the second person.

You hitchhike. Timidly at first, barely flashing your fist, leaning almost imperceptibly in the direction of your imaginary destination. A squirrel runs along a tree limb. You hitchhike the squirrel. A blue jay flies by. You flag it down.

The effect of this second-person narration is odd and original; the author observes Sissy Hankshaw, and yet his direct address implies an intimate and affectionate relationship that makes it easy to move further into her mind

Your thumbs separate you from other humans. You begin to sense a presence about your thumbs. You wonder if there is not magic there.

In this example it is a character clearly delineated and distinguished from the reader who is the you of the narrative. But the second person can also be used as a means of making the reader into a character, as in Lorrie Moore's "How to Become a Writer":

First, try to be something, anything, else. A movie star/astronaut. A movie star/missionary. A movie star/kindergarten teacher. President of the World. Fail miserably. It is best if you fail at an early age—say, fourteen. Early, critical disillusionment is necessary so that at fifteen you can write long haiku sentences about thwarted desire. It is a pond, a cherry blossom, a wind brushing against sparrow wing leaving for mountain. Count the syllables. Show it to your mom.

Here again the effect of the second person is unusual and complex. The author assigns you, the reader, specific characteristics and reactions, and thereby—assuming that you go along with her characterization of you—pulls you deeper and more intimately into the story.

It is unlikely that the second person will ever become a major mode of narration as the first and third are, but for precisely that reason you may find it an attractive experiment.

FIRST PERSON

A story is told in the first person when it is a character who speaks. The term "narrator" is sometimes loosely used to refer to any teller of a tale, but strictly speaking a story has a narrator only when it is told in the first person by one of the characters. This character may be the protagonist, the *I* telling *my* story, in which case that character is a *central narrator*; or the character may be telling a story about someone else, in which case he or she is a *peripheral narrator*.

In either case it's important to indicate early which kind of narrator we have so that we know who the story's protagonist is, as in the first paragraph of Alan Sillitoe's "The Loneliness of the Long-Distance Runner."

As soon as I got to Borstal they made me a long-distance cross-country runner. I suppose they thought I was just the build for it because I was long and skinny for my age (and still am) and in any case I didn't mind it much, to tell you the truth, because running had always been made much of in our family, especially running away from the police.

The focus here is immediately thrown on the *I* of the story, and we expect that *I* to be the central character whose desires and decisions impel the action. But from the opening lines of R. Bruce Moody's *The Decline and Fall of Daphne Finn*, it is Daphne who is brought alive by attention and detail, while the narrator is established as an observer and recorder of his subject.

"Is it really you?"

Melodious and high, this voice descended to me from behind and above—as it seemed it was always to do—indistinct as bells in another country.

Unable to answer in the negative, I turned from my desk, looked up, and smiled sourly.

"Yes," I said, startling a face which had been peering over my shoulder, a face whose beauty it was apparent at the outset had made no concession to convention. It retreated as her feet staggered back.

The central narrator is always, as the term implies, at the center of the action; the peripheral narrator may be in virtually any position that is not the center. He or she may be the second most important character in the story, or may not be involved in the action at all but merely placed in a position to observe. The narrator may characterize himself or herself in detail or may remain detached and scarcely identifiable. It is even possible to make the first-person narrator plural, as William Faulkner does in "A Rose for Emily," where the story is told by a narrator identified only as one of us, the people of the town in which the action has taken place.

That a narrator may be either central or peripheral, that a character may tell either his own story or someone else's, is both commonly assumed and obviously logical. But the author and editor Rust Hills, in his book *Writing in General and the Short Story in Particular*, takes interesting and persuasive exception to this idea. When

point of view fails, Hills argues, it is always because the perception we are using for the course of the story is different from that of the character who is moved or changed by the action. Even when a narrator seems to be a peripheral observer and the story is "about" someone else, in fact it is the narrator who is changed, and must be, in order for us to be satisfied by our emotional identification with him or her.

This, I believe, is what will always be the case in successful fiction: that either the character moved by the action will be the point-of-view character, or else the point of view character will *become* the character moved by the action. Call it Hills' Law.

Obviously, this view does not mean that we have to throw out the useful fictional device of the peripheral narrator. Hills uses the familiar examples of The Great Gatsby and Heart of Darkness to illustrate his meaning. In the former, Nick Carroway as a peripheral narrator observes and tells the story of Jay Gatsby, but by the end of the book it is Nick's life that has been changed by what he has observed. In the latter, Marlow purports to tell the tale of the ivory hunter Kurtz, even protesting that "I don't want to bother you much with what happened to me personally." By the end of the story, Kurtz (like Gatsby) is dead, but it is not the death that moves us so much as what, "personally," Marlow has learned through Kurtz and his death. The same can be said of The Decline and Fall of Daphne Finn; the focus of the action is on Daphne, but the pain, the passion, and the loss are those of her biographer. Even in "A Rose for Emily," where the narrator is a collective "we," it is the implied effect of Miss Emily on the town that moves us, the emotions of the townspeople that we share. Because we tend to identify with the means of perception in a story, we are moved with that perception; even when the overt action of the story is elsewhere, it is often the act of observation itself that provides the epiphany.

The thing to recognize about a first-person narrator is that because she or he is a character, she or he has all the limitations of a human being and cannot be omniscient. The narrator is confined to reporting what she or he could realistically know. More than that, although the narrator may certainly interpret actions, deliver dictums, and predict the future, these remain the fallible opinions of a human being; we are not bound to accept them as we are bound to accept the interpretations, truths, and predictions of the omniscient author. You may want us to accept the narrator's word, and then the most difficult part of your task, and the touchstone of your story's success, will be to convince us to trust and believe the narrator. On the other hand, it may be an important part of your purpose that we should reject the narrator's opinions and form our own. In the latter case, the narrator is "unreliable," a phenomenon that will be taken up in chapter 8.

To Whom?

In choosing a point of view, the author implies an identity not only for the teller of the tale, but also for the audience.

THE READER

Most fiction is addressed to a literary convention, "the reader." When we open a book, we tacitly accept our role as a member of this unspecified audience. If the story begins, "I was born of a drunken father and an illiterate mother in the peat bogs of Galway during the Great Potato Famine," we are not, on the whole, alarmed. We do not face this clearly deceased Irishman who has crossed the Atlantic to take us into his confidence and demand, "Why are you telling me all this?"

Notice that the tradition of "the reader" assumes the universality of the audience. Most stories do not specifically address themselves to a segment or period of humanity, and they make no concessions to such differences as might exist between reader and author; they assume that anyone who reads the story can be brought around to the same understanding of it the author has. In practice most writers, though they do not acknowledge it in the text and may not admit it to themselves, are addressing someone who can be brought around to the same understanding as themselves. The author of a "Harlequin Romance" addresses the story to a generalized "reader" but knows that his or her likely audience is trained by repetition of the formula to expect certain Gothic features—rich lover, virtuous heroine, threatening house, colorful costume. Slightly less formulaic is the notion of "a New Yorker story," which is presumably what the author perceives that the editors perceive will be pleasing to the people who buy The New Yorker. Anyone who pens or types what he or she hopes is "literature" is assuming that his or her audience is literate, which leaves out better than half the world. My mother, distressed at the difficulty of my fictional style, used to urge me to write for "the masses," by which she meant subscribers to Reader's Digest, whom she thought to be in need of cheering and escape. I considered this a very narrow goal until I realized that my own ambition to be "universal" was more exclusive still: I envisioned my audience as made up of people who would not subscribe to the Reader's Digest.

Nevertheless, the most common assumption of the tale-teller, whether omniscient author or narrating character, is that the reader is an amenable and persuasible Everyman, and that the telling needs no justification.

But there are various exceptions to this tendency which can be used to dramatic effect and which always involve a more definite characterizing of the receiver of the story. The author may address "the reader" but assign that reader specific traits that we, the actual readers, must then accept as our own if we are to accept the fiction. Nineteenth-century novelists had a tradition of addressing "You, gentle reader," "Dear reader," and the like, and this minimal characterization was a technique for implying mutual understanding. In "The Loneliness of the Long-Distance Runner," by Alan Sillitoe, on the other hand, the narrator divides the world into "us" and "you." We, the narrator and his kind, are the outlaws, all those who live by their illegal wits; you, the readers, are by contrast law-abiding, prosperous, educated, and rather dull. To quote again from "The Loneliness of the Long-Distance Runner":

I suppose you'll laugh at this, me saying the governor's a stupid bastard when I know hardly how to write and he can read and write and add-up like a professor.

But what I say is true right enough. He's stupid and I'm not, because I can see further into the likes of him than he can see into the likes of me.

The clear implication here is that the narrator can see further into the likes of us readers than we can see into the likes of him, and much of the effective irony of the story rests in the fact that the more we applaud and identify with the narrator, the more we must accept his condemning characterization of "us."

ANOTHER CHARACTER

More specifically still, the story may be told to another character, or characters, in which case we as readers "overhear" it; the teller of the tale does not acknowledge us even by implication. Just as the third-person author telling "her story" is theoretically more impersonal than the first-person character telling "my story," so "the reader" is theoretically a more impersonal receiver of the tale than another character. I insert the word "theoretically" because, with regard to point of view more than any other element of fiction, any rule laid down seems to be an invitation to rule breaking by some original and inventive author.

In the epistolary novel or story, the narrative consists entirely of letters written from one character to another, or between characters. The recipient of the letter may be a relative stranger—a newspaper, an authority figure, a dead person, god, or saint—as in this example from Sandra Cisneros's "Little Miracle, Kept Promises":

Dear San Lázaro,

My mother's comadre Demetria said if I prayed to you that like maybe you could help me because you were raised from the dead and did a lot of miracles and maybe if I lit a candle every night for seven days and prayed, you might maybe could help me with my face breaking out with so many pimples....

Or the recipient may be an intimate, like the "R." of Alice Munro's "Before the Change":

R. The days you were here Mrs. B. was off for Christmas with her family. (She has a husband who has been sick with emphysema it seems for half his life, and no children, but a horde of nieces and nephews and connections.) I don't think you saw her at all. But she saw you. She said to me yesterday, "Where's that Mr. So-and-so you were supposed to be engaged to?"

Or the convention of the story may be that of a monologue, spoken aloud by one character to another.

May I, monsieur, offer my services without running the risk of intruding? I fear you may not be able to make yourself understood by the worthy ape who presides over the fate of this establishment. In fact, he speaks nothing but Dutch. Unless you authorize me to plead your case, he will not guess that you want gin.

Albert Camus, The Fall

Again, the possible variations are infinite; the narrator may speak in intimate confessional to a friend or lover, or may present his case to a jury or a mob; she may be writing a highly technical report of the welfare situation, designed to hide her emotions; he may be pouring out his heart in a love letter he knows (and we know) he will never send.

In any of these cases, the convention employed is the opposite of that employed in a story told to "the reader." The listener as well as the teller is involved in the action; the assumption is not that we readers are there but that we are not. We are eavesdroppers, with all the ambiguous intimacy that position implies.

THE SELF

An even greater intimacy is implied if the character's story is as secret as a diary or as private as a mind, addressed to *the self* and not intended to be heard by anyone inside or outside the action.

In a *diary* or *journal*, the convention is that the thoughts are written but not expected to be read by anyone except the writer.

November 6 Something has got into the Chief of my Division. When I arrived at the office he called me and began as follows: "Now then, tell me. What's the matter with you? . . . I know you're trailing after the Director's daughter. Just look at yourself—what are you? Just nothing. You haven't a penny to your name. Look in the mirror. How can you even think of such things?" The hell with him! Just because he's got a face like a druggist's bottle and that quiff of hair on his head all curled and pomaded.

Nikolai Gogol, The Diary of a Madman

The protagonist here is clearly using his diary to vent his feelings and does not intend it to be read by anyone else. Still, he has deliberately externalized his secret thoughts in a journal. Because the author has the power to enter a character's mind, the reader also has the power to eavesdrop on thoughts, read what is not written, hear what is not spoken, and share what cannot be shared.

Overheard thoughts are generally of two kinds, of which the more common is *interior monologue*, the convention being that we follow that character's thoughts in their sequence, though in fact the author, for our convenience, sets out those thoughts with a coherence and logic that no human mind ever possessed.

I must organize myself. I must, as they say, pull myself together, dump this cat from my lap, stir—yes, resolve, move, do. But do what? My will is like the rosy dustlike light in this room: soft, diffuse, and gently comforting. It lets me do . . . anything . . . nothing. My ears hear what they happen to; I eat what's put before me; my eyes see what blunders into them; my thoughts are not thoughts, they are dreams. I'm empty or I'm full . . . depending; and I cannot choose. I sink my claws in Tick's fur and scratch the bones of his back until his rear rises amorously. Mr. Tick, I murmur, I must organize myself, I must pull myself together. And Mr. Tick rolls over on his belly, all ooze.

William H. Gass, "In the Heart of the Heart of the Country"

This interior monologue ranges, as human thoughts do, from sense impression to self-admonishment, from cat to light to eyes and ears, from specific to general and back again. But the logical connections between these things are all provided; the mind "thinks" logically and grammatically as if the character were trying to express himself.

Stream of consciousness acknowledges the fact that the human mind does not operate with the order and clarity of the monologue just quoted. Even what little we know of its operations makes clear that it skips, elides, makes and breaks images, leaps faster and further than any mere sentence can suggest. Any mind at any moment is simultaneously accomplishing dozens of tasks that cannot be conveyed simultaneously. As you read this sentence, part of your mind is following the sense of it; part of your mind is directing your hand to hold the book open; part of it is twisting your spine into a more comfortable position; part of it is still lingering on the last interesting image of this text, Mr. Tick rolling over on his belly, which reminds you of a cat you had once that was also all ooze, which reminds you that you're nearly out of milk and have to finish this chapter before the store closes—and so forth.

In *Ulysses*, James Joyce tried to catch the speed and multiplicity of the mind with the technique that has come to be known as stream of consciousness. The device is difficult and in many ways thankless: Since the speed of thought is so much faster than that of writing or speaking, and stream of consciousness tries to suggest the process as well as the content of the mind, it requires a more, not less, rigorous selection and arrangement than ordinary grammar requires. But Joyce and a very few other writers have handled stream of consciousness as an ebullient and exciting way of capturing the mind.

Yes because he never did a thing like that before as ask to get his breakfast in bed with a couple of eggs since the City Arms hotel when he used to be pretending to be laid up with a sick voice doing his highness to make himself interesting to that old faggot Mrs. Riordan that he thought he had a great leg of and she never left us a farthing all for masses for herself and her soul greatest miser ever was actually afraid to lay out 4d for her methylated spirit telling me all her ailments she had too much old chat in her about politics and earthquakes

and the end of the world let us have a bit of fun first God help the world if all the women were her sort . . .

James Joyce, Ulysses

The preceding two examples, of interior monologue and stream of consciousness, respectively, are written in the first person, so that we overhear the minds of narrator characters. Through the omniscient and limited omniscient authors we may also overhear the thoughts of the characters, and when this is the case there is a curious doubling or crossing of literary conventions. Say that the story is told by a limited omniscient author, who is therefore speaking to "the reader." But this author may also enter the mind of a character, who is speaking to himself or herself. The passage from *The Odd Woman* on page 200 is of this sort. Here is a still more striking example:

Dusk was slowly deepening. Somewhere, he could not tell exactly where, a cricket took up a fitful song. The air was growing soft and heavy. He looked over the fields, longing for Bobo . . .

He shifted his body to ease the cold damp of the ground, and thought back over the day. Yeah, hed been dam right erbout not wantin t go swimmin. N ef hed followed his right min hed neverve gone n got inter all this trouble.

Richard Wright, "Big Boy Leaves Home"

Though this story, first published in 1938, makes use of an old style of dialect misspelling, Wright moves gracefully between the two voices. An authorial voice—educated, eloquent, and mature—tells us what is in Big Boy's mind: he could not tell exactly where, longing for Bobo; and a dialect voice lets us overhear Big Boy's thoughts, adolescent and uneducated: Yeah, hed been dam right. If either of these voices were absent, the passage would be impoverished; it needs the scope of the author and the immediacy of the character to achieve its effect.

In a *tour de force* story, "Tambourine Lady," John Edgar Wideman succeeds even in the unlikely fusion of third-person narrative and stream of consciousness, so that although the answer to the question "who speaks?" is technically "the author," nevertheless we are aware of the point-of-view character speaking to herself in rapid-fire associative thought:

... She thinks about how long it takes to get to the end of your prayers, how the world might be over and gone while you still saying the words to yourself. Words her mama taught her, words her mama said her mother had taught her so somebody would always be saying them world without end amen. So God would not forget his children . . .

In What Form?

The form of the story, like the teller and the listener, can be more or less specified as part of the total point of view. The form may announce itself without justification as a generalized story, either written or spoken; or it may suggest reportage, confessional, interior monologue, or stream of consciousness; or it may be overtly identified as monologue, oratory, journal, or diary. The relationship between the teller of a tale and its receiver often automatically implies a form for the telling, so that most of the forms above have already been mentioned. The list is not exhaustive; you can tell your story in the form of a catalogue or a television commercial as long as you can also contrive to give it the form of a story.

Form is important to point of view because the form in which a story is told indicates the degree of self-consciousness on the part of the teller; this will in turn affect the language chosen, the intimacy of the relationship, and the honesty of the telling. A written account will imply less spontaneity, on the whole, than one that appears to be spoken aloud, which suggests less spontaneity than thought. A narrator writing a letter to his grandmother may be less honest than he is when he tells the same facts aloud to his friend.

Certain relationships established by the narrative between teller and audience make certain forms more likely than others, but almost any combination of answers is possible to the questions: Who speaks? To whom? In what form? If you are speaking as an omniscient author to the literary convention of "the reader," we may assume that you are using the convention of "written story" as your form. But you might say:

Wait, step over here a minute. What's this in the corner, stuffed down between the bedpost and the wall?

If you do this, you slip at least momentarily into the different convention of the spoken word—the effect is that we are drawn more immediately into the scene—and the point of view of the whole is slightly altered. A central narrator might be thinking, and therefore "talking to herself," while actually angrily addressing her thoughts to another character. Conversely, one character might be writing a letter to another but letting the conscious act of writing deteriorate into a betrayal of his own secret thoughts. Any complexities such as these will alter and inform the total point of

Here are the opening paragraphs from Lorrie Moore's short story "People Like That Are the Only People Here," in which the point of view is extremely complex. An adequate understanding of it will require—more than a definition or a diagram—a series of yes but's and but also's.

A beginning, an end: there seems to be neither. The whole thing is like a cloud that just lands, and everywhere inside it is full of rain. A start: the Mother finds a blood clot in the Baby's diaper. What is the story? Who put this here? It is big and bright, with a broken, khaki-colored vein in it. Over the weekend, the Baby had looked listless and spacy, clayey and grim. But today he looks fine—so

what is this thing, startling against the white diaper, like a tiny mouse heart packed in snow? Perhaps it belongs to someone else. Perhaps it is something menstrual, something belonging to the Mother or the Babysitter, something the Baby has found in a wastebasket and for his own demented reasons stowed away here. (Babies-they're crazy! What can you do?) In her mind, the Mother takes this away from his body and attaches it to someone else's. There. Doesn't that make more sense?

Still, she phones the children's hospital and the clinic. Blood in the diaper. she says, and sounding alarmed and perplexed, the woman on the other end says, "Come in now."

Such pleasing instant service! Just say "blood." Just say "diaper." Look what

In the examination room, the pediatrician, the nurse, and the head resident all seem less alarmed and perplexed than simply perplexed. At first, stupidly, the Mother is calmed by this. But soon, besides peering and saying "Hmm," the doctor, the nurse, and the head resident are all drawing their mouths in, bluish and tight—morning glories sensing noon. They fold their arms across their white-coated chests, unfold them again, and jot things down. They order an ultrasound. Bladder and kidneys. Here's the card. Go downstairs, turn left.

In Radiology, the Baby stands anxiously on the table, naked against the Mother, as she holds him still against her legs and waist, the Radiologist's cold scanning disk moving about the Baby's back. The Baby whimpers, looks up at the Mother. Let's get out of here, his eyes beg. Pick me up!

Who speaks? The opening is so tentative and perplexed that this seems to be some character's speculation, and we think we are in the presence of a first-person narrator. But no. By the third sentence it's clear the passage is written in the third person—"the Mother finds"—and that we are in the limited omniscient, privy to the Mother's thoughts, sometimes overhearing them directly: "Who put this here?" Yet this central character whose thoughts we share calls herself and others by the names of types: the Mother, the Baby, the Babysitter. No one would think of herself or her baby in this way. Even her babysitter would have a name. And this Mother's thoughts are sometimes colder, more distant than the things anyone would say out loud in this situation. She talks in literary terms, striking metaphors. She is sarcastic. She fires off jokes. All the same, when she enters the baby's mind—"Let's get out of here"—we trust her.

To whom? The narrative clearly addresses the convention of "the reader." Yet because the narrative is at one and the same time so closely fused with the mother's thoughts and so deliberately distanced, the effect is that the Mother is talking to herself and also saying things to herself that she doesn't mean, bucking herself up, distracting herself with one-liners, denying. ("Babies-they're crazy! What can you do?")

In what form? Again, the form is the convention of "a story" and, indeed, this is insisted on by the familiar opening reference to Aristotle's beginning, middle, and end, and the Mother's cry, "What is the story?" We are not surprised later to find out that

the protagonist is a short-story writer—who, moreoever, disdains the form of the memoir and refuses to take notes on the baby's illness—the "notes", of course, that we are reading. (In the original publication of this story, The New Yorker compounded the paradox by labeling it "Fiction" but publishing a picture of the author in the middle of the first page, captioned with a quotation from the story in which the Mother says "This isn't fiction.") The bleak rhythm and the starkness of the images, whether visceral ("mouse heart packed in snow") or gratingly pretty ("morning glories sensing noon") betray the desperation of the Writer even as the Mother protects herself with blunt jokes.

The amazing thing is that the complexities of the point of view do not in the least confuse us! We do not feel that the author is inept at point of view, but on the contrary that she has captured with great precision the paradoxes and contradictions of the protagonist's emotional state. We feel no awkward point-of-view shift because all the terms of the contract—those same paradoxes and contradictions—are laid out for us in the opening paragraph.

In order to deal with a viewpoint as complex as this, it will be necessary to deal not only with who speaks to whom in what form, but also with distance and limitation, subjects treated in chapter 8.

Girl

IAMAICA KINCAID

Wash the white clothes on Monday and put them on the stone heap; wash the color clothes on Tuesday and put them on the clothesline to dry; don't walk barehead in the hot sun; cook pumpkin fritters in very hot sweet oil; soak your little cloths right after you take them off; when buying cotton to make yourself a nice blouse, be sure that it doesn't have gum on it, because that way it won't hold up well after a wash; soak salt fish overnight before you cook it; is it true that you sing benna in Sunday school?; always eat your food in such a way that it won't turn someone else's stomach: on Sundays try to walk like a lady and not like the slut you are so bent on becoming; don't sing benna in Sunday school; you mustn't speak to wharf-rat boys, not even to give directions; don't eat fruits on the street—flies will follow you; but I don't sing benna on Sundays at all and never in Sunday school; this is how to sew on a button; this is how to make a buttonhole for the button you have just sewed on; this is how to hem a dress when you see the hem coming down and so to prevent yourself from looking like the slut I know you are so bent on becoming; this is how you iron your father's khaki shirt so that it doesn't have a crease; this is how you iron your father's khaki pants so that they don't have a crease; this is how you grow okra—far from the house, because okra tree harbors red ants; when you are growing dasheen, make sure it gets plenty of water or else it makes your throat itch when you are eating it; this is how you sweep a corner; this is how you sweep a whole house; this is how you sweep a yard; this is how you smile to someone you don't like too much; this is how you smile to someone you don't like at all; this is how you smile to someone you like completely; this is how you set a table for tea; this is how you set a table for dinner; this is how you set a table for dinner with an important guest; this is how you set a table for lunch; this is how you set a table for breakfast; this is how to behave in the presence of men who don't know you very well, and this way they won't recognize immediately the slut I have warned you against becoming; be sure to wash every day, even if it is with your own spit; don't squat down to play marbles—you are not a boy, you know; don't pick people's flowers—you might catch something; don't throw stones at blackbirds, because it might not be a blackbird at all; this is how to make a bread pudding; this is how to make doukona; this is how to make pepper pot; this is how to make a good medicine for a cold; this is how to make a good medicine to throw away a child before it even becomes a child; this is how to catch a fish; this is how to throw back a fish you don't like, and that way something bad won't fall on you; this is how to bully a man; this is how a man bullies you; this is how to love a man, and if this doesn't work there are other ways, and if they don't work don't feel too bad about giving up; this is how to spit up in the air if you feel like it, and this is how to move quick so that it doesn't fall on you; this is how to make ends meet; always squeeze bread to make sure it's fresh; but what if the baker won't let me feel the bread?; you mean to say that after all you are really going to be the kind of woman who the baker won't let near the bread?

Suggestions for Discussion

- 1. Who speaks in "Girl"? Is it written in the first or second person? If in the first person, is the narrator central or peripheral?
- 2. To Whom? In this short compass, how does Kincaid manage to create the character of the daughter in such a way that we see her consistent inconsistency?
- 3. In what form? Describe the form as fully as you can.
- 4. This very short story is written as a single ongoing sentence. How does it nevertheless have the form of a story? Conflict, crisis, and resolution? Connection and disconnection?
- 5. The story contains several details that, if you live in the continental United States, are likely to be obscure to you: benna, dasheen, doukona. It's also possible that you can't exactly see pumpkin fritters, wharf-rat boys, an okra tree, a pepper pot. How does the author make sound, tone, and approximate meaning add to your understanding?

Hips

SANDRA CISNEROS

I like coffee, I like tea.
I like the boys and the boys like me.
Yes, no, maybe so. Yes, no, maybe so...

One day you wake up and they are there. Ready and waiting like a new Buick with the keys in the ignition. Ready to take you where?

They're good for holding a baby when you're cooking, Rachel says, turning the jump rope a little quicker. She has no imagination.

You need them to dance, says Lucy.

If you don't get them you may turn into a man. Nenny says this and she believes it. She is this way because of her age.

That's right, I add before Lucy or Rachel can make fun of her. She is stupid alright, but she is my sister.

But most important, hips are scientific, I say repeating what Alicia already told me. It's the bones that let you know which skeleton was a man's when it was a man and which a woman's.

They bloom like roses, I continue because it's obvious I'm the only one who can speak with any authority; I have science on my side. The bones just one day open. Just like that. One day you might decide to have kids, and then where are you going to put them? Got to have room. Bones got to give.

But don't have too many or your behind will spread. That's how it is, says Rachel whose mama is as wide as a boot. And we just laugh.

What I'm saying is who here is ready? You gotta be able to know what to do with hips when you get them, I say making it up as I go. You gotta know how to walk with hips, practice you know—like if half of you wanted to go one way and the other half the other.

That's to lullaby it, Nenny says, that's to rock the baby asleep inside you. And then she begins singing seashells, copper bells, eevy, ivy, o-ver.

I'm about to tell her that's the dumbest thing I've ever heard, but the more I think about it . . .

You gotta get the rhythm, and Lucy begins to dance. She has the idea, though she's having trouble keeping her end of the double-dutch steady.

It's gotta be just so, I say. Not too fast and not too slow. Not too fast and not too slow.

We slow the double circles down to a certain speed so Rachel who has just jumped in can practice shaking it.

I want to shake like hoochi-coochie, Lucy says. She is crazy.

I want to move like heebie-jeebie, I say picking up on the cue.

I want to be Tahiti. Or merengue. Or electricity.

Or tembleque!

Yes, tembleque. That's a good one. And then it's Rachel who starts it:

Skip, skip snake in your hips. Wiggle around and break your lip.

Lucy waits a minute before her turn. She is thinking. Then she begins:

The waitress with the big fat hips who pays the rent with taxi tips . . . says nobody in town will kiss her on the lips because . . . because she looks like Christopher Columbus! Yes, no, maybe so. Yes, no, maybe so.

She misses on maybe so. I take a little while before my turn, take a breath, and dive in:

Some are skinny like chicken lips. Some are baggy like soggy Band-Aids after you get out of the bathtub. I don't care what kind I get. Just as long as I get hips.

Everybody getting into it now except Nenny who is still humming not a girl, not a boy, just a little baby. She's like that.

When the two arcs open wide like jaws Nenny jumps in across from me, the rope tick-ticking, the little gold earrings our mama gave her for her First Holy Communion bouncing. She is the color of a bar of naphtha laundry soap, she is like the little brown piece left at the end of the wash, the hard little bone, my sister. Her mouth opens. She begins:

My mother and your mother were washing clothes. My mother punched your mother right in the nose. What color blood came out?

Not that old song, I say. You gotta use your own song. Make it up, you know? But she doesn't get it or won't. It's hard to say which. The rope turning, turning, turning.

Engine, engine number nine, running down Chicago line. If the train runs off the track do you want your money back?

Do you want your MONEY back? Yes, no, maybe so. Yes, no, maybe so. . . .

I can tell Lucy and Rachel are disgusted, but they don't say anything because she's my sister.

Yes, no, maybe, so. Yes, no, maybe so . . .

Nenny, I say, but she doesn't hear me. She is too many light-years away. She is in a world we don't belong to anymore. Nenny. Going. Going.

Y-E-S spells yes and out you go!

Suggestions for Discussion

- 1. "Hips" begins "One day you wake up . . ." Is it written in the second person?
- 2. How does the narrator's language let us know where she feels strong and authoritative, where vulnerable or defensive?
- 3. Many people speak to many in this very short space. To whom does the narrator speak the story?
- 4. What does the secondary form of skipping-rope rhyme add to the basic story form—how does it help to tell the story?
- 5. Is skipping rope an action? Is the making up of rhymes an action? How do these characterize?

Royal Beatings

ALICE MUNRO

Royal Beating. That was Flo's promise. You are going to get one Royal Beating.

The word *Royal* lolled on Flo's tongue, took on trappings. Rose had a need to picture things, to pursue absurdities, that was stronger than the need to stay out of trouble, and instead of taking this threat to heart she pondered: How is a beating royal? She came up with a tree-lined avenue, a crowd of formal spectators, some white horses and black slaves. Someone knelt, and the blood came leaping out like banners. An occasion both savage and splendid. In real life they didn't approach such dignity, and it was only Flo who tried to supply the event with some high air of necessity and regret. Rose and her father soon got beyond anything presentable.

Her father was king of the royal beatings. Those Flo gave never amounted to much; they were quick cuffs and slaps dashed off while her attention remained else-

where. You get out of my road, she would say. You mind your own business. You take that look off your face.

They lived behind a store in Hanratty, Ontario. There were four of them: Rose, her father, Flo, Rose's young half brother, Brian. The store was really a house, bought by Rose's father and mother, when they married and set up here in the furniture- and upholstery-repair business. Her mother could do upholstery. From both parents Rose should have inherited clever hands, a quick sympathy with materials, an eye for the nicest turns of mending, but she hadn't. She was clumsy, and when something broke she couldn't wait to sweep it up and throw it away.

Her mother had died. She said to Rose's father during the afternoon, "I have a feeling that is so hard to describe. It's like a boiled egg in my chest, with the shell left on." She died before night, she had a blood clot on her lung. Rose was a baby in a basket at the time, so of course could not remember any of this. She heard it from Flo, who must have heard it from her father. Flo came along soon afterward, to take over Rose in the basket, marry her father, open up the front room to make a grocery store. Rose, who had known the house only as a store, who had known only Flo for a mother, looked back on the sixteen or so months her parents spent here as an orderly, far gentler and more ceremonious time, with little touches of affluence. She had nothing to go on but some eggcups her mother had bought, with a pattern of vines and birds on them, delicately drawn as if with red ink; the pattern was beginning to wear away. No books or clothes or pictures of her mother remained. Her father must have got rid of them, or else Flo would. Flo's only story about her mother, the one about her death, was oddly grudging. Flo liked the details of a death: the things people said, the way they protested or tried to get out of bed or swore or laughed (some did those things), but when she said that Rose's mother mentioned a hard-boiled egg in her chest she made the comparison sound slightly foolish, as if her mother really was the kind of person who might think you could swallow an egg

Her father had a shed out behind the store, where he worked at his furniture repairing and restoring. He caned chair seats and backs, mended wickerwork, filled cracks, put legs back on, all most admirably and skillfully and cheaply. That was his pride: to startle people with such fine work, such moderate, even ridiculous charges. During the Depression people could not afford to pay more, perhaps, but he continued the practice through the war, through the years of prosperity after the war, until he died. He never discussed with Flo what he charged or what was owing. After he died she had to go out and unlock the shed and take all sorts of scraps of paper and torn envelopes from the big wicked-looking hooks that were his files. Many of these she found were not accounts or receipts at all but records of the weather, bits of information about the garden, things he had been moved to write down.

Ate new potatoes, 25th June. Record.

Dark Day, 1880's, nothing supernatural. Clouds of ash from forest fires.

Aug 16, 1938. Giant thunderstorn in evng. Lightning str. Pres. Church, Turberry Twp. Will of God?

Scald strawberries to remove acid. All things are alive. Spinoza.

Flo thought Spinoza must be some new vegetable he planned to grow, like broccoli or eggplant. He would often try some new thing. She showed the scrap of paper to Rose and asked, did she know what Spinoza was? Rose did know, or had an idea she was in her teens by that time—but she replied that she did not. She had reached an age where she thought she could not stand to know any more, about her father, or about Flo; she pushed any discovery aside with embarrassment and dread.

There was a stove in the shed, and many rough shelves covered with cans of paint and varnish, shellac and turpentine, jars of soaking brushes and also some dark sticky bottles of cough medicine. Why should a man who coughed constantly, whose lungs took in a whiff of gas in the war (called, in Rose's earliest childhood, not the First, but the Last, War), spend all his days breathing fumes of paint and turpentine? At the time, such questions were not asked as often as they are now. On the bench outside Flo's store several old men from the neighborhood sat gossiping, drowsing, in the warm weather, and some of these old men coughed all the time too. The fact is they were dying, slowly and discreetly, of what was called, without any particular sense of grievance, "the foundry disease." They had worked all their lives at the foundry in town, and now they sat still, with their wasted yellow faces, coughing, chuckling, drifting into aimless obscenity on the subject of women walking by, or any young girl on a bicycle.

From the shed came not only coughing but speech, a continual muttering, reproachful or encouraging, usually just below the level at which separate words could be made out. Slowing down when her father was at a tricky piece of work, taking on a cheerful speed when he was doing something less demanding, sandpapering or painting. Now and then some words would break through and hang clear and nonsensical on the air. When he realized they were out, there would be a quick bit of cover-up coughing, a swallowing, an alert, unusual silence.

"Macaroni, pepperoni, Botticelli, beans—"

What could that mean? Rose used to repeat such things to herself. She could never ask him. The person who spoke these words and the person who spoke to her as her father were not the same, though they seemed to occupy the same space. It would be the worst sort of taste to acknowledge the person who was not supposed to be there; it would not be forgiven. Just the same, she loitered and listened.

The cloud-capped towers, she heard him say once. "The cloud-capped towers, the gorgeous palaces."

That was like a hand clapped against Rose's chest, not to hurt, but astonish her, to take her breath away. She had to run then, she had to get away. She knew that was enough to hear, and besides, what if he caught her? It would be terrible.

This was something the same as bathroom noises. Flo had saved up and had a bathroom put in, but there was no place to put it except in a corner of the kitchen. The door did not fit, the walls were only beaverboard. The result was that even the tearing of a piece of toilet paper, the shifting of a haunch, was audible to those working or talking or eating in the kitchen. They were all familiar with each other's nether voices, not only in their more explosive moments but in their intimate sighs and growls and pleas and statements. And they were all most prudish people. So no one ever seemed to hear, or be listening, and no reference was made. The person creating the noises in the bathroom was not connected with the person who walked out.

They lived in a poor part of town. There was Hanratty and West Hanratty, with the river flowing between them. This was West Hanratty. In Hanratty the social structure ran from doctors and dentists and lawyers down to foundry workers and factory workers and draymen; in West Hanratty it ran from factory workers and foundry workers down to large improvident families of casual bootleggers and prostitutes and unsuccessful thieves. Rose thought of her own family as straddling the river, belonging nowhere, but that was not true. West Hanratty was where the store was and they were, on the straggling tail end of the main street. Across the road from them was a blacksmith shop, boarded up about the time the war started, and a house that had been another store at one time. The Salada Tea sign had never been taken out of the front window; it remained as a proud and interesting decoration though there was no Salada Tea for sale inside. There was just a bit of sidewalk, too cracked and tilted for roller-skating, though Rose longed for roller skates and often pictured herself whizzing along in a plaid skirt, agile and fashionable. There was one streetlight, a tin flower; then the amenities gave up and there were dirt roads and boggy places, front-yard dumps and strange-looking houses. What made the houses strange-looking were the attempts to keep them from going completely to ruin. With some the attempt had never been made. These were gray and rotted and leaning over, falling into a landscape of scrub hollows, frog ponds, cattails, and nettles. Most houses, however, had been patched up with tarpaper, a few fresh shingles, sheets of tin, hammered-out stovepipes, even cardboard. This was, of course, in the days before the war, days of what would later be legendary poverty, from which Rose would remember mostly low-down things—serious-looking anthills and wooden steps, and a cloudy, interesting, problematical light on the world.

There was a long truce between Flo and Rose in the beginning. Rose's nature was growing like a prickly pineapple, but slowly, and secretly, hard pride and skepticism overlapping, to make something surprising even to herself. Before she was old enough to go to school, and while Brian was still in the baby carriage, Rose stayed in the store with both of them—Flo sitting on the high stool behind the counter, Brian asleep by the window; Rose knelt or lay on the wide creaky floorboards, working with crayons on pieces of brown paper too torn or irregular to be used for wrapping.

People who came to the store were mostly from the houses around. Some country people came too, on their way home from town, and a few people from Hanratty, who walked across the bridge. Some people were always on the main street, in and out of stores, as if it was their duty to be always on display and their right to be welcomed. For instance, Becky Tyde.

Becky Tyde climbed up on Flo's counter, made room for herself beside an open tin of crumbly jam-filled cookies.

"Are these any good?" she said to Flo, and boldly began to eat one. "When are you going to give us a job, Flo?"

"You could go and work in the butcher shop," said Flo innocently. "You could go

and work for your brother."

"Roberta?" said Becky with a stagey sort of contempt. "You think I'd work for him?" Her brother who ran the butcher shop was named Robert but often called Roberta, because of his meek and nervous ways. Becky Tyde laughed. Her laugh was loud and noisy like an engine bearing down on you.

She was a big-headed loud-voiced dwarf, with a mascot's sexless swagger, a red velvet tam, a twisted neck that forced her to hold her head on one side, always looking up and sideways. She wore little polished high-heeled shoes, real lady's shoes. Rose watched her shoes, being scared of the rest of her, of her laugh and her neck. She knew from Flo that Becky Tyde had been sick with polio as a child, that was why her neck was twisted and why she had not grown any taller. It was hard to believe that she had started out differently, that she had ever been normal. Flo said she was not cracked, she had as much brains as anybody, but she knew she could get away with anything.

"You know I used to live out here?" Becky said, noticing Rose. "Hey! What's-your-name! Didn't I used to live out here, Flo?"

"If you did it was before my time," said Ho, as if the didn't know anything.

"That was before the neighborhood got so downhill. Excuse me saying so. My father built his house out here and he built his slaughterhouse and we had half an acre of orchard."

"Is that so?" said Flo, using her humoring voice, full of false geniality, humility even. "Then why did you ever move away?"

"I told you, it got to be such a downhill neighborhood," said Becky. She would put a whole cookie in her mouth if she felt like it, let her cheeks puff out like a frog's. She never told any more.

Flo knew anyway, and who didn't. Everyone knew the house, red brick with the veranda pulled off and the orchard, what was left of it, full of the usual outflow—car seats and washing machines and bedsprings and junk. The house would never look sinister, in spite of what had happened in it, because there was so much wreckage and confusion all around.

Becky's old father was a different kind of butcher from her brother, according to Flo. A bad-tempered Englishman. And different from Becky in the matter of mouthiness. His was never open. A skinflint, a family tyrant. After Becky had polio he wouldn't let her go back to school. She was seldom seen outside the house, never outside the yard. He didn't want people gloating. That was what Becky said, at the trial. Her mother was dead by that time and her sisters married. Just Becky and Robert at home. People would stop Robert on the road and ask him, "How about your sister, Robert? Is she altogether better now?"

"Yes."

[&]quot;Does she do the housework? Does she get your supper?"

[&]quot;Yes."

[&]quot;And is your father good to her, Robert?"

The story being that the father beat them, had beaten all his children and beaten his wife as well, beat Becky more now because of her deformity, which some people believed he had caused (they did not understand about polio). The stories persisted and got added to. The reason that Becky was kept out of sight was now supposed to be her pregnancy, and the father of the child was supposed to be her own father. Then people said it had been born, and disposed of.

"What?"

"Disposed of," Flo said. "They used to say go and get your lamb chops at Tyde's, get them nice and tender! It was all lies in all probability," she said regretfully.

Rose could be drawn back—from watching the wind shiver along the old torn awning, catch in the tear—by this tone of regret, caution, in Flo's voice. Flo telling a story—and this was not the only one, or even the most lurid one, she knew—would incline her head and let her face go soft and thoughtful, tantalizing, warning.

"I shouldn't even be telling you this stuff."

More was to follow.

Three useless young men, who hung around the livery stable, got together—or were got together, by more influential and respectable men in town—and prepared to give old man Tyde a horsewhipping, in the interests of public morality. They blacked their faces. They were provided with whips and a quart of whisky apiece, for courage. They were: Ielly Smith, a horse-racer and a drinker; Bob Temple, a ballplayer and strongman; and Hat Nettleton, who worked on the town dray, and had his nickname from a bowler hat he wore, out of vanity as much as for the comic effect. He still worked on the dray, in fact; he had kept the name if not the hat, and could often be seen in public—almost as often as Becky Tyde—delivering sacks of coal, which blackened his face and arms. That should have brought to mind his story, but didn't. Present time and past, the shady melodramatic past of Flo's stories, were quite separate, at least for Rose. Present people could not be fitted into the past. Becky herself, town oddity and public pet, harmless and malicious, could never match the butcher's prisoner, the cripple daughter, a white streak at the window: mute, beaten, impregnated. As with the house, only a formal connection could be made.

The young men primed to do the horsewhipping showed up late, outside Tyde's house, after everybody had gone to bed. They had a gun, but they used up their ammunition firing it off in the yard. They yelled for the butcher and beat on the door; finally they broke it down. Tyde concluded they were after his money, so he put some bills in a handkerchief and sent Becky down with them, maybe thinking those men would be touched or scared by the sight of a little wry-necked girl, a dwarf. But that didn't content them. They came upstairs and dragged the butcher out from under his bed, in his nightgown. They dragged him outside and stood him in the snow. The temperature was four below zero, a fact noted later in court. They meant to hold a mock trial but they could not remember how it was done. So they began to beat him and kept beating him until he fell. They yelled at him, *Butcher's meat!* and continued beating him while his nightgown and the snow he was lying in turned red. His son Robert said in court that he had not watched the beating. Becky said that Robert had watched at first but had run away and hid. She herself had watched all the way

through. She watched the men leave at last and her father make his delayed bloody progress through the snow and up the steps of the veranda. She did not go out to help him, or open the door until he got to it. Why not? she was asked in court, and she said she did not go out because she just had her nightgown on, and she did not open the door because she did not want to let the cold into the house.

Old man Tyde then appeared to have recovered his strength. He sent Robert to harness the horse, and made Becky heat water so that he could wash. He dressed and took all the money and with no explanation to his children got into the cutter and drove to Belgrave where he left the horse tied in the cold and took the early-morning train to Toronto. On the train he behaved oddly, groaning and cursing as if he was drunk. He was picked up on the streets of Toronto a day later, out of his mind with fever, and was taken to a hospital, where he died. He still had all the money. The cause of death was given as pneumonia.

But the authorities got wind, Flo said. The case came to trial. The three men who did it all received long prison sentences. A farce, said Flo. Within a year they were all free, had all been pardoned, had jobs waiting for them. And why was that? It was because too many higher-ups were in on it. And it seemed as if Becky and Robert had no interest in seeing justice done. They were left well-off. They bought a house in Hanratty. Robert went into the store. Becky after her long seclusion started on a career of public sociability and display.

That was all. Flo put the lid down on the story as if she was sick of it. It reflected no good on anybody.

"Imagine," Flo said.

Flo at this time must have been in her early thirties. A young woman. She wore exactly the same clothes that a woman of fifty, or sixty, or seventy, might wear: print housedresses loose at the neck and sleeves as well as the waist; bib aprons, also of print, which she took off when she came from the kitchen into the store. This was a common costume, at the time, for a poor though not absolutely poverty-stricken woman; it was also, in a way, a scornful deliberate choice. Flo scorned slacks, she scorned the outfits of people trying to be in style, she scorned lipstick and permanents. She wore her own black hair cut straight across, just long enough to push behind her ears. She was tall but fine-boned, with narrow wrists and shoulders, a small head, a pale, freckled, mobile, monkeyish face. If she had thought it worthwhile, and had the resources, she might have had a black-and-pale, fragile, nurtured sort of prettiness; Rose realized that later. But she would have to have been a different person altogether; she would have to have learned to resist making faces, at herself and others.

Rose's earliest memories of Flo were of extraordinary softness and hardness. The soft hair, the long, soft, pale cheeks, soft almost invisible fuzz in front of her ears and above her mouth. The sharpness of her knees, hardness of her lap, flatness of her front.

When Flo sang:

"Oh the buzzin' of the bees in the cigarette trees And the soda-water fountain . . ." Rose thought of Flo's old life before she married her father, when she worked as a waitress in the coffee shop in Union Station, and went with her girlfriends Mavis and Irene to Centre Island, and was followed by men on dark streets and knew how pay phones and clevators worked. Rose heard in her voice the reckless dangerous life of cities, the gum-chewing sharp answers.

And when she sang:

"Then slowly, slowly, she got up And slowly she came nigh him And all she said, that she ever did say, Was young man, I think you're dyin'!"

Rose thought of a life Flo seemed to have had beyond that, earlier than that, crowded and legendary, with Barbara Allan and Becky Tyde's father and all kinds of outrages and sorrows jumbled up together in it.

The royal beatings. What got them started?

Suppose a Saturday, in spring. Leaves not out yet but the doors open to the sunlight. Crows. Ditches full of running water. Hopeful weather. Often on Saturdays Flo left Rose in charge of the store—it's a few years now, these are the years when Rose was nine, ten, eleven, twelve—while she herself went across the bridge to Hanratty (going uptown they called it) to shop and see people, and listen to them. Among the people she listened to were Mrs. Lawyer Davies, Mrs. Anglican Rector Henley-Smith, and Mrs. Horse-Doctor McKay. She came home and imitated their flibberty voices. Monsters, she made them seem, of foolishness, and showiness, and selfapprobation.

When she finished shopping she went into the coffee shop of the Queen's Hotel and had a sundae. What kind? Rose and Brian wanted to know when she got home, and they would be disappointed if it was only pineapple or butterscotch, pleased if it was a Tin Roof, or Black and White. Then she smoked a cigarette. She had some ready-rolled that she carried with her, so that she wouldn't have to roll one in public. Smoking was the one thing she did that she would have called showing off in anybody else. It was a habit left over from her working days, from Toronto. She knew it was asking for trouble. Once, the Catholic priest came over to her right in the Oueen's Hotel, and flashed his lighter at her before she could get her matches out. She thanked him but did not enter into conversation, lest he should try to convert

Another time, on the way home, she saw at the town end of the bridge a boy in a blue jacket, apparently looking at the water. Eighteen, nineteen years old. Nobody she knew. Skinny, weakly-looking, something the matter with him, she saw at once. Was he thinking of jumping? Just as she came up even with him, what does he do but turn and display himself, holding his jacket open, also his pants. What he must have suffered from the cold, on a day that had Flo holding her coat collar tight around her throat.

When she first saw what he had in his hand, Flo said, all she could think of was What is he doing out here with a baloney sausage?

She could say that. It was offered as truth; no joke. She maintained that she despised dirty talk. She would go out and yell at the old men sitting in front of her store.

"If you want to stay where you are you better clean your mouths out!"

Saturday, then. For some reason Flo is not going uptown, has decided to stay home and scrub the kitchen floor. Perhaps this has put her in a bad mood. Perhaps she was in a bad mood, anyway, due to people not paying their bills, or the stirringup of feelings in spring. The wrangle with Rose has already commenced, has been going on forever, like a dream that goes back and back into other dreams, over hills and through doorways, maddeningly dim and populous and familiar and elusive. They are carting all the chairs out of the kitchen preparatory to the scrubbing, and they have also got to move some extra provisions for the store, some cartons of canned goods, tins of maple syrup, coal-oil cans, jars of vinegar. They take these things out to the woodshed. Brian, who is five or six by this time, is helping drag the tins.

"Yes." says Flo. carrying on from our lost starting point. "Yes, and that filth you taught to Brian."

"What filth?"

"And he doesn't know any better."

There is one step down from the kitchen to the woodshed, a bit of carpet on it so worn Rose can't ever remember seeing the pattern. Brian loosens it, dragging a tin. "Two Vancouvers," she says softly.

Flo is back in the kitchen. Brian looks from Flo to Rose and Rose says again in a slightly louder voice, an encouraging singsong, "Two Vancouvers—"

"Fried in snot!" finishes Brian, not able to control himself any longer.

"Two pickled arseholes—"

"-tied in a knot!"

There it is. The filth.

Two Vancouvers fried in snot! Two pickled arseholes tied in a knot!

Rose has known that for years, learned it when she first went to school. She came home and asked Flo, what is a Vancouver?

"It's a city. It's a long ways away."

"What else besides a city?"

Flo said, what did she mean, what else? How could it be fried, Rose said, approaching the dangerous moment, the delightful moment, when she would have to come out with the whole thing.

"Two Vancouvers fried in snot!/Two pickled arseholes tied in a knot!"

"You're going to get it!" cried Flo in a predictable rage. "Say that again and you'll get a good clout!"

Rose couldn't stop herself. She hummed it tenderly, tried saying the innocent words aloud, humming through the others. It was not just the words *snot* and *arsehole* that gave her pleasure, though of course they did. It was the pickling and tying and the unimaginable Vancouvers. She saw them in her mind shaped rather like octopuses, twitching in the pan. The tumble of reason; the spark and spit of craziness.

Lately she has remembered it again and taught it to Brian, to see if it has the same effect on him, and of course it has.

"Oh, I heard you!" says Flo. "I heard that! And I'm warning you!"

So she is. Brian takes the warning. He runs away, out the woodshed door, to do as he likes. Being a boy, free to help or not, involve himself or not. Not committed to the household struggle. They don't need him anyway, except to use against each other, they hardly notice his going. They continue, can't help continuing, can't leave each other alone. When they seem to have given up they really are just waiting and building up steam.

Flo gets out the scrub pail and the brush and the rag and the pad for her knees, a dirty red rubber pad. She starts to work on the floor. Rose sits on the kitchen table, the only place left to sit, swinging her legs. She can feel the cool oilcloth, because she is wearing shorts, last summer's tight faded shorts, dug out of the summer-clothes bag. They smell a bit moldy from winter storage.

Flo crawls underneath, scrubbing with the brush, wiping with the rag. Her legs are long, white, and muscular, marked all over with blue veins as if somebody had been drawing rivers on them with an indelible pencil. An abnormal energy, a violent disgust, is expressed in the chewing of the brush at the linoleum, the swish of the rag.

What do they have to say to each other? It doesn't really matter. Flo speaks of Rose's smart-aleck behavior, rudeness and sloppiness and conceit. Her willingness to make work for others, her lack of gratitude. She mentions Brian's innocence, Rose's corruption. Oh, don't you think you're somebody, says Flo, and a moment later, Who do you think you are? Rose contradicts and objects with such poisonous reasonableness and mildness, displays theatrical unconcern. Flo goes beyond her ordinary scorn and self-possession and becomes amazingly theatrical herself, saying it was for Rose that she sacrificed her life. She saw her father saddled with a baby daughter and she thought, What is that man going to do? So she married him, and here she is, on her knees.

At that moment the bell rings, to announce a customer in the store. Because the fight is on, Rose is not permitted to go into the store and wait on whoever it is. Flo gets up and throws off her apron, groaning—but not communicatively; it is not a groan whose exasperation Rose is allowed to share—and goes in and serves. Rose hears her using her normal voice.

"About time! Sure is!"

She comes back and ties on her apron and is ready to resume.

"You never have a thought for anybody but your ownself! You never have a thought for what I'm doing."

"I never asked you to do anything. I wish you never had. I would have been a lot better off."

Rose says this smiling directly at Flo, who has not yet gone down on her knees. Flo sees the smile, grabs the scrub rag that is hanging on the side of the pail, and throws it at her. It may be meant to hit her in the face but instead it falls against Rose's leg and she raises her foot and catches it, swinging it negligently against her ankle.

"All right," says Flo. "You've done it this time. All right."

Rose watches her go to the woodshed door, hears her tramp through the woodshed, pause in the doorway, where the screen door hasn't yet been hung, and the storm door is standing open, propped with a brick. She calls Rose's father. She calls him in a warning, summoning voice, as if against her will preparing him for bad news. He will know what this is about.

The kitchen floor has five or six different patterns of linoleum on it. Ends, which Flo got for nothing and ingeniously trimmed and fitted together, bordering them with tin strips and tacks. While Rose sits on the table waiting, she looks at the floor, at this satisfying arrangement of rectangles, triangles, some other shape whose name she is trying to remember. She hears Flo coming back through the woodshed, on the creaky plank walk laid over the dirt floor. She is loitering, waiting too. She and Rose can carry this no further by themselves.

Rose hears her father come in. She stiffens, a tremor runs through her legs, she feels them shiver on the oilcloth. Called away from some peaceful, absorbing task, away from the words running in his head, called out of himself, her father has to say something. He says, "Well? What's wrong?"

Now comes another voice of Flo's. Enriched, hurt, apologetic, it seems to have been manufactured on the spot. She is sorry to have called him from his work. Would never have done it if Rose was not driving her to distraction. How to distraction? With her back talk and impudence and her terrible tongue. The things Rose has said to Flo are such that if Flo had said them to her mother, she knows her father would have thrashed her into the ground.

Rose tries to butt in, to say this isn't true.

What isn't true?

Her father raises a hand, doesn't look at her, says, "Be guiet."

When she says it isn't true, Rose means that she herself didn't start this, only responded, that she was goaded by Flo, who is now, she believes, telling the grossest sort of lies, twisting everything to suit herself. Rose puts aside her other knowledge that whatever Flo has said or done, whatever she herself has said or done, does not really matter at all. It is the struggle itself that counts, and that can't be stopped, can never be stopped, short of where it has got to now.

Flo's knees are dirty, in spite of the pad. The scrub rag is still hanging over Rose's foot.

Her father wipes his hands, listening to Flo. He takes his time. He is slow at getting into the spirit of things, tired in advance, maybe, on the verge of rejecting the role he has to play. He won't look at Rose, but at any sound or stirring from Rose, he holds up his hand.

"Well, we don't need the public in on this, that's for sure," Flo says, and she goes to lock the door of the store, putting in the store window the sign that says BACK

SOON, a sign Rose made for her with a great deal of fancy curving and shading of letters in black and red crayon. When she comes back she shuts the door to the store, then the door to the stairs, then the door to the woodshed.

Her shoes have left marks on the clean wet part of the floor.

"Oh, I don't know," she says now, in a voice worn down from its emotional peak. "I don't know what to do about her." She looks down and sees her dirty knees (following Rose's eyes) and rubs at them viciously with her bare hands, smearing the dirt

"She humiliates me," she says, straightening up. There it is, the explanation. "She humiliates me," she repeats with satisfaction. "She has no respect."

"I do not!"

"Quiet, you!" says her father.

"If I hadn't called your father you'd still be sitting there with that grin on your face! What other way is there to manage you?"

Rose detects in her father some objections to Flo's rhetoric, some embarrassment and reluctance. She is wrong, and ought to know she is wrong, in thinking that she can count on this. The fact that she knows about it, and he knows she knows, will not make things any better. He is beginning to warm up. He gives her a look. This look is at first cold and challenging. It informs her of his judgment, of the hopelessness of her position. Then it clears, it begins to fill up with something else, the way a spring fills up when you clear the leaves away. It fills with hatred and pleasure. Rose sees that and knows it. Is that just a description of anger, should she see his eyes filling up with anger? No. Hatred is right. Pleasure is right. His face loosens and changes and grows younger, and he holds up his hand this time to silence Flo.

"All right," he says, meaning that's enough, more than enough, this part is over, things can proceed. He starts to loosen his belt.

Flo has stopped anyway. She has the same difficulty Rose does, a difficulty in believing that what you know must happen really will happen, that there comes a time when you can't draw back.

"Oh, I don't know, don't be too hard on her." She is moving around nervously as if she has thoughts of opening some escape route. "Oh, you don't have to use the belt on her. Do you have to use the belt?"

He doesn't answer. The belt is coming off, not hastily. It is being grasped at the necessary point. All right you. He is coming over to Rose. He pushes her off the table. His face, like his voice, is quite out of character. He is like a bad actor, who turns a part grotesque. As if he must savor and insist on just what is shameful and terrible about this. That is not to say he is pretending, that he is acting, and does not mean it. He is acting, and he means it. Rose knows that, she knows everything about him.

She has since wondered about murders, and murderers. Does the thing have to be carried through, in the end, partly for the effect, to prove to the audience of onewho won't be able to report, only register, the lesson—that such a thing can happen, that there is nothing that can't happen, that the most dreadful antic is justified, feelings can be found to match it?

She tries again looking at the kitchen floor, that clever and comforting geometrical arrangement, instead of looking at him or his belt. How can this go on in front of such daily witnesses—the linoleum, the calendar with the mill and creek and autumn trees, the old accommodating pots and pans?

Hold out your hand!

Those things aren't going to help her, none of them can rescue her. They turn bland and useless, even unfriendly. Posts can show malice, the patterns of linoleum can leer up at you, treachery is the other side of dailiness.

At the first, or maybe the second, crack of pain, she draws back. She will not accept it. She runs around the room, she tries to get to the doors. Her father blocks her off. Not an ounce of courage or of stoicism in her, it would seem. She runs, she screams, she implores. Her father is after her, cracking the belt at her when he can, then abandoning it and using his hands. Bang over the ear, then bang over the other ear. Back and forth, her head ringing. Bang in the face. Up against the wall and bang in the face again. He shakes her and hits her against the wall, he kicks her legs. She is incoherent, insane, shrieking. Forgive me! Oh please, forgive me!

Flo is shrieking too. Stop, stop!

Not yet. He throws Rose down. Or perhaps she throws herself down. He kicks her legs again. She has given up on words but is letting out a noise, the sort of noise that makes Flo cry, Oh, what if people can hear her? The very last-ditch willing sound of humiliation and defeat it is, for it seems Rose must play her part in this with the same grossness, the same exaggeration, that her father displays, playing his. She plays his victim with a self-indulgence that arouses, and maybe hopes to arouse, his final, sickened contempt.

They will give this anything that is necessary, it seems, they will go to any lengths.

Not quite. He has never managed really to injure her, though there are times, of course, when she prays that he will. He hits her with an open hand, there is some restraint in his kicks.

Now he stops, he is out of breath. He allows Flo to move in, he grabs Rose up and gives her a push in Flo's direction, making a sound of disgust. Flo retrieves her, opens the stair door, shoves her up the stairs.

"Go on up to your room now! Hurry!"

Rose goes up the stairs, stumbling, letting herself stumble, letting herself fall against the steps. She doesn't bang her door because a gesture like that could still bring him after her, and anyway, she is weak. She lies on the bed. She can hear through the stovepipe hole Flo snuffling and remonstrating, her father saying angrily that Flo should have kept quiet then, if she did not want Rose punished she should not have recommended it. Flo says she never recommended a hiding like that.

They argue back and forth on this. Flo's frightened voice is growing stronger, getting its confidence back. By stages, by arguing, they are being drawn back into themselves. Soon it's only Flo talking; he will not talk anymore. Rose has had to fight down her noisy sobbing, so as to listen to them, and when she loses interest in listening, and wants to sob some more, she finds she can't work herself up to it. She has passed into a state of calm, in which outrage is perceived as complete and final. In this state events and possibilities take on a lovely simplicity. Choices are mercifully clear. The words that come to mind are not the quibbling, seldom the conditional.

"Never" is a word to which the right is suddenly established. She will never speak to them, she will never look at them with anything but loathing, she will never forgive them. She will punish them; she will finish them. Encased in these finalities, and in her bodily pain, she floats in curious comfort, beyond herself, beyond responsibility.

Suppose she dies now? Suppose she commits suicide? Suppose she runs away? Any of these things would be appropriate. It is only a matter of choosing, of figuring out the way. She floats in her pure superior state as if kindly drugged.

And just as there is a moment, when you are drugged, in which you feel perfectly safe, sure, unreachable, and then without warning and right next to it a moment in which you know the whole protection has fatally cracked, though it is still pretending to hold soundly together, so there is a moment now—the moment, in fact, when Rose hears Flo step on the stairs—that contains for her both present peace and freedom and a sure knowledge of the whole down-spiralling course of events from now on.

Flo comes into the room without knocking, but with a hesitation that shows it might have occurred to her. She brings a jar of cold cream. Rose is hanging on to advantage as long as she can, lying face down on the bed, refusing to acknowledge or answer.

"Oh, come on," Flo says uneasily. "You aren't so bad off, are you? You put some of this on and you'll feel better."

She is bluffing. She doesn't know for sure what damage has been done. She has the lid off the cold cream. Rose can smell it. The intimate, babyish, humiliating smell. She won't allow it near her. But in order to avoid it, the big ready clot of it in Flo's hand, she has to move. She scuffles, resists, loses dignity, and lets Flo see there is not really much the matter.

"All right," Flo says. "You win. I'll leave it here and you can put it on when you like."

Later still a tray will appear. Flo will put it down without a word and go away. A large glass of chocolate milk on it, made with Vita-Malt from the store. Some rich streaks of Vita-Malt around the bottom of the glass. Little sandwiches, neat and appetizing. Canned salmon of the first quality and reddest color, plenty of mayonnaise. A couple of butter tarts from a bakery package, chocolate biscuits with a peppermint filling. Rose's favorites, in the sandwich, tart, and cookie line. She will turn away, refuse to look, but left alone with these eatables will be miserably tempted; roused and troubled and drawn back from the thoughts of suicide or flight by the smell of salmon, the anticipation of crisp chocolate, she will reach out a finger, just to run it around the edge of one of the sandwiches (crusts cut off!) to get the overflow, get a taste. Then she will decide to eat one, for strength to refuse the rest. One will not be noticed. Soon, in helpless corruption, she will eat them all. She will drink the chocolate milk, eat the tarts, eat the cookies. She will get the malty syrup out of the bottom of the glass with her finger, though she sniffles with shame. Too late.

Flo will come up and get the tray. She may say, "I see you got your appetite still," or, "Did you like the chocolate milk, was it enough syrup in it?" depending on how chastened she is feeling, herself. At any rate, all advantage will be lost. Rose will understand that life has started up again, that they will all sit around the table eating

again, listening to the radio news. Tomorrow morning, maybe even tonight. Unseemly and unlikely as that may be. They will be embarrassed, but rather less than you might expect considering how they have behaved. They will feel a queer lassitude, a convalescent indolence, not far off satisfaction.

One night after a scene like this they were all in the kitchen. It must have been summer, or at least warm weather, because her father spoke of the old men who sat on the bench in front of the store.

"Do you know what they're talking about now?" he said, and nodded his head toward the store to show who he meant, though of course they were not there now, they went home at dark.

"Those old coots," said Flo. "What?"

There was about them both a geniality not exactly false but a bit more emphatic than was normal, without company.

Rose's father told them then that the old men had picked up the idea somewhere that what looked like a star in the western sky, the first star that came out after sunset, the evening star, was in reality an airship hovering over Bay City, Michigan, on the other side of Lake Huron. An American invention, sent up to rival the heavenly bodies. They were all in agreement about this, the idea was congenial to them. They believed it to be lit by ten thousand electric light bulbs. Her father had ruthlessly disagreed with them, pointing out that it was the planet Venus they saw, which had appeared in the sky long before the invention of an electric light bulb. They had never heard of the planet Venus.

"Ignoramuses," said Flo. At which Rose knew, and knew her father knew, that Flo had never heard of the planet Venus either. To distract them from this, or even apologize for it, Flo put down her teacup, stretched out with her head resting on the chair she had been sitting on and her feet on another chair (somehow she managed to tuck her dress modestly between her legs at the same time), and lay stiff as a board, so that Brian cried out in delight, "Do that! Do that!"

Flo was double-jointed and very strong. In moments of celebration or emergency she would do tricks.

They were silent while she turned herself around, not using her arms at all but just her strong legs and feet. Then they all cried out in triumph, though they had seen it before.

lust as Flo turned herself Rose got a picture in her mind of that airship, an elongated transparent bubble, with its strings of diamond lights, floating in the miraculous American sky.

"The planet Venus!" her father said, applauding Flo. "Ten thousand electric lights!"

There was a feeling of permission, relaxation, even a current of happiness, in the room.

Years later, many years later, on a Sunday morning, Rose turned on the radio. This was when she was living by herself in Toronto.

It was a different kind of place in our day. Yes, it was.

It was all horses then. Horses and buggies. Buggy races up and down the main street on the Saturday nights.

"Just like the chariot races," says the announcer's, or interviewer's, smooth encouraging voice.

I never seen a one of them.

"No, sir, that was the old Roman chariot races I was referring to. That was before your time."

Musta been before my time. I'm a hunerd and two years old.

"That's a wonderful age, sir."

It is so.

She left it on, as she went around the apartment kitchen, making coffee for herself. It seemed to her that this must be a staged interview, a scene from some play, and she wanted to find out what it was. The old man's voice was so vain and belligerent, the interviewer's quite hopeless and alarmed, under its practiced gentleness and ease. You were surely meant to see him holding the microphone up to some toothless, reckless, preening centenarian, wondering what in God's name he was doing here, and what would he say next?

"They must have been fairly dangerous."

What was dangerous?

"Those buggy races."

They was. Dangerous. Used to be the runaway horses. Used to be a-plenty of accidents. Fellows was dragged along on the gravel and cut their face open. Wouldna matter so much if they was dead. Heh.

Some of them horses was the high-steppers. Some, they had to have the mustard under their tail. Some wouldn step out for nothin. That's the thing it is with the horses. Some'll work and pull till they drop down dead and some wouldn pull your cock out of a pail of lard. Hehe.

It must be a real interview after all. Otherwise they wouldn't have put that in, wouldn't have risked it. It's all right if the old man says it. Local color. Anything rendered harmless and delightful by his hundred years.

Accidents all the time then. In the mill. Foundry. Wasn't the precautions.

"You didn't have so many strikes then, I don't suppose? You didn't have so many unions?"

Everybody taking it easy nowadays. We worked and we was glad to get it. Worked and was glad to get it.

"You didn't have television."

Didn't have no TV. Didn't have no radio. No picture show.

"You made your own entertainment."

That's the way we did.

"You had a lot of experiences young men growing up today will never have." *Experiences*.

"Can you recall any of them for us?"

I eaten groundhog meat one time. One winter. You wouldna cared for it. Heh.

There was a pause, of appreciation, it would seem, then the announcer's voice saying that the foregoing had been an interview with Mr. Wilfred Nettleton of Han-

233

ratty, Ontario, made on his hundred and second birthday, two weeks before his death, last spring. A living link with our past. Mr. Nettleton had been interviewed in the Wawanash County Home for the Aged.

Hat Nettleton.

Horsewhipper into centenarian. Photographed on his birthday, fussed over by nurses, kissed no doubt by a girl reporter. Flashbulbs popping at him. Tape recorder drinking in the sound of his voice. Oldest resident. Oldest horsewhipper. Living link

with our past.

Looking out from her kitchen window at the cold lake, Rose was longing to tell somebody. It was Flo would would enjoy hearing. She thought of her saying *Imagine!* in a way that meant she was having her worst suspicions gorgeously confirmed. But Flo was in the same place Hat Nettleton had died in, and there wasn't any way Rose could reach her. She had been there even when that interview was recorded, though she would not have heard it, would not have known about it. After Rose put her in the Home, a couple of years earlier, she had stopped talking. She had removed herself, and spent most of her time sitting in a corner of her crib, looking crafty and disagreeable, not answering anybody, though she occasionally showed her feelings by biting a nurse.

Suggestions for Discussion

- 1. Who speaks? To Whom? In what form? Identify several ways in which these three questions are *not* adequate to describe the point of view of "Royal Beatings."
- 2. How many different kinds of externally observed details are used to characterize the opaque characters?
- 3. The last long section of "Royal Beatings" begins on page 224 with a question: "Royal beatings. What got them started?" Is the answer provided in a summary or a scene? How does the word "Suppose" affect the point of view?
- 4. What specific effect does this story achieve that you would most like to be able to achieve? Try it.

Retrospect

- 1. Analyze the *limited omniscient* voice in "The Things They Carried," "Where Are You Going, Where Have You Been?," "Girls at War" and /or "Bullet in the Brain." How limited is it in each case? How much freedom in time, space, and characters' minds has the author allowed her/himself?
- 2. Examine the second-person passage on page 19 of *The Writing Life*. What techniques does Annie Dillard use to get you to accept this picture of "you"?

- 3. How objective is the author of Mary Robison's "Yours"? How does the author direct your sympathies through this relatively factual account?
- 4. "A Very Old Man with Enormous Wings" takes great liberties with point of view, occupying various minds without indicating early on that this is the author's right, and in ways advised against in this chapter. What techniques does Gabriel García Marquez use to get you to accept this?

Writing Assignments

- 1. Write a short scene about the birth or death of anything (person, plant, animal, machine, scheme, passion, etc.). Use all five areas of knowledge of the *editorial omniscient author*. Be sure to give us the thoughts of more than one character, tell us something about at least one character that he or she doesn't realize, include something from past or future, and deliver a universal truth.
- 2. Write a love scene, serious or comic, from the *limited omniscient* viewpoint—objective observation and the thoughts of one character. Make this character believe that the other loves her or him, while the external actions make clear to the reader that this is not so.
- 3. Write about a recent dream, using the viewpoint of the objective author. Without any comment or interpretation whatever, report the events (the more bizarre, the better) as they occur.
- 4. Write a monologue from the point of view of a mother—your own or imaginary—laying down the rules for her child.
- 5. Write a letter from a central narrator to another character from whom the narrator wants a great deal of money. Convince us as readers that the money is deserved.
- 6. Place a character in an uncomfortable social situation and write a passage in the *limited omniscient*, in which his/her dialogue is in sharp contrast to his/her interior monologue.

8

ASSORTED LIARS Point of View, Part II

- · At What Distance?
- With What Limitations?

As with the chemist at her microscope and the lookout in his tower, fictional point of view always involves the *distance*, close or far, of the perceiver from the thing perceived. Point of view in fiction, however, is immensely complicated by the fact that distance is not only, though it may be partly, spatial. It may also be temporal. Or the distance may be intangible and involve a judgment—moral, intellectual, and/or emotional. More complicated still, the narrator or characters or both may view the action from one distance, the author and reader from another.

At What Distance?

Authorial distance, sometimes called *psychic distance*, is the degree to which we as readers feel on the one hand intimacy and identification with, or on the other hand detachment and alienation from, the characters in a story.

Several of the techniques already described in this book—abstract nouns, summary, typicality, apparent objectivity—can be used to create a feeling of distance and detachment in the reader toward the characters.

It started in the backyards. At first the men concentrated on heat and smoke, and on dangerous thrusts with long forks. Their wives gave them aprons in railroad stripes, with slogans on the front—Hot Stuff, The Boss—to spur them on. Then it began to get mixed up who should do the dishes, and you can't fall back on paper plates forever, and around that time the wives got tired of making

butterscotch brownies and jello salads with grated carrots in them and wanted to make money instead, and one thing led to another.

Margaret Atwood, "Simmering"

Closeness and sympathy can be achieved by concrete detail, scene, a character's thoughts, and so forth.

She dreams she does not already have three children. A squeeze around the flowers in her hands chokes off three and four and five years of breath. Instantly she is ashamed and frightened in her superstition. She looks for the first time at the preacher, forces humility into her eyes, as if she believes he is, in fact, a man of God. She can imagine God, a small black boy, timidly pulling the preacher's coattail.

Alice Walker, "Roselily"

Or a combination of techniques may make us feel simultaneously sympathetic and detached—a frequent effect of comedy—as in this example:

I'm a dishwasher in a restaurant. I'm not trying to impress anybody. I'm not bragging. It's just what I do. It's not the glamorous job people make it out to be. Sure, you make a lot of dough and everybody looks up to you and respects you, but then again there's a lot of responsibility. It weighs on you. It wears on you. Everybody wants to be a dishwasher these days, I guess, but they've got an idealistic view of it.

Robert McBrearty, "The Dishwasher"

As author you may ask us to identify completely with one character and totally condemn another. One character may judge another harshly while you as author suggest that we should qualify that judgment. If there is also a narrator, that narrator may think himself morally superior while behind his back you make sure that we will think him morally deficient. Further, the four members of the author-reader-character-narrator relationship may operate differently in various areas of value: The character calls the narrator stupid and ugly; the narrator thinks herself ugly but clever; the author and the reader know that she is both intelligent and beautiful.

Any complexity or convolution in the relationship among author, narrator, and characters can make successful fiction. The one relationship in the dialogue in which there must not be any opposition or distance is between author and reader. We may find the characters and/or the narrator bad, stupid, and tasteless and still applaud the book as just, brilliant, and beautiful. But if the hero's agony strikes us as ridiculous, if the comedy leaves us cold—if we say that the *book* is bad, stupid, or tasteless—then we are in opposition to the author's values and reject his or her "point of view" in the sense of "opinion." Ultimately, the reader must accept the es-

sential attitudes and judgments of the author, even if only provisionally, if the fiction is going to work.

I can think of no exception to this rule, and it is not altered by experimental plays and stories in which the writer's purpose is to embarrass, anger, or disgust us. Our acceptance of such experiments rests on our understanding that the writer did want to embarrass, anger, or disgust us, just as we accept being frightened by a horror story because we know that the writer set out to frighten us. If we think the writer is disgusting by accident, ineptitude, or moral depravity, then we are "really" disgusted and the fiction does not work.

It is a frustrating experience for many beginning (and established) authors to find that, whereas they meant the protagonist to appear sensitive, their readers find him self-pitying; whereas the author meant her to be witty, the readers find her vulgar. When this happens there is a failure of authorial or psychic distance: The author did not have sufficient perspective on the character to convince us to share his or her judgment. I recall one class in which a student author had written, with excellent use of image and scene, the story of a young man who fell in love with an exceptionally beautiful young woman, and whose feelings turned to revulsion when he found out she had had a mastectomy. The most vocal feminist in the class loved this story, which she described as "the exposé of a skuzzwort." This was not, from the author's point of view, a successful reading of his story.

SPATIAL AND TEMPORAL DISTANCE

The author's or narrator's attitude may involve distance in time or space or both. When a story begins "Long ago and far away," we are instantly transported by a tone we recognize as belonging to fairy tale, fantasy, and neverland. Any time you (or your narrator) begin by telling us that the events you are relating took place in the far past, you distance us, making a submerged promise that the events will come to an end, since they "already have."

That spring, when I had a great deal of potential and no money at all, I took a job as a janitor. That was when I was still very young and spent money very freely, and when, almost every night, I drifted off to sleep lulled by sweet anticipation of that time when my potential would suddenly be realized and there would be capsule biographies of my life on the dust jackets of many books.

James Alan McPherson, "Gold Coast"

Here a distance in time indicates the attitude of the narrator toward his younger self, and his indulgent, self-mocking tone (*lulled by sweet anticipation of that time when my potential would suddenly be realized*) invites us as readers to identify with the older, narrating self. We know that he is no longer lulled by such fantasies, and, at least for the duration of the story, neither are we. That is, we are close to the narrator, distanced from him as a young man, so that the distance in time also involves distance in attitude.

By contrast, the young protagonist of Frederick Busch's Sometimes I Live in the Country is presented in perceptions, vocabulary, and syntax that, even though in the third person, suggest we are inside the child's mind, temporally close to him. At the same time, these techniques distance us psychically, since we are aware of the difference between our own perceptions and way of speaking, and the child's.

The sky sat on top of their hill. He was between the grass and the black air and the stars. Pop's gun was black too and it was colder than the ground. It filled his mouth. It was a small barrel but it filled his mouth up. He gagged on the gun that stuffed up into his head. He decided to close his eyes. Then he opened them. He didn't want to miss anything. He pulled the trigger but nothing happened. He didn't want to pull the trigger but he did.

In the next passage, the author makes use of space to establish an impersonal and authoritative tone.

An unassuming young man was traveling, in midsummer, from his native city of Hamburg, to Davos-Platz in the Canton of Grisons, on a three weeks' visit.

From Hamburg to Davos is a long journey—too long, indeed, for so brief a stay. It crosses all sorts of country; goes up hill and down dale, descends from the plateau of Southern Germany to the shore of Lake Constance, over its bounding waves and on across marshes once thought to be bottomless.

Thomas Mann, The Magic Mountain

Here Mann distances us from the young man by characterizing him perfunctorily, not even naming him, and describes the place travelogue style, inviting us to take a panoramic view. This choice of tone establishes a remoteness that is emotional as well as geographical, and would do so even if the reader happened to be a native of Grisons. (Eventually we will become intimately involved with Davos and the unassuming young man, who is in for a longer stay than he expects.)

By closing the literal distance between the reader and the subject, the intangible distance can be closed as well.

Her face was half an inch from my face. The curtain flapped at the open window and her pupils pulsed with the coming and going of the light. I know Jill's eyes; I've painted them. They're violent and taciturn, a ring of gas-blue points like cold explosion to the outside boundary of iris, the whole held back with its brilliant lens. A detonation under glass.

Janet Burroway, Raw Silk

In the extreme closeness of this focus, we are brought emotionally close, invited to share the narrator's perspective of Jill's explosive eyes.

It will be obvious that using time and space as a means of controlling the reader's

emotional closeness or distance involves all the elements of atmosphere discussed in chapter 6. This is true of familiarity, which invites identification with a place, and of strangeness, which alienates. And it is true of summary, which distances, and of scene, which draws us close. If you say, "There were twelve diphtheria outbreaks in Coeville over the next thirty years," you invite us to take a detached historical attitude. But if you say, "He forced his finger into her throat and tilted her toward the light to see, as he'd expected, the grayish membrane reaching toward the roof of her mouth and into her nose," the doctor may remain detached, but we as readers cannot.

There is a grammatical technique, very often misused, involving the switching of tense. Most fiction in English is written in the past tense (*She put her foot on the shovel and leaned all her weight against it*). The author's constant effort is to give this past the immediacy of the present. A story may be written in the present tense (*She puts her foot on the shovel and leans all her weight against it*). The effect of using the present tense, a technique that has become increasingly popular in the last twenty years, is to reduce distance and increase immediacy: We are there. Generally speaking, the tense once established should not be changed.

Danforth got home about five o'clock in the morning and fixed himself a peanut butter sandwich. He eats it over the sink, washing it down with half a carton of chocolate milk. He left the carton on the sink and stumbled up to bed.

The change of tense in the second sentence is pointless; it violates the reader's sense of time to have the action skip from past to present and back again and produces no compensating effect. It may be an unfortunate side effect of the new popularity of present tense narrative that such tense-wobble is more and more frequently seen. It's important to recognize and avoid, though, because like shifts in point of view, tense shifts send a signal to readers and editors that the writer is not in control of the craft.

There are times, however, when a change of tense can be functional and effective. In the story "Gold Coast," we are dealing with two time frames, one having to do with the narrator's earlier experiences as a janitor, and one in which he acknowledges the telling.

I left the rug on the floor because it was dirty and too large for my new apartment. I also left the two plates given me by James Sullivan, for no reason at all. Sometimes I want to go back to get them, but I do not know how to ask for them or explain why I left them in the first place.

The tense change here is logical and functional: It acknowledges the past of the "story" and the present of the "telling"; it also incidentally reinforces our emotional identification with the older, narrating self.

Sometimes, a shift into the present tense even without a strictly logical justification can achieve the effect of intensity and immediacy, so that the emotional distance between reader and character is diminished. When alone he had a dreadful and distressing desire to call someone, but he knew beforehand that with others present it would be still worse. "Another dose of morphine—to lose consciousness. I will tell him, the doctor, that he must think of something else. It's impossible, impossible, to go on like this."

An hour and another pass like that. But now there's a ring at the doorbell. Perhaps it's the doctor? It is. He comes in fresh, hearty, plump and cheerful.

Leo Tolstoy, The Death of Ivan Ilyich

This switch from the past to the present draws us into the character's anguish and makes the doctor's arrival more intensely felt. Notice that Ivan Ilyich's thoughts—"Another dose of morphine"—which occur naturally in the present tense, serve as a transition from past to present so that we are not jolted by the change. In *The Death of Ivan Ilyich*, Tolstoy keeps the whole scene of the doctor's visit in the present tense, while Ivan Ilyich's consciousness is at a pitch of pain, contempt for the doctor, and hatred for his wife; then, as the focus moves to the wife, the tense slips back into the past.

The thrill of hatred he feels for her makes him suffer from her touch. Her attitude towards him and his disease is still the same. Just as the doctor had adopted a certain relation to his patient which he could not abandon, so had she formed one toward him . . . and she could not now change that attitude.

A switch from past to present tense can be effectively employed to depict moments of special intensity, but this device needs both to be saved for those crucial moments and to be controlled so carefully in the transition that the reader is primarily aware of the intensity, rather than the tense.

INTANGIBLE DISTANCE

Spatial and temporal distance, then, can imply distance in the attitude of the teller toward his or her material. But authorial distance may also be implied through *tone* without any tangible counterpart.

The word "tone," applied to fiction, is a metaphor derived from music and also commonly—and metaphorically—used to describe color and speech. When we speak of a "tone of voice" we mean that an attitude is conveyed, and this attitude is determined by the situation and by the relation of the persons involved in the situation. Tone can match, emphasize, alter, or contradict the meaning of the words.

The situation is that Louise stumbles into her friend Judy's apartment, panting, hair disheveled, coat torn, and face blanched. Judy rushes to support her. "You look awful! What happened?" Here the tone conveys alarm, openness, and a readiness to sympathize.

Judy's son wheels in grinning, swinging a baseball bat, shirt torn, mud-splattered, and missing a shoe. "You look awful! What happened?" Judy's tone is angry, exasperated.

Louise's ex-boyfriend drops by that night decked out in a plaid polyester sports coat and an electric-blue tie. "You look awful! What happened?" Louise says, her tone light, but cutting, so that he knows she means it.

Judy's husband comes back from a week in Miami and takes off his shirt to model his tan. "You look awful! What happened?" she teases, playful and flirting, so that he

knows she means he looks terrific.

In each of these situations the attitude is determined by the situation and the emotional relationships of the persons involved, and in life as in acting the various tones would be conveyed by vocal means—pitch, tempo, plosion, nasality—reinforced by posture, gesture, and facial expression. When we apply the word "tone" to fiction, we tacitly acknowledge that we must do without these helpful signs. The author, of course, may describe pitch, posture, and the like, or may identify a tone as "cutting" or "playful," but these verbal and adverbial aids describe only the tone used among characters, whereas the fictional relationship importantly includes an author who must also convey identification or distance, sympathy or judgment, and who must choose and arrange words so that they match, emphasize, alter, or contradict their inherent meaning.

Tone itself is an intangible, and there are probably as many possible tones as there are possible situations, relationships, and sentences. But in a very general way, we will trust, in literature as in life, a choice of words that seems appropriate in intensity or value to the meaning conveyed. If the intensity or value seems inappropriate, we will start to read between the lines. If a woman putting iodine on a cut says "Ouch," we don't have to search for her meaning. But if the cut is being stitched up without anesthetic, then "Ouch" may convey courage, resignation, and trust. If she says "Ouch" when her lover strokes her cheek, then we read anger and recoil into the word.

In the same way, you as author manipulate intensity and value in your choice of language, sometimes matching meaning, sometimes contradicting, sometimes overstating, sometimes understating, to indicate your attitude to the reader.

She was a tall woman of imperious mien, handsome, with definite black eyebrows. Her smooth black hair was parted exactly. For a few moments she stood steadily watching the miners as they passed along the railway; then she turned toward the brook course. Her face was calm and set, her mouth was closed with disillusionment.

D. H. Lawrence, "Odour of Chrysanthemums"

There is in this passage no discrepancy between the thing conveyed and the intensity with which it is conveyed, and we take the words at face value, accepting that the woman is as the author says she is. The phrase "imperious mien" has itself an imperious tone about it (I doubt one would speak of a real cool mien). The syntax is as straightforward as the woman herself. (Notice how the rhythm alters with "For a few moments," so that the longest and most flowing clause follows the passing miners.) You might describe the tone of the passage as a whole as "calm and set."

The next example is quite different.

Mrs. Herriton did not believe in romance, nor in transfiguration, nor in parallels from history, nor in anything that may disturb domestic life. She adroitly changed the subject before Philip got excited.

E. M. Forster, Where Angels Fear to Tread

This is clearly also a woman of "imperious mien," and the author purports, like the first, to be informing us of her actions and attitudes. But unlike the first example, the distance here between the woman's attitude and the author's is apparent. It is possible to "believe in" both romance and transfiguration, which are concepts. If Lawrence should say of the woman in "Odour of Chrysanthemums" that "she did not believe in romance, nor in transfiguration," we would accept it as a straightforward part of her characterization. But how can one believe in parallels? *Belief* is too strong a word for *parallels*, and the discrepancy makes us suspicious. Not to "believe" in "anything that may disturb domestic life" is a discrepancy of a severer order, unrealistic and absurd. The word "adroitly" presents a value judgment, one of praise. But placed as it is between "anything that may disturb domestic life" and "before Philip got excited," it shows us that Mrs. Herriton is manipulating the excitement out of domestic life.

Irony. Discrepancies of intensity and value are ironic. Any time there is a discrepancy between what is said and what we are to accept as the truth, we are in the presence of an irony. There are three basic types of irony.

Verbal irony is a rhetorical device in which the author (or character) says one thing and means another. The passage from "The Dishwasher" at the beginning of this chapter displays verbal irony, where the "glamour" and "responsibility" of the job point up the opposite. Mrs. Herriton's "adroitly changed the subject" is also a form of verbal irony. When the author goes on to say, "Lilia tried to assert herself, and said that she should go to take care of her mother. It required all Mrs. Herriton's kindness to prevent her," there is further verbal irony in the combination of "required" and "kindness."

Dramatic irony is a device of plot in which the reader or audience knows more than the character does. The classical example of dramatic irony is *Oedipus Rex*, where the audience knows that Oedipus himself is the murderer he seeks. There is dramatic irony in "Bullet in the Brain," where the reader (and other characters) realize the seriousness of Anders's situation when he does not.

Cosmic irony is an all-encompassing attitude toward life, which takes into account the contradictions inherent in the human condition. The story "Where Are You Going, Where Have You Been?", in which Connie's contemptuous desire to get away from her family is fulfilled, and she is destroyed by it, demonstrates cosmic irony.

Any of these types of irony will inform the author's attitude toward the material and will be reflected in his or her tone. Any of them will involve authorial distance,

since the author means, knows, or wishes to take into account—and also intends the reader to understand—something not wholly conveyed by the literal meaning of the words.

Of the two passages quoted previously, we may say that the first, from Lawrence, is without irony; the second, from Forster, contains an irony presented by the author, understood by the reader, and directed against the character described. The following passage, again about a woman of imperious mien, is more complex because it introduces the fourth possible member of the narrative relationship, the narrator; and it also involves temporal distance.

She was a tall woman with high cheekbones, now more emphasized than ever by the loss of her molar teeth. Her lips were finer than most of her tribe's and wore a shut, rather sour expression. Her eyes seemed to be always fixed on the distance, as though she didn't "see" or mind the immediate, but dwelt in the eternal. She was not like other children's grandmothers we knew, who would spoil her grandchildren and had huts "just outside the hedge" of their sons' homesteads. Grandmother lived three hills away, which was inexplicable.

Jonathan Kariara, "Her Warrior"

This paragraph begins, like Lawrence's, without irony, as a strong portrait of a strong woman. Because we trust the consistent tone of the first two sentences, we also accept the teller's simile "as though she didn't see or mind the immediate," which emphasizes without contradicting. Up to this point the voice seems to have the authority of an omniscient author, but in the fourth sentence the identity of the narrator is introduced—one of the woman's grandchildren. Because the past tense is used, and even more because the language is measured and educated, we instantly understand that the narrator is telling of his childhood perceptions from an adult, temporally distanced perspective. Curiously, the final word of the final sentence presents us with a contradiction of everything we have just found convincing. It cannot be "inexplicable" that this woman lived three hills away, because it has already been explained to us that she lived in deep and essential remoteness.

This irony is not directed primarily against the character of the grandmother but by the narrator against himself as a child. Author, narrator, and reader all concur in an intellectual distance from the child's mind and its faulty perceptions. At the same time, there is perhaps a sympathetic identification with the child's hurt, and therefore a residual judgment of the grandmother.

With What Limitations?

In each of the excerpts in the section "Intangible Distance" we trust the teller of the tale. We may find ourselves in opposition to characters perceived or perceiving, but we identify with the attitudes, straightforward or ironic, of the authors and narrators who present us these characters. We share, at least for the duration of the narrative, their norms.

THE UNRELIABLE NARRATOR

It is also possible to mistrust the teller. Authorial distance may involve not a deliberate attitude taken by the speaker, but distance on the part of the author from the narrator. The answer to the question *Who speaks?* may itself necessitate a judgment, and again this judgment may imply opposition of the author (and reader) on any scale of value—moral, intellectual, aesthetic, or physical—and to these I would add educational and experiential (probably the list can be expanded further).

If the answer to *Who speaks?* is a child, a bigot, a jealous lover, an animal, a schizophrenic, a murderer, a liar, the implications may be that the narrator speaks with limitations we do not necessarily share. To the extent that the narrator displays and betrays such limitations, she or he is an *unreliable narrator*; and the author, without a word to call his own, must let the reader know that the story is not to be trusted.

Here is a fourth woman, imperious and sour, who tells her own story.

I have always, always, tried to do right and help people. It's a part of my community duty and my duty to God. But I can tell you right now, you don't never gets no thanks for it! . . .

Use to be a big ole fat sloppy woman live cross the street went to my church. She had a different man in her house with her every month! She got mad at me for tellin the minister on her about all them men! Now, I'm doin my duty and she got mad! I told her somebody had to be the pillar of the community and if it had to be me, so be it! She said I was the pill of the community and a lotta other things, but I told the minister that too and pretty soon she was movin away. Good! I like a clean community!

J. California Cooper, "The Watcher"

We mistrust every judgment this woman makes, but we are also aware of an author we do trust, manipulating the narrator's tone to expose her. The outburst is fraught with ironies, but because the narrator is unaware of them, they are directed against herself. We can hear that interference is being dressed up as duty. When she brags in cliché, we agree that she's more of a pill than a pillar. When she appropriates biblical language—so be it!—we suspect that even the minister might agree. Punctuation itself, the self-righteous overuse of the exclamation point, suggests her inappropriate intensity. It occurs to us we'd probably like the look of that "big ole fat sloppy" neighbor; and we know for certain why that neighbor moved away.

In this case the narrator is wholly unreliable, and we're unlikely to accept any judgment she could make. But it is also possible for a narrator to be reliable in some areas of value and unreliable in others. Mark Twain's Huckleberry Finn is a famous case in point. Here Huck has decided to free his friend Jim, and he is astonished that Tom Sawyer is going along with the plan.

Well, one thing was dead sure; and that was, that Tom Sawyer was in earnest and was actuly going to help steal that nigger out of slavery. That was the thing that was too many for me. Here was a boy that was respectable, and well brung up; and had a character to lose; and folks at home that had characters; and he was bright and not leather-headed; and knowing and not ignorant; and not mean, but kind; and yet here he was, without any more pride, or rightness, or feeling, than to stoop to this business, and make himself a shame, and his family a shame, before everybody. I couldn't understand it, no way at all.

The extended irony in this excerpt is that slavery should be defended by the respectable, the bright, the knowing, the kind, and those of character. We reject Huck's assessment of Tom as well as the implied assessment of himself as worth so little that he has nothing to lose by freeing a slave. Huck's moral instincts are better than he himself can understand. (Notice, incidentally, how Huck's lack of education is communicated by word choice and syntax and how sparse the misspellings are.) So author and reader are in intellectual opposition to Huck the narrator, but morally identify with him.

The unreliable narrator—who has become one of the most popular characters in modern fiction—is far from a newcomer to literature and in fact predates fiction. Every drama contains characters who speak for themselves and present their own cases, and from whom we are partly or wholly distanced in one area of value or another. So we admire Oedipus's intellect but are exasperated by his lack of intuition, we identify with Othello's morality but mistrust his logic, we trust Mr. Spock's brain but not his heart, we count on Seinfeld's wit but not his morals. As these examples suggest, the unreliable narrator often presents us with an example of consistent inconsistency and always presents us with dramatic irony, because we always "know" more than he or she does about the characters, the events, and the significance of both.

AN EXERCISE IN UNRELIABILITY

The following four passages represent narrations by four relatively mad madmen. How mad is each? To whom does each speak? In what form? Which of their statements are reliable? Which are unreliable? Which of them admit to madness? Is the admission reliable? What ironies can you identify, and against whom is each directed? What is the attitude of the author behind the narrator? By what choice and arrangement of words do you know this?

The doctor advised me not to insist too much on looking so far back. Recent events, he says, are equally valuable for him, and above all my fancies and dreams of the night before. But I like to do things in their order, so directly I left the doctor (who was going to be away from Trieste for some time). I bought and read a book on psychoanalysis, so that I might begin from the very beginning, and make the doctor's task easier. It is not difficult to understand, but very boring. I have stretched myself out after lunch in an easy chair, pencil and paper in hand. All the lines have disappeared from my forehead as I sit here with my mind completely relaxed. I seem to be able to see my thoughts as something quite apart from myself. I can watch them rising, falling, their only form of

activity. I seize my pencil in order to remind them that it is the duty of thought to manifest itself. At once the wrinkles collect on my brow as I think of the letters that make up every word.

Italo Svevo, Confessions of Zeno

Madrid, Februarius the thirtieth

So I'm in Spain. It all happened so quickly that I hardly had time to realize it. This morning the Spanish delegation finally arrived for me and we all got into the carriage. I was somewhat bewildered by the extraordinary speed at which we traveled. We went so fast that in half an hour we reached the Spanish border. But then, nowadays there are railroads all over Europe and the ships go so fast too. Spain is a strange country. When we entered the first room, I saw a multitude of people with shaven heads. I soon realized, though, that these must be Dominican or Capuchin monks because they always shave their heads. I also thought that the manners of the King's Chancellor, who was leading me by the hand, were rather strange. He pushed me into a small room and said: "You sit quiet and don't you call yourself King Ferdinand again or I'll beat the nonsense out of your head." But I knew that I was just being tested and refused to submit.

Nikolai Gogol, The Diary of a Madman

Pushed back into sleep as I fight to emerge, pushed back as they drown a kitten, or a child fighting to wake up, pushed back by voices and lullabies and bribes and bullies, punished by tones of voices and by silences, gripped into sleep by medicines and syrups and dummies and dope.

Nevertheless I fight, desperate, like a kitten trying to climb out of the slippysided zinc pail it has been flung in, an unwanted, unneeded cat to drown, better dead than alive, better asleep than awake, but I fight, up and up into the light, greeting dark now as a different land, a different texture, a different state of the Light.

Doris Lessing, Briefing for a Descent into Hell

Come into my cell. Make yourself at home. Take the chair; I'll sit on the cot. No? You prefer to stand by the window? I understand. You like my little view. Have you noticed that the narrower the view the more you can see? For the first time I understand how old ladies can sit on their porches for years.

Don't I know you? You look very familiar. I've been feeling rather depressed and I don't remember things very well. I think I am here because of that or because I committed a crime. Perhaps it's both. Is this a prison or a hospital or a prison hospital? A Center for Aberrant Behavior? So that's it. I have behaved aberrantly. In short, I'm in the nuthouse.

UNRELIABILITY IN OTHER VIEWPOINTS

I have said that a narrator cannot be omniscient, although he or she may be reliable. It may seem equally plausible that the phenomenon of unreliability can apply only to a narrator, who is by definition a fallible human being. But the subtleties of authorial distance are such that it is possible to indicate unreliability through virtually any point of view. If, for example, you have chosen a limited omniscient viewpoint including only external observation and the thoughts of one character, then it may be that the character's thoughts are unreliable and that he or she misrepresents external facts. Then you must make us aware through tone that you know more than you have chosen to present. William Golding, in The Inheritors, tells his story in the third person, but through the eyes and thoughts of a Neanderthal who has not yet developed the power of deductive reasoning.

The man turned sideways in the bushes and looked at Lok along his shoulder. A stick rose upright and there was a lump of bone in the middle. Suddenly Lok understood that the man was holding the stick out to him but neither he nor Lok could reach across the river. He would have laughed if it were not for the echo of screaming in his head. The stick began to grow shorter at both ends. Then it shot out to full length again.

The dead tree by Lok's ear acquired a voice.

"Clop!"

His ears twitched and he turned to the tree. By his face there had grown a twig: a twig that smelt of other, and of goose, and of the bitter berries that Lok's stomach told him he must not eat.

The imaginative problem here, imaginatively embraced, is that we must supply the deductive reasoning of which our point of view character is incapable. Lok has no experience of bows or poison arrows, nor of "men" attacking each other, so his conclusions are unreliable. "Suddenly Lok understood" is an irony setting us in opposition to the character's intellect; at the same time, his innocence makes him morally sympathetic. Since the author does not intervene to interpret for us, the effect is very near that of an unreliable narrator.

Other experiments abound. Isaac Loeb Peretz tells the story of "Bontsha the Silent" from the point of view of the editorial omniscient, privy to the deliberations of the angels, but with Yiddish syntax and "universal truths" so questionable that the omniscient voice itself is unreliable. Conversely, Faulkner's The Sound and the Fury is told through several unreliable narrators, each with an idiosyncratic and partial perception of the story, so that the cumulative effect is of an omniscient author able not only to penetrate many minds but also to perceive the larger significance.

I'm conscious that this discussion of point of view contains more analysis than advice, and this is because very little can be said to be right or wrong about point of view as long as the reader ultimately identifies with the author; as long, that is, as you make it work. In Aspects of the Novel E. M. Forster speaks vaguely, but with undeniable accuracy, of "the power of the writer to bounce the reader into accepting what he says." He then goes on to prove categorically that Dickens's Bleak House is a disaster, "Logically all to pieces, but Dickens bounces us, so that we do not mind the shiftings of the view point."

The one imperative is that the reader must bounce with, not against, the author. Virtually any story can be told from virtually any point of view and convey the same attitude of the author.

Suppose, for example, that you are going to write this story: Two American soldiers, one a seasoned corporal and the other a newly arrived private, are sent on a mission in a Far Eastern "police action" to kill a sniper. They track, find, and capture the Asian, who turns out to be a fifteen-year-old boy. The corporal offers to let the private pull the trigger, but he cannot. The corporal kills the sniper and triumphantly cuts off his ear for a trophy. The young soldier vomits; ashamed of himself, he pulls himself together and vows to do better next time.

Your attitude as author of this story is that war is inhumane and dehumanizing. You may write the story from the point of view of the editorial omniscient, following the actions of the hunters and the hunted, going into the minds of corporal, private, and sniper, ranging the backgrounds of each and knowing the ultimate pointlessness of the death, telling us, in effect, that war is inhumane and dehumanizing.

Or you may write it from the point of view of the corporal as an unreliable narrator, proud of his toughness and his expertise, condescending to the private, certain the Asians are animals, glorying in his trophy, betraying his inhumanity.

Between these two extremes of total omniscience and total unreliability, you may take any position of the middle ground. The story might be written in the limited omniscient, presenting the thoughts only of the anxious private and the external actions of the others. It might be written objectively, with a cold and detached accuracy of military detail. It might be written by a peripheral narrator, a war correspondent, from interviews and documents; as a letter home from the private to his girl; as a field report from the corporal; as an interior monologue of the young sniper during the seconds before his death.

Any of these modes could contain your meaning, any of them fulfill your purpose. Your central problem as a writer might prove to be the choosing. But whatever your final choice of point of view in the technical sense, your point of view in the sense of opinion—that war is inhumane and dehumanizing—could be revealed.

Gryphon

CHARLES BAXTER

On Wednesday afternoon, between the geography lesson on ancient Egypt's handoperated irrigation system and an art project that involved drawing a model city next to a mountain, our fourth-grade teacher, Mr. Hibler, developed a cough. This cough began with a series of muffled throat clearings and progressed to propulsive

noises contained within Mr. Hibler's closed mouth. "Listen to him," Carol Peterson whispered to me. "He's gonna blow up." Mr. Hibler's laughter—dazed and infrequent—sounded a bit like his cough, but as we worked on our model cities we would look up, thinking he was enjoying a joke, and see Mr. Hibler's face turning red, his cheeks puffed out. This was not laughter. Twice he bent over, and his loose tie, like a plumb line, hung down straight from his neck as he exploded himself into a Kleenex. He would excuse himself, then go on coughing. "I'll bet you a dime," Carol Peterson whispered, "we get a substitute tomorrow."

Carol sat at the desk in front of mine and was a bad person—when she thought no one was looking she would blow her nose on notebook paper, then crumble it up and throw it into the wastebasket—but at times of crisis she spoke the truth. I knew I'd lose the dime.

"No deal," I said.

When Mr. Hibler stood us up in formation at the door just prior to the final bell, he was almost incapable of speech. "I'm sorry, boys and girls," he said. "I seem to be coming down with something."

"I hope you feel better tomorrow, Mr. Hibler," Bobby Kryzanowicz, the faultless brown-noser said, and I heard Carol Peterson's evil giggle. Then Mr. Hibler opened the door and we walked out to the buses, a clique of us starting noisily to hawk and cough as soon as we thought we were a few feet beyond Mr. Hibler's earshot.

Five Oaks being a rural community, and in Michigan, the supply of substitute teachers was limited to the town's unemployed community college graduates, a pool of about four mothers. These ladies fluttered, provided easeful class days, and nervously covered material we had mastered weeks earlier. Therefore it was a surprise when a woman we had never seen came into the class the next day, carrying a purple purse, a checkerboard lunchbox, and a few books. She put the books on one side of Mr. Hibler's desk and the lunchbox on the other, next to the Voice of Music phonograph. Three of us in the back of the room were playing with Heever, the chameleon that lived in the terrarium and on one of the plastic drapes, when she walked in.

She clapped her liands at us. "Little boys," she said, "why are you bent over together like that?" She didn't wait for us to answer. "Are you tormenting an animal? Put it back. Please sit down at your desks. I want no cabals this time of the day," We just stared at her. "Boys," she repeated, "I asked you to sit down."

I put the chameleon in his terrarium and felt my way to my desk, never taking my eyes off the woman. With white and green chalk, she had started to draw a tree on the left side of the blackboard. She didn't look usual. Furthermore, her tree was outsized, disproportionate, for some reason.

"This room needs a tree," she said, with one line drawing the suggestion of a leaf. "A large, leafy, shady, deciduous . . . oak."

Her fine, light hair had been done up in what I would learn years later was called a chignon, and she wore gold-rimmed glasses whose lenses seemed to have the faintest blue tint. Harold Knardahl, who sat across from me, whispered "Mars," and I nodded slowly, savoring the imminent weirdness of the day. The substitute drew another branch with an extravagant arm gesture, then turned around and said, "Good morning. I don't believe I said good morning to all you yet."

Facing us, she was no special age—an adult is an adult—but her face had two prominent lines, descending vertically from the sides of her mouth to her chin. I knew where I had seen those lines before: Pinocchio. They were marionette lines. "You may stare at me," she said to us, as a few more kids from the last bus came into the room, their eyes fixed on her, "for a few more seconds, until the bell rings. Then I will permit no more staring. Looking I will permit. Staring, no. It is impolite to stare, and a sign of bad breeding. You cannot make a social effort while staring."

Harold Knardahl did not glance at me, or nudge, but I heard him whisper "Mars" again, trying to get more mileage out of his single joke with the kids who had just come in.

When everyone was seated, the substitute teacher finished her tree, put down her chalk fastidiously on the phonograph, brushed her hands, and faced us. "Good morning," she said. "I am Miss Ferenczi, your teacher for the day. I am fairly new to your community, and I don't believe any of you know me. I will therefore start by telling you a story about myself."

While we settled back, she launched into her tale. She said her grandfather had been a Hungarian prince; her mother had been born in some place called Flanders, had been a pianist, and had played concerts for people Miss Ferenczi referred to as "crowned heads." She gave us a knowing look. "Grieg," she said, "the Norwegian master, wrote a concerto for piano that was," she paused, "my mother's triumph at her debut concert in London." Her eyes searched the ceiling. Our eyes followed. Nothing up there but ceiling tile. "For reasons that I shall not go into, my family's fortunes took us to Detroit, then north to dreadful Saginaw, and now here I am in Five Oaks, as your substitute teacher, for today, Thursday, October the eleventh. I believe it will be a good day: All the forecasts coincide. We shall start with your reading lesson. Take out your reading book. I believe it is called Broad Horizons, or something along those lines."

Jeannie Vermeesch raised her hand. Miss Ferenczi nodded at her. "Mr. Hibler always starts the day with the Pledge of Allegiance," Jeannie whined.

"Oh, does he? In that case," Miss Ferenczi said, "you must know it very well by now, and we certainly need not spend our time on it. No, no allegiance pledging on the premises today, by my reckoning. Not with so much sunlight coming into the room. A pledge does not suit my mood." She glanced at her watch. "Time is flying. Take out Broad Horizons."

She disappointed us by giving us an ordinary lesson, complete with vocabulary word drills, comprehension questions, and recitation. She didn't seem to care for the material, however. She sighed every few minutes and rubbed her glasses with a frilly perfumed handkerchief that she withdrew, magician style, from her left sleeve.

After reading we moved on to arithmetic. It was my favorite time of the morning, when the lazy autumn sunlight dazzled its way through ribbons of clouds past the windows on the east side of the classroom, and crept across the linoleum floor. On the playground the first group of children, the kindergartners, were running on the quack grass just beyond the monkey bars. We were doing multiplication tables. Miss Ferenczi had made John Wazny stand up at his desk in the front row. He was supposed to go through the tables of six. From where I was sitting, I could smell the Vitalis soaked into John's plastered hair. He was doing fine until he came to six times eleven and six times twelve. "Six times eleven," he said, "is sixty-eight. Six times twelve is . . ." He put his fingers to his head, quickly and secretly sniffed his fingertips, and said, "seventy-two." Then he sat down.

"Fine," Miss Ferenczi said. "Well now. That was very good."

"Miss Ferenczi!" One of the Eddy twins was waving her hand desperately in the air. "Miss Ferenczi! Miss Ferenczi!"

"Yes?"

"John said that six times eleven is sixty-eight and you said he was right!"

"Did I?" She gazed at the class with a jolly look breaking across her marionette's face. "Did I say that? Well, what is six times eleven?"

"It's sixty-six!"

She nodded. "Yes. So it is. But, and I know some people will not entirely agree with me, at some times it is sixty-eight."

"When? When is it sixty-eight?"

We were all waiting.

"In higher mathematics, which you children do not yet understand, six times eleven can be considered to be sixty-eight." She laughed through her nose. "In higher mathematics numbers are . . . more fluid. The only thing a number does is contain a certain amount of something. Think of water. A cup is not the only way to measure a certain amount of water, is it?" We were staring, shaking our heads. "You could use saucepans or thimbles. In either case, the water would be the same. Perhaps," she started again, "it would be better for you to think that six times eleven is sixty-eight only when I am in the room."

"Why is it sixty-eight," Mark Poole asked, "when you're in the room?"

"Because it's more interesting that way," she said, smiling very rapidly behind her blue-tinted glasses. "Besides, I'm your substitute teacher, am I not?" We all nodded. "Well, then, think of six times eleven equals sixty-eight as a substitute fact."

"A substitute fact!"

"Yes." Then she looked at us carefully. "Do you think," she asked, "that anyone is going to be hurt by a substitute fact?"

We looked back at her.

"Will the plants on the windowsill be hurt?" We glanced at them. There were sensitive plants thriving in a green plastic tray, and several wilted ferns in small clay pots. "Your dogs and cats, or your moms and dads?" She waited. "So," she concluded, "what's the problem?"

"But it's wrong," Janice Weber said, "isn't it?"

"What's your name, young lady?"

"Janice Weber."

"And you think it's wrong, Janice?"

"I was just asking."

"Well, all right. You were just asking. I think we've spent enough time on this matter by now, don't you, class? You are free to think what you like. When your teacher, Mr. Hibler, returns, six times eleven will be sixty-six again, you can rest assured. And it will be that for the rest of your lives in Five Oaks. Too bad, eh?" She raised her eyebrows and glinted herself at us. "But for now, it wasn't. So much for that. Let us go to your assigned problems for today, as painstakingly outlined, I see, in Mr. Hibler's lesson plan. Take out a sheet of paper and write your names in the upper left-hand corner."

For the next half hour we did the rest of our arithmetic problems. We handed them in and went on to spelling, my worst subject. Spelling always came before lunch. We were taking spelling dictation and looking at the clock. "Thorough," Miss Ferenczi said. "Boundary." She walked in the aisles between the desks, holding the spelling book open and looking down at our papers. "Balcony." I clutched my pencil. Somehow, the way she said those words, they seemed foreign, Hungarian, misvoweled and mis-consonanted. I stared down at what I had spelled. Balconie. I turned my pencil upside down and erased my mistake. Balconey. That looked better, but still incorrect. I cursed the world of spelling and tried erasing it again and saw the paper beginning to wear away. Balkony. Suddenly I felt a hand on my shoulder.

"I don't like that word either," Miss Ferenczi whispered, bent over, her mouth near my ear. "It's ugly. My feeling is, if you don't like a word, you don't have to use

it." She straightened up, leaving behind a slight odor of Clorets.

At lunchtime we went out to get our trays of sloppy joes, peaches in heavy syrup, coconut cookies, and milk, and brought them back to the classroom, where Miss Ferenczi was sitting at the desk, eating a brown sticky thing she had unwrapped from tightly rubber-banded wax paper. "Miss Ferenczi," I said, raising my hand. "You don't have to eat with us. You can eat with the other teachers. There's a teachers' lounge," I ended up, "next to the principal's office."

"No, thank you," she said. "I prefer it here."

"We've got a room monitor," I said. "Mrs. Eddy." I pointed to where Mrs. Eddy, Joyce and Judy's mother, sat silently at the back of the room, doing her knitting.

"That's fine," Miss Ferenczi said. "But I shall continue to eat here, with you children. I prefer it," she repeated.

"How come?" Wayne Razmer asked without raising his hand.

"I talked with the other teachers before class this morning," Miss Ferenczi said, biting into her brown food. "There was a great rattling of the words for the fewness of ideas. I didn't care for their brand of hilarity. I don't like ditto machine jokes."

"Oh," Wayne said.

"What's that you're eating?" Maxine Sylvester asked, twitching her nose. "Is it food?"

"It most certainly is food. It's a stuffed fig. I had to drive almost down to Detroit to get it. I also bought some smoked sturgeon. And this," she said, lifting some green leaves out of her lunchbox, "is raw spinach, cleaned this morning before I came out here to the Garfield-Murry School."

"Why're you eating raw spinach?" Maxine asked.

"It's good for you," Miss Ferenczi said. "More stimulating than soda pop or smelling salts." I bit into my sloppy joe and stared blankly out the window. An almost invisible moon was faintly silvered in the daytime autumn sky. "As far as food is concerned," Miss Ferenczi was saying, "you have to shuffle the pack. Mix it up. Too many people eat . . . well, never mind."

"Miss Ferenczi," Carol Peterson said, "what are we going to do this afternoon?" "Well," she said, looking down at Mr. Hibler's lesson plan, "I see that your teacher, Mr. Hibler, has you scheduled for a unit on the Egyptians." Carol groaned. "Yessss," Miss Ferenczi continued, "that is what we will do: the Egyptians. A remarkable people. Almost as remarkable as the Americans. But not quite." She lowered her head, did her quick smile, and went back to eating her spinach.

After noon recess we came back into the classroom and saw that Miss Ferenczi had drawn a pyramid on the blackboard, close to her oak tree. Some of us who had been playing baseball were messing around in the back of the room, dropping the bats and the gloves into the playground box, and I think that Ray Schontzeler had just slugged me when I heard Miss Ferenczi's high-pitched voice quavering with emotion. "Boys," she said, "come to order right this minute and take your seats. I do not wish to waste a minute of class time. Take out your geography books." We trudged to our desks and, still sweating, pulled out *Distant Lands and Their People*. "Turn to page forty-two." She waited for thirty seconds, then looked over at Kelly Munger. "Young man," she said, "why are you still fossicking in your desk?"

Kelly looked as if his foot had been stepped on. "Why am I what?"

"Why are you . . . burrowing in your desk like that?"

"I'm lookin' for the book, Miss Ferenczi."

Bobby Kryzanowicz, the faultless brown-noser who sat in the first row by choice, softly said, "His name is Kelly Munger. He can't ever find his stuff. He always does that."

"I don't care what his name is, especially after lunch," Miss Ferenczi said. "Where is your book?"

"I just found it." Kelly was peering into his desk and with both hands pulled at the book, shoveling along in front of it several pencils and crayons, which fell into his lap and then to the floor.

"I hate a mess," Miss Ferenczi said. "I hate a mess in a desk or a mind. It's . . . unsanitary. You wouldn't want your house at home to look like your desk at school, now, would you?" She didn't wait for an answer. "I should think not. A house at home should be as neat as human hands can make it. What were we talking about? Egypt. Page forty-two. I note from Mr. Hibler's lesson plan that you have been discussing the modes of Egyptian irrigation. Interesting, in my view, but not so interesting as what we are about to cover. The pyramids and Egyptian slave labor. A plus on one side, a minus on the other." We had our books open to page forty-two, where there was a picture of a pyramid, but Miss Ferenczi wasn't looking at the book. Instead, she was staring at some object just outside the window.

"Pyramids," Miss Ferenczi said, still looking past the window. "I want you to think about the pyramids. And what was inside. The bodies of the pharaohs, of course, and their attendant treasures. Scrolls. Perhaps," Miss Ferenczi said, with something gleeful but unsmiling in her face, "these scrolls were novels for the pharaohs, helping

them to pass the time in their long voyage through the centuries. But then, I am joking." I was looking at the lines on Miss Ferenczi's face. "Pyramids," Miss Ferenczi went on, "were the repositories of special cosmic powers. The nature of a pyramid is to guide cosmic energy forces into a concentrated point. The Egyptians knew that; we have generally forgotten it. Did you know," she asked, walking to the side of the room so that she was standing by the coat closet, "that George Washington had Egyptian blood, from his grandmother? Certain features of the Constitution of the United States are notable for their Egyptian ideas."

Without glancing down at the book, she began to talk about the movement of souls in Egyptian religion. She said that when people die, their souls return to Earth in the form of carpenter ants, or walnut trees, depending on how they behaved— "well or ill"—in life. She said that the Egyptians believed that people act the way they do because of magnetism produced by tidal forces in the solar system, forces produced by the sun and by its "planetary ally," Jupiter. Jupiter, she said, was a planet, as we had been told, but had "certain properties of stars." She was speaking very fast. She said that the Egyptians were great explorers and conquerors. She said that the greatest of all the conquerors, Genghis Khan, had had forty horses and forty young women killed on the site of his grave. We listened. No one tried to stop her. "I myself have been in Egypt," she said, "and have witnessed much dust and many brutalities." She said that an old man in Egypt who worked for a circus had personally shown her an animal in a cage, a monster, half bird and half lion. She said that this monster was called a gryphon and that she had heard about them but never seen them until she traveled to the outskirts of Cairo. She said that Egyptian astronomers had discovered the planet Saturn, but had not seen its rings. She said that the Egyptians were the first to discover that dogs, when they are ill, will not drink from rivers, but wait for rain, and hold their jaws open to catch it.

"She lies."

We were on the school bus home. I was sitting next to Carl Whiteside, who had bad breath and a huge collection of marbles. We were arguing. Carl thought she was lying. I said she wasn't, probably.

"I didn't believe that stuff about the bird," Carl said, "and what she told us about the pyramids? I didn't believe that either. She didn't know what she was talking about."

"Oh, yeah?" I had liked her. She was strange. I thought I could nail him. "If she was lying," I said, "what'd she say that was a lie?"

"Six times eleven isn't sixty-eight. It isn't ever. It's sixty-six, I know for a fact."

"She said so. She admitted it. What else did she lie about?"

"I don't know," he said. "Stuff."

"What stuff?"

"Well." He swung his legs back and forth. "You ever see an animal that was half lion and half bird?" He crossed his arms. "It sounded real fakey to me."

"It could happen," I said. I had to improvise, to outrage him. "I read in this newspaper my mom bought in the IGA about this scientist, this mad scientist in the

Swiss Alps, and he's been putting genes and chromosomes and stuff together in test tubes, and he combined a human being and a hamster." I waited, for effect. "It's called a humster."

"You never." Carl was staring at me, his mouth open, his terrible bad breath making its way toward me. "What newspaper was it?"

"The National Enquirer," I said, "that they sell next to the cash registers." When I saw his look of recognition, I knew I had bested him. "And this mad scientist," I said, "his name was, um, Dr. Frankenbush." I realized belatedly that this name was a mistake and waited for Carl to notice its resemblance to the name of the other famous mad master of permutations, but he only sat there.

"A man and a hamster?" He was staring at me, squinting, his mouth opening in distaste. "Jeez. What'd it look like?"

When the bus reached my stop, I took off down our dirt road and ran up through the back yard, kicking the tire swing for good luck. I dropped my books on the back steps so I could hug and kiss our dog, Mr. Selby. Then I hurried inside. I could smell Brussels sprouts cooking, my unfavorite vegetable. My mother was washing other vegetables in the kitchen sink, and my baby brother was hollering in his yellow playpen on the kitchen floor.

"Hi, Mom," I said, hopping around the playpen to kiss her, "Guess what?" "I have no idea."

"We had this substitute today, Miss Ferenczi, and I'd never seen her before, and she had all these stories and ideas and stuff."

"Well. That's good." My mother looked out the window behind the sink, her eyes on the pine woods west of our house. Her face and hairstyle always reminded other people of Betty Crocker, whose picture was framed inside a gigantic spoon on the side of the Bisquick box; to me, though, my mother's face just looked white. "Listen, Tommy," she said, "go upstairs and pick your clothes off the bathroom floor, then go outside to the shed and put the shovel and ax away that your father left outside this morning."

"She said that six times eleven was sometimes sixty-eight!" I said. "And she said she once saw a monster that was half lion and half bird." I waited. "In Egypt, she said."

"Did you hear me?" my mother asked, raising her arm to wipe her forehead with the back of her hand. "You have chores to do."

"I know," I said. "I was just telling you about the substitute."

"It's very interesting," my mother said, quickly glancing down at me, "and we can talk about it later when your father gets home. But right now you have some work to do."

"Okay, Mom." I took a cookie out of the jar on the counter and was about to go outside when I had a thought. I ran into the living room, pulled out a dictionary next to the TV stand, and opened it to the G's. Gryphon: "variant of griffin." Griffin: "a fabulous beast with the head and wings of an eagle and the body of a lion." Fabulous was right. I shouted with triumph and ran outside to put my father's tools back in their place.

Miss Ferenczi was back the next day, slightly altered. She had pulled her hair down and twisted it into pigtails, with red rubber bands holding them tight one inch from the ends. She was wearing a green blouse and pink scarf, making her difficult to look at for a full class day. This time there was no pretense of doing a reading lesson or moving on to arithmetic. As soon as the bell rang, she simply began to talk.

She talked for forty minutes straight. There seemed to be less connection between her ideas, but the ideas themselves were, as the dictionary would say, fabulous. She said she had heard of a huge jewel, in what she called the Antipodes, that was so brilliant that when the light shone into it at a certain angle it would blind whoever was looking at its center. She said that the biggest diamond in the world was cursed and had killed everyone who owned it, and that by a trick of fate it was called the Hope diamond. Diamonds are magic, she said, and this is why women wear them on their fingers, as a sign of the magic of womanhood. Men have strength, Miss Ferenczi said, but no true magic. That is why men fall in love with women but women do not fall in love with men: they just love being loved. George Washington had died because of a mistake he made about a diamond. Washington was not the first *true* President, but she did not say who was. In some places in the world, she said, men and women still live in the trees and eat monkeys for breakfast. Their doctors are magicians. At the bottom of the sea are creatures thin as pancakes which have never been studied by scientists because when you take them up to the air, the fish explode.

There was not a sound in the classroom, except for Miss Ferenczi's voice, and Donna DeShano's coughing. No one even went to the bathroom.

Beethoven, she said, had not been deaf; it was a trick to make himself famous, and it worked. As she talked, Miss Ferenczi's pigtails swung back and forth. There are trees in the world, she said, that eat meat: their leaves are sticky and close up on bugs like hands. She lifted her hands and brought them together, palm to palm. Venus, which most people think is the next closest planet to the sun, is not always closer, and, besides, it is the planet of greatest mystery because of its thick cloud cover. "I know what lies underneath those clouds," Miss Ferenczi said, and waited. After the silence, she said, "Angels. Angels live under those clouds." She said that angels were not invisible to everyone and were in fact smarter than most people. They did not dress in robes as was often claimed but instead wore formal evening clothes, as if they were about to attend a concert. Often angels do attend concerts and sit in the aisles where, she said, most people pay no attention to them. She said the most terrible angel had the shape of the Sphinx. "There is no running away from that one," she said. She said that unquenchable fires burn just under the surface of the earth in Ohio, and that the baby Mozart fainted dead away in his cradle when he first heard the sound of a trumpet. She said that someone named Narzim al Harrardim was the greatest writer who ever lived. She said that planets control behavior, and anyone conceived during a solar eclipse would be born with webbed feet.

"I know you children like to hear these things," she said, "these secrets, and that is why I am telling you all this." We nodded. It was better than doing comprehension questions for the readings in *Broad Horizons*.

"I will tell you one more story," she said, "and then we will have to do some arithmetic." She leaned over, and her voice grew soft. "There is no death," she said. "You

must never be afraid. Never. That which is, cannot die. It will change into different earthly and unearthly elements, but I know this as sure as I stand here in front of you, and I swear it: you must not be afraid. I have seen this truth with these eyes. I know it because in a dream God kissed me. Here." And she pointed with her right index finger to the side of her head, below the mouth, where the vertical lines were carved into her skin.

Absent-mindedly we all did our arithmetic problems. At recess the class was out on the playground, but no one was playing. We were all standing in small groups, talking about Miss Ferenczi. We didn't know if she was crazy, or what. I looked out beyond the playground, at the rusted cars piled in a small heap behind a clump of sumac, and I wanted to see shapes there, approaching me.

On the way home, Carl sat next to me again. He didn't say much, and I didn't either. At last he turned to me. "You know what she said about the leaves that close up on bugs?"

"Huh?"

"The leaves," Carl insisted. "The meat-eating plants. I know it's true. I saw it on television. The leaves have this icky glue that the plants have got smeared all over them and the insects can't get off 'cause they're stuck. I saw it." He seemed demoralized. "She's tellin' the truth."

"Yeah."

"You think she's seen all those angels?"

I shrugged.

"I don't think she has," Carl informed me. "I think she made that part up."

"There's a tree," I suddenly said. I was looking out the window at the farms along County Road H. I knew every barn, every broken windmill, every fence, every anhydrous ammonia tank, by heart. "There's a tree that's . . . that I've seen . . ."

"Don't you try to do it," Carl said. "You'll just sound like a jerk."

I kissed my mother. She was standing in front of the stove. "How was your day?" she asked.

"Fine."

"Did you have Miss Ferenczi again?"

"Yeah."

"Well?"

"She was fine, Mom," I asked, "can I go to my room?"

"No," she said, "not until you've gone out to the vegetable garden and picked me a few tomatoes." She glanced at the sky. "I think it's going to rain. Skedaddle and do it now. Then you come back inside and watch your brother for a few minutes while I go upstairs. I need to clean up before dinner." She looked down at me. "You're looking a little pale, Tommy." She touched the back of her hand to my forehead and I felt her diamond ring against my skin. "Do you feel all right?"

"I'm fine," I said, and went out to pick the tomatoes.

Coughing mutedly, Mr. Hibler was back the next day, slipping lozenges into his mouth when his back was turned at forty-five minute intervals and asking us how much of the prepared lesson plan Miss Ferenczi had followed. Edith Atwater took the responsibility for the class of explaining to Mr. Hibler that the substitute hadn't always done exactly what he would have done, but we had worked hard even though she talked a lot. About what? he asked. All kinds of things, Edith said. I sort of forgot. To our relief, Mr. Hibler seemed not at all interested in what Miss Ferenczi had said to fill the day. He probably thought it was woman's talk; unserious and not suited for school. It was enough that he had a pile of arithmetic problems from us to correct.

For the next month, the sumac turned a distracting red in the field, and the sun traveled toward the southern sky, so that its rays reached Mr. Hibler's Halloween display on the bulletin board in the back of the room, fading the scarecrow with a pumpkin head from orange to tan. Every three days I measured how much farther the sun had moved toward the southern horizon by making small marks with my black Crayola on the north wall, ant-sized marks only I knew were there, inching west.

And then in early December, four days after the first permanent snowfall, she appeared again in our classroom. The minute she came in the door, I felt my heart begin to pound. Once again, she was different: this time, her hair hung straight down and seemed hardly to have been combed. She hadn't brought her lunchbox with her, but she was carrying what seemed to be a small box. She greeted all of us and talked about the weather. Donna DeShano had to remind her to take her overcoat off.

When the bell to start the day finally rang, Miss Ferenczi looked out at all of us and said, "Children, I have enjoyed your company in the past, and today I am going to reward you." She held up the small box. "Do you know what this is?" She waited. "Of course you don't. It is a tarot pack."

Edith Atwater raised her hand. "What's a tarot pack, Miss Ferenczi?"

"It is used to tell fortunes," she said. "And that is what I shall do this morning. I shall tell your fortunes, as I have been taught to do."

"What's fortune?" Bobby Kryzanowicz asked.

"The future, young man. I shall tell you what your future will be. I can't do your whole future, of course. I shall have to limit myself to the five-card system, the wands, cups, swords, pentacles, and the higher arcanes. Now who wants to be first?"

There was a long silence. Then Carol Peterson raised her hand.

"All right," Miss Ferenczi said. She divided the pack into five smaller packs and walked back to Carol's desk, in front of mine. "Pick one card from each of these packs," she said. I saw that Carol had a four of cups, a six of swords, but I couldn't see the other cards. Miss Ferenczi studied the cards on Carol's desk for a minute. "Not bad," she said. "I do not see much higher education. Probably an early marriage. Many children. There's something bleak and dreary here, but I can't tell you what. Perhaps just the tasks of a housewife life. I think you'll do very well, for the most

part." She smiled at Carol, a smile with a certain lack of interest. "Who wants to be next?"

Carl Whiteside raised his hand slowly.

"Yes," Miss Ferenczi said, "let's do a boy." She walked over to where Carl sat. After he picked his five cards, she gazed at them for a long time. "Travel," she said. "Much distant travel. You might go into the Army. Not too much romantic interest here. A late marriage, if at all. Squabbles. But the Sun is in your major arcana, here, yes, that's a very good card." She giggled. "Maybe a good life."

Next I raised my hand, and she told me my future. She did the same with Bobby Kryzanowicz, Kelly Munger, Edith Atwater, and Kim Foor. Then she came to Wayne Razmer. He picked his five cards, and I could see that the Death card was one of them.

"What's your name?" Miss Ferenczi asked.

"Wayne."

"Well, Wayne," she said, "you will undergo a great metamorphosis, the greatest, before you become an adult. Your earthly element will leap away, into thin air, you sweet boy. This card, this nine of swords here, tells of suffering and desolation. And this ten of wands, well, that's certainly a heavy load."

"What about this one?" Wayne pointed to the Death card.

"That one? That one means you will die soon, my dear." She gathered up the cards. We were all looking at Wayne. "But do not fear," she said. "It's not really death, so much as change." She put the cards on Mr. Hibler's desk. "And now, let's do some arithmetic."

At lunchrime Wayne went to Mr. Faegre, the principal, and told him what Miss Ferenczi had done. During the noon recess, we saw Miss Ferenczi drive out of the parking lot in her green Rambler. I stood under the slide, listening to the other kids coasting down and landing in the little depressive bowl at the bottom. I was kicking stones and tugging at my hair right up to the moment when I saw Wayne come out to the playground. He smiled, the dead fool, and with the fingers of his right hand he was showing everyone how he had told on Miss Ferenczi.

I made my way toward Wayne, pushing myself past two girls from another class. He was watching me with his little pinhead eyes.

"You told," I shouted at him. "She was just kidding."

"She shouldn't have," he shouted back. "We were supposed to be doing arithmetic."

"She just scared you," I said. "You're a chicken. You're a chicken, Wayne. You are. Scared of a little card," I singsonged.

Wayne fell at me, his two fists hammering down on my nose. I gave him a good one in the stomach and then I tried for his head. Aiming my fist, I saw that he was crying. I slugged him.

"She was right," I yelled. "She was always right! She told the truth!" Other kids were whooping. "You were just scared, that's all!"

And then large hands pulled at us, and it was my turn to speak to Mr. Faegre.

In the afternoon Miss Ferenczi was gone, and my nose was stuffed with cotton clotted with blood, and my lip had swelled, and our class had been combined with Mrs. Mantei's sixth-grade class for a crowded afternoon science unit on insect life in ditches and swamps. I knew where Mrs. Mantei lived: she had a new house trailer just down the road from us, at the Clearwater Park. She was no mystery. Somehow she and Mr. Bodine, the other fourth-grade teacher, had managed to fit forty-five desks into the room. Kelly Munger asked if Miss Ferenczi had been arrested, and Mrs. Mantei said, no, of course not. All that afternoon, until the buses came to pick us up, we learned about field crickets and two-striped grasshoppers, water bugs, cicadas, mosquitoes, flies, and moths. We learned about insects' hard outer shell, the exoskeleton, and the usual parts of the mouth, including the labrum, mandible, maxilla, and glossa. We learned about compound eyes and the four-stage metamorphosis from egg to larva to pupa to adult. We learned something, but not much, about mating. Mrs. Mantei drew, very skillfully, the internal anatomy of the grasshopper on the blackboard. We learned about the dance of the honeybee, directing other bees in the hive to pollen. We found out about which insects were pests to man, and which were not. On lined white pieces of paper we made lists of insects we might actually see, then a list of insects too small to be clearly visible, such as fleas; Mrs. Mantei said that our assignment would be to memorize these lists for the next day, when Mr. Hibler would certainly return and test us on our knowledge.

Suggestions for Discussion

- 1. Who speaks to whom in what form?
- 2. What temporal distance is established by the language of the first paragraph between the narrator as he tells the story and his childhood self? How?
- 3. The phrase with which the story begins, "On Wednesday afternoon," tells us less about time than about the familiarity of the narrator to the scene. What means are used to indicate the period in which the story takes place?
- 4. The character of Miss Ferenczi is presented directly through her speech, appearance, and action, and she is also interpreted and judged by the narrator and other children. How does our psychic distance from these judgments help create her character?
- 5. What are the limitations of the boy's understanding? Where does the grown author understand more? What effect does the author achieve by this balance of sympathy and distance?

Jealous Husband Returns in Form of Parrot ROBERT OLEN BUTLER

I never can quite say as much as I know. I look at other parrots and I wonder if it's the same for them, if somebody is trapped in each of them paying some kind of price for living their life in a certain way. For instance, "Hello," I say, and I'm sitting on a perch in a pet store in Houston and what I'm really thinking is Holy shit. It's you. And what's happened is I'm looking at my wife.

"Hello," she says, and she comes over to me and I can't believe how beautiful she is. Those great brown eyes, almost as dark as the center of mine. And her nose—I don't remember her for her nose but its beauty is clear to me now. Her nose is a little too long, but it's redeemed by the faint hook to it.

She scratches the back of my neck.

Her touch makes my tail flare. I feel the stretch and rustle of me back there. I bend my head to her and she whispers, "Pretty bird."

For a moment I think she knows it's me. But she doesn't, of course. I say "Hello" again and I will eventually pick up "pretty bird." I can tell that as soon as she says it, but for now I can only give her another hello. Her fingertips move through my feathers and she seems to know about birds. She knows that to pet a bird you don't smooth his feathers down, you ruffle them.

But of course she did that in my human life, as well. It's all the same for her. Not that I was complaining, even to myself, at that moment in the pet shop when she found me like I presume she was supposed to. She said it again, "Pretty bird," and this brain that works like it does now could feel that tiny little voice of mine ready to shape itself around these sounds. But before I could get them out of my beak there was this guy at my wife's shoulder and all my feathers went slick flat like to make me small enough not to be seen and I backed away. The pupils of my eyes pinned and dilated and pinned again.

He circled around her. A guy that looked like a meat packer, big in the chest and thick with hair, the kind of guy that I always sensed her eyes moving to when I was alive. I had a bare chest and I'd look for little black hairs on the sheets when I'd come home on a day with the whiff of somebody else in the air. She was still in the same goddamn rut.

A "hello" wouldn't do and I'd recently learned "good night" but it was the wrong suggestion altogether, so I said nothing and the guy circled her and he was looking at me with a smug little smile and I fluffed up all my feathers, made myself about twice as big, so big he'd see he couldn't mess with me. I waited for him to draw close enough for me to take off the tip of his finger.

But she intervened. Those nut-brown eyes were before me and she said, "I want him."

And that's how I ended up in my own house once again. She bought me a large black wrought-iron cage, very large, convinced by some young guy who clerked in the bird department and who took her aside and made his voice go much too soft when he was doing the selling job. The meat packer didn't like it. I didn't either. I'd missed a lot of chances to take a bite out of this clerk in my stay at the shop and I regretted that suddenly.

But I got my giant cage and I guess I'm happy enough about that. I can pace as much as I want. I can hang upside down. It's full of bird toys. That dangling thing over there with knots and strips of rawhide and a bell at the bottom needs a good thrashing a couple of times a day and I'm the bird to do it. I look at the very dangle of it and the thing is rough, the rawhide and the knotted rope, and I get this restlessness back in my tail, a burning thrashing feeling, and it's like all the times when I was sure there was a man naked with my wife. Then I go to this thing that feels so familiar and I bite and bite and it's very good.

I could have used the thing the last day I went out of this house as a man. I'd found the address of the new guy at my wife's office. He'd been there a month in the shipping department and three times she'd mentioned him. She didn't even have to work with him and three times I heard about him, just dropped into the conversation. "Oh," she'd say when a car commercial came on the television, "that car there is like the one the new man in shipping owns. Just like it." Hey, I'm not stupid. She said another thing about him and then another and right after the third one I locked myself in the bathroom because I couldn't rage about this anymore. I felt like a damn fool whenever I actually said anything about this kind of feeling and she looked at me like she could start hating me real easy and so I was working on saying nothing, even if it meant locking myself up. My goal was to hold my tongue about half the time. That would be a good start.

But this guy from shipping. I found out his name and his address and it was one of her typical Saturday afternoons of vague shopping. So I went to his house, and his car that was just like the commercial was outside. Nobody was around in the neighborhood and there was this big tree in the back of the house going up to a second floor window that was making funny little sounds. I went up. The shade was drawn but not quite all the way. I was holding on to a limb with arms and legs wrapped around it like it was her in those times when I could forget the others for a little while. But the crack in the shade was just out of view and I crawled on along till there was no limb left and I fell on my head. Thinking about that now, my wings flap and I feel myself lift up and it all seems so avoidable. Though I know I'm different now. I'm a bird.

Except I'm not. That's what's confusing. It's like those times when she would tell me she loved me and I actually believed her and maybe it was true and we clung to each other in bed and at times like that I was different. I was the man in her life. I was whole with her. Except even at that moment, holding her sweetly, there was this other creature inside me who knew a lot more about it and couldn't quite put all the evidence together to speak.

My cage sits in the den. My pool table is gone and the cage is sitting in that space and if I come all the way down to one end of my perch I can see through the door and down the back hallway to the master bedroom. When she keeps the bedroom door open I can see the space at the foot of the bed but not the bed itself. That I can

sense to the left, just out of sight. I watch the men go in and I hear the sounds but I

can't quite see. And they drive my crazy.

I flap my wings and I squawk and I fluff up and I slick down and I throw seed and I attack that dangly toy as if it was the guy's balls, but it does no good. It never did any good in the other life either, the thrashing around I did by myself. In that other life I'd have given anything to be standing in this den with her doing this thing with some other guy just down the hall and all I had to do was walk down there and turn the corner and she couldn't deny it anymore.

But now all I can do is try to let it go. I sidestep down to the opposite end of the cage and look out the big sliding glass doors to the backyard. It's a pretty yard. There are great placid maple trees with good places to roost. There's a blue sky that plucks at the feathers on my chest. There are clouds. Other birds. Fly away. I could just fly away.

I tried once and I learned a lesson. She forgot and left the door to my cage open and I climbed beak and foot, beak and foot, along the bars and curled around to stretch sideways out the door and the vast scene of peace was there at the other end of the room. I flew.

And a pain flared through my head and I fell straight down and the room whirled around and the only good thing was she held me. She put her hands under my wings and lifted me and clutched me to her breast and I wish there hadn't been bees in my head at the time so I could have enjoyed that, but she put me back in the cage and wept awhile. That touched me, her tears. And I looked back to the wall of sky and trees. There was something invisible there between me and that dream of peace. I remembered, eventually, about glass, and I knew I'd been lucky, I knew that for the little fragile-boned skull I was doing all this thinking in, it meant death.

She wept that day but by the night she had another man. A guy with a thick Georgia truck-stop accent and pale white skin and an Adam's apple big as my seed ball. This guy has been around for a few weeks and he makes a whooping sound down the hallway, just out of my sight. At times like that I want to fly against the bars of the cage, but I don't. I have to remember how the world has changed.

She's single now, of course. Her husband, the man that I was, is dead to her. She does not understand all that is behind my "hello." I know many words, for a parrot. I am a yellow-nape Amazon, a handsome bird, I think, green with a splash of yellow at the back of my neck. I talk pretty well, but none of my words are adequate. I can't make her understand.

And what would I say if I could? I was jealous in life. I admit it. I would admit it to her. But it was because of my connection to her. I would explain that. When we held each other, I had no past at all, no present but her body, no future but to lie there and not let her go. I was an egg hatched beneath her crouching body, I entered as a chick into her wet sky of a body, and all that I wished was to sit on her shoulder and fluff my feathers and lay my head against her cheek, my neck exposed to her hand. And so the glances that I could see in her troubled me deeply, the movement of her eyes in public to other men, the laughs sent across a room, the tracking of her mind behind her blank eyes, pursuing images of others, her distraction even in our

bed, the ghosts that were there of men who'd touched her, perhaps even that very day. I was not part of all those other men who were part of her. I didn't want to connect to all that. It was only her that I would fluff for but these others were there also and I couldn't put them aside. I sensed them inside her and so they were inside me. If I had the words, these are the things I would say.

But half an hour ago there was a moment that thrilled me. A word, a word we all knew in the pet shop, was just the right word after all. This guy with his cowboy belt buckle and rattlesnake boots and his pasty face and his twanging words of love trailed after my wife, through the den, past my cage, and I said, "Cracker." He even flipped his head back a little at this in surprise. He'd been called that before to his face, I realized. I said it again. "Cracker." But to him I was a bird and he let it pass. "Cracker," I said. "Hello, cracker." That was even better. They were out of sight through the hall doorway and I hustled along the perch and I caught a glimpse of them before they made the turn to the bed and I said, "Hello, cracker," and he shot me one last glance.

It made me hopeful. I eased away from that end of the cage, moved toward the scene of peace beyond the far wall. The sky is chalky blue today, blue like the brow of the blue-front Amazon who was on the perch next to me for about a week at the store. She was very sweet, but I watched her carefully for a day or two when she first came in. And it wasn't long before she nuzzled up to a cockatoo named Gordo and I knew she'd break my heart. But her color now in the sky is sweet, really. I left all those feelings behind me when my wife showed up. I am a faithful man, for all my suspicions. Too faithful, maybe. I am ready to give too much and maybe that's the problem.

The whooping began down the hall and I focused on a tree out there. A crow flapped down, his mouth open, his throat throbbing, though I could not hear his sound. I was feeling very odd. At least I'd made my point to the guy in the other room. "Pretty bird," I said, referring to myself. She called me "pretty bird" and I believed her and I told myself again, "Pretty bird."

But then something new happened, something very difficult for me. She appeared in the den naked. I have not seen her naked since I fell from the tree and had no wings to fly. She always had a certain tidiness in things. She was naked in the bedroom, clothed in the den. But now she appears from the hallway and I look at her and she is still slim and she is beautiful, I think—at least I clearly remember that as her husband I found her beautiful in this state. Now, though, she seems too naked. Plucked. I find that a sad thing. I am sorry for her and she goes by me and she disappears into the kitchen. I want to pluck some of my own feathers, the feathers from my chest, and give them to her. I love her more in that moment, seeing her terrible nakedness, than I ever have before.

And since I've had success in the last few minutes with words, when she comes back I am moved to speak. "Hello," I say, meaning, You are still connected to me, I still want only you. "Hello," I say again. Please listen to this tiny heart that beats fast at all times for you.

And she does indeed stop and she comes to me and bends to me. "Pretty bird," I

say and I am saying, You are beautiful, my wife, and your beauty cries out for protection. "Pretty." I want to cover you with my own nakedness. "Bad bird," I say. If there are others in your life, even in your mind, then there is nothing I can do. "Bad." Your nakedness is touched from inside by the others. "Open," I say. How can we be whole together if you are not empty in the place that I am to fill?

She smiles at this and she opens the door to my cage. "Up," I say, meaning, Is there no place for me in this world where I can be free of this terrible sense of others?

She reaches in now and offers her hand and I climb onto it and I tremble and she says, "Poor baby."

"Poor baby," I say. You have yearned for wholeness too and somehow I failed you.

I was not enough. "Bad bird," I say. I'm sorry.

And then the cracker comes around the corner. He wears only his rattlesnake boots. I take one look at his miserable, featherless body and shake my head. We keep our sexual parts hidden, we parrots, and this man is a pitiful sight. "Peanut," I say. I presume that my wife simply has not noticed. But that's foolish, of course. This is, in fact, what she wants. Not me. And she scrapes me off her hand onto the open cage door and she turns her naked back to me and embraces this man and they laugh and stagger in their embrace around the corner.

For a moment I still think I've been eloquent. What I've said only needs repeating for it to have its transforming effect. "Hello," I say. "Hello. Pretty bird. Pretty. Bad bird. Bad. Open. Up. Poor baby. Bad bird." And I am beginning to hear myself as I really sound to her. "Peanut." I can never say what is in my heart to her. Never.

I stand on my cage door now and my wings stir. I look at the corner to the hall-way and down at the end the whooping has begun again. I can fly there and think of

things to do about all this.

But I do not. I turn instead and I look at the trees moving just beyond the other end of the room. I look at the sky the color of the brow of a blue-front Amazon. A shadow of birds spanks across the lawn. And I spread my wings. I will fly now. Even though I know there is something between me and that place where I can be free of all these feelings, I will fly. I will throw myself there again and again. Pretty bird. Bad bird. Good night.

Suggestions for Discussion

- 1. What is the contract made with the reader in the opening paragraph of "Jealous Husband Returns in Form of Parrot"? How does the author set up the degree of reliability of the narrator? How reliable is this parrot, and in what sphere?
- 2. What sorts of irony does the author use, and to what effect? In particular, how does the parrot's inability to speak contribute to the "narrator's" eloquence?

- 3. How does Robert Olen Butler mix the frames of reference of husband and parrot to reinforce the claims of each?
- 4. How does he achieve the switch in our sympathy at the end of the story?

Retrospect

- 1. Locate examples of *verbal*, *dramatic*, and *cosmic irony* in stories you have read thus far. How could you adapt these devices to your own work in progress?
- 2. Find evidence that "Royal Beatings" is told from the vantage point of "many years later." How does this affect the point of view of the story as a whole? Find passages where Rose interprets the motives or intentions of others. Where and how does Alice Munro make us trust these interpretations (even, at one point, "She knows everything about him") when we can't verify them by getting inside the others' minds?
- 3. In "Saint Marie," how reliable is the narrator? In what ways do you identify and in what ways are you in opposition to her? How is this direction of your sympathies achieved? How does temporal distance affect the point of view?
- 4. Return to the passage from "People Like That Are the Only People Here" at the end of the preceding chapter, and see what kinds of distance and what limitations in the central character contribute to the tone. How does Moore manipulate your sympathy with the Mother?
- 5. Would you describe the speaker in Jamaica Kincaid's "Girl" as an unreliable narrator? Why or why not?

Writing Assignments

- Choose a crucial incident from a child's life (your own or invented) and write about it from the temporally distanced perspective of an adult narrator.
- 2. Rewrite the same incident in the child's language from the point of view of the child as narrator.
- 3. Write a passage from the point of view of a central narrator who is spatially distanced from the events he or she describes. Make the contrast significant—write of a sea voyage from prison, of home from an alien country, of a closet from a mountaintop, or the like.
- 4. Write a short scene from the point of view of anything nonhuman (a plant, object, animal, Martian, angel). We may sympathize or not with the perceptions of the narrator, but try to imagine or invent the terms, logic, and frame of reference this character would use.
- 5. Write from the point of view of a narrator who passes scathing judgments on another character, but let us know that the narrator really loves or envies the other.

- 6. Let your narrator begin with a totally unacceptable premise—illogical, ignorant, bigoted, insane. In the passage, let us gradually come to sympathize with his or her view.
- 7. Take any assignment you have previously done and recast it from another point of view. This may (but will not simply) involve changing the person in which it is written. Alter the means of perception or point-of-view character so that we have an entirely different perspective on the events. But let your attitude as author remain the same.

IS AND IS NOT Comparison

- Types of Metaphor and Simile
 - · Metaphoric Faults to Avoid
 - · Allegory
 - Symbol
 - The Objective Correlative

As the concept of distance implies, every reader reading is a self-deceiver. We simultaneously "believe" a story and know that it is a fiction, a fabrication. Our belief in the reality of the story may be so strong that it produces physical reactions—tears, trembling, sighs, gasps, a headache. At the same time, as long as the fiction is working for us, we know that our submission is voluntary; that we have, as Samuel Taylor Coleridge pointed out, suspended disbelief. "It's just a movie," says the exasperated father as he takes his shrieking six-year-old out to the lobby. For the father the fiction is working; for the child it is not.

The necessity of disbelief was demonstrated for me some years ago with the performance of a play that ended with too "good" a hanging. The harness was too well hidden, the actor too adept at purpling and bloating his face when the trap fell. Consternation rippled through the audience: My God, they've hanged the *actor*. Because the illusion was too like reality, the illusion was destroyed and the audience was jolted from its belief in the story back into the real world of the performance.

Simultaneous belief and awareness of illusion are present in both the content and the craft of literature, and what is properly called artistic pleasure derives from the tension of this is and is not.

The content of a plot tells us that something happens that does not happen, that people who do not exist behave in such a way, and that the events of life—which we know to be random, unrelated, and unfinished—are necessary, patterned, and come to closure. When someone declares interest or pleasure in a story "because it really happened," he or she is expressing an unartistic and anti-artistic preference, subscribing to the lie that events can be accurately translated into the medium of words. Pleasure in artistry comes precisely when the illusion rings true without, however, destroying the knowledge that it is an illusion.

In the same way, the techniques of every art offer us the tension of things that are and are not alike. This is true of poetry, in which rhyme is interesting because *tend* sounds like *mend* but not exactly like; it is true of music, whose interest lies in variations on a theme; of composition, where shapes and colors are balanced in asymmetry. And it is the fundamental nature of metaphor, from which literature derives.

Just as the content of a work must not be too like life to destroy the knowledge that it is an illusion, so the likenesses in the formal elements of art must not be too much alike. Rich rhyme, in which *tend* rhymes with *contend* and *pretend*, is boring and restrictive, and virtually no poet chooses to write a whole poem in it. Repetitive tunes jingle; symmetrical compositions tend toward decor.

Metaphor is the literary device by which we are told that something is, or is like, something that it clearly is not, or is not exactly like. What a good metaphor does is surprise us with the unlikeness of the two things compared while at the same time convincing us of the aptness or truth of the likeness. In the process it can illuminate the meaning not only of the thing at hand, but of the story and its theme. A bad metaphor fails to surprise or convince or both—and so fails to illuminate.

Types of Metaphor and Simile

The simplest distinction between kinds of comparison, and usually the first one grasped by beginning students of literature, is between *metaphor* and *simile*. A simile makes a comparison with the use of *like* or *as*, a metaphor without. Though this distinction is technical, it is not entirely trivial, for a metaphor demands a more literal acceptance. If you say, "a woman is a rose," you ask for an extreme suspension of disbelief, whereas "a woman is like a rose" is a more sophisticated form, acknowledging the artifice in the statement.

Historically, metaphor preceded simile, originating in a purely sensuous comparison. When we speak of "the eyes of a potato," or "the eye of the needle," we mean simply that the leaf bud and the thread hole *look like* eyes. We don't mean to suggest that the potato or the needle can see. The comparisons do not suggest any essential or abstract quality to do with sight.

Both metaphor and simile have developed, however, so that the resonance of comparison is precisely in the essential or abstract quality that the two objects share. When a writer speaks of "the eyes of the houses" or "the windows of the soul," the comparison of eyes to windows does contain the idea of transmitting vision between the inner and the outer. When we speak of "the king of beasts," we don't mean that a lion wears a crown or sits on a throne (though it is relevant that in children's sto-

ries the lion often does precisely that, in order to suggest a primitive physical likeness); we mean that king and lion share abstract qualities of power, position, pride, and bearing.

In both metaphor and simile a physical similarity can yield up a characterizing abstraction. So if "a woman" is either "a rose" or "like a rose," the significance lies not in the physical similarity but in the essential qualities that such similarity implies: slenderness, suppleness, fragrance, beauty, color—and perhaps the hidden threat of thorns.

Every metaphor and simile I have used so far is either a cliché or a dead metaphor (both of which will be discussed later). Each of them may at one time have surprised by their aptness, but by now each has been used so often that the surprise is gone. I wished to use familiar examples in order to clarify that resonance of comparison depends on the abstractions conveyed in the likeness of the things compared. A good metaphor reverberates with the essential; this is the writer's principle of choice.

So Flannery O'Connor, in "A Good Man Is Hard to Find," describes the mother as having "a face as broad and innocent as a cabbage." A soccer ball is roughly the same size and shape as a cabbage; so is a schoolroom globe; so is a street lamp. But if the mother's face had been as broad and innocent as any of these things, she would be a different woman altogether. A cabbage is also rural, heavy, dense, and cheap, and so it conveys a whole complex of abstractions about the woman's class and mentality. There is, on the other hand, no innocence in the face of Shrike, in Nathanael West's Miss Lonelyhearts, who "buried his triangular face like a hatchet in her neck."

Sometimes the aptness of a comparison is achieved by taking it from an area of reference relevant to the thing compared. In *Dombey and Son*, Charles Dickens describes the ships' instrument maker, Solomon Gills, as having "eyes as red as if they had been small suns looking at you through a fog." The simile suggests a seascape, whereas in *One Flew over the Cuckoo's Nest*, Ken Kesey's Ruckly, rendered inert by shock therapy, has eyes "all smoked up and gray and deserted inside like blown fuses." But the metaphor may range further from its original, in which case the abstraction conveyed must strike us as strongly and essentially appropriate. William Faulkner's Emily Grierson in "A Rose for Emily" has "haughty black eyes in a face the flesh of which was strained across the temple and about the eyesockets as you imagine a lighthouse-keeper's face ought to look." Miss Emily has no connection with the sea, but the metaphor reminds us not only of her sternness and self-sufficiency, but also that she has isolated herself in a locked house. The same character as an old woman has eyes that "looked like two pieces of coal pressed into a lump of dough," and the image domesticates her, robs her of her light.

Both metaphors and similes can be *extended*, meaning that the writer continues to present aspects of likeness in the things compared.

There was a white fog . . . standing all around you like something solid. At eight or nine, perhaps, it lifted as a shutter lifts. We had a glimpse of the towering multitude of trees, of the immense matted jungle, with the blazing little ball of

sun hanging over it—all perfectly still—and then the shutter came down again, smoothly, as if sliding in greased grooves.

Joseph Conrad, Heart of Darkness

Notice that Conrad moves from a generalized image of "something solid" to the specific simile "as a shutter lifts"; reasserts the simile as a metaphor, "then the shutter came down again"; and becomes still more specific in the extension "as if sliding in greased grooves."

Also note that Conrad emphasizes the dumb solidity of the fog by comparing the larger natural image with the smaller manufactured object. This is a technique that contemporary writers have used to effects both comic and profound, as when Frederick Barthelme in *The Brothers* describes a young woman "with a life stretching out in front of her like so many unrented videos" or a man's head "bobbing like an enormous Q-Tip against the little black sky."

In a more usual metaphoric technique, the smaller or more ordinary image is compared with one more significant or intense, as in this example from Louise Erdrich's "Machimanito," where the narrator invokes the names of Anishinabe Indians dead of tuberculosis:

Their names grew within us, swelled to the brink of our lips, forced our eyes open in the middle of the night. We were filled with the water of the drowned, cold and black—airless water that lapped against the seal of our tongues or leaked slowly from the corners of our eyes. Within us, like ice shards, their names bobbed and shifted.

A conceit, which can be either metaphor or simile, is a comparison of two things radically and startlingly unlike—in Samuel Johnson's words, "yoked by violence together." A conceit is as far removed as possible from the purely sensuous comparison of "the eyes of the potato." Ir compares two things that have very little or no immediately apprehensible similarity; and so it is the nature of the conceit to be long. The author must explain to us, sometimes at great length, why these things can be said to be alike. When John Donne compares a flea to the Holy Trinity, the two images have no areas of reference in common, and we don't understand. He must explain to us that the flea, having bitten both the poet and his lover, now has the blood of three souls in its body.

The conceit is more common to poetry than to prose because of the density of its imagery, but it can be used to good effect in fiction. In *The Day of the Locust*, Nathanael West uses a conceit in an insistent devaluation of love. The screenwriter Claude Estee says:

Love is like a vending machine, eh? Not bad. You insert a coin and press home the lever. There's some mechanical activity inside the bowels of the device. You receive a small sweet, frown at yourself in the dirty mirror, adjust your hat, take a

firm grip on your umbrella and walk away, trying to look as though nothing had happened.

"Love is like a vending machine" is a conceit; if the writer didn't explain to us in what way love is like a vending machine, we'd founder trying to figure it out. So he goes on to develop the vending machine in images that suggest not "love" but seamy sex. The last image—"trying to look as though nothing had happened"—has nothing to do with the vending machine; we accept it because by this time we've fused the two ideas in our minds.

Tom Robbins employs conceit in *Even Cowgirls Get the Blues*, in a playfully self-conscious, mock-scientific comparison of Sissy Hankshaw's thumbs to a pearl.

As for the oyster, its rectal temperature has never been estimated, although we must suspect that the tissue heat of the sedentary bivalve is as far below good old 98.6 as that of the busy bee is above. Nonetheless, the oyster, could it fancy, should fancy its excremental equipment a hot item, for what other among Creation's crapping creatures can convert its bodily wastes to treasure?

There is a metaphor here, however strained. The author is attempting to draw a shaky parallel between the manner in which the oyster, when beset by impurities or disease, coats the offending matter with its secretions—and the manner in which Sissy Hankshaw, adorned with thumbs that many might consider morbid, coated the offending digits with glory.

The comparison of pearl and thumbs is a conceit because sensuous similarity is not the point: Sissy's thumbs are not necessarily pale or shiny. The similarity is in the abstract idea of converting "impurities" to "glory."

A *dead metaphor* is one so familiar that it has in effect ceased to be a metaphor; it has lost the force of the original comparison and acquired a new definition. Fowler's *Modern English Usage* uses the word "sift" to demonstrate the dead metaphor, one that has "been used so often that speaker and hearer have ceased to be aware that the words used are not literal."

Thus, in The men were sifting the meal we have a literal use of sift; in Satan hath desired to have you, that he may sift you as wheat, sift is a live metaphor; in the sifting of evidence, the metaphor is so familiar that it is about equal chances whether sifting or examination will be used, and that a sieve is not present to the thought.

English abounds in dead metaphors. Abounds is one, where the overflowing of liquid is not present to the thought. When a person runs for office, legs are not present to the thought, nor is an arrow when we speak of someone's aim, hot stones when we go through an ordeal, headgear when someone caps a joke. Unlike clichés, dead metaphors enrich the language. There is a residual resonance from the original metaphor but no pointless effort on the part of the mind to resolve the tension of like and unlike. English is fertile with metaphors (including those eyes of the po-

tato and the needle) that have died and been resurrected as idiom, a "manner of speaking."

Metaphoric Faults to Avoid

Comparison is not a frivolity. It is, on the contrary, the primary business of the brain. Some eighteenth-century philosophers spoke of the human mind as a "tabula rasa," a blank slate on which sense impressions were recorded, compared, and grouped. Now we're more likely to speak of the mind as a "computer" (notice that both images are metaphors), "storing" and "sorting" "data." What both acknowledge is that comparison is the basis of all learning and all reasoning. When a child burns his hand on the stove and hears his mother say, "It's hot," and then goes toward the radiator and again hears her say, "It's hot," the child learns not to burn his fingers. The implicit real-life comparison is meant to convey a fact, and it teaches a mode of behavior. By contrast, the goal of literary comparison is to convey not a fact but a perception, and thereby to enlarge our scope of understanding. When we speak of "the flames of torment," our impulse is comprehension and compassion.

Nevertheless, metaphor is a dirty word in some critical circles, because of the strain of the pursuit. Clichés, mixed metaphors, and similes that are inept, unapt, obscure, or done to death mar good prose and tax the patience of the most willing reader. After eyes have been red suns, burnt-out fuses, lighthouse keepers, and lumps of coal, what else can they be?

The answer is, always something. But because by definition metaphor introduces an alien image into the flow of the story, metaphor is to some degree always self-conscious. Badly handled, it calls attention to the writer rather than the meaning and produces a sort of hiccup in the reader's involvement. A good metaphor fits so neatly that it fuses to and illuminates the meaning; or, like the Robbins passage quoted previously, it acknowledges its self-consciousness so as to take the reader into the game. Generally speaking, where metaphors are concerned, less is more and, if in doubt, don't.

Now I want to analyze the preceding paragraph. It contains at least seven dead metaphors: alien, flow, handled, calls, fits, fuses, and illuminates. A metaphor is not a foreigner; a story is not water; we do not take comparisons in our fingers; metaphors have no vocal cords, they are not puzzle pieces, they do not congeal, and they give off no light rays. But each of these words has acquired a new definition and so settles into its context without strain. At the same time, the metaphoric echoes of these words make them more interesting than their abstract synonyms: introduces an image from a different context into the meaning of the story . . . badly written, it makes us aware of the writer . . . a good metaphor is so directly relevant that it makes the meaning more understandable—these abstract synonyms contain no imagery, and so they make for flatter writing. I have probably used what Fowler speaks of as a "moribund or dormant, but not stone-dead" metaphor when I speak of Robbins "taking the reader into the game." If I were Robbins, I'd probably have said, "inviting the reader to sit down at the literary pinochle table," which is a way of acknowledging that "taking the reader into the game" is a familiar metaphor; that is, it's a way of taking us into

the game. I have used one live metaphor—"produces a sort of hiccup in the reader's involvement"—and I think I will leave it there to defend itself.

There are more *don'ts* than *dos* to record for the writing of metaphor and simile, because every good comparison is its own justification by virtue of being apt and original.

To study good metaphor, read. In the meantime, avoid the following:

Cliché metaphors are metaphors on their way to being dead. They are inevitably apt comparisons; if they were not, they wouldn't have been repeated often enough to become clichés. But because they have not acquired new definitions, the reader's mind must make the imaginative leap to an image. The image fails to surprise, and we blame the writer for this expenditure of energy without a payoff. Or, to put it a worse way:

Clichés are the last word in bad writing, and it's a crying shame to see all you bright young things spoiling your deathless prose with phrases as old as the hills. You must keep your nose to the grindstone, because the sweet smell of success only comes to those who march to the tune of a different drummer.

It's a sad fact that because you have been born into the twentieth century, you may not say that eyes are like pools or stars, and you should be very wary of saying that they flood with tears. These have been so often repeated that they've become shorthand for emotions (attractions in the first and second instances, grief in the third) without the felt force of those emotions. Anytime you as writer record an emotion without convincing us to feel that emotion, you introduce a fatal distance between author and reader. Therefore, neither may your characters be hawk-eyed nor eagle-eyed; nor may they have ruby lips or pearly teeth or peaches-and-cream complexions or necks like swans or thighs like hams. I once gave a character spatulate fingers—and have been worrying about it ever since. If you sense—and you may—that the moment calls for the special intensity of metaphor, you may have to sift through a whole stock of clichés that come readily to mind. Or it may be time for freewriting, clustering, and giving the mind room to play. Sometimes your internal critic may reject as fantastic the comparison that, on second look, proves fresh and apt.

In any case, *pools* and *stars* have become clichés for *eyes* because they capture and manifest something essential about the nature of eyes. As long as eyes continue to contain liquid and light, there will be a new way of saying so. And a metaphor freshly pursued can even take advantage of the shared writer-reader consciousness of familiar images. Here William Golding, in *The Inheritors*, describes his Neanderthal protagonist's first tears, which mark his evolution into a human being.

There was a light now in each cavern, lights faint as the starlight reflected in the crystals of a granite cliff. The lights increased, acquired definition, brightened, lay each sparkling at the lower edge of a cavern. Suddenly, noiselessly, the lights became thin crescents, went out, and streaks glistened on each cheek. The lights appeared again, caught among the silvered curls of the beard. They hung,

elongated, dropped from curl to curl and gathered at the lowest tip. The streaks on the cheeks pulsed as the drops swam down them, a great drop swelled at the end of a hair of the beard, shivering and bright. It detached itself and fell in a silver flash.

In this sharply focused and fully extended metaphor of eyes as caverns, Golding asks us to draw on a range of familiar light imagery: starlight, crystal, crescent moon, silver. The light imagery usually associated with eyes attaches to the water imagery of tears, though neither eyes nor tears are named. There is a submerged acknowledgment of cliché, but there is no cliché; Golding has reinvested the familiar images with their comparative and emotional force.

In both serious and comic writing, the consciousness of the familiar can be a peripheral advantage if you find a new way of exploiting it. It is a cliché to say, "You'll break my heart," but when Linda Ronstadt sings, "Break my mind, break my mind," the heart is still there, and the old image takes on new force. Although you may not say her eyes are like pools, you may say her eyes are like the scummy duck pond out back, and we'll find it comic partly because we know the cliché is lurking under the scum.

Cliché can also be useful as a device for establishing authorial distance from a character or narrator. If the author tells us that Rome wasn't built in a day, we're likely to think the author has little to contribute to human insight; but if a character says so, in speech or thought, the judgment attaches to the character rather than to the author.

The door closed and he turned to find the dumpy figure, surmounted by the atrocious hat, coming toward him. "Well," she said, "you only live once and paying a little more for it, I at least won't meet myself coming and going."

"Some day I'll start making money . . ."

"I think you're doing fine," she said, drawing on her gloves. "You've only been out of school a year. Rome wasn't built in a day."

Flannery O'Connor, "Everything That Rises Must Converge" (italics added)

Though you can exploit the familiar by acknowledging it in a new way, it is never sufficient to put a cliché in quotation marks: *They hadn't seen each other for "eons."* Writers are sometimes tempted to do this in order to indicate that they know a cliché when they see one. Unfortunately, quotation marks have no power to renew emotion. All they say is, "I'm being lazy and I know it."

Far-fetched metaphors are the opposite of clichés: They surprise but are not apt. As the dead metaphor far-fetched suggests, the mind must travel too far to carry back the likeness, and too much is lost on the way. When such a comparison does work, we speak laudatorily of a "leap of the imagination." But when it does not, what we face is in effect a failed conceit: The explanation of what is alike about these two things does not convince. Very good writers in the search for originality sometimes fetch

too far. Ernest Hemingway's talent was not for metaphor, and on the rare occasions that he used a metaphor, he was likely to strain. In this passage from A Farewell to Arms, the protagonist has escaped a firing squad and is fleeing the war.

You had lost your cars and your men as a floorwalker loses the stock of his department in a fire. There was, however, no insurance. You were out of it now. You had no more obligation. If they shot floorwalkers after a fire in the department store because they spoke with an accent they had always had, then certainly the floorwalkers would not be expected to return when the store opened again for business. They might seek other employment; if there was any other employment and the police did not get them.

Well, this doesn't work. We may be willing to see the likeness between stock lost in a department store fire and men and cars lost in a military retreat; but "they" don't shoot floorwalkers as the Italian military shot defeated line officers. And although a foreign accent might be a disadvantage in a foreign war, it's hard to see how a floorwalker could be killed because of one, although it might make it hard for him to get hired in the first place, if . . . The mind twists trying to find any illuminating or essential logic in the comparison of a soldier to a floorwalker, and fails, so that the protagonist's situation is trivialized in the attempt.

Mixed metaphors are so called because they ask us to compare the original image with things from two or more different areas of reference: As you walk the path of life, don't founder on the reefs of ignorance. Life can be a path or a sea, but it cannot be both at the same time. The point of the metaphor is to fuse two images in a single tension. The mind is adamantly unwilling to fuse three.

Separate metaphors or similes too close together, especially if they come from areas of reference very different in value or tone, disturb in the same way the mixed metaphor does. The mind doesn't leap; it staggers.

They fought like rats in a Brooklyn sewer. Nevertheless her presence was the axiom of his heart's geometry, and when she was away you would see him walking up and down the street dragging his cane along the picket fence like an idle boy's stick.

Any of these metaphors or similes might be acceptable by itself, but rats, axioms, and boys' sticks connote three different areas and tones, and two sentences cannot contain them all.

Mixed metaphors and metaphors too close together may be used for comic or characterizing effect. *The New Yorker* has been amusing its readers for decades with a filler item called "Block That Metaphor." But the laugh is always on the writer/speaker, and put-down humor, like a bad pun, is more likely to produce a snicker than an insight. Just as writers are sometimes tempted to put a cliché in quotation marks, they are sometimes tempted to mix metaphors and then apologize for it, in some such phrase as "to mix the metaphor," or, "if I may be permitted a mixed metaphor." It doesn't work. Don't apologize and don't mix.

Obscure and overdone metaphors falter because the author has misjudged the difficulty of the comparison. The result is either confusion or an insult to the reader's intelligence. In the case of obscurity, a similarity in the author's mind isn't getting onto the page. One student described the spines on a prickly pear cactus as being "slender as a fat man's fingers." I was completely confused by this. Was it ironic, that the spines weren't slender at all? Ah no, he said, hadn't I noticed how startling it was when someone with a fleshy body had bony fingers and toes? The trouble here was that the author knew what he meant but had left out the essential abstraction in the comparison, the startling quality of the contrast: "the spines of the fleshy prickly pear, like slender fingers on a fat man."

In this case, the simile was underexplained. It's probably a more common impulse—we're so anxious to make sure the reader gets it—to explain the obvious. In the novel Raw Silk, I had the narrator describe quarrels with her husband, "which I used to face with my dukes up in high confidence that we'd soon clear the air. The air can't be cleared now. We live in marital Los Angeles. This is the air—polluted, poisoned." A critic friend pointed out to me that anybody who didn't know about L.A. smog wouldn't get it anyway, and that all the last two words did was ram the comparison down the reader's throat. He was right. "The air can't be cleared now. We live in marital Los Angeles. This is the air." The rewrite is much stronger because it neither explains nor exaggerates; and the reader enjoys supplying the metaphoric link.

Metaphors using *topical references*, including brand names, esoteric objects, or celebrity names, can work as long as a sense of the connection is given; don't rely for effect on knowledge that the reader may not have. To write, "He looked just like Michael Jackson," is to make Jackson do your job; and if the reader happens to be a Beethoven buff, or Hungarian, or reading your story in the twenty-first century, there may be no way of knowing what the reference refers to. "He had the liquid, androgynous movements of Michael Jackson" will convey the sense even for someone who doesn't own a television. Likewise, "She was as beautiful as Theda Bara" may not mean much to you, whereas if I say, "She had the saucer eyes and satin hair of Theda Bara," you'll get it, close enough.

Allegory

Allegory is a narrative form in which comparison is structural rather than stylistic. An allegory is a continuous fictional comparison of events, in which the action of the story represents a different action or a philosophical idea. The simplest illustration of an allegory is a fable, in which, for example, the race between the tortoise and the hare is used to illustrate the philosophical notion that "the race is not always to the swift." Such a story can be seen as an extended simile, with the original figure of the comparison suppressed: The tortoise and the hare represent types of human beings, but people are never mentioned and the comparison takes place in the reader's mind. George Orwell's Animal Farm is a less naive animal allegory, exploring ideas about corruption in a democratic society. Muriel Spark's The Abbey is a historical allegory, representing, without any direct reference to Richard Nixon, the

events of Nixon's presidential term through allegorical machinations in a nunnery. The plots of such stories are self-contained, but their significance lies in the reference to outside events or ideas.

In the hands of Dante, John Bunyan, Franz Kafka, Samuel Beckett, Ursula K. Le Guin, and a handful of contemporary authors (of whom two are represented at the end of this chapter), the allegory has yielded works of serious philosophical and political insight. But it is a tricky form and can seem to smirk. A naive philosophical fable leads to a simpleminded idea that can be stated in a single phrase; a social satire rests on our familiarity with the latest Washington sex scandal, sports lockout, or celebrity brouhaha, and so appeals to a limited and insular readership.

Symbol

A symbol differs from metaphor and simile in that it need not contain a comparison. A symbol is an object or event that, by virtue of association, represents something more or something other than itself. Sometimes an object is invested arbitrarily with such meaning, as a flag represents a nation and patriotism. Sometimes a single event stands for a whole complex of events, as the crucifixion of Christ stands as well for resurrection and redemption. Sometimes an object is invested with a complex of qualities through its association with the event, like the cross itself. These symbols are not metaphors; the cross represents redemption but is not similar to redemption, which cannot be said to be wooden or T-shaped. In "Everything That Rises Must Converge" by Flannery O'Connor, the protagonist's mother encounters a black woman wearing the same absurd hat of which she has been so proud. The hat can in no way be said to "resemble" desegregation, but in the course of the story it comes to represent the tenacious nostalgia of gentility and the aspirations of the new black middle class, and therefore the unacknowledged "converging" of equality.

Nevertheless, most literary symbols, including this one, do in the course of the action derive their extra meaning from some sort of likeness on the level of emotional or ideological abstraction. The hat is not "like" desegregation, but the action of the story reveals that both women are able to buy such a hat and choose it; this is a concrete example of equality, and so represents the larger concept of equality.

Margaret Drabble's novel The Garrick Year recounts the disillusionment of a young wife and mother who finds no escape from her situation. The book ends with a family picnic in an English meadow and the return home.

On the way back to the car, Flora dashed at a sheep that was lying in the path, but unlike all the others it did not get up and move: it stared at us instead with a sick and stricken indignation. Flora passed quickly on, pretending for pride's sake that she had not noticed its recalcitrance; but as I passed, walking slowly, supported by David, I looked more closely and I saw curled up and clutching at the sheep's belly a real snake. I did not say anything to David: I did not want to admit that I had seen it, but I did see it, I can see it still. It is the only wild snake that I have ever seen. In my book on Herefordshire it says that that part of the country is notorious for its snakes. But "Oh, well, so what," is all that one can

say, the Garden of Eden was crawling with them too, and David and I managed to lie amongst them for one whole pleasant afternoon. One just has to keep on and to pretend, for the sake of the children, not to notice. Otherwise one might just as well stay at home.

The sheep is a symbol of the young woman's emotional situation. It does resemble her, but only on the level of the abstractions: sickness, indignation, and yet resignation at the fatal dangers of the human condition. There is here a metaphor that could be expressed as such (*she was sick and resigned as the sheep*), but the strength of the symbol is that such literal expression does not take place: We let the sheep stand in the place of the young woman while we reach out to the larger significance.

A symbol may also begin as and grow from a metaphor, so that it finally contains more qualities than the original comparison. In John Irving's novel *The World According to Garp*, the young Garp mishears the word "undertow" as "under toad" and compares the danger of the sea to the lurking fantasies of his childish imagination. Throughout the novel the "under toad" persists, and it comes symbolically to represent all the submerged dangers of ordinary life, ready to drag Garp under just when he thinks he is swimming under his own power. Likewise, the African continent in *Heart of Darkness* is dark like the barbaric reaches of the soul; but in the course of the novella we come to understand that darkness is shot with light and light with darkness, that barbarity and civilization are inextricably intermixed, and that the heart of darkness is the darkness of the heart.

One important distinction in the use of literary symbols is between those symbols of which the character is aware, and therefore "belong" to him or her, and those symbols of which only writer and reader are aware, and therefore belong to the work. This distinction is often important to characterization, theme, and distance. In the passage quoted from *The Garrick Year*, the narrator is clearly aware of the import of the sheep, and her awareness suggests her intelligence and the final acceptance of her situation, so that we identify with her in recognizing the symbol. The mother in "Everything That Rises Must Converge," on the other hand, does not recognize the hat as a symbol, and this distances us from her perception. She is merely disconcerted and angered that a black woman can dress in the same style she does, whereas for author and reader the coincidence symbolizes a larger convergence.

Sometimes the interplay between these types of symbol—those recognized by the characters and those seen only by writer and reader—can enrich the story in scope or irony. In *The Inheritors*, from which I've quoted several times, the Neanderthal tribe has its own religious symbols—a root, a grave, shapes in the ice cap—that represent its life-cycle worship. But in the course of the action, flood, fire, and a waterfall recall biblical symbols that allow the reader to supply an additional religious interpretation, which the characters would be incapable of doing. Again, in "Everything That Rises Must Converge," the mother sees her hat as representing first her taste and pride, and later the outrageousness of black presumption. For the reader it has the opposite and ironic significance, as a symbol of equality.

Symbols are subject to all the same faults as metaphor: cliché, strain, obscurity, obviousness, and overwriting. For these reasons, and because the word "Symbolism"

also describes a particular late-nineteenth-century movement in French poetry, with connotations of obscurity, dream, and magical incantation, *symbolism* as a method has sometimes been treated with scorn in the hard-nosed twentieth century.

Yet is seems to me incontrovertible that the writing process is inherently and by definition symbolic. In the structuring of events, the creation of character and atmosphere, the choice of object, detail, and language, you are selecting and arranging toward the goal that these elements should signify more than their mute material existence. If this were not so, then you would have no principle of choice and might just as well write about any other sets of events, characters, and objects. If you so much as say, "as innocent as a cabbage," the image is minutely symbolic, not a statement of fact but selected to mean something more and something other than itself.

People constantly function symbolically. We must do so because we rarely know exactly what we mean, and if we do we are not willing to express it, and if we are willing we are not able, and if we are able we are not heard, and if we are heard we are not understood. Words are unwieldy and unyielding, and we leap past them with intuition, body language, tone, and symbol. "Is the oven supposed to be on!" he asks. He is only peripherally curious about whether the oven is supposed to be on. He is really complaining: You're scatterbrained and extravagant with the money I go out and earn. "If I don't preheat it, the muffins won't crest," she says, meaning: You didn't catch me this time! You're always complaining about the food, and God knows I wear myself out trying to please you. "We used to have salade niçoise in the summertime," he recalls, meaning: Don't be so damn triumphant. You're still extravagant, and you haven't got the class you used to have when we were young. "We used to keep a garden," she says, meaning: You're always away on weekends and never have time to do anything with me because you don't love me anymore; I think you have a mistress. "What do you expect of me!" he explodes, and neither of them is surprised that ovens, muffins, salads, and gardens have erupted. When people say "we quarreled over nothing," this is what they mean—they quarreled over symbols.

The Objective Correlative

But the conflict in a fiction cannot be "over nothing," and as a writer you must search for the concrete external manifestations that are adequate to the inexpressible feeling. T. S. Eliot used the term "objective correlative" to describe this process and this necessity.

The only way of expressing emotion in the form of art is by finding an "objective correlative"; in other words, a set of objects, a situation, a chain of events which shall be the formula of that particular emotion; such that when the external facts, which must terminate in sensory experience, are given, the emotion is immediately invoked.

Notice that in Eliot's definition an "objective correlative" contains and evokes an *emotion*. Unlike many other sorts of symbols—scientific formulae, notes of music, the letters of the alphabet—the purpose of artistic symbol is to invoke emotion, and that emotion is specific to the particular work. The "romance" and "pity" invoked by *Romeo and Juliet* are not the same romance and pity invoked by *Anna Karenina* or *Gone With the Wind*, because the external manifestations in each work (objects, situtations, events) define the nature of the emotion.

Some kinds of symbol—religious, patriotic, political, for example—also arouse emotion, but using such a symbol in a story cannot be relied on to produce the expected emotion in the reader; indeed, the author may choose to make it arouse some other emotion entirely.

Here is the opening passage of Rick Moody's *Purple America*, in which biblical diction gives rise to powerful metaphor that is not specifically religious:

Whosover knows the folds and complexities of his own mother's body, he shall never die. Whosoever knows the latitudes of his mother's body, whosoever has taken her into his arms and immersed her baptismally in the first-floor tub, lifting one of her alabaster legs and then the other over its lip, whosoever bathes her with Woolworth's soaps in sample sizes, whosoever twists the creaky taps and tests the water on the inside of his wrist, whosoever shovels a couple of tablespoons of rose bath salts under the billowing faucet and marvels at their vermillion color, whosoever bends by hand her sclerotic limbs . . .

In this passage we recognize the New Testament echoes before we recognize the event taking place, and so are startled with an image that seems both incestuous and blasphemous, until it hinges between the phrases "baptismally" and "first-floor tub" to become an act of filial devotion both holy and trashy, partaking of both "alabaster" and "Woolworth's."

In Eliot's insight, the objects, situation, and events of a particular work contain its particular effect, and if they do not contain the desired emotional effect, that effect cannot be produced in that work, either by its statement in abstractions or by appeal to outside symbols. The "objective" sensory experience (objects, situation, events) must be "co-relative" to the emotion, each corresponding to the other, for that is the only way of expressing emotion in the form of art.

When literary symbols fail, it is most often in this difficult and essential mutuality. In a typical example, we begin the story in a room of a dying woman alone with her collection of perfume bottles. The story ranges back over her rich and sensuous life, and at the end we focus on an empty perfume bottle. It is meant to move us at her death, but it does not. Yet the fault is not in the perfume bottle. Presumably a perfume bottle may express mortality as well as a hat may express racial equality. The fault is in the use of the symbol, which has not been integrated into the texture of the story. As Bonnie Friedman puts it in *Writing Past Dark*: "Before a rhing can be a symbol it must be a thing. It must do its job as a thing in the world before and during and after you have projected all your meaning all over it." In the case of the per-

fume bottle we would need to be convinced, perhaps, of the importance this woman placed on scent as essence, need to know how the collection has played a part in the conflicts of her life, need to see her fumbling now toward her favorite, so that we could emotionally equate the spilling or evaporation of the scent with the death of her own spirit.

A symbolic object, situation, or event may err because it is insufficiently integrated into the story, and so seems to exist for its own sake rather than to emanate naturally from the characters' lives. It may err because the objective correlative is inadequate to the emotion it is supposed to evoke. Or it may err because it is too heavy or heavy-handed; that is, the author keeps pushing the symbol at us, nudging us in the ribs to say: Get it? In any of these cases we will say that the symbol is *artificial*—a curious word in the critical vocabulary, analogous to the charge of a *formula* plot, since *art*, like *form*, is a word of praise. All writing is "artificial," and when we charge it with being so, we mean that it isn't artificial enough, that the artifice has not concealed itself so as to give the illusion of the natural, and that the artificer must go back to work.

San

LAN SAMANTHA CHANG

My father left my mother and me one rainy summer morning, carrying a new umbrella of mine. From our third-floor window I watched him close the front door and pause to glance at the sky. Then he opened my umbrella. I liked the big red flower pattern—it was *fuqi*, prosperous—but in the hands of a man, even a handsome man like my father, the umbrella looked gaudy and ridiculous. Still, he did not hunch underneath but carried it high up, almost jauntily.

As I watched him walk away, I remembered a Chinese superstition. The Mandarin word for umbrella, *san*, also means "to fall apart." If you acquire an umbrella without paying for it, your life will fall apart. My father had scoffed at such beliefs. The umbrella had been a present from him. Now I stood and watched it go, bright and ill-fated like so many of his promises.

Later that morning the roof of our apartment sprang a leak. Two tiles buckled off the kitchen floor, revealing a surprising layer of mud, as if my mother's mopping over the years had merely pushed the dirt beneath the tiles and all along we'd been living over a floor of soot.

My mother knelt with a sponge in one hand. She wouldn't look at me. Her heavy chignon had come undone and a thick lock of hair wavered down her neck.

"Can I help?" I asked, standing over her. She did not answer but stroked the tiles with her sponge.

I put the big rice cooker underneath the leak. Then I went to my room. All morning, I studied problems for my summer school math class. I heard my mother, in the kitchen, start to sob. I felt only fear—a dense stone in my chest—but I put even

this aside so I could study. My father had taught me to focus on the equations in front of me, and so I spent the hours after he left thinking about trigonometry, a subject he had loved.

My mathematical talent had sprung from an early backwardness. As a child I could not count past three: my father, my mother, and me.

"Caroline is making progress in her English lessons, but she remains baffled by the natural numbers," read an early report card. "She cannot grasp the *countability* of blocks and other solid objects. For this reason I am recommending that she repeat the first grade."

This comment left my father speechless. He believed I was a brilliant child. And mathematics had been his favorite subject back in China, before political trouble had forced him to quit school and, eventually, the country.

"Counting," he said in English, when he was able to talk again. His dark eyebrows swooped over the bridge of his aquiline nose. Despite his drastic ups and downs, bad news always caught him by surprise. But he recovered with typical buoyancy. "Don't worry, Lily," he told my mother. "It's those western teachers. I'll teach her how to count."

And so my father, himself an unreliable man, taught me to keep track of things. We counted apples, bean sprouts, grains of rice. I learned to count in pairs, with ivory chopsticks. We stood on the corner of Atlantic Avenue, counting cars to learn big numbers. We spent a lovely afternoon in Prospect Park, counting blades of grass aloud until we both had scratchy throats.

"Keep going," he urged me on as the shadows lengthened. "I want you to be able to count all the money I'm going to make, here in America."

By the time I was seven I had learned the multiplication tables to twenty-timestwenty. In the following year I learned to recite the table of squares and the table of cubes, both so quickly that the words blended together into a single stream, almost meaningless: "Oneeighttwentysevensixtyfouronetwentyfivetwosixteenthree-fortythree . . ."

As I chanted, my father would iron the white shirt and black trousers he wore to his waiter's job, a "temporary" job. Or he stood in the kirchen, Mondays off, with three blue balls and one red ball, juggling expertly beneath the low tin ceiling. Each time the red ball reached his hand I was ordered to stress a syllable. Thus "One, eight, twenty-seven, sixty-four."

"Pronounce," said my father, proud of his clear r's. To succeed in America, he was sure, required good pronunciation as well as math. He often teased my mother for pronouncing my name *Calorin*, "like a diet formula," he said. They had named me for Caroline after Caroline Kennedy, who was born shortly before their arrival in the States. After all, my father's name was Jack. And if the name was good enough for a president's daughter, then certainly it was good enough for me.

After I learned to count I began, belatedly, to notice things. Signs of hard luck and good fortune moved through our apartment like sudden storms. A pale stripe on my father's tanned wrist revealed where his watch had been. A new pair of aquamarine

slippers shimmered on my mother's feet. A beautiful collection of fourteen cacti, each distinct, bloomed on our fire escape for several summer months and then vanished.

I made careful explorations of our apartment. At the back of the foyer closet, inside the faded red suitcase my mother had brought from China, I discovered a cache of little silk purses wrapped in a cotton shirt. When I heard her footsteps I instinctively closed the suitcase and pretended I was looking for a pair of mittens. Then I went to my room and shut the door, slightly dizzy with anticipation and guilt.

A few days later when my mother was out, I opened one purse. Inside was a swirling gold pin with pearl and coral flowers. I made many secret visits to the closet, a series of small sins. Each time I opened one more treasure. There were bright green, milky white, and carmine bracelets. Some of the bracelets were so small I could not fit them over my hand. There was a ring with a pearl as big as a marble. A strand of pearls, each the size of a large pea. A strand of jade beads carved in the shape of small buddhas. A rusty key.

"Do you still have keys to our old house in China?" I asked my father.

"That's the past, Caroline," he said. "Wanle. It is gone."

Surrounded by questions, I became intrigued by the answers to things. My report cards showed that I became a good student, a very good student, particularly in math. At twelve, I was the only person from my class to test into a public school for the gifted in Manhattan. My father attended the school event where this news was announced. I remember his pleased expression as we approached the small, crowded auditorium. He had piled all of our overcoats and his fedora over one arm, but with the other he opened the door for my mother and me. As I filed past he raised his eyebrows and nodded—proud, but not at all surprised by my achievement.

He believed in the effortless, in splurging and quick riches. While I studied, bent and dogged, and my mother hoarded things, my father strayed from waitering and turned to something bigger. He had a taste for making deals, he said to us. A nose for good investments. Some friends were helping him. He began to stay out late and come home with surprises. On good nights, he brought us presents: a sewing kit, a pink silk scarf. Once he climbed out of a taxicab with a hundred silver dollars in my old marble bag.

On bad nights, my father whistled his way home. I sometimes woke to his high music floating from the street. I sat up and spied at him through the venetian blind. He no longer wore his waiter's clothes; his overcoat was dark. I could just make out the glitter of his shiny shoes. He stepped lightly, always, on bad nights, although he'd whistled clear across the bridge to save on subway fare. He favored Stephen Foster tunes and Broadway musicals. he flung his head back on a long, pure note. When he reached our door he stood still for a moment and squared his shoulders.

My mother, too, knew what the whistling meant.

"Stayed up for me?"

"I wasn't tired."

I crept to my door to peek at them. My mother staring at her feet. My father's hopeful face, his exaggerated brightness. My mother said, "Go to sleep, Caroline."

But I had trouble sleeping. I could feel him slipping away from us, drifting far in search of some intoxicating music. Each time he wandered off, it seemed to take more effort to recall us. He began to speak with his head cocked, as if listening for something. He often stood at the living room window, staring at the street.

"Does Baba have a new job?" I asked my mother.

"No." She looked away.

I felt sorry I'd asked. Questions caused my mother pain. But I was afraid to ask my father. In his guarded face he held a flaming knowledge: a kind of faith, a glimpse of opportunities that lay beyond my understanding:

All that year I hunted clues, made lists of evidence.

Missing on February 3:

carved endtable painting of fruit (from front hallway) jade buddha camera (mine)

I followed him. One evening after I missed my camera, I heard the front door slam. I grabbed my coat and bolted down the stairs. I dodged across the street half a block back, peering around pedestrians and traffic signs, my eyes fixed on his overcoat and fedora. At the subway station I waited by the token booth and dashed into the bright car behind him, keeping track of his shiny shoes through the swaying windows. I almost missed him when he left the train. Outside it was already dusk. The tall, cold shapes of City Hall and the courthouses loomed over us and I followed at a distance. I felt light as a puff of silk, breathing hard, excited, almost running.

Past the pawn shops, the off-track betting office with its shuffling line of men in old overcoats, toward the dirty, crowded streets of Chinatown, its neon signs winking on for the night. Groups of teenagers, chattering in Cantonese, looked strangely at me and kept walking.

"Incense, candles, incense, xiaojie?" A street vendor held a grimy handful toward me.

"No thanks," I panted. I almost lost him but then ahead I recognized his elegant stride. He turned into a small, shabby building, nodding to an old man who stood at the door. I hung around outside, stamping my shoes on the icy sidewalk.

After a minute the old man walked over to me. "Your father does not know you followed him," he told me in Chinese. "You must go home. Go home, and I will not tell him you were here."

For a minute I couldn't move. He was exactly my height. His short hair was white but his forehead strangely unlined, his clothes well-made. It was his expensive tweed overcoat that made me turn around. That and the decaying, fetid odor of his teeth, and the fact that he knew my father well enough to recognize my features, knew he would not have wanted me to follow him. I reboarded the train at the Canal Street station. Back in the apartment, I stayed up until well past midnight, but I didn't hear him come home.

I didn't need to follow him. I should have known that eventually he would show his secret to me, his one pupil. A few months later, on the night before my fourteenth birthday, he motioned me to stay seated after supper. The hanging lamp cast a circle of light over the worn kitchen table.

"I'm going to teach you some math," he said.

I glanced at his face, but his eyes glowed black and expressionless in their sockets, hollow in the lamplight.

Over his shoulder I saw my mother check to see that we were occupied. Then she walked into the foyer and opened the closet door, where the jewelry was. I felt a tingle of fear, even though I had concealed my visits perfectly.

"Concentrate," said my father. "Here is a penny. Each penny has two sides: heads and tails. You understand me, Caroline?"

I nodded. The dull coin looked like a hole in his palm.

"Hao," he said: good. His brown hand danced and the penny flipped onto the table. Heads. "Now, if I throw this coin many many times, how often would I get heads?"

"One-half of the time."

He nodded.

"Hao," he said. "That is the huo ran lu. The huo ran lu for heads is one-half. If you know that, you can figure out the huo ran lu that I will get two heads if I throw twice in a row." He waited a minute. "Think of it as a limiting of possibilities. The first throw cuts the possibilities in half."

I looked into the dark tunnel of my father's eyes and, following the discipline of his endless drilling, I began to understand where we had been going. Counting, multiplication, the table of squares. "Half of the half," I said. "A quarter."

He set the coins aside and reached into his shirt pocket. Suddenly, with a gesture of his hand, two dice lay in the middle of the yellow circle of light. Two small chunks of ivory, with tiny black pits in them.

"Count the sides," he said.

The little cube felt cold and heavy. "Six."

My father's hand closed over the second die. "What is the huo ran lu that I will get a side with only two dots?"

My mind wavered in surprise at his intensity. But I knew the answer. "One-sixth," I said.

He nodded. "You are a smart daughter," he said.

I discovered that I had been holding onto the table leg with my left hand, and I let go. I heard the creak of the hall closet door but my father did not look away from the die in his hand.

"What is the huo ran lu that I can roll the side with two dots twice in a row?" he said.

"One thirty-sixth."

"Three times in a row?"

"One two-hundred-and-sixteenth."

"That is very good!" he said. "Now, the *huo ran lu* that I will be able to roll a two is one-sixth. Would it be a reasonable bet that I will not roll a two?"

I nodded.

"We could say, if I roll a two, you may have both pennies."

I saw it then, deep in his eyes—a spark of excitement, a piece of joy particularly his. It was there for an instant and disappeared. He frowned and nodded toward the table as if to say: pay attention. Then his hand flourished and the die trickled into the light. I bent eagerly over the table, but my father sat perfectly still, impassive. Two dots.

When I looked up at him in astonishment I noticed my mother, standing in the doorway, her two huge eyes burning in her white face.

"Jack."

My father started, but he didn't turn around to look at her. "Yes, Lily," he said.

The die grew wet in my hand.

"What are you doing?"

"Giving the child a lesson."

"And what is she going to learn from this?" My mother's voice trembled but it did not rise. "Where will she go with this?"

"Lily," my father said.

"What will become of us?" my mother almost whispered. She looked around the kitchen. Almost all of the furniture had disappeared. The old kitchen table and the three chairs, plus our rice cooker, were virtually the only things left in the room.

I grabbed the second die and left the table. In my room as I listened to my parents next door in the kitchen I rolled one die two hundred and sixteen times, keeping track by making marks on the back of a school notebook. But I failed to reach a two more than twice in a row.

"The suitcase, Jack. Where is it?"

After a moment my father muttered, "I'll get it back. Don't you believe me?"

"I don't know." She began to cry so loudly that even though I pressed my hands against my ears I could still hear her. My father said nothing. I hunched down over my knees, trying to shut them out.

"You promised me, you promised me you'd never touch them!"

"I was going to bring them back!"

"We have nothing for Caroline's birthday . . ."

Something crashed against the other side of my bedroom wall. I scuttled to the opposite wall and huddled in the corner of my bed.

For a long period after I heard nothing but my mother's sobbing. Then they left the kitchen. The house was utterly silent. I realized I had wrapped my arms around my knees to keep from trembling. I felt strange and light-headed: oh, but I understood now. My father was a gambler, a *dutu*, an apprentice of chance. Of course.

With the understanding came a desperate need to see both of them. I stood up and walked through the living room to my parents' bedroom. The door was ajar. I peered in.

The moonlight, blue and white, shifted and flickered on the bed, on my mother's long black hair twisting over her arm. Her white fingers moved vaguely. I felt terrified for her. He moved against her body in such a consuming way, as if he might pass

through her, as if she were incorporeal. I watched for several minutes before my mother made a sound that frightened me so much I had to leave.

The next morning my eyes felt sandy and strange. We strolled down Atlantic Avenue, holding hands, with me in the middle because it was my birthday. My mother's stride was tentative, but my father walked with the calculated lightness and unconcern of one who has nothing in his pockets. Several gulls flew up before us, and he watched with delight as they wheeled into the cloudy sky. The charm of Brooklyn, this wide shabby street bustling with immigrants like ourselves, was enough to make him feel lucky.

He squeezed my hand, a signal that I should squeeze my mother's for him. We'd played this game many times over the years, but today I hesitated. My mother's hand did not feel like something to hold onto. Despite the warm weather her fingers in mine were cold. I squeezed, however, and she turned. He looked at her over the top of my head, and my mother, seeing his expression, lapsed into a smile that caused the Greek delivery boys from the corner pizza parlor to turn their heads as we passed. She and my father didn't notice.

We walked past a display of furniture on the sidewalk—incomplete sets of dining chairs, hat stands, old sewing tables—and I stared for a minute, for I thought I saw something standing behind a battered desk: a rosewood dresser my parents had brought from Taiwan; it used to be in my own bedroom. I once kept my dolls in the bottom left drawer, the one with the little scar where I had nicked it with a roller skate. . . . Perhaps it only had a similar shape. But it could very well be our dresser. I knew better than to point it out. I turned away.

"Oh, Jack, the flowers!" my mother exclaimed in Chinese. She let go of my hand and rushed to DeLorenzio's floral display, sank down to smell the potted gardenias with a grace that brought my father and me to a sudden stop.

My father's black eyebrows came down over his eyes. "Ni qu gen ni mama tan yi tan, go talk to your mother," he said, giving me a little push. I frowned. "Go on."

She was speaking with Mr. DeLorenzio, and I stood instinctively on their far side, trying to act cute despite my age in order to distract them from what my father was doing. He stood before the red geraniums. He picked up a plant, considered it, and set it down with a critical shake of his head.

"And how are you today sweetheart?" Mr. DeLorenzio bent toward me, offering me a close-up of his gray handlebar moustache. Behind him, my father disappeared from view.

"She's shy," said my mother proudly. After a few minutes I tugged her sleeve, and she said goodbye to the florist. We turned, continued walking down the street.

"Where is your father?"

"I think he's somewhere up there."

I pulled her toward the corner. My father stepped out from behind a pet store, smiling broadly, holding the pot of geraniums.

"It's going to rain," he proclaimed, as if he'd planned it himself.

The drops felt light and warm on my face. We ran to the nearest awning, where

my mother put on her rain bonnet. Then my father disappeared, leaving us standing on the sidewalk. I didn't notice him leave. All of a sudden he was just gone.

"Where's Baba?" I asked my mother.

"I don't know," she said, calmly tucking her hair into the plastic bonnet. The geraniums stood at her feet. I looked around us. The sidewalks had become slick and dark; people hurried along. The wind blew cool in my face. Then the revolving doors behind us whirled and my father walked out.

"There you are," my mother said.

"Here, Caroline," said my father to me. He reached into his jacket and pulled out the umbrella. It lay balanced on his palm, its brilliant colors neatly furled, an offer-

I wanted to refuse the umbrella. For a moment I believed that if I did, I could separate myself from both of my parents, and our pains, and everything that bound me

I looked up at my father's face. He was watching me intently. I took the umbrella. "Thanks," I said. He smiled. The next day, he was gone.

My mother had her hair cut short and dressed in mourning colors; this attitude bestowed on her a haunting, muted beauty. She was hired for the lunch shift at a chic Manhattan Chinese restaurant. Our lives grew stable and very quiet. In the evenings I studied while my mother sat in the kitchen, waiting, cutting carrots and mushroom caps into elaborate shapes for our small stir-frys, or combining birdseed for the feeder on the fire escape in the exact proportions that my father had claimed would bring the most cardinals and the fewest sparrows. I did the homework for advanced placement courses. I planned to enter Columbia with the academic standing of a sophomore. We spoke gently to each other about harmless, tactful things. "Peanut sauce," we said. "Shopping." "Homework." "Apricots."

I studied trigonometry. I grew skillful in that subject without ever liking it. I learned calculus, linear algebra, and liked them less and less, but I kept studying, seeking the comfort that arithmetic had once provided. Things fall apart, it seems, with terrible slowness. I could not see that true mathematics, rather than keeping track of things, moves toward the unexplainable. A swooping line descends from nowhere, turns, escapes to some infinity. Centuries of scholars work to solve a single puzzle. In mathematics, as in love, the riddles matter most.

In the months when I was failing out of Columbia, I spent a lot of my time on the subway. I rode to Coney Island, to the watery edge of Brooklyn, and stayed on the express train as it changed directions and went back deep under the river, into Manhattan. Around City Hall or 14th Street a few Chinese people always got on the train, and I sometimes saw a particular kind of man, no longer young but his face curiously unlined, wearing an expensive but shabby overcoat and shiny shoes. I would watch until he got off at his stop. Then I would sit back and wait as the train pulsed through the dark tunnels under the long island of Manhattan, and sometimes the light would blink out for a minute and I would see blue sparks shooting off the tracks. I was waiting for the moment around 125th Street where the express train rushed up into daylight. This sudden openness, this coming out of darkness into a new world, helped me understand how he must have felt. I imagined him bent over a pair of dice that glowed like tiny skulls under the yellow kitchen light. I saw him walking out the door with my flowery umbrella, pausing to look up at the sky and the innumerable, luminous possibilities that lay ahead.

Suggestions for Discussion

- 1. How does the author change and enlarge the meaning of the phrase "a new umbrella of mine" during the course of "San"?
- 2. What metaphorical significance does one or more of the characters place on each of the following, and where do they have a different or additional significance for the reader: the word "san," "countability," mathematics, juggling, the name "Caroline," the faded red suitcase, the mother's haircut, the subway train.
- 3. Where and how does Lan Samantha Chang make the "evidence" of the father's shifting fortunes also symbolic?
- 4. Describe the emotion for which "San" is an objective correlative. How do objects, situation, and chain of events add up to "the formula of that particular emotion"?

The Falling Girl

DINO BUZZATI

English translation by Lawrence Venuti

Marta was nineteen. She looked out over the roof of the skyscraper, and seeing the city below shining in the dusk, she was overcome with dizziness.

The skyscraper was silver, supreme and fortunate in that most beautiful and pure evening, as here and there the wind stirred a few fine filaments of cloud against an absolutely incredible blue background. It was in fact the hour when the city is seized by inspiration and whoever is not blind is swept away by it. From that airy height the girl saw the streets and the masses of buildings writhing in the long spasm of sunset, and at the point where the white of the houses ended, the blue of the sea began. Seen from above, the sea looked as if it were rising. And since the veils of the night were advancing from the east, the city became a sweet abyss burning with pulsating lights. Within it were powerful men, and women who were even more powerful, furs and violins, cars glossy as onyx, the neon signs of nightclubs, the entrance halls of

darkened mansions, fountains, diamonds, old silent gardens, parties, desires, affairs, and, above all, that consuming sorcery of the evening which provokes dreams of

greatness and glory.

Seeing these things, Marta hopelessly leaned out over the railing and let herself go. She felt as if she were hovering in the air, but she was falling. Given the extraordinary height of the skyscraper, the streets and squares down at the bottom were very far away. Who knows how long it would take her to get there. Yet the girl was falling.

At that hour the terraces and balconies of the top floors were filled with rich and elegant people who were having cocktails and making silly conversation. They were scattered in crowds, and their talk muffled the music. Marta passed before them and several people looked out to watch her.

Flights of that kind (mostly by girls, in fact) were not rare in the skyscraper and they constituted an interesting diversion for the tenants; this was also the reason

why the price of those apartments was very high.

The sun had not yet completely set and it did its best to illuminate Marta's simple clothing. She wore a modest, inexpensive spring dress bought off the rack. Yet the lyrical light of the sunset exalted it somewhat, making it chic.

From the millionaires' balconies, gallant hands were stretched out toward her, offering flowers and cocktails. "Miss, would you like a drink? . . . Gentle butterfly, why not stop a minute with us?"

She laughed, hovering, happy (but meanwhile she was falling): "No, thanks, friends. I can't. I'm in a hurry."

"Where are you headed?" they asked her.

"Ah, don't make me say," Marta answered, waving her hands in a friendly goodbye.

A young man, tall, dark, very distinguished, extended an arm to snatch her. She liked him. And yet Marta quickly defended herself: "How dare you, sir?" and she had time to give him a little tap on the nose.

The beautiful people, then, were interested in her and that filled her with satisfaction. She felt fascinating, stylish. On the flower-filled terraces, amid the bustle of waiters in white and the bursts of exotic songs, there was talk for a few minutes, perhaps less, of the young woman who was passing by (from top to bottom, on a vertical course). Some thought her pretty, others thought her so-so, everyone found her interesting.

"You have your entire life before you," they told her, "why are you in such a hurry? You still have time to rush around and busy yourself. Stop with us for a little while, it's only a modest little party among friends, really, you'll have a good time."

She made an attempt to answer but the force of gravity had already quickly carried her to the floor below, then two, three, four floors below; in fact, exactly as you gaily rush around when you are just nineteen years old.

Of course, the distance that separated her from the bottom, that is, from street level, was immense. It is true that she began falling just a little while ago, but the street always seemed very far away.

In the meantime, however, the sun had plunged into the sea; one could see it disappear, transformed into a shimmering reddish mushroom. As a result, it no longer emitted its vivifying rays to light up the girl's dress and make her a seductive comet. It was a good thing that the windows and terraces of the skyscraper were almost all illuminated and the bright reflections completely gilded her as she gradually passed by.

Now Marta no longer saw just groups of carefree people inside the apartments; at times there were even some businesses where the employees, in black or blue aprons, were sitting at desks in long rows. Several of them were young people as old or older than she, and weary of the day by now, every once in a while they raised their eyes from their duties and from typewriters. In this way they too saw her, and a few ran to the windows. "Where are you going? Why so fast? Who are you?" they shouted to her. One could divine something akin to envy in their words.

"They're waiting for me down there," she answered. "I can't stop. Forgive me." And again she laughed, wavering on her headlong fall, but it wasn't like her previous laughter anymore. The night had craftily fallen and Marta started to feel cold.

Meanwhile, looking downward, she saw a bright halo of lights at the entrance of a building. Here long black cars were stopping (from the great distance they looked as small as ants), and men and women were getting out, anxious to go inside. She seemed to make out the sparkling of jewels in that swarm. Above the entrance flags were flying.

They were obviously giving a large party, exactly the kind that Marta dreamed of ever since she was a child. Heaven help her if she missed it. Down there opportunity was waiting for her, fate, romance, the true inauguration of her life. Would she arrive in time?

She spitefully noticed that another girl was falling about thirty meters above her. She was decidedly prettier than Marta and she wore a rather classy evening gown. For some unknown reason she came down much faster than Marta, so that in a few moments she passed by her and disappeared below, even though Marta was calling her. Without doubt she would get to the party before Marta; perhaps she had a plan all worked out to supplant her.

Then she realized that they weren't alone. Along the sides of the skyscraper many other young women were plunging downward, their faces taut with the excitement of the flight, their hands cheerfully waving as if to say: look at us, here we are, entertain us, is not the world ours?

It was a contest, then. And she only had a shabby little dress while those other girls were dressed smartly like high-fashion models and some even wrapped luxurious mink stoles tightly around their bare shoulders. So self-assured when she began the leap, Marta now felt a tremor growing inside her; perhaps it was just the cold; but it may have been fear too, the fear of having made an error without remedy.

It seemed to be late at night now. The windows were darkened one after another, the echoes of music became more rare, the offices were empty, young men no longer leaned out from the windowsills extending their hands. What time was it? At the entrance to the building down below—which in the meantime had grown larger,

and one could now distinguish all the architectural details—the lights were still burning, but the bustle of cars had stopped. Every now and then, in fact, small groups of people came out of the main floor wearily drawing away. Then the lights of the entrance were also turned off.

Marta felt her heart tightening. Alas, she wouldn't reach the ball in time. Glancing upwards, she saw the pinnacle of the skyscraper in all its cruel power. It was almost completely dark. On the top floors a few windows here and there were still lit. And above the top the first glimmer of dawn was spreading.

In a dining recess on the twenty-eighth floor a man about forty years old was having his morning coffee and reading his newspaper while his wife tidied up the room. A clock on the sideboard indicated 8:45. A shadow suddenly passed before the window.

"Alberto!" the wife shouted. "Did you see that? A woman passed by."

"Who was it?" he said without raising his eyes from the newspaper.

"An old woman," the wife answered. "A decrepit old woman. She looked fright-ened."

"It's always like that," the man muttered. "At these low floors only falling old women pass by. You can see beautiful girls from the hundred-and-fiftieth floor up. Those apartments don't cost so much for nothing."

"At least down here there's the advantage," observed the wife, "that you can hear the thud when they touch the ground."

"This time not even that," he said, shaking his head, after he stood listening for a few minutes. Then he had another sip of coffee.

Suggestions for Discussion

- 1. One of the things Buzzati does in this story is to revitalize the cliché "life is a journey." What techniques does he employ to do this?
- 2. How, by diction, imagery, and metaphor, does Buzzati let you know that you are in some other reality? Is "Falling Girl" an allegory? What situation might it stand for without mentioning?
- 3. What is accomplished by mixing the ideas of "flight" and "fall"?
- 4. Identify some easily understood metaphors. Identify some in which it is not so clear what corresponds to what. Why is the story set up this way?

Menagerie

CHARLES JOHNSON

Among watchdogs in Seattle, Berkeley was known generally as one of the best. Not the smartest, but steady. A pious German shepherd (Black Forest origins, probably), with big shoulders, black gums, and weighing more than some men, he sat guard inside the glass door of Tilford's Pet Shoppe, watching the pedestrians scurry along First Avenue, wondering at the derelicts who slept ever so often inside the foyer at night, and sometimes he nodded when things were quiet in the cages behind him, lulled by the bubbling of the fishtanks, dreaming of an especially fine meal he'd once had, or the little female poodle, a real flirt, owned by the aerobic dance teacher (who was no saint herself) a few doors down the street; but Berkelev was, for all his woolgathering, never asleep at the switch. He took his work seriously. Moreover, he knew exactly where he was at every moment, what he was doing, and why he was doing it, which was more than can be said for most people, like Mr. Tilford, a real gumboil, whose ways were mysterious to Berkeley. Sometimes he treated the animals cruelly, or taunted them; he saw them not as pets but profit. Nevertheless, no vandals, or thieves, had ever brought trouble through the doors or windows of Tilford's Pet Shoppe, and Berkeley, confident of his power but never flaunting it, faithful to his master though he didn't deserve it, was certain that none ever would.

At closing time, Mr. Tilford, who lived alone, as most cruel men do, always checked the cages, left a beggarly pinch of food for the animals, and a single biscuit for Berkeley. The watchdog always hoped for a pat on his head, or for Tilford to play with him, some sign of approval to let him know he was appreciated, but such as this never came. Mr. Tilford had thick glasses and a thin voice, was stubborn, hottempered, a drunkard and a loner who, sliding toward senility, sometimes put his shoes in the refrigerator, and once—Berkeley winced at the memory—put a Persian he couldn't sell in the Mix Master during one of his binges. Mainly, the owner drank and watched television, which was something else Berkeley couldn't understand. More than once he'd mistaken gunfire on screen for the real thing (a natural error, since no one told him violence was entertainment for some), howled loud enough to bring down the house, and Tilford booted him outside. Soon enough, Berkeley stopped looking for approval; he didn't bother to get up from biting fleas behind the counter when he heard the door slam.

But it seemed one night too early for closing time. His instincts on this had never been wrong before. He trotted back to the darkened storeroom; then his mouth snapped shut. His feeding bowl was as empty as he'd last left it.

"Say, Berkeley," said Monkey, whose cage was near the storeroom. "What's goin' on? Tilford didn't put out the food."

Berkeley didn't care a whole lot for Monkey, and usually he ignored him. He was downright wicked, a comedian always grabbing his groin to get a laugh, throwing feces, or fooling with the other animals, a clown who'd do anything to crack up the iguana, Frog, Parrot, and the Siamese, even if it meant aping Mr. Tilford, which he

did well, though Berkeley found this parody frightening, like playing with fire, or literally biting the hand that fed you. But he, too, was puzzled by Tilford's abrupt departure.

"I don't know," said Berkeley. "He'll be back, I guess."

Monkey, his head through his cage, held onto the bars like a movie inmate. "Wanna bet?"

"What're you talking about?"

"Wake up," said Monkey. "Tilford's sick. I seen better faces on dead guppies in the fishtank. You ever see a pulmonary embolus?" Monkey ballooned his cheeks, then started breathing hard enough to hyperventilate, rolled up both red-webbed eyes, then crashed back into his cage, howling.

Not thinking this funny at all, Berkeley padded over to the front door, gave Monkey a grim look, then curled up against the bottom rail, waiting for Tilford's car to appear. Cars of many kinds, and cars of different sizes, came and went, but that Saturday night the owner did not show. Nor the next morning, or the following night, and on the second day it was not only Monkey but every beast, bird, and fowl in the Shoppe that shook its cage or tank and howled at Berkeley for an explanation—an ear-shattering babble of tongues, squawks, trills, howls, mewling, bellows, hoots, blorting, and belly growls because Tilford had collected everything from baby alligators to zebra-striped fish, an entire federation of cultures, with each animal having its own distinct, inviolable nature (so they said), the rows and rows of counters screaming with a plurality of so many backgrounds, needs, and viewpoints that Berkeley, his head splitting, could hardly hear his own voice above the din.

"Be patient!" he said. "Believe me, he's comin' back!"

"Come off it," said one of three snakes. "Monkey says Tilford's dead. Question is, what're we gonna do about it?"

Berkeley looked, witheringly, toward the front door. His empty stomach gurgled like a sewer. It took a tremendous effort to untangle his thoughts. "If we can just hold on a—"

"We're hungry!" shouted Frog. "We'll starve before old Tilford comes back!"

Throughout this turmoil, the shouting, beating of wings, which blew feathers everywhere like confetti, and an angry slapping of fins that splashed water to the floor, Monkey simply sat quietly, taking it all in, stroking his chin as a scholar might. He waited for a space in the shouting, then pushed his head through the cage again. His voice was calm, studied, like an old-time barrister before the bar. "Berkeley? Don't get mad now, but I think it's obvious that there's only one solution."

"What?"

"Let us out," said Monkey. "Open the cages."

"No!"

"We've got a crisis situation here." Monkey sighed like one of the elderly, tired lizards, as if his solution bothered even him. "It calls for courage, radical decisions. You're in charge until Tilford gets back. That means you gotta feed us, but you can't do that, can you? Only one here with hands is *me*. See, we all have different talents, unique gifts. If you let us out, we can pool our resources. I can *open* the feed bags!"

"You can?" The watchdog swallowed.

"Uh-huh." He wiggled his fingers dexterously, then the digits on his feet. "But somebody's gotta throw the switch on this cage. I can't reach it. Dog, I'm asking you to be democratic! Keeping us locked up is fascist!"

The animals clamored for release; they took up Monkey's cry, "Self-determination!" But everything within Berkeley resisted this idea, the possibility of chaos it promised, so many different, quarrelsome creatures uncaged, set loose in a low ceilinged Shoppe where even he had trouble finding room to turn around between the counters, pens, displays of paraphernalia, and heavy, bubbling fishtanks. The chances for mischief were incalculable, no question of that, but slow starvation was certain if he didn't let them in the storeroom. Furthermore, he didn't want to be called a fascist. It didn't seem fair, Monkey saying that, making him look bad in front of the others. It was the one charge you couldn't defend yourself against. Against his better judgement, the watchdog rose on his hindlegs and, praying this was the right thing, forced open the cage with his teeth. For a moment Monkey did not move. He drew breath loudly and stared at the open door. Cautiously, he stepped out, stood up to his full height, rubbed his bony hands together, then did a little dance and began throwing open the other cages one by one.

Berkeley cringed. "The tarantula, too?"

Monkey gave him a cold glance over one shoulder. "You should get to know him, Berkeley. Don't be a bigot."

Berkeley shrank back as Tarantula, an item ordered by a Hell's Angel who never claimed him, shambled out—not so much an insect, it seemed to Berkeley, as Pestilence on legs. ("Be fair!" he scolded himself. "He's okay, I'm okay, we're all okay.") He watched helplessly as Monkey smashed the ant farm, freed the birds, and then the entire troupe, united by the spirit of a bright, common future, slithered, hopped, crawled, bounded, flew, and clawed its way into the storeroom to feed. All except crankled, old Tortoise, whom Monkey hadn't freed, who, in fact, didn't want to be released and snapped at Monkey's fingers when he tried to open his cage. No one questioned it. Tortoise had escaped the year before, remaining at large for a week, and then he returned mysteriously on his own, his eyes strangely unfocused, as if he'd seen the end of the world, or a vision of the world to come. He hadn't spoken in a year. Hunched inside his shell, hardly eating at all, Tortoise lived in the Shoppe, but you could hardly say he was part of it, and even the watchdog was a little leery of him.

Berkeley, for his part, had lost his hunger. He dragged himself, wearily, to the front door, barked frantically when a woman walked by, hoping she would stop, but after seeing the window sign, which read—DESOLC—from his side, she stepped briskly on. His tail between his legs, he went slowly back to the storeroom, hoping for the best, but what he found there was no sight for a peace-loving watchdog.

True to his word, Monkey had broken open the feed bags and boxes of food, but the animals, who had always been kept apart by Tilford, discovered as they crowded into the tiny storeroom and fell to eating that sitting down to table with creatures so different in their gastronomic inclinations took the edge off their appetites. The birds found the eating habits of the reptiles, who thought eggs were a delicacy, disgusting and drew away in horror; the reptiles, who were proud of being cold-blooded,

and had an elaborate theory of beauty based on the aesthetics of scales, thought the body heat of the mammals cloying and nauseating, and refused to feed beside them, and this was fine for the mammals, who, led by Monkey, distrusted anyone odd enough to be born in an egg, and dismissed them as lowlifes on the evolutionary scale; they were shoveling down everything—bird food, dog biscuits, and even the thin wafers reserved for the fish.

"Don't touch that!" said Berkeley. "The fish have to eat, too! They can't leave the tanks!"

Monkey, startled by the watchdog, looked at the wafers in his fist thoughtfully for a second, then crammed them into his mouth. "That's their problem."

Deep inside, Berkeley began a rumbling bark, let it build slowly, and by the time it hit the air it was a full-throated growl so frightening that Monkey jumped four, maybe five feet into the air. He threw the wafers at Berkeley. "Okay—okay, give it to 'em! But remember one thing, dog: You're a mammal, too. It's unnatural to take sides against your own kind."

Scornfully, the watchdog turned away, trembling with fury. He snuffled up the wafers in his mouth, carried them to the huge, man-sized tanks, and dropped them in amongst the sea horses, guppies, and jellyfish throbbing like hearts. Goldfish floated toward him, his voice and fins fluttering. He kept a slightly startled expression. "What the hell is going on? Where's Mr. Tilford?"

Berkeley strained to keep his voice steady. "Gone."

"For good?" asked Goldfish. "Berkeley, we heard what the others said. They'll let us starve—"

"No," he said. "I'll protect you."

Goldfish bubbled relief, then looked panicky again. "What if Tilford doesn't come back ever?"

The watchdog let his head hang. The thought seemed too terrible to consider. He said, more to console himself than Goldfish, "It's his Shoppe. He has to come back."

"But suppose he is dead, like Monkey says." Goldfish's unblinking, lidless eyes grabbed at Berkeley and refused to release his gaze. "Then it's our Shoppe, right?"

"Eat your dinner."

Goldfish called, "Berkeley, wait—"

But the watchdog was deeply worried now. He returned miserably to the front door. He let fly a long, plaintive howl, his head tilted back like a mountaintop wolf silhouetted by the moon in a Warner Brothers cartoon—he did look like that—his insides hurting with the thought that if Tilford was dead, or indifferent to their problems, that if no one came to rescue them, then they were dead, too. True, there was a great deal of Tilford inside Berkeley, what he remembered from his training as a pup, but this faint sense of procedure and fair play hardly seemed enough to keep order in the Shoppe, maintain the peace, and more important provide for them as the old man had. He'd never looked upon himself as a leader, preferring to attribute his distaste for decision to a rare ability to see all sides. He was no hero like Old Yeller, or the legendary Gellert, and testing his ribs with his teeth, he wondered how much weight he'd lost from worry. Ten pounds? Twenty pounds? He covered both eyes with his black paws, whimpered a little, feeling a failure of nerve, a soft white

core of fear like a slug in his stomach. Then he drew breath and, with it, new determination. The owner couldn't be dead. Monkey would never convince him of that, He simply had business elsewhere. And when he returned, he would expect to find the Shoppe as he left it. Maybe even running more smoothly, like an old Swiss watch that he had wound and left ticking. When the watchdog tightened his jaws, they creaked at the hinges, but he tightened them all the same. His eyes narrowed. No evil had visited the Shoppe from outside. He'd seen to that. None, he vowed, would destroy it from within.

But he could not be everywhere at once. The corrosion grew day by day. Cracks, then fissures began to appear, it seemed to Berkeley, everywhere, and in places where he least expected them. Puddles and pyramidal plops were scattered underfoot like traps. Bacterial flies were everywhere. Then came maggots. Hamsters gnawed at electrical cords in the storeroom. Frog fell sick with a genital infection. The fish, though the gentlest of creatures, caused undertow by demanding day-and-night protection, claiming they were handicapped in the competition for food, confined to their tanks, and besides, they were from the most ancient tree; all life came from the sea, they argued, the others owed them.

Old blood feuds between beasts erupted, too, grudges so tired you'd have thought them long buried, but not so. The Siamese began to give Berkeley funny looks, and left the room whenever he entered. Berkeley let him be, thinking he'd come to his senses. Instead, he jumped Rabbit when Berkeley wasn't looking, the product of this assault promising a new creature—a cabbit—with jackrabbit legs and long feline whiskers never seen in the Pet Shoppe before. Rabbit took this badly. In the beginning she sniffed a great deal, and with good reason—rape was a vicious thing—but her grief and pain got out of hand, and soon she was lost in it with no way out, like a child in a dark forest, and began organizing the females of every species to stop cohabiting with the males. Berkeley stood back, afraid to butt in because Rabbit said that it was none of his damned business and he was as bad as all the rest. He pleaded reason, his eyes burnt-out from sleeplessness, with puffy bags beneath them, and when that did no good, he pleaded restraint.

"The storeroom's half-empty," he told Monkey on the fifth day. "If we don't start rationing the food, we'll starve."

"There's always food."

Berkeley didn't like the sound of that. "Where?"

Smiling, Monkey swung his eyes to the fishtanks.

"Don't you go near those goldfish!"

Monkey stood at bay, his eyes tacked hatefully on Berkeley, who ground his teeth, possessed by the sudden, wild desire to bite him, but knowing, finally, that he had the upper hand in the Pet Shoppe, the power. In other words, bigger teeth. As much as he hated to admit it, his only advantage, if he hoped to hold the line, his only trump, if he truly wanted to keep them afloat, was the fact that he outweighed them all. They were afraid of him. Oddly enough, the real validity of his values and viewpoint rested, he realized, on his having the biggest paw. The thought fretted him. For all his idealism, truth was decided in the end by those who could be bloodiest in fang and claw. Yet and still, Monkey had an arrogance that made Berkeley weak in the knees.

"Dog," he said, scratching under one arm, "you got to sleep sometime."

And so Berkeley did. After hours of standing guard in the storeroom, or trying to console Rabbit, who was now talking of aborting the cabbit, begging her to reconsider, or reassuring the birds, who crowded together in one corner against, they said, threatening moves by the reptiles, or splashing various medicines on Frog, whose sickness had now spread to the iguana-after all this, Berkeley did drop fitfully to sleep by the front door. He slept greedily, dreaming of better days. He twitched and woofed in his sleep, seeing himself schtupping the little French poodle down the street, and it was good, like making love to lightning, she moved so well with him; and then of his puppyhood, when his worst problems were remembering where he'd buried food from Tilford's table, or figuring out how to sneak away from his mother, who told him all dogs had cold noses because they were late coming to the Ark and had to ride next to the rail. His dream cycled on, as all dreams do, with greater and greater clarity from one chamber of vision to the next until he saw, just before waking, the final drawer of dream-work spill open on the owner's return. Splendidly dressed, wearing a bowler hat and carrying a walking stick, sober, with a gentle smile for Berkeley (Berkeley was sure), Tilford threw open the Pet Shoppe door in a blast of wind and burst of preternatural brilliance that rayed the whole room, evaporated every shadow, and brought the squabbling, the conflict of interpretations, mutations, and internecine battles to a halt. No one dared move. They stood frozen like fish in ice, or a bird caught in the crosswinds, the colorless light behind the owner so blinding it obliterated their outlines, blurred their precious differences, as if each were a rill of the same ancient light somehow imprisoned in form, with being-formed itself the most preposterous of conditions, outrageous, when you thought it through, because it occasioned suffering, meant separation from other forms, and the illusion of identity, but even this ended like a dream within the watchdog's dream, and only he and the owner remained. Reaching down, he stroked Berkeley's head. And at last he said, like God whispering to Samuel: Well done. It was all Berkeley had ever wanted. He woofed again, snoring like a sow, and scratched in his sleep; he heard the owner whisper begun, which was a pretty strange thing for him to say, even for Tilford, even in a dream. His ears strained forward; begun, Tilford said again. And for an instant Berkeley thought he had the tense wrong, intending to say, "Now we can begin," or something prophetically appropriate like that, but suddenly he was awake, and Parrot was flapping his wings and shouting into Berkeley's ear.

"The gun," said Parrot. "Monkey has it."

Berkeley's eyes, still phlegmed by sleep, blearily panned the counter. The room was swimming, full of smoke from a fire in the storeroom. He was short of wind. And, worse, he'd forgotten about the gun, a Smith and Wesson, that Tilford had bought after pet shop owners in Seattle were struck by thieves who specialized in stealing exotic birds. Monkey had it now. Berkeley's water ran down his legs. He'd propped the pistol between the cash register and a display of plastic dog collars, and his wide, yellow grin was frighteningly like that of a general Congress had just given the go-ahead to on a scorched-earth policy.

"Get it!" said Parrot. "You promised to protect us, Berkeley!"

For a few fibrous seconds he stood trembling paw-deep in dung, the odor of decay

burning his lungs, but he couldn't come full awake, and still he felt himself to be on the fringe of a dream, his hair moist because dreaming of the French poodle had made him sweat. But the pistol . . . There was no power balance now. He'd been outplayed. No hope unless he took it away. Circling the counter, head low and growling, or trying to work up a decent growl, Berkeley crept to the cash register, his chest pounding, bunched his legs to leap, then sprang, pretending the black explosion of flame and smoke was like television gunfire, though it ripped skin right off his ribs, sent teeth flying down his throat, and blew him back like an empty pelt against Tortoise's cage. He lay still. Now he felt nothing in his legs. Purple blood like that deepest in the body cascaded to the floor from his side, rushing out with each heartbeat, and he lay twitching a little, only seeing now that he'd slept too long. Flames licked along the floor. Fish floated belly up in a dark, unplugged fishtank. The females had torn Siamese to pieces. Spackled lizards were busy sucking baby canaries from their eggs. And in the holy ruin of the Pet Shoppe the tarantula roamed free over the corpses of Frog and Iguana. Beneath him, Berkeley heard the ancient Tortoise stir, clearing a nasty throat clogged from disuse. Only he would survive the spreading fire. given his armor. His eyes burning from the smoke, the watchdog tried to explain his dream before the blaze reached them. "We could have endured, we had enough in common—for Christ's sake, we're all animals."

"Indeed," said Tortoise grimly, his eyes like headlights in a shell that echoed cavernously. "Indeed."

Suggestions for Discussion

- 1. Find several clichés. Whose clichés are they? What function do they serve in the story?
- 2. What techniques does Charles Johnson use to get us to identify with a dog as protagonist? Where is that identification qualified or limited?
- 3. "Menagerie" is in the tradition of animal allegories, but it is not a fable; no "moral" can be simply stated. How many different ways could you interpret Tilford, Berkeley, the behavior of the Monkey and the Tortoise, the Cabbit, Berkeley's dream? How through these or in other ways does Johnson render complex the comparison of a pet shop to a "federation of cultures"?
- 4. Who speaks? Why did the author choose this point of view?
- 5. Examine the deterioration of society in the pet shop. How do events escalate so that "each battle is bigger than the last"?

Retrospect

- 1. Find at least a dozen metaphors for writing in the excerpt from Annie Dillard's *The Writing Life* at the end of chapter 1. Make up half a dozen of your own that seem true to the process as you experience it.
- 2. How does Tobias Wolff use the idea "the line is endless" in "Bullet in the Brain" to build a symbol?
- 3. Consider the possibility that Gabriel García Marquez's "A Very Old Man with Enormous Wings" is an allegory of "the artist." Does such a possibility enhance or diminish the story for you?
- 4. The last paragraph of "Gryphon" by Charles Baxter describes in detail an entymology lesson that the children are given after the departure of Miss Ferenczi. What symbolical resonances can you see in this lesson?
- 5. In Sandra Cisneros's "Hips," how are hips spoken of literally, how are they used in metaphor, and how, ultimately, do they become a symbol? Of what?

Writing Assignments

- 1. Write a passage using at least three cliché metaphors, finding a way to make each fresh and original.
- 2. Take any dead metaphor and write a comic or serious scene that reinvests the metaphor with its original comparative force. Here are a few sample suggestions (your own will be better).

Sifting the evidence. (The lawyer uses a colander, a tea strainer, two coffee filters, and a garlic press to decide the case.)

Speakeasy. (Chicago, 1916. A young libertine tricks a beautiful but repressed young woman into an illegal basement bar. He thinks drink will loosen her up. What it loosens is not her sensuality but her tongue, and what she says he doesn't want to hear.)

Peck on the cheek. (Alfred Hitchcock has done this one already, perhaps?)

Bus terminal.

Advertising jingle.

Soft shoulders.

Don't spoil your lunch.

Broken home.

Good-bye.

3. Write two one-page scenes, each containing an extended metaphor or simile. In one, compare an ordinary object to something of great size or significance. In the other, compare a major thing or phenomenon to something smaller and more mundane or less intense.

- 4. Write a short scene involving a conflict between two people over an object. Let the object take on symbolic significance. It may have the same significance to the two people, or a different significance to each.
- 5. Let an object smaller than a breadbox symbolize hope, redemption, or love to the central character. Let it symbolize something else entirely to the reader.
- 6. List all the clichés you can think of to describe a pair of blue eyes. Then write a paragraph in which you find a fresh, new metaphor for blue eyes.
- 7. In an earlier piece you have written, identify a few clichés. Cut them. Replace them with concrete details or more original similes or metaphors.

10

I GOTTA USE WORDS WHEN I TALK TO YOU

Theme

- · Idea and Morality in Theme
- · How Fictional Elements Contribute to Theme
 - · Developing Theme as You Write

How does a fiction mean?

Most literature textbooks begin a discussion of theme by warning that theme is not the *message*, not the *moral*, and that the *meaning* of a piece cannot be paraphrased. Theme contains an idea but cannot be stated as an idea. It suggests a morality but offers no moral. Then what is theme, and how as a writer can you pursue that rich resonance?

First of all, theme is what a story is about. But that is not enough, because a story may be "about" a dying Samurai or a quarreling couple or two kids on a trampoline, and those would not be the themes of those stories. A story is also "about" an abstraction, and if the story is significant, that abstraction may be very large; yet thousands of stories are about love, other thousands about death, and still other thousands about both love and death, and to say this is to say little about the theme of any of them.

I think it might be useful to borrow an idea from existentialist philosophy, which asks the question: What is what is? That is, what is the nature of that which exists? We might start to understand theme if we ask the question: What about what it's about? What does the story have to say about the idea or abstraction that seems to be contained in it? What attitudes or judgments does it imply? Above all, how do the

techniques particular to fiction contribute to our experience of those ideas and attitudes in the story?

Idea and Morality in Theme

Literature is stuck with ideas in a way other arts are not. Music, paradoxically the most abstract of the arts, creates a logical structure that need make no reference to the world outside itself. It may express a mood, but it need not draw any conclusions. Shapes in painting and sculpture may suggest forms in the physical world, but they need not represent the world, and they need not contain a message. But words mean. The grammatical structure of the simplest sentence contains a concept, whatever else it may contain, so that an author who wishes to treat words solely as sound or shape may be said to make strange music or pictures but not literature.

Yet those who choose to deal in the medium of literature consistently denigrate concepts and insist on the value of the particular instance. Here is Vladimir Nabokov's advice to a reader.

.) <u>fondle details.</u> There is nothing wrong about the moonshine of generalization *after* the sunny trifles of the book have been lovingly collected. If one begins with ready-made generalization, one begins at the wrong end and travels away from the book before one has started to understand it.

Joan Didion parallels the idea in an essay on "Why I Write."

I am not a scholar. I am not in the least an intellectual, which is not to say that when I hear the word "intellectual" I reach for my gun, but only to say that I do not think in abstracts. During the years when I was an undergraduate at Berkeley I tried, with a kind of hopeless late-adolescent energy, to buy some temporary visa into the world of ideas, to forge for myself a mind that could deal with the abstract.

In short I tried to think. I failed. My attention veered inexorably back to the specific, to the tangible, to what was generally considered, by everyone I knew then and for that matter have known since, the peripheral. I would try to contemplate the Hegelian dialectic and would find myself concentrating instead on the flowering pear tree outside my window and the particular way the petals fell on the floor.

Didion takes a Socratic stance here, ironically pretending to naïveté and modesty as she equates "thinking" with "thinking in the abstract." Certainly her self-deprecation is ironic in light of the fact that she is not only a novelist but also one of the finest intellects among our contemporary essayists. But she acknowledges an assumption that's both very general and very seriously taken, that *thought* means *dealing with the abstract*, and that abstract thought is more real, central, and valid than specific concrete thought.

What both these passages suggest is that a writer of fiction approaches concepts,

abstractions, generalizations, and truths through their particular embodiments—showing, not telling. "Literature," says John Ciardi, "is never only about ideas, but about the experience of ideas." T.S. Eliot points out that the creation of this experience is itself an intellectual feat.

We talk as if thought was precise and emotion was vague. In reality there is precise emotion and there is vague emotion. To express precise emotion requires as great intellectual power as to express precise thought.

The value of the literary experience is that it allows us to judge an idea at two levels of consciousness, the rational and the emotional, simultaneously. The kind of "truth" that can be told through thematic resonance is many-faceted and can acknowledge the competing of many truths, exploring paradox and contradiction.

There is a curious prejudice built into our language that makes us speak of telling *the* truth but telling *a* lie. No one supposes that all conceivable falsehood can be wrapped up in a single statement called "the lie"; lies are manifold, varied, and specific. But truth is supposed to be absolute: the truth, the whole truth, and nothing but the truth. This is, of course, impossible nonsense, and *telling a lie* is a truer phrase then *telling the truth*. Fiction does not have to tell *the* truth, but *a* truth.

Anton Chekov wrote that "the writer of fiction should not try to solve such questions as those of God, pessimism and so forth." What is "obligatory for the artist," he said, is not "solving a problem," but "stating a problem correctly." John Keats went even further in pursuing a definition of "the impersonality of genius." "The only means of strengthening one's intellect is to make up one's mind about nothing—to let the mind be a thoroughfare for all thoughts." And he defined genius itself as negative capability, "that is when a man is capable of being in uncertainties, mysteries and doubts, without any irritable reaching after fact and reason."

A story, then, speculates on a possible truth. It is not an answer or a law but a supposition, an exploration. Every story reaches in its climax and resolution an interim solution to a specifically realized dilemma. But it offers no ultimate solution.

The contrast with the law here is relevant. Abstract reasoning works toward generalization and results in definitions, laws, and absolute judgments. Imaginative reasoning and concrete thought work toward instances and result in emotional experience, revelation, and the ability to contain life's paradoxes in tension—which may explain the notorious opposition of writers to the laws and institutions of their theme. Lawmakers struggle to define a moral position in abstract terms such that it will justly account for every instance to which it is applied. (This is why the language of law is so tedious and convoluted.) Poets and novelists continually goad them by producing instances the law does not account for and referring by implication to the principle behind and beyond the law. (This why the language of literature is so dense and compact.)

The idea that is proposed, supposed, or speculated about in a fiction may be simple and idealistic, like the notion in "Cinderella" that the good and beautiful will triumph. Or it may be profound and unprovable, like the theme in *Oedipus Rex* that man cannot escape his destiny but may be ennobled in the attempt. Or it may be de-

306

liberately paradoxical and offer no guidelines that can be used in life, as in Jane Austen's *Persuasion*, where the heroine, in order to adhere to her principles, must follow advice given on principles less sound than her own.

In any case, while exploring an idea the writer conveys an attitude toward that idea. Rust Hills puts it this way:

... coherence in the world [an author] creates is constituted of two concepts he holds, which may be in conflict: one is his world view, his sense of the way the world is; and the other is his sense of morality, the way the world ought to be.

Literature is a persuasive art, and we respond to it with the tautology of literary judgment, that a fiction is "good" if it's "good." No writer who fails to convince us of the validity of his or her vision of the world can convince us of his or her greatness. The Victorians used literature to teach piety, and the Aesthetes asserted that Victorian piety was a deadening lie. Albert Camus believed that no serious writer in the twentieth century could avoid political commitment, whereas for Joyce the true artist could be a God but must not be a preacher. Each of these stances is a moral one. Those who defend escape literature do so on the grounds that people need to escape. Those who defend hardcore pornography argue that we can't prove an uncensored press makes for moral degeneracy, whereas it can be historically demonstrated that a censored press makes for political oppression. Anarchistic, nihilistic, and antisocial literature is always touted as offering a neglected truth. I have yet to hear anyone assert that literature leads to laziness, madness, and brutality and then say that it doesn't matter.

The writer, of course, may be powerfully impelled to impose a limited vision of the world as it ought to be, and even to tie that vision to a social institution, wishing not only to persuade and convince but also to propagandize. But because the emotional force of literary persuasion is in the realization of the particular, the writer is doomed to fail. The greater the work, the more it refers us to some permanent human impulse rather than a given institutional embodiment of that impulse. Fine writing expands our scope by continually presenting a new way of seeing, a further possibility of emotional identification; it flatly refuses to become a law. I am not a Roman Catholic like Gerard Manley Hopkins and cannot be persuaded by his poetry to become one; but in a moment near despair I can drive along an Illinois street in a Chevrolet station wagon and take strength from the lines of a Jesuit in the Welsh wasteland. I am not a communist as Bertolt Brecht was and cannot be convinced by his plays to become one; but I can see the hauteur of wealth displayed on the Gulf of Mexico and recognize, from a parable of the German Marxist, the difference between a possession and a belonging.

In the human experience, emotion, logic, and judgment are inextricably mixed, and we make continual cross-references between and among them. You're just sulking. (I pass judgment on your emotion.) What do you think of this idea? (How do you judge this logic?) Why do I feel this way? (What is the logic of this emotion?) It makes no sense to be angry about it. (I pass judgment on the logic of your emotion.) Literature attempts to fuse three areas of experience organically, denying the force of none

of them, positing that no one is more real than the others. This is why I have insisted throughout this book on detail and scene (immediate felt experience), the essential abstractions conveyed therein (ideas), and the attitude implied thereby (judgment).

Not all experience reveals, but all revelation comes through experience. Books aspire to become a part of that revelatory experience, and the books that are made in the form of fiction attempt to do so by re-creating the experience of revelation.

How Fictional Elements Contribute to Theme

Whatever the idea and attitudes that underlie the theme of a story, that story will bring them into the realm of experience through its particular and unique pattern. Theme involves emotion, logic, and judgment, all three—but the pattern that forms the particular experience of that theme is made up of every element of fiction this book has discussed: the arrangement, shape, and flow of the action, as performed by the characters, realized in their details, seen in their atmosphere, from a unique point of view, through the imagery and the rhythm of the language.

This book, for example, contains at least eight stories that may be said to have "the generation gap" as a major theme: "How Far She Went," "Where Are You Going, Where Have You Been?", "Saint Marie," "Girl," "Royal Beatings," "Gryphon," "San," and (at the end of this chapter) "Ralph the Duck." It could also be argued that "The Usc of Force," "Girls at War," And "The Falling Girl" share the theme. Some of these are written from the point of view of a member of the older generation, some from the point of view of the younger. In some, conflict is resolved by bridging the gap; in others, it is not. The characters are variously poor, middle-class, rural, urban, male, female, adolescent, middle-aged, old, Asian, black, white. The imagery variously evokes food, schooling, madness, religion, gambling, sex, speed, war, death, and writing. It is in the different uses of the elements of fiction that each story makes unique what it has to say about, and what attitude it takes toward, the idea of "the generation gap."

What follows is as short a story as you are likely to encounter in print. It is spare in the extreme—almost, as its title suggests, an outline. Yet the author has contrived in this miniscule compass to direct every fictional element we have discussed toward the exploration of several large themes.

A Man Told Me the Story of His Life

GRACE PALEY

Vicente said: I wanted to be a doctor. I wanted to be a doctor with my whole heart.

I learned every bone, every organ in the body. What is it for? Why does it work?

The school said to me: Vicente, be an engineer. That would be good. You understand mathematics.

I said to the school: I want to be a doctor. I already know how the organs connect. When something goes wrong, I'll understand how to make repairs.

The school said: Vicente, you will really be an excellent engineer. You show on all the tests what a good engineer you will be. It doesn't show whether you'll be a good doctor.

I said: Oh, I long to be a doctor. I nearly cried. I was seventeen. I said: But perhaps you're right. You're the teacher. You're the principal. I know I'm young.

The school said: And besides, you're going into the army.

And then I was made a cook. I prepared food for two thousand men. Now you see me. I have a good job. I have three children. This is my wife, Consuela. Did you know I saved her life?

Look, she suffered pain. The doctor said: What is this? Are you tired? Have you had too much company? How many children? Rest overnight, then tomorrow we'll make tests.

The next morning I called the doctor. I said: She must be operated on immediately. I have looked in the book. I see where her pain is. I understand what the pressure is, where it comes from. I see clearly the organ that is making trouble.

The doctor made a test. He said: She must be operated at once. He said to me: Vicente, how did you know?

I think it would be fair to say this story is about the waste of Vicente's talent through the bad guidance of authority. I'll start by staying, then, that *waste* and *power* are its central themes. How are the elements of fiction arranged in the story to present them?

The *conflict* is between Vicente and the figures of authority he encounters: teacher, principal, army, doctor. His desire at the beginning of the story is to become a doctor (in itself a figure of authority), and this desire is thwarted by persons of increasing power. In the *crisis action* what is at stake is his wife's life. In this "last battle" he succeeds as a doctor, so that the *resolution* reveals the *irony* of his having been denied in the first place.

The story is told from the point of view of a first-person central narrator, but with an important qualification. The title, "A Man Told Me the Story of His Life," and the first two words, "Vicente said," posit a peripheral narrator reporting what Vicente said. If the story was titled "My Life" and began, "I wanted to be a doctor," Vicente might be making a public appeal, a boast of how wronged he has been. As it is, he told his story privately to the barely sketched author who now wants it known, and this leaves Vicente's modesty intact.

The modesty is underscored by the simplicity of his *speech*, a *rhythm* and word choice that suggest educational *limitations* (perhaps that English is a second language). At the same time, that simplicity helps us *identify* with Vicente morally. Clearly, if he has educational limitations, it is not for want of trying to get an education! His credibility is augmented by *understatement*, both as a youth—"But perhaps

you're right. You're the teacher."—and as a man—"I have a good job. I have three children." This apparent acceptance makes us trust him at the same time as it makes us angry on his behalf.

It's consistent with the spareness of the language that we do not have an accumulation of minute or vivid details, but the degree of *specificity* is nevertheless a clue to where to direct our sympathy. In the title Vicente is just "A Man." As soon as he speaks he becomes an individual with a name. "The school," collective and impersonal, speaks to him, but when he speaks it is to single individuals, "the teacher," "the principal," and when he speaks of his wife she is personalized as "Consuela."

Moreover, the sensory details are so arranged that they relate to each other in ways that give them *metaphoric* and *symbolic significance*. Notice, for example, how Vicente's desire to become a doctor "with my whole heart" is immediately followed by, "I learned every bone, every organ in the body." Here the factual anatomical study refers us back to the heart that is one of those organs, suggesting by implication that Vicente is somebody who knows what a heart is. He knows how things "connect."

An engineer, of course, has to know how things connect and how to make repairs. But so does a doctor, and the authority figures of the school haven't the imagination to see the connection. The army, by putting him to work in a way that involves both connections and anatomical parts, takes advantage of his by-now clear ability to order and organize things—he feeds two thousand men—but it is too late to repair the misdirection of such talents. We don't know what his job is now; it doesn't matter, it's the wrong one.

As a young man, Vicente asked, "What is it for? Why does it work?", revealing a natural fascination with the sort of question that would, of course, be asked on an anatomy test. But no such test is given, and the tests that are given are irrelevant. His wife's doctor will "make tests," but like the school authorities he knows less than Vicente does, and so asks insultingly personal questions. In fact you could say that all the authorities of the story fail the test.

This analysis, which is about two and a half times as long as the story, doesn't begin to exhaust the possibilities for interpretation, and you may disagree with any of my suggestions. But it does indicate how the techniques of characterization, plot, detail, point of view, image, and metaphor all reinforce the themes of waste and power. The story is so densely conceived and developed that it might fairly be titled "Connections," "Tests," "Repairs," "What Is It For?", or "How Did You Know?"—any one could lead us toward the themes of waste and the misguidance of authority.

Not every story is or needs to be as intensely interwoven in its elements as "A Man Told Me the Story of His Life," but the development of theme always involves such interweaving to a degree. It is a standard to work toward.

Developing Theme as You Write

In an essay, your goal is to say as clearly and directly as possible what you mean. In fiction, your goal is to make people and make them do things, and, ideally, never to "say what you mean" at all. Theoretically, an outline can never harm an essay: This is what I have to say, and I'll say it through points A, B, and C. But if a writer sets

310

out to write a story to illustrate an idea, the fiction will almost inevitably be thin. Even if you begin with an outline, as many writers do, it will be an outline of the action and not of your "points." You may not know the meaning of the story until the characters begin to tell you what it is. You'll begin with an image of a person or a situation that seems vaguely to embody something important, and you'll learn as you go what that something is. Likewise, what you mean will emerge in the reading experience and take place in the reader's mind, "not," as the narrator says of Marlow's tales in *Heart of Darkness*, "inside like a kernel but outside, enveloping the tale which brought it out."

But at some point in the writing process, you may find yourself impelled by, under pressure of, or interested primarily in your theme. It will seem that you have set yourself this lonely, austere, and tortuous task because you do have something to say. At this point you will, and you should, begin to let that sorting-comparing-cataloging neocortex of your brain go to work on the stuff of your story. John Gardner describes the process in *The Art of Fiction*.

Theme, it should be noticed, is not imposed on the story but evoked from within it—initially an intuitive but finally an intellectual act on the part of the writer. The writer muses on the story idea to determine what it is in it that has attracted him, why it seems to him worth telling. Having determined . . . what interests him—and what chiefly concerns the major character . . . he toys with various ways of telling his story, thinks about what has been said before about (his theme), broods on every image that occurs to him, turning it over and over, puzzling it, hunting for connections, trying to figure out—before he writes, while he writes, and in the process of repeated revisions—what it is he really thinks. . . . Only when he thinks out a story in this way does he achieve not just an alternative reality or, loosely, an imitation of nature, but true, firm art—fiction as serious thought.

This process—worrying a fiction until its theme reveals itself, connections occur, images recur, a pattern emerges—is more conscious than readers know, beginning writers want to accept, or established writers are willing to admit. It has become a popular—cliché—stance for modern writers to claim that they haven't the faintest idea what they meant in their writing. Don't ask me; read the book. If I knew what it meant, I wouldn't have written it. It means what it says. When an author makes such a response, it is well to remember that an author is a professional liar. What he or she means is not that there are no themes, ideas, or meanings in the work but that these are not separable from the pattern of fictional experience in which they are embodied. It also means that, having done the difficult writerly job, the writer is now unwilling also to do the critic's work. But beginning critics also resist. Students irritated by the analysis of literature often ask, "How do you know she did that on purpose? How do you know it didn't just happen to come out that way?" The answer is that you don't. But what is on the page is on the page. An author no less than a reader or critic can see an emerging pattern, and the author has both the possibility

and the obligation of manipulating it. When you have put something on the page, you have two possibilities, and only two: You may cut it or you are committed to it. Gail Godwin asks:

But what about the other truths you lost by telling it that way?

Ah, my friend, this is my question too. The choice is always a killing one.

One option must die so that another may live. I do little murders in my workroom every day.

Often the choice to commit yourself to a phrase, an image, a line of dialogue will reveal, in a minor convulsion of understanding, what you mean. I have written no story or novel in which this did not occur in trivial or dramatic ways. I once sat bolt upright at 4:00 A.M. in a strange town with the realization that my sixty-year-old narrator, in a novel full of images of hands and manipulation, had been lying to me for two hundred pages. Sometimes the realistic objects or actions of a work will begin to take on metaphoric or symbolic associations with your theme, producing a crossing of references, or what Richmond Lattimore calls a "symbol complex." In a novel about a woman who traveled around the world, I employed images of dangerous water and the danger of losing balance, both physically and mentally. At some point I came up with—or, as it felt, was given—the image of a canal, the lock in which water finds its balance. This unforeseen connection gave me the purest moment of pleasure I had in writing that book. Yet I dare say no reader could identify it as a moment of particular intensity; nor, I hope, would any reader be consciously aware that the themes of danger and balance joined there.

Jane Austen once wrote to her sister that the theme of her novel *Mansfield Park* was "ordination." In the two hundred years since that letter, critics have written many times the number of words in the novel trying to explain what she meant. And yet the novel is well-understood, forcefully experienced, and intelligently appreciated. The difficulty is not in understanding the book but in applying the "kernel" definition to its multiplicity of ideas and richness of theme.

The fusion of elements into a unified pattern is the nature of creativity, a word devalued in latter years to the extent that it has come to mean a random gush of self-expression. God, perhaps, created out of the void; but in the world as we know it, all creativity, from the sprouting of an onion to the painting of *Guernica*, is a matter of selection and arrangement. A child learns to draw one circle on top of another, to add two triangles at the top and a line at the bottom, and in this particular pattern of circles, triangles, and lines has made a creature of an altogether different nature: a cat! The child draws one square on top of another and connects the corners and has made three dimensions where there are only two. And although these are tricks that can be taught and learned, they partake of the essential nature of creativity, in which several elements are joined to produce not merely a whole that is greater than the sum of its parts, but a whole that is something altogether other. At the conception of an embryo or a short story, there occurs a conjunction of two unlike things, whether cells or ideas, that have never been joined before. Around this conjunction

other cells, other ideas accumulate in a deliberate pattern. That pattern is the unique personality of the creature, and if the pattern does not cohere, it miscarries or is stillborn.

The organic unity of a work of literature cannot be taught—or, if it can, I have not discovered a way to teach it. I can suggest from time to time that concrete image is not separate from character, which is revealed in dialogue and point of view, which may be illuminated by simile, which may reveal theme, which is contained in plot as water is contained in an apple. But I cannot tell you how to achieve this; nor, if you achieve it, will you be able to explain very clearly how you have done so. Analysis separates in order to focus; it assumes that an understanding of the parts contributes to an understanding of the whole, but it does not produce the whole. Scientists can determine with minute accuracy the elements, in their proportions, contained in a piece of human skin. They can gather these elements, stir and warm them, but the result will not be skin. A good critic can show you where a metaphor does or does not illuminate character, where the character does or does not ring true in an action. But the critic cannot tell you how to make a character breathe; the breath is talent and can be neither explained nor produced.

No one can tell you what to mean, and no one can tell you how. I am conscious of having avoided the phrase *creative writing* in these pages, largely because all of us who teach creative writing find the words sticking in our throats. I myself would like to see courses taught in creative algebra, creative business administration, creative nursing, and creative history. (I once taught an advanced workshop in destructive writing—polemic, invective, libel, gratuitous violence, pornography, propaganda—in which students trying forms of writing they are supposed to avoid proved as creative as any group I ever encountered.) The mystique and the false glamour of the writing profession grow partly out of a mistaken belief that people who can express profound ideas and emotions have ideas and emotions more profound than the rest of us. It isn't so. The ability to express is a special gift with a special craft to support it and is spread fairly equally among the profound, the shallow, and the mediocre.

All the same, I am abashedly conscious that the creative exists—in algebra and nursing as in words—and that it mysteriously surfaces in the trivia of human existence: numbers, bandages, words. In the unified pattern of a fiction there is even something to which the name of magic may be given, where one empty word is placed upon another and tapped with a third, and a flaming scarf or a long-eared hope is pulled out of the tall black heart. The most magical thing about this magic is that once the trick is explained, it is not explained, and the better you understand how it works, the better it will work again.

Birth, death, work, and love continue to occur. Their meanings change from time to time and place to place, and new meanings engender new forms, which capture and create new meanings until they tire, while birth, death, work, and love continue to recur. Something to which we give the name of "honor" seems to persist, though in one place and time it is embodied in choosing to die for your country, in another, choosing not to. A notion of "progress" survives, though it is expressed now in technology, now in ecology, now in the survival of the fittest, now in the protection of

the weak. There seems to be something corresponding to the human invention of "love," though it takes its form now in tenacious loyalty, now in letting go.

Ideas are not new, but the form in which they are expressed is constantly renewed, and new forms give life to what used to be called (in the old form) the eternal verities. An innovative writer tries to forge, and those who follow try to perfect, forms that so fuse with meaning that form itself expresses.

Ralph the Duck

FREDERICK BUSCH

I woke up at 5:25 because the dog was vomiting. I carried seventy-five pounds of heaving golden retriever to the door and poured him onto the silver, moonlit snow. "Good boy," I said because he'd done his only trick. Outside he retched, and I went back up, passing the sofa on which Fanny lay. I tiptoed with enough weight on my toes to let her know how considerate I was while she was deserting me. She blinked her eyes. I swear I heard her blink her eyes. Whenever I tell her that I hear her blink her eyes, she tells me I'm lying; but I can hear the damp slap of lash after I have made her weep.

In bed and warm again, noting the red digital numbers (5:29) and certain that I wouldn't sleep, I didn't. I read a book about men who kill each other for pay or for their honor. I forget which, and so did they. It was 5:45, the alarm would buzz at 6:00, and I would make a pot of coffee and start the wood stove; I would call Fanny and pour her coffee into her mug; I would apologize because I always did, and then she would forgive me if I hadn't been too awful— I didn't think I'd been that bad—and we would stagger through the day, exhausted but pretty sure we were all right, and we'd sleep that night, probably after sex, and then we'd awaken in the same bed to the alarm at 6:00, or the dog, if he returned to the frozen deer carcass he'd been eating in the forest on our land. He loved what made him sick. The alarm went off, I got into jeans and woolen socks and a sweatshirt, and I went downstairs to let the dog in. He'd be hungry, or course.

I was the oldest college student in America, I thought. But of course I wasn't. There were always ancient women with their parchment for skin who graduated at seventy-nine from places like Barnard and the University of Georgia. I was only forty-two, and I hardly qualified as a student. I patrolled the college at night in a Bronco with a leaky exhaust system, and I went from room to room in the classroom buildings, kicking out students who were studying or humping in chairs—they'd do it anywhere—and answering emergency calls with my little blue light winking on top of the truck. I didn't carry a gun or a billy, but I had a flashlight that took six batteries and I'd used it twice on some of my overprivileged northeastern-playboy part-time classmates. On Tuesdays and Thursdays I would awaken at 6:00 with my wife,

and I'd do my homework, and work around the house, and go to school at 11:30 to sit there for an hour and a half while thirty-five stomachs growled with hunger and boredom, and this guy gave instruction about books. Because I was on the staff, the college let me take a course for nothing every term. I was getting educated, in a kind of slow-motion way—it would have taken me something like fifteen or sixteen years to graduate, and I would no doubt get an F in gym and have to repeat—and there were times when I respected myself for it. Fanny often did, and that was fair incentive.

I am not unintelligent. You are not an unintelligent writer, my professor wrote on my paper about Nathaniel Hawthorne. We had to read short stories, I and the other students, and then we had to write little essays about them. I told how I saw Kafka and Hawthorne in similar light, and I was not unintelligent, he said. He ran into me at dusk one time, when I answered a call about a dead battery and found out it was him. I jumped his Buick from the Bronco's battery, and he was looking me over, I could tell, while I clamped onto the terminals and cranked it up. He was a tall, handsome guy who never wore a suit. He wore khakis and sweaters, loafers or sneaks, and he was always talking to the female students with the brightest hair and best builds. But he couldn't get a Buick going on an ice-cold night, and he didn't know enough to look for cells going bad. I told him he was going to need a new battery and he looked me over the way men sometimes do with other men who fix their cars for them.

"Vietnam?"

I said, "Too old."

"Not at the beginning. Not if you were an adviser. So-called. Or one of the Phoenix Project fellas?"

I was wearing a watch cap made of navy wool and an old Marine fatigue jacket. Slick characters like my professor like it if you're a killer or at least a onetime middleweight fighter. I smiled like I knew something. "Take it easy," I said, and I went back to the truck to swing around the cemetery at the top of the campus. They'd been known to screw in down-filled sleeping bags on horizontal stones up there, and the dean of students didn't want anybody dying of frostbite while joined at the hip to a matriculating fellow resident of our northeastern camp for the overindulged.

He blinked his high beams at me as I went. "You are not an unintelligent driver," I said.

Fanny had left me a bowl of something with sausages and sauerkraut and potatoes, and the dog hadn't eaten too much more than his fair share. He watched me eat his leftovers and then make myself a king-sized drink composed of sourmash whiskey and ice. In our back room, which is on the northern end of the house, and cold for sitting in that close to dawn, I saw and watched the texture of the sky change. It was going to snow, and I wanted to see the storm come up the valley. I woke up that way, sitting in the rocker with its loose right arm, holding a watery drink, and thinking right away of the girl I'd convinced to go back inside. She'd been standing outside her dormitory, looking up at a window that was dark in the midst of all those lighted panes—they never turned a light off, and often left the faucets run half the night—

crying onto her bathrobe. She was barefoot in shoe-pacs, the brown ones so many of them wore unlaced, and for all I know she was naked under the robe. She was beautiful, I thought, and she was somebody's red-headed daughter, standing in a quadrangle how many miles from home weeping.

"He doesn't love anyone," the kid told me. "He doesn't love his wife—I mean his ex-wife. And he doesn't love the ex-wife before that, or the one before that. And you know what? He doesn't love me. I don't know anyone who *does*!"

"It isn't your fault if he isn't smart enough to love you," I said, steering her toward the truck.

She stopped. She turned. "You know him?"

I couldn't help it. I hugged her hard, and she let me, and then she stepped back, and of course I let her go. "Don't you *touch* me! Is this sexual harassment? Do you know the rules? Isn't this sexual harassment?"

"I'm sorry," I said at the door to the truck. "But I think I have to be able to give you a grade before it counts as harassment."

She got in. I told her we were driving to the dean of students' house. She smelled like marijuana and something very sweet, maybe one of those coffee-with-cream liqueurs you don't buy unless you hate to drink.

As the heat of the truck struck her, she started going kind of clay-gray-green, and I reached across her to open the window.

"You touched my breast!" she said.

"It's the smallest one I've touched all night, I'm afraid."

She leaned out the window and gave her rendition of my dog.

But in my rocker, waking up, at whatever time in the morning in my silent house, I thought of her as someone's child. Which made me think of ours, of course. I went for more ice, and I started on a wet breakfast. At the door of the dean of students' house, she'd turned her chalky face to me and asked, "What grade would you give me, then?"

It was a week composed of two teachers locked out of their offices late at night, a Toyota with a flat and no spare, an attempted rape on a senior girl walking home from the library, a major fight outside a fraternity house (broken wrist and significant concussion), and variations on breaking-and-entering. I was scolded by the director of nonacademic services for embracing a student who was drunk; I told him to keep his job, but he called me back because I was right to hug her, he said, and also wrong, but what the hell, and would I please stay. I thought of the fringe benefits—graduation in only sixteen years—so I went back to work.

My professor assigned a story called "A Rose for Emily," and I wrote him a paper about the mechanics of corpse fucking, and how, since she clearly couldn't screw her dead boyfriend, she was keeping his rotten body in bed because she truly loved him. I called the paper "True Love." He gave me a B and wrote See me, pls. In his office after class, his feet up on his desk, he trimmed a cigar with a giant folding knife he kept in his drawer.

"You got to clean the hole out," he said, "or they don't draw."

"I don't smoke," I said.

"Bad habit. Real *habit*, though. I started in smoking 'em in Georgia, in the service. My C.O. smoked 'em. We collaborated on a brothel inspection one time, and we ended up smoking these with a couple of women." He waggled his eyebrows at me, now that his malehood was established.

"Were the women smoking them too?"

He snorted laughter through his nose while the greasy smoke came curling off his thin, dry lips. "They were pretty smoky, I'll tell ya!" Then he propped his feet—he was wearing cowboy boots that day—and he sat forward. "It's a little hard to explain. But—hell. You just don't say *fuck* when you write an essay for a college prof. Okay!" Like a scoutmaster with a kid he'd caught in the outhouse jerking off: "All right? You don't wanna do that."

"Did it shock you?"

"Fuck, no, it didn't shock me. I just told you. It violates certain proprieties."

"But if I'm writing it to you, like a letter—"

"You're writing it for posterity. For some mythical reader someplace, not just me. You're making a *statement*."

"Right. My statement said how hard it must be for a woman to fuck with a corpse."

"And a point worth making. I said so. Here."

"But you said I shouldn't say it."

"No. Listen. Just because you're taking about fucking, you don't have to say *fuck*. Does that make it any clearer?"

"No."

"I wish you'd lied to me just now," he said.

I nodded. I did too.

"Where'd you do your service?" he asked.

"Baltimore, Baltimore, Maryland."

"What's in Baltimore?"

"Railroads. I liaised on freight runs of army matériel. I killed a couple of bums on the rod with my bare hands, though."

He snorted again, but I could see how disappointed he was. He'd been banking on my having been a murderer. Interesting guy in one of my classes, he must have told some terrific woman at an overpriced meal: I just *know* the guy was a rubout specialist in the Nam, he had to have said. I figured I should come to work wearing my fatigue jacket and a red bandana tied around my head. Say "Man" to him a couple of times, hang a fist in the air for grief and solidarity, and look terribly worn, exhausted by experiences he was fairly certain that he envied me. His dungarees were ironed, I noticed.

On Saturday we went back to the campus because Fanny wanted to see a movie called *The Seven Samurai*. I fell asleep, and I'm afraid I snored. She let me sleep until the auditorium was almost empty. Then she kissed me awake. "Who was screaming in my dream?" I asked her.

"Kurosawa," she said.

"Who?"

"Ask your professor friend."

I looked around, but he wasn't there. "Not an un-weird man," I said.

We went home and cleaned up after the dog and put him out. We drank a little Spanish brandy and went upstairs and made love. I was fairly premature, you might say, but one way and another by the time we fell asleep we were glad to be there with each other, and glad that it was Sunday coming up the valley toward us, and nobody with it. The dog was howling at another dog someplace, or at the moon, or maybe just his moon-thrown shadow on the snow. I did not strangle him when I opened the back door and he limped happily past me and stumbled up the stairs. I followed him into our bedroom and groaned for just being satisfied as I got into bed. You'll notice I didn't say fuck.

He stopped me in the hall after class on a Thursday, and asked me How's it goin, just one of the kickers drinking sour beer and eating pickled eggs and watching the tube in a country bar. How's it goin. I nodded. I wanted a grade from the man, and I did want to learn about expressing myself. I nodded and made what I thought was a smile. He'd let his mustache grow out and his hair grow longer. He was starting to wear dark shirts with lighter tics. I thought he looked like someone in *The Godfather*. He still wore those light little loafers or his high-heeled cowboy boots. His corduroy pants looked baggy. I guess he wanted them to look that way. He motioned me to the wall of the hallway, and he looked and said, "How about the Baltimore stuff?"

I said, "Yeah?"

"Was that really true?" He was almost blinking, he wanted so much for me to be a damaged Vietnam vet just looking for a bell tower to climb into and start firing from. The college didn't have a bell tower you could get up into, though I'd once spent an ugly hour chasing a drunken ATO down from the roof of the observatory. "You were just clocking through boxcars in Baltimore!"

I said, "Nah."

"I thought so!" He gave a kind of sigh.

"I killed people," I said.

"You know, I could have sworn you did," he said.

I nodded, and he nodded back. I'd made him so happy.

The assignment was to write something to influence somebody. He called it Rhetoric and Persuasion. We read an essay by George Orwell and "A Modest Proposal" by Jonathan Swift. I liked the Orwell better, but I wasn't comfortable with it. He talked about "niggers," and I felt him saying it two ways.

I wrote "Ralph the Duck."

Once upon a time, there was a duck named Ralph who didn't have any feathers on either wing. So when the cold wind blew, Ralph said, Brr, and shivered and shook.

What's the matter? Ralph's mommy asked.

I'm cold, Ralph said.

Oh, the mommy said. Here. I'll keep you warm.

So she spread her big, feathery wings, and hugged Ralph tight, and when the cold wind blew, Ralph was warm and snuggly, and fell fast asleep.

The next Thursday, he was wearing canvas pants and hiking boots. He mentioned kind of casually to some of the girls in the class how whenever there was a storm he wore his Lake District walking outfit. He had a big, hairy sweater on. I kept waiting for him to make a noise like a mountain goat. But the girls seemed to like it. His boots made a creaky squeak on the linoleum of the hall when he caught up with me after class.

"As I told you," he said, "it isn't unappealing. It's just—not a college theme."

"Right," I said. "Okay. You want me to do it over?"

"No," he said. "Not at all. The D will remain your grade. But I'll read something else if you want to write it."

"This'll be fine," I said.

"Did you understand the assignment?"

"Write something to influence someone—Rhetoric and Persuasion."

We were at his office door and the redheaded kid who had gotten sick in my truck was waiting for him. She looked at me like one of us was in the wrong place, which struck me as accurate enough. He was interested in getting into his office with the redhead, but he remembered to turn around and flash me a grin he seemed to think he was known for.

Instead of going on shift a few hours after class, the way I'm supposed to, I told my supervisor I was sick, and I went home. Fanny was frightened when I came in, because I don't get sick and I don't miss work. She looked at my face and she grew sad. I kissed her hello and went upstairs to change. I always used to change my clothes when I was a kid, as soon as I came home from school. I put on jeans and a flannel shirt and thick wool socks, and I made myself a dark drink of sourmash. Fanny poured herself some wine and came into the cold northern room a few minutes later. I was sitting in the rocker, looking over the valley. The wind was lining up a lot of rows of cloud so that the sky looked like a baked trout when you lift the skin off. "It'll snow," I said to her.

She sat on the old sofa and waited. After a while, she said, "I wonder why they always call it a mackerel sky?"

"Good eating, mackerel," I said.

Fanny said, "Shit! You're never that laconic unless you feel crazy. What's wrong? Who'd you punch out at the playground?"

"We had to write a composition," I said.

"Did he like it?"

"He gave me a D."

"Well, you're familiar enough with D's. I never saw you get this low over a grade."

"I wrote about Ralph the Duck."

She said, "You did?" She said, "Honey." She came over and stood beside the rocker and leaned into me and hugged my head and neck. "Honey," she said. "Honey."

It was the worst of the winter's storms, and one of the worst in years. That afternoon they closed the college, which they almost never do. But the roads were jammed with snow over ice, and now it was freezing rain on top of that, and the only people working at the school that night were the operator who took emergency calls and me. Everyone else had gone home except the students, and most of them were inside. The ones who weren't were drunk, and I kept on sending them in and telling them to act like grown-ups. A number of them said they were, and I really couldn't argue. I had the bright beams on, the defroster set high, the little blue light winking, and a thermos of sourmash and hot coffee that I sipped from every time I had to get out of the truck or every time I realized how cold all that wetness was out there.

About eight o'clock, as the rain was turning back to snow and the cold was worse, the roads impossible, just as I was done helping a country sander on the edge of the campus pull a panel truck out of a snowbank, I got the emergency call from the college operator. We had a student missing. The roommates thought the kid was heading for the quarry. This meant I had to get the Bronco up on a narrow road above the campus, above the old cemetery, into all kinds of woods and rough track that I figured would be choked with ice and snow. Any kid up there would really have to want to be there, and I couldn't go in on foot, because you'd only want to be there on account of drugs, booze, or craziness, and either way I'd be needing blankets and heat, and then a fast ride down to the hospital in town. So I dropped into four-wheel drive to get me up the hill above the campus, bucking snow and sliding on ice, putting all the heater's warmth up onto the windshield because I couldn't see much more than swarming snow. My feet were still cold from the tow job, and it didn't seem to matter that I had on heavy socks and insulated boots I'd coated with water-proofing. I shivered, and I thought of Ralph the Duck.

I had to grind the rest of the way, from the cemetery, in four-wheel low, and in spite of the cold I was smoking my gearbox by the time I was close enough to the quarry—they really did take a lot of rocks for the campus buildings from there—to see I'd have to make my way on foot to where she was. It was a kind of scooped-out shape, maybe four or five stories high, where she stood—well, wobbled is more like it. She was as chalky as she'd been the last time, and her red hair didn't catch the light anymore. It just lay on her like something that had died on top of her head. She was in a white nightgown that was plastered to her body. She had her arms crossed as if she wanted to be warm. She swayed, kind of, in front of the big, dark, scooped-out rock face, where the trees and brush had been cleared for trucks and earthmovers. She looked tiny against all the darkness. From where I stood, I could see the snow driving down in front of the lights I'd left on, but I couldn't see it near her. All it looked like around her was dark. She was shaking with the cold, and she was crying.

I had a blanket with me, and I shoved it down the front of my coat to keep it dry for her, and because I was so cold. I waved. I stood in the lights and I waved. I don't know what she saw—a big shadow, maybe. I surely didn't reassure her, because when she saw me she backed up, until she was near the face of the quarry. She couldn't go any farther.

I called, "Hello! I brought a blanket. Are you cold? I thought you might want a blanket."

Her roommates had told the operator about pills, so I didn't bring her the coffee laced with mash. I figured I didn't have all that much time, anyway, to get her down

and pumped out. The booze with whatever pills she'd taken would make her die that much faster.

I hated that word. Die. It made me furious with her. I heard myself seething when I breathed. I pulled my scarf and collar up above my mouth. I didn't want her to see how close I might come to wanting to kill her because she wanted to die.

I called, "Remember me?"

I was closer now. I could see the purple mottling of her skin. I didn't know if it was cold or dying. It probably didn't matter much to distinguish between them right now, I thought. That made me smile. I felt the smile, and I pulled the scarf down so she could look at it. She didn't seem awfully reassured.

"You're the sexual harassment guy," she said. She said it very slowly. Her lips were clumsy. It was like looking at a ventriloquist's dummy.

"I gave you an A," I said.

"When?"

"It's a joke," I said. "You don't want me making jokes. You want me to give you a nice warm blanket, though. And then you want me to take you home."

She leaned against the rock face when I approached. I pulled the blanket out, then zipped my jacket back up. The snow had stopped, I realized, and that wasn't really a very good sign. It felt like an arctic cold descending in its place. I held the blanket out to her, but she only looked at it.

"You'll just have to turn me in," I said. "I'm gonna hug you again."

She screamed, "No more! I don't want any more hugs!"

But she kept her arms on her chest, and I wrapped the blanket around her and stuffed a piece into each of her tight, small fists. I didn't know what to do for her feet. Finally, I got down on my haunches in front of her. She crouched down too, protecting herself.

"No," I said. "No, You're fine."

I took off the woolen mittens I'd been wearing. Mittens keep you warmer than gloves because they trap your hand's heat around the fingers and palms at once. Fanny had knitted them for me. I put a mitten as far onto each of her feet as I could. She let me. She was going to collapse, I thought.

"Now, let's go home," I said. "Let's get you better."

With her funny, stiff lips, she said, "I've been very self-indulgent and weird and I'm sorry. But I'd really like to die." She sounded so reasonable that I found myself nodding in agreement as she spoke.

"You can't just die," I said.

"Aren't I dying already? I took all of them," and then she giggled like a child, which of course is what she was. "I borrowed different ones from other people's rooms. See, this isn't some teenage cry for like help. Understand? I'm seriously interested in death and I have to like stay out here a little longer and fall asleep. All right?

"You can't do that," I said. "You ever hear of Vietnam?"

"I saw that movie," she said. "With the opera in it? Apocalypse? Whatever."

"I was there!" I said. "I killed people! I helped to kill them! And when they die, you see their bones later on. You dream about their bones and blood on the ends of

the splintered ones, and this kind of mucous stuff coming out of their eyes. You probably heard of guys having dreams like that, didn't you? Whacked-out Vietnam vers? That's me, see? So I'm telling you, I know about dead people and their eyeballs and everything falling out. And people keep dreaming about the dead people they knew, see? You can't make people dream about you like that! It isn't fair!"

"You dream about me?" She was ready to go. She was ready to fall down, and I was

going to lift her up and get her to the truck.

"I will," I said. "If you die."

"I want you to," she said. Her lips were hardly moving now. Her eyes were closed.

"I want you all to."

I dropped my shoulder and put it into her waist and picked her up and carried her down to the Bronco. She was talking, but not a lot, and her voice leaked down my back. I jammed her into the truck and wrapped the blanket around her better and then put another one down around her feet. I strapped her in with the seat belt. She was shaking, and her eyes were closed and her mouth open. She was breathing. I checked that twice, once when I strapped her in, and then again when I strapped myself in and backed hard into a sapling and took it down. I got us into first gear, held the clutch in, leaned over to listen for breathing, heard it—shallow panting, like a kid asleep on your lap for a nap—and then I put the gear in and howled down the hillside on what I thought might be the road.

We passed the cemetery. I told her that was a good sign. She didn't respond. I found myself panting too, as if we were breathing for each other. It made me dizzy, but I couldn't stop. We passed the highest dorm, and I dropped the truck into four-wheel high. The cab smelled like burnt oil and hot metal. We were past the chapel now, and the observatory, the president's house, then the bookstore. I had the blue light winking and the V-6 roaring, and I drove on the edge of out-of-control, sensing the skids just before I slid into them, and getting back out of them as I needed to. I took a little fender off once, and a bit of the corner of a classroom building, but I worked us back on course, and all I needed to do now was negotiate the sharp left turn around the Administration Building past the library, then floor it for the straight run to the town's main street and then the hospital.

I was panting into the mike, and the operator kept saying, "Say again?"

I made myself slow down some, and I said we'd need stomach pumping, and to get the names of the pills from her friends in the dorm, and I'd be there in less than five or we were crumpled up someplace and dead.

"Roger," the radio said. "Roger all that." My throat tightened and tears came into

my eyes. They were helping us, they'd told me: Roger.

I said to the girl, whose head was slumped and whose face looked too blue all through its whiteness, "You know, I had a girl once. My wife, Fanny. She and I had a small girl one time."

I reached over and touched her cheek. It was cold. The truck swerved, and I got my hands on the wheel. I'd made the turn past the Ad Building using just my left. "I can do it in the dark," I sang to no tune I'd ever learned. "I can do it with one hand." I said to her, "We had a girl child, very small. Now, I do not want you dying."

I came to the campus gates doing fifty on the ice and snow, smoking the engine,

grinding the clutch, and I bounced off a wrought iron fence to give me the curve going left that I needed. On a pool table, it would have been a bank shot worth applause. The town cop picked me up and got out ahead of me and let the street have all the lights and noise I could want. We banged up to the emergency room entrance and I was out and at the other door before the cop on duty, Elmo St. John, could loosen his seat belt. I loosened hers, and I carried her into the lobby of the ER. They had a gurney, and doctors, and they took her away from me. I tried to talk to them, but they made me sit down and do my shaking on a dirty sofa decorated with drawings of little spinning wheels. Somebody brought me hot coffee, I think it was Elmo, but I couldn't hold it.

"They won't," he kept saying to me. "They won't."

"What?"

"You just been sitting there for a minute and a half like St. Vitus dancing, telling me, Don't let her die. Don't her her die."

"Oh."

"You all right?"

"How about the kid?"

"They'll tell us soon."

"She better be all right."

"That's right."

"She—somebody's gonna have to tell me plenty if she isn't."

"That's right."

"She better not die this time," I guess I said.

Fanny came downstairs to look for me. I was at the northern windows, looking through the mullions down the valley to the faint red line along the mounds and little peaks of the ridge beyond the valley. The sun was going to come up, and I was looking for it.

Fanny stood behind me. I could hear her. I could smell her hair and the sleep on her. The crimson line widened, and I squinted at it. I heard the dog limp in behind her, catching up. He panted and I knew why his panting sounded familiar. She put her hands on my shoulders and arms. I made muscles to impress her with, and then I let them go, and let my head drop down until my chin was on my chest.

"I didn't think you'd be able to sleep after that," Fanny said.

"I brought enough adrenaline home to run a football team."

"But you hate being a hero, huh? You're hiding in here because somebody's going to call, or come over, and want to talk to you—her parents for shooting sure, sooner or later. Or is that supposed to be part of the service up at the playground? Saving their suicidal daughters. Almost dying to find them in the woods and driving too fast for *any* weather, much less what we had last night. Getting their babies home. The bastards." She was crying. I knew she would be, sooner or later. I could hear the soft sound of her lashes. She sniffed and I could feel her arm move as she felt for the tissues on the coffee table.

"I have them over here," I said. "On the windowsill."

"Yes." She blew her nose, and the dog thumped his tail. He seemed to think it one of Fanny's finer tricks, and he had wagged for her for thirteen years whenever she'd done it. "Well, you're going to have to talk to them."

"I will," I said. "I will." the sun was in our sky now, climbing. We had built the room so we could watch it climb. "I think that jackass with the smile, my prof? She showed up a lot at his office, the last few weeks. He called her 'my advisee,' you know? The way those guys sound about what they're achieving by getting up and shaving and going to work and saying the same thing every day? Every year? Well, she was his advisee, I bet. He was shoving home the old advice."

"She'll be okay," Fanny said. "Her parents will take her home and love her up and get her some help." She began to cry again, then she stopped. She blew her nose, and the dog's tail thumped. She kept a hand between my shoulder and my neck. "So tell me what you'll tell a waiting world. How'd you talk her out?"

"Well, I didn't, really. I got up close and picked her up and carried her is all."

"You didn't say anything?"

"Sure I did. Kid's standing in the snow outside of a lot of pills, you're gonna say something."

"So what'd you say?"

"I told her stories," I said. "I did Rhetoric and Persuasion."

Fanny said, "Then you go in early on Thursday, you go in half an hour early, and you get that guy to jack up your grade."

Suggestions for Discussion

- 1. What is "Ralph the Duck" about? How does the author use each of the following to say something about what it's about: action, dialogue, setting, thought, concrete detail, metaphor?
- 2. Consider the following in their relation to the theme of "Ralph the Duck"; how does each contribute: "He loved what made him sick" (page 313); not unintelligent; grades; "and I did want to learn about expressing myself" (page 317); sexual harassment; Rhetoric and Persuasion?
- 3. What does Ralph the Duck symbolize to the narrator and his wife? Does it operate differently as a symbol in the story? How does this contribute to theme?
- 4. Find moments in the story that moved you and try to analyze why they were effective. What emotions are expressed in those moments, what ideas are inherent, what judgments are implied?
- 5. Compare some successful effect in "Ralph the Duck" with a similar effect in another story in this book. Are the techniques also similar? Have the authors made comparable choices in detail, dialogue, irony, diction, action?

Ad Infinitum: A Short Story

JOHN BARTH

At the far end of their lawn, down by the large pond or small marshy lake, he is at work in "his" daylily garden—weeding, feeding, clearing out dead growth to make room for new—when the ring of the telephone bell begins this story. They spend so much of their day outdoors, in the season, that years ago they installed an outside phone bell under the porch roof overhang. As a rule, they bring a cordless phone out with them, too, onto the sundeck or the patio, where they can usually reach it before the answering machine takes over. It is too early in the season, however, for them to have resumed that convenient habit. Anyhow, this is a weekday midmorning; she's indoors still, in her studio. She'll take the call.

The telephone rings a second time, but not a third. On his knees in the daylily garden, he has paused, trowel in hand, and straightened his back. He returns to his homely work, which he always finds mildly agreeable but now suddenly relishes: simple physical work with clean soil in fine air and sunlight. The call could be routine: some bit of business, some service person. In the season, he's the one who normally takes weekday morning calls, not to interrupt her concentration in the studio; but it's not quite the season yet. The caller could be a friend—although their friends generally don't call them before noon. It could be a telephone solicitor: There seem to be more of those every year, enough to lead them to consider unlisting their number, but not quite yet to unlist it. It could be a misdial.

If presently she steps out onto the sundeck, looking for him, whether to bring him the cordless phone if the call is for him or to report some news, this story's beginning will have ended, its middle begun.

Presently she steps out onto the sundeck, overlooking their lawn and the large pond or small lake beyond it. She had been at her big old drafting-table, working—trying to work, anyhow; pretending to work; maybe actually almost really working—when the phone call began this story. From her upholstered swivel chair, through one of the water-facing windows of her studio, she could see him on hands and knees down in his daylily garden along the water's edge. Indeed, she had been more or less watching him, preoccupied in his old jeans and sweatshirt and gardening gloves, while she worked or tried or pretended to work at her worktable. At the first ring, she saw him straighten his back and square his shoulders, his trowel-hand resting on his thigh-top, and at the second (which she had waited for before picking up the receiver) look houseward and remove one glove. At the non-third ring, as she said hello to the caller, he pushed back his eyeglasses with his ungloved hand. She had continued then to watch him—returning to his task, his left hand still ungloved for picking out the weeds troweled up with his right—as she received the caller's news.

The news is bad indeed. Not quite so bad, perhaps, as her very-worst-case scenario, but considerably worse than her average-feared scenarios, and enormously

worse than her best-case, hoped-against-hope scenarios. The news is of the sort that in one stroke eliminates all agreeable plans and expectations—indeed, all prospect of real pleasure from the moment of its communication. In effect, the news puts a period to this pair's prevailingly happy though certainly not carefree life; there cannot imaginably be further delight in it, of the sort that they have been amply blessed with through their years together. All that is over now: for her already; for him and for them as soon as she relays the news to him—which, of course, she must and promptly will.

Gone. Finished. Done with.

Meanwhile, *she* knows the news, but he does not, yet. From her worktable she sees him poke at the lily-bed mulch with the point of his trowel and pinch out by the roots, with his ungloved other hand, a bit of chickweed, wire grass, or ground ivy. She accepts the caller's terse expression of sympathy and duly expresses in return her appreciation for that unenviable bit of message-bearing. She has asked only a few questions—there aren't many to be asked—and has attended the courteous, pained, terrible but unsurprising replies. Presently she replaces the cordless telephone on its base and leans back for a moment in her comfortable desk chair to watch her mate at his ordinary, satisfying work and to assimilate what she has just been told.

There is, however, no assimilating what she has just been told—or, if there is, that assimilation is to be measured in years, even decades, not in moments, days, weeks, months, seasons. She must now get up from her chair, walk through their modest, pleasant house to the sundeck, cross the lawn to the daylily garden down by the lake or pond, and tell him the news. She regards him for some moments longer, aware that as he proceeds with his gardening, his mind is almost certainly on the phone call. He will be wondering whether she's still speaking with the caller or has already hung up the telephone and is en route to tell him the news. Perhaps the call was merely a routine bit of business, not worth reporting until their paths recross at coffee break or lunchtime. A wrong number, even, it might have been, or another pesky telephone solicitor. He may perhaps be half-deciding by now that it was, after all, one of those innocuous possibilities.

She compresses her lips, closes and reopens her eyes, exhales, rises, and goes to tell him the news.

He sees her, presently, step out onto the sundeck, and signals his whereabouts with a wave of his trowel in case she hasn't yet spotted him down on his knees in the daylily garden. At that distance, he can read nothing in her expression or carriage, but he notes that she isn't bringing with her the cordless telephone. Not impossibly, of course, she could be simply taking a break from her studio work to stretch her muscles, refill her coffee mug, use the toilet, enjoy a breath of fresh springtime air, and report to him that the phone call was nothing—a misdial, or one more canvasser. She has stepped from the deck and begun to cross the lawn, himward, unurgently. He resumes weeding out the wire grass that perennially invades their flower beds, its rhizomes spreading under the mulch, secretly reticulating the clean soil and

choking the lily bulbs. A weed, he would agree, is not an organism wicked in itself, it's simply one of nature's creatures going vigorously about its natural business in a place where one wishes that it would not. He finds something impressive, even awesome, in the intricacy and tenacity of those rhizomes and their countless interconnections; uproot one carefully and it seems to network the whole bed—the whole lawn, probably. Break it off at any point and it redoubles like the monster Whatsitsname in Greek mythology. The Hydra. So it's terrible, too, in its way, as well as splendid, that blind tenacity, that evolved persistence and virtual ineradicability, heedless of the daylilies that it competes with and vitiates, indifferent to everything except its mindless self-proliferation. It occurs to him that, on the other hand, that same persistence is exactly what he cultivates in their flowers, pinching back the rhododendrons and dead-heading yesterday's lilies to encourage multiple blooms. An asset here, a liability there, from the gardener's point of view, while Nature shrugs its nonjudgmental shoulders. Unquestionably, however, it would be easier to raise a healthy crop of wire grass by weeding out the daylilies than vice versa.

With such reflections he distracts himself, or tries or pretends to distract himself, as she steps unhurriedly from the sundeck and begins to cross the lawn, himward.

She is, decidedly, in no hurry to cross the lawn and say what she must say. There is her partner, lover, best friend, and companion, at his innocent, agreeable work: half chore, half hobby, a respite from his own busy professional life. Apprehensive as he will have been since the telephone call, he is still as if all right; she, too, and their life and foreseeable future—as if still all right. In order to report to him the dreadful news, she must cross the entire lawn, with its central Kwanzan cherry tree: a magnificently spreading, fully mature specimen, just now at the absolute pink peak of its glorious bloom. About halfway between the sundeck and that Kwanzan cherry stands a younger and smaller, but equally vigorous, Zumi crab apple that they themselves put in a few seasons past to replace a storm-damaged predecessor. It, too, is a near-perfect specimen of its kind, and likewise at or just past the peak of its flowering, the new green leaves thrusting already through the white clustered petals. To reach her husband with the news, she must pass under that Kwanzan cherry—the centerpiece of their property, really, whose great widespread limbs they fear for in summer thunder squalls. For her to reach that cherry tree will take a certain small time: perhaps twenty seconds, as she's in no hurry. To stroll leisurely even to the Zumi crab apple takes ten or a dozen seconds—about as long as it takes to read this sentence aloud. Walking past that perfect crab apple, passing under that resplendent cherry, crossing the remaining half of the lawn down to the lily garden and telling him the news—these sequential actions will comprise the middle of this story, already in progress.

In the third of a minute required for her to amble from sundeck to cherry tree—even in the dozen seconds from deck to crab apple (she's passing that crab apple now)—her companion will have weeded his way perhaps one trowel's length farther through his lily bed, which borders that particular stretch of pond- or lakeside for several yards, to the far corner of their lot, where the woods begin. Musing upon this

circumstance—a reflex of insulation, perhaps, from the devastating news—puts her in mind of Zeno's famous paradox of Achilles and the tortoise. Swift Achilles, Zeno teases, can never catch the tortoise, for in whatever short time required for him to close half the hundred yards between them, the sluggish animal will have moved perhaps a few inches; and in the very short time required to halve that remaining distance, an inch or two more, et cetera—ad infinitum, inasmuch as finite distances, however small, can be halved forever. It occurs to her, indeed—although she is neither philosopher nor mathematician—that her husband needn't even necessarily be moving away from her, so to speak, as she passes now under the incredibly fullblossomed canopy of the Kwanzan cherry and pauses to be quietly reastonished, if scarcely soothed, by its splendor. He (likewise Zeno's tortoise) could remain fixed in the same spot; he could even rise and stroll to meet her, run to meet her under that flowered canopy; in every case and at whatever clip, the intervening distances must be halved, re-halved, and re-re-halved forever, ad infinitum. Like the figured lovers in Keat's "Ode on a Grecian Urn" (another image from her college days), she and he will never touch, although unlike those, these are living people en route to the howmany-thousandth tête-á-tête of their years together-when, alas, she must convey to him her happiness-ending news. In John Keat's words and by the terms of Zeno's paradox, forever will he love, and she be fair. Forever they'll go on closing the distance between them—as they have in effect been doing, like any well-bonded pair, since Day One of their connection—yet never closing it altogether: asymptotic curves that eternally approach, but never meet.

But of course they will meet, very shortly, and before even then they'll come within hailing distance, speaking distance, murmuring distance. Here in the middle of the middle of the story, as she re-emerges from under the bridal-like canopy of cherry blossoms into the tender midmorning sunlight, an osprey suddenly plummets from the sky to snatch a small fish from the shallows. They both turn to look. He, the nearer, can see the fish flip vainly in the raptor's talons; the osprey aligns its prey adroitly fore-and-aft, head to wind, to minimize drag, and flaps off with it toward its rickety treetop nest across the pond or lake.

The fish is dying. The fish is dying. The fish is dead.

When he was a small boy being driven in his parents' car to something he feared—a piano recital for which he felt unready, a medical procedure that might hurt, some new town or neighborhood that the family was moving to—he used to tell himself that as long as the car-ride lasted, all would be well, and wish it would last forever. The condemned en route to execution must feel the same, he supposes, while at the same time wanting the dread thing done with: The tumbril has not yet arrived at the guillotine; until it does, we are immortal, and here meanwhile is this once pleasing avenue, this handsome small park with its central fountain, this plane-tree-shaded corner where, in happier times . . .

A gruesome image occurs to him, from his reading of Dante's *Inferno* back in college days: The Simoniacs, traffickers in sacraments and holy offices, are punished in Hell by being thrust head-downward for all eternity into holes in the infernal rock.

Kneeling to speak with them in that miserable position, Dante is reminded of the similar fate of convicted assassins in his native Florence, executed by being bound hand and foot and buried alive head-down in a hole. Before that hole is filled, the officiating priest bends down as the poet is doing, to hear the condemned man's last confession—which, in desperation, the poor wretch no doubt prolongs, perhaps adding fictitious sins to his factual ones in order to postpone the end—and in so doing (it occurs to him now, turning another trowelsworth of soil as his wife approaches from the cherry tree) appending one more real though venial sin, the sin of lying, to the list yet to be confessed.

Distracted, he breaks off a wire-grass root.

"Time," declares the Russian critic Mikhail Bakhtin, "is the true hero of every feast." It is also the final dramaturge of every story. History is a Mandelbrot set, as infinitely subdivisible as is space in Zeno's paradox. No interval past or future but can be partitioned and sub-partitioned, articulated down through ever finer, self-similar scales like the infinitely indented coastlines of fractal geometry. This intelligent, as-if-stillhappy couple in late mid-story—what are they doing with such reflections as these but attempting unsuccessfully to kill time, as Time is unhurriedly but surely killing them? In narrated life, even here (halfway between cherry tree and daylily garden) we could suspend and protract the remaining action indefinitely, without "freezeframing" it as on Keats's urn; we need only slow it, delay it, atomize it, flash back in time as the woman strolls forward in space with her terrible news. Where exactly on our planet are these people, for example? What pond or lake is that beyond their pleasant lawn, its olive surface just now marbled with spring-time yellow pollen? Other than one osprey nest in a dead but still-standing oak, what is the prospect of its farther shore? We have mentioned the man's jeans, sweatshirt, gloves, and eyeglasses, but nothing further of his appearance, age, ethnicity, character, temperament, and history (other than that he once attended college), and (but for that same detail) nothing whatsoever of hers; nor anything, really, of their life together, its gratifications and tribulations, adventures large or small, careers, corner-turnings. Have they children? Grandchildren, even? What sort of telephone solicitors disturb their evidently rural peace? What of their house's architecture and furnishings, its past owners, if any, and the history of the land on which it sits—back to the last glaciation, say, which configured "their" pond or lake and its topographical surround? Without our woman's pausing for an instant in her hasteless but steady course across those few remaining yards of lawn, the narrative of her final steps might suspend indefinitely their completion. What variety of grasses does that lawn comprise, interspersed with what weeds, habitating what insecta and visited by what birds? How, exactly, does the spring air feel on her sober-visaged face? Are his muscles sore from gardening, and, if so, is that degree of soreness, from that source, agreeable to him or otherwise? What is the relevance, if any, of their uncertainty whether that water beyond their lawn is properly to be denominated a large pond or a small lake, and has that uncertainty been a running levity through their years there? Is yonder osprey's nest truly rickety, or only apparently so? The middle of this story nears its end, but has not reached it yet, not yet. There's time still, still world

enough and time. There are narrative possibilities still unforeclosed. If our lives are stories, and if this story is three-fourths told, it is not yet four-fifths told; if four-fifths, not yet five-sixths, et cetera—and meanwhile, meanwhile it is *as if* all were still well.

In non-narrated life, alas, it is a different story, as in the world of actual tortoises, times, and coastlines. It might appear that in Time's infinite sub-segmentation, 11:00 A.M. can never reach 11:30, far less noon; it might appear that Achilles can never reach the tortoise, nor any story its end, nor any news its destined hearer—yet reach it they do, in the world we know. Stories attain their denouement by selective omission, as do real-world coastline measurements; Achilles swiftly overtakes the tortoise by ignoring the terms of Zeno's paradox. Time, however, more wonderful than these, omits nothing, ignores nothing, yet moves inexorably from hour to hour in just five dozen minutes.

The story of our life is not our life; it is our story. Soon she must tell him the

Our lives are not stories. Now she must tell him the news.

This story will never end. This story ends.

Suggestions for Discussion

- 1. How does John Barth combine the ideas "bad news" and "short story" to reveal the theme of "Ad Infinitum: A Short Story"?
- 2. How important is it to the theme of the story that the nature of the bad news, or even who it relates to, is never known to us? Why did the author make this choice?
- 3. Why does the author repeat or insist on the following: it isn't quite the season yet; beginning, middle, end; Zeno's paradox; crossing the lawn; daylily, wiregrass, cherry, and apple; the dying fish?
- 4. What is the point of view of this story? Who speaks? How does the author prepare us to accept an alternation between two minds in this very short compass? How necessary to the story is this choice?

Retrospect

- 1. Consider the question "Where are you going?" in the title of Joyce Carol Oates's story. How does the question relate plot to theme?
- 2. Neither "exile" nor "immigration" nor "assimilation" is ever mentioned in "San." How do you know that these are included in the theme of the story?
- 3. How are setting, dialogue, plot, and characterization interrelated to reveal the theme of "The Only Traffic Signal on the Reservation Doesn't Flash Red Anymore"?

- 4. In Charles Baxter's "Gryphon," how are the words *crazy*, *fabulous*, and *knowledge* explored, and how is our usual understanding of those words altered?
- 5. What is "Menagerie" about? What does it say about what it's about? How necessary to the "objective correlative" of this story is its animal cast of characters?
- 6. Consider the themes of *language*, *judgment*, and *time* in "Bullet in the Brain." How many ways does Tobias Wolff use techniques of fiction to relate these themes?
- 7. Which of the stories in this volume offer an inversion of a "truth" that you ordinarily accept about, for instance, the nature of reality, sanity, time, goodness? How successfully does each offer its alternative truth?

Writing Assignments

These five exercises are arranged in order of ascending difficulty. The first is the easiest, and it is likely to produce a bad story. If it produces a bad story, it will be invaluably instructive to you, and you will be relieved of the onus of ever doing it again. If it produces a good story, then you have done something else, something more, and something more original than the assignment asks for. If you prefer to do exercise 4 or 5, then you may already have doomed yourself to the writing craft and should prepare to be very poor for a few years while you discover what place writing will have in your life.

- Take a simple but specific political, religious, scientific, or moral idea. It
 may be one already available to us in a formula of words, or it may be one
 of your own, but it should be possible to state it in less than ten words.
 Write a short story that illustrates the idea. Do not state the idea at all.
 Your goals are two: that the idea should be perfectly clear to us so that it
 could be extracted as a moral or message, and that we should feel we have
 experienced it.
- 2. Take as your title a common proverb or maxim, such as *power corrupts*, honesty is the best policy, walk softly and carry a big stick, haste makes waste. Let the story make the title ironic, that is, explore a situation in which the advice or statement does not apply.
- 3. Taking as a starting point some incident or situation from your own life, write a story with one of the following themes: nakedness, blindness, thirst, noise, borders, chains, clean wounds, washing, the color green, dawn. The events themselves may be minor (a story about a slipping bicycle chain may ultimately be more effective than one about a chain gang). Once you have decided on the structure of the story, explore everything you think, know, or believe about your chosen theme and try to incorporate that theme in imagery, dialogue, event, character, and so forth.

- 4. Identify the belief you hold most passionately and profoundly. Write a short story that explores an instance in which this belief is untrue.
- 5. Write a short story that you have wanted to write all term and have not written because you knew it was too big for you and you would fail. You may fail. Write it anyway.

11

PLAY IT AGAIN, SAM Revision

- Worry It and Walk Away
 - Criticism
 - · Revision Questions
- · An Example of the Revision Process

The creative process is not all inventive; it is partly corrective, critical, nutritive, and fostering—a matter of getting this creature to be the best that it can be. William C. Knott, in *The Craft of Fiction*, cogently observes that "anyone can write—and almost everyone you meet these days is writing. However, only the writers know how to rewrite. It is this ability alone that turns the amateur into a pro."

Revising is a process more dreaded than dreadful. The resistance to rewriting is, if anything, greater than the resistance to beginning in the first place. Yet the chances are that once you have committed yourself to a first draft, you'll be unable to leave it in an unfinished and unsatisfying state. You'll be *unhappy* until it's right. Making it right will involve a second commitment, to seeing the story fresh and creating it again with the advantage of this "re-vision." Alice Munro, in the introduction to her *Selected Stories*, describes the risk, the readiness, and the reward.

... The story, in the first draft, has put on rough but adequate clothes, it is "finished" and might be thought to need no more than a lot of technical adjustments, some tightening here and expanding there, and the slipping in of some telling dialogue and chopping away of flabby modifiers. It's then, in fact, that the story is in the greatest danger of losing its life, of appearing so hopelessly misbegotten that my only relief comes from abandoning it. It doesn't do enough.

It does what I intended, but it turns out that my intention was all wrong. \dots I go around glum and preoccupied, trying to think of ways to fix the problem. Usually the right way pops up in the middle of this.

A big relief. Renewed energy. Resurrection.

Except that it isn't the right way. Maybe a way to the right way. Now I write pages and pages I'll have to discard. New angles are introduced, minor characters brought center stage, lively and satisfying scenes are written, and it's all a mistake. Out they go. But by this time I'm on the track, there's no backing out. I know so much more than I did, I know what I want to happen and where I want to end up and I just have to keep trying till I find the best way of getting there.

To find the best way of getting there, you may have to "see-again" more than once. The process of revision involves external and internal insight; you'll need your conscious critic, your creative instinct, and readers you trust. You may need each of them several times, not necessarily in that order. A story gets better not just by polishing and refurbishing, not by improving a word choice here and an image there, but by taking risks with the structure, re-envisioning, being open to new meaning itself.

Worry It and Walk Away

To write your first draft, you banished the internal critic. Now make the critic welcome. Revision is work, but the strange thing is that you may find you can concentrate on the work for much longer than you could play at freedrafting. It has occurred to me that writing a first draft is very like tennis or softball—I have to be psyched for it. Energy level up, alert, on my toes. A few hours is all I can manage, and at the end of it I'm wiped out. Revision is like careful carpentry, and if I'm under a deadline or just determined to get this thing crafted and polished, I can be good for twelve hours of it.

The first round of rewrites is probably a matter of letting your misgivings surface. Focus for a while on what seems awkward, overlong, undeveloped, flat, or flowery. Tinker. Tighten. Sharpen. More important at this stage than finishing any given page or phrase is that your're getting to know your story in order to open it to new possibilities. You will also get tired of it; you may feel stuck.

Then put it away. Don't look at it for a matter of days or weeks—until you feel fresh on the project. In addition to getting some distance on your story, your're mailing it to your unconscious. Carolyn Bly says, "Here is the crux of it: between the conscious and unconscious mind we are more complex and given to concept than we are in the conscious mind."

"Complex" means that you can begin to see your story organically; "concept" means that you may discover what it is really about. Rollo May, in *The Courage to Create*, makes a similar point.

Everyone uses from time to time such expressions as, "a thought pops up," an idea comes "from the blue" or "dawns" or "comes as though out of a dream," or

"it suddenly hit me." These are various ways of describing a common experience: the breakthrough of ideas from some depth below the level of awareness.

May describes getting stuck doing research on a psychological study; the evidence contradicted his theory that children rejected by their mothers would universally display symptoms of anxiety. He sat for long hours moiling and baffled, "caught by an insoluble problem."

Late one day, putting aside my books and papers in the little office I used in that shelter house, I walked down the street toward the subway. I was tired. I tried to put the whole troublesome business out of my mind. About fifty feet away from the entrance to the Eighth Street station, it suddenly struck me "out of the blue," as the not-unfitting expression goes, that those young women who didn't fit my hypothesis were all from the proletarian class. I saw at that instant that it is not rejection by the mother that is the original trauma which is the source of anxiety; it is rather rejection that is lied about.

Here, May solves a logical problem not by consciously working it out, but by letting it go. In the process he sees a new connection and realizes what his project is about—not rejection after all, but dishonesty.

It is my experience that such connections and such realizations occur over and over again in the course of writing a short story or novel. Often I will believe that because I know who my characters are and what happens to them, I know what my story is about—and often I find I'm wrong, or that my understanding is shallow or incomplete.

In the first draft of a recent novel, for instance, I opened with the sentence, "It took a hundred and twelve bottles of champagne to see the young Poindexters off to Arizona." A page later one character whispered to another that the young Mr. Poindexter in question had "consumption." I worked on this book for a year (taking my characters off to Arizona where they dealt with the desert heat, lack of water, alcoholism, loss of religion, and the development of mining interests and the building trade) before I saw the connection between "consumption" and "champagne." When I understood that simple link, I understood the overarching theme—surely latent in the idea from the moment it had taken hold of me—between tuberculosis, spiritual thirst, consumerism, and addiction, all issues of "consumption."

It might seem dismaying that you should see what your story is about only after you have written it. Try it; you'll like it. Nothing is more exhilarating than the discovery that a complex pattern has lain in your mind ready to unfold.

Note that in the early stages of revision, both the worrying and the walking away are necessary. Perhaps it is bafflement itself that plunges us to the unconscious space where the answer lies.

Criticism

Once you have thought your story through, drafted it, and worked on it to the best of your ability, someone else's eyes can help to refresh the vision of your own. Wise professionals rely on the help of an agent or editor at this juncture (although even the wisest still smart at censure); anyone can rely on the help of friends, family, or classmates. The trick to making good use of criticism is to be utterly selfish about it. Be greedy for it. Take it all in. Ultimately you are the laborer, the arbiter, and the boss in any dispute about your story, so you can afford to consider any problem and any solution. Most of us feel not only committed to what we have put on the page, but also defensive on its behalf—wanting, really, only to be told that it is a work of genius or, failing that, to find out that we have gotten away with it. Therefore, the first exigency of revision is that you learn to hear, absorb, and accept criticism.

It used to be popular to speak of "constructive criticism" and "destructive criticism," but these are misleading terms suggesting that positive suggestions are useful and negative criticism useless. In practice the opposite is usually the case. You're likely to find that the most constructive thing a reader can do is say *I don't believe this*, *I don't like this*, *I don't understand this*, pointing to precisely the passages that made you uneasy. This kind of laying-the-finger-on-the-trouble-spot produces an inward groan, but it's also satisfying; you know just where to go to work. Often the most destructive thing a reader can do is offer you a positive suggestion—Why don't you have him crash the car?—that is irrelevant to your vision of the story. Be suspicious of praise that is too extravagant, of blame that is too general. If your impulse is to defend the story or yourself, still the impulse. Behave as if bad advice were good advice, and give it serious consideration. You can reject it after you have explored it for anything of use it may offer.

Once again, walk away—Kenneth Atchity, in A Writer's Time, advises compulsory "vacations" at crucial points in the revising process—and let the criticism cook

until you feel ready, impatient, to get back to writing.

When you feel that you have acquired enough distance from the story to see it anew, go back to work. Make notes of your plans, large and small. Talk to yourself in your journal about what you want to accomplish and where you think you have failed. Let your imagination play with new images or passages of dialogue. Always keep a copy (and/or a document on disk) of the story as it is so that you can go back to the original, and then be ruthless with another copy. Eudora Welty advises cutting sections apart and pinning them back together so that they can be easily re- and rearranged. I like to take the whole surface of the kitchen table as a cut-and-paste board. Some people can keep the story in their heads and do their rearranging directly onto the computer screen—which in any case has made the putting-back-together process less tedious than retyping.

Revision Questions

As you plan the revision and as you rewrite, you will know (and your critics will tell you) what problems are unique to your story. There are also general, almost universal, pitfalls that you can avoid if you ask yourself the following questions:

What is my story about? Another way of saying this is What is the pattern of change? Once this pattern is clear, you can check your draft to make sure you've included all the crucial moments of discovery and decision. Is there a crisis action?

Is there unnecessary summary? Remember that it is a common impulse to try to cover too much ground. Tell your story in the fewest possible scenes; cut down on summary and unnecessary flashback. These dissipate energy and lead you to tell rather than show.

Why should the reader turn from the first page to the second? Is the language fresh? Are the characters alive? Does the first sentence, paragraph, page introduce real tension? If it doesn't, you have probably begun at the wrong place. If you are unable to find a way to introduce tension on the first page, you may have to doubt whether you have a story after all.

Is it original? Almost every writer thinks first, in some way or other, of the familiar, the usual, the given. This character is a stereotype, that emotion is too easy, that phrase is a cliché. First-draft laziness is inevitable, but it is also a way of being dishonest. A good writer will comb the work for clichés and labor to find the exact, the honest, and the fresh.

Is it clear? Although ambiguity and mystery provide some of our most profound pleasures in literature, beginning writers are often unable to distinguish between mystery and muddle, ambiguity and sloppiness. You may want your character to be rich with contradiction, but we still want to know whether that character is male or female, black or white, old or young. We need to be oriented on the simplest level of reality before we can share your imaginative world. Where are we? When are we? Who are they? How do things look? What time of day or night is it? What's the weather? What's happening?

Is it self-conscious? Probably the most famous piece of advice to the rewriter is William Faulkner's "kill all your darlings." When you are carried away with the purple of your prose, the music of your alliteration, the hilarity of your wit, the profundity of your insights, then the chances are that you are having a better time writing than the reader will have reading. No reader will forgive you, and no reader should. Just tell the story. The style will follow of itself if you just tell the story.

Where is it too long? Most of us, and even the best of us, write too long. We are so anxious to explain every nuance, cover every possible aspect of character, action, and setting that we forget the necessity of stringent selection. In fiction, and especially in the short story, we want sharpness, economy, and vivid, telling detail. More than necessary is too much. I have been helped in my own tendency to tell all by a friend who went through a copy of one of my novels, drawing a line through the last sentence of about every third paragraph. Then in the margin he wrote, again and again, "Hit it, and get out." That's good advice for anyone.

Where is it undeveloped in character, action, imagery, theme? In any first, second, or third draft of a manuscript there are likely to be necessary passages sketched, skipped, or skeletal. What information is missing, what actions are incomplete, what motives obscure, what images inexact? Where does the action occur too abruptly so that it loses its emotional force? Is the crisis presented as a scene?

Where is it too general? Originality, economy, and clarity can all be achieved through the judicious use of significant detail. Learn to spot general, vague, and fuzzy terms. Be suspicious of yourself anytime you see nouns like someone and everything, adjectives like huge and handsome, adverbs like very and really. Seek instead a partic-

ular thing, a particular size, an exact degree.

Although the dread of "starting over" is a real and understandable one, the chances are that the rewards of revising will startlingly outweigh the pains. Sometimes a character who is dead on the page will come to life through the addition of a few sentences or significant details. Sometimes a turgid or tedious paragraph can become sharp with a few judicious cuts. Sometimes dropping page one and putting page seven where where page three used to be can provide the skeleton of an otherwise limp story. And sometimes, often, perhaps always, the difference between an amateur rough-cut and a publishable story is in the struggle at the rewriting stage.

An Example of the Revision Process

Short-story writer Stephen Dunning won the 1990 "World's Best Short Story Contest" with a tight, complex and evocative story that illustrates most of the principles discussed in this book. "Wanting to Fly" has, in 245 words and eight characters, a power struggle that builds and comes to a crisis, dialogue that reveals character and moves the action, a strong voice, irony, metaphor, and a pattern of change that reveals a theme.

Assuming that a story of such density was not "tossed off," I asked Dunning if he would share his revision process with other writers. What follows are four (of perhaps nine or ten) versions of the story, with Dunning's generous notes. He says:

Mornings I often fast-write, try to hang onto my dreams. Not "free-write," but go so fast I leave censors behind, stumble and goof, hoping to trick myself into a little chunk I like. A word or an image. (Much less often, an "idea.")

Very inefficient! I collect fast-writes (I do them on a processor now, for speed) and when I have a stack, I search for chunks of language that interest me. I do this search with high-lighters in hand—pink, for hot items, yellow, for "maybe," green that means "Huh!" Things that puzzle me, but might be important. Obsessions, for example. I highlight words, phrases, images, "talk," mistakes. (Unproved theory of mine: write fast enough, make enough mistakes, you can track your obsessions. They leak out on you.)

How much do I glean?

As little as possible. I've learned, a few words per page. An occasional sentence.

I type these little chunks fresh, set them up in their new environment. Then I doodle, connecting items with lines, starring something special. Now I'm ready to "practice writing," which is what practicing writers do.

How? By answering my own questions: Why does this interest me? What else can I say about it? What does it remind me of? What would ____(Mother, my childhood sweetheart, Jesus, my mean sister, Winston Churchill—plug in someone who fits) say about this?

In a journal entry dated "somewhere around Halloween 1989," Dunning produced the "fast-write" (what I've referred to in this book as freedrafting) that provided the seeds of the story "Wanting to Fly." The fast-write passage is reproduced here exactly as it came from his word processor, "stumble and goofs" intact.

Version 1

fqast write from dreamsone is a computer dream. it's twenty two fifty eighjt st clair with the mansion full of statues, hedges. thje magraw boiys danny, oliver, the disapproving one with glasses in the mansion games i did ook, better than the midget biully k but often last with danny ollie. a bunch of other boys, the skinny lop-jawed one who spit at me in fooitball. the golden moment, facing him down. leary, he weas. hius name. stsate fair time, aboiut ten guys playing ball leary was spitting and and tried to tackle me on the rocks, us others, us good guys, would try not to, ill fighjt you fair and square. god, i was good. the other boys waiting. leary backing down. some superboy hero! the evenings when the magraws had to go, id fly over into the mansion. crosbys'. sail from our back porch, go low over the hedges between crosbys and us, soar arouind statues, swoop along hedges. then poull up into resting places, a sectret birdself, something i swear i did, i was a bird, i flew. i restded on statues and tree limbs. i can see the hedges and statues. did the dream go bad? at some pooint i wasn't in it, but watching. dozens of little figures, Boschian. a camera scan a huge painting made up of hundreds of little vignettes of weird, gnome like, devilish flyuers. pictogfraphs, almost, but lots of soaring and dipping. i know it was not the way it shoild be. i was watching, helpless to make everone everhything stop. the other flyers shoildn't be there. my place to fly. the night waas purple and i love the lightness and speed of my flying. then the dream ended, I tried to identify the wonder of it. it seemed to end on Where did these wondrous things come from? They weren't the neightborhood boys. not worried///tjhere at the ened.

This first-draft-of-something-or-other clearly draws on both dreams and memory. In the second version (which Dunning says is four or five drafts/editings toward a possible story) the bird-boy of the dream has transmogrified into a human cannon-ball, and the author has achieved a gently ironic distance from the character. This is done partly by the self-conscious device of providing a "frame" with a writer in it—something that many writers do, sometimes in a early version, sometimes in final publication. Perhaps the introduction of an autobiographical element in the

frame helps to find authorial distance. Here are the first several paragraphs of this draft:

Version 2

Leroy slid open the bottom drawer where they kept his costumes. The white and red looked shabby; the silver looked ok. Nylon, and shiny. He thought of something he wanted to write.

"Part four," he wrote. "I always wanted to fly."

I was eight years old, in third, in Mrs. McKissup's third grade, when my father took me to State Fair. In the grandstand, after the horse races, sitting close to the track and the infield stage, we saw a man in silver tights and big handlebar moustache shot from a cannon. The name I remember is "The Great Zambini," but that doesn't look exactly right. Later my father gave me names like "The Flying Weenie" and "Zamboosi, the Goosey."

That same night of the State Fair I tried to paint my BVD longies with the gold paint in the tiny spray can Mother used to gild the birdcage. Right over my belly button I made a spot the size of a golden apple before the paint ran out. When my father saw it he paddled my ass with his hairbrush. That May, for my ninth birthday, Mother gave me a silver-grey t-shirt with a picture of Halley's comet flashing in red across the front.

Leroy got up from the table to get a beer. In the Lucky Lager six-pack, Carmen had set two cans of Diet Pepsi. Hint, hint, lay off the sauce. Leroy rolled his eyes and twisted out one of the beers. Well, that was like her, fairly comical.

I could fly in that shirt. Summer evenings in the eerie dusk after supper I wheeled around the neighborhood, content to fly alone. Daytimes at Duncan Frenzel's house I pumped the backyard tire swing higher than anyone and learned how to fly out from it just right before the swing reached the top of its arc. I flew out three or four feet beyond Duncan. At school in the sixth grade me and two buddies took over the primary grades' slide and slid down on our stocking feet, launching off from the lip to see who could jump farthest. Mrs. McKissup came over to tell us to let the little children use the slide. When Mrs. McKissup's back was turned, we went back to the slide, and before that day is out, of course, the three of us are in Mr. Beaver's office.

He calls us "childish" and "selfish." This happens again, he'll have to call our parents. Duncan giggles then, and gets a dirty look. When Mr. Beaver asks what would we do if we were trying to run a decent school, we both giggle. Maybe we had the same idea. Mine was to get rid of Mrs. McKissup and let our student teacher teach. She was beautiful, like a model.

My father heard about it anyway and beat me with the hairbrush until finally I cried and spit "I hate you!" in his face.

—and so forth. This version continues alternating the struggles of the writer Leroy and his girlfriend Carmen with the story of the boy as he leaves home, joins the car-

nival, deals with his father's death, becomes a human cannonball, and gets into and out of a relationship with another runaway named Annette.

Dunning confesses that the second version puzzles him, and that it's possible "the market" was beginning to play a role. "My hunch is: I was trying to get a piece both for the PEN Syndicated Fiction Award" (which Dunning has won twice) "and for the World's Best Short Short Story Contest. Both contests have word limits—PEN's 2,500 and WBSSSC's severe 250."

Dunning also felt that both contests had "taboos, stated or inferred." Perhaps for that reason he drew back in a subsequent long version from the narrator's loss of virginity to a bittersweet kissing scene. Gone also are the characters of the writer and his girlfriend Carmen, and the whole frame with its writer writing. The boy's story is sharpened and tightened, but otherwise remains substantially the same.

It's interesting that at this point Dunning began to title his versions, a clue that he had a sense of shape and theme. The progression of titles indicates a subtle shift of emphasis, from "Flying," to "I Always Wanted to Fly," to "Wanting to Fly."

By the time he came to write the penultimate version, Dunning knew he was aiming for the 250-word maximum demanded by the World's Best Short Short Story Contest. He had drastically pruned and condensed. "Note a shift to the present," he says, "a fine way to cut words." One consequence of the shortening is that characters are squashed to sketches ("Bye-bye, Annette: In longer versions she was prominent; here she's a walk-on.") Yet this distilling represents a natural process of characterization, and the richness of the earlier portraits no doubt contributes to the vividness of the final one.

This version of Dunning's story is reproduced as a facsimile of his working manuscript. He says, "Here the inked numbers in the upper right corner indicate that with my pen editings, I've cut 338 to 307. (Lord, Lord! Another 57 to go.)"

Version 3

WORLD'S BEST SHORT STORY CONTEST 991/620/551/496/418/400/369/362/338

I always wanted to fly.

At State Fair we see a man in silver tights and handle-bar moustache shot from a cannon, 'The Great Zambini'? Father calls me names like 'Zamboosi, the Goosey' and That night, when I paint my BVD's with Ma's birdcage spray, he paddles me good.

My ninth birthday Ma gives me a silver-grey t-shirt with Halley's comet flashing across the front. I can fly in that shirt. (Arms out stiff, I tilt around the neighborhood.) Duncan Frenzel and I use the kindergarten slide. Mrs McKissup comes over: ''Now you big boys, let the children use it.''

We don't listen. Before long we're in Mr. Beaver's office.

''Childish,'' he says. ''Selfish.'' Duncan giggles, and gets a look.) Mr. Beaver asks what we'd do if we was trying to run a decent school. We both giggle, and Father gets the (eld) call. He beats me with his hairbrush.

(We nail it good to Frenzel's porch roof, but) Our renailed good to F's roof
frigerator-carton slide isn't steady. Duncan lands
wrong, screaming and hollering, and I call the police,
where his ma works. (Turns out) the ankle was broke. When
it rains, Mr. Frenzel's (porch) roof sprinkles like a
watering can.

watering can.

That was my last beating.

The last time Father beats me is for that.

Wallace's Carnival hires me to assemblo rides (tents and clean after animals.) A dollar a day, food, sleep where I can. We leave for Toledo the next day, Willie Farley driving the ferris—wheel truck, (another runaway named Annette in the middle, me against the door.)

It's Willie teaches me to fly.

And I've been flying ever since. Once I'm famous, Father and me get along fine. I'm home from Cole Brothers

when he drowns. January fifth, ice-fishing with Arn Bower. Father knows the ice is thin, but breaks through and comes up under it Before they get him out,) I see his face, mouth open and lopsided, a giant perch.

Arn Bower starts keeping Ma company, (and that's good.) Wherever I fly there's women for me

The award-winning and published version of Dunning's story is so dense that it verges on that hybrid form, the prose poem. Of his final revisions the author has this to say:

At some point there's tension between the stuff (language, content) and the form. One effect, unfortunate, is sentences that sound more like telegrams than art. But another effect comes from the demands of the form, inviting the writer to imaginative uses of language. Not altogether different from writing a haiku or a sonnet, is it? In the third version I wrote:

We don't listen. Before long we're in Mr. Beaver's office.

Trying to hang onto the stuff and still honing the piece, the final version reads:

In two minutes Duncan and me're in Beaver's office.

A slender nine words instead of ten! The final version has a little more stuff and shows (images) more than it tells. It's more specific—In two minutes instead of Before long-adding a word!; names (Duncan and me), and has that lovely contraction (me + are into me're)

Makes me smile even now.

Final Version

Wanting to Fly STEPHEN DUNNING

At State Fair a man in silver tights and handlebar moustache—some name like The Great Zambini—blasts from a cannon. Driving home, Father calls me "Goosey Zamboosi" and "Flying Weenie." But later, when I spray my BVD's with

Ma's birdcage paint, he paddles me good.

Again.

For my ninth birthday, Ma gives me a silver-grey t-shirt with Halley's comet flashing across. I can fly in that shirt—arms stiff, tilting. Then Mrs. McKissup catches us on the kindergarten slide. "You boys! Let the children use it."

In two minutes Duncan and me're in Beaver's office.

"Childish," Mr. Beaver says. "Selfish." Duncan giggles. "What would you do, you're trying to run a decent school?" We both giggle.

Father uses the hairbrush.

Duncan and me nail a refrigerator-carton to Frenzels' porch roof. Duncan falls awful hard, grabbing his ankle. "It's broke," he hollers. I run for his ma. Next rain the Frenzels' roof sprinkles like a watering can.

My last beating ever.

Wallace's Carnival hires me to assemble rides—dollar a day, food, sleep anywhere I can. We head for Toledo, Willie Farley driving the ferris-wheel truck. It's Willie teaches me cannon-flying. I get pretty famous.

Then of course Father and me get along. I'm home from Cole Brothers when Father drowns, ice-fishing with Arn Bower. Before they hook him, I see his face—mouth open and lopsided, a giant perch.

Arn Bower starts keeping Ma company, and that's good. There's women wherever I fly.

What you have just read is the story of a story, with Dunning as hero trying to catch a little bit of a literal dream, wrestling it, messing up, sidetracked, persistent, pulled by contradictory forces (the dream, the market), learning as he goes, changing as the thing he is making changes. If you think that is a lot of trouble to go to for 250 words, think again. That's what writing is.

I remember that in my freshmen English class at the University of Arizona, Patrick McCarthy was trying to impress us with how hard we ought to work. He described his own struggle the night before, till 2 A.M., for a single paragraph. He was a powerful storyteller, and he made it grindlingly awful. I was appalled. I put up my hand. "But doesn't it," I asked cheerfully, "get easier!"

McCarthy though a moment. "No," he said. "It doesn't get easier. It gets better." And that's the truth of it. There are fine professional writers who never, as a contemporary said of Shakespeare, "blot a word." (Twentieth-century translation: blip a word.) But they are precious few, and you and I are not among them. The minute we get comfortable doing something, we'll do something else; the minute we reach our standards, we'll raise them. The reward will probably not be fame or money or even an intense life replete with talk of illusion and reality, art and death. More likely the reward will be, now and then, some such thing as a "lovely contraction." It'll be enough.

What follows are two short stories, or two versions of a story, by Raymond Carver. "The Bath" and its longer counterpart "A Small, Good Thing." Anecdote and opinion differ on which of these Carver wrote first; he was famous for constant revision and for publishing alternate versions of the same material. In an interview with Larry McCaffrey and Sinda Gregory, however, Carver said of "The Bath" that it "hadn't been told originally, it had been messed around with, condensed and compressed . . . to highlight the qualities of menace that I wanted to emphasize." He also said, "In my own mind I consider them to be really two entirely different stories, not just different versions of the same story; it's hard to even look on them as coming from the same source."

The Bath

RAYMOND CARVER

Saturday afternoon the mother drove to the bakery in the shopping center. After looking through a loose-leaf binder with photographs of cakes taped onto the pages, she ordered chocolate, the child's favorite. The cake she chose was decorated with a spaceship and a launching pad under a sprinkling of white stars. The name Scotty would be iced on in green as if it were the name of the spaceship.

The baker listened thoughtfully when the mother told him Scotty would be eight years old. He was an older man, this baker, and he wore a curious apron, a heavy thing with loops that went under his arms and around his back and then crossed in front again where they were tied in a very thick knot. He kept wiping his hands on the front of the apron as he listened to the woman, his wet eyes examining her lips as she studied the samples and talked.

He let her take her time. He was in no hurry.

The mother decided on the spaceship cake, and then she gave the baker her name and her telephone number. The cake would be ready Monday morning, in plenty of time for the party Monday afternoon. This was all the baker was willing to say. No pleasantries, just this small exchange, the barest information, nothing that was not necessary.

Monday morning, the boy was walking to school. He was in the company of another boy, the two boys passing a bag of potato chips back and forth between them. The birthday boy was trying to trick the other boy into telling what he was going to give in the way of a present.

At an intersection, without looking, the birthday boy stepped off the curb, and was promptly knocked down by a car. He fell on his side, his head in the gutter, his legs in the road moving as if he were climbing a wall.

The other boy stood holding the potato chips. He was wondering if he should finish the rest or continue on to school.

The birthday boy did not cry. But neither did he wish to talk anymore. He would not answer when the other boy asked what it felt like to be hit by a car. The birthday boy got up and turned back for home, at which time the other boy waved good-bye and headed off for school.

The birthday boy told his mother what had happened. They sat together on the sofa. She held his hands in her lap. This is what she was doing when the boy pulled his hands away and lay down on his back.

Of course, the birthday party never happened. The birthday boy was in the hospital instead. The mother sat by the bed. She was waiting for the boy to wake up. The father hurried over from his office. He sat next to the mother. So now the both of them waited for the boy to wake up. They waited for hours, and then the father went home to take a bath.

The man drove home from the hospital. He drove the streets faster than he should. It had been a good life till now. There had been work, fatherhood, family. The man had been lucky and happy. But fear made him want a bath.

He pulled into the driveway. He sat in the car trying to make his legs work. The child had been hit by a car and he was in the hospital, but he was going to be all right. The man got out of the car and went up to the door. The dog was barking and the telephone was ringing. It kept ringing while the man unlocked the door and felt the wall for the light switch.

He picked up the receiver. He said, "I just got in the door!"

"There's a cake that wasn't picked up."

This is what the voice on the other end said.

"What are you saying?" the father said.

"The cake," the voice said. "Sixteen dollars."

The husband held the receiver against his ear, trying to understand. He said, "I don't know anything about it."

"Don't hand me that," the voice said.

The husband hung up the telephone. He went into the kitchen and poured himself some whiskey. He called the hospital.

The child's condition remained the same.

While the water ran into the tub, the man lathered his face and shaved. He was in the tub when he heard the telephone again. He got himself out and hurried through the house, saying, "Stupid, stupid," because he wouldn't be doing this if he'd stayed where he was in the hospital. He picked up the receiver and shouted, "Hello!"

The voice said, "It's ready."

The father got back to the hospital after midnight. The wife was sitting in the chair by the bed. She looked up at the husband and then she looked back at the child. From an apparatus over the bed hung a bottle with a tube running from the bottle to the child.

"What's this?" the father said.

"Glucose," the mother said.

The husband put his hand to the back of the woman's head.

"He's going to wake up," the man said.

"I know," the woman said.

In a little while the man said, "Go home and let me take over."

She shook her head. "No," she said.

"Really," he said. "Go home for a while. You don't have to worry. He's sleeping, is all."

A nurse pushed open the door. She nodded to them as she went to the bed. She took the left arm out from under the covers and put her fingers on the wrist. She put the arm back under the covers and wrote on the clipboard attached to the bed.

"How is he?" the mother said.

"Stable," the nurse said. Then she said, "Doctor will be in again shortly."

"I was saying maybe she'd want to go home and get a little rest," the man said. "After the doctor comes."

"She could do that," the nurse said.

The woman said, "We'll see what the doctor says." She brought her hand up to her eyes and leaned her head forward.

The nurse said, "Of course."

The father gazed at his son, the small chest inflating and deflating under the covers. He felt more fear now. He began shaking his head. He talked to himself like this. The child is fine. Instead of sleeping at home, he's doing it here. Sleep is the same wherever you do it.

The doctor came in. He shook hands with the man. The woman got up from the chair.

"Ann," the doctor said and nodded. The doctor said, "Let's just see how he's doing." He moved to the bed and touched the boy's wrist. He peeled back an eyelid and then the other. He turned back the covers and listened to the heart. He pressed his fingers here and there on the body. He went to the end of the bed and studied the chart. He noted the time, scribbled on the chart, and then he considered the mother and the father.

This doctor was a handsome man. His skin was moist and tan. He wore a threepiece suit, a vivid tie, and on his shirt were cufflinks.

The mother was talking to herself like this. He has just come from somewhere with an audience. They gave him a special medal.

The doctor said, "Nothing to shout about, but nothing to worry about. He should wake up pretty soon." The doctor looked at the boy again. "We'll know more after the tests are in."

"Oh, no," the mother said.

The doctor said, "Sometimes you see this."

The father said, "You wouldn't call this a coma, then?"

The father waited and looked at the doctor.

"No, I don't want to call it that," the doctor said. "He's sleeping. It's restorative. The body is doing what it has to do."

"It's a coma," the mother said. "A kind of coma."

The doctor said, "I wouldn't call it that."

He took the woman's hands and patted them. He shook hands with the husband.

The woman put her fingers on the child's forehead and kept them there for a while. "At least he doesn't have a fever," she said. Then she said, "I don't know. Feel his head."

The man put his fingers on the boy's forehead. The man said, "I think he's supposed to feel this way."

The woman stood there awhile longer, working her lip with her teeth. Then she moved to her chair and sat down.

The husband sat in the chair beside her. He wanted to say something else. But there was no saying what it should be. He took her hand and put it in his lap. This made him feel better. It made him feel he was saying something. They sat like that

for a while, watching the boy, not talking. From time to time he squeezed her hand until she took it away.

"I've been praying," she said.

"Me too," the father said. "I've been praying too."

A nurse came back in and checked the flow from the bottle.

A doctor came in and said what his name was. This doctor was wearing loafers.

"We're going to take him downstairs for more pictures," he said. "And we want to do a scan."

"A scan?" the mother said. She stood between this new doctor and the bed.

"It's nothing," he said.

"My God," she said.

Two orderlies came in. They wheeled a thing like a bed. They unhooked the boy from the tube and slid him over onto the thing with wheels.

It was after sunup when they brought the birthday boy back out. The mother and father followed the orderlies into the elevator and up to the room. Once more the parents took up their places next to the bed.

They waited all day. The boy did not wake up. The doctor came again and examined the boy again and left after saying the same things again. Nurses came in. Doctors came in. A technician came in and took blood.

"I don't understand this," the mother aid to the technician.

"Doctor's orders," the technician said.

The mother went to the window and looked out at the parking lot. Cars with their lights on were driving in and out. She stood at the window with her hands on the sill. She was talking to herself like this. We're into something now, something hard.

She was afraid.

She saw a car stop and a woman in a long coat get into it. She made believe she was that woman. She made believe she was driving away from here to someplace else.

The doctor came in. He looked tanned and healthier than ever. He went to the bed and examined the boy. He said, "His signs are fine. Everything's good."

The mother said, "But he's sleeping."

"Yes," the doctor said.

The husband said, "She's tired. She's starved."

The doctor said, "She should rest. She should eat. Ann," the doctor said.

"Thank you," the husband said.

He shook hands with the doctor and the doctor patted their shoulders and left.

"I suppose one of us should go home and check on things," the man said. "The dog needs to be fed."

"Call the neighbors," the wife said. "Someone will feed him if you ask them to." She tried to think who. She closed her eyes and tried to think anything at all.

After a time she said, "Maybe I'll do it. Maybe if I'm not here watching, he'll wake up. Maybe it's because I'm waiting that he won't."

"That could be it," the husband said.

"I'll go home and take a bath and put on something clean," the woman said.

"I think you should do that," the man said.

She picked up her purse. He helped her into her coat. She moved to the door, and looked back. She look at the child, and then she looked at the father. The husband nodded and smiled.

She went past the nurses' station and down to the end of the corridor, where she turned and saw a little wating room, a family in there, all sitting in wicker chairs, a man in a khaki shirt, a baseball cap pushed back on his head, a large woman wearing a housedress, slippers, a girl in jeans, hair in dozens of kinky braids, the table littered with flimsy wrappers and styrofoam and coffee sticks and packets of salt and pepper.

"Nelson," the woman said. "Is it about Nelson?"

The woman's eyes widened.

"Tell me now, lady," the woman said. "Is it about Nelson?"

The woman was trying to get up from her chair. But the man had his hand closed over her arm.

"Here, here," the man said.

"I'm sorry," the mother said. "I'm looking for the elevator. My son is in the hospital. I can't find the elevator."

"Elevator is down that way," the man said, and he aimed a finger in the right direction.

"My son was hit by a car," the mother said. "But he's going to be all right. He's in shock now, but it might be some kind of coma too. That's what worries us, the coma part. I'm going out for a little while. Maybe I'll take a bath. But my husband is with him. He's watching. There's a chance everything will change when I'm gone. My name is Ann Weiss."

The man shifted in his chair. He shook his head.

He said, "Our Nelson."

She pulled into the driveway. The dog ran out from behind the house. He ran in circles on the grass. She closed her eyes and leaned her head against the wheel. She listened to the ticking of the engine.

She got out of the car and went to the door. She turned on lights and put on water for tea. She opened a can and fed the dog. She sat down on the sofa with her

The telephone rang.

"Yes!" she said. "Hello!" she said.

"Mrs. Weiss," a man's voice said.

"Yes," she said. "This is Mrs. Weiss. Is it about Scotty?" she said.

"Scotty," the voice said. "It is about Scotty," the voice said. "It has to do with Scotty, yes."

A Small, Good Thing

RAYMOND CARVER

Saturday afternoon she drove to the bakery in the shopping center. After looking through a loose-leaf binder with photographs of cakes taped onto the pages, she ordered chocolate, the child's favorite. The cake she chose was decorated with a space ship and launching pad under a sprinkling of white stars at one end of the cake, and a planet made of red frosting at the other end. His name, Scotty, would be in raised green letters beneath the planet. The baker, who was an older man with a thick neck, listened without saying anything when she told him the cild would be eight years old next Monday. The baker wore a white apron that looked like a smock. Straps cut under his arms, went around in back and then to the front again where they were secured under his heavy waist. He wiped his hands on his apron as he listened to her. He kept his eyes down on the photographs and let her talk. He let her take her time. He'd just come to work and he'd be there all night, baking, and he was in no real hurry.

She gave the baker her name, Ann Weiss, and her telephone number. The cake would be ready on Monday morning, just out of the oven, in plenty of time for the child's party that afternoon. The baker was not jolly. There were no pleasantries between them, just the minimum exchange of words, the necessary information. He made her feel uncomfortable, and she didn't like that. While he was bent over the counter with the pencil in his hand, she studied his coarse features and wondered if he'd ever done anything else with his life besides be a baker. She was a mother and thirty-three years old, and it seemed to her that everyone, especially someone the baker's age—a man old enough to be her father—must have children who'd gone through this special time of cakes and birthday parties. There must be that between them, she thought. But he was abrupt with her, not rude, just abrupt. She gave up trying to make friends with him. She looked into the back of the bakery and could see a long, heavy wooden table with aluminum pie pans stacked at one end, and beside the table a metal container filled with empty racks. There was an enormous oven. A radio was playing country-western music.

The baker finished printing the information on the special order card and closed up the binder. He looked at her and said, "Monday morning." She thanked him and drove home.

On Monday morning, the birthday boy was walking to school with another boy. They were passing a bag of potato chips back and forth and the birthday boy was trying to find out what his friend intended to give him for his birthday that afternoon. Without looking, he stepped off the curb at an intersection and was immediately knocked down by a car. He fell on his side with his head in the gutter and his legs out in the road. His eyes were closed, but his legs began to move back and forth as if he were trying to climb over something. His friend dropped the potato chips and

started to cry. The car had gone a hundred feet or so and stopped in the middle of the road. A man in the driver's seat looked back over his shoulder. He waited until the boy got unsteadily to his feet. The boy wobbled a little. He looked dazed, but okay. The driver put the car into gear and drove away.

The birthday boy didn't cry, but he didn't have anything to say about anything either. He wouldn't answer when his friend asked him what it felt like to be hit by a car. He walked home, and his friend went on to school. But after the birthday boy was inside his house and was telling his mother about it, she sitting beside him on the sofa, holding his hands in her lap, saying, "Scotty, honey, are you sure you feel all right, baby?" thinking she would call the doctor anyway, he suddenly lay back on the sofa, closed his eyes, and went limp. When she couldn't wake him up, she hurried to the telphone and called her husband at work. Howard told her to remain to calm. remain calm, and then he called an ambulance for the child and left for the hospital himself.

Of course, the birthday party was cancelled. The child was in the hospital with a mild concussion and suffering from shock. There'd been vomiting, and his lungs had taken in fluid which needed pumping out that afternoon. Now he simply seemed to be in a very deep sleep—but no coma, Doctor Francis had emphasized; no coma, when he saw the alarm in the parents' eyes. At eleven o'clock that Monday night when the boy seemed to be resting comfortably enough after the many X-rays and the lab work, and it was just a matter of his waking up and coming around, Howard left the hospital. He and Ann had been at the hospital with the child since that morning, and he was going home for a short while to bathe and to change clothes. "I'll be back in an hour," he said. She nodded. "It's fine," she said. "I'll be right here." He kissed her on the forehead, and they touched hands. She sat in a chair beside the bed and looked at the child. She was waiting for him to wake up and be all right. Then she could begin to relax.

Howard drove home from the hospital. He took the wet, dark streets very fast, then caught himself and slowed down. Until now, his life had gone smoothly and to his satisfaction—college, marriage, another year of college for the advanced degree in business, a junior partnership in an investment firm. Fatherhood. He was happy and, so far, lucky—he knew that. His parents were still living, his brothers and his sister were established, his friends from college had gone out to take their places in the world. So far he had kept away from any real harm, from those forces he knew existed and that could cripple or bring down a man, if the luck went bad, if things suddenly turned. He pulled into the driveway and parked. His left leg began to tremble. He sat in the car for a minute and tried to deal with the present situation in a rational manner. Scotty had been hit by a car and was in the hospital, but he was going to be all right. He closed his eyes and ran his hand over his face. In a minute, he got out of the car and went up to the front door. The dog was barking inside the house. The telephone rang and rang while he unlocked the door and fumbled for the light switch. He shouldn't have left the hospital, he shouldn't have. "God dammit!" he said. He picked up the receiver and said, "I just walked in the door!"

"There's a cake here that wasn't picked up," the voice on the other end of the line said.

"What are you saying?" Howard asked.

"A cake," the voice said. "A sixteen dollar cake."

Howard held the receiver against his ear, trying to understand. "I don't know anything about a cake," he said. "Jesus, what are you talking about?"

"Don't hand me that," the voice said.

Howard hung up the telephone. He went into the kitchen and poured himself some whiskey. He called the hospital. But the child's condition remained the same; he was still sleeping and nothing had changed there. While water poured into the tub, Howard lathered his face and shaved. He'd just stretched out in the tub and closed his eyes when the telpheon began to ring. He hauled himself out, grabbed a towel, and hurried through the house, saying "Stupid, stupid," for having left the hospital. But when he picked up the receiver and shouted, "Hello!" there was no sound at the other end of the line. Then the caller hung up.

He arrived back at the hospital a little after midnight. Ann still sat in the chair beside the bed. She looked at Howard, and then she looked back at the child. The child's eyes stayed closed, the head was still wrapped in bandages. His breathing was quiet and regular. From an apparatus over the bed hung a bottle of glucose with a tube running from the bottle to the boy's arm.

"How is he?" Howard said. "What's all this?" waving at the glucose and the tube.

"Doctor Francis's orders," she said. "He needs nourishment. He needs to keep up his strength. Why doesn't he wake up, Howard? I don't understand, if he's all right."

Howard put his hand against the back of her head. He ran his fingers through her hair. "He's going to be all right. He'll wake up in a little while. Doctor Francis knows what's what."

After a time he said, "Maybe you should go home and get some rest. I'll stay here. Just don't put up with this creep who keeps calling. Hang up right away."

"Who's calling?" she asked.

"I don't know who, just somebody with nothing better to do than call up people. You go on now."

She shook her head. "No," she said, "I'm fine."

"Really," he said. "Go home for a while, and then come back and spell me in the morning. It'll be all right. What did Doctor Francis say? He said Scotty's going to be all right. We don't have to worry. He's just sleeping now, that's all."

A nurse pushed the door open. She nodded at them as she went to the bedside. She took the left arm out from under the covers and put her fingers on the wrist, found the pulse, and then consulted her watch. In a little while she put the arm back under the covers and moved to the foot of the bed where she wrote something on a clipboard attached to the bed.

"How is he?" Ann said. Howard's hand was a weight on her shoulder. She was aware of the pressure from his fingers.

"He's stable," the nurse said. Then she said, "Doctor will be in again shortly. Doctor's back in the hospital. He's making rounds right now."

"I was saying maybe she'd want to go home and get a little rest," Howard said. "After the doctor comes," he said.

"She could do that," the nurse said. "I think you should both feel free to do that, if you wish." The nurse was a big Scandinavian woman with blond hair. There was the trace of an accent in her speech.

"We'll see what the doctor says," Ann said. "I want to talk to the doctor. I don't think he should keep sleeping like this. I don't think that's a good sign." She brought her hand up to her eyes and let her head come forward a little. Howard's grip tightened on her shoulder, and then his hand moved to her neck where his fingers began to knead the muscles there.

"Doctor Francis will be here in a few minutes," the nurse said. Then she left the room.

Howard gazed at his son for a time, the small chest quietly rising and falling under the covers. For the first time since the terrible minutes after Ann's telephone call to him at his office, he felt a genuine fear starting in his limbs. He began shaking his head, trying to keep it away. Scotty was fine, but instead of sleeping at home in his own bed he was in a hospital bed with bandages around his head and a tube in his arm. But this help was what he needed right now.

Doctor Francis came in and shook hands with Howard, though they'd just seen each other a few hours before. Ann got up from the chair. "Doctor?"

"Ann," he said and nodded. "Let's just first see how he's doing," the doctor said. He moved to the side of the bed and took the boy's pulse. He peeled back one eyelid and then the other. Howard and Ann stood beside the doctor and watched. Then the doctor turned back the covers and listened to the boy's heart and lungs with his stethoscope. He pressed his fingers here and there on the abdomen. When he was finished he went to the end of the bed and studied the chart. He noted the time, scribbled something on the chart, and then looked at Howard and Ann.

"Doctor, how is he?" Howard said. "What's the matter with him exactly?"

"Why doesn't he wake up?" Ann said.

The doctor was a handsome, big-shouldered man with a tanned face. He wore a three-piece suit, a striped tie, and ivory cuff-links. His grey hair was combed along the sides of his head, and he looked as if he had just come from a concert. "He's all right," the doctor said. "Nothing to shout about, he could be better, I think. But he's all right. Still, I wish he'd wake up. He should wake up pretty soon." The doctor looked at the boy again. "We'll know some more in a couple of hourse, after the results of a few more tests are in. But he's all right, believe me, except for that hair-line fracture of the skull. He does have that."

"Oh, no," Ann said.

"And a bit of a concussion, as I said before. Of course, you know he's in shock," the doctor said. "Sometimes you see this in shock cases."

"But he's out of any real danger?" Howard said. "You said before he's not in a coma. You wouldn't call this a coma then, would you, doctor?" Howard waited. He looked at the doctor.

"No, I don't want to call it a coma," the doctor said and glanced over at the boy once more. "He's just in a very deep sleep. It's a restorative, a measure the body is taking on its own. He's out of any real danger, I'd say that for certain, yes. But we'll

know more when he wakes up and the other tests are in. Don't worry," the doctor said.

"It's a coma," Ann said. "Of sorts."

"It's not a coma yet, not exactly," the doctor said. "I wouldn't want to call it a coma. Not yet anyway. He's suffered shock. In shock cases this kind of reaction is common enough; it's a temporary reaction to bodily trauma. Coma. Well, coma is a deep, prolonged unconsciousness that could go on for days, or weeks even. Scotty's not in that area, not as far as we can tell anyway. I'm certain his condition will show improvement by morning. I'm betting that it will anyway. We'll know more when he wakes up, which shouldn't be long now. Of course, you may do as you like, stay here or go home for a time. But by all means feel free to leave the hospital for a while if you want. This is not easy, I know." The doctor gazed at the boy again, watching, and then he turned to Ann and said, "You try not to worry, little mother. Believe me, we're doing all that can be done. It's just a question of a little more time now." He nodded at her, shook hands with Howard again, and then he left the room.

Ann put her hand over her child's forehead. "At least he doesn't have a fever," she said. Then she said, "My God, he feels so cold though. Howard? Is he supposed to feel like this. Feel his head."

Howard touched the child's temples. His own breathing had slowed. "I think he's supposed to feel this way right now," he said. "He's in shock, remember? That's what the doctor said. The doctor was just in here. He would have said something if Scotty wasn't okay."

Ann stood there a while longer, working her lip with her teeth. Then she moved over to her chair and sat down.

Howard sat in the chair next to her chair. They looked at each other. He wanted to say something else and reassure her, but he was afraid too. He took her hand and put it in his lap, and this made him feel beter, her hand being there. He picked up her hand and squeezed it. Then he just held her hand. They sat like that for a while, watching the boy and not talking. From time to time he squeezed her hand. Finally, she took her hand away.

"I've been praying," she said.

He nodded.

She said, "I almost thought I'd forgotten how, but it came back to me. All I had to do was close my eyes and say, 'Please, God, help us—help Scotty'; and then the rest was easy. The words were right there. Maybe if you prayed too," she said to him.

"I've already prayed," he said. "I prayed this afternoon, yesterday afternoon, I mean, after you called, while I was driving to the hospital. I've been praying," he said.

"That's good," she said. For the first time now, she felt they were together in it, this trouble. She realized with a start it had only been happening to her and to Scotty. She hadn't let Howard into it, though he was there and needed all along. She felt glad to be his wife.

The same nurse came in and took the boy's pulse again and checked the flow from the bottle hanging above the bed. In an hour another doctor came in. He said his name was Parsons, from Radiology. He had a bushy moustache. He was wearing loafers, a western shirt, and a pair of jeans.

"We're going to take him downstairs for more pictures," he told them. "We need to do some more pictures, and we want to do a scan."

"What's that?" Ann said. "A scan?" She stood between this new doctor and the bed. "I thought you'd already taken all your X-rays."

"I'm afraid we need some more," he said. "Nothing to be alarmed about. We just need some more pictures, and we want to do a brain scan on him."

"My God," Ann said.

"It's perfectly normal procedure in cases like this," this new doctor said. "We just need to find out for sure why he isn't back awake yet. It's normal medical procedure, and nothing to be alarmed about. We'll be taking him down in a few minutes," this doctor said.

In a little while two orderlies came into the room with a gurny. They were black-haired, dark-complexioned men in white uniforms, and they said a few words to each other in a foreign tongue as they unhooked the boy from the tube and moved him from his bed to the gurny. Then they wheeled him from the room. Howard and Ann got on the same elevator. Ann stood beside the gurny and gazed at the child. She closed her eyes as the elevator began its descent. The orderlies stood at either end of the gurny without saying anything, though once one of the men made a comment to the other in their own language, and the other man nodded slowly in response.

Later that morning, just as the sun was beginning to lighten the windows in the waiting room outside the X-ray department, they brought the boy out and moved him back up to his room. Howard and Ann rode up on the elevator with him once more, and once more they took up their places beside the bed.

They waited all day, but still the boy did not wake up. Occasionally one of them would leave the room to go downstairs to the cafeteria to drink coffee and then, as if suddenly remembering and feeling guilty, get up from the table and hurry back to the room. Doctor Francis came again that afternoon and examined the boy once more and then left after telling them he was coming along and could wake up any minute now. Nurses, different nurses than the night before, came in from time to time. Then a young woman from the lab knocked and entered the room. She wore white slacks and a white blouse and carried a little tray of things which she put on the stand beside the bed. Without a word to them, she took blood from the boy's arm. Howard closed his eyes as the woman found the right place on the boy's arm and pushed the needle in.

"I don't understand this," Ann said to the woman.

"Doctor's orders," the young woman said. "I do what I'm told to do. They say draw that one, I draw. What's wrong with him, anyway?" she said. "He's a sweetie."

"He was hit by a car," Howard said. "A hit and run."

The young woman shook her head and looked again at the boy. Then she took her tray and left the room.

"Why won't he wake up?" Ann said. "Howard? I want some answers from these people."

Howard didn't say anything. He sat down again in the chair and crossed one leg over the other. He rubbed his face. He looked at his son and then he settled back in the chair, closed his eyes, and went to sleep.

Ann walked to the window and looked out at the parking lot. It was night and cars were driving into and out of the parking lot with their lights on. She stood at the window with her hands gripping the sill and knew in her heart that they were into something now. Something hard. She was afraid, and her teeth began to chatter until she tightened her jaws. She saw a big car stop in front of the hospital and someone, a woman in a long coat, got into the car. For a minute she wished she were that woman and somebody, anybody, was driving her away from here to somewhere else, a place where she would find Scotty waiting for her when she stepped out of the car, ready to say Mom and let her gather him in her arms.

In a little while Howard woke up. He looked at the boy again, and then he got up from the chair, stretched, and went over to stand beside her at the window. They both stared out at the parking lot. They didn't say anything. But they seemed to feel each other's insides now, as though the worry had made them transparent in a perfectly natural way.

The door opened and Doctor Francis came in. He was wearing a different suit and tie this time. His gray hair was combed along the sides of his head, and he looked as if he had just shaved. He went straight to the bed and examined the boy. "He ought to have come around by now. There's just no good reason for this," he said. "But I can tell you we're all convinced he's out of any danger. We'll just feel better when he wakes up. There's no reason, absolutely none, why he shouldn't come around. Very soon. Oh, he'll have himself a dilly of a headache when he does, you can count on that. But all of his signs are fine. They're as normal as can be."

"Is it a coma then?" Ann said.

The doctor rubbed his smooth cheek. "We'll call it that for the time being, until he wakes up. But you must be worn out. This is hard. Feel free to go out for a bite," he said. "It would do you good. I'll put a nurse in here while you're gone, if you'll feel better about going. Go and have yourselves something to eat."

"I couldn't eat," Ann said. "I'm not hungry."

"Do what you need to do, of course," the doctor said. "Anyway, I wanted to tell you that all the signs are good, the tests are positive, nothing at all negative, and just as soon he wakes up he'll be over the hill."

"Thank you, doctor," Howard said. He shook hands with the doctor again. The doctor patted Howard's shoulder and went out.

"I suppose one of us should go home and check things," Howard said. "Slug needs to be fed, for one thing."

"Call one of the neighbors," Ann said. "Call the Morgans. Anyone will feed a dog if you ask them to."

"All right," Howard said. After a while he said, "Honey why don't you do it? Why don't you go home and check on things, and then come back? It'll do you good. I'll

356

be right here with him. Seriously," he said. "We need to keep up our strength on this. We'll want to be here for a while even after he wakes up."

"Why don't you go?" she said. "Feed Slug. Feed yourself."

"I already went," he said. "I was gone for exactly an hour and fifteen minutes. You go home for an hour and freshen up. Then come back. I'll stay here."

She tried to think about it, but she was too tired. She closed her eyes and tried to think about it again. After a time she said, "Maybe I will go home for a few minutes. Maybe if I'm not just sitting right here watching him every second he'll wake up and be all right. You know? Maybe he'll wake up if I'm not here. I'll go home and take a bath and put on clean clothes. I'll feed Slug. Then I'll come back."

"I'll be right here," he said. "You go home, honey, and then come back. I'll be right here keeping an eye on things." His eyes were bloodshot and small, as if he'd been drinking for a long time. His clothes were rumpled. His beard had come out again. She touched his face, and then she took her hand back. She understood he wanted to be by himself for a while, to not have to talk or share his worry for a time. She picked up her purse from the nightstand, and he helped her into her coat.

"I won't be long," she said.

"Just sit and rest for a little while when you get home," he said. "Eat something. Take a bath. After you get out of the bath, just sit for a while and rest. It'll do you a world of good, you'll see. Then come back down here," he said. "Let's try not to worry. You heard what Doctor Francis said."

She stood in her coat for a minute trying to recall the doctor's exact words, looking for any nuances, any hint of something behind his words other than what he had said. She tried to remember if his expression had changed any when he bent over to examine the child. She remembered the way his features had composed themselves as he rolled back the child's eyelids and then listened to his breathing.

She went to the door where she turned and looked back. She looked at the child, and then she looked at the father. Howard nodded. She stepped out of the room and pulled the door closed behind her.

She went past the nurses' station and down to the end of the corridor, looking for the elevator. At the end of the corridor she turned to her right where she found a little waiting room where a Negro family sat in wicker chairs. There was a middle-aged man in a khaki shirt and pants, a baseball cap pushed back on his head. A large woman wearing a house dress and slippers was slumped in one of the chairs. A teenaged girl in jeans, hair done in dozens of little braids, lay stretched out in one of the chairs smoking a cigarette, her legs crossed at the ankles. The family swung their eyes to her as she entered the room. The little table was littered with hamburger wrappers and styrofoam cups.

"Franklin," the large woman said as she roused herself. "Is about Franklin?" Her eyes widened. "Tell me now, lady," the woman said. "Is about Franklin?" She was trying to rise from her chair, but the man had closed his hand over her arm.

"Here, here," he said. "Evelyn."

"I'm sorry," Ann said. "I'm looking for the elevator. My son is in the hospital, and now I can't find the elevator."

"Elevator is down that way, turn left," the man said as he aimed a finger.

The girl drew on her cigarette and stared at Ann. Her eyes were narrowed to slits, and her broad lips parted slowly as she let the smoke escape. The Negro woman let her head fall on her shoulder and looked away from Ann, no longer interested.

"My son was hit by a car," Ann said to the man. She seemed to need to explain herself. "He has a concussion and a little skull fracture, but he's going to be all right. He's in shock now, but it might be some kind of coma too. That's what really worries us, the coma part. I'm going out for a little while, but my husband is with him. Maybe he'll wake up while I'm gone."

"That's too bad," the man said and shifted in the chair. He shook his head. He looked down at the table, and then he looked back at Ann. She was still standing there. He said, "Our Franklin, he's on the operating table. Somebody cut him. Tried to kill him. There was a fight where he was at. At this party. They say he was just standing and watching. Not bothering nobody. But that don't mean nothing these day. Now he's on the operating table. We're just hoping and praying, that's all we can do now." He gazed at her steadily.

Ann looked at the girl again, who was still watching her, and at the older woman who kept her head down, but whose eyes were now closed. Ann saw the lips moving silently, making words. She had a urge to ask what those words were. She wanted to talk more with these people who were in the same kind of waiting she was in. She was afraid, and they were afraid. They had that in common. She would have liked to have said something else about the accident, told them more about Scotty, that it had happened on the day of his birthday, Monday, and that he was still unconscious. Yet she didn't know how to begin. She stood there looking at them without saying anything more.

She went down the corridor the man had indicated and found the elevator. She stood for a minute in front of the closed dorrs, still wondering if she was doing the right thing. Then she put out her finger and touched the button.

She pulled into the driveway and cut the engine. She closed her eyes and leaned her head against the wheel for a minute. She listened to the ticking sounds the engine made as it began to cool. Then she got out of the car. She could hear the dog barking inside the house. She went to the front door, which was unlocked. She went inside and turned on lights and put on a kettle of water for tea. She opened some dog food and fed Slug on the back porch. The dog ate in hungry little smacks. It kept running into the kitchen to see that she was going to stay. As she sat down on the sofa with her tea, the telephone rang.

"Yes!" she said as she answered. "Hello!"

"Mrs. Weiss," a man's voice said. It was five o'clock in the morning, and she thought she could hear machinery or equipment of some kind in the background.

"Yes, yes! What is it?" she said. "This is Mrs. Weiss. This is she. What is it, please?" She listened to whatever it was in the background. "Is it Scotty, for Christ's sake?"

"Scotty," the man's voice said. "It's about Scotty, yes. It has to do with Scotty, that problem. Have you forgotten about Scotty?" the man said. Then he hung up. She dialed the hospital's number and asked for the third floor. She demanded in-

formation about her son from the nurse who answered the telephone. Then she asked to speak to her husband. It was, she said, an emergency.

She waited, turning the telephone cord in her fingers. She closed her eyes and felt sick to her stomach. She would have to make herself eat. Slug came in from the back porch and lay down near her feet. He wagged his tail. She pulled at his ear while he licked her fingers. Howard was on the line.

"Somebody just called here," she said. She twisted the telephone cord. "He said, he said it was about Scotty." She cried.

"Scotty's fine," Howard told her. "I mean he's still sleeping. There's been no change. The nurse has been in twice since you've been gone, they're in here every thirty minutes or so. A nurse or else a doctor. He's all right."

"Somebody called, he said it was about Scotty," she said.

"Honey, you rest for a little while, you need the rest. Then come back here. It must be that same caller I had. Just forget it. Come back down here after you've rested. Then we'll have breakfast or something."

"Breakfast," she said. "I don't want any breakfast."

"You know what I mean," he said. "Juice, something, I don't know. I don't know anything, Ann. Jesus, I'm not hungry either. Ann, it's hard to talk now. I'm standing here at the desk. Doctor Francis is coming again at eight o'clock this morning. He's going to have something to tell us then, something more definite. That's what one of the nurses said. She didn't know any more than that. Ann? Honey, maybe we'll know something more then. At eight o'clock. Come back here before eight. Meanwhile, I'm right here and Scotty's all right. He's still the same," he added.

"I was drinking a cup of tea," she said, "when the telephone rang. They said it was about Scotty. There was a noise in the background. Was there a noise in the background on that call you had, Howard?"

"I don't remember," he said. "Maybe the driver of the car, maybe he's a psychopath and found out about Scotty somehow. But I'm here with him. Just rest like you were going to do. Take a bath and come back by seven or so, and we'll talk to the doctor together when he gets here. It's going to be all right, honey. I'm here, and there are doctors and nurses around. They say his condition is stable."

"I'm scared to death," she said.

She ran water, undressed, and got into the tub. She washed and dried quickly, not taking the time to wash her hair. She put on clean underwear, wool slacks, and a sweater. She went into the living room where the dog looked up at her and let its tail thump once against the floor. It was just starting to get light outside when she went out to the car.

She drove into the parking lot of the hospital and found a space close to the front door. She felt she was in some obscure way responsible for what had happened to the child. She let her thoughts move to the Negro family. She remembered the name "Franklin" and the table that was covered with hamburger papers, and the teenaged girl staring at her as she drew on her cigarette. "Don't have children," she told the girl's image as she entered the front door of the hospital. "For God's sake, don't."

She took the elevator up to the third floor with two nurses who were just young on duty. It was Wednesday morning, a few minutes before seven. There was a page for a Doctor Madison as the elevator doors slid open on the third floor. She got off behind the nurses, who turned in the other direction and continued the conversation she had interrupted when she'd gotten into the elevator. She walked down the corridor to the little alcove where the Negro family had been waiting. They were gone now, but the chairs were scattered in such a way that it looked as if people had just jumped from them the minute before. The table top cluttered with the same cups and papers, the ashtray was filled with cigarette butts.

She stopped at the nurses' station just down the corridor from the waiting room. A nurse was standing behind the counter, brushing her hair and yawning.

"There was a Negro man in surgery last night," Ann said. "Franklin was his name. His family was in the waiting room. I'd like to inquire about his condition."

A nurse who was sitting at the desk behind the counter looked up from a chart in front of her. The telephone buzzed and she picked up the receiver, but she kept her eyes on Ann.

"He passed away," said the nurse at the counter. The nurse held the hairbrush and kept looking at her. "Are you a friend of the family or what?"

"I met the family last night," Ann said. "My own son is in the hospital. I guess he's in shock. We don't know for sure what's wrong. I just wondered about Mr. Franklin, that's all. Thank you." She moved down the corridor. Elevator doors the same color as the walls slid open and a gaunt, bald man in white pants and white canvas shoes pulled a heavy cart off the elevator. She hadn't noticed these doors last night. The man wheeled the cart out into the corridor and stopped in front of the room nearest the elevator and consulted a clipboard. Then he reached down and slid a tray out of the cart. He rapped lightly on the door and entered the room. She could smell the unpleasant odors of warm food as she passed the cart. She hurried past the other station without looking at any of the nurses and pushed open the door to the child's room.

Howard was standing at the window with his hands behind his back. He turned around as she came in.

"How is he?" she said. She went over to the bed. She dropped her purse on the floor beside the nightstand. She seemed to have been gone a long time. She touched the child's face. "Howard?"

"Doctor Francis was here a little while ago," Howard said. She looked at him closely and thought his shoulders were bunched a little.

"I thought he wasn't coming until eight o'clock this morning," she said quickly. "There was another doctor with him. A neurologist."

"A neurologist," she said.

Howard nodded. His shoulders were bunching, she could see that. "What'd they say, Howard? For Christ's sake, what'd they say? What is it?

"They said they're going to take him down and run more tests on him, Ann. They think they're going to operate, honey. Honey, they are going to operate. They can't figure out why he won't wake up. It's more than just shock or concussion, they know

that much now. It's in his skull, the fracture, it has something, something to do with that, they think. So they're going to operate. I tried to call you, but I guess you'd already left the house."

"Oh God," she said. "Oh, please, Howard, please," she said, taking his arms.

"Look!" Howard said then. "Scotty! Look, Ann!" He turned her toward the bed. The boy had opened his eyes, then closed them. He opened them again now. The eyes stared straight ahead for a minute, then moved slowly in his head until they rested on Howard and Ann, then traveled away again.

"Scotty," his mother said, moving to the bed.

"Hey, Scott," his father said. "Hey, son."

They leaned over the bed. Howard took the child's hand in his hands and began to pat and squeeze the hand. Ann bent over the boy and kissed his forehead again and again. She put her hands on either side of his face. "Scotty, honey, it's mommy and daddy," she said. "Scotty?"

The boy looked at them, but without any sign of recognition. Then his eyes scrunched closed, his mouth opened and he howled until he had no more air in his lungs. His face seemed to relax and soften then. His lips parted as his last breath was puffed through his throat and exhaled gently through the clenched teeth.

The doctors called it a hidden occlusion and said it was a one-in-a-million circumstance. Maybe if it could have been detected somehow and surgery undertaken immediately, it could have saved him. But more than likely not. In any case, what would they have been looking for? Nothing had shown up in the tests or in the Xrays. Doctor Francis was shaken. "I can't tell you how badly I feel. I'm so very sorry, I can't tell you," he said as he led them into the doctors' lounge. There was a doctor sitting in a chair with his legs hooked over the back of another chair, watching an early morning TV show. He was wearing a green delivery room outfit, loose green pants and green blouse, and a green cap that covered his hair. He looked at Howard and Ann and then looked at Doctor Francis. He got to his feet and turned off the set and went out of the room. Doctor Francis guided Ann to the sofa, sat down beside her and began to talk in a low, consoling voice. At one point he leaned over and embraced her. She could feel his chest rising and falling evenly against her shoulder. She kept her eyes open and let him hold her. Howard went into the bathroom, but he left the door open. After a violent fit of weeping, he ran water and washed his face. Then he came out and sat down at the little table that held a telephone. He looked at the telephone as though deciding what to do first. He made some calls. After a time, Doctor Francis used the telephone.

"Is there anything else I can do for the moment?" he asked them.

Howard shook his head. Ann stared at Doctor Francis as if unable to comprehend his words.

The doctor walked them to the hospital's front door. People were entering and leaving the hospital. It was eleven o'clock in the morning. Ann was aware of how slowly, almost reluctantly she moved her feet. It seemed to her that Doctor Francis was making them leave, when she felt they should stay, when it would be more the right thing to do, to stay. She gazed out into the parking lot and then turned around and looked back at the front of the hospital. She began shaking her head. "No, no," she said. "I can't leave him here, no." She heard herself say that and thought how unfair it was that the only words that came out were the sort of words used on TV shows where people were stunned by violent or sudden deaths. She wanted her words to be her own. "No," she said, and for some reason the memory of the Negro woman's head lolling on the woman's shoulder came to her. "No," she said again.

"I'll be talking to you later in the day," the doctor was saying to Howard. "There are still some things that have to be done, things that have to be cleared up to our satisfaction. Some things that need explaining."

"An autopsy," Howard said.

Doctor Francis nodded.

"I understand," Howard said. Then he said, "Oh Jesus. No, I don't understand, Doctor. I can't, I can't. I just can't."

Doctor Francis put his arm around Howard's shoulders. "I'm sorry. God, how I'm sorry." He let go of Howard's shoulders and held out his hand. Howard looked at the hand, and then he took it. Doctor Francis put his arms around Ann once more. He seemed full of some goodness she didn't understand. She let her head rest on his shoulder, but her eyes stayed open. She kept looking at the hospital. As they drove out of the parking lot, she looked back at the hospital once more.

At home, she sat on the sofa with her hands in her coat pockets. Howard closed the door to the child's room. He got the coffee maker going and then he found an empty box. He had thought to pick up some of the child's things. But instead he sat down beside her on the sofa, pushed the box to one side, and leaned forward, arms between his knees. He began to weep. She pulled his head over into her lap and patted his shoulder. "He's gone," she said. She kept patting his shoulder. Over his sobs she could hear the coffee maker hissing in the kitchen. "There, there," she said tenderly. "Howard, he's gone. He's gone and now we'll have to get used to that. To being alone."

In a little while Howard got up and began moving aimlessly around the room with the box, not putting anything into it, but collecting some things together on the floor at one end of the sofa. She continued to sit with her hands in her coat pockets. Howard put the box down and brought coffee into the living room. Later, Ann made calls to relatives. After each call had been placed and the party had answered, Ann would blurt out a few words and cry for a minute. Then she would quietly explain, in a measured voice, what had happened and tell them about arrangements. Howard took the box out to the garage where he saw the child's bicycle. He dropped the box and sat down on the pavement beside the bicycle. He took hold of the bicycle awkwardly so that it leaned against his chest. He held it, the rubber pedal sticking into his chest. He gave the wheel a turn.

Ann hung up the telephone after talking to her sister. She was looking up another number, when the telephone rang. She picked it up on the first ring.

"Hello," she said, and she heard something in the background, a humming noise. "Hello!" she said. "For God's sake," she said. "Who is this? What is it you want?"

"Your Scotty, I got him ready for you," the man's voice said. "Did you forget him?"

"You evil bastard!" she shouted into the receiver. "How can you do this, you evil son of a bitch?"

"Scotty," the man said. "Have you forgotten about Scotty?" Then the man hung up on her.

Howard heard the shouting and came in to find her with her head on her arms over the table, weeping. He picked up the receiver and listened to the dial tone.

Much later, just before midnight, after they had dealt with many things, the telephone rang again.

"You answer it," she said. "Howard, it's him, I know." They were sitting at the kitchen table with coffee in front of them. Howard had a small glass of whisky beside his cup. He answered on the third ring.

"Hello," he said. "Who is this? Hello! Hello!" The line went dead. "He hung up," Howard said. "Whoever it was."

"It was him," she said. "That bastard, I'd like to kill him," she said. "I'd like to shoot him and watch him kick," she said.

"Ann, my God," he said.

"Could you hear anything?" she said. "In the background? A noise, machinery, something humming?"

"Nothing, really. Nothing like that," he said. "There wasn't much time. I think there was some radio music. Yes, there was a radio going, that's all I could tell. I don't know what in God's name is going on," he said.

She shook her head. "If I could, could get, my hands, on him." It came to her then. She knew who it was. Scotty, the cake, the telephone number. She pushed the chair away from the table and got up. "Drive me down to the shopping center," she said. "Howard."

"What are you saying?"

"The shopping center. I know who it is who's calling. I know who it is. It's the baker, the son-of-a-bitching baker, Howard. I had him bake a cake for Scotty's birthday. That's who's calling. That's who has the number and keeps calling us. To harass us about the cake. The baker, that bastard."

They drove out to the shopping center. The sky was clear and stars were out. It was cold, and they ran the heater in the car. They parked in front of the bakery. All of the shops and stores were closed, but there were cars at the far end of the lot in front of the cinema. The bakery windows were dark, but when they looked through the glass they could see a light in the back room and, now and then, a big man in an apron moving in and out of the white, even light. Through the glass she could see the display cases and some little tables and chairs. She tried the door. She rapped on the glass. But if the baker heard them he gave no sign. He didn't look in their direction.

They drove around behind the bakery and parked. They got out of the car. There was a lighted window too high up for them to see inside. A sign near the back door said, "The Pantry Bakery, Special Orders." She could hear faintly a radio playing inside and something—an oven door?—creak as it was pulled down. She knocked on the door and waited. Then she knocked again, louder. The radio was turned down

and there was a scraping sound now, the distant sound of something, a drawer, being pulled open and then closed.

Someone unlocked the door and opened it. The baker stood in the light and peered out at them. "I'm closed for business," he said. "What do you want at this hour? It's midnight. Are you drunk or something?"

She stepped into the light that fell through the open door. He blinked his heavy eyelids as he recognized her.

"It's you," he said.

"It's me," she said. "Scotty's mother. This is Scotty's father. We'd like to come in." The baker said, "I'm busy now. I have work to do."

She stepped inside the doorway anyway. Howard came in behind her. The baker moved back. "It smells like a bakery in here. Doesn't it smell like a bakery in here, Howard?"

"What do you want?" the baker said. "Maybe you want your cake? That's it, you decided you want your cake. You ordered a cake, didn't you?"

"You're pretty smart for a baker," she said. "Howard, this is the man who's been calling us. This is the baker man." She clenched her fists. She stared at him fiercely. There was a deep burning inside her, an anger that made her feel larger than herself, larger than either of these men.

"Just a minute here," the baker said. "You want to pick up your three day old cake? That it? I don't want to argue with you, lady. There it sits over there, getting stale. I'll give it to you for half of what I quoted you. No. You want it? You can have it. It's no good to me, no good to anyone now. It cost me time and money to make that cake. If you want it, okay, if you don't, that's okay too. I have to get back to work." He looked at them and rolled his tongue behind his teeth.

"More cakes," she said. She knew she was in control of it, of what was increasing her. She was calm.

"Lady, I work sixteen hours a day in this place to earn a living," the baker said. He wiped his hands on his apron. "I work night and day in here, trying to make ends meet." A look crossed Ann's face that made the baker move back and say, "No trouble now." He reached to the counter and picked up a rolling pin with his right hand and began to tap it against the palm of his other hand. "You want the cake or not? I have to get back to work. Bakers work at night," he said again. His eyes were small, mean-looking, she thought, nearly lost in the bristly flesh around his cheeks. His neck was thick with fat.

"We know bakers work at night," Ann said. "They make phone calls at night too. You bastard," she said.

The baker continued to tap the rolling pin against his hand. He glanced at Howard. "Careful, careful," he said to Howard.

"My son's dead," she said with a cold, even finality. "He was hit by a car Monday morning. We've been waiting with him until he died. But of course, you couldn't be expected to know that, could you? Bakers can't know everything. Can they, Mr. Baker? But he's dead. He's dead, you bastard!" Just as suddenly as it had welled in her the anger dwindled, gave way to something else, a dizzy feeling of nausea. She leaned against the wooden table that was sprinkled with flour, put her hands over her face

and began to cry, her shoulders rocking back and forth. "It isn't fair," she said. "It isn't, isn't fair.

Howard put his hand at the small of her back and looked at the baker. "Shame on you," Howard said to him. "Shame."

The baker put the rolling pin back on the counter. He undid his apron and threw it on the counter. He looked at them, and then he shook his head slowly. He pulled a chair out from under a card table that held papers, and receipts, an adding machine and a telephone directory. "Please sit down," he said. "Let me get you a chair," he said to Howard. "Sit down now, please." The baker went into the front of the shop and returned with two little wrought-iron chairs. "Please sit down you people."

Ann wiped her eyes and looked at the baker. "I wanted to kill you," she said. "I wanted you dead."

The baker had cleared a space for them at the table. He shoved the adding machine to one side, along with the stacks of note paper and receipts. He pushed the telephone directory onto the floor, where it landed with a thud. Howard and Ann sat down and pulled their chairs up to the table. The baker sat down too.

"I don't blame you," the baker said, putting his elbows on the table. "First. Let me say how sorry I am. God alone knows how sorry. Listen to me. I'm just a baker, I don't claim to be anything else. Maybe once, maybe years ago I was a different kind of human being. I've forgotten, I don't know for sure. But I'm not any longer, if I ever was. Now I'm just a baker. That don't excuse my offense, I know. But I'm deeply sorry. I'm sorry for your son, and I'm sorry for my part in this. Sweet, sweet Jesus," the baker said. He spread his hands out on the table and turned them over to reveal his palms. "I don't have any children myself, so I can only imagine what you must be feeling. All I can say to you now is that I'm sorry. Forgive me, if you can," the baker said. "I'm not an evil man, I don't think. Not evil, like you said on the phone. You got to understand that what it comes down to is I don't know how to act anymore, it would seem. Please," the man said, "let me ask you if you can find it in your hearts to forgive me?"

It was warm inside the bakery. In a minute, Howard stood up from the table and took off his coat. He helped Ann from her coat. The baker looked at them for a minute and then nodded and got up from the table. He went to the oven and turned off some switches. He found cups and poured coffee from an electric coffee maker. He put a carton of cream on the table, and a bowl of sugar.

"You probably need to eat something," the baker said. "I hope you'll eat some of my hot rolls. You have to eat and keep going. Eating is a small, good thing in a time like this," he said.

He served them warm cinnamon rolls just out of the oven, the icing still runny. He put butter on the table and knives to spread the butter. Then the baker sat down at the table with them. He waited. He waited until they each took a roll from the platter and began to eat. "It's good to eat something," he said, watching them. "There's more. Eat up. Eat all you want. There's all the rolls in the world here."

They are rolls and drank coffee. Ann was suddenly hungry, and the rolls were warm and sweet. She ate three of them, which pleased the baker. Then he began to talk. They listened carefully. Although they were tired and in anguish, they listened to what the baker had to say. They nodded when the baker began to speak of lone-liness, and the sense of doubt and limitation that had come to him in his middle years. He told them what it was like to be childless all these years. To repeat the days with the ovens endlessly full and endlessly empty. The party food, the celebrations he'd worked over. Icing knuckle-deep. The tiny wedding couples stuck into cakes. Hundreds of them, no, thousands by now. Birthdays. Just imagine all those candles burning. He had a necessary trade. He was a baker. He was glad he wasn't a florist. It was better to be feeding people. This was a better smell anytime than flowers.

"Smell this," the baker said, breaking open a dark loaf. "It's a heavy bread, but rich." They smelled it, then he had them taste it. It had the taste of molasses and coarse grains. They listened to him. They ate what they could. They swallowed the dark bread. It was like daylight under the flourescent trays of light. They talked on into the early morning, the high pale cast of light in the windows, and they did not think of leaving.

Suggestions for Discussion

- 1. Larry McCaffrey and Sinda Gregory speak of the period in which Raymond Carver wrote "A Small, Good Thing" as a time of "opening up" for the author, in which he explores "more interior territory using less constricted language." Compare the first scenes of the two versions. How does the fuller language alter your perception of the characters, the atmosphere?
- 2. In an interview, Carver said that in contrast to the menace of "The Bath," "there's a lot more optimism" in "A Small, Good Thing." What techniques does Carver use in the former to create menace, in the latter to suggest optimism? How does the addition of the scene in the bakery at the end of the story alter its theme?
- 3. The mother's confrontation with the family in the waiting room (pages 348 and 356–357) is dramatically different in the two versions. What effect was the author seeking in each case, and how do the techniques differ?
- 4. Focus on how each of the stories employs one element of fiction described in this book: plot, or detail, or dialogue, or point of view, and so forth. How does a different use of the techniques involved lead to a different story?
- 5. An adaptation of "A Small, Good Thing" was included in the Robert Altman film Short Cuts, based on several of Carver's stories. See the film and consider how the story is further altered by revisions made for the film. For example, the driver of the car that hits the boy is changed from a man to a woman, and one we know in another context. How does this alter the ultimate atmosphere, theme, and our sympathies and judgments?

Retrospect

1. Pick any story in this book that dissatisfied you. Imagine that you are the editor of a magazine that is going to publish it. What suggestions for revision would you make to the author?

Writing Assignments

- 1. If you did Assignment 4 in chapter 2 (the postcard short story), rewrite your story, making it at least three times as long, so that the development enriches the action and the characters.
- 2. Choose any other story you wrote this term; rewrite it, improving it any way you can, but also cutting its original length by a least one quarter.
- 3. Pick a passage from your journal and use Stephen Dunning's method (page 337) of highlighting "words, phrases, images, talk, mistakes." Cluster and/or freedraft a passage from some of these highlightings. Rewrite the passage. Put it away for a few days. Is it a story? Rewrite it. Put it away. Rewrite it.
- 4. A class project: Spend about a half hour in class writing a scene that involves a conflict between two characters. Make a copy of what you write. Take one copy home and rewrite it. Send the other copy home with another class member for him or her to make critical comments and suggestions. Compare your impulses with those of your reader. On the following day, forgive your reader. On the day after that, rewrite the passage once more, incorporating any of the reader's suggestions that prove useful.

APPENDIX A

KINDS OF FICTION

What follows is a discussion of some kinds of fiction likely to be found in current books and magazines, which are also the kinds of contemporary narrative most likely to show up in the workshop. This is not by any means a comprehensive list, nor does it deal with the forms that represent the history of narrative—myth, tale, fable, allegory, and so forth—some of which are mentioned elsewhere in this book.

Mainstream refers to fiction that deals with subject matter with a broad appeal—situations and emotions common to and of interest to large numbers of readers in the culture for which it is intended. Mainstream fiction is literary fiction if its appeal is also lodged in the original, interesting, and illuminating use of the language; the term also implies a degree of care in the psychological exploration of its characters, and an attempt to shed light on the human condition. All of the stories in this volume fall under the general category of literary fiction.

Literary fiction differs from genre fiction fundamentally in the fact that the former is character-driven, the latter plot-driven. There is a strong tendency—though it is not a binding rule—of genre fiction to imply that life is fair, and to let the hero or heroine, after great struggle, win out in the end; and of literary fiction to posit that life is not fair, that triumph is partial, happiness tentative, and the heroine and hero are subject to mortality. Literary fiction also strives (though postmodern critics often and interestingly dispute whether the attempt to escape convention is futile) to reveal its meaning through the creation of unexpected or unusual characters, through patterns of action and turns of event that will surprise the reader. Genre fiction, on the other hand, tends to develop character stereotypes and set patterns of action that become part of the expectation, the demand, and the pleasure of the readers of that genre.

Readers of the **romance** genre, for example, will expect a plucky-but-down-on-her-luck heroine, a handsome and mysterious hero with some dark secret (usually a dark-haired woman) in his background, a large house, a woods (through which the heroine will at some point flee in scanty clothing), and an eventual happy ending with the heroine in the hero's arms. These elements can be seen in embryo in the literary fiction of the Brontë sisters; by now, in the dozens of Harlequin and Silhou-

ette romances on the supermarket rack, they have become formulaic, and the language is similar from book to book.

Like romance, most genres have developed from a kind of fiction that was at one time mainstream and represented a major social problem or concern. Early romance, for example, dealt with the serious question of how a woman was to satisfy the need for both stability and love in married life, how to be both independent and secure in a society with rigid sexual rules. The detective story evolved simultaneously with widespread and intense interest in science, an optimistic expectation that violence and mystery could be rationally explained. The western dealt with the ambivalence felt by large numbers of westward-traveling Euro-Americans about the civilizing of the wilderness, the desire to rid the West of its brutality, the fear that "taming" it would also destroy its promise of solitude and freedom. Science fiction, the most recently developed and still developing genre, similarly deals with ambivalence about technology, the near-miraculous accomplishments of the human race through science, the dangers to human feeling, soul, and environment. The surge in popularity of fantasy fiction can probably be attributed to nostalgia for a time still more free of technological accomplishment and threat, since fantasy employs a medieval setting and solves problems through magic, whereas science fiction is set in the future and solves problems through intelligence and technology. It is relevant that science fiction usually deals with some problem that can be seen to have a counterpart in the contemporary culture (space travel, international or interplanetary intrigue, mechanical replacement of body parts, genetic manipulation), whereas the plots of fantasies tend to deal with obsolete or archaic traumas—wicked overlords, demon interlopers, and so forth. Because of this contemporary concern, science fiction seems capable at this point in history of a deployment much more varied and original than other genres, and more often engages the attention of writers (and filmmakers) with literary intentions and ambitions. Among such writers are William Gibson, Ursula K. LeGuin, Philip K. Dick, and Doris Lessing.

In any case, the many other genres, including but not confined to adventure, spy, horror, and thriller, each have their own set of conventions of character, language, and events. Note again that the very naming of these kinds of fiction implies a narrowing; unlike mainstream fiction, they appeal to a particular restricted range of interest.

Many—perhaps most—teachers of fiction writing do not accept manuscripts in genre, and I believe there's good reason for this, which is that whereas writing literary fiction can teach you how to write good genre fiction, writing genre fiction does not teach you how to write good literary fiction—does not, in effect, teach you "how to write," by which I mean how to be original and meaningful in words. Further, dealing in the conventions and hackneyed phrases of romance, horror, fantasy, and so forth can operate as a form of personal denial, using writing as a means of avoiding rather than uncovering your real concerns. It may be fine to offer readers an escape through fiction, but it isn't a way to educate yourself as a writer, and it's also fair to say that escape does not represent the goal of a liberal education, which is to pursue, inquire, seek, and extend knowledge of whatever subject is at hand, fiction no less than science.

Partly because many college teachers of creative writing do not welcome genre fiction in the classroom, there has developed a notion of a "workshop story" that is realistic, sensitive, and small. I have never known a teacher who solicited such stories, or any particular sort of story. Leaps of imagination, originality, and genuine experimentation are in my experience welcome to both instructors and students. But it is true that often what seems wild and crazy to the student writer has occurred to others before. Stories set in dreams, outer space, game shows, heaven and hell, may seem strange and wonderful by comparison with daily life, but they are familiar as "experiments" and likely to be less startling to their readers than the author expects, whereas extreme focus on what the author has experienced may seem striking and fresh. Realism—the attempt to render an authentic picture of life, in such a way that the reader identifies with one or more characters—is a fair starting point for the pursuit of literary fiction. The writer's attempt at verisimilitude is comparable to the scientific method of observation and verification. Realism is also a convention, and not the only way to begin to write; but like the drawing of still life in the study of painting it can impart skills that will be useful in more sophisticated efforts whether they are realistic or not. Many of the stories in this book are realistic; "How Far She Went," "Royal Beatings," and "Ralph the Duck," for example, might be seen as attempts to reveal in recognizable detail the drama of ordinary life.

Experimental fiction is always possible, however. It's more difficult by far to describe what is experimental in fiction than what is cliché, because by definition the experimental is the thing that nobody expects or predicts. There are, however, a number of kinds of experiments that have attracted enough writers in the past few decades that they have come to be recognized as subsets of literary fiction, and yet still retain the tentative, exploratory air of the experimental. A few of these are worth mentioning.

Metafiction is interesting because it takes as its subject matter the writing of fiction. It calls attention to its own techniques, insists continually that what is happening is that a story is being written and read. Often the writing of the story is used as a metaphor for some other human struggle or endeavor, or the author uses the narrative to remind us that we make meaning of our lives by making up stories. "Ad Infinitum: A Short Story" by John Barth in this volume is an example of metafiction. Laurence Sterne's *Tristram Shandy* is sometimes credited with being the inspiration for the self-reflexive genre of metafiction. Those interested in the techniques might seek out other John Barth stories and novels, especially the long story "Lost in the Funhouse" in the collection of the same name, or John Fowles's novel *The French Lieutenant's Woman*.

Magic realism uses the techniques and devices of realism—verisimilitude, ordinary lives and settings, familiar psychology—and introduces events of impossible or fantastic nature, never leaving the tone and techniques of realism. Whereas fantasy will attempt to bedazzle its readers with the amazing quality of the magic, magic realism works in the opposite direction, to convince the reader that the extraordinary occurs in the context and the guise of the ordinary. David Lodge, in *The Art of Fiction*, interestingly points out that the practitioners of magic realism tend to have lived through some sort of historical upheaval—a political coup or terror, a literal

war or gender war. Flight, he points out, is a central image in this fiction, because the defiance of gravity represents a persistent "human dream of the impossible." Gabriel García Marquez, whose "A Very Old Man with Enormous Wings" appears in this volume, is a foremost practitioner of magic realism, and his novel *One Hundred Years of Solitude* is the best-known example of the genre. Interested readers might look for *Labyrinths* by Jorge Luis Borges, who is often considered the father of this experimental mode.

Minimalism (also called miniaturism) refers to a flat, spare, and subdued style of writing, characterized by an accumulation of (sometimes apparently random) detail that gives an impression of benumbed emotion. The point of view tends to be objective or near-objective, the events reported without interpretation and accumulating toward a tense, disturbing—and inconclusive—conclusion. Raymond Carver's "The Bath" and "A Small, Good Thing" are examples of minimalism, the former more minimalist than the latter, and his story collections are exemplars of the style. Others who write in the minimalist mode include Amy Hempel and Ann Beattie.

It's always comforting to have a good reference book on hand when an unfamiliar literary term comes up. Two I recommend are the *The Fiction Dictionary* by Laurie Henry (Cincinnati: Story Press, 1995) and *The Bedford Glossary of Critical and Literary Terms* by Ross Murfin and Supryia M. Ray (Boston and New York: Bedford Books, 1997).

APPENDIX B

SUGGESTIONS FOR FURTHER READING

Like writing programs and writers' conferences, books on writing have proliferated in the last quarter-century, and you can probably find a new one on the Internet or the library bookshelf for every week of the year. Browse for your own favorites—don't forget to write meanwhile. Here are some—most of them written by writers for writers—that have struck me as most useful, graceful, or original:

- Aristotle, *The Poetics*. This is the first extant work of literary criticism and the essay from which all later criticism derives. There are numerous good translations.
- Atchity, Kenneth. A Writer's Time: A Guide to the Writer's Process from Vision through Revision. New York: Norton, 1988. Atchity focuses on the problem every writer complains about most and offers startling perceptions and helpful directions for finding and apportioning time.
- Barzun, Jacques. On Writing, Editing, and Publishing. Chicago: University of Chicago Press, 1986. Is it possible to be elegant, irascible, practical, and witty, at the same time, at the full stretch of each? Read it and see.
- Baxter, Charles. Burning Down the House: Essays on Fiction. St. Paul: Graywolf Press, 1997. Discursive, insightful, and large-minded, Baxter ruminates on craft in its relation to our culture. Some of his best passages convincingly and interestingly challenge traditional ideas laid down in Writing Fiction.
- Bell, Madison Smartt. Narrative Design: A Writer's Guide to Structure. New York: Norton, 1997. Bell begins and ends with the assumption that all the elements of fiction are subservient to narrative form. His close readings of stories shows how the authors have gone about making choices that contribute to overall design. His chapter on "Unconscious Mind" is brilliant, and the whole book is full of insight.
- Bernays, Anne, and Pamela Painter. What If? Writing Exercises for Fiction Writers. New York: Harper Collins, 1995. Bernays and Painter identify more than seventy-five situations that a writer may face and provide exercises for each; in-

- cluded are student examples and clear descriptions of objectives. This book is useful and provocative.
- Bly, Carol. *The Passionate*, *Accurate Story*. Minneapolis: Milkweed Editions, 1990. A genuine original, this book makes a thoughtful plea for value in writing and writing from your values. It combines the insights of literary technique, therapy, and ethics. Since it is written in the form of interlocking stories, it reads quickly and entertainingly.
- Booth, Wayne C. *The Rhetoric of Fiction*, 2nd ed. Chicago: University of Chicago Press, 1983. This is a thorough, brilliant, and difficult discussion of point of view, which well repays the effort of its reading.
- Brande, Dorothea. *Becoming a Writer*. Los Angeles: J. P. Tarcher, 1981. For those who are overmeticulous, or who have a hard time getting started, Brande's mind-freeing exercises may be enormously helpful.
- Brown, Kurt, ed. Writers on Life and Craft. Boston: Beacon, ongoing. This series culls the best of the lectures, talks, and keynote speeches from writing conferences around the country. It is various and thoughtful, and cheaper than travel.
- Brown, Rita Mae. Starting from Scratch: A Different Kind of Writer's Manual. New York: Bantam, 1988. This book is different in its upbeat energy and reassurance.
- Busch, Frederick. A Dangerous Profession: A Book about the Writing Life. New York: St. Martin's Press, 1998. Busch pulls out all the stops as he explores some authors, himself included, driven to write despite the risks and discontents. He has also edited Letters to a Fiction Writer (New York: Norton, 1999), a rich compendium of advice from writers living and dead.
- Burke, Carol, and Molly Best Tinsley. *The Creative Process*. New York: St Martin's Press, 1993. Nicely balanced between explanation and exercises, this book seeks to jog the writer's imagination in fiction, poetry, and the essay forms.
- Cassill, R. V. Writing Fiction, 2nd ed. Englewood Cliffs, N. J.: Prentice-Hall, 1975. This wise book and its even better first edition are out-of-print and likely to be long since purloined from your library shelf. Complain to the publisher.
- Danford, Natalie and John Kulka, editors. Scribner's Best of the College Fiction Workshops. New York: Scribner's, 1997–1999. An ongoing series of short story collections culled from workshops around the country by the writing programs, then the series editors, and then a guest editor chosen each year. It gives you a chance to see what's new and what's best in college writing. From the year 2000 it moves from Scribner's to Harcourt Brace, where it will be called Best New American Voices.
- Dillard, Annie. *The Writing Life*. New York: HarperCollins, 1989. This stunningly written account of "your day's triviality" touches drudgery itself with luminous significance. Every writer should read it. Also recommended is Dillard's *Living by Fiction* (New York: Harper, 1982).

- Edwards, Betty. Drawing on the Right Side of the Brain, rev. ed. Los Angeles: J. P. Tarcher, 1989. Although it is aimed at the artist rather than the writer, this book offers invaluable help for writers as well in the ability to think spatially and vividly.
- Elbow, Peter. Writing without Teachers. New York and Oxford: Oxford, 1973. Elbow is excellent on how to keep going, growing, and cooking when you haven't the goads of teacher and deadline. Writing with Power (New York and Oxford: Oxford, 1981) is not aimed specifically at the imaginative writer, but still has useful advice and a good section on revising.
- Forster, E. M. Aspects of the Novel. New York: Harcourt Brace Jovanovich, 1956. Forster delivered these Clark Lectures at Trinity College, Cambridge, England, in 1927. They are talkative, informal, and informative—still the best analysis of literature from a writer's point of view—a must.
- Friedman, Bonnie. Writing Past Dark. New York: HarperCollins, 1993. Richly written ruminations on the writer's life illuminates this book. If you think writing is a lonely task, and you can only afford one book, buy this one.
- Gardner, John. The Art of Fiction: Notes on Craft for Young Writers. New York: Alfred A. Knopf, 1984. The Art of Fiction is a new classic among books on writing. Gardner's advice is based on his experience as a teacher of creative writing and is addressed to "the serious beginning writer." The book is clear, practical, and a delight to read. Also recommended is Gardner's On Becoming a Novelist (New York: HarperCollins, 1985).
- Gass, William. Fiction and the Figures of Life. Boston: David R. Godine, 1979. Gass writes of character, language, philosophy, and form, from acute angles in stunning prose—a joy to read.
- Goldberg, Natalie. Writing Down the Bones. Boston: Shambala, 1986. Also, Wild Mind. New York: Bantam, 1990. Goldberg is the guru of can-do, encouraging the writer with short, pithy, personal, and lively cheerings-on.
- Heffron, Jack, editor. *The Best Writing on Writing*. Cincinnati: Story Press, ongoing. "The Best" series brings together book excerpts, articles, and lectures by writers. It is always a well-chosen selection and an excellent source of current thought about the craft.
- Hills, Rust. Writing in General and the Short Story in Particular. Boston: Houghton Mifflin, 1987. A former literary editor of Esquire Magazine, Hills has written a breezy, enjoyable guide to fictional technique with good advice on every page.
- Huddle, David. The Writing Habit: Essays. Layton, Utah: Peregrine Smith Books, 1991. Huddle has a level voice and a sound sense of what it is to live with the habit. He is kind without sentimentality; this book is highly recommended.
- James, Henry. *The House of Fiction*. Westport, Conn.: Greenwood, 1973. The master of indirection goes directly to the heart of the house of fiction.

- Jason, Philip K., and Allan B. Lefcowitz. *Creative Writer's Handbook*, 2nd ed. Englewood Cliffs, N. J.: Prentice-Hall, 1994. This is a comprehensive, thoughtful and readable guide to craft.
- Kaplan, David Michael. Revision: A Creative Approach to Writing and Rewriting Fiction. Cincinnati: Story Press, 1997. Kaplan convinces you that writing is revising, and that not only style and structure but meaning itself depend on the seeing-again part of the process. He's a pleasure to read, so you know he has practiced his preachings.
- Kercheval, Jesse Lee. Building Fiction: How to Develop Plot and Structure. Cincinnati: Story Press, 1997. This personal and personable guide to fiction actually covers much more than structure and does so in a clear, encouraging way.
- Lamott, Anne. Bird by Bird. New York: Pantheon, 1994. Breezy, easy-reading, and full of witty, good advice, Bird by Bird (of which a chapter appears in this book) takes you from shitty first drafts through publication blues.
- Lodge, David. *The Art of Fiction*. London: Penguin, 1992. A collection of Lodge's articles for British and American newspapers, this is not a how-to book but a work of short critical analyses. Nevertheless it crackles with insight and advice for writers.
- Madden, David. Revising Fiction: A Handbook for Fiction Writers. New York: New American Library, 1995. Although it is too weighty to operate as a handbook, this volume, uniquely devoted to the art of revising, shows the process convincingly and in full. Also useful as a reference tool is Madden's A Primer of the Novel for Readers and Writers, Lanham, Md.: Scarecrow Press, 1980.
- May, Rollo. *The Courage to Create*. New York: Bantam, 1984. May's book is a philosophic classic on the subject.
- Minot, Stephen. *Three Genres*, 6th ed. Upper Saddle River, N. J.: Prentice-Hall, 1998. This text covers the writing of poetry, fiction, and drama, so that each is necessarily treated briefly. Nevertheless, Minot is direct and insightful, well worth reading.
- Nelson, Victoria. On Writer's Block: A New Approach to Creativity. Boston: Houghton Mifflin, 1993. Among the new breed of writers' books that use the insights of psychology and therapy, this is exceptionally helpful. Nelson is sensible as well as sensitive. Her suggestions work.
- Novakovich, Josip. *Fiction Writer's Workshop*. Cincinnati: Story Press, 1995. Designed as a "workshop" you can take on your own, this is a practical and sensible guide through the elements of fiction.
- Olsen, Tillie. Silences. New York: Delacorte Press, 1978. Silences is comprised of eloquent essays, of which the title piece is a must.
- Pack, Robert, and Jay Parini, eds. Writers on Writing. Middlebury, Vt.: Middlebury College Press, 1991. Described by the editors as a "celebration," this volume

- collects twenty-five eloquent essays by established writers who offer advice and experience that is practical, witty, confessional, flip, and moving and/or profound.
- Petracca, Michael. The Graceful Lie: A Method for Making Fiction. Upper Saddle River, N. J.: Prentice Hall, 1999. Petracca adds his personable voice to the chorus of encouragement, and he also offers advice for writing in a number of forms and genres: prose poetry, creative nonfiction, young adult, mystery, historical, and science as well as literary fiction.
- Rico, Gabriele Lusser. Writing the Natural Way. Los Angeles: J. P. Tarcher, 1983. Rico describes in full the technique of clustering and offers useful techniques for freeing the imagination.
- Shelnutt, Eve. *The Writing Room*. Marietta, Ga.: Longstreet Press, 1989. This is a wide-ranging, outspoken, often persuasive discussion of the crafts of fiction and poetry, with examples, analyses, and exercises.
- Sloane, William. *The Craft of Writing*, edited by Julia Sloane. New York: Norton, 1983. This book was culled posthumously from the notes of one of the great teachers of fiction writing. The advice he gives is solid and memorable, and the reader's only regret is that there isn't more.
- Stafford, William. Writing the Australian Crawl, edited by Donald Hall. Ann Arbor, Mich.: University of Michigan Press, 1978. The poet has affable and practical advice for fiction writers too. Also, You Must Revise Your Life. Ann Arbor, Mich.: University of Michigan Press, 1986, is an inspiriting potpourri of poems, essays, and interviews on writing.
- Stern, Jerome. Making Shapely Fiction. New York: Norton, 1991. In this witty, useful guide, Stern illustrates various possible shapes for stories; he includes a cogent list of don'ts and discusses the elements of good writing in dictionary form so that you can use the book as a handy reference.
- Strunk, William C., and E. B. White. *The Elements of Style*, 3rd ed. Boston: Allyn and Bacon, 1979. Strunk provides the rules for correct usage and vigorous writing in this briefest and most useful of handbooks.
- Ueland, Barbara. If You Want to Write. St. Paul: Graywolf Press, 1987. "Everybody is talented. Everybody is original," Ueland says, and she says it convincingly in this book that holds up very well since its first edition in 1938.
- Welty, Eudora. One Writer's Beginnings. Cambridge, Mass.: Harvard Press, 1984. One of the best autobiographies ever offered by a writer, Welty's book is moving, funny, and full of insight.
- Willis, Meredith Sue. Personal Fiction Writing, 1984; Blazing Pencils, 1990; and Deep Revision, 1993, all published by Teachers & Writers Collaborative, New York. Willis teaches from elementary to college-level and developmental workshops, both fiction and non-fiction, so her advice is a bit diffuse, but excellent never-

- theless, and on the whole bears out her contention that "the heart of what happens in writing is shared by all writers, professional and avocational, adult and child." Deep Revision, especially, has many useful "do this" sections.
- Woodruff, Jay, ed. A Piece of Work: Five Writers Discuss Their Revisions. Iowa City, Ia.: University of Iowa Press, 1993. Poets and fiction writers (including Tobias Wolff and Joyce Carol Oates whose stories are included in this volume) discuss their drafts, their writing processes, and much more.
- Ziegler, Alan. The Writing Workshop (in two volumes). New York: Teachers and Writers Collaborative, 1981 and 1984. The author calls these useful books a "survey course" in writing. They are mainly intended for teachers of writing but can be adapted to use as a self-teaching tool; they're full of interesting practical advice.
- Zinsser, William, ed. Inventing the Truth: The Art and Craft of Memoir. Boston: Houghton Mifflin, 1988. Although this series of talks, originally given at the New York Public Library, is not aimed at the fiction writer, they shine with hints on how to use the subject matter of your life from five fine writers: Annie Dillard, Toni Morrison, Russell Baker, Alfred Kazin, and Lewis Thomas.

Marketing

Of the guides and services offered to writers, three of the most helpful follow.

- Associated Writing Programs (Tallwood House, Mail Stop 1E3, George Mason University, Fairfax, VA 22030). Those enrolled in the creative writing program of a college or university that is a member of AWP are automatically members; others can join for a reasonable fee. AWP's services include a magazine, The Writer's Chronicle, a catalog of writing programs, a placement service, an annual meeting, and a number of awards and publications. The organization is probably the nearest thing to a "network" of writers in the nation and can provide contact with other writers, as well as valuable information on prizes, programs, presses, and the ideas current in the teaching of writing.
- Poets & Writers, Inc. (72 Spring St., New York, NY 10012). Poets & Writers issues a bimonthly magazine of the same name that has articles of high quality and interest to writers, and provide information on contests and on magazines and publishers soliciting manuscripts. The organization also has a number of useful publications that are periodically revised: the Directory of American Poets and Fiction Writers, Literary Agents: A Writer's Guide, Author and Audience: A Readings and Workshops Guide, and an annual listing called Writers' Conferences.
- Writer's Market. Cincinnati: Writer's Digest Books, ongoing. A new edition comes out each year with practical advice on how to sell manuscripts as well as lists of book and magazine publishers, agents, foreign markets, and other services for writers.

Credits

Chinua Achebe, "Girls at War" from GIRLS AT WAR AND OTHER STORIES by Chinua Achebe. Copyright © 1972, 1973 by Chinua Achebe. Used by permission of Doubleday, a division of Random House, Inc. and Harold Ober Associates Incorporated.

Sherman Alexie, "The Only Traffic Signal on the Reservation Doesn't Flash Red Anymore" from THE LONE RANGER AND TONTO FISTFIGHT IN HEAVEN by Sherman Alexie. Copyright © 1993 by Sherman Alexie. Used by permission of Grove/Atlantic, Inc.

John Barth, "Ad Infinitum" from ON WITH THE STORY by John Barth. Copyright © 1996 by John Barth. By permission of Little, Brown and Company.

Charles Baxter, "Gryphon" from THROUGH THE SAFETY NET by Charles Baxter. Copyright © 1985 by Charles Baxter. Reprinted by permission of Viking Penguin, a division of Penguin Putnam, Inc.

Frederick Busch, "Ralph the Duck" from ABSENT FRIENDS by Frederick Busch. Copyright © 1989 by Frederick Busch. Reprinted by permission of Alfred A. Knopf, Inc.

Robert Olen Butler, from "Jealous Husband Returns in Form of Parrot" from TABLOID DREAMS, copyright© 1996 by Robert Olen Butler. Reprinted by permission of Henry Holt and Company, Inc.

Dino Buzzati, "The Falling Girl" from RESTLESS NIGHTS by Dino Buzzati, translated by Lawrence Venuti. Translation Copyright © 1983 by Lawrence Venuti Used with permission.

Raymond Carver, "A Small Good Thing" from CATHEDRAL by Raymond Carver. Copyright © 1985 by Raymond Carver. Reprinted by permission of Random House, Inc. "The Bath" from WHAT WE TALK ABOUT WHEN WE TALK ABOUT LOVE by Raymond Carver. Copyright © 1981 by Raymond Carver. Reprinted by permission of Random House, Inc.

Lan Samantha Chang, "San" from HUNGER by Lan Samantha Chang. Copyright © 1998 by Lan Samantha Chang. Reprinted by permission of W. W. Norton & Company, Inc.

John Cheever, "The Enormous Radio" from THE STORIES OF JOHN CHEEVER by John Cheever. Copyright © 1947 by John Cheever. Reprinted by permission of Alfred A. Knopf, Inc.

Sandra Cisneros, "Hips" by Sandra Cisneros from THE HOUSE ON MANGO STREET. Copyright © 1984 by Sandra Cisneros. Published by Vintage Books, a division of Random House, Inc., New York and in hardcover by Alfred A. Knopf, Inc. in 1994. Reprinted by permission of Susan Bergholz Literary Services, New York. All rights reserved.

Annie Dillard, from THE WRITING LIFE by Annie Dillard. Copyright © 1989 by Annie Dillard. Reprinted by permission of HarperCollins Publishers, Inc.

Stephen Dunning, "Wanting to Fly" and Drafts by Stephen Dunning. Copyright © 1990 by Stephen Dunning. Reprinted by permission of the author.

Louise Erdrich, "Saint Marie" from LOVE MEDICINE (New and Expanded Version) by Louise Erdrich, © 1984, 1993 by Louise Erdrich. Reprinted by permission of Henry Holt and Company, Inc.

Mary Hood, "How Far She Went" from HOW FAR SHE WENT by Mary Hood. Copyright © 1984 by Mary Hood. Reprinted by permission of The University of Georgia Press.

Charles Johnson, "Menagerie" reprinted with the permission of Scribner, a Division of Simon & Schuster from SORCERER'S APPRENTICE by Charles Johnson. Copyright © 1986 by Charles Johnson.

Jamaica Kincaid, "Girl" from AT THE BOTTOM OF THE RIVER by Jamaica Kincaid. Copyright © 1983 by Jamaica Kincaid. Reprinted by permission of Farrar, Straus & Giroux, Inc.

Anne Lamott, "Shitty First Drafts" from BIRD BY BIRD by Anne Lamott. Copyright © 1994 by Anne Lamott. Reprinted by permission of Pantheon Books, a division of Random House, Inc.

Ursula K. Le Guin, "The Ones Who Walk Away from Omelas." First appeared in NEW DIMENSIONS 3. Copyright © 1973 by Ursula K. Le Guin. Reprinted by permission of the author and Virginia Kidd Literary Agency.

Gabriel García Marquez, "A Very Old Man with Enormous Wings" from LEAF STORM AND OTHER STORIES by Gabriel García Marquez. Copyright © 1971 by Gabriel García Marquez. Reprinted by permission of HarperCollins Publishers, Inc.

Lorrie Moore, "People Like That Are the Only People Here" from BIRDS OF AMERICA by Lorrie Moore. Copyright © 1998 by Lorrie Moore. Reprinted by permission of Alfred A. Knopf, Inc.

Alice Munro, "Royal Beatings" from SELECTED STORIES by Alice Munro. Copyright © 1977, 1978 by Alice Munro. Reprinted by permission of Alfred A. Knopf, Inc. and McClelland & Stewart, Inc., The Canadian Publishers.

Joyce Carol Oates, "Where Are You Going, Where Have You Been?" by Joyce Carol Oates. Copyright © 1970 by Joyce Carol Oates. Reprinted by permission of John Hawkins & Associates, Inc.

Tim O'Brien, "The Things They Carried" from THE THINGS THEY CARRIED. Copyright © 1990 by Tim O'Brien, Reprinted by permission of Houghton Mifflin Co./Seymour Lawrence. All rights reserved.

Grace Paley, "A Man Told Me the Story of His Life" from LATER THE SAME DAY by Grace Paley. Copyright © 1985 by Grace Paley. Reprinted by permission of Farrar, Straus & Giroux, Inc.

Mary Robison, "Yours" from AN AMATEUR'S GUIDE TO THE NIGHT by Mary Robison. Copyright © 1983 by Mary Robison. Reprinted by permission of Random House, Inc.

William Carlos Williams, "The Use of Force" by William Carlos Williams, from THE COLLECTED STO-RIES OF WILLIAM CARLOS WILLIAMS. Copyright © 1938 by William Carlos Williams. Reprinted by permission of New Directions Publishing Corp.

Tobias Wolff, "Bullet in the Brain" from THE NIGHT IN QUESTION by Tobias Wolff. Copyright © 1996 by Tobias Wolff. Reprinted by permission of Alfred A. Knopf, Inc.

Index

Abbey, The (Spark), 277–278	Beckett, Samuel, Murphy, 140
abstraction, 59	Becoming a Writer (Brande), 5
abstract reasoning, 304–305	Before and After (Brown), 181
Achebe, Chinua, Girls at War, 145-156	"Before the Change" (Munro), 133, 207
action, 106–108	Bellow, Saul, Seize the Day, 139–140
dialogue for advancing, 132	Bentley, Eric, Life of the Drama, The, 97
active voice, 61–63	Bergson, Henri, "On Laughter," 94
"Ad Infinitum: A Short Story" (Barth), 324–330	"Big Boy Leaves Home" (Wright), 210
advancing the action, dialogue for, 132	Bird by Bird (Lamott), 16–19
adventure stories, 368	Bluest Eye, The (Morrison), 132
"Age of Grief, The" (Smiley), 106–107	Bly, Carolyn, 333
Alexandria Quartet (Durrell), 2	Passionate, Accurate Story, The, 198
Alexie, Sherman, "Only Traffic Signal on the Reservation	Bodily Harm (Atwood), 30, 32
Doesn't Flash Red Anymore, The" 119–126	"Body Language" (Schoemperlen), 201
alien and familiar settings, 175–176	"Bontsha the Silent" (Peretz), 247
All American Girls (Haynes), 138	Book of Common Prayer (Didion), 131
allegory, 277–278	Bradbury, Ray, Martian Chronicles, 175
Animal Farm (Orwell), 97, 277	Brande, Dorothea, Becoming a Writer, 5, 11
appearance, 102, 104–106, 127	"Breathing" (Dubus), 184
Aristotle, Poetics, The, 37, 99–100	Brecht, Bertolt, 306
"Artificial Nigger, The" (O'Connor), 141	Briefing for a Descent into Hell (Lessing), 246
artificial symbol, 282	Brookner, Anita, Look at Me, 1–2
Art of Fiction, The (Gardner), 10, 54, 59–60, 310	Brothers, The (Barthelme), 271
Aspects of the Novel (Forster), 28, 200, 247–248	Brown, Rosellen, Before and After, 181, 184
Atchity, Kenneth, Writer's Time, A, 335	"Bullet in the Brain" (Wolff), 190–194, 242
atmosphere	Burning Down the House (Baxter), 29, 176
setting and, 169–178	Burroway, Janet
time, distance, and, 238–239	Buzzards, The, 12
Atwood, Margaret	Raw Silk, 238, 277
Bodily Harm, 30, 32	Busch, Frederick
Edible Woman, The, 105	"Company," 65–66
Lady Oracle, 179–180	"Ralph the Duck," 313–323
"Simmering," 235–236	Sometimes I Live in the Country, 238
Auden, W. H., 14 audience, 205–210	"Bus to St. James's, The" (Cheever), 170
	Butler, Robert Olen, "Jealous Husband Returns in Form of
another character as, 207–208 reader as, 206–207	Parrot," 261–264
self as, 208–210	Butler, Samuel, Erewhon, 169
Austen, Jane	Buzzards, The (Burroway), 12
Emma, 141–142	Buzzati, Dino, "Falling Girl, The," 290–293
Mansfield Park, 104, 311	Caine Mutiny, The (Wouk), 140
Persuasion, 65, 306	Camus, Albert, 306
author	Fall, The, 207–208
objective, 201–202	
omniscient, 197–201	caricature, 96 Carlson, Ron, 11
authorial distance, 235–237	
authorial interpretation, 102–103	Carroll, Lewis, Through the Looking Glass, 130 Carter, Angela, Heroes and Villains, 178
authorial intrusion, 200	Carver, Raymond
autobiography, in fiction, 9–10	
autobiography, in fiction, 9–10	"Bath, The," 344–348
"Babysitter, The" (Coover), 173, 175, 176	"Neighbors," 108
background, conflict and, 170–171	"Small, Good Thing, A," 349–365
backstory, 182	Catch-22 (Heller), 177
Ballard, J. G., "Chronopolis," 168–169	central narrator, 204 Chang, Lan Samantha, S <i>an</i> ., 282–290
"Barbie-Q" (Cisneros), 98	
Barth, John, "Ad Infinitum: A Short Story," 324–330	character, 144–145. See also characterization; point of view another, as audience, 207–208
Barthelme, Frederick, Brothers, The, 271	conflict and, 170–171
Barzun, Jacques, "Writer's Discipline, A," 2	characterization, 94–126, 127–166
"Bath, The" (Carver), 344–348	action, 106–108
Bausch, Richard	action, 100–106 appearance, 104–106
"Consolation," 34	complexity, 100–100
"Fireman's Wife, The," 132	and conflict, 139–143
Baxter, Charles, 30	creating a group or crowd, 143–144
Burning Down the House, 29, 176	credibility, 97–99
Gryphon, 248–260	direct presentation method, 102, 104–108, 127–144

format and style in, 135-138	Cuomo, George, 3
indirect presentation method, 102-103	"Cure, The" (Cheever), 107
purpose, 99–100	
speech in, 128–135	Day of the Locust, The (West), 271-272
thought in, 138–139	"Dead, The" (Joyce), 64
Cheever, John	dead metaphor, 272
"Bus to St. James's, The," 170	Death of Ivan Ilyich, The (Tolstoy), 141, 240
"Cure, The," 107	Decline and Fall of Daphne Finn, The (Moody), 204, 205
"Enormous Radio, The," 109–116	DeLillo, Don, Underworld, 144, 168
Chekov, Anton, 305	dénouement, 35
Child in Time, A (McEwan), 184	destiny, 106
"Chronopolis" (Ballard), 168–169	detail
Ciardi, John, 305	in characterization, 95–96
	concrete, 55–56
"Cinderella," 305	
story form diagram of, 35 37	insufficient, 59
circumstantial summary, 180	sense, 55
Cisneros, Sandra	significant, 54–59
"Barbie-Q," 98	detective story, 368
"Hips," 215–217	dialect, 136-137
"Little Miracle, Kept Promises," 207	dialogue, 129–138
classical epic, viewpoint in, 199	action and, 133
	for advancing action, 132
cliché, 270, 274–275	
clustering, 5–8	format and style of, 135–138
Cocteau, Jean, 15	freewriting and, 131
communication, speech and, 128–135	memory and, 132
"Commuter Marriage, The" (Wickersham), 128	plausibility of, 135
"Company" (Busch), 65–66	for revealing the past, 132
comparison, 268–302	tags for, 136
allegory, 277–278	diary, 208, 211
faults to avoid, 273–277	Diary of a Madman, The (Gogol), 208, 246
metaphor and simile, 269–273	Dickens, Charles, 3
	Dombey and Son, 97
objective correlative, 280–282	
symbol, 278–280	Didion, Joan
complexity, 100–102	Book of Common Prayer, 131
computers, 9	"Why I Write," 304
conceit, 271–272	dilemma, 12
concrete detail, 55–56	Dillard, Annie, 9
Confessions of Felix Krull, Confidence Man (Mann), 54-55, 62	"Writing Life, The," 19–25
Confessions of Zeno (Svevo), 246	direct dialogue, 129-130
conflict	direct presentation method, of characterization, 104-108,
character, setting, and, 170–171	127–144
	disbelief, 269
crisis, resolution, and, 29–33, 38–39	
between presentation methods, 139–143	disconnection, connection and, 33–35
connection, 12	"Dishwasher, The" (McBrearty), 236, 242
disconnection and, 33–35, 37	Dispossessed, The (LeGuin), 169
Conrad, Joseph, Heart of Darkness, 205, 271, 310	distance
"Consolation" (Bausch), 34	authorial, 235–237
continuing, 13–15	intangible, 240–243
conversation, 129	spatial and temporal, 237-240
Cooper, J. California, "Watcher, The," 244	Dombey and Son (Dickens), 97
	Donne, John, 271
Coover, Robert	
"Babysitter, The," 173, 175, 176	Drabble, Margaret, Garrick Year, The, 278–279
"Gingerbread House, The," 173–174	drafts and drafting, 14. See also revision
"Panel Game," 173, 174	first, 16–19
Pricksongs and Descants, 173	dramatic irony, 242
cosmic, 141	Dubus, Andrew, "Breathing," 184
cosmic irony, 242	Dunning, Stephen, "Wanting to Fly," 337-343
Courage to Create, The (May), 333-334	Dunnock, Mildred, 102
Craft of Fiction, The (Knott), 332	Durrell, Lawrence
Craft of Writing, The (Sloane), 96, 129	Alexandria Quartet, 2
	Justine, 62–63
credibility, 97–99	Justille, 02-03
crisis, 36	DUL WI TH /A 13 107
conflict, resolution, and, 29–33	Edible Woman, The (Atwood), 105
recognition scenes and, 37	editorial omniscient author, 198
as scene, 180–181	Elements of Style, The (Strunk), 54
criticism, and revision, 8-9, 335	Eliot, T. S., 305
crowd, 143–144	"Sacred Wood, The," 280

Emma (Austen), 141-142	"Girl" (Kincaid), 213–214
emotion	Girls at War (Achebe), 145-156
speech and, 133	God Bless You, Mr. Rosewater (Vonnegut), 130
writing about, 11	Godwin, Gail, 3, 311
endings, happy, 31	Odd Woman, The, 199-200, 210
"Enormous Radio, The" (Cheever), 109-116	Gogol, Nikolai, Diary of a Madman, The, 208, 246
epiphany, 37-38	Going After Cacciato (O'Brien), 177
epistolary novel or story, 207	Goldberg, Natalie, 15
Erdrich, Louise	"Gold Coast" (McPherson), 237
"Machimanito," 271	Golding, William
Saint Marie, 156-164	Inheritors, The, 100, 247, 274-275, 279
Erewhon (Butler), 169	Pincher Martin, 178
essay, fiction compared with, 309-310	"Good Man Is Hard to Find, A" (O'Connor), 270
Even Cowgirls Get the Blues (Robbins), 203, 272	Gordimer, Nadine, Sport of Nature, A, 184-185
events, 40-41	grammar, 66–67
"Everything That Rises Must Converge" (O'Connor), 170,	Grass, Gunter, Tin Drum, The, 105
275, 278, 279	Great Gatsby, The (Fitzgerald), 205
experience, writing about, 9–12	group, 143–144
experimental fiction, 369	Gryphon (Baxter), 248-260
F II TI (O) 207 200	Hall, Donald, 3
Fall, The (Camus), 207–208	Hall, James W., Under Cover of Daylight, 183
"falling action," 35–37	Hamlet (Shakespeare), 32
"Falling Girl, The" (Buzzati), 290–293	Hansen, Ron, Mariette in Ecstasy, 61–62
Farewell to Arms, A (Hemingway), 177, 276	happy endings, 31
far-fetched metaphors, 275–276	harmony, character, setting, and, 170–171
Faulkner, William, 336	Haynes, David, All American Girls, 138
"Rose for Emily, The," 204	Heart of Darkness (Conrad), 205, 271, 310
Sound and the Fury, The, 247	Heller, Joseph, Catch-22, 177
feeling, in literature, 53–54	Helprin, Mark, "Schreuderspitze, The," 97
Female Friends (Weldon), 105	Hemingway, Ernest, 3, 101
fiction, kinds of, 367-370	Farewell to Arms, A, 177, 276
fictional elements, in theme, 307	"Hills Like White Elephants," 201
filtering, 59–61	Old Man and the Sea, The, 133
"Fireman's Wife, The" (Bausch), 132	Heroes and Villains (Carter), 178
first drafts, 16-19	"Her Warrior" (Kariara), 243
first person, 204–205	
Fitzgerald, F. Scott, 175	Hills, Rust, Writing in General and the Short Story in Particular, 204–205
Great Gatsby, The, 205	
flashback, 182–183	"Hills Like White Elephants" (Hemingway), 201
foreground, conflict and, 170	"Hips" (Cisneros), 215–217
form	history. See time, narrative
of novel, 42	Hood, Mary, How Far She Went, 46–51
point of view and, 211–213	Hopkins, Gerard Manley, 306
format, of dialogue, 135-138	horror stories, 368
formula plot, 282	House, Humphry, 39–40
formula story, 28	How Far She Went (Hood), 46–51
Fornes, Maria Irene, 4	"How I Contemplated the World from the Detroit House of
Forster, E. M., 40	Correction and Began My Life Over Again" (Oates),
Aspects of the Novel, 28, 200, 247-248	96–97
Passage to India, A, 174	Huckleberry Finn (Twain), 244–245
Where Angels Fear to Tread, 242	Humphries, Rolfe, 64
Four-Gated City (Lessing), 100	Hurston, Zora Neale, "Gilded Six-Bits, The," 140
freewriting, 4–5, 11–12	Hustvedt, Siri, "Mr. Morning," 128–129
dialogue writing and, 131	
Freitag, Gustav, 35	Ibuse, Masuji, "Tajinko Village," 105
Friedman, Bonnie, Writing Past Dark, 281–282	idea, theme and, 304–307
,	illusion, 269–270
	imagery. See metaphors; simile
Gardner, John, 15	impersonal author. See objective author
Art of Fiction, The, 10, 54, 59-60, 310	incongruity, 12
Garrick Year, The (Drabble), 278-279	indirect character presentation, 102–103
Gass, William H., "In the Heart of the Country," 209	indirect speech, 129
generalized story, 211	inevitability, 106
Genet, Jean, Our Lady of the Flowers, 100	Inheritors, The (Golding), 100, 247, 274-275, 279
genre fiction, 367–368, 369	intangible distance, 240–243
"Gilded Six-Bits, The" (Hurston), 140	irony and, 242–243
"Gingerbread House, The" (Coover), 173–174	tone of voice and, 240–241

interior monologue, 208–209	mainstream fiction, 367
"In the Heart of the Country" (Gass), 209	Making Shapely Fiction (Stern), 181
irony	Mann, Thomas
cosmic, 242–243	Confessions of Felix Krull, Confidence Man, 54–55, 62
dramatic, 242	Magic Mountain, The, 238
unreliable narrator and, 245	Mansfield Park (Austen), 104, 311
verbal, 242	"Man Told Me the Story of His Life, A" (Paley), 307–308
Irving, John, World According to Garp, The, 279	Mariette in Ecstasy (Hansen), 61–62
iring, join, worm recording to only, rice, 215	Marquez, Gabriel García, Very Old Man with Enormous Wings
James, Henry, 10	A, 185–189
Portrait of a Lady, 103	Marquis of Lumbria, The (Unamuno), 103
"Jealous Husband Returns in Form of Parrot" (Butler),	Martian Chronicles (Bradbury), 175
261–264	Martin Dressler (Millhauser), 168
Johnson, Charles, "Menagerie," 294–300	May, Rollo, Courage to Create, The, 333–334
	McBrearty, Robert, "Dishwasher, The," 236, 242
Johnson, Claudia, 11, 33–34	McEwan, Ian, Child in Time, A, 184
Johnson, Samuel, 271	
Josipovici, Gabriel, 14	McKee, Mel, 31
journal, 211	McPherson, James Alan, "Gold Coast," 237
characterization and, 95–96	Mechanics, 66–67
self as audience in, 208	memory, dialogue and, 132
journal keeping, 3–4	"Menagerie" (Johnson), 294–300
clustering for, 7	message, theme and, 303
Joyce, James, 37, 306	metafiction, 369
"Dead, The," 64	metaphors, 269–273
1 /lysses, 209–210	clichés and, 274–275
Justine (Durrell), 62–63	dead, 272
	far-fetched, 275–276
Kandy-Kolored Tangerine-Flake Streamline Baby, The (Wolfe),	faults to avoid, 273–277
175	mixed, 276
Kariara, Jonathan, "Her Warrior," 243	obscure, 277
Kelley, William Levin, "Passing," 98	overdone, 277
Kesey, Ken, One Flew Over the Cuckoo's Nest, 100, 270	topical references and, 278
Kincaid, Jamaica, "Girl," 213–214	"Method" acting, 95
Knott, William C., Craft of Fiction, The, 332	methods of character presentation, 102-103
Kostner, Richard, 2	Middlemarch, 101
	Millhauser, Steven, Martin Dressler, 168
Lady Oracle (Atwood), 179–180	minimalism, 370
Lamott, Anne, Bird by Bird, 16-19	Minot, Stephen, Three Genres, 12
Lancelot (Percy), 246	Miss Lonelyhearts (West), 270
Larkin, Philip, 3	mixed metaphors, 276
Lattimore, Richard, 311	Modern English Usage (Fowler), 272
law, abstract reasoning and, 305	Mom Kills Self and Kids (Saperstein), 101
Lawrence, D. H., "Odour of Chrysanthemums," 241, 242	monologue, 131, 211
Le Guin, Ursula K., 33	interior, 208–209
Dispossessed, The, 169	mood, dialogue for setting, 131
Lessing, Doris	Moody, R. Bruce, Decline and Fall of Daphne Finn, The, 204,
Briefing for a Descent into Hell, 246	205
Four-Gated City, 100	Moody, Rick, Purple America, 281
Life of the Drama, The (Bentley), 97	Moore, Lorrie, 10
"Life You Save May Be Your Own, The" (O'Connor), 171–172	"People Like That Are the Only People Here," 132,
limited omniscient viewpoint, 199–201	211–213
linking verbs, 62–63	morality, theme and, 304–307
literary experience, value of, 305	Morrison, Toni
literary fiction, 367	Bluest Eye, The, 132
literature, story as form of, 28–29	"Recitatif," 106
"Little Miracle, Kept Promises" (Cisneros), 207	Moskowitz, Cheryl, 102
"Loneliness of the Long-Distance Runner, The" (Sillitoe),	"Self as Source, The," 101
204, 206–207	"Mr. Morning" (Hustvedt), 128–129
"Long Distance" (Smiley), 139	Mrs. Dalloway (Woolf), 59, 97
	Munro, Alice, 1
Look at Me (Brookner), 1–2	"Before the Change," 133, 207
"Machimanito" (Frdrich), 271	0.
	"Royal Beatings," 217–233
Madden, David Primer of the Novel for Readers and Writers, A, 182	Selected Stories, 332–333
Suicide's Wife, The, 30	Murphy (Beckett), 140
	Nahakay Vladimir 304
Magic Mountain, The (Mann), 238 magic realism, 369–370	Nabakov, Vladimir, 304 narrative, 34
magic rearism, 507-570	Harrative, JT

-l:kili	B
plausibility of, 135	Persuasion (Austen), 65, 306
narrative time. See time, narrative	Pillow Book (Shonagun), 11
narrator, 204. See also audience; person	Pincher Martin (Golding), 178
unreliable, 244–245	place and time, 167–195
"Neighbors" (Carver), 108	plausibility, 135
Nelson, Victoria, On Writer's Block: A New Approach to Creativity, 15	plot
New Yorker, The, audience for, 206	conflict, crisis, and resolution in, 29–33, 38–39 connection and disconnection in, 33–35
novel	defined, 39
form of, 42	revenge in, 38
short story compared with, 41–42	story and, 39–41
short story compared with, 41–42	story form as check mark shape and, 35–39
Oates, Joyce Carol	Poetics, The (Aristotle), 37, 99–100
"How I Contemplated the World from the Detroit House	poetry, conceit in, 271
of Correction and Began My Life Over Again,"	point of view, 196–234, 235–267
96–97	audience and, 205–210
"Where Are You Going, Where Have You Been?" 80–92,	distance, 235–243
242	form and, 211–213
objective author, 201–202	limitations of, 243–248
objective correlative, 280–282	person and, 197–205
O'Brien, Tim	shifts in, 202
Going After Cacciato, 177	Porter, Katherine Anne, "Rope," 128
"Things They Carried, The", 66, 67–79	Portrait of a Lady (James), 103
obscure metaphors, 277	power, shifting of, 32–33
O'Connor, Flannery	present tense, 239–240
"Artificial Nigger, The," 141	Pricksongs and Descants (Coover), 173
"Everything That Rises Must Converge," 170, 275, 278,	Primer of the Novel for Readers and Writers, A (Madden), 182
279	prose rhythm, 63–66
"Good Man Is Hard to Find, A," 270	psychic distance. See authorial distance
"Life You Save May Be Your Own, The," 171–172	punctuation, 66–67
Odd Woman, The (Godwin), 199–200, 210	of dialogue, 136–137
"Odour of Chrysanthemums" (Lawrence), 241, 242	Purple America (Moody), 281
Oedipus Rex (Sophocles), 40, 305	purpose, in characterization, 99–100
dramatic irony in, 242	parpose, in characteristicin, 3,5 200
Old Man and the Sea, The (Hemingway), 133	questions about revision, 336–337
Olsen, Tillie, "Tell Me a Riddle," 64–65	quotation marks, for dialogue, 136–137
omniscient author, 197–201	1
One Flew Over the Cuckoo's Nest (Kesey), 100, 270	"Ralph the Duck" (Busch), 313-323
one-mind limited omniscient viewpoint, 200-201	Raw Silk (Burroway), 238, 277
"On Laughter" (Bergson), 94	reader, as audience, 206–207
"Only Traffic Signal on the Reservation Doesn't Flash Red	Reader's Digest, audience for, 206
Anymore, The" (Alexie), 119-126	realism, 368
On Writer's Block: A New Approach to Creativity (Nelson), 15	"Recitatif" (Morrison), 106
opaque character, 201	recognition scenes, 37
oratory, 211	rejection letter, 28
Orwell, George, Animal Farm, 97, 277	resolution, crisis, conflict, and, 29-33, 38-39
Our Lady of the Flowers (Genet), 100	revenge, 13, 38
overdone metaphors, 278	revision
	criticism and, 8–9, 335
Paley, Grace, "Man Told Me the Story of His Life, A,"	example of, 337–342
307–308	letting go and, 333–335
"Panel Game" (Coover), 173, 174	questions about, 336–337
Passage to India, A (Forster), 174	rewriting, 333. See also revision
"Passing" (Kelley), 98	rhythm, prose, 63–66
Passionate, Accurate Story, The (Bly), 198	Rico, Gabriele, Writing the Natural Way, 5, 6
past, flashback and, 182	Right Stuff, The (Wolfe), 58-59
"pathetic fallacy," 63	Robbins, Tom, Even Cowgirls Get the Blues, 203, 272
"People Like That Are the Only People Here" (Moore), 132,	Robison, Mary, Yours, 117-118
211–213	romance genre, 367
Percy, Walker, Lancelot, 246	Romeo and Juliet (Shakespeare), 33
Peretz, Isaac Loeb, "Bontsha the Silent," 247	"Rope" (Porter), 128
peripheral narrator, 204	"Rose for Emily, The" (Faulkner), 204
person, 197–205	"Roselily" (Walker), 236
defined, 202	"Royal Beatings" (Munro), 217–233
first, 204–205	Ruskin, John, 63
second, 202-203	The same of the sa
third 197_202	"Sacred Wood, The" (Fliot), 280

Satnt Murie (Erdrich), 156-164	Stanislavski Method, 95
San (Chang), 282-290	starting to write, 3–13
Saperstein, Alan, Mom Kills Self and Kids, 101	Stern, Jerome, 167
Sartre, Jean-Paul, 178	Making Shapely Fiction, 181
scene, 178–182	Stevenson, Robert Lewis, Strange Case of Dr. Jekyll and Mr.
crisis as, 180–181	Hyde, The, 101
dialogue for setting, 131	story
summary compared with, 181	defined, 39
Schoemperlen, Diane, "Body Language," 201	plot and, 39–41
"Schreuderspitze, The" (Helprin), 97	story form and structure, 27-52
science fiction, 368	conflict, crisis, and resolution, 29–33
second person, 202-203	connection and disconnection, 33-35
Seize the Day (Bellow), 139-140	short story and novel, 41-42
Selected Stories (Munro), 332–333	story and plot, 39-41
self, as audience, 208–210	story form as check mark, 35-39
"Self as Source, The" (Moskowitz), 101	storytelling, 27
self-betrayal, 141	Forster on, 28
sense detail, 55	Strange Case of Dr. Jekyll and Mr. Hyde, The (Stevenson), 101
sequential summary, 180	stream of consciousness, 209
setting, 169–178	Strunk, William, Jr., Elements of Style, 54
alien and familiar, 175–176	style, of dialogue, 135-138
symbolic and suggestive, 171-174	subject, choosing, 9-13
setting the scene, with dialogue, 131	Suicide's Wife, The (Madden), 30
Settle, Mary Lee, 3	summary, 129, 178–182
Shaara, Michael, 32	function of, 181
Shakcapeare, William	scene compared with, 181
Hamlet, 32	Svevo, Italo, Confessions of Zeno, 246
Romeo and Juliet, 33	symbol, 278–280
symbolic and suggestive setting in, 171	symbolic and suggestive setting, 171-174
shape, of short story, 35–39	symbolism, 279–280
Shedding Skin (Ward), 130	
Shonagun, Sei, Pillow Book, 11	"Tajinko Village" (Ibuse), 105
short story	"Tambourine Lady" (Wideman), 210
novel compared with, 41–42	Taylor, Sheila, 14
shape of, 35–39	teller. See narrator
showing and telling, 53–93	"Tell Me a Riddle" (Olsen), 64–65
active voice in, 61–63	temporal distance, 237-240
filtering in, 59–61	tense. See also time, narrative
mechanics in, 66-67	change of, 239-240
prose rhythm in, 63–66	tension, 141, 142
significant detail in, 54-59	speech and, 133, 134
significant detail, 54-59	theme, 15–16
Sillitoe, Alan, "Loneliness of the Long-Distance Runner,	developing, 309-313
The," 204, 206–207	dialogue for, 131–132
simile, 269–273	fictional elements and, 307-309
"Simmering" (Atwood), 235–236	idea and morality in, 304-307
Sloane, William, 131	"Things They Carried, The" (O'Brien), 66, 67-79
Craft of Writing, The, 96, 129	third person, 197–202
slow motion, 183–185	This Boy's Life (Wolff), 33
"Small, Good Thing, A" (Carver), 349–365	thought, 102, 138-139
Smiley, Jane	Three Genres (Minot), 12
"Age of Grief, The," 106–107	thrillers, 368
"Long Distance," 139	Through the Looking Glass (Carroll), 130
social justification, of literature, 96	time, narrative, 167–195. See also distance; tense
Sometimes I Live in the Country (Busch), 238	aspects of, 178–185
Sophocles, Oedipus Rex, 40, 242, 305	flashback, 182–183
sound. See speech	setting and atmosphere, 169–178
Sound and the Fury, The (Faulkner), 247	slow motion, 183–185
Spark, Muriel, Abbey, The, 277–278	summary and scene, 178–182
spatial distance, 237–240	Tin Drum, The (Grass), 105
speech, 102, 128–138. See also dialogue	Tolstoy, Leo
function of, 133	Death of Ivan Ilyich, The, 141, 240
spelling, 66–67	War and Peace, 177, 199
Sport of Nature, A (Gordimer), 184–185	tonal dialogue tags, 136
spy stories, 368	tone of voice, 240–241
Stafford, William, 15	topical references, metaphors and, 278
standard English 137	transplant 13

Twain, Mark, Huckleberry Finn, 244–245 typical character, 96

Ulysses (Joyce), 209–210
Unamuno, Miguel de, Marquis of Lumbria, The, 103
Under Cover of Daylight (Hall), 183
Underworld (DeLillo), 144, 168
universal character, 96
unreliable narrator, 244–245
Updike, John, 137

"Use of Force, The" (Williams), 31-32, 42-45

verbal irony, 242
verbs, linking, 62–63
Very Old Man with Enormous Wings, A (Marquez), 185–189
viewpoint. See point of view
voice. See also Point of view; speech; tone of voice;
active, 61–63
Vonnegut, Kurt, God Bless You, Mr. Rosewater, 130

Wakowski, Diane, 3 Walker, Alice, "Roselily," 236 "Wanting to Fly" (Dunning), 337-343 War and Peace (Tolstoy), 177, 199 Ward, Robert, Shedding Skin, 130 "Watcher, The" (Cooper), 244 Watership Down, 94 weakness, power of, 32-33 Weldon, Fay, Female Friends, 105 Welty, Eudora, 335 West, Nathanael Day of the Locust, The, 271-272 Miss Lonelyhearts, 270 western story, 368 Where Angels Fear to Tread (Forster), 242 "Where Are You Going, Where Have You Been?" (Oates), 80-92, 100, 242 "Why I Write" (Didion), 304

Wickersham, Joan, "Commuter Marriage, The," 128 Wideman, John Edgar, "Tambourine Lady," 210 Williams, Joy, "Woods," 131 Williams, William Carlos, "Use of Force, The," 31-32, 42-45 Wolfe, Thomas, 3 Wolfe, Tom Kandy-Kolored Tangerine-Flake Streamline Baby, The, 175 Right Stuff, The, 58-59 Wolff, Tobias "Bullet in the Brain," 190-194, 242 This Boy's Life, 33 "Woods" (Williams), 131 Woolf, Virginia, Mrs. Dalloway, 59 World According to Garp, The (Irving), 279 "World's Best Short Short Story Contest," Dunning and, 337 Wouk, Herman, Caine Mutiny, The, 140 Wright, Richard, "Big Boy Leaves Home," 210 writer's block, 14-15 "Writer's Discipline, A" (Barzun), 2 Writer's Time, A (Atchity), 335 writing choosing a subject, 9-13 clustering, 5-8 computers in, 9 continuing, 13-15 first drafts, 16-19 freewriting, 4-5, 11-12 journal keeping, 3-4, 7 starting, 3-13 theme in, 15-16 Writing in General and the Short Story in Particular (Hills), 204-205 "Writing Life, The" (Dillard), 19-25 Writing Past Dark (Friedman), 281-282 Writing process, 1-26 Writing the Natural Way (Rico), 5, 6

"Yours" (Robison), 117-118